WALKER EVANS

THE GETTY MUSEUM COLLECTION

WALKER EVANS

THE GETTY MUSEUM COLLECTION

Judith Keller

THE J. PAUL GETTY MUSEUM · MALIBU, CALIFORNIA

© 1995 The J. Paul Getty Museum
17985 Pacific Coast Highway
Malibu, California 90265-5799

Mailing address:
P.O. Box 2112
Santa Monica, California 90407-2112

Christopher Hudson, Publisher
Mark Greenberg, Managing Editor

John Harris, Editor
Patrick Dooley, Designer
Amy Armstrong, Production
Coordinator
Ellen Rosenbery, Photographer

Typeset by Graphic Composition, Inc.,
Athens, Georgia
Printed by Amilcare Pizzi S.P.A

Library of Congress
Cataloging-in-Publication Data

Keller, Judith.
 Walker Evans : the Getty
Museum collection / Judith
Keller.
 p. cm.
 Includes bibliographical
references (p.) and index.
 ISBN 0-89236-317-7 (cloth)
 1. Photography, Artistic—
Catalogs. 2. Evans, Walker,
1903–1975—Catalogs. 3. J. Paul
Getty Museum—Photograph
collections—Catalogs.
4. Photograph collections—
California—Malibu—Catalogs.
I. Evans, Walker, 1903–1975.
II. J. Paul Getty Museum.
III. Title.
TR653.K457 1995
779′.092—dc20 95-1592
 CIP

Frontispiece: Walker Evans. *Times
Square/ Broadway Composition*, 1930
[no. 69].

The following have generously given
permission to use extended quotations
from copyrighted or previously
unpublished materials in this book:
from *The Bridge* by Hart Crane, with
the permission of Liveright Publishing
Corporation, copyright 1933, © 1958,
1970 by Liveright Publishing
Corporation; The Museum of Modern
Art, New York, for selected passages
from two letters: Thomas Mabry to
Lincoln Kirstein, April 29, 1938, and
Thomas Mabry to George Davis,
October 6, 1938, in the exhibition files
for *American Photographs by Walker
Evans* in the Office of the Registrar.

Photo credits: *Residence on Elmwood
Street* or *Victorian House* by Ralph
Steiner: © Murray Weiss;
Cuttingsville, Vermont by Walker
Evans: courtesy Mr. Robert Mann of
Robert Mann Gallery, New York;
Playroom by Ezra, Stoller: © Esto,
courtesy Ms. Erica Stoller.

The J. Paul Getty Museum
acknowledges the cooperation of
The Walker Evans Archive at The
Metropolitan Museum of Art.

CONTENTS

FOREWORD

With the camera, it's all or nothing. You either get what you're after at once, or what you do has to be worthless. I don't think the essence of photography has the hand in it so much. The essence is done very quietly with a flash of the mind, and with a machine. I think too that photography is editing, editing after the taking. After knowing what to take, you have to do the editing.

Walker Evans in an interview with Leslie Katz, 1971

This book reveals not only the flashes of Walker Evans's mind but also the editing and darkroom labor that resulted in so many memorable images. It is the first publication of the J. Paul Getty Museum's collection of Evans's work, nearly 1,200 prints and various manuscript materials, a uniquely broad and varied record of his achievement. It was formed initially through our purchase in 1984 of the collection of Arnold Crane, then enlarged over the past ten years by judicious purchases. Many of the images are familiar, such as the photographs of tenant farmers Evans made in Alabama in the 1930s, and many more are unfamiliar, such as the pictures of Florida in the early 1940s, or the Polaroid studies he made as a seventy-year-old with an undiminished visual curiosity. In the wealth of contextual and bibliographical information assembled here, even readers who know Evans's work well are bound to find much that is new.

Over the past several years, Judith Keller has undertaken the task of ordering and interpreting this largely unstudied material. To her, and to those who helped her assemble this book, I am deeply grateful.

John Walsh
Director

PREFACE AND
ACKNOWLEDGMENTS

Walker Evans: The Getty Museum Collection documents the J. Paul Getty Museum's collection of 1,192 photographs by Walker Evans, the largest group of rare prints held by an American institution. In 1984, a Department of Photographs was founded at the Getty with the acquisition of a number of private collections, among them those of Arnold Crane, Samuel Wagstaff, Jr., and the team of Volker Kahmen and Georg Heusch. The holdings of each of these connoisseurs included sizable numbers of photographs by Evans, with a monumental group of 1,114 prints coming from Crane and a smaller, but very select, cluster of forty-one from Wagstaff and eighteen from Kahmen-Heusch. Crane, a Chicago lawyer and photographer who was one of the first serious American collectors of photography, chose work from Evans's studio in consultation with the artist during the late 1960s. The collector has said that the two men went through Evans's lifework in an effort to glean "those photographs which were the most important and the finest for what, he agreed, would make up the most comprehensive collection of his work."[1] Wagstaff, an art historian and former museum curator, did not develop the same close relationship with Evans but did admire his work and, soon after he began collecting in the mid-1970s, obtained a wide-ranging selection composed of early New York pictures, 1930s images of sculpture, and subjects from *Fortune* essays of the 1950s, such as "common tools" and luxury ocean liners. Evans's New York dealer Robert Schoelkopf and the Connecticut vendor George Rinhart were Wagstaff's sources for these acquisitions; four prints handled by Schoelkopf were actually from the collection of Crane. The German collectors Kahmen and Heusch brought Evans into their collection of primarily European photography (with another exception being the work of Lewis Hine) in the late 1970s, after seeing the offerings of Harry H. Lunn, Jr., at international art fairs in Cologne and Basel. The prints they purchased from Lunn reflect a special affinity for the simple interiors that Evans favored throughout his career.

The Getty's representation of the work of Walker Evans spans the five decades of his career, from the late 1920s to the early 1970s. This being so, it was logical to organize this immense amount of material chronologically, from the 1927 photographs of the Lindbergh parade in Manhattan to the final Polaroids of 1974. It was also reasonable, given the contents of the Getty collection and Evans's many years of work as a *Fortune* photographer, to construct the introductory texts with an emphasis on Evans's published work, that is, the images that appeared

in journals and books from 1929 to 1966. Arnold Crane's interest in collecting had begun with books of photographic images and, in gathering Evans's prints, he seems to have been most sensitive to those materials related to the original mock-up or layout for a publishing project. Crane sometimes assembled numerous unused variants that Evans apparently made while working through the "cumulative meaning" of one of these series.[2] In addition to placing the Getty collection pictures in the context of Evans's career as a professional photographer and his development as an artist, I have attempted to situate them in the broader context of the culture of his time, paying particular attention to connections with popular culture. Perhaps because of early exposure (his father was an executive in the advertising business), or his friend James Agee's preoccupation with motion pictures, or the need to make a living by satisfying magazine editors, Evans became a discriminating recorder of popular culture.

I expect that most people encountering the more than one thousand pictures contained in this catalogue will be struck by the consistency of the themes and imagery Evans employed or found congenial. Even in his initial forays into the streets of New York, his major artistic motifs announced themselves: signage and other "found" objects, portraits, and architecture. This remarkable thematic continuity over nearly fifty years creates an impressive unity in the sequence of photographs in the following pages.

This collection catalogue is not intended to supply a full account of the artist's life. Two works will help fill this significant gap in the literature. Belinda Rathbone's *Walker Evans: A Biography* appeared just as my own book was going to press; James Mellow's study of Evans's life and career is now in preparation. For readers who are unacquainted with the basic facts of Evans's life, I have provided a brief chronology.

I have arranged the Evans material chronologically in five parts, dividing those parts into ten chapters. Each

introductory chapter is followed by a catalogue section of the relevant Getty photographs and their documentation. Regarding published works, those images closest to the published image usually appear first, with variants following. Duplicates in the Getty collection and selected close variants are not reproduced; however, catalogue entries for these prints will be found interspersed with the documentation for related illustrated material.

The ten chapters are followed by three appendixes. They are: "Ephemera," concerning the archival materials related to Evans that were attached to the Crane collection; a listing of Getty prints involved in several 1938 projects for the Museum of Modern Art (MoMA) that were connected to the *American Photographs* exhibition; and an enumeration of one-person and group exhibitions of Evans's work. These are followed by a chronological Evans bibliography (the most comprehensive to date) and an index to the most important people, places, and monuments referred to in the text and catalogue entries.

Walker Evans's working technique and subject matter were well established by the mid-1930s. He used both handheld and view cameras, from a "vest pocket" tourist model to a 35mm Leica or an 8 x 10-inch Deardorff camera. He created negatives on glass plates, sheet film, and roll film, and positive in-camera images on Ektachrome and Kodachrome transparencies and Polaroid SX-70 instant film. Jerry Thompson has expertly chronicled the technical development of both Evans's snapshot and formalist aesthetic in his 1982 essay "Walker Evans: Some Notes on His Way of Working."[3] The reader is referred to Thompson for further discussion of the photographer's darkroom technique and the arsenal of equipment with which he practiced his art over the years. (At his death, Evans owned twenty-one cameras, excluding antique specimens.) As Thompson points out, Evans himself did not like to be asked about technique or to talk about print quality as a goal in itself. On the other hand, in a 1971 interview he stressed that printing technique, though it should

not be evident, is quite important.[4] The Getty collection is made up principally of prints produced by Evans close to the time of the negatives and thus provides a rare opportunity to study the entire evolution of his printing style. The photographs range in size from the 2⁷⁄₁₆ x 1½-inch abstractions of circa 1930 (some, like no. 76, in their original window mats) to a 13⅜ x 9⅞-inch enlargement of a detail from a 1936 Atlanta view (no. 499). The variety of Evans's original presentations is also found in the Getty pieces, ranging from prints trimmed and mounted to lightweight board with a small margin, to prints dry-mounted with the mount trimmed to the image, to—in the case of a rare group of pictures from his 1938 exhibition at MoMA—prints mounted on Masonite with black tape concealing the edges of this heavy board. Untrimmed prints that might be considered work or proof prints are found in the collection as well, sometimes bearing annotations about process. An array of the signature and address stamps that Evans was so fond of can be seen in the Getty prints; as explained below (pp. xvi–xvii), these cannot consistently be used in dating the prints, but they can be considered evidence of the dates when the photographer was reviewing the work.

The Getty's holdings are remarkably rich, not only in terms of print quality but in the representation of many variant versions Evans made of his subjects, both in the field and in the darkroom, and in the revelation of extended boundaries for familiar and little-known photographic series. I can only hope that I have in some measure given this bountiful resource its due.

As with any museum project, the making of this book was very much a collaboration involving many individuals at the Getty and elsewhere. I owe a special debt to Deborah Gribbon, Associate Director and Chief Curator, and Weston Naef, Curator of the Department of Photographs, whose support made possible a leave from my usual departmental responsibilities in the fall of 1993 and a library office in which to spend that leave preparing this manuscript. My thanks to them and to Julie Smith in the

Director's office and Jason Patt of Information Systems for their part in facilitating this crucial arrangement. This time devoted to final research and writing in the Getty Library allowed me to discover just how impressive the holdings and personnel of that department are; I would like to thank Anne-Mieke Halbrook and, in particular, Judith Edwards and Chris Jahnke of her staff, for patiently handling all of my requests. Brent Sverdloff in the Getty's Department of Special Collections also deserves thanks for assisting me with the journals and other rare publications in that collection.

In the Department of Photographs, my chief collaborator has been Michael Hargraves, who has devotedly assisted me in several revisions of the cataloguing records and in many other aspects of the assemblage of the catalogue sections of this book. He has helped to draft the chronology, revise and update the list of exhibitions (Appendix C) and the bibliography, and prepare the index. He has also provided unflagging energy in the search to confirm dates, places, and other details of catalogue entries. His optimism, and his persistence in the face of sometimes uncooperative technology, have been invaluable to the realization of this project. Laura Muir, the Department of Photographs Intern for 1993–94, was also a positive force in seeing this manuscript finished. In addition to assisting with research details such as the compilation of Evans portfolio information (now part of the bibliography), she prepared the essay on Evans documents in the collection (Appendix A) and the listing of collection prints related to the production of *Walker Evans: American Photographs* (Appendix B).

The months spent by Carol Payne, Department of Photographs Intern for 1989–90, in compiling a first draft of the catalogue records for the Evans collection should be acknowledged. The records she entered into the Museum's Collections Management System were the starting point for our work. William Johnson, who was commissioned to assemble an Evans bibliography in 1991, should be cred-

ited with the first drafts of what are now the bibliography and exhibitions sections.

Jean Smeader and Victoria Gray both gave their careful attention to making numerous revisions of the manuscript. Conservators James Evans, Marc Harnly, Ernie Mack, and Nancy Reinhold have all, over the past four years, contributed to the treatment and proper housing of the Evans collection. They often worked in collaboration with Andrea Hales and Julian Cox to make sure that the proper post-conservation photography was completed for the catalogue. Ellen Rosenbery of the Museum's Department of Photographic Services carried out a most vital element of this collection catalogue, the excellent reproduction photography. In the same department, Rebecca Vera-Martinez supervised the reprinting of more than two thousand Walker Evans copy prints, most of which were printed by Mari Umekubo. Charles Passela, head of Photographic Services, worked with Amy Armstrong and Julian Cox to make sure the Museum's high standards for illustration quality were met. Christine Lee, Carla Williams, and Jeanie Won assisted Julian Cox in the documentation process and put together several drafts of the seventeen notebooks that eventually joined catalogue entries to copy prints to form the working version of this catalogue. For study purposes, Douglas Benjamin of the Department of Photographic Services of the Getty Center for the History of Art and the Humanities produced Cibachrome prints from a selection of Evans transparencies.

Designer Patrick Dooley is responsible for masterfully fashioning an unwieldy mass of material into a clear and useful book that honors Evans's own taste for the functional. He was fortunate to have the assistance of Jeffrey Cohen, Eileen Delson, Leslie Fitch, Kurt Hauser, and Vicki Karten. In the Museum's Department of Publications, John Harris had the equally daunting task of wrestling with this oversized manuscript. His sensitive but pragmatic editorial approach proved to be a good match

for the project. Amy Armstrong of Publication Services played a vital role as the production coordinator of this massive volume. She was ably assisted by Jessica Hershorn.

During the course of my research, I benefited from the generosity and efficient offices of many other museums and archives including: the Amon Carter Museum, the Art Institute of Chicago, the Harry Ransom Humanities Research Center at the University of Texas, the International Museum of Photography at George Eastman House, the Library of Congress, the Menil Collection, the Metropolitan Museum of Art, the Museum of Modern Art, the National Gallery of Art (Washington, D.C.), the National Gallery of Canada, the New York Public Library, the San Francisco Museum of Modern Art, the St. Louis Museum of Art, and the University of Louisville Photographic Archives. Among the staff at these institutions who took time away from their own projects to assist me were Jim Borcoman, Beverly Brannan, Verna Curtis, Roy Flukinger, Nicole Friedler, Thomas Frontini, Sarah Greenough, J. Russell Harris, Andrea Inselmann, Wynne Phelan, Sandra Phillips, Rona Roob, Ann Thomas, and Virginia-Lee Webb. Additional institutions furnished me with information about their Evans holdings, including the Addison Gallery of American Art, the Museum of Fine Arts, Houston (Anne Tucker and Maggie Olvey), the Minneapolis Museum of Art (Christian Peterson), the Akron Museum of Art (Barbara Tannenbaum), and the Smith College Museum of Art (Michael Goodison). In correspondence and phone conversations, Deborah Walk, Archivist at the John and Mable Ringling Museum of Art, provided answers to many of my questions about Sarasota, Karl Bickel, the Ringlings, and the history of circus trains.

Private collectors on both the East and West Coasts were extremely gracious in making their holdings available to me for study. Those I visited include Timothy Baum, Susan Ehrens and Leland Rice, Chip Gliedman,

Arthur and Carol Goldberg, Ben Hill, the Paul Sack Collection (Cindy Herron, curator), and Clark Worswick. Harry H. Lunn, Jr., and Howard Greenberg also shared with me pictures by Evans from their personal collections, and Rodger Kingston made available a listing of his extensive library of Evans literature and ephemera.

I appreciate the time taken by John Hill, executor of the Walker Evans Estate, and the three Estate beneficiaries—Virginia Hubbard, Charles Lindley (by descent from Frances Lindley), and Eliza Mabry—to visit the Getty, review our collection, and talk with me about Evans. Mr. Hill as well as Belinda Rathbone, Evans's biographer, have both willingly shared their expertise and offered moral support while this catalogue was in process. I am also grateful to Jane Sargeant, to whom Evans was married from 1941 to 1955, and Isabelle Storey, whom he married in 1960, for their reminiscences about Evans and their efforts to satisfy my questions about specific book projects and trips represented in our collection.

Friends and printers of Evans's have responded conscientiously to my inquiries. I would like to thank Jim Dow, Lee Friedlander, Ed Grazda, and, especially, Jerry Thompson, for their advice in matters related to Evans's photographic techniques. Conversations with a handful of colleagues, such as Claudia Bohn-Spector, John Gossage,

Sarah Greenough, Jeff Rosenheim, Allan Sekula, William Stott, and Clark Worswick, have furthered my understanding of the major series found in our collection. Maria Morris Hambourg's early counsel to persevere with the concept of a complete collection catalogue was continually recalled as a source of encouragement. For their recollections and insights regarding the 1938 and 1966 Evans exhibitions at the Museum of Modern Art, I owe a debt to Beaumont Newhall and John Szarkowski. Harry H. Lunn, Jr., who since 1975 has been the main source of Evans prints to the market, provided an enlightening history of the cache of prints that left the photographer's hands shortly before his death.

This catalogue was read in manuscript by Jay Fisher, Diana Hulick, and Weston Naef, each of whom made valuable comments that helped me improve its form and content.

Finally, I would like to thank my husband, Ken Breisch, who always believed this book could be done and was worth doing. It is dedicated to him and to my son, Rush Clinger.

Judith Keller
Associate Curator
Department of Photographs

NOTES

1. *Walker Evans*, introduction by Arnold H. Crane (New York: Sidney Janis Gallery, 1978), n.p.

2. *Walker Evans at Work*, with an essay by Jerry Thompson (New York: Harper and Row, 1982), 15.

3. Ibid., 9–17.

4. Leslie Katz, "Interview with Walker Evans," *Art in America* 59 (Mar./Apr. 1971), 86.

NOTES TO THE READER

Catalogue entries include title, date, dimensions, accession number, marks and inscriptions, references, and exhibitions where applicable. They are sequenced as described in the statement that introduces each of the ten catalogue sections.

Unbracketed titles are believed to be those established by Evans. Square brackets around titles indicate that they are assigned or descriptive titles supplied by the author. If different titles are found in two or more reliable sources, all titles are listed and separated with a slash. One or more asterisks following a title indicate that it was taken from a book or other published source that appears in the references section for the entry. Evans's spelling and punctuation have been retained, as have the spelling and punctuation of titles in their published form.

The majority of the Getty Collection prints are those made by Evans close to the time of the negative; therefore the date for each entry refers to that established for both negative and print by the photographer's inscription or a published source. Where dating was not available through inscription or previous publication, an approximate date has been established by the author. In a few cases, where a separate printing date is specifically

known, dates for both negative and print are given. A print thought to have been made by Evans, or under his supervision, at a substantially later unknown date is designated as "printed later" and the given date is that of the negative only. These later prints probably date in most cases to the late 1960s or early 1970s, when the demand for Evans's work for sale and exhibition had escalated; he was then reprinting earlier negatives in preparation for such events as his 1971 MoMA retrospective. Except for prints used at *Fortune* for page layouts, Evans made his own prints until the late 1960s–early 1970s, when he came to depend on professional printers and friends to carry out this work following his directions.

All images are gelatin silver prints except where noted. If the medium indicated is color transparency, the reference is to roll film cut irregularly between the frames and lacking sprocket holes, with an image size that is uniformly 2 ¼ x 2 ¼ inches.

Dimensions of the image are given in centimeters, followed by dimensions in inches in parentheses, with height preceding width. Measurements are given in the following order: image, sheet, mount. Sheet size is indicated only where it differs from that of the image; otherwise,

image size equals sheet size. A mount thought to be assembled by Evans near the time of the printing for initial presentation of the photograph is referred to as an "original mount." A mount of unknown date or appearing to be later than the time of the print is listed simply as "mount." With a few Getty prints from circa 1930, photographs are found in Evans's own mats, cut from a heavyweight paper, with an opening that overmats the photographic sheet; these rare examples of Evans's early style of presentation are indicated as "original window mat" in the catalogue entries and their outside dimensions are given.

Accession numbers reflect the Museum's standard way of designating the year of acquisition, the object type, the lot number, and the individual number for each collection item. The majority of prints in the Evans collection were acquired in 1984 and will therefore have accession numbers beginning "84." The Museum refers to single prints from monographic suites as "XM," those single prints from mixed lots are assigned an "XP" number, and a few items in this catalogue bear the identification of "XG," meaning they come from lots composed of several object types (transparencies, archival materials, etc.). Most of the Evans collection items in this last category are described in Appendix A rather than in the catalogue sections. The lot numbers are a key to provenance as well as to a unit designated by the registrar. For instance, lots "84.XM.956" and "84.XG.963" refer exclusively to prints obtained from the Arnold Crane collection.

Marks and inscriptions are recorded according to location on the object, with those appearing on the print preceding those on the mount, and recto preceding verso. Any mat inscriptions appear last. (Mats, unless otherwise stated, are not Evans's but rather those of the collector Arnold Crane or a vendor. In several instances, the Crane mats contain multiple prints; the inscriptions that appear on those mats are repeated in the entries for each of the photographs affected.) The photographer's inscriptions precede all others. If not specifically noted, all inscriptions are by an unknown hand or the collector. All inscriptions are italicized. The following abbreviations are used: u. = upper; l. = lower. Inscriptions precede stamps and labels. Stamps and labels have been abbreviated (see below, pp. xvi–xvii).

The provenance is Arnold Crane unless otherwise noted.

References cited are either to the first published source of an image or to one of the basic Evans books cited in the list of abbreviations (pp. xviii–xix).

In most cases, references to publications have to do with the appearance of a particular image rather than the Getty print per se. A published source followed by "(variant)" means that the Getty print comes from the same negative but represents a cropping that differs in either minor or significant ways from that which has already appeared on the printed page. In some cases, the slight differences may be due to trimming by designers or printers in the production process. "Variant" is also used in the several instances of reverse printing that occur in the Getty collection.

References to exhibitions indicate that the Getty print was the print included in that exhibition. For information about those prints loaned by Evans to the Museum of Modern Art for the 1938 exhibition *Walker Evans: American Photographs*, see Appendix B.

Those images not illustrated are Getty variants or duplicates. By "Getty variant" is meant a print that represents a different cropping from the same negative that produced the Getty print described in the preceding catalogue entry. A duplicate print has the same cropping and displays printing effects identical or very similar to those in the entry that precedes it.

Stamps and Labels

With the help of Evans biographer Belinda Rathbone, we have tried to establish dates for the stamps that incorporate the addresses of the photographer's different studios and residences over the years. However, the signature stamps are difficult to date, Evans seems to have reused stamps throughout his career, and some of the Getty prints bear more than one stamp. Therefore, the fourteen stamps found on Getty prints cannot always be used as reliable guides to the dating of the photographs. All are wet stamps in black ink.

Walker Evans

Stamp A (not dated)

WALKER EVANS

Stamp B (not dated)

WALKER EVANS

Stamp C (not dated)

PROPERTY OF WALKER EVANS

Stamp D (not dated)

PHOTOGRAPH WALKER EVANS 179 COLUMBIA HEIGHTS BROOKLYN

Stamp E (ca. 1928–30)

WALKER EVANS 163 EAST 94th STREET NEW YORK 28, N. Y.

Stamp F (1960–63)

WALKER EVANS 124 EAST 85th ST. NEW YORK 28, N.Y.

Stamp G (1963–65)

WALKER EVANS 1681 YORK AVE. NEW YORK 28, N. Y.

Stamp H (1941–ca. 1963)

WALKER EVANS 1681 YORK AVENUE NEW YORK, N. Y. 10028

Stamp I (ca. 1963–71)

WALKER EVANS BOX 310 RTE. 3 OLD LYME, CONN.

Stamp J (1966–75)

WALKER EVANS BOX 310 RTE. 3 OLD LYME. CONN. 06371

Stamp K (1966–75)

WALKER EVANS

Stamp L (not dated)

WALKER EVANS 163 EAST 94th ST. NEW YORK 28, N. Y.

Stamp M (1960–63)

WALKER EVANS BOX 310 RTE. 3 OLD LYME, CONN.

Stamp N (1973–75)

Lunn Gallery stamp (1975)

According to Harry H. Lunn, Jr., in September 1974, George Rinhart and Tom Bergen acquired what was essentially the contents of the photographer's studio at the time. Lunn then purchased 5,500 prints from Rinhart and Bergen in February 1975. Since Evans was too ill at the time of these negotiations to sign this large archive of prints, it was decided that an "Estate Stamp" would be created, with Evans's approval, as a means of authentication for these photographs. The stamp was produced by Rinhart; the completion of the category (see key provided by Lunn below) and gallery reference numbers (indicated in the two-part box below the "signature") was carried out for the Lunn Gallery inventory by Lunn and Maurizia Grossman, gallery director. With Lunn's approval, the stamp is referred to as the Lunn Gallery stamp in this catalogue.

 I. AP (*American Photographs*, 1938)
 II. MoMA (*Walker Evans*, 1971)
 III. FSA (*Walker Evans: Photographs from the Farm Security Administration*, 1973)
 IV. Portraits
 V. *Fortune* series
 VI. Subway
VII. Container Corporation, 1960s?; *Vogue* Foundation Heads
VIII. Bridgeport, 1941
 IX. Victorian Architecture, 1931
 X. Southern Architecture, 1935
 XI. Southern Views, 1968–72
XII. Fisherman's House, Biloxi, 1945; Faulkner's Mississippi (*Vogue*); Florida, 1941; California, 1947
XIII. Third Avenue Series, 1962
XIV. New York, 1928–34
 XV. Chicago, 1946
XVI. Tahiti, 1932
XVII. Churches, 1961; New York Trash, 1962; New York Cast Iron, 1963
XVIII. Cuba, 1933
XIX. The Boom in Ballet, 1945
 XX. African Masks, 1935
XXI. Miscellaneous
XXII. Color
XXIII. Maine, 1962–69; Nova Scotia, 1969–71; New Hampshire and Miscellaneous New England; Colorado, 1967
XXIV. Dress (*Fortune*), 1963
XXV. London, 1953–75
XXVI. Summer at Harbor Point, Michigan, 1960

MoMA label (1938)

MoMA II label (1938)

COLLECTION
ARNOLD H. CRANE, CHICAGO, U. S. A.

CRANE stamp (not dated)

LIST OF ABBREVIATIONS

In the catalogue entries, frequently cited works have been identified by the following abbreviations.

AFAS *African Folktales and Sculpture*. Folktales selected and edited by Paul Radin, with the collaboration of Elinore Marvel; introduction to the tales by Paul Radin; sculpture selected with an introduction by James Johnson Sweeney. New York: Pantheon Books, 1952.

AMP Walker Evans. *American Photographs*. New York: Museum of Modern Art, 1938.

ANA-JJS James Johnson Sweeney. *African Negro Art*. New York: Museum of Modern Art, 1935.

ANA-WE *African Negro Art: A Corpus of Photographs by Walker Evans* . . . Typescript of 45 pp., prepared by Dorothy Canning Miller. New York: Museum of Modern Art, 1935. Four portfolios of original prints.

APERTURE *Walker Evans*. Introduction by Lloyd Fonvielle. Millerton, N.Y.: Aperture, 1979.

BB *The Brooklyn Bridge*. New York: Eakins Press, 1994. Portfolio of gravures.

BRIDGE Hart Crane. *The Bridge*. Paris: Black Sun Press, 1930. Limited edition.

BRIDGE-AM Hart Crane. *The Bridge*. New York: Horace Liveright, 1930. 1st ed., 1st printing. Frontispiece by WE.

CRANE *Walker Evans*. Introduction by Arnold H. Crane. New York: Sidney Janis Gallery, 1978.

CUBA Carleton Beals. *The Crime of Cuba*. Philadelphia and London: J. B. Lippincott, 1933.

FAL *Walker Evans: First and Last*. New York: Harper and Row, 1978.

FORTUNE Lesley K. Baier. *Walker Evans at "Fortune," 1945–1965*. Wellesley, Mass.: Wellesley College Museum, 1977.

FOURTEEN *Walker Evans: Fourteen Photographs*. New Haven, Conn.: Ives-Sillman, 1971. Portfolio.

FSA *Walker Evans: Photographs for the Farm Security Administration, 1935–1938*. Introduction by Jerold C. Maddox. New York: Da Capo Press, 1975.

HAVANA *Walker Evans: Havana 1933*. Text by Gilles Mora; sequence by John T. Hill; translated from the French by Christie McDonald. New York: Pantheon Books, 1989.

LUNN *I*. Washington, D.C.: Lunn Gallery and Graphics International Ltd., 1977. Portfolio.

LUNPFM–41 James Agee and Walker Evans. *Let Us Now Praise Famous Men: Three Tenant Families*. Boston: Houghton Mifflin, 1941.

LUNPFM–60 Revised edition of the above, published 1960.

MAC Walker Evans. *Many Are Called*. Boston: Houghton Mifflin, 1966.

MANCO Karl Bickel. *The Mangrove Coast*. New York: Coward-McCann, 1942.

MFTI Walker Evans. *Message from the Interior*. Essay by John Szarkowski. New York: Eakins Press, 1966.

MoMA *Walker Evans*. Introduction by John Szarkowski. New York: Museum of Modern Art, 1971.

SP *Walker Evans: Selected Photographs*. New York: Double Elephant Press, 1974. Portfolio.

WCP *Wheaton College Photographs*. Foreword by J. Edgar Park. Norton, Mass.: Wheaton College, 1941.

WEAIR *Walker Evans: Artist in Residence*. Introduction by Matthew Wysocki. Hanover, N.H.: Hopkins Center, Dartmouth College, 1972.

WEAW *Walker Evans at Work; 745 Photographs Together with Documents Selected from Letters, Memoranda, Interviews, Notes*. Essay by Jerry L. Thompson. New York: Harper and Row, 1982.

WEBR *Walker Evans*. Essay by Dr. Volker Kahmen. Rolandseck, West Germany: Edition Bahnhof Rolandseck, 1978.

NOTE: James Johnson Sweeney's 1935 MoMA catalogue *African Negro Art* (ANA-JJS) is cited in individual catalogue entries as a basic reference for Evans's work on that exhibition because it contains an exhibition checklist that must be cross-referenced with a second checklist (with a different numerical sequence) in the MoMA typescript volumes (ANA-WE) that accompany 477 original photographs by Evans made during that exhibition. However, Sweeney's book does not contain photographs by Evans and so is not included in the bibliography.

WALKER EVANS: A CHRONOLOGY

1903 Born November 3 in St. Louis, Missouri, the son of Walker Evans, Jr., and Jessie Crane. Raised in Toledo, Ohio; Kenilworth, Illinois; and New York City.

1922–23 After attending the Loomis School, Windsor, Connecticut, studies literature and languages at Phillips Academy, Andover, Massachusetts, and later at Williams College, Williamstown, Massachusetts.

1923–26 Works odd jobs in New York at a bookshop and the New York Public Library.

1926–27 Travels in Europe. Attends literature lectures at the Sorbonne. Takes snapshots with a Kodak Vest Pocket roll-film camera. Occasionally works in the former studio of Nadar.

1927–28 Returns to New York and lives in Brooklyn Heights. Meets Hart Crane, who moves into the same neighborhood. Continues to photograph with a roll-film camera and a borrowed Leica. Works nights as a clerk for a Wall Street brokerage firm until 1929.

1929 Develops friendship with Lincoln Kirstein.

1930 First publication of three photographs in *The Bridge* by Hart Crane. Photographs published in *Hound & Horn*,

Architectural Review, and *Creative Art*. Begins to work with large-format camera (6 ½ x 8 ½ inches), initially with glass-plate negatives.

1931 Photographs Victorian architecture while traveling with Kirstein and John Brooks Wheelwright through Boston, the north shore of Massachusetts, Martha's Vineyard, Northampton, Greenfield, and Sarasota Springs, New York. Exhibits with Margaret Bourke-White and Ralph Steiner at John Becker Gallery, New York.

1931–32 Shares Greenwich Village studio with Ben Shahn.

1932 Two-man show with George Platt Lynes at Julien Levy Gallery, New York. On board private yacht, travels to Tahiti with still camera and movie equipment.

1933 Makes photographs in Cuba during May and June for book *The Crime of Cuba* by Carleton Beals, published later that year. Meets Ernest Hemingway. First solo exhibition at MoMA entitled *Walker Evans: Photographs of Nineteenth-Century Houses*. Begins to use 8 x 10-inch format camera.

1934 First story for *Fortune* magazine: "The Communist Party." Visits Florida. Diego Rivera's *Portrait of America* appears, containing several of Evans's photographs of

Rivera's New York murals.

1935 Commissioned to photograph *African Negro Art* exhibition at MoMA; an exhibition selected from these photographs circulates to sixteen sites between 1935 and 1937. Travels to New Orleans to make photographs of antebellum architecture. Meets Jane Smith Ninas. In June, July, and November makes photographs for Resettlement Administration (RA) in West Virginia and Pennsylvania. From October continues photographic work for the RA (later the Farm Security Administration [FSA]), primarily in the South, as an official staff photographer working under Roy Stryker.

1936 Continues photographing for Stryker in Mississippi, Georgia, and South Carolina. Takes three weeks off in July and August for a *Fortune* assignment with the writer James Agee, reporting on white sharecropper families in Alabama. Though *Fortune* rejects the work, their collaboration eventually results in *Let Us Now Praise Famous Men* (1941).

1937 On a last trip for the FSA, travels in February with photographer Edwin Locke, documenting flood areas in Arkansas and Tennessee.

1938 Exhibition at MoMA entitled *Walker Evans: American Photographs*, accompanied by the publication *American Photographs*, with an essay by Kirstein. The exhibition circulates to ten venues over the next two years. Begins subway series in New York using a concealed 35mm Contax camera.

1940–41 Receives Guggenheim Fellowship and completes subway series. Marries Jane Smith Ninas. Publication of *Let Us Now Praise Famous Men*. Makes photographs on commission in Florida, Bridgeport (Connecticut), and Norton (Massachusetts). Begins to use 2¼-inch twin-lens reflex camera.

1942 Publication of *The Mangrove Coast* by Karl Bickel, with photographic illustrations by WE.

1943–45 As staff writer prepares book reviews for *Time* magazine.

1945 Becomes staff photographer at *Fortune*. In 1948, with the new title of Special Photographic Editor, is given the task of creating a distinctive photographic style for the journal. His title is again changed, to Associate Editor, in the 1950s. Makes numerous photographic and text contributions until 1965 (see bibliography); color work appears from 1945 on.

1947 Retrospective exhibition at the Art Institute of Chicago.

1950 For *Fortune* makes photographic series of the American industrial landscape as seen though the window of a moving train.

1953 In *African Folktales and Sculpture*, Bollingen Foundation publishes 113 photographic illustrations by WE of African art made in 1935.

1955 Divorces Jane Smith Ninas. Death of James Agee. *Fortune* essay "The Congressional" (November), with photographs by Robert Frank and text by WE.

1956 First appearance of the subway portraits in *i.e. The Cambridge Review*.

1959 Receives second Guggenheim Fellowship.

1960 *Let Us Now Praise Famous Men* is reissued with twice the number of illustrations by WE. Marries Isabelle Boeschenstein von Steiger.

1960s–70s Makes personal photographs in Nova Scotia, Maine, New Hampshire, and Cape May, New Jersey.

1962 New edition of *American Photographs*, accompanied by an exhibition at MoMA. Receives Carnegie Corporation Award.

1965 Leaves *Fortune*. Appointed to position of Professor of Photography/Graphic Design at School of Art and Architecture, Yale University, New Haven, Connecticut.

1966 Publication of *Many Are Called* and *Message from the Interior*. Exhibition of *Walker Evans: Subway Photographs* at MoMA and another selection of forty prints at the Robert Schoelkopf Gallery, New York. First paperback edition of *Let Us Now Praise Famous Men*.

1968 Receives honorary degree from Williams College, Williamstown, Massachusetts. Becomes Fellow, American Academy of Arts and Letters.

1971 Retrospective exhibition at MoMA, organized by John Szarkowski, with an accompanying monograph. First portfolio, *Walker Evans: Fourteen Photographs*, issued by Ives-Sillman.

1972 Artist-in-residence, Dartmouth College, Hanover, New Hampshire.

1973 Receives a grant from Mark Rothko Foundation. Photographs with Polaroid SX-70 camera.

1974 Becomes Professor Emeritus, Yale University. A second portfolio, *Walker Evans: Selected Photographs*, published by Double Elephant Press, with fifteen gelatin silver prints. Injured in a fall, cannot make photographs.

1975 Dies April 10 in New Haven, Connecticut.

NOTE

This compilation was created, in part, by consulting the following existing chronologies:

Auer, Michèle and Michel. *Photographers Encyclopaedia International, 1839 to the Present*. Hermance, Switzerland: Editions Camera Obscura, 1985.

Brix, Michael, and Birgit Mayer, eds. *Walker Evans America*. New York: Rizzoli, 1991.

Greenough, Sarah. *Walker Evans: Subways and Streets*. Washington, D.C.: National Gallery of Art, 1991.

Mora, Gilles, and John T. Hill. *Walker Evans: The Hungry Eye*. New York: Harry N. Abrams, 1993.

Walker Evans. Millerton, N.Y.: Aperture, 1979.

1926–1934

Circa 1930: New York and New England

Cuba

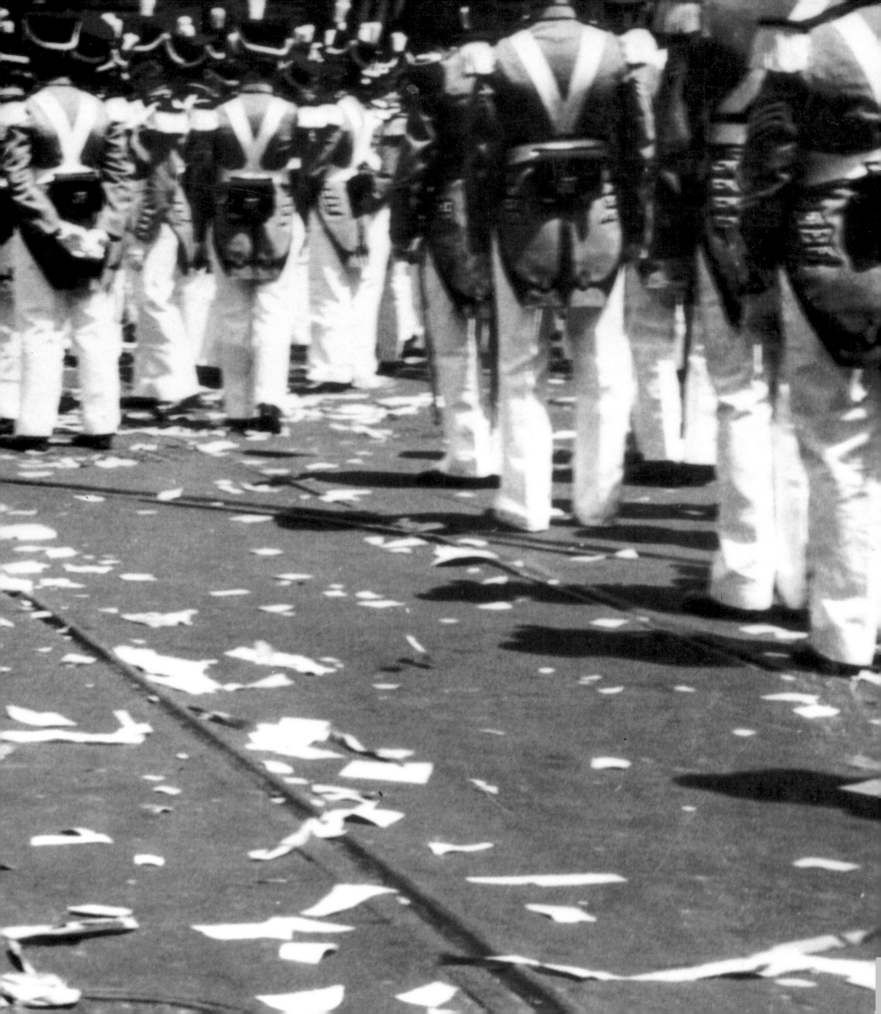

CIRCA 1930: NEW YORK AND NEW ENGLAND

The police estimated that between three million and four and a half million people were out in the streets—so many, in fact, that they issued a special warning to householders not to leave their homes unguarded. Ticker tape and confetti rained down on the open car, with the bareheaded Lindbergh and the silk-hatted Mayor perched on top of the rear seat. New York had never seen anything like the storm of paper. It far exceeded the Armistice Day celebration that ended World War I.

Walter S. Ross, *The Last Hero: Charles A. Lindbergh*[1]

In the spring of 1927, Walker Evans, then a young man of twenty-three, returned to New York after more than a year spent in Paris attending classes at the Sorbonne, reading French literature, meditating on plans for a writing career, and making a few photographs. It was the spring of Charles Lindbergh's solo nonstop flight across the Atlantic. The ticker-tape parade held in his honor (nos. 2–4) seems to have presented Evans with his first opportunity for taking out his camera and exploring this American city. He is known to have made a few photographs while in Europe, including the rather tentative self-portrait in the Getty collection (no. 1), but the earliest dated U.S. images are the views of marching-band members assembled on confetti-littered streets (no. 3). Perhaps the shy novice photographer felt that he needed the protection of the crowd to begin working on the street; he would be inconspicuous among the throngs hoping for a glance at the young aviator (who was, coincidentally, Evans's exact contemporary), and he would not attempt to photograph individuals, only

Walker Evans. *Lindbergh Day Parade* (detail), June 13, 1924 [no. 3].

the parade. He inscribed one of the Getty prints "Waiting for the parade to start, downtown, Lindbergh day, June 13."[2] Foreshadowing the style of his mature work, the mood of Evans's picture is understated, more that of the calm and quiet that follow a parade, reflecting nothing of the energy and excitement that must have filled the air as New Yorkers welcomed home their new hero. Lindbergh's fame, based on this single achievement, would be pervasive and long-standing. One historian has proposed that the importance of Lindbergh's heroic role was its duality: he represented both the past and the future.[3] He was celebrated by some as a self-sufficient individual, a pioneer who came out of the Old West. For others, he represented the progress of American industry and the exciting potential of the machine.

Lindbergh's celebrity—like the contradictory attitudes it embodied—was only one aspect of the world in which Evans began to operate as an image maker. In international politics, Leon Trotsky was expelled from the Soviet Communist Party in 1927, the same year that the Surrealists Aragon, Breton, and Eluard became members of the French Communist Party and the Mexican artist Diego Rivera attended May Day celebrations in Moscow,

watched closely by J. Edgar Hoover as he passed through New York en route to Russia. Chiang Kai-shek instigated civil war in China, and the anarchists Nicola Sacco and Bartolomeo Vanzetti were executed in Massachusetts. Henry Ford governed the most successful company in American history, but that spring, to the horror of Wall Street, he shut down his assembly line in order to retool for a new product: the Model A. In 1927, expanding his empire, Ford founded the town of Fordlandia in Brazil, whose purpose would be to supply his massive factory, the Rouge, with cheap rubber. He also hired the painter-photographer Charles Sheeler to document the physical plant as well as the assembly-line production at the enormous Rouge works outside Detroit.

In 1927, the world of literature saw the publication of Marcel Proust's final volume of *À la Recherche du temps perdu* and Ernest Hemingway's collection of short stories *Men Without Women*; Hart Crane completed the "subway" section ("The River") of his epic poem, *The Bridge*. Two small literary journals appeared, *Hound & Horn* and *Transition*. Evans would be a regular contributor to *Hound & Horn*, which was begun at Harvard by an enterprising undergraduate named Lincoln Kirstein; *Transition*, also a venue for photography, was patronized by the wealthy aspiring poet and sometime photographer Harry Crosby, who with his wife, Caresse, founded the Black Sun Press that year. In entertainment, Hollywood issued its first film with synchronized sound, *The Jazz Singer*, Mae West brought her production of *Sex* to the stage, Fritz Lang created his Expressionist masterwork *Metropolis*, and Isadora Duncan, the pioneer of modern dance, met with her famous demise. The year Evans began to photograph New York was also the year the chronicler of Paris, Eugène Atget, died. It was at this same time that Evans may have met Ralph Steiner, a photographer who, like Atget, would exert considerable influence on his early work.[4] Evans probably first encountered Kirstein and Steiner at the salon of Muriel Draper, one of the chief

organizers of the *Machine-Age Exposition*, a show of 444 drawings, sculptures, photographs, and architects' models, as well as machine guns, crankshafts, propellers, and engines, held in New York that May.

In the South, the circus entrepreneur John Ringling began construction in Sarasota, Florida, on the art museum that would house his collection of Baroque paintings. More relevant to Evans's future projects was Ringling's decision to invest in Sarasota as the new winter quarters for his "Greatest Show on Earth." Closer to home, the Graybar Building, one of the Manhattan skyscrapers that would become a subject for Evans's camera, was recognized as "the largest office building in the world" and boasted a capacity of 20,000 on thirty-three floors.[5] Midtown New York would soon become the site of John D. Rockefeller, Jr.'s, "Radio City" (or Rockefeller Center), an unprecedented building program calling for the construction of fourteen Modernist structures and requiring the demolition of 229 brownstones. Negotiations for what would be the home of the seventy-story RCA building and Radio City Music Hall began in 1928, but before Rockefeller started planning this "modern ideal of the skyscraper metropolis," he became involved with an Episcopalian clergyman from Virginia and a project to restore Colonial Williamsburg.[6] He met with the Reverend William A. R. Goodwin in May of 1927 and agreed to begin purchasing strategic property; the shared vision of Goodwin and Rockefeller eventually brought about the "most ambitious restoration project ever undertaken in America," or what James Agee, in a 1935 essay for *Fortune* magazine, would call "Mr. Rockefeller's $14,000,000 Idyl."[7]

If the adventurous young Lindbergh was revered as a symbol of a nostalgia for the past that simultaneously promoted faith in a mass-produced future, Rockefeller was perhaps that future's most powerful enactor. Although it is not known if Evans photographed the construction of Rockefeller Center, his most important exhibition, *American Photographs* of 1938, was held in the Time-Life Build-

ing there. It was housed in the temporary quarters of the Museum of Modern Art (MoMA), an institution founded in 1929 by Rockefeller's wife, Abby Aldrich Rockefeller (together with Mrs. Cornelius Sullivan and Miss Lizzie Bliss), and one to which Evans's escalating reputation would be closely tied. Mrs. Rockefeller was an early collector of American folk art; MoMA's pioneering 1932–33 show *American Folk Art: The Art of the Common Man, 1750–1900* was assembled largely from her holdings and no doubt stimulated Evans's bent for this genre, which would later manifest itself in his images of naive sign-painting and homemade grave markers. In 1933, Evans would observe the infamous ordeal of Diego Rivera's commissioned murals for the RCA building—murals created and then quickly destroyed at the behest of his patrons, the Rockefeller family, because of their subversive political content—and for more than twenty years he would work in this same complex, Rockefeller Center, as an employee of both *Time* and *Fortune* magazines.[8] In the first years of his work in photography, as he wrestled with the International Style and its application to that most American of subjects, the skyscraper, Evans would also be infected with Rockefeller's passion for America's past.

Evans took a night job on Wall Street in order to support his serious daytime pursuit of the art of photography. From his apartment in Brooklyn Heights, he wandered along the waterfront, up to the piers of that engineering marvel the Brooklyn Bridge, photographing and sometimes talking with his friend and neighbor Hart Crane. The resulting views of the bridge and the New York skyline seen from its span have been reproduced and discussed in Alan Trachtenberg's *Brooklyn Bridge: Fact and Symbol.*[9] Trachtenberg and others have presented these images in the context of Crane's structuring of his epic poem, *The Bridge*, which the photographs illustrated in lieu of the paintings by Joseph Stella that the writer had originally hoped to use.[10]

Two of the three pictures that finally appeared as gravure plates in the 1930 Black Sun Press deluxe edition of *The Bridge* are found at the Getty (nos. 17–18), along with four variant croppings of the image used for the frontispiece to the first American edition (nos. 19–22), four prints closely related to the other views included by Trachtenberg (nos. 13–16), a few more radically Constructivist compositions derived from the deceptively fragile-looking elements of this massive form (nos. 11–12), and six unpublished views of the city (nos. 5–10), apparently made from a perch somewhere on the bridge.

This work of circa 1929, in which Evans seems to be reducing the basic elements of a major American monument to the fragmentary, two-dimensional aspects of European Modernism, was nonetheless seen by some as prefiguring his later collaborations with American writers, such as James Agee. His friend of these early years, Lincoln Kirstein, wrote in his afterword to Evans's 1938 *American Photographs*: "It is no chance that, after Crane, Walker Evans should have worked with James Agee, the author of *Permit Me Voyage*, whose verse, springing at once from Catholic liturgy, moving pictures, music and spoken language, is our purest diction since Eliot. Walker Evans's eye is a poet's eye. It finds corroboration in the poet's voice."[11] As we will see, the Brooklyn Bridge pictures can be read as prophetic; the images that Evans would publish in at least four different journals around 1930 might also be said to foreshadow his career in photojournalism and his twenty-year tenure at *Fortune*.

Evans's New York images are well represented at the Getty, including rooftop billboards, people lingering on street corners, and skyscrapers under construction, photographs that were credited to Evans in issues of the art-world journal *Creative Art* (nos. 49–51, 68–69, 92–93); "the quarterly magazine of the American scene," *USA* (nos. 66–67); the small literary journal *Hound & Horn* (nos. 29–30, 82, 94, 143, 169–71, 227–28, 233, 237–38); and the monthly publication on architecture, *Architectural*

Record (nos. 70, 116). From the brief texts that occasionally ran with the Evans portfolios or the rare reviews of his exhibited work, one obtains a contemporary view of his evolving style and reputation. Walter Knowlton, critiquing a spring 1931 show of photographs by Evans, Ralph Steiner, and Margaret Bourke-White at the John Becker Gallery, sized Evans up as a formalist:

> *Walker Evans is a patternist. Faces, reflections in store windows, shadows, bare, brick walls are worked up by him into often wonderful contrapositions. Often he is precious; occasionally he is exceptionally poetic. Sometimes he lets the significance of the thing in its daily function play an interesting counter-point to its significance in the picture. Mostly he sees nature not socially but pictorially; as an assemblage of lights, lines and forms to be caught in an interesting arrangement.*[12]

Less than six months earlier, the same journal, *Creative Art*, had run a photo-essay of four pictures, "Mr. Walker Evans records a City's scene," that surprisingly introduced Evans by emphasizing his associations with the business rather than the art world of New York:

> *Mr. Walker Evans is a Commercial Photographer, working in New York. He has been in Europe where he studied modern Continental methods, and has since spent some time in experimenting. He now records in a vivid and peculiarly appropriate manner the scene of which he is a product.*[13]

The commentator for *Creative Art* no doubt borrowed from the notes on contributors printed in *USA* the previous summer, when Evans's work appeared there. This short-lived magazine of literature, art, politics, industrial design, and just about anything else the editors felt reflected the special character of the "American Scene,"

billed Evans as someone who had "studied in Europe, experimented for several years and now has set out to interpret with vivid and fresh inspiration the scene of which he is a product."[14] Though at this point the critics were referring to his "city scene" or New York imagery, it is noteworthy that by 1930 Evans was being praised as an artist who, after spending time abroad, had embraced the national or American scene as his subject.

USA had chosen one of Evans's Brooklyn Bridge pictures as the cover image for their summer 1930 number, an issue that also contained the photographic work of Edward Weston, Ralph Steiner, and Willard Morgan. This view (not at the Getty) of the underside of the massive nineteenth-century structure was made from the same spot as the first plate in *The Bridge* (no. 17) and shows the prow of the same ocean-going vessel seen moving past the bridge in the latter image. Evans apparently maintained this vantage point on the embankment for some time, watching the river traffic and keeping the belly of the bridge centered in his sights while making at least four other negatives.[15] Among the most dramatic is one not published until 1979 (and not among the Getty prints) that daringly presents the rushing diagonals of the bridge bed disappearing into the smoke of river tugs.[16] Foreground and background are confused by clouds of smoke billowing across the lower portion of the picture. The black, hard-edged form of the bridge that dominates three-quarters of the composition dissolves into the familiar picturesque image of the city skyline; Evans's creation, though it has a definite Constructivist edge, is finally reminiscent of Pictorialist Alvin Langdon Coburn's 1910 collection of New York views.[17]

Inside this issue of *USA*, a second Evans image, captioned "Sky Webs," fills an entire page and is constructed of the web or infrastructure of several huge, rooftop neon signs (no. 66). Probably made atop the twenty-one-story U.S. Rubber Company building then at

Broadway and Fifty-seventh Street, this image seems to have been Evans's first effort to work with signage on a grand scale. The geometric skeleton of the enormous signs counterbalances the curvilinear shapes of the "U.S. RUBBER" sign, seen forward and backward.[18] In addition to a large print of the *USA* image, the Getty collection includes a second, much smaller photograph (no. 67) that appears to be from the same negative but is considerably less cropped on the right side and displays in the bottom quarter a whole section of elaborate shadows cast by the foreground signs, which Evans eliminated from the published image.

In the fall of 1930, *Hound & Horn* featured an Evans portfolio, "New York City," in an issue that offered essays on the writing of Henry Adams, the art of Pisanello, and Vsevolod Meyerhold's theater, as well as short fiction by Erskine Caldwell and Kay Boyle.[19] The four photographs in the portfolio were largely attempts to apply elements of the New Vision advocated by László Moholy-Nagy and other European artist-photographers to subjects Evans had found on Manhattan streets, near the tenements, and at the Port of New York (nos. 29, 82). However, the first plate, titled simply *Sixth Avenue* (no. 94), was something of a portrait, albeit an anonymous image of a pedestrian caught by chance in the midst of city traffic. This is the sort of street portrait that Evans would favor throughout his career and that can be seen at the Getty in other prints of the period (such as nos. 87, 96, 98–99, 108, 110, 113). Evans's close-up view of an unidentified New York resident may be seen as a radical updating of Coburn's portrayal of city life (fig. 1). The photographer has brazenly closed in on this African American stranger, whose face is framed in an abundant fur collar, by cropping the image somewhat at the bottom edge and substantially more at the left. For Coburn, it was important to present the everyday activity of the street against a backdrop of distinguished Manhattan architecture; for Evans, the goal was to record a glimpse of random faces against

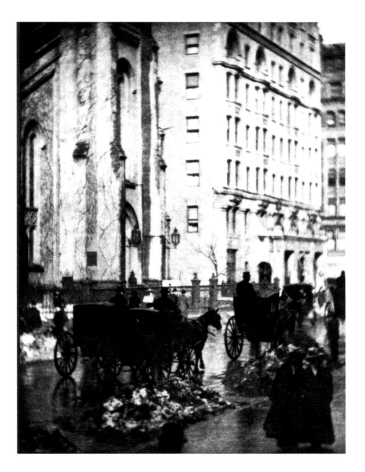

Figure 1. Alvin Langdon Coburn (British, born United States, 1882–1966). *The Holland House.* Photogravure from the book *New York* (London: Duckworth and Co., 1910), pl. 5. 20 x 14.6 cm (6 ⅞ x 5 ¾ in.). JPGM 84.XO.1133.5.

the chaos of crowds, automobiles, and mass transit. In this Sixth Avenue view, the entrance to the elevated train that anchors the right edge of the picture proved to be more than an interesting background detail. As another Getty print reveals (no. 95), Evans devoted one more negative to the sign-covered staircase itself, allowing the repeated announcements for "ROYAL BAKING POWDER" to create a decorative pattern that is cleverly enhanced by the irregular interruptions of shadows from a cast-iron railing.

Perhaps more in the vein of the contemporary European avant-garde was a selection of five architectural views Evans published in the fall of 1930, in the *Architec-*

tural Record.[20] The group of halftones, headed "Photographic Studies," was laid out one to a page and enlarged to as much as 10 ½ x 7 ⅝ inches. Abstracted details of office buildings (no. 116) and industrial exteriors photographed from extreme angles comprise the majority, with the fourth plate (no. 70), a view of the crisscrossing of gigantic grain-elevator components, being the most prominent reference to earlier work by the German architect Erich Mendelsohn, whose photographs Evans probably knew from his 1926 collection *Amerika*, and the American painter Charles Sheeler, whose Precisionist views of Ford's Rouge plant were available in the same journals to which Evans was contributing.[21] Besides this published picture, the Getty possesses four additional compositions based on the elaborate cylinders and rectangles of grain elevators or other unidentified factory structures. The most severe of these (no. 74) is a small (4 ⁵⁄₁₆ x 2 ⁹⁄₁₆-inch) print representing the intersection of two factory shafts, one a narrow, vertical, whitewashed tower with two small square windows that seems to stand on a precarious diagonal, the other a dark, shallow horizontal that comes in from the upper right and appears to neatly buttress the white tower against the picture frame. The stark elegance of this industrial subject is comparable to the best of the work produced by European practitioners of the New Vision, like Albert Renger-Patzsch's revolutionary, worm's-eye view of a soaring factory chimney of circa 1925 (fig. 2).[22]

Later in this year, when Evans's career as a published photographer seemed to be taking shape, *Creative Art* also featured a contribution from him: four views prefaced by a collage of typeface spelling out the essential qualities of modern city life.[23] The first of these, *Broadway Composition* (no. 68), a photomontage created from several Leica negatives, can be found at the Getty in a large (9 ¾ x 8 ⁹⁄₁₆-inch) photograph, as well as in a variant printing (no. 69) that includes the large neon letter *N*, added to the composition at the upper left. As he did with the "U.S. Rubber" picture, Evans is again composing entirely with

signs, here illuminated ones isolated against the black of night. This prototypical Jazz Age piece may have been a tribute to the latest "photoplays," but in retrospect it seems to have been inspired by Evans's fascination with the title of a new jailbreak melodrama, *The Big House* (1930), starring Wallace Beery and Robert Montgomery. The unembellished, almost boxy shape of the letters, in combination with the subject they implied (although actually referring to a prison rather than a private residence), understandably attracted the notice of someone who would soon take up the theme of American vernacular architecture, and the large Victorian dwelling specifically. The graphic, as well as iconographic, potential of this miscellany of Broadway signage was not lost on Evans. The last plate, *New York City's Quick Lunch*, featuring three men eating at a storefront lunch counter, is represented at the Getty by two slight variations on the published image (nos. 92–93). The diners appear completely involved in getting a fast bite to eat, entertained all the while by activity on the street, but apparently not distracted by the photographer's presence directly opposite them on the sidewalk. Despite the difficulties posed by the reflections on the large glass window, Evans evidently enjoyed this post outside the busy lunch counter. He stayed to photograph several other trios of crowded customers, as revealed by two prints in the Getty collection (nos. 90–91).

From its first issue in 1927, architecture was discussed regularly in the pages of *Hound & Horn*. Two Evans pictures, apparently commissioned for the purpose, accompanied an installment of what was called the "Architecture Chronicle" in the April–June 1931 issue.[24] This piece by Lyman Paine was subtitled "Is Character Necessary?" and took two new buildings—the New York chapter of the American Red Cross and the new home of the New School for Social Research—as comparative examples. Paine's point was that the Red Cross building, which he characterized as having the appearance of "a miniature skyscraper," had no character, while Joseph Urban's New

School, "a small, steel skeleton building" that is closeted in "an envelope of brick and glass," was "intense and assertive," "decisive, unambiguous."[25] Although trying to give it height, Evans's view of the ill-proportioned Red Cross building is nearly as undistinguished as its architecture; on the other hand, his representation of the New School is not as dynamic as the modern structure but does emphasize its striking difference from the surrounding neighborhood of three-story row houses and its prominent use of glass as a design element.

These two *Hound & Horn* pictures are not part of the Getty collection, but numerous other views of New York architecture from about 1930 are, including five prints related to an image that appeared as an illustration for Frank Lloyd Wright's "The Tyranny of the Skyscraper" (nos. 47–51).[26] Wright's piece, actually one of his recent Kahn lectures for Princeton that had just appeared in the monograph *Modern Architecture*, was being reprinted by *Creative Art* with six new illustrations. These included two skyscraper views by Evans, one panorama of the city provided by Wide World Photos, two Expressionist lithographs of cavernous city streets by Adriaan Lubbers, and one architectural photograph by Ralph Steiner deliberately made from an exaggerated angle in order, it would seem, to emphasize Wright's caption: "All skyscrapers have been whittled to a point."[27] As the title of Wright's essay suggests, he was highly critical of the skyscrapers being constructed in the late twenties, and, after saying a few good things about what he refers to as the first skyscraper, the Wainwright Building (1890–91) designed by his mentor, Louis Sullivan, he launches into a tirade against the increased congestion and the "dull craze for verticality and vertigo" that the "vogue of the skyscraper" and the attendant real-estate boom had generated.[28] Calling the newest high-rises monotonous and barbaric, deriding the "clumsy imitation masonry" of their inappropriate historicizing styles, Wright, who believed that skyscrapers should only be built on the spacious prairies in an honest,

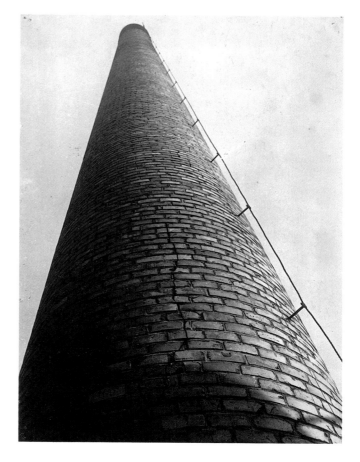

Figure 2. Albert Renger-Patzsch (German, 1897–1966). *Factory Smokestack*, ca. 1925. Gelatin silver print, 23.3 x 17.1 cm (9 3/16 x 6 3/4 in.). JPGM 84.XM.138.32.

functional style, closed with a gloomy pronouncement on this still-popular architectural form: "Space as a becoming psychic element of the American city is gone. Instead of this fine sense is come the tall and narrow stricture. The skyscraper envelope is not ethical, beautiful, or permanent. It is a commercial exploit or a mere expedient. It has no higher ideal of unity than commercial success."[29]

The Evans illustration (no. 51) represented in prints at the Getty shows the construction site for the fifty-three-story Lincoln Building that was erected at Forty-second Street and Park Avenue in 1930. The construction company that completed this one-million-square-foot "aristocrat among New York office buildings" ran a

full-page advertisement in *Fortune* immediately before that journal began an extensive six-part series on every aspect of the building of skyscrapers.[30] Although it was becoming more commonplace, the scale of this peculiarly American invention continued to escalate and was still a source of fascination for businessmen, as well as the man on the street. Probably encouraged by his European friends and roommates of the late twenties, the architect-photographer Paul Grotz and the artist-poet Hans Skolle, Evans took up the skyscraper as a challenge for his inexperienced eye. Images he made of the Graybar, Chrysler, International Telephone, and Flatiron buildings are among the Getty's holdings (nos. 36–37, 42, 45, 75). Some of these skyscraper studies, in fact, exist in prints he made as proofs to identify the negatives and remain affixed to their original negative sleeves (see nos. 46, 48–49, 52, 56). It is possible that Evans photographed some of these other modern colossi, as well as the Lincoln Building, in conjunction with the Wright article, but, since *Creative Art* credits the Becker Galleries (where the photographer's work was coincidentally on view) for the use of the May 1931 images, it is more likely that the journal's editors found what they liked in a preexisting group of prints. The Evans plate that introduces the article, though unidentified, appears to be a vertiginous, high-angle view of the massive facade of the thirty-three-floor Graybar Building. This 1927 structure covering almost an entire city square is represented at the Getty not by this image but by a view, titled by Evans *Skyscraper Detail Abstract* (no. 46), that more completely reduces it to a two-dimensional, gridlike arrangement.

Of more interest in regard to the Getty collection is the second Evans illustration (no. 51), which represents the Lincoln Building construction area and is captioned "What beauty the whole has is haphazard." The editors, or Wright himself, no doubt selected this composition not only for its suggestion of the burgeoning construction business but also for the layers of stepped-back Italianate towers (the very thing the author abhorred) topping the older, already densely packed skyscrapers of the background. Two other Getty pieces (nos. 49–50), each a very different and more complete printing of the negative, are evidence of Evans's often uninhibited cropping, a technique that he adopted whenever necessary "to obtain a better picture."[31] In addition to this panoramic sweep of the upper reaches of the construction zone at Forty-second Street and Park Avenue, Evans made a vertical view highlighting a gigantic crane at the site (no. 47). Silhouetted against the sky, it has greater height and more graceful lines than the surrounding Beaux-Arts high-rises of 1920s Manhattan.

The publication of these skyscraper compositions was significant, especially in conjunction with Wright's highly critical commentary on the state of contemporary urban architecture, for Evans had recently become engaged in a project to document nineteenth-century houses of New York State and New England.[32] The idea, and funds, for this documentation effort came from *Hound & Horn* founder Lincoln Kirstein. Kirstein, son of a wealthy Boston merchant, apparently persuaded Evans and the socialist poet John Brooks Wheelwright, whose father had been an important Boston architect, to travel through Massachusetts with him in search of domestic Victorian architecture, in particular, the Gothic, Greek, and Gingerbread styles of that eclectic era.

Although a young man just out of Harvard with strong ties to the newly formed Museum of Modern Art, Kirstein was obsessed with the historian Henry Adams, the events of the Civil War, and the possibility of creating on film "a monumental history of the American art of building in its most imaginative and impermanent period."[33] The book that Kirstein envisioned Evans illustrating never appeared, but thirty-nine of the views Evans obtained during these rather informal "research" trips were eventually assembled in the fall of 1933 in an exhibition at MoMA, *Walker Evans: Photographs of Nineteenth-Century Houses*. The exhibition prints, along with sixty-one other photo-

graphs from the project, were donated to MoMA that year by Kirstein. The Getty holds three prints of exhibition images (nos. 154 [reversed], 157, 194); one print (no. 156), though not exhibited, was among the images in the Kirstein gift.

This exhibition, though hanging in New York for a brief three weeks, circulated to fourteen other venues from Vermont to Illinois to West Virginia and was part of a wave of nostalgia then spawning ambitious public and private preservation projects, such as Rockefeller's Williamsburg, Henry Ford's Greenfield Village (dedicated in 1929), and the Historic American Buildings Survey, a federal program chartered the month Evans's pictures went on view.[34] Announcing the show in MoMA's *Bulletin* of December 1933, Kirstein declared Evans's images of historic struc-tures "perfect documents" and described the way in which they were achieved:

> *Evans' style is based on moral virtues of patience, surgical accuracy and self-effacement. In order to force details into their firmest relief, he could only work in brilliant sunlight, and the sun had to be on the correct side of the streets. Often many trips to the same house were necessary to avoid shadows cast by trees or other houses; only the spring and fall were favorable seasons. The forms were sharpened until so precise an image was achieved, that many of the houses seem to exist in an airless nostalgia for the past to which Edward Hopper in his noble canvases pays a more personal tribute.*[35]

A retrospective exhibition of Hopper's paintings, in fact, hung concurrently at MoMA; the Hopper cata-logue was written by another artist of the American Scene, Charles Burchfield.[36] The work of Hopper and Burchfield, already known for their distinctive treatment of the theme of the Victorian house, as well as the work of the photogra-pher Ralph Steiner, all probably contributed to Evans's

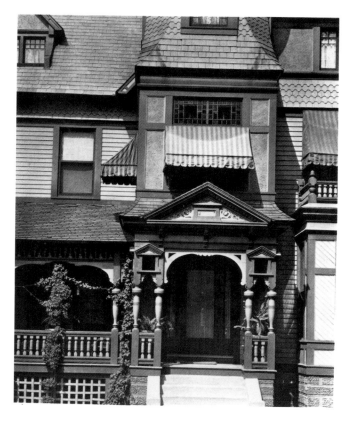

Figure 3. Ralph Steiner (American, 1899–1986). *Residence on Elmwood Street*, ca. 1929. Halftone from *USA* (Spring 1930), 21.6 x 17.2 cm (8 ½ x 6 ¾ in.). © Murray Weiss.

early enthusiasm for nineteenth-century subjects. In fact, Burchfield and Steiner illustrated a May 1930 *Fortune* essay called "Vanishing Backyards," ironically based on the efforts of Mrs. Rockefeller and Mrs. Henry Ford to clean up American roadsides.[37] While commending the millionaires' wives, the author gives praise to "the record of things that are passing" put together by Burchfield and Steiner: "They have assembled a record—not of the new America, its skyscrapers, its airplanes, its dynamos—but of the America which remains unregenerate, its back porches and backyards, its ugliness and its waste."[38]

Steiner, a professional photographer also recog-nized for his experimental motion-picture work, was, like Evans, featured in the pages of *USA*; the spring 1930 issue of that quarterly ran his elaborate gingerbread facade *Resi-*

dence on Elmwood Avenue (fig. 3) adjacent to an article titled "Sentimentality and Mechanism" and a one-page layout of four pictures with the caption: "The Touch of a Vanished Hand, Fugitive glimpses of an America that is almost gone."[39] Like the *Fortune* essay, the latter contained what has become a classic in Steiner's oeuvre, the rocking-chair image now called *American Baroque* but then designated as *Observation Post in Mohawk County.* This photograph of a finely crafted wicker rocker on an old frame porch, casting elaborate shadows on aged wooden slats, had appeared in the pages of Kirstein's *Hound & Horn* in the fall of 1929.[40] The simple antiquated subject, representing a sophisticated piece of folk art as well as the severe lines of rural architecture in upper New York State, may well have suggested new directions to Evans before he launched into the tour planned by Kirstein and Wheelwright. In later years, Steiner would be one of the few photographers Evans would credit as a source for his

own style; his influence might be discerned in the best of the images from the Victorian house project, as seen in a few Getty examples, such as the impenetrable-looking Greek Revival house from Upstate New York (no. 158), the small Gothic Massachusetts house with its decorated gable and prominent "For Sale" sign (no. 155), and the Gingerbread pump house found in Kennebunkport that Evans would modestly dub *The Maine Pump* (no. 194). The popularity of Victorian vernacular architecture would vacillate over the decades, but Evans would continue to investigate its peculiar design possibilities for the rest of his career, photographing barns, mills, railroad stations, water towers, and residences. In 1955, John Maass, one of the earliest architectural historians to speak in defense of the Victorian house, would remark that the photographer was unique in his persistent efforts to take "a close look" at these structures created by "forgotten carpenters" rather than trained architects.[41]

NOTES

1. Walter S. Ross, *The Last Hero: Charles A. Lindbergh,* rev. ed. (New York: Harper and Row, 1976), 135.

2. See no. 2.

3. See John W. Ward, "The Meaning of Lindbergh's Flight," *American Quarterly* X:1 (Spring 1958), 3–16, for the development of this thesis about the pilot's double role and an investigation of why he became such a powerful American symbol.

4. Steiner briefly recounts the circumstances of his first meeting with Evans in an unpublished memoir in a private collection, New York.

5. W. Parker Chase, *New York: The Wonder City, 1932* (New York: Wonder City Publishing Co., 1932; facs. ed., New York: New York Bound, 1983), 243.

6. William H. Jordy, *American Buildings and Their Architects* (New York: Anchor Books, 1972), 84. At the conclusion of his first chapter, "Rockefeller Center and Corporate Urbanism," Jordy states that this com-

plex "provided the most complete embodiment of the modern ideal of the skyscraper metropolis of the period."

7. Raymond B. Fosdick, *John D. Rockefeller, Jr.: A Portrait* (New York: Harper and Brothers, 1956), 272. See Fosdick's chapter on "Williamsburg" for a complete history of this project. Agee's article "Mr. Rockefeller's $14,000,000 Idyl . . . which is the colonial City of Williamsburg, second capital of Virginia, now restored to history" appeared in *Fortune* 12 (July 1935), 69–73. Agee also prepared a screenplay on Williamsburg for television in the early 1950s.

8. While Evans was a staff writer reviewing books for *Time* (1943–45) and a staff photographer for *Fortune* (1945–65), Time, Inc., the parent company, was housed in the Time and Life Building at 9 Rockefeller Plaza (the eleventh building in the complex, completed in 1938) and, subsequently, in the building constructed by Rock-Time, Inc. between Fiftieth and Fifty-first Streets on Sixth Avenue in 1957.

9. Alan Trachtenberg, *Brooklyn Bridge: Fact and Symbol* (Chicago: University of Chicago Press, 1979). See especially "A Walker Evans Portfolio," 171–83, and "Afterword: Walker Evans's Brooklyn Bridge," 185–93.

10. Hart Crane, *The Bridge* (Paris: Black Sun Press, 1930), with three photographs by Walker Evans. See JPGM 84.XB.1143 for one of the special copies dedicated to Walker Evans from this limited-edition work. The first American edition of *The Bridge* (New York: Horace Liveright, 1930) used a single Evans photograph—a fourth image not selected for the Black Sun Press gravure plates—as a frontispiece. For one of the first attempts to discuss Evans's illustrations in relation to Crane's text, see Gordon K. Grigsby, "The Photographs in the First Edition of *The Bridge*," *Texas Studies in Literature and Language* 4:1 (Spring 1962), 5–11.

11. Lincoln Kirstein, "Photographs of America: Walker Evans," in Walker

Evans, *American Photographs* (New York: Museum of Modern Art, 1938), 194.

12. Walter Knowlton, "Around the Galleries," *Creative Art* 8:5 (May 1931), 375–76.

13. "Mr. Walker Evans Records a City's Scene," *Creative Art*, Dec. 1930, 454.

14. *USA,* Summer 1930, 117.

15. See *Walker Evans at Work* (New York: Harper and Row, 1982), 40–41.

16. See Trachtenberg, *Brooklyn Bridge: Fact and Symbol,* p. 173.

17. Alvin Langdon Coburn, *New York* (London: Duckworth, 1910), with a foreword by H. G. Wells; 20 plates (JPGM 84.XO.1133.1–.20). See particularly plates 2, 3, 7, and 19.

18. The Robert Miller Gallery, New York, possesses a view (8 ½ x 5 ½ inches) that pictures the building (now identified as the twenty-story U.S. Rubber Building) and the rooftop signage

from the street level looking up. This view, in fact, presents considerable contrasts in style, since it includes in the foreground the romantic stone image of a river god, part of the large Piccirilli fountain sculpture (ca. 1912) dedicated "To the Freemen who died in the War with Spain" that still stands at the southwest corner of Central Park. The signs that Evans would make the subject of the Getty pictures are seen here in the background atop the high-rise, framed by a muscular male nude figure in a contorted, Rodinesque pose.

19. Walker Evans, "New York City," *Hound & Horn* IV:1 (Oct.–Dec. 1930), n.p.

20. Walker Evans, "Photographic Studies," *Architectural Record*, Sept. 1930, 193–98.

21. See especially the section called "Das Gigantische" in Erich Mendelsohn, *Amerika: Bilderbuch Eines Architekten* (Berlin: Rudolf Mosse, 1926). Sheeler's Rouge compositions appeared in *Hound & Horn* in the Apr.–June 1930 issue (III:3) and in the spring 1930 number of *USA*; a year later, they appeared with an article by Samuel M. Kootz, "Ford Plant Photos of Charles Sheeler" in *Creative Art* 8:4 (Apr. 1931), 264–67. An earlier source for a selection of these Ford images would have been Sheeler's portfolio of six photographs in *Transition* (Nov. 1929), published under the title "The Industrial Mythos" with an introduction by Eugene Jolas.

22. See László Moholy-Nagy, *Painting, Photography, Film* (Cambridge, Mass.: MIT Press, 1973; first publ. 1925 as vol. 8 in *Bauhausbucher*), 59, 133, for the probable first publication of this image.

23. Evans, "Mr. Walker Evans Records a City's Scene," 453–56.

24. Lyman Paine, "Architecture Chronicle: Is Character Necessary?" *Hound & Horn* IV:3 (Apr.–June 1931), 411–15, ills. unpaginated.

25. Ibid., 412–13.

26. Frank Lloyd Wright, "The Tyranny of the Skyscraper," *Creative Art* 8:5 (May 1931), 324–32. The Evans photographs appear on p. 324 (a view of the Graybar Building) and p. 328 (a view of skyscrapers surrounding the construction site of the Lincoln Building).

27. Ibid., 332.

28. Ibid., 328.

29. Ibid., 332.

30. Chase, *New York*, 236. The advertisement for United Engineers and Constructors, Inc., ran in the first volume of *Fortune* in April 1930. In July of that year, the magazine began a monthly feature called "Skyscrapers" that ran through December 1930. The first installment opened with a view by staff-photographer Margaret Bourke-White of the "massive finial of the Chrysler Tower before its sheathing in Nirosta Steel."

31. Evans discussed his attitude toward the matter of editing, cropping, and printing in "Interview with Walker Evans" by Leslie Katz, *Art in America* 59 (Mar.–Apr. 1971), 86.

32. Robert O. Ware's unpublished master's thesis, "Walker Evans: The Victorian House Project, 1930–1931" (University of New Mexico, 1989), is the first extensive examination of this pivotal architectural series. Ware's discussion of Kirstein's influence on Evans and his stylistic development during this period is interesting, if perhaps exaggerated.

33. Lincoln Kirstein, "Walker Evans' Photographs of Victorian Architecture," *Bulletin of the Museum of Modern Art* 1:4 (Dec. 1933), 4. See *Hound & Horn*, 1927–34; *The Hound & Horn Letters*, edited by Mitzi Berger Hamovitch (Athens, Ga.: University of Georgia Press, 1982); and Lincoln Kirstein, "Forty-eight Years After: *Hound & Horn*," in *By With To & From: A Lincoln Kirstein Reader*, edited by Nicholas Jenkins (New York: Farrar, Straus and Giroux, 1991), 20–30, for Kirstein's interests circa 1930.

34. This show may also have inspired the photographic survey and exhibition *The Urban Vernacular of the Thirties, Forties, and Fifties: American Cities Before the War*, carried out by Berenice Abbott and Henry-Russell Hitchcock in 1934. However, the Evans-Kirstein project might be seen rather as complementary to the work of Hitchcock and Abbott since Hitchcock had initiated a series of architectural exhibitions at Wesleyan University in 1933 and this one on the urban vernacular was the sixth to take place. See Janine A. Mileaf, *Constructing Modernism: Berenice Abbott and Henry-Russell Hitchcock*, exh. cat. (Middletown, Conn.: Davison Art Center, Wesleyan University, 1993), for a description and analysis of the *American Cities* show.

35. Kirstein, "Walker Evans' Photographs of Victorian Architecture," 4.

36. Charles Burchfield, *Edward Hopper Retrospective Exhibition, November 1–December 7, 1933* (New York: Museum of Modern Art, 1933).

37. "Vanishing Backyards," *Fortune* I:4 (May 1930), 77–81.

38. Ibid., 79.

39. *USA*, Spring 1930, p. 6 (*Residence on Elmwood Avenue*) and p. 21 (*The Touch of a Vanished Hand*).

40. *Hound & Horn* III:1 (Oct.–Dec. 1929), n.p.

41. John Maass, "In Defense of the Victorian House," *American Heritage* 6:6 (Oct. 1955), 41; see also the nine illustrations by Evans, 37–40.

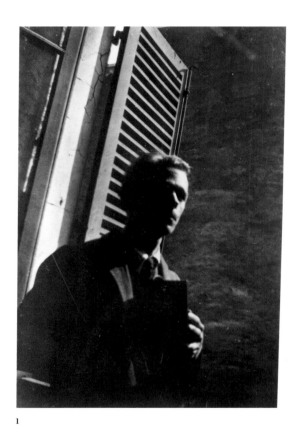

1

Circa 1930: New York and New England

Excluding the Cuban work of 1933 represented in the next chapter, the photographs that follow cover the years 1926 to 1934 and are arranged in a loosely chronological fashion in six categories: Lindbergh parade pictures, the Brooklyn Bridge, architectural studies, street pictures (people and shop fronts), Victorian architecture (including domestic interiors), and miscellaneous subjects dating to 1934.

1
[*Self-Portrait, Paris*], September 1926
Image: 10.5 x 6.9 cm (4 ⅛ x 2 ²³⁄₃₂ in.);
original window mat: 33 x 21.5 cm
(13 x 8 ½ in.)
89.XM.48
MARKS & INSCRIPTIONS: (Recto) on
1.25 x 3.5 cm (⁷⁄₁₆ x 1 ⁷⁄₁₆ in.) typed
label affixed to mat, at l. right, *SELF*
[-]*PORTRAIT/PARIS 1926*.
PROVENANCE: Paul Grotz; Eugene
Prakapas.
REFERENCES: WEAW, p. 18 (variant).

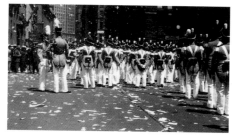

2

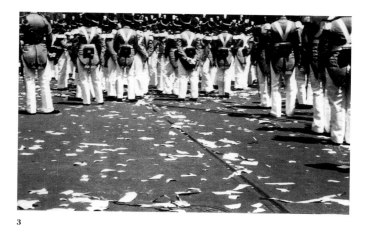

3

5

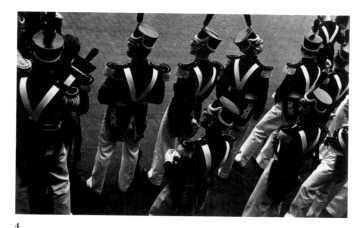

4

6

2
Waiting for Parade to Start, Down-town, Lindbergh Day, June 13, 1927
3.4 x 5.9 cm (1 ⅜ x 2 ⁵/₁₆ in.)
84.XM.956.39
MARKS & INSCRIPTIONS: (Verso) titled and dated at center, in black ink, by Evans: *Waiting for parade/to start, downtown,/Lindbergh day, June 13, 192*– [last number cut off]; at l. left, Evans stamp A; at l. right, stamped in black ink, *83*; imprinted at l. right, *VELOX*; at l. left, in pencil, Crane no. *L65.58(Evans)*.

3
[*Lindbergh Day Parade*], June 13, 1927
10 x 16.3 cm (3 ¹⁵/₁₆ x 6 ⅜ in.)
84.XM.956.40
MARKS & INSCRIPTIONS: (Verso) at l. left, Evans stamp A, and in pencil, Crane no. *L65.59(Evans)*.

4
[*Lindbergh Day Parade?*], June 13, 1927
14.8 x 23.1 cm (5 ⅞ x 9 ⅛ in.) [on original mount trimmed to image]
84.XM.956.41

MARKS & INSCRIPTIONS: (Verso) at u. right, Evans stamp A; at l. left, in pencil, Crane no. *L65.65(Evans)*.

5
[*Manhattan Skyline with Brooklyn Bridge Trussing*], October 1928
3.7 x 5.8 cm (1 ⁷/₁₆ x 2 ⁵/₁₆ in.)
84.XM.956.80
MARKS & INSCRIPTIONS: (Verso) dated at u. center, in black ink, by Evans: *Oct 1928*; at center, partial Evans stamp K; at l. right, wet stamp, in black ink, *23*.

6
[*Manhattan Skyline from Brooklyn Bridge*], ca. 1928–30
7.8 x 5.5 cm (3 ⅛ x 2 ⅛ in.)
84.XM.956.79
MARKS & INSCRIPTIONS: (Verso) at center, Evans stamp K; (recto, mat) at left edge, in pencil, *5,6,7*; at l. left, in pencil, Crane nos. *L65.29,.30,.32*.

7

8

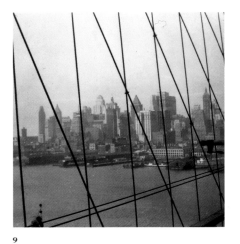

9

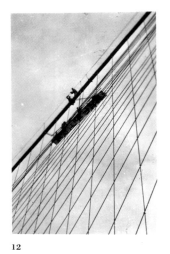

12

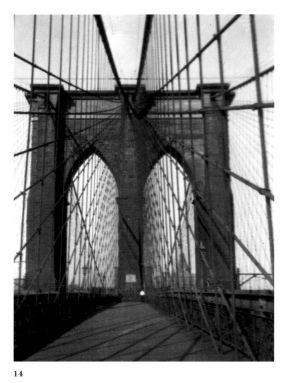

13

14

7
[*Manhattan Skyline from Brooklyn Bridge*], ca. 1929–30
8.7 x 11.4 cm (3 ⁷⁄₁₆ x 4 ½ in.)
84.XM.956.71
MARKS & INSCRIPTIONS: (Recto, mat) at l. right, in pencil, *36*; at l. left, in pencil, Crane no. *L65.3(Evans)*.

8
[*Manhattan Skyline from Brooklyn Bridge*], ca. 1928–30
3.9 x 5.4 cm (1 ⁹⁄₁₆ x 2 ⅛ in.)
84.XM.956.78
MARKS & INSCRIPTIONS: (Verso) at center,

partial Evans stamp K; (recto, mat) at left edge, in pencil, *5,6,7*; at l. left, in pencil, Crane nos. *L65.29,.30.,.32*.

9
[*Brooklyn Bridge*], 1929
14.8 x 14.1 cm (5 ¹³⁄₁₆ x 5 ⁹⁄₁₆ in.)
84.XM.956.10
MARKS & INSCRIPTIONS: (Verso) at u. center, in pencil, *H4717*; at center, in pencil, *S. S neg & pos*; at center, in pencil, *F-3* [inverted]; at u. right, *SS*; at l. right, *for/Fortune*; at l. center, in blue ink, *H-4717*; at center, in blue crayon, *WF4-26* [inverted]; at l. right,

Evans stamp A; (recto, mat) at l. left, in pencil, Crane no. *L65.1*.

10
[*Brooklyn Bridge*], 1929
6 x 9.8 cm (2 ⅜ x 3 ⅞ in.)
84.XM.956.9
MARKS & INSCRIPTIONS: (Verso) at l. right, Evans stamp A; and in pencil, *for/Fortune*; (recto, mat) at l. left, in pencil, Crane no. *L65.45(Evans)*.

11
[*Brooklyn Bridge*], 1929
6.3 x 4 cm (2 ½ x 1 ⁹⁄₁₆ in.)

84.XM.956.3
MARKS & INSCRIPTIONS: (Verso) at center, partial Evans stamp B; at l. left, in pencil, Crane no. *32* [circled]/ *L65.18(Evans)*.
REFERENCES: WEAW, p. 42 (variant).

12
[*Brooklyn Bridge*], 1929
6 x 3.8 cm (2 ⅜ x 1 ½ in.)
84.XM.956.4
MARKS & INSCRIPTIONS: (Verso) at center, partial Evans stamp B; at left edge, in pencil, *10–28*, and stamped in blue ink, *2*, and partial Evans stamp B; at

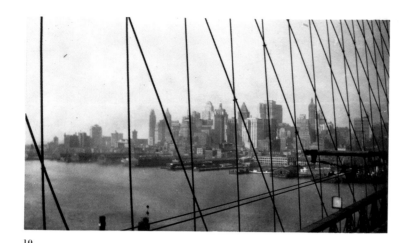

10

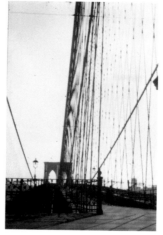

11

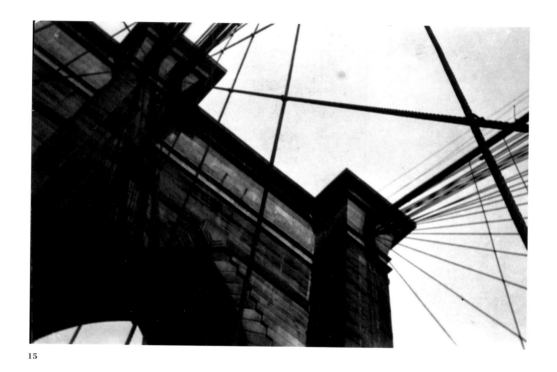

15

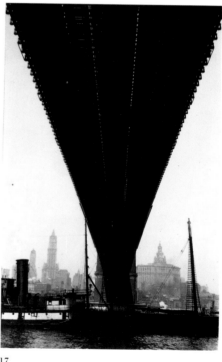

17

l. left, *30* [circled]; at bottom edge, in pencil, Crane no. *L65.17(Evans).*
REFERENCES: WEAW, p. 42 (variant); BB, n.p.

13
[*Brooklyn Bridge*], 1929
6.2 x 4.1 cm (2 ½ x 1 ⅝ in.)
84.XM.956.1
MARKS & INSCRIPTIONS: (Verso) at u. center, partial Evans stamp B; at l. left, in pencil, Crane no. *L65.42(Evans).*
REFERENCES: WEAW, p. 43 (variant, u. right).

14
[*Brooklyn Bridge*], 1929
9.5 x 7.8 cm (3 ¾ x 2 ¹¹⁄₁₆ in.)
84.XM.956.5
MARKS & INSCRIPTIONS: (Verso) at center, partial Evans stamp B; at l. left, in pencil, Crane no. *L65.43(Evans).*
REFERENCES: BB, n.p. (variant).

15
[*Brooklyn Bridge*], ca. 1929
9.2 x 13.6 cm (3 ⅝ x 5 ⅜ in.)
84.XM.956.7
MARKS & INSCRIPTIONS: (Verso) at l. right, in pencil, *FROM* [Evans stamp

A]/*FORTUNE*; at l. left, in pencil, Crane no. *L65.41(Evans).*

16
[*Brooklyn Bridge*], ca. 1929
8.8 x 13.5 cm (3 ½ x 5 ⁵⁄₁₆ in.)
84.XM.956.8
MARKS & INSCRIPTIONS: (Verso) at l. left, Evans stamp A; at center, in pencil, *8* [circled]; at l. left, in pencil, Crane no. *L65.40(Evans).*
NOTE: Not illustrated; variant of no. 15.

17
Brooklyn Bridge, 1929
10.2 x 6.1 cm (4 x 2 ⁷⁄₁₆ in.)
84.XM.956.6
MARKS & INSCRIPTIONS: (Verso) at center, in pencil, by Evans, *Brooklyn Bridge/ 1929*; along right edge, Evans stamp B; at l. left, in pencil, Crane no. *L65.78(Evans).*
REFERENCES: BRIDGE, pl. 1 (variant); WEAW, p. 40 (variant, l. right image).

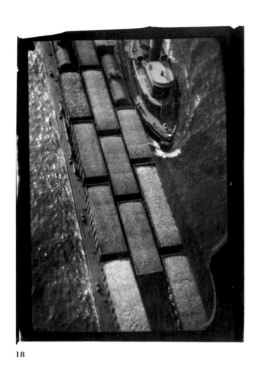

18

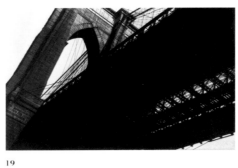

19

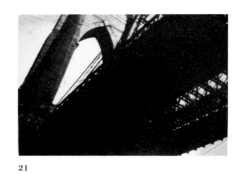

21

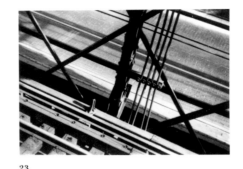

23

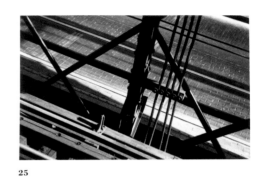

25

26

28

18
East River, New York City, 1930
Image: 23.2 x 15.2 cm
(9 ⅛ x 5 ¹⁵⁄₁₆ in.); sheet: 25.8 x 17.6 cm
(10 ⅛ x 6 ¹⁵⁄₁₆ in.)
84.XM.956.72
MARKS & INSCRIPTIONS: (Verso) titled,
signed and dated at center, in pencil,
by Evans, *East River NYC/1930/
Walker Evans*; at l. right, Crane stamp;
at u. left, in pencil, by Arnold Crane,
AHCrane Coll; (recto, mat) at l. right,
in pencil, *45*; on white paper label, in
pencil, *New York City 1930-/Scene-7*
[illegible; last two words crossed out]

19
[*Brooklyn Bridge*], 1928–29
14.9 x 23.1 cm (5 ⅞ x 9 ⅛ in.)
84.XM.956.138
MARKS & INSCRIPTIONS: (Verso) signed
and dated at left, in pencil, by Evans,
Walker Evans/1928; at right, in pencil,
Crane no. *L65.34*.

*View from the Brooklyn Bridge/One of
Illustrations from "The Bridge"/Hart
Crane*; at l. left, in pencil, Crane
no. *L65.2(Evans)*.
REFERENCES: BRIDGE, pl. 2 (variant);
BB, n.p.

20
The Bridge, 1928–29
Image: 8.2 x 12.8 cm (3 ¼ x 5 ¹⁄₁₆ in.);
original mount: 17.9 x 23 cm
(7 ¹⁄₁₆ x 9 ¹⁄₁₆ in.)
84.XM.956.70
MARKS & INSCRIPTIONS: (Recto, mount)
signed and dated at l. right, in pencil,
by Evans, *Walker Evans 1929*; at
center top edge, in pencil, by Evans,
Reproduce entire photo: no signature.
[last two words underlined]; at l. left,

REFERENCES: BRIDGE-AM, frontispiece;
BB, n.p. (variant).

20
The Bridge, 1928–29
Image: 8.2 x 12.8 cm (3 ¼ x 5 ¹⁄₁₆ in.);
original mount: 17.9 x 23 cm
(7 ¹⁄₁₆ x 9 ¹⁄₁₆ in.)
84.XM.956.70
MARKS & INSCRIPTIONS: (Recto, mount)
signed and dated at l. right, in pencil,
by Evans, *Walker Evans 1929*; at
center top edge, in pencil, by Evans,
Reproduce entire photo: no signature.
[last two words underlined]; at l. left,

The Bridge; (verso, mount) at u. left, in
pencil, by Arnold Crane, *A H Crane
Collection*; at center, in pencil, *Brook-
lyn/The/Bridge N.Y. 1929/3 ¼ x 5″/*
[arrow pointing upward]/*CUT 17* [num-
ber circled] *Full Scale*; at center,
Crane stamp; (recto, mat)
at l. right, in pencil, *26*; at l. left, in
pencil, Crane no. *L65.107(Evans)*.
REFERENCES: CRANE, no. 26; BB, n.p.
NOTE: Not illustrated; variant of no. 19.

21
[*Brooklyn Bridge*], 1929
3.9 x 5.6 cm (1 ⁹⁄₁₆ x 2 ³⁄₁₆ in.)

29

32

84.XM.956.2

MARKS & INSCRIPTIONS: (Verso) at
u. edge, Evans stamp A; at u. left, in
pencil, *250W10S*; at l. center, in pencil,
by Arnold Crane, *withdrawn 12/71
AHC*; at center, Crane stamp; at l. left,
in pencil, Crane no. *L65.38(Evans)*.

22
[*Brooklyn Bridge*], ca. 1928–29
3.9 x 6.2 cm (1 $^{9}/_{16}$ x 2 $^{7}/_{16}$ in.)
84.XM.488.11
MARKS & INSCRIPTIONS: (Verso) at u. left,
Evans stamp A twice [one partial]; at

center, Crane stamp; at bottom, in pen-
cil, by Arnold Crane, *Donated to Art
Inst. of Chicago Dec. 69/A H Crane*.
PROVENANCE: Arnold Crane; Robert
Schoelkopf; Samuel Wagstaff, Jr.
NOTE: Not illustrated; variant of no. 21.

23
[*Brooklyn Bridge*], 1929
4 x 5.7 cm (1 $^{9}/_{16}$ x 2 $^{1}/_{4}$ in.) [on AZO
postcard stock]
84.XM.488.7
MARKS & INSCRIPTIONS: (Verso) at center,
Evans stamp A and in pencil, *6?*.
PROVENANCE: Arnold Crane; Robert
Schoelkopf; Samuel Wagstaff, Jr.

24
[*Brooklyn Bridge*], 1929
4.1 x 5.7 cm (1 $^{5}/_{8}$ x 2 $^{1}/_{4}$ in.)
84.XM.956.33
MARKS & INSCRIPTIONS: (Verso) at u. cen-
ter, Evans stamp A; at center, in
pencil, *5*; at l. left, in pencil, Crane
no. *L65.39(Evans)*.
REFERENCES: CRANE, no 5.
NOTE: Not illustrated; duplicate of
no. 23.

25
Brooklyn Bridge, 1929
Image: 11.2 x 17.2 cm (4 $^{7}/_{16}$ x 6 $^{25}/_{32}$ in.);
original mount: 27.9 x 22.7 cm
(10 $^{15}/_{16}$ x 8 $^{15}/_{16}$ in.)
84.XM.956.120
MARKS & INSCRIPTIONS: (Recto, mount)
signed at l. right, in pencil, by Evans,
Walker Evans; at l. left, in pencil, by
Evans, *Brooklyn Bridge 1929*; (verso,
mount) at center, Evans stamp K;
(recto, mat) at l. right, in pencil, *27*; at
l. left, in pencil, Crane
no. *L65.117(Evans)*.

26
[*Railroad Track Detail, New York*],
1929
8.2 x 14.7 cm (3 $^{1}/_{4}$ x 5 $^{13}/_{16}$ in.)
84.XM.956.36
MARKS & INSCRIPTIONS: (Verso) at l. left,
Evans stamp A; at l. left, in pencil,
Crane no. *L65.44(Evans)*.
REFERENCES: CRANE, no. 15.

27
[*Railroad Track Detail, New York*],
1929
3.5 x 6 cm (1 $^{3}/_{8}$ x 2 $^{3}/_{8}$ in.)
84.XM.956.119
MARKS & INSCRIPTIONS: (Verso) at l. cen-
ter, in pencil, by Evans, *N.Y. 1929*; at
l. left, Evans stamp A; at center, in
pencil, *52* [inverted]; at u. left, in pen-
cil, *#15*; at u. right, [arrow pointing
upward]; at r. center, in pencil,
1 $^{5}/_{8}$ x 2 $^{3}/_{8}$"; at l. left, in pencil, Crane
no. *L65.112(Evans)*.
REFERENCES: CRANE, no. 15.
NOTE: Not illustrated; variant of no. 26.

28
[*Railroad Track Detail, New York*],
ca. 1929
Image: 8 x 14.2 cm (3 $^{3}/_{16}$ x 5 $^{9}/_{16}$ in.);
original mount: 27.9 x 22.9 cm
(10 $^{15}/_{16}$ x 9 in.)
84.XM.488.8
MARKS & INSCRIPTIONS: (Verso, mount)
signed at center, in pencil, *Walker
Evans*; at l. center, in pencil, *600-*;

at l. right, in pencil, Wagstaff
no. *W. Evans 5*.
PROVENANCE: George Rinhart; Samuel
Wagstaff, Jr.

29
[*Port of New York**], ca. 1928–29
Image: 13 x 22.6 cm (5 $^{1}/_{8}$ x 8 $^{7}/_{8}$ in.);
original mount: 18.2 x 25.8 cm
(7 $^{1}/_{8}$ x 10 $^{3}/_{16}$ in.)
84.XM.956.43
MARKS & INSCRIPTIONS: (Verso) at u. left,
Evans stamp I; at l. right, Crane
stamp; at l. left, in pencil, Crane
no. *L65.77*.
REFERENCES: *"New York City,"
Hound & Horn, Oct.–Dec. 1930, n.p.
(variant); WEAW, p. 39 (variant).

30
[*Port of New York**], ca. 1928–29
Image: 6.3 x 10.8 cm (2 $^{1}/_{2}$ x 4 $^{1}/_{4}$ in.);
original mount: 28.2 x 19.5 cm
(11 $^{1}/_{8}$ x 7 $^{11}/_{16}$ in.)
84.XM.488.4
MARKS & INSCRIPTIONS: (Recto, mount)
signed and dated, at l. right, *Walker
Evans 1928*; (verso, mount) at l. right,
in pencil, *Manhattan/1929, 11B, X*,
and Wagstaff no. *W. Evans 12*.
PROVENANCE: George Rinhart; Samuel
Wagstaff, Jr.
REFERENCES: *"New York City," *Hound
& Horn*, Oct.–Dec. 1930, n.p.(variant);
WEAW, p. 39 (variant).
NOTE: Not illustrated; variant of no. 29.

31
[*Port of New York**], ca. 1928–29
6.3 x 10.7 cm (2 $^{1}/_{2}$ x 4 $^{1}/_{4}$ in.)
84.XM.956.115
MARKS & INSCRIPTIONS: (Verso) at center,
Evans stamp K; at l. center, in pencil,
by Arnold Crane, *Withdrawn AHC/12/
71*; at u. left, *'29/AHC*; at l. right, Crane
stamp; (recto, mat) at l. right, in pen-
cil, *2*; at l. left, in pencil, Crane
no. *L65.119(Evans)*.
REFERENCES: *"New York City," *Hound
& Horn*, Oct.–Dec. 1930, n.p. (vari-
ant); WEAW, p. 39 (variant).
NOTE: Not illustrated; duplicate of
no. 30.

32
Manhattan Dock, 1928
6.4 x 3.8 cm (2 $^{1}/_{2}$ x 1 $^{1}/_{2}$ in.)
84.XM.956.114
MARKS & INSCRIPTIONS: (Verso) titled
and dated at center, in pencil, by
Evans, *MANHATTAN/DOCK/1928/
2 $^{1}/_{2}$ x 1 $^{1}/_{2}$*; (recto, mat) at l. left, in
pencil, Crane no. *L65.121(Evans)*; at
l. center, in pencil on white paper
taped to mat, *Manhatten* (sic) *Dock/
Slip 1928* [underlined]/*Orig. Format
used/by W.E. = (orig./condition)*.
REFERENCES: CRANE, no. 1.

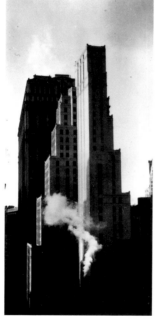

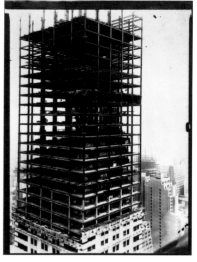

34

35

36

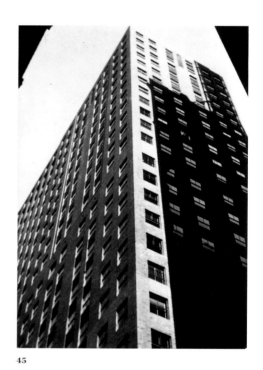

41

42

45

33
[*Manhattan Dock*], 1928
6.3 x 3.8 (2 ½ x 1 ½ in.)
84.XM.956.37
MARKS & INSCRIPTIONS: (Verso) at center,
Evans stamp I; at center, in pencil, *21*;
at left, *50W155*; at l. left, in pencil,
Crane no. *L65.67(Evans)*.
NOTE: Not illustrated; duplicate of
no. 32.

34
[*Manhattan Dock*], 1928
18.1 x 11.9 cm (7 ⅛ x 4 ¹¹⁄₁₆ in.) [on
original mount trimmed to image]

84.XM.956.38
MARKS & INSCRIPTIONS: (Verso) at l. left,
Evans stamp B and in pencil, Crane
no. *L65.68(Evans)*.

35
[*Detail of Ship, New York*], 1928
20.3 x 30.4 cm (8 x 12 in.) [on original
mount trimmed to image]
84.XM.956.65
MARKS & INSCRIPTIONS: (Verso) at
u. right, in pencil, by Evans, *#4/N.Y.
1928*; at l. left, in pencil, *CUT 5* [space]
9″ [arrow pointing to right] *WIDE*; at
u. right, Evans stamp A twice [one par-

tial]; also, in pencil, line from u. left to
l. right; at l. right, in pencil, *CROP*
[crossed out in black ink], with arrow
to line; from top right to bottom right,
ruled pencil line ⅛ in. from edge;
(recto, mat) at l. right, in pencil, *4*; at
l. left, in pencil, Crane
no. *L65.6(Evans)*.
REFERENCES: CRANE, no. 4.

36
Chrysler Building, ca. 1929–30
Image: 16.8 x 11.9 cm
(6 ⅝ x 4 ¹³⁄₁₆ in.); sheet:
17.6 x 12.6 cm (6 ¹⁵⁄₁₆ x 4 ³¹⁄₃₂ in.)

84.XM.956.135
MARKS & INSCRIPTIONS: (Verso) titled at
center, in pencil, by Evans, *Chrysler
Bldg.*; at l. center, Evans stamp J; at
l. left, in pencil, Crane no. *L65.49*.

37
[*Chrysler Building Construction, New
York**], 1930
15.7 x 11.3 cm (6 ³⁄₁₆ x 4 ¹⁵⁄₁₆ in.)
84.XM.956.136
MARKS & INSCRIPTIONS: (Verso) Evans
stamp B; at l. left, in pencil, Crane
no. *L65.50*.
REFERENCES: *APERTURE, p. 25.

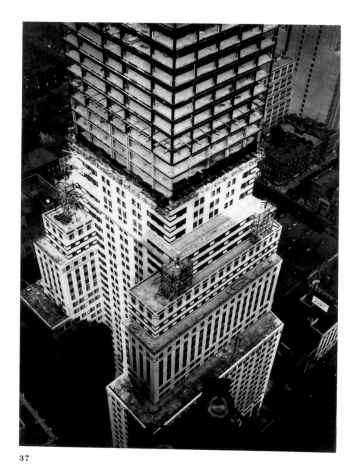

37

38

39

38
[*View of Mid-Town Manhattan*], 1930
Image: 12.9 x 8.3 cm (5 ⅛ x 3 ⁵⁄₁₆ in.);
original mount: 19.1 x 15.3 cm
(7 ½ x 6 ⅟₁₆ in.)
84.XM.956.89
MARKS & INSCRIPTIONS: (Recto, mount) signed and dated at l. right, in pencil, by Evans, *Walker Evans/1930*; (verso, mount) at l. center, Crane stamp;

(recto, mat) at l. right, in pencil, *44*; at l. left, in pencil, *L65.12(Evans)*.

39
[*Cityscape with "Stepped" Building*], ca. 1928–29
7.8 x 5.5 cm (3 ⅟₁₆ x 2 ³⁄₁₆ in.) [on AZO postcard stock]
84.XM.488.6
MARKS & INSCRIPTIONS: (Verso) at u. left, Evans stamp A; at center, in pencil by Arnold Crane, *Donated to Art Inst. of Chicago 1969/Arnold Crane*; at center, in pencil, *2*; at right, Crane stamp.
PROVENANCE: Arnold Crane; Robert Schoelkopf; Samuel Wagstaff, Jr.

40
[*Cityscape with "Stepped" Building*], ca. 1928–29
7.9 x 5.5 cm (3 ⅛ x 2 ³⁄₁₆ in.) [on AZO postcard stock]
84.XM.956.91
MARKS & INSCRIPTIONS: (Verso) at center, in pencil, *23*; at center, Evans stamp A; (recto, mat) at l. right, in pencil, *8,9*; at l. left, in pencil, Crane nos. *L65.33/L65.35 (Evans)*.
NOTE: Not illustrated; duplicate of no. 39.

41
[*Manhattan*], 1929
9.6 x 4.3 cm (3 ²⁵⁄₃₂ x 1 ¹¹⁄₁₆ in.)
84.XM.956.128
MARKS & INSCRIPTIONS: (Recto, mat) at l. right, in pencil, *33*; at l. left, in pencil, Crane no. *L65.118(Evans)*; on white paper taped to mat, at l. center, in pencil, *Manhatter* [sic] *1929* [underlined]/*Orig format*.

42
[*Architectural Study, International Telephone Building*], October 1928
6.1 x 4 cm (2 ⅜ x 1 ⁹⁄₁₆ in.)
84.XM.956.117
MARKS & INSCRIPTIONS: (Verso) at center, in black ink, by Evans, *From S. William St./near Broad St./Rear view of International/Telephone Bldg./(Oct 1928)*; along right edge, in pencil, Crane no. *L65.110(Evans)*.

43
[*Architectural Study, International Telephone Building*], October 1928
6.2 x 3.9 cm (2 ⁷⁄₁₆ x 1 ⁹⁄₁₆ in.)
84.XM.956.20
MARKS & INSCRIPTIONS: (Verso) at l. center, Evans stamp A; at u. center, in pencil, *35* [inverted]; at l. left, in pencil, Crane no. *L65.62(Evans)*.
NOTE: Not illustrated; duplicate of no. 42.

44
[*Architectural Study, International Telephone Building*], October 1928
6.3 x 3.9 cm (2 ½ x 1 ⁹⁄₁₆ in.)
84.XM.956.22
MARKS & INSCRIPTIONS: (Verso) at l. center, Evans stamp A; at right center, in pencil, *27*; at l. left, in pencil, Crane no. *L65.61(Evans)*; (recto, mat) on white paper taped at l. center, in pencil, *from S. William St./ near Broad St./Rear view of Inter/National Telephone/Bldg. (Oct 1928)*.
NOTE: Not illustrated; duplicate of no. 42.

45
Graybar Building, 1929
17.7 x 12.1 cm (7 x 4 ¾ in.) [on original mount trimmed to image]
84.XM.956.26
MARKS & INSCRIPTIONS: (Verso) signed at center, in pencil, possibly by Evans, *W. Evans*; titled and dated at u. right, by Evans, *Graybar Bldg 1929*; at l. left, Evans stamp A; at l. left, in pencil, Crane no. *L65.79(Evans)*.

47

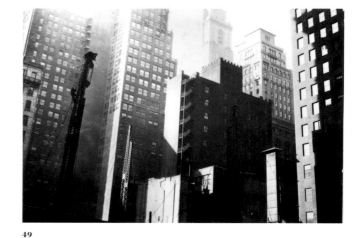

49

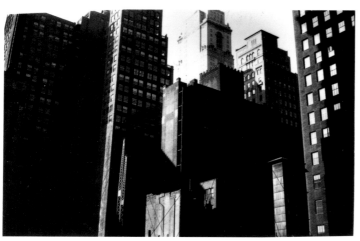

50

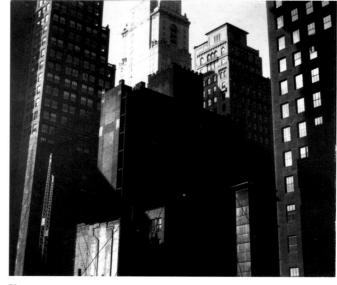

51

46
*Skyscraper Detail Abstract, Graybar
Building*, ca. 1929
Image: 6.3 x 3.9 cm (2 ½ x 1 ¹⁷/₃₂ in.);
original mount [negative sleeve]:
26.6 x 21.8 cm (10 ½ x 8 ⁹/₁₆ in.)
84.XM.956.28
MARKS & INSCRIPTIONS: (Recto, mount)
titled and dated at u. left, in pencil,
by Evans, *Skyscraper detail abstract/
Graybar Bldg 1929? [space] vest
pocket*; (verso, mount) at l. left, in pen-
cil, *35* and Crane no. *L65.80(Evans)*.
NOTE: Not illustrated; variant of
no. 45.

47
[*New York City, Lincoln Building Con-
struction, Forty-second Street and Park
Avenue*], 1929–30
9.1 x 5.7 cm (3 ⅝ x 2 ¼ in.) [on AZO
postcard stock]
84.XM.956.82
MARKS & INSCRIPTIONS: (Verso) at right,
Evans stamp B; at l. left, in pencil,
Crane no. *L65.15(Evans)*.

48
[*New York City, Lincoln Building Con-
struction, Forty-second Street and Park
Avenue*], ca. 1929–30
Image: 9.4 x 5.6 cm (3 ¹¹/₁₆ x 2 ¼ in.);
original mount [negative sleeve]:
26.6 x 21.8 cm (10 ½ x 8 ⁹/₁₆ in.)
84.XM.956.30
MARKS & INSCRIPTIONS: (Recto, mount)
titled at u. left, in pencil, by Evans,
*NEW YORK CITY/Lincoln bldg construc-
tion*; at center, in pencil, by Evans,
2 ¼ x 4 ¼; (mount, verso)
at l. left, in pencil, *33* and Crane
no. *465.36(Evans)*.
NOTE: Not illustrated; variant of no. 47.

49
[*New York City, Lincoln Building Con-
struction, Forty-second Street and Park
Avenue*], 1929–30
Image: 6.5 x 9.1 cm (2 ⁹/₁₆ x 3 ⁹/₁₆ in.);
original mount [negative sleeve]:
26.6 x 21.8 cm (10 ½ x 8 ⁹/₁₆ in.)
84.XM.956.32
MARKS & INSCRIPTIONS: (Recto, mount)
at u. left, in pencil, by Evans, *NEW
YORK CITY/Lincoln Bldg construction*;
and at u. right, by Evans, *2 ¼ x 4 ¼*;
(verso, mount) at l. left, in pencil, *34*
and Crane no. *L65.83 (Evans)*.

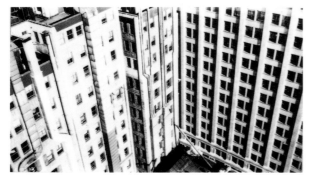

52

54

55

58

REFERENCES: Frank Lloyd Wright, "The Tyranny of the Skyscraper," *Creative Art*, vol. 8, no. 5 (May 1931), p. 328 (variant); WEAW, p. 27 (variant).

50
[*New York City, Lincoln Building Construction, Forty-second Street and Park Avenue*], 1929–30
6.3 x 9.3 cm (2 ½ x 3 ⅝ in.)
84.XM.956.90
MARKS & INSCRIPTIONS: (Verso) at l. left, Evans stamp A; (recto, mat) at l. right, in pencil, *8,9*; at l. left, in pencil, Crane nos. *L65.33/L65.35 (Evans).*

51
[*New York City, Lincoln Building Construction, Forty-second Street and Park Avenue*], 1929–30
13.9 x 15.8 cm (5 ½ x 6 ¼ in.)
84.XM.956.25
MARKS & INSCRIPTIONS: (Verso) at u. left, Evans stamp E; at center, wet stamp, in black ink, *2361*; at l. left, in pencil, Crane no. *L65.34(Evans).*
REFERENCES: Frank Lloyd Wright, "The

Tyranny of the Skyscraper," *Creative Art* 8 (May 1931), p. 328 (variant); WEAW, p. 27 (variant).

52
New York City, Skyscrapers, Abstract Detail, ca. 1929
Image: 6.4 x 10.8 cm (2 ⁹⁄₁₆ x 4 ¼ in.); original mount [negative sleeve]: 26.6 x 21.8 cm (10 ½ x 8 ⁹⁄₁₆ in.)
84.XM.956.31
MARKS & INSCRIPTIONS: (Recto, mount) titled at u. left, in pencil, by Evans, *NEW YORK CITY/skyscrapers, abstract detail*; and at u. right, *2 ¼ x 4 ¼*; (verso, mount) at l. right, in pencil, [*10*]; at l. left, in pencil, Crane no. *L65.81(Evans).*

53
[*New York City, Skyscrapers, Abstract Detail*], ca. 1929
Image: 15 x 24.5 cm (5 ¹³⁄₁₆ x 9 ²¹⁄₃₂ in.); sheet: 17.9 x 25.3 cm (7 ¹⁄₁₆ x 9 ³¹⁄₃₂ in.)
84.XM.956.132
MARKS & INSCRIPTIONS: (Verso) at r. center, Evans stamp A; at u. center, in pencil, arrow pointing upward, *NO CROPPING/SHOW ALL + MARGINS*; at u. left, in pencil, *#236 CHICAGO, N.D.*; at l. left, *CUT 4* [circled] *9″* [arrow pointing to right] *WIDE/L65.82* [last line is Crane no.]; in pencil, diagonal line from u. left to l. right.
REFERENCES: CRANE, no. 228 (incorrectly titled *Chicago*).
NOTE: Not illustrated; variant of no. 52.

54
[*Architectural Study*] ca. 1928–29
6.1 x 5.4 cm (2 ⁷⁄₁₆ x 2 ⅛ in.)
84.XM.956.83
MARKS & INSCRIPTIONS: (Verso), at center, Evans stamp A [inverted].

55
East 14th Street, October 1928
3.8 x 5.9 cm (1 ⁹⁄₁₆ x 2 ⁵⁄₁₆ in.)
84.XM.956.84
MARKS & INSCRIPTIONS: (Verso) titled at u. left, in black ink, by Evans, *E14ST/10-28*; at center, Evans stamp A; at l. right, wet stamp, in black ink, *23*; (recto, mat) in pencil, Crane nos. *Mpls./L65.19.22,23(Evans).*

56
Construction Detail of Skyscraper/[East 14th Street], 1928
Image: 4 x 6 cm (1 ⁹⁄₁₆ x 2 ⅜ in.); original mount [negative sleeve]: 26.6 x 21.8 cm (10 ½ x 8 ⁹⁄₁₆ in.)
84.XM.956.29
MARKS & INSCRIPTIONS: (Recto, mount) at u. left, in pencil, by Evans, *construction detail of skyscraper*; (verso, mount) at l. left, in pencil, *36* and Crane no. *L65.21(Evans).*
NOTE: Not illustrated; variant of no. 55.

57
[*East Fourteenth Street*], ca. 1928–29
9.1 x 14 cm (3 ⅝ x 5 ½ in.)
84.XM.956.23
MARKS & INSCRIPTIONS: (Verso) at u. left, Evans stamp E; at center, wet stamp, in black ink, *2369*; at l. left, in pencil, Crane no. *L65.20(Evans).*
NOTE: Not illustrated; variant of no. 55.

58
[*Architectural Study with Cranes and Cables*], ca. 1928–29
6.2 x 4 cm (2 ⁷⁄₁₆ x 1 ⁹⁄₁₆ in.)
84.XM.956.118
MARKS & INSCRIPTIONS: (Verso) at l. center, Evans stamp A; at center, in pencil, *30*; at l. left, in pencil, Crane no. *65.111(Evans).*
REFERENCES: WEAW, p. 26 (variant).

59
[*Architectural Study with Cranes and Cables*], ca. 1928–29
6.3 x 4.1 cm (2 ½ x 1 ⅝ in.)
84.XM.956.19
MARKS & INSCRIPTIONS: (Verso) at u. center, Evans stamp A; at u. center, in pencil, *31*; at l. left, in pencil, Crane no. *L65.64(Evans).*
REFERENCES: WEAW, p. 26 (variant).
NOTE: Not illustrated; duplicate of no. 58.

61

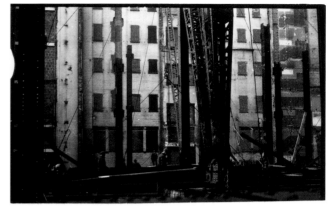

62

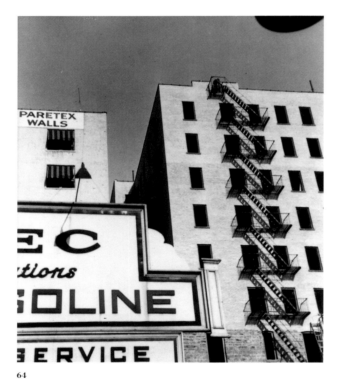

64

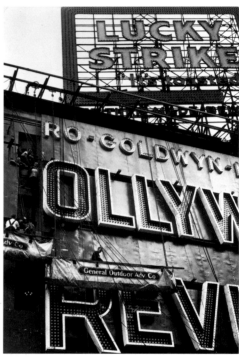

65

60
[*Architectural Study with Crane and Cables*], ca. 1928–29
6.3 x 4.1 cm (2 ½ x 1 ⅝ in.)
84.XM.956.21
MARKS & INSCRIPTIONS: (Verso) at center, Evans stamp A; at center, in pencil: *32*; at l. left, in pencil, Crane no. *L65.31(Evans)*.
REFERENCES: WEAW, p. 26 (variant).
NOTE: Not illustrated; duplicate of no. 58.

61
[*Architectural Study with Crane*], ca. 1928–29

6.5 x 7.8 cm (2 ⁹⁄₁₆ x 3 ¹⁄₁₆ in.)
84.XM.956.85
MARKS & INSCRIPTIONS: (Verso) at l. left, Evans stamp A; (recto, mat) at l. left, in pencil, Crane nos. *Mpls./ L65.19,.22,.23(Evans)*.

62
[*Architectural Study, Construction Site with Welders*], ca. 1928–29
Image: 5.4 x 8.3 cm (2 ⅛ x 3 ¼ in.)
84.XM.488.3
MARKS & INSCRIPTIONS: (Verso) at center, Evans stamp A.
PROVENANCE: Arnold Crane; Robert Schoelkopf; Samuel Wagstaff, Jr.

63
[*Architectural Study, Construction Site with Welders*], ca. 1928–29
5.3 x 8.7 cm (2 ⅛ x 3 ⁷⁄₁₆ in.)
84.XM.956.86
MARKS & INSCRIPTIONS: (Verso) at u. right, Evans stamp A; (recto, mat) at l. left, in pencil, Crane nos. *Mpls./ L65.19,.22,.23(Evans)*.
NOTE: Not illustrated; variant of no. 62.

64
Bronx, New York City, ca. 1928–29
15 x 12.7 cm (5 ⅞ x 5 in.); original mount 15 x 12.7 cm (5 ⅞ x 5 in.)
84.XM.956.24
MARKS & INSCRIPTIONS: (Verso, mount) at center, in pencil, by Evans, *Bronx, N.Y.C.*; at center, Evans stamp B; at l. left, in pencil, Crane no. *L65.56 (Evans)*.

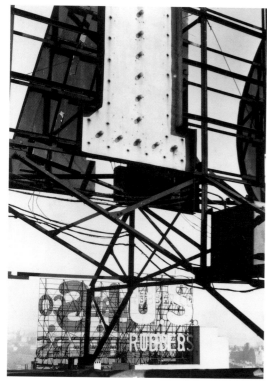

66

67

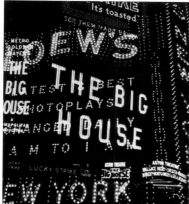

68

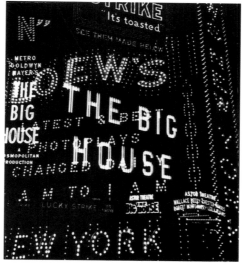

69

Webs," *USA*, Summer 1930, p. 102;
*FAL, pl. 4 (variant).
EXHIBITIONS: *Neither Speech Nor Language: Photography and the Written Word*, J. Paul Getty Museum, Malibu, Calif., Feb. 28–May 12, 1991.

67
[*Manhattan**], ca. 1928–30
Image: 10.5 x 6.1 cm (4 ⅛ x 2 ⅜ in.);
original mount: 11.5 x 9 cm
(4 ½ x 3 ⁹⁄₁₆ in.)
84.XM.956.48
MARKS & INSCRIPTIONS: (Recto, mount)
dated at u. left, in pencil, by Evans,
1930; at right edge, Evans stamp A;
(verso, mount) at center, Evans stamp
A; (recto, mat) at l. left, in pencil,
Crane no. *L65.46(Evans)*.
REFERENCES: *FAL, p. 4 (variant).

68
Times Square/[*Broadway Composition**], 1930
24.8 x 21.8 cm (9 ¾ x 8 ⁹⁄₁₆ in.) [on
mount trimmed to image]
84.XM.488.10
MARKS & INSCRIPTIONS: (Verso) signed at
l. right, in pencil, by Evans, *Walker
Evans*; at u. center, in pencil, by
Evans, *Times Square, 1931 (?)/Composition of 2 Leica snapshots, enlarged.*;
at u. left, *?*; at center, *— 5 in —*; at
right center: *T-4*; at l. right, *Evans–6*;
at right center, wet stamp, in red ink,
No Line and wet stamp, in blue ink,
101017.
PROVENANCE: George Rinhart; Samuel
Wagstaff, Jr.
REFERENCES: *"Mr. Walker Evans
Records a City's Scene," *Creative Art*,
Dec. 1930, p. 454 (variant).

69
[*Times Square*]/[*Broadway Composition**], 1930
27 x 23.4 cm (10 ⅝ x 9 ¼ in.) [on original mount trimmed to image]
84.XM.956.46
MARKS & INSCRIPTIONS: (Verso) signed at
l. right, in pencil, by Evans,
Walker Evans; at u. right, in pencil, *4
BROADWAY/WALKER EVANS/CARE JULIEN
LEVY/602 MADISON AVE/NEW YORK*; at
l. left, in pencil, Crane no. *L65.76
(Evans)*.
REFERENCES: *WEAW, p. 31 (variant).
EXHIBITIONS: *Experimental Photography: The Machine Age*, J. Paul Getty
Museum, Malibu, Calif., Sept. 26–
Dec. 10, 1989.

EXHIBITIONS: *Neither Speech Nor Language: Photography and the Written Word*, J. Paul Getty Museum, Malibu, Calif., Feb. 28–May 12, 1991.

65
Outdoor Advertisements, ca. 1929
21.9 x 14.4 cm (8 ⅝ x 5 ¹¹⁄₁₆ in.)
84.XM.956.137
MARKS & INSCRIPTIONS: (Verso) at u. center, in ink, by Evans, *OUTDOOR
ADVERTISEMENTS*; at center, in ink, by
Evans, *WALKER EVANS/63 PARK AVE.*

N.Y.C.; in pencil: *Walker Evans*; at l.
center, in pencil, *Shown in the exhibition of photographs/for Commerce
Industry and Science/of the National
Alliance of Art/and Industry.*; at
l. right, in ink, *3* [circled]; at l. left, in
pencil, Crane no. *L65.47*.
REFERENCES: WEAW, p. 30 (variant,
l. right).
EXHIBITIONS: *Experimental Photography: The Machine Age*, J. Paul Getty
Museum, Malibu, Calif., Sept. 26–
Dec. 10, 1989.

66
[*Manhattan**], ca. 1928–30
Image: 23.4 x 15.6 cm (9 ⁷⁄₃₂ x 6 ⅛ in.);
original mount: 29.1 x 20.4 cm
(11 ½ x 8 ¹⁄₃₂ in.)
84.XM.956.49
MARKS & INSCRIPTIONS: (Verso, mount)
signed at l. right, in
pencil, by Evans, *Walker Evans*; at
u. center, in pencil: *17#/New York,
ca. 1929*; in pencil, cropping marks
outlining print with diagonal line from
u. left to u. right corners.
REFERENCES: Walker Evans, "Sky

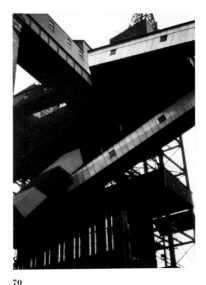

70

71

72

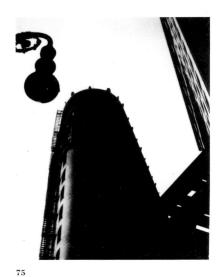

75

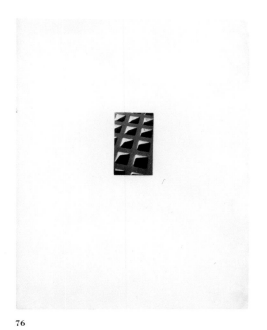

76

77

70
[*Industrial Architecture*], ca. 1929–30
19.6 x 13.7 cm (7 ¾ x 5 ⅜ in.)
84.XM.956.134
MARKS & INSCRIPTIONS: (Verso) at center,
Evans stamp B; at l. left, in pencil,
Crane no. *L65.48*.
REFERENCES: "Photographic Studies,"
Architectural Record, Sept. 1930,
p. 197; WEAW, p. 39 (variant).

71
Grain Elevator, ca. 1930
Image: 22.2 x 14.5 cm
(8 ¾ x 5 ¹¹⁄₁₆ in.); original mount:
22.6 x 16.4 cm (8 ⅞ x 6 ½ in.)

84.XM.956.96
MARKS & INSCRIPTIONS: (Verso, mount) at
center, in black ink, by Evans, *no. 6/
GRAIN ELEVATOR/BY WALKER EVANS/63
PARK AVE., N.Y.C./Industrial photo;
intended as/study of industrial architec-
ture/price of prints $15.* —; at u. left, in
pencil, *#38*; at center, in pencil, *ca.
1930*; at l. left, in ink, arrow pointing
to left/*crop white margins*; at l. left, in
pencil, *cut 9 ⅝″* [arrow pointing
upward] *HIGH*; in pencil, rectangular
box drawn to indicate edges of print
with diagonal line from u. left to bot-
tom right; (recto, mat) at l. right, in

pencil, *38*; at l. left, in pencil, Crane
no. *L65.11(Evans)*.
REFERENCES: CRANE, no. 38.

72
[*Grain Elevator with Conveyors,
Possibly Canada*], 1931
Image: 13.5 x 10.4 cm
(5 ⁵⁄₁₆ x 4 ³⁄₃₂ in.); original mount:
16.7 x 13.5 cm (6 ⁹⁄₁₆ x 5 ⁵⁄₁₆ in.)
84.XM.488.17
MARKS & INSCRIPTIONS: (Recto, mount)
signed and dated at l. right below
print, in pencil, by Evans,
Walker Evans 1931.

PROVENANCE: George Rinhart; Samuel
Wagstaff, Jr.

73
[*Factory with Conveyors*]/[*Montreal
Grain Elevators**], ca. 1930
12.1 x 11.5 cm (4 ¾ x 4 ½ in.)
84.XM.956.35
MARKS & INSCRIPTIONS: (Verso) at u. cen-
ter, Evans stamp K; at l. left, in pencil,
Crane no. *L65.57(Evans)*.
REFERENCES: Titled **Montreal Grain
Elevators* in Crane inventory list.

73

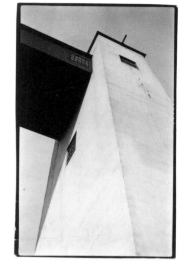

74

78

79

74
[*Factory Tower, New York*], ca. 1930
Image: 11 x 6.5 cm (4 5/16 x 2 9/16 in.);
sheet: 11.2 x 6.8 cm
(4 3/8 x 2 11/16 in.)
84.XM.956.129
MARKS & INSCRIPTIONS: (Verso) at center,
Evans stamp B; at r. center, Crane
stamp; at l. left in pencil, *AZ04/45 S.
50W*; (recto, mat) at l. right, in pencil,
39; at l. left, in pencil, Crane
no. *L65.122(Evans)*.

75
[*Flat Iron Building, New York*],
ca. 1928–29
5.5 x 4.1 cm (2 1/8 x 1 5/8 in.)
84.XM.956.81
MARKS & INSCRIPTIONS: (Verso) at l. cen-
ter, Evans stamp A; at l. left, in pencil,
Crane no. *L65.14(Evans)*.

76
Bronx, 1928
Image: 6.2 x 3.8 cm (2 7/16 x 1 1/2 in.);
original window mat: 27.8 x 21.5 cm
(11 x 8 7/16 in.)
84.XM.488.2

MARKS & INSCRIPTIONS: (Recto, mat)
signed inside, in pencil below print,
Walker Evans; at l. left, in pencil, *N.Y./
1928*; at l. right, by Evans, *Bronx/
1928*; (verso, mat) blindstamped out-
side at u. left, *BAINBRIDGE/DRAWING
PAPER N° G-61*; at bottom center, in pen-
cil, *650*; at l. right, in pencil, Wagstaff
no. *W Evans 13* [space] *7*.
PROVENANCE: George Rinhart; Samuel
Wagstaff, Jr.

77
Manhattan, October 1928
Image: 3.8 x 6.3 cm (1 1/2 x 2 1/2 in.);
original window mat: 27 x 21.6 cm
(10 5/8 x 8 1/2 in.)
84.XM.956.27
MARKS & INSCRIPTIONS: (Verso) at top
edge, in black ink and pencil, by
Evans, *44st betw 2nd & 1st* [space]
10-28; at l. right, wet stamp, in black
ink, *1*; at l. left, in pencil, Crane
no. *L65.72(Evans)*; (recto, mat) at
l. right, in pencil, by Evans, *Manhat-
tan/1928*; (verso, mat) at l. center,
Evans stamp A; at u. left, in pencil,
B49/5; at l. right, in pencil, *6*; at l. left,
in pencil, Crane no. *L65.72(Evans)*.

78
[*Glass Roof of Pennsylvania Station,
New York City*], ca. 1928–29
3.9 x 5.3 cm (1 9/16 x 2 1/16 in.)
84.XM.488.5
MARKS & INSCRIPTIONS: (Recto and
verso, mat) at l. right on both, in
pencil, Wagstaff no. *W. Evans 16*.
PROVENANCE: Arnold Crane; Robert
Schoelkopf; Samuel Wagstaff, Jr.
REFERENCES: WEAW, p. 39 (variant, cen-
ter left image).

79
Wall Street Windows, ca. 1929
29.9 x 19.2 cm (11 3/4 x 7 9/16 in.) [on
original mount trimmed to image]
84.XM.956.116
MARKS & INSCRIPTIONS: (Verso) titled,
signed and dated at u. center, in
pencil, by Evans, *Wall St. Windows,
1929?/Walker Evans*; at l. right, Crane
stamp; at l. left, in pencil, Crane
no. *L65.126* and *Arnold H.
Crane Collection*.

80
[*Wall Street Windows*], ca. 1929
29.2 x 19 cm (11 1/2 x 7 1/2 in.) [on origi-
nal mount trimmed to image]
84.XP.208.22
MARKS & INSCRIPTIONS: (Verso) at u. cen-
ter, in pencil, *8* [circled]; at u. right,
NS 35; at l. center, *XIV-105/c.1929*; at
l. left, *#2*; at l. center, Lunn Gallery
stamp, and within boxes, in pencil,
XIV and *105*.
PROVENANCE: Daniel Wolf.
NOTE: Not illustrated; duplicate of
no. 79.

81

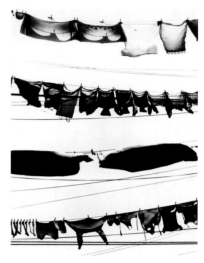

82

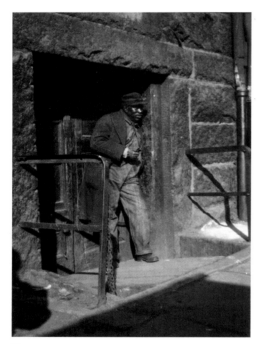

85

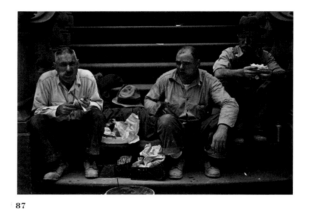

87

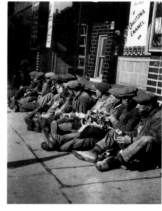

88

81
[*Detail of Mooring Chains, New Bedford, Massachusetts*], 1928
Image: 5.5 x 8.8 cm (2 ³/₁₆ x 3 ½ in.); original mount: 8 x 11.2 cm (3 ⅛ x 4 ⅜ in.)
84.XM.488.9
MARKS & INSCRIPTIONS: (Recto, mount) signed and dated at l. right, in pencil, by Evans, *Walker Evans 1928*; (verso, mount) at center, *1* [circled]; at l. right, in pencil, Wagstaff no. *W. Evans 11*.
PROVENANCE: George Rinhart; Samuel Wagstaff, Jr.

REFERENCES: MoMA, p. 27 (variant, dated 1931).

82
Washington Street, New York City/ [*Wash Day**], ca. 1930
27.5 x 20.3 cm (10 ⅞ x 8 in.)
84.XM.956.45
MARKS & INSCRIPTIONS: (Verso) at center, in pencil, by Evans, *Washington St. NYC*; at l. center, Evans stamp A; at l. right, in pencil, *Arnold Crane Collection*; at l. left, in pencil, Crane no. *L65.71(Evans)*.

REFERENCES: *"New York City," *Hound & Horn*, Oct.–Dec. 1930, n.p.; APERTURE, p. 11 (variant).

83
[*Clothesline and Smokestacks*], ca. 1930
Image: 13.2 x 19.5 cm (5 ¼ x 7 ¹¹/₁₆ in.); original mount: 17.4 x 25.7 cm (6 ¹³/₁₆ x 10 ⅛ in.)
84.XM.956.42
MARKS & INSCRIPTIONS: (Verso, mount) at center, Evans stamp E; at l. right, Crane stamp.

84
[*Clothesline and Smokestacks*], ca. 1930
19.9 x 13.3 cm (7 ²⁷/₃₂ x 5 ¼ in.)
84.XM.956.112
MARKS & INSCRIPTIONS: (Verso) at l. right, Evans stamp A.; (recto, mat) at l. left, in pencil, Crane no. *L65.120 (Evans)*.

85
Longshoreman, South Street, New York City, 1928
20 x 14 cm (7 ⅞ x 5 ½ in.)
84.XM.956.52
MARKS & INSCRIPTIONS: (Verso) at center, in pencil, by Evans, *Longshoreman/*

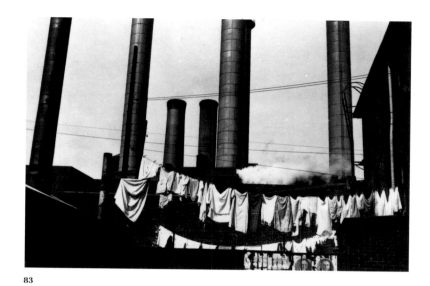

83

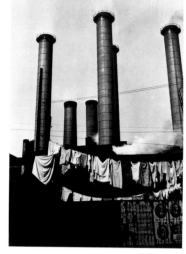

84

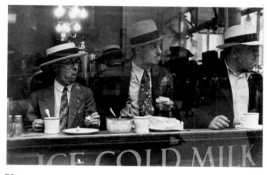

90

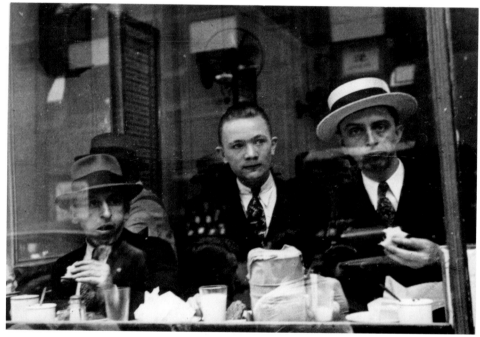

91

South Street NYC/photo 1928; at
l. right, Evans stamp A; at l. left, in
pencil, Crane no. *65.52(Evans)*.
REFERENCES: WEAW, p. 22 (variant).

86
[*Longshoreman*], 1928
6.2 x 4.1 cm (2 ⁷⁄₁₆ x 1 ⅝ in.)
84.XM.956.127
MARKS & INSCRIPTIONS: (Verso) at center,
Evans stamp A; (recto, mat) at l. right,
in pencil, *66, 67*; at l. left, in pencil,
Crane nos. *L65.123.124(Evans)*.
REFERENCES: WEAW, p. 22.
NOTE: Not illustrated; variant of no. 85.

87
[*Three Workmen Eating Lunch*],
ca. 1928–29
11.8 x 17.5 cm (4 ¹¹⁄₁₆ x 6 ⅞ in.)
84.XM.956.56
MARKS & INSCRIPTIONS: (Verso) at right
center, Evans stamp B; at l. left, in
pencil, Crane no. *L65.54(Evans)*.

88
[*Workmen Eating Lunch*], ca. 1928–29
5.6 x 4.1 cm (2 ⁷⁄₃₂ x 1 ¹⁹⁄₃₂ in.)
84.XM.956.126
MARKS & INSCRIPTIONS: (Verso) at l. cen-
ter, in pencil, by Evans, *11–28* and
Evans stamp A; (recto, mat) at l. right,
in pencil, *66, 67*; at l. left, in pencil,

Crane nos. *L65.123 124(Evans)*.
REFERENCES: WEAW, p. 22 (variant).

89
[*Workmen Eating Lunch*], ca. 1928–29
Image: 19 x 14.9 cm (7 ½ x 5 ⅞ in.);
sheet: 19 x 14.9 cm (7 ¹⁵⁄₁₆ x 6 ¹⁄₁₆ in.)
84.XM.956.53
MARKS & INSCRIPTIONS: (Verso) at
l. right, Evans stamp A; at l. left, in
pencil, Crane no. *L65.53(Evans)*.
REFERENCES: WEAW, p. 22 (variant).
NOTE: Not illustrated; variant of no. 88.

90
[*New York Lunch Counter*], ca. 1930
14.7 x 22.5 cm (5 ¹³⁄₁₆ x 8 ⅞ in.)

84.XM.956.62
MARKS & INSCRIPTIONS: (Verso) at
l. right, Evans stamp A; (recto, mat) at
l. left, in pencil, Crane no. *L65.25*
(*Evans*).

91
[*New York Lunch Counter*], ca. 1930
12.5 x 17.4 cm (4 ¹⁵⁄₁₆ x 6 ²⁷⁄₃₂ in.) [on
original mount trimmed to image]
84.XM.956.68
MARKS & INSCRIPTIONS: (Verso) at center,
Evans stamp K; (recto, mat) at l. left,
in pencil, Crane no. *L65.24(Evans)*.
REFERENCES: FAL, p. 14 (variant).

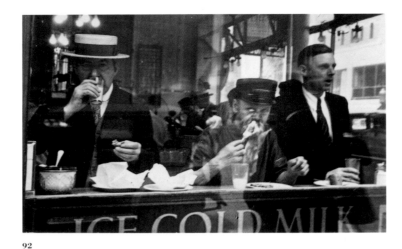

92

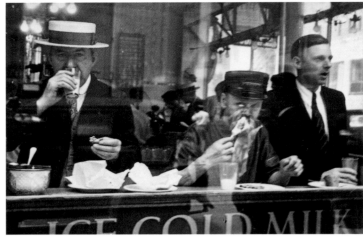

93

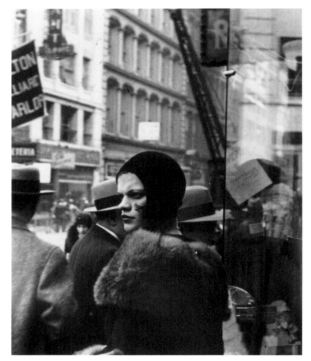

96

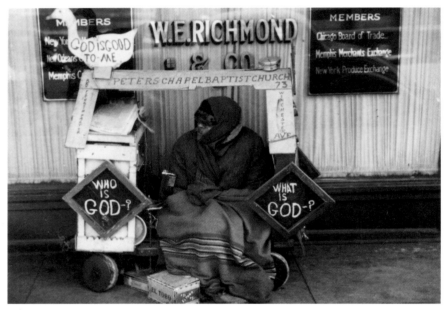

97

92
New York Lunch Counter, ca. 1930
12.5 x 20.0 cm (4 ¹⁵/₁₆ x 7 ⅞ in.) [on
original mount trimmed to image]
84.XM.956.125
MARKS & INSCRIPTIONS: (Verso) at center,
in black ink, by Evans, *NEW YORK
LUNCH COUNTER/PHOTOGRAPH BY
WALKER EVANS*; at u. center, Evans
stamp K; at l. right, Crane stamp;
(recto, mat) at l. left, in pencil, *53* and
Crane no. *L65.113(Evans)*.
REFERENCES: "Mr. Walker Evans
Records a City's Scene," *Creative Art*,
Dec. 1930, p. 456 (variant, titled

"'Hurry up please, it's time.' New York
City's quick lunch . . . "); WEAW, p. 47
(variant, l. right).

93
[*New York Lunch Counter*], ca. 1930
12.2 x 18 cm (4 ¹³/₁₆ x 7 ¹/₁₆ in.) [on
mount trimmed to image]
84.XM.956.57
MARKS & INSCRIPTIONS: (Verso) at
l. right, Evans stamp A; at l. left, in
pencil, Crane no. *L65.26(Evans)*.
REFERENCES: "Mr. Walker Evans
Records a City's Scene," *Creative Art*,
Dec. 1930, p. 456 (variant, titled

"'Hurry up please, it's time,' New York
City's quick lunch . . . ").

94
6th Avenue/[Forty-second Street]*,
1929
Image: 12 x 18.5 cm (4 ¾ x 7 ⁵/₁₆ in.);
original mount: 18.7 x 21.7 cm
(7 ⅜ x 8 ⁹/₁₆ in.)
84.XM.956.506
MARKS & INSCRIPTIONS: (Recto, mount)
signed at l. right, in pencil, by Evans,
Walker Evans; dated at l. left, in pen-
cil, by Evans, *1931*; (verso, mount) at

u. left, in pencil, *6th Ave./1929*; at
l. center, Crane stamp; (recto, mat)
at l. right, in pencil, *63*; at l. left, in
pencil, Crane no. *L68.13(Evans)*; at
l. center, in pencil on white label
taped down, *N.Y. 1931/Pubd in/
HOUND & HORN/Also American
Photographs*.
REFERENCES: "New York City," *Hound
& Horn*, Oct.–Dec. 1930, n.p. (first pub-
lication of image); *AMP, 1938, Part I,
no. 19 (variant); FAL, p. 12 (variant);
APERTURE, p. 21 (variant); WEAW,
p. 45 (variant).

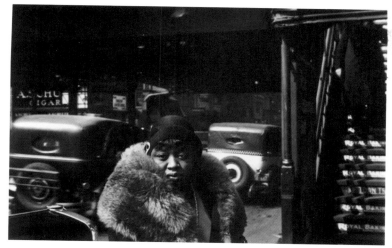

94

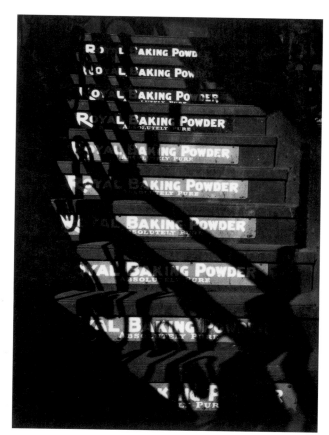

95

98

95
[*Royal Baking Powder Steps*], 1929
19.7 x 14.1 cm (7 ¾ x 5 ⁹⁄₁₆ in.) [on original mount trimmed to image]
84.XM.956.64
MARKS & INSCRIPTIONS: (Verso) at center, Evans stamp K; (recto, mat) at l. right, in pencil, *64*; at l. left, in pencil, Crane no. *L65.5(Evans)*.
REFERENCES: WEAW, p. 38 (variant).

96
[*Girl in Fulton Street, New York**], 1929
17 x 13.6 cm (6 ¹¹⁄₁₆ x 5 ⅜ in.) [on original mount trimmed to image]

84.XM.956.490
MARKS & INSCRIPTIONS: (Verso) at center, Evans stamp F; at l. right, Crane stamp; at u. right, in pencil, on white label, *117*; (recto, mat) at l. left, in pencil, Crane no. *L68.12(Evans)*; on white label taped to mat, in pencil, *Girl in Fulton St./N.Y. 1929/AMER PHOTOS P43/HOUND & HORN*.
REFERENCES: *AMP, Part I, no. 17 (variant); FAL, p. 13 (variant); APERTURE, p. 23; WEAW, p. 45 (variant).

97
[*"Who is God?" Street Preacher's Wagon, New York*], ca. 1929
11.6 x 16.1 cm (4 ⁹⁄₁₆ x 6 ¹¹⁄₃₂ in.)
84.XM.956.333
MARKS & INSCRIPTIONS: (Verso) at right center, Evans stamp B; (recto, mat) at l. right, *239*; at l. left, in pencil, Crane no. *L78.4(Evans)*.

98
[*Female Pedestrian, New York*], ca. 1929–31
14.5 x 16.6 cm (5 ¹¹⁄₁₆ x 6 ⁹⁄₁₆ in.) [on original mount trimmed to image]

84.XM.956.88
MARKS & INSCRIPTIONS: (Verso) at u. right, Evans stamp I; at u. right, in pencil, *#62 N.Y. ca.1931*; at l. left, *CUT 25* [circled] *3 ¾"* [arrow pointing upward] *HIGH*; at l. right, Crane stamp; in pencil, diagonal line from u. left to l. right corner; (recto, mat) at l. right, in pencil, *62*; at l. left, in pencil, Crane no. *L65.8(Evans)*.
REFERENCES: CRANE, no. 61 (dated 1931).

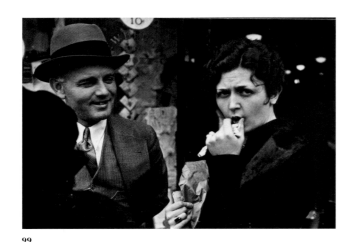

99

100

101

102

103

104

99
[*Couple in Front of Newberry's, New York City*], ca. 1930
15.1 x 21.3 cm (5 ¹⁵/₁₆ x 8 ⁷/₁₆ in.) [on original mount trimmed to image]
84.XM.956.102
MARKS & INSCRIPTIONS: (Verso) at u. left, Evans stamp A; at l. left, in pencil, Crane no. *L78.26.* [Note: no. 814 previously affixed to verso mount.]
REFERENCES: FAL, p. 17 (variant); WEAW, p. 45 (variant).

100
[*Woman in Front of Newberry's, New York City*], ca. 1930
Image: 11.7 x 9 cm (4 ¹⁹/₃₂ x 3 ¹⁷/₃₂ in.); original mount:
12.9 x 9.6 cm (5 ¹/₁₆ x 3 ¹³/₁₆ in.)
84.XM.956.101
MARKS & INSCRIPTIONS: (Verso, mount) at l. right, Evans stamp A; at l. left, in pencil, Crane no. *L78.27(Evans).*
REFERENCES: FAL, p. 17 (variant); WEAW, p. 45 (variant).

101
[*Coney Island*], ca. 1928–29
27.8 x 19.7 cm (10 ¹⁵/₁₆ x 7 ¾ in.) [on

original mount trimmed to image]
84.XM.956.11
MARKS & INSCRIPTIONS: (Verso) signed at center, in pencil, by Evans, *Walker Evans*; at l. left, in pencil, Crane no. *L65.75(Evans).*
REFERENCES: WEAW, p. 35 (variant).

102
[*Couple at Coney Island**], 1928
18.6 x 15.5 cm (7 ⁵/₁₆ x 6 ¹/₁₆ in.)
84.XM.956.464
MARKS & INSCRIPTIONS: (Verso) at center, Evans stamp B; at center, in pencil, *14* [circled]; at l. left, in pencil, Crane

no. *L68.28(Evans)* and *110A.*
REFERENCES: *AMP, Part I, no. 41 (variant); FAL, p. 11 (variant).
EXHIBITIONS: *Art of Photography,* Museum of Fine Arts, Houston, Tex., Feb. 11–Apr. 30, 1989.

103
[*Coney Island**], 1929
23.3 x 14.8 cm (9 ³/₁₆ x 5 ¹³/₁₆ in.) [on Masonite trimmed to image]
84.XM.956.435
MARKS & INSCRIPTIONS: (Verso, mount) signed at l. center, in pencil, by Evans, *Walker Evans*; at l. center, in

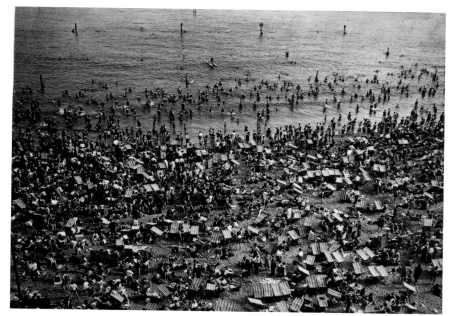

105

106

107

pencil, *A.P. 1: I-11*; at center, Evans
stamp F; on MoMA label, at u. center,
in pencil, *A.P. 1: I-11/eleven*; on MoMA
label, at l. right, in blue ink, *GR.V*;
typed on label, *EVANS/CONEY ISLAND
BOARDWALK, 1929/40/38.2299*; at l. left,
in pencil, Crane no. *L69.2(Evans)*.
REFERENCES: *FAL, p. 10 (variant);
WEAW, p. 24 (variant).

104
[*Coney Island Boardwalk**], 1929
Image: 21.4 x 14.4 cm
(8 ⁷/₁₆ x 5 ²¹/₃₂ in.); original hole-

punched mount: 27.9 x 21.6 cm
(11 x 8 ½ in.)
84.XM.956.462
MARKS & INSCRIPTIONS: (Recto, mount)
at l. center, in black ink, *Part One.
#11. Coney Island 'Boardwalk['']/1929*;
at u. right, in pencil, *99.3* [next to right
angle and crossed out]; at l. left, *OK
to/Retouch*; at center, *1 to 8 ¼*; at
l. right, *I-11* [circled]; at l. right, *11*; at
l. right, in red pencil, *S.*; (verso,
mount) at u. center, in pencil, *I-11*; at
l. center, *H2416-86/86/NO* [within a
box] *150 h*; at l. right, *11*; at center,
Evans stamp A; at l. left, in pencil,

Crane no. *L68.8(Evans)*.
REFERENCES: *AMP, Part I, no. 11;
WEAW, p. 24 (variant).

105
[*Coney Island Beach*], ca. 1929
22.5 x 30.9 cm (8 ⁷/₈ x 12 ³/₁₆ in.)
84.XM.956.121
MARKS & INSCRIPTIONS: (Verso) at
l. right, Evans stamp A; (recto, mat)
at l. left, in pencil, *24* and in pencil,
Crane no. *L65.114(Evans)*.

106
Coney Sands, 1930
30.8 x 18.3 cm (12 ⅛ x 7 ³/₁₆ in.)
84.XM.956.13
MARKS & INSCRIPTIONS: (Verso) titled,
dated and signed at center, in pencil,
by Evans, *Coney Sands 1930/enlarged
snapshot/by/w/Walker Evans*; at u. left,
in pencil, *CROP* [arrow pointing up]/
#12; at l. left, in pencil, *12 CUT 27* [27
is circled] *5 ¼"* [arrow pointing
upward] *HIGH/—CROP* [arrow pointing
down] *1S* [space] *43.-15-140*; in pencil,
diagonal line from u. left to l. right; at
l. left, in pencil, on white label, Crane
no. *L65.69/(Evans)*.
REFERENCES: CRANE, no. 236; WEAW,
p. 25 (dated 1928–29).

107
[*Coney Sands*], 1930
20.1 x 17.5 cm (7 ¹⁵/₁₆ x 6 ⅞ in.) [on
mount trimmed to image]
84.XM.956.12
MARKS & INSCRIPTIONS: (Verso) at center,
Evans stamp B; at u. left, partial
Evans stamp B; at l. left, in pencil,
Crane no. *L65.70(Evans)*
REFERENCES: WEAW, p. 25 (variant,
dated 1928–29).

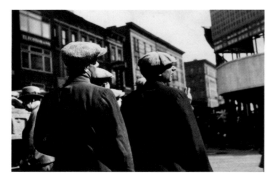

108

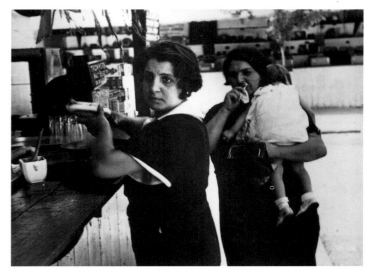

109

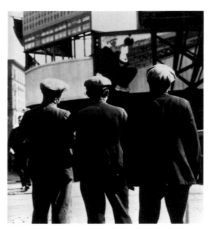

110

111

112

108
[*Two Men and a Woman at Amusement Park*], ca. 1929
15.4 x 21 cm (6 ⅟₁₆ x 8 ⁵⁄₁₆ in.) [on original mount trimmed to image]
84.XM.956.92
MARKS & INSCRIPTIONS: (Verso) at u. right, Evans stamp I; at u. left, in pencil, by Arnold Crane, *Brooklyn Amusement Pk/1934*; at l. right, Crane stamp; at l. left, in pencil, Crane no. *L65.84.(Evans)*; (recto, mat) at l. left, in pencil, Crane no. *L65.84(Evans)*.
REFERENCES: WEAW, p. 47 (variant).

109
[*Two Women at a Hot Dog Stand, Possibly Coney Island*], ca. 1930
15.3 x 20.2 cm (6 x 7 ¹⁵⁄₁₆ in.) [on original mount trimmed to image]
84.XM.956.694
MARKS & INSCRIPTIONS: (Verso) at l. right, Evans stamp A; at l. left, in pencil, Crane no. *L78.15(Evans)*.

110
59th Street, New York City/[*Construction of Bloomingdale's*], ca. 1929–30
20.1 x 29.8 cm (7 ¹⁵⁄₁₆ x 11 ¾ in.)
84.XM.956.50

MARKS & INSCRIPTIONS: (Verso) titled at center, in pencil, by Evans, *59th St. NYC*; at l. left, Evans stamp A, and in pencil, Crane no. *L65.73(Evans)*.

111
[*Fifty-ninth Street, New York City, Construction of Bloomingdale's*], ca. 1929–30
20.1 x 17.7 cm (7 ¹⁵⁄₁₆ x 6 ¹⁵⁄₁₆ in.) [on original mount trimmed to image]
84.XM.956.55
MARKS & INSCRIPTIONS: (Verso) at center, Evans stamps A and B;
at l. left, in pencil, Crane no. *L65.74 (Evans)*.

112
We Are Building a New and Bigger Bloomingdale's, ca. 1929–30
Image: 30.6 x 20.8 cm
(13 ⅟₁₆ x 8 ³⁄₁₆ in.); original mount: 35.4 x 27.5 cm (14 x 10 ⅞ in.)
84.XM.956.131
MARKS & INSCRIPTIONS: (Recto, mount) Signed and dated at l. right, in pencil, by Evans, *Walker Evans 1931*; (verso, mount) at u. center, in pencil, by Evans, *We are building a new and bigger Bloomingdale's/1931?*; at l. right, Evans stamp A; at l. left, in pencil, Crane no. *L65.51*.

113

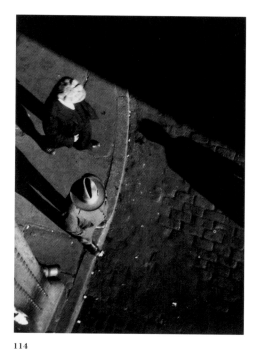

114

115

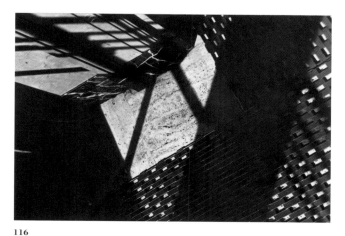

116

117

113
[*Man Wearing Sandwich-Board Sign Advertising Washington Street Photo Studio*], ca. 1930
19.6 x 12.2 cm (7 ¾ x 4 ¹³⁄₁₆ in.)
84.XM.956.66
MARKS & INSCRIPTIONS: (Verso) at u. right, Evans stamp I twice; at l. right, Crane stamp; (recto, mat) at l. right, in pencil, Crane no. *L65.7 (Evans)*.

114
[*New York City Street Corner, High Angle View*], 1929
18.3 x 12.7 cm (7 ¼ x 5 in.) [on mount trimmed to image]
84.XM.956.47
MARKS & INSCRIPTIONS: (Verso) signed at l. right, in pencil, by Evans, *Walker Evans*; at u. left, in pencil, *Arnold Crane Collection*; at center, Crane stamp; (recto, mat) on white paper taped to mat, in pencil, *N.Y. 1929/From/Hound & Horn*.
REFERENCES: WEAW, p. 29 (variant, l. center).

115
[*New York City Street Corner, High Angle View*], ca. 1929
6.6 x 4 cm (2 ⅝ x 1 ⅝ in.)
84.XM.956.34
MARKS & INSCRIPTIONS: (Verso) at u. center, Evans stamp A; at l. center, in pencil, *NYC–29*; at center, *56*; at l. left, in pencil, Crane no. *L65.60(Evans)*.
REFERENCES: WEAW, p. 29 (variant, l. left).

116
[*Abstraction, New York**], 1929
Image: 12.6 x 18.6 cm
(4 ³¹⁄₃₂ x 7 ⁵⁄₁₆ in.); original mount [F & R Monogram Board]: 27.9 x 21.2 cm
(11 x 8 ⁵⁄₁₆ in.)
84.XM.956.122
MARKS & INSCRIPTIONS: (Verso, mount) at center, Evans stamp K and in pencil, *#21 Abstraction, N.Y. 1929*; at l. left, *CUT 10* [circled] *3 ⅝"* [arrow pointing upward] *HIGH*; at center bottom edge, *72.5-20-145*; at l. center, Crane stamp twice; (recto, mat) at l. right, in pencil, *21*; at l. left, in pencil, Crane no. *L65.115(Evans)*; on white paper taped to mat, in pencil, *Abstraction/ 1929/NY*.
REFERENCES: "Photographic Studies," *Architectural Record*, Sept. 1930, p. 194 (vertical orientation); *CRANE, no. 21 (reversed); WEAW, p. 39 (variant, vertical orientation).

117
[*Abstraction with Shadow and Grating Patterns*], 1930
16.5 x 10.9 cm (6 ½ x 4 ¼ in.)
84.XM.956.75
MARKS & INSCRIPTIONS: (Verso) at center, partial Evans stamp B; (recto, mat) at l. right, in pencil, *52*; at l. left, in pencil, Crane no. *L65.9(Evans)*.

118

119

120

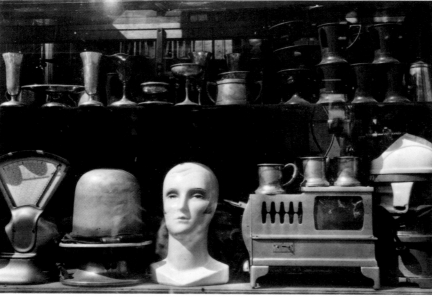

122

123

118
[Walker Evans's Darkroom, 92 Fifth Avenue, New York City], 1930
20 x 14.8 cm (7 ⅞ x 5 ¹³⁄₁₆ in.)
84.XM.956.73
MARKS & INSCRIPTIONS: (Verso) at l. center, Evans stamp A; (recto, mat) at l. right, in pencil, *41*; at l. left, in pencil, Crane no. *L65.13(Evans)*.
REFERENCES: WEAW, p. 64 (variant).

119
92–5th Ave. Darkroom, 1930
Image: 19.6 x 14.7 cm
(7 ¾ x 5 ¹³⁄₁₆ in.); original mount:

22.8 x 17.3 cm (9 x 6 ⅞ in.)
84.XM.956.97
MARKS & INSCRIPTIONS: (recto, mount) signed at l. right, in pencil, by Evans, *Walker Evans*; at l. left, in pencil, by Evans, *92–5th Ave. darkroom 1930*; (recto, mat) at l. right, *40*; at l. left, in pencil, Crane no. *L65.4(Evans)*.
REFERENCES: WEAW, p. 64 (variant).

120
[Votive Candles, New York City]/ [South Street, New York City**]*,
ca. 1929
Image: 25.2 x 17.4 cm

(9 ¹⁵⁄₁₆ x 6 ⅞ in.); sheet: 25.2 x 20.2 cm
(9 ¹⁵⁄₁₆ x 7 ³¹⁄₃₂ in.)
84.XM.956.44
MARKS & INSCRIPTIONS: (Verso) at center, Evans stamp A; at l. left, in pencil, Crane no. *L65.103(Evans)*.
REFERENCES: *FAL, p. 8; **APERTURE, p. 17 (variant, dated 1932).

121
[Votive Candles, New York City]*,
ca. 1929
Image: 25.1 x 17.5 cm (9 ⅞ x 6 ⅞ in.);
sheet: 25.1 x 20.1 cm
(9 ⅞ x 7 ¹⁵⁄₁₆ in.); original mount:

26.4 x 20.9 cm (10 ⁷⁄₁₆ x 8 ¼ in.)
84.XM.488.12
MARKS & INSCRIPTIONS: (Verso, mount) signed at center, in pencil, *Walker Evans*; at u. center, in pencil, MoMA loan number, *38.2382/Evans*; at l. center, in pencil, *650*; at l. right, in pencil, Wagstaff no. *W. Evans 2*.
PROVENANCE: George Rinhart; Samuel Wagstaff, Jr.
REFERENCES: *FAL, p. 8 (variant); WEAW, p. 46 (variant).
NOTE: Not illustrated; duplicate of no. 120.

124

125

126

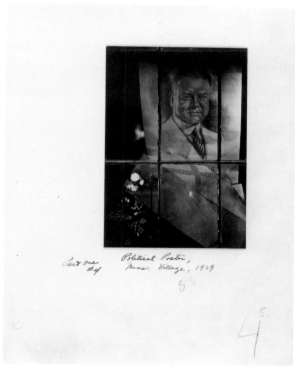

127

122
[*Secondhand Shop Window*], 1930
Image: 11.5 x 16.3 cm (4 ½ x 6 ⅜ in.);
original mount: 29.8 x 25.7 cm
(11 ¾ x 10 ⅛ in.)
84.XM.956.63
MARKS & INSCRIPTIONS: (Recto, mount)
signed at right, in pencil, by Evans,
Walker Evans; at left, in pencil, by
Evans, *1930*; (verso, mount) at l. cen-
ter, Crane stamp twice; (recto, mat)
at l. right, in pencil, *43*; at l. left, in
pencil, Crane no. *L65.27(Evans)*.

123
Sam Loveman, 1929
Image: 15.5 x 11.2 cm
(6 ¹⁄₁₆ x 4 ⁷⁄₁₆ in.); original mount:
23.9 x 22.4 cm (9 ⅜ x 8 ¹³⁄₁₆ in.)
84.XM.956.74
MARKS & INSCRIPTIONS: (Recto, mount)
signed and dated at l. right, in pencil,
by Evans, *Walker Evans 1929*; at l. left,
in pencil, by Evans, *"Sam Loveman"*;
(verso, mount) at center, Crane stamp;
(recto, mat) on inside, at l. left, in pen-
cil, Crane no. *L65.28(Evans)*.

124
[*Photomontage Portrait of Berenice
Abbott*], ca. 1929–30
11.1 x 11.9 cm (4 ⅜ x 4 ¹¹⁄₁₆ in.)
86.XM.519
MARKS & INSCRIPTIONS: (Verso) signed at
l. left, in pencil, by Evans, *Walker
Evans*.
PROVENANCE: Brent Sikkema [Vision
Gallery].

125
[*Two Horses*], 1929
8.2 x 10.8 cm (3 ¼ x 4 ¼ in.)
84.XM.956.60
MARKS & INSCRIPTIONS: (Verso) signed
and dated at u. left, in pencil, by
Evans, *Walker Evans 1929*; at l. left, in
pencil, Crane no. *L65.63(Evans)*.

126
[*Torso of a Woman by Wilhelm
Lehmbruck*], 1929–30
Image: 22.5 x 17.5 cm (8 ⅞ x 6 ²⁹⁄₃₂ in.);
original mount
[F & R Monogram Board]:
28.9 x 38 cm (15 ¹⁵⁄₁₆ x 11 in.)
84.XM.488.15
MARKS & INSCRIPTIONS: (Recto, mount)
signed and dated at right below print,
in pencil, by Evans, *Walker Evans
1929*; (verso, mount) at u. center, in
pencil, *Photo of "Torso of a Woman"
by Wilhelm Lehmbruck/belonging to
Smith College/(#7 in Museum of Mod-
ern Art Sculpture Catalog)/Taken by
Walker Evans/Gift to Museum—April
1930*; at u. right, in orange crayon,
14.30 [crossed out] and in pencil,
17.30 [circled]; at l. right, in pencil,
Wagstaff no. *W. Evans 8*.
PROVENANCE: George Rinhart; Samuel
Wagstaff, Jr.

127
[*Political Poster, Massachusetts
Village**], 1929
Image: 15.5 x 10.6 cm (6 ⅛ x 4 ⁵⁄₃₂ in.);
original hole-punched mount:
27.9 x 21.6 cm (11 x 8 ½ in.)
84.XM.956.495
MARKS & INSCRIPTIONS: (Recto, mount)
at l. left, in black ink, *Part One/#4*; at
l. center, *Political Poster,/Mass. Vil-
lage, 1929*; at center, in pencil, *S.S.*; at
l. right, *4*; at l. right, in red pencil, *S.*;
(verso, mount) at center, Evans stamp
B; at l. right, in pencil, *H2416-86/86/
NO* [within a box] *150h*; at l. center,
Crane stamp; (recto, mat) at l. left, in
pencil, *AP16*; at l. right, *34*; at l. left, in
pencil, Crane no. *L68.64(Evans)*.
REFERENCES: *AMP, Part I, no. 4, (vari-
ant); FAL, p. 49 (variant); APERTURE,
p. 41 (variant); WEAW, p. 68 (l. right
image, dated 1930–31).

128

131

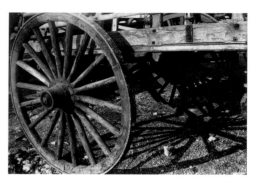

132

135

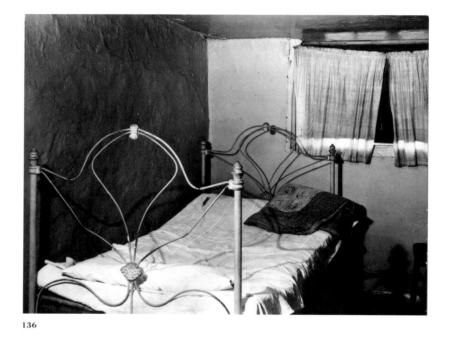

136

128
[*Stamped-Tin Relic**], 1929
Image: 11.4 x 16.2 cm (4 ½ x 6 ⅜ in.);
original mount: 19.5 x 23.7 cm
(7 ²¹/₃₂ x 9 ⁵/₁₆ in.)
84.XM.488.16
MARKS & INSCRIPTIONS: (Recto, mount)
signed and dated [incorrectly] at
l. right below print, in pencil, by
Evans, *Walker Evans 1931*; at u. right
and l. right, in blue ink, by Evans,
II-1; (verso, mount) at u. right, in blue
ink, by Evans, *II-1*; at l. right, in pen-
cil, *X92*; at l. right, in pencil, Wagstaff
no. *W.Evans 7*.

PROVENANCE: George Rinhart; Samuel
Wagstaff, Jr.
REFERENCES: *AMP, Part II, no. 1 (vari-
ant); FAL, p. 59 (variant, dated 1929).

129
[*Stamped-Tin Relic**], 1929
Image: 11.4 x 16.4 cm (4 ½ x 6 ¹⁵/₃₂ in.);
original mount: 25.8 x 39 cm
(18 x 15 in.)
84.XM.956.509
MARKS & INSCRIPTIONS: (Recto, mount)
signed at r. center below print, in pen-
cil, by Evans, *Walker Evans*; (verso,
mount) at center, in pencil, by Evans,

Crane; at center, Evans stamp K; at
l. center, *RIGHTS RESERVED*; at
l. left, in pencil, Crane no. *L68.34
(Evans)*.
REFERENCES: *AMP, Part II, no. 1; FAL,
p. 59 (variant).
NOTE: Not illustrated; duplicate of
no. 128.

130
[*Stamped-Tin Relic**], 1929
10.8 x 16 cm (4 ⁹/₃₂ x 6 ⁵/₁₆ in.) [on
Masonite trimmed to image]
84.XM.956.445
MARKS & INSCRIPTIONS: (Verso, mount)

signed on MoMA label, at r. center, by
Evans, *Walker Evans*; typed on MoMA
label, *EVANS/STAMPED TIN RELIC, 1929/
87/38.2947*; at u. right, in pencil on
MoMA label, *II-1*; at l. right, in black
ink on MoMA label, *GR XVIII*; at l. left,
in pencil, Crane no. *L69.7(Evans)*.
REFERENCES: *AMP, Part II, no. 1; FAL,
p. 59 (variant).
NOTE: Not illustrated; variant of
no. 128.

131
[*Tin Relic**], 1930
Image: 15.4 x 18.3 cm

133

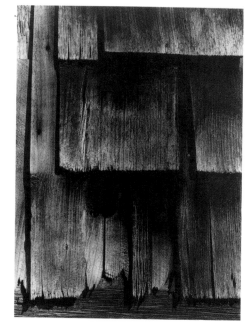

134

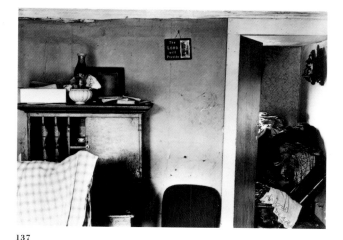

137

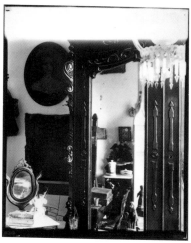

138

134
[*Wood Shingles*], ca. 1930
Image: 16.2 x 11.5 cm (6 ⅜ x 4 ¹⁷⁄₃₂ in.);
original mount [F & R Monogram
Board], 22.8 x 19.2 cm (9 x 7 ⁹⁄₁₆ in.)
84.XM.956.100
MARKS & INSCRIPTIONS: (Verso, mount) at
l. left, Evans stamp A and in pencil,
Crane no. *L78.44(Evans)*.

135
[*Wood Shingles*], 1930
Image: 16.5 x 11.5 cm (6 ½ x 4 ¹⁷⁄₃₂ in.);
original mount [F & R Monogram
Board]: 35.4 x 27.9 cm (14 ¹⁵⁄₁₆ x 11 in.)
84.XM.488.13
MARKS & INSCRIPTIONS: (Recto, mount)
signed and dated at l. right below
print, in pencil, by Evans, *Walker
Evans 1930*; (verso, mount) at u. left,
in pencil, by Evans, *Hang to dry at
1:30*; at l. right, in pencil, Wagstaff
no. *W.E. 10*.
PROVENANCE: George Rinhart; Samuel
Wagstaff, Jr.

136
[*Hudson Street Boardinghouse Detail,
New York**], 1931
14.2 x 18.3 cm (5 ⅝ x 7 ⁷⁄₃₂ in.) [on orig-
inal mount trimmed to image]
84.XM.956.483
MARKS & INSCRIPTIONS: (Verso) dated at
center, in pencil, by Evans, *1931*; at
center, Evans stamp F; at l. right,
Crane stamp; at u. right, in pencil, on
white label, *I 43*; at l. left, in pencil,
Crane no. *L68.29(Evans)*; (recto, mat)
at l. left, in pencil, Crane no. *L68.29
(Evans)*.
REFERENCES: *AMP, Part I, no. 43.

137
[*New York State Farm Interior**], 1931
14.8 x 20 cm (5 ²⁷⁄₃₂ x 7 ²⁹⁄₃₂ in.) [on
original mount trimmed to image]
84.XM.956.499
MARKS & INSCRIPTIONS: (Verso) at center,
Evans stamp F; at u. right, in pencil,
on white label, *I 15*; (recto, mat) at
l. left, in pencil, Crane no. *L68.11
(Evans)*.
REFERENCES: *AMP, Part I, no. 15
(variant).

138
[*Interior with Mirror and Framed
Mementos*], ca. 1930–31
21.5 x 16.5 cm (8 ⁷⁄₁₆ x 6 ½ in.)
84.XM.956.51
MARKS & INSCRIPTIONS: (Verso) at
l. right, Evans stamp A; at l. left, in
pencil, Crane no. *L65.89(Evans)*.

(6 ¹⁄₁₆ x 7 ³⁄₁₆ in.); original hole-
punched mount: 27.9 x 21.6 cm
(11 x 8 ½ in.)
84.XM.956.478
MARKS & INSCRIPTIONS: (Recto, mount)
at l. left, in black ink, *Part Two/#37*;
at l. center, *Tin Relic/1930*; at l. cen-
ter, in pencil, *SS* and *OK* [mostly
erased]; at l. right, *86*; (verso, mount)
at l. center, in pencil, *H2416—86/86/
NO* [in a box] *150 h*; at l. right, *86*; at
center, Evans stamp B; at l. center,
Crane stamp; (recto, mat) at l. left, in
pencil, *AP 184*; at l. left, in pencil,
Crane no. *L68.60(Evans)*.

REFERENCES: *AMP, Part II, no. 37 (vari-
ant); SP, pl. 12 (variant); FAL, p. 20
(variant).

132
[*Wheel of a Carriage*], 1930
Image: 11.1 x 15.6 cm (4 ⅜ x 6 ⅛ in.)
[sight]; original overmat [affixed to
print face and original mount]:
18.2 x 26.6 cm (7 ³⁄₁₆ x 10 ¹⁵⁄₃₂ in.)
84.XM.488.14
MARKS & INSCRIPTIONS: (Recto, mat)
signed and dated at l. right below
print, in pencil, by Evans, *Walker
Evans 1930*; (verso, mat) at l. right, in

pencil, Wagstaff no. *W. Evans 9*.
PROVENANCE: George Rinhart; Samuel
Wagstaff, Jr.

133
[*Window of a Shingled House*],
ca. 1930
Image: 16.4 x 11.5 cm
(6 ⁷⁄₁₆ x 4 ¹⁷⁄₃₂ in.); original mount:
22 x 14.7 cm (8 ¹¹⁄₁₆ x 5 ²⁵⁄₃₂ in.)
84.XM.956.103
MARKS & INSCRIPTIONS: (Verso, mount)
signed at r. center, in pencil, by
Evans, *Walker Evans*; at l. left, in
pencil, Crane no. *L78.43(Evans)*.

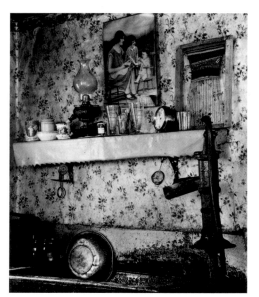

139

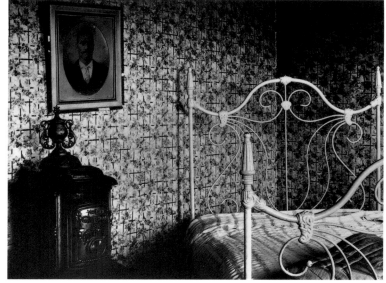

140

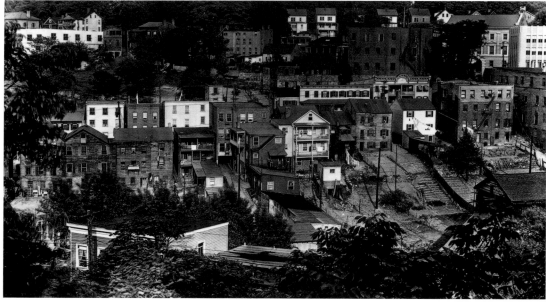

144

139
[*Kitchen, Truro, Massachusetts**], ca. 1931
Image: 13 x 10.5 cm (5 ⅛ x 4 ⅛ in.); original mount: 20.3 x 15.1 cm 8 x 5 ¹⁵⁄₁₆ in.)
84.XM.956.69
MARKS & INSCRIPTIONS: (Verso) at u. right, Evans stamp B; (recto, mat) at l. left, in pencil, Crane no. *L65.91* (*Evans*).
REFERENCES: *MoMA, p. 35 (variant); WEAW, p. 71 (variant).

140
[*Bed and Stove, Truro, Massachusetts**]/[*Truro, Massachusetts***], 1931
Image: 15.3 x 19.6 cm (6 ¹⁄₃₂ x 7 ²³⁄₃₂ in.); [on mount trimmed to image affixed to second mount]; second mount: 43.2 x 38 cm (17 x 17 ¹⁵⁄₁₆ in.)
84.XM.956.130
MARKS & INSCRIPTIONS: (Recto, mount) signed at l. right, in pencil, by Evans, *Walker Evans*; (verso, mount) at center, Evans stamp C; at center, in pencil, *The Iron Bed, 1931*; at l. left, in pencil, Crane no. *L65.100*.
REFERENCES: *FOURTEEN, p. 3; **FAL,

p. 52 (variant); APERTURE, p. 43 (variant); WEAW, p. 71 (variant).

141
The Cactus Plant/[*Interior Detail of a Portuguese House, Truro, Massachusetts*], 1930–31
19.9 x 15.1 cm (7 ¹³⁄₁₆ x 5 ¹⁵⁄₁₆ in.) [on original mount trimmed to image]
84.XM.956.467
MARKS & INSCRIPTIONS: (Verso) titled and dated at center, in pencil, by Evans, *The Cactus Plant/1931*; at l. center, Evans stamp B; at center, in pencil, *I-38*; at l. left, in pencil, Crane no. *L68.27*(*Evans*).

REFERENCES: AMP, Part I, no. 38 (dated 1930); FAL, p. 53 (variant); WEAW, p. 70.

142
[*The Cactus Plant*]/[*Interior Detail of a Portuguese House, Truro, Massachusetts*], 1930–31; printed November 9, 1967, by Jim Dow
Image: 20.3 x 15.6 cm (8 x 6 ⁵⁄₁₆ in.); sheet: 25.1 x 20 cm (9 ¹⁵⁄₁₆ x 7 ⅞ in.)
84.XM.129.1
MARKS & INSCRIPTIONS: (Verso) at center, in pencil, by Jim Dow, *J.D./Agfa Bro-*

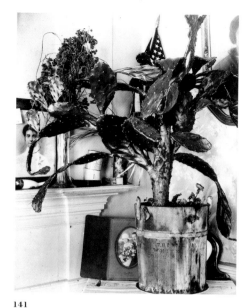

141

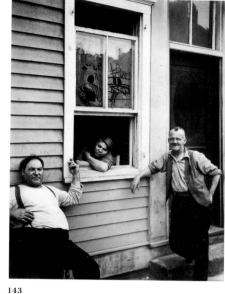

143

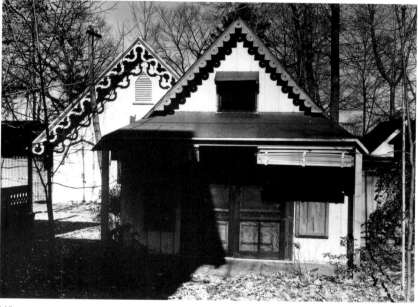

145

vira III, *4/11/9/67*; at l. left, *E16*; at
l. right, *12* [circled]; at l. right, Lunn
Gallery stamp, and within boxes, in
pencil, *1* and *84*.
PROVENANCE: Lunn Gallery; Volker
Kahmen and Georg Heusch.
REFERENCES: WEAW, p. 70 (variant);
AMP, Part I, no. 38 (variant); FAL, p. 53
(variant); WEBR, p. 15, no. 16 (titled in
German and dated, *Haus eines Portu-
giesen*, 1930).
EXHIBITIONS: *Walker Evans*, Bahnhof
Rolandseck, West Germany, Oct. 5–
Nov. 30, 1978.
NOTE: Not illustrated; variant of
no. 141.

143
[*Ossining: New York: 1932**]/[*People in
Summer, New York State Town***]/
[*Town People, Ossining, New York*],
1930–32
15.6 x 11.4 cm (6 ⅛ x 4 ½ in.)
[mounted on Masonite trimmed to
image]
84.XM.956.442
MARKS & INSCRIPTIONS: (Verso, mount)
signed at center right, in pencil on
MoMA label, by Evans, *Walker Evans*;
at l. left, in pencil, Crane no. *L69.6
(Evans)*; at l. center, Crane stamp;
typed on MoMA label, *EVANS/TOWN*

PEOPLE, 1931/102/38.3055; in pencil,
on MoMA label, [*Ossining, N.Y.*]; in
ink, at l. right, on MoMA label, *GR III*.
REFERENCES: *"Photographs by Walker
Evans," *Hound & Horn*, Apr.–June
1933 (variant, dated 1932); **AMP
(1938), Part I, no. 45 (variant, dated
1930); FAL, p. 22 (variant).

144
[*View of Ossining, New York**], 1930
11.5 x 19.9 cm (4 ½ x 7 ²⁷/₃₂ in.) [on
Masonite trimmed to image]
84.XM.956.436
MARKS & INSCRIPTIONS: (Verso, mount)

signed at l. right, in pencil, by Evans,
Walker Evans; at l. right, Evans stamp
F; typed on MoMA label, *EVANS/VIEW
OF OSSINING, 1930/101/38.3045*; at
u. right, in pencil, on MoMA label, *A.P.
II- 4*; at l. right, in black ink, on MoMA
label, *GR.III*; at right, on MoMA label,
Evans stamp F; at l. left, in pencil,
Crane no. *L69.8(Evans)*.
REFERENCES: *AMP, Part II, no. 4
(variant).

145
[*Cottage*], 1930
14.2 x 19.3 cm (5 ⅝ x 7 ⅝ in.)
84.XM.956.14
MARKS & INSCRIPTIONS: (Verso) at left
edge, Evans stamp B; at l. left, in
pencil, Crane no. *L65.93(Evans)*.

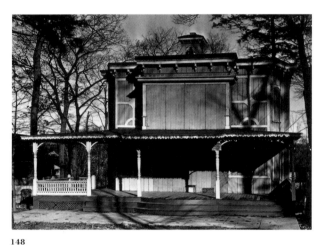

146

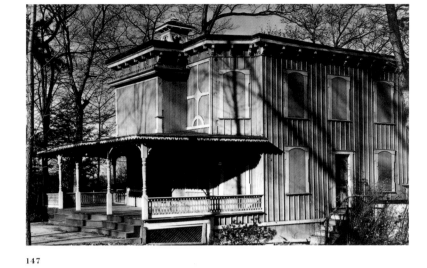

147

148

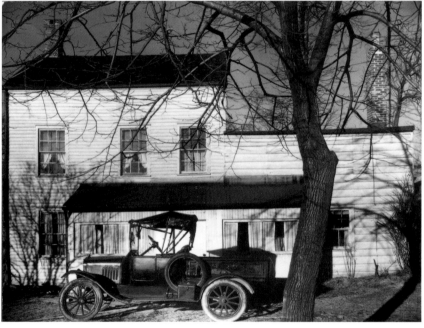

149

146
[*Roofs of Two Cottages*], 1930
15.2 x 19.7 cm (6 x 7 ¾ in.)
84.XM.956.139
MARKS & INSCRIPTIONS: (Verso) at l. center, Evans stamp K; at l. left, in pencil, Crane no. *L65.92*.

147
[*Ossining, New York**], 1931
12.5 x 18.9 cm (4 ¹⁵/₁₆ x 7 ⁷/₁₆ in.) [on original mount trimmed to image]
84.XM.956.87
MARKS & INSCRIPTIONS: (Verso) at center, in pencil, *WE*; at l. right, Evans stamp

A; (recto, mat) at l. right, in pencil, *54*; at l. left, in pencil, Crane no. *L65.95(Evans)*
REFERENCES: *MoMA, p. 44 (variant); CRANE, no. 54.

148
[*House, Ossining, New York*], 1931
Image: 14.1 x 18.5 cm
(5 ⁹/₁₆ x 7 ⁵/₁₆ in.); original mount:
17.6 x 20.9 cm (6 ¹⁵/₁₆ x 8 ¼ in.)
84.XM.956.16
MARKS & INSCRIPTIONS: (Verso, mount) at center, Evans stamp A; at l. left, in pencil, Crane no. *L65.96(Evans)*.

149
[*Westchester, New York, Farmhouse*], 1931
17.4 x 21.8 cm (6 ⅞ x 8 ⁹/₁₆ in.) [on Masonite trimmed to image]
84.XM.956.441
MARKS & INSCRIPTIONS: (Verso) at u. center, in pencil, *No number/Evans*; (verso, original detached paper mount) at u. center, in pencil, *No number* [crossed out]/*Evans*; at center, in pencil, *no. 14* [space] *1931* [space] *38.2945/Evans/#14*; at l. right, in pencil, *W.*; (verso, Masonite mount) signed at center on MoMA label, in pencil, by

Evans, *Walker Evans*; typed on MoMA label, *EVANS/WESTCHESTER, NEW YORK, FARM HOUSE/14/38.2945*; on MoMA label, in black ink, *GR-IV*; at center on MoMA label and at l. right on mount, Evans stamp F; at l. center, in pencil, *A.P.-II-8*; at l. left, in pencil, Crane no. *L69.9*.
REFERENCES: WEAW, p. 56.
EXHIBITIONS: *Art of Photography*, Museum of Fine Arts, Houston, Tex., Feb. 11–Apr. 30, 1989.

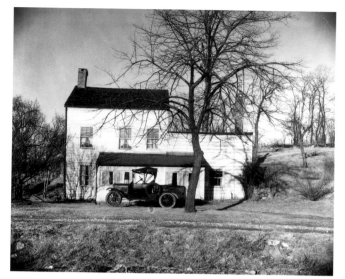

150

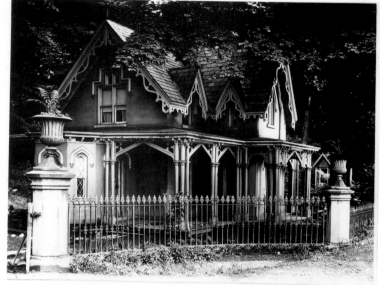

28. Gothic Gate Cottage near
Poughkeepsie, N. Y., 1931

152

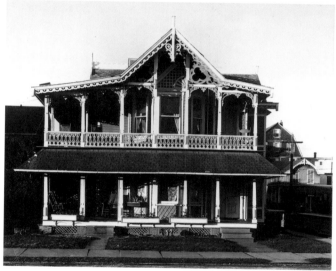

151

150
[*Westchester, New York, Farmhouse**],
1931
18.9 x 22.7 cm (7 ⁷⁄₁₆ x 8 ¹⁵⁄₁₆ in.)
84.XM.956.511
MARKS & INSCRIPTIONS: (Verso) at l. cen-
ter, Evans stamp F; at u. center, in
pencil, *Ep #4/A.A.A. Sequence*; at
u. right, in pencil, on white label, *II 8*;
at l. left, in pencil, Crane no. *L68.39*.
REFERENCES: *AMP, Part 2, no. 8 (vari-
ant); FOURTEEN, p. 13 (variant); FAL,
p. 48 (variant); APERTURE, p. 39 (vari-
ant); WEAW, p. 57 (top image).

151
[*Jigsaw House at Ocean City, New
Jersey**], 1931
14.8 x 17.4 cm (5 ¹³⁄₁₆ x 6 ⁷⁄₈ in.) [on
original mount trimmed to image]
84.XM.956.471
MARKS & INSCRIPTIONS: (Verso) at center,
Evans stamp B; at l. right, Crane
stamp; at u. right, on white label, in
pencil, *II 33*; at l. left, in pencil, Crane
no. *L68.58(Evans)*.
REFERENCES: *AMP, Part II, no. 33
(variant).

152
[*Gothic Cottage near Poughkeepsie,
New York*], 1931
Image: 15.7 x 19.8 cm
(6 ³⁄₁₆ x 7 ¹³⁄₁₆ in.); original hole-
punched mount: 27.9 x 21.6 cm
(11 x 8 ½ in.)
84.XM.956.461
MARKS & INSCRIPTIONS: (Recto, mount)
at u. right, in black ink, *Part Two/Cat.
No. 28*; at l. center, *28. Gothic Cottage
near/Poughkeepsie, N.Y., 1931*; at
u. right, in pencil, *92.5* [beside a right
angle]; at l. right, *78*; (verso, mount)
at l. right, in pencil, *78*; at l. center,

H2416-86 [underlined]*/86/No.* [within
a box] *150 h*; at l. left, in pencil, Crane
no. *L68.56(Evans)*.
REFERENCES: AMP, Part II, no. 28.

153
[*Gothic Gate Cottage near Poughkeep-
sie, New York**], 1931
16.4 x 21.1 cm (6 ¹³⁄₃₂ x 8 ⁵⁄₁₆ in.);
sheet: 19.7 x 24.6 cm
(7 ²⁵⁄₃₂ x 9 ¹¹⁄₁₆ in.)
84.XM.956.480
MARKS & INSCRIPTIONS: (Verso) initialled
at center, in pencil, by Evans, *WE*
[sideways]; at l. center, Evans stamp

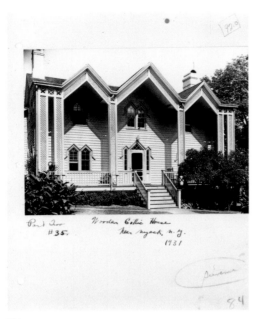

154

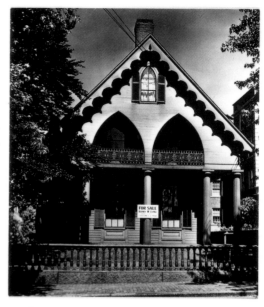

155

B; at u. right, in pencil, on white label, *II 28*; typed on MoMA-2 label, *38.2271/ Evans*; (recto, mat) at l. right, in pencil, *55*; at l. left, in pencil, Crane no. *L68.57(Evans)*.
REFERENCES: *AMP, Part II, no. 28 (variant).
NOTE: Not illustrated; variant of no. 152.

154
[*Wooden Gothic House, Near Nyack, New York*], 1931
Image: 15.3 x 19.8 cm
(6 ¹⁄₃₂ x 7 ¹³⁄₁₆ in.); original hole-punched mount: 27.9 x 21.6 cm
(11 x 8 ½ in.)

84.XM.956.481
MARKS & INSCRIPTIONS: (Recto, mount) at l. left, in black ink, *Part Two/#35*; at l. center, *Wooden Gothic House/Near Nyack, N.Y./1931*; at u. right, in pencil, *92.0* [within a box]; at l. right, ___*a_i* [circled, illegible inscription]; at l. right, *84*; (verso, mount) at center, Evans stamp A; at l. right, in pencil, *H2416-86/86/86/NO* [within box] *150 h*; at l. right, *84*; (recto, mat) at l. right, in pencil, *56*; at l. left, in pencil, Crane no. *L68.59(Evans)*.
REFERENCES: AMP, Part II, no. 35; WEAW, p. 52 (variant).

155
[*Wooden Gothic House, Massachusetts*], 1930
Image: 13.3 x 11.1 cm (5 ⁷⁄₃₂ x 4 ⅜ in.); original hole-punched mount: 27.9 x 21.6 cm (11 x 8 ½ in.)
84.XM.956.486
MARKS & INSCRIPTIONS: (Recto, mount) at u. right, in black ink, *Part Two/Cat. No. 26*; at l. center, *26. Wooden Gothic House,/Mass., 1930*; at l. right, in pencil, *76*; (verso, mount) at center, Evans stamp A, at l. right, in pencil, *H2416-86/86/NO* [in a box] *150 h*; at l. right, *76*; (recto, mat) at l. right, in

pencil, *51*; at l. left, in pencil, Crane no. *L68.54(Evans)*.
REFERENCES: AMP, Part II, no. 26.

156
Massachusetts, Vicinity Boston/
[*Samuel Haven House, Dedham, 1795, Extensively Altered*], 1931
15.6 x 21.6 cm (6 ⅛ x 8 ½ in.)
94.XM.6.1
MARKS & INSCRIPTIONS: (Verso) at center, in pencil, by Evans, *Massachusetts, vicinity Boston*; at l. center, Evans stamp A; at l. left corner, in pencil, *#4*; at l. right corner, in pencil, *416*; at

156

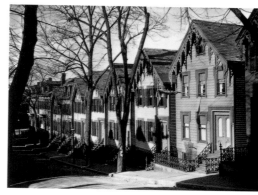

157

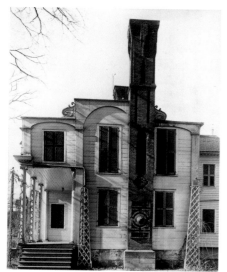

158

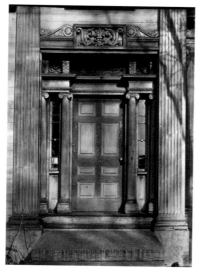

159

160

u. left, in pencil, *19th C. Greek House, Dedham, Mass, 1931/used in 1933 MoMA show*; at right center, Lunn Gallery stamp, and within boxes, in pencil, *IX* and *38*.
PROVENANCE: George Rinhart and Tom Bergen; Harry H. Lunn, Jr.

157
[*Gingerbread, Side View, Dedham, Massachusetts*], ca. 1930–31
7.8 x 13.4 cm (3 ⅛ x 5 ¼ in.)
84.XM.956.77
MARKS & INSCRIPTIONS: (Verso) at u. left, in pencil, *WE*; at l. left, Evans stamp A; (recto, mat) at l. left, in pencil, Crane no. *mpls-/L65.94(Evans)*.

158
Greek Revival House, Upstate New York, ca. 1930–31
19 x 14.9 cm (7 ½ x 5 ⅞ in.)
84.XM.956.18
MARKS & INSCRIPTIONS: (Verso) at center, in pencil, by Evans, *Greek revival house* [illegible] *upstate N.Y.* and Evans stamp A; on ⅜ x ⅝ in. white label, at l. left, Crane no. *L65.97/ Evans*.
REFERENCES: "Homes of Americans," *Fortune*, Apr. 1946, p. 154 (variant, titled *Residence near Cherry Valley, New York* [*nineteenth century*]).

159
[*Ionic Doorway, New York State**], 1931
Image: 21 x 16.3 cm (8 ¼ x 6 ¹³/₃₂ in.); sheet: 24.5 x 19.3 cm (9 ²¹/₃₂ x 7 ⁹/₁₆ in.)
84.XM.956.331
MARKS & INSCRIPTIONS: (Verso) at center, Evans stamp A; at l. right, Crane stamp; at l. left, in pencil, Crane no. *L67.52*.
REFERENCES: **FAL, p. 58 (variant).

160
South Boston Street/[*Wooden Houses, Boston**], 1930
Image: 11.1 x 14.4 cm

(4 ⅜ x 5 ²¹/₃₂ in.); original mount: 19.8 x 18.2 cm (7 ¾ x 7 ³/₁₆ in.)
84.XM.956.489
MARKS & INSCRIPTIONS: (Verso, mount) signed at u. center, in pencil, by Evans, *Walker Evans*; at center, in pencil, by Evans, *South Boston Street*; at l. right, in pencil, *EVANS/53.497*; at center, Crane stamp; at l. left, in pencil, Crane no. *L68.55(Evans)*; (recto, mat) at l. left, in pencil, Crane no. *L68.55(Evans)*.
REFERENCES: **AMP, Part II, no. 27 (variant); *American Photographs*, 1962 ed., dust-jacket cover image (variant).

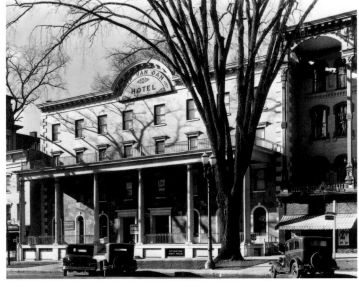

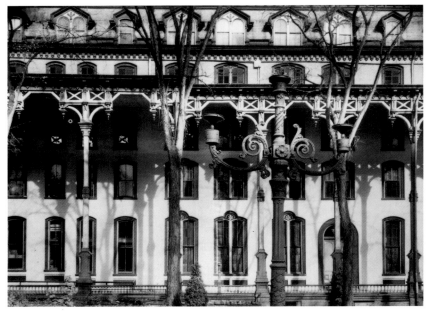

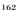

161

162

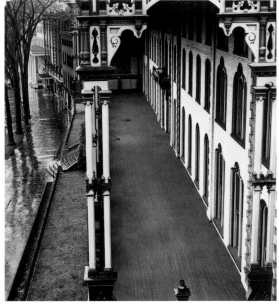

163

164

161
[*Millworkers' Houses in Willimantic, Connecticut**], 1931
Image: 14.6 x 18.8 cm (5 ¾ x 7 ¹³⁄₃₂ in.) [on original mount trimmed to image]; second original hole-punched mount: 28 x 21.6 cm (11 x 8 ½ in.)
84.XM.956.458
MARKS & INSCRIPTIONS: (Recto, mount) at l. left, in black ink, *Part Two/#21*; at center, *Millworkers' houses in/Willimantic, Conn./1931.*; at u. right, in pencil, *97.5* [beside a right angle]; at l. right, *71*; at l. center, *7 ⅛ x 5 ⁵⁄₁₆* [mostly erased] and —*7 ⅛*— [mostly

erased]; at l. right, in red pencil: *S.*; (verso, mount) at l. center, Evans stamp B; at l. right, *71* and *H2416-86/86 NO* [within a box] *150 h.*; at l. left, in pencil, Crane no. *L68.50(Evans)*.
REFERENCES: *AMP, Part II, no. 21; WEAW, p. 55 (variant).

162
[*Rip Van Dam Hotel, Saratoga Springs, New York*], ca. 1930–31
Image: 15.4 x 18.3 cm (6 ¹⁄₁₆ x 7 ⁷⁄₃₂ in.); original mount [Royal Crest Illustrating Board]: 16.5 x 19.7 cm (6 ½ x 7 ¾ in.)

84.XM.956.124
MARKS & INSCRIPTIONS: (Verso, mount) at u. center, Evans stamp A and in pencil, MoMA no. *38.2375/Evans*.

163
Grand Union Hotel, Courtyard, Saratoga, New York, 1930
15.4 x 20.3 cm (6 ¹⁄₁₆ x 8 in.)
84.XM.956.15
MARKS & INSCRIPTIONS: (Verso) at u. right, in pencil, by Evans, *Grand Union Hotel/Courtyard/Saratoga NY*; at center, Evans stamp K; at l. left, in pencil, Crane no. *L65.101(Evans)*.

164
[*Porch of Hotel, Saratoga Springs, New York*], ca. 1930
15.1 x 13.1 cm (5 ¹⁵⁄₁₆ x 5 ³⁄₁₆ in.)
84.XM.956.94
MARKS & INSCRIPTIONS: (Verso) at l. center, Evans stamp A; at l. center, in pencil, *53 1/2*[space]/*3 3/4*[space]/*67 1/4*; (recto, mat) at l. right, in pencil, *48*; at l. left, Crane no. *L65.99(Evans)*.
REFERENCES: WEAW, p. 59 (variant).

165
[*Porch of Hotel, Saratoga Springs, New York*], 1930

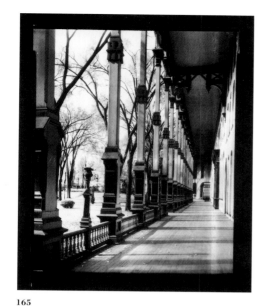

165

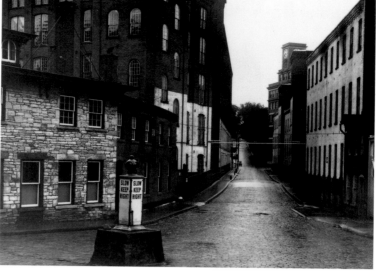

166

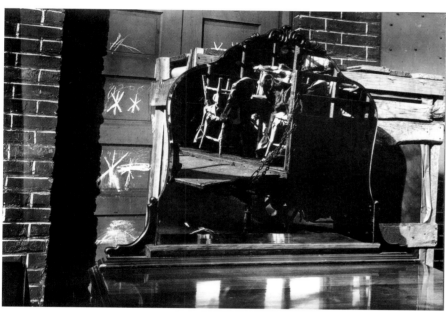

167

168

Image: 19.7 x 16 cm (7 ¾ x 6 ¼ in.); sheet: 23.4 x 18.7 cm (9 3/16 x 7 3/8 in.)
84.XM.956.113
MARKS & INSCRIPTIONS: (Verso) at u. left, Evans stamp K inverted; at l. left, in pencil, Crane no. L65.125.
REFERENCES: WEAW, p. 62 (variant).

166
[Factory Street, Amsterdam, New York*], 1930
Image: 14 x 18.2 cm (5 17/32 x 7 3/16 in.); original hole-punched mount: 27.9 x 21.6 cm (11 x 8 ½ in.)
84.XM.956.494

MARKS & INSCRIPTIONS: (Recto, mount) at l. left, in black ink, Part Two/#12; at l. center, Factory Street in/Amsterdam, N.Y., 1930; at u. right, in pencil, 100; at l. right, 62. (verso, mount) at u. center, in pencil, #50 Factory Street/Amsterdam, N.Y. 1930; in pencil, cropping marks outlining print edges with diagonal line from u. left to l. right; at l. left, CUT 2 [circled] 7 ¼″ [arrow pointing to right] WIDE; at l. center, H2416-86/86/NO [in a box] 150 h; at l. right, 62; (recto, mat) at l. right, 50; at l. left, in pencil, Crane no. L68.42 (Evans).
REFERENCES: AMP, Part II, no. 12 (vari-

ant); FAL, p. 21 (variant); Crane, no. 50; *APERTURE, p. 29.

167
[Street Scene, Brooklyn*], ca. 1931
11.5 x 16.2 cm (4 ½ x 6 3/8 in.)
84.XM.956.58
MARKS & INSCRIPTIONS: (Verso) at u. left, partial Evans stamp K inverted; at l. left, in pencil, Crane no. L65.55 (Evans).
REFERENCES: *MoMA, p. 32 (variant).

168
[Lunch Wagon Detail, New York*], 1931

Image: 19.7 x 13.7 cm (7 ¾ x 5 3/8 in.) [on original mount trimmed to image]; second original hole-punched mount: 27.9 x 21.6 cm (11 x 8 ½ in.)
84.XM.956.516
MARKS & INSCRIPTIONS: (Recto, mount) at l. left, in black ink, Part one #9; at l. center, Lunch Wagon Detail/New York, 1931; at l. center, in pencil, S.S.; at l. right, 9; (verso, mount) at l. center, Evans stamp A and in pencil, H2416-86/86/NO [in a box] 150 h; at l. left, in pencil, Crane no. L68.7.
REFERENCES: *AMP, Part I, no. 9.

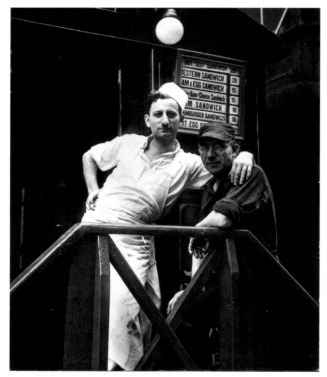

169

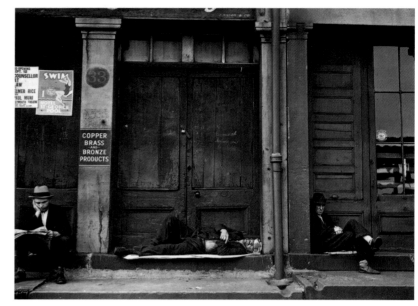

171

172

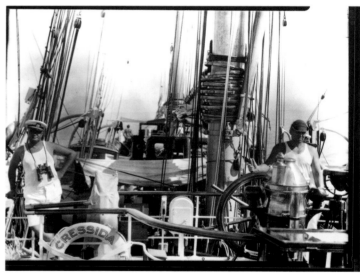

174

169
[*Second Avenue Lunch: 1933*]/[*Posed Portraits, New York***], 1931
18.3 x 14.9 cm (7 3/16 x 5 7/8 in.) [on Masonite trimmed to image]
84.XM.956.439
MARKS & INSCRIPTIONS: (Verso, mount) at center, in pencil, MoMA no. *38.2335/ #38* [sideways]; typed on MoMA label, *EVANS/POSED PORTRAITS, NEW YORK, 1931/38/38.2335*; in ink on MoMA label, *GR VIII*; at l. center, in pencil on MoMA label, *OA18690*; at l. left, in pencil, Crane no. *L69.5(Evans)*.

REFERENCES: **Hound & Horn*, Apr.–June 1933 (variant); ***AMP, Part I, no. 40 (variant); SP, pl. 11 (variant); FAL, p. 60 (variant); APERTURE, p. 49 (variant).

170
[*Second Avenue Lunch: 1933*]/[*Posed Portraits, New York City***], 1931
20.3 x 14 cm (8 x 5 1/2 in.)
84.XM.956.503
MARKS & INSCRIPTIONS: (Verso) at center, Evans stamp B and Crane stamp.
REFERENCES: **Hound & Horn*, Apr.–June 1933 (variant); ***AMP, Part

I, no. 40 (variant); SP, pl. 11 (variant); FAL, p. 60 (variant); APERTURE, p. 49 (variant).
EXHIBITIONS: *Art of Photography*, Museum of Fine Arts, Houston, Tex., Feb. 11–Apr. 30, 1989.
NOTE: Not illustrated; variant of no. 169.

171
[*South Street, New York**], 1932
14.2 x 18.7 cm (5 19/32 x 6 11/32 in.) [on original mount trimmed to image]
84.XM.956.513
MARKS & INSCRIPTIONS: (Verso) at center,

Evans stamp B; at l. center, Crane stamp; at l. left, in pencil, Crane no. *L68.32*.
REFERENCES: *Hound & Horn*, Oct.–Dec. 1932 (variant); **AMP, Part I, no. 48 (variant).

172
[*South Street, New York**], 1932; printed later
Image: 15.5 x 20.5 cm (6 1/8 x 8 1/16 in.); sheet: 19.6 x 24.7 cm (7 11/16 x 9 3/4 in.)
84.XM.956.504
MARKS & INSCRIPTIONS: (Recto) at left, in negative, *EASTMAN-SAFETY-*

175

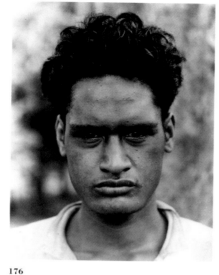

176

177

178

KODAK 130; (verso) at l. center, in pencil, by Evans, *South Street NYC/1931*; at u. center, Evans stamp D; at center, Evans stamp F; at right center, in pencil, *1/2*; at u. right, in pencil, on white label, *I 49*; (recto, mat) at u. left, in pencil, *AP106*; at l. right, *60*; at l. left, in pencil, Crane no. *L68.65(Evans)*.
REFERENCES: *AMP, Part I, no. 49 (variant); FAL, p. 9.

173
[*South Street, New York**], 1932; printed later
Image: 16 x 20.4 cm (6 ⁵/₁₆ x 8 ¹/₃₂ in.); sheet: 19.6 x 24.6 cm (7 ²³/₃₂ x 9 ¹¹/₁₆ in.)
84.XM.956.455
MARKS & INSCRIPTIONS: (Recto) at left, in negative, *EASTMAN-SAFETY-KODAK 130* [reversed]; (verso) at u. right, Evans stamp B; at left edge, in pencil, *South St. N.Y.C.–1931* [date underlined]; at r. center, *2/1*; at l. right, in pencil, by Arnold Crane, *withdrawn/AH Crane*; at l. left, in

pencil, Crane no. *L68.33(Evans)*.
REFERENCES: *AMP, Part I, no. 49 (variant); FAL, p. 9.
NOTE: Not illustrated; duplicate of no. 172.

174
[*Bridge of the "Cressida" with Two Sailors, Voyage to Tahiti*], 1932
16.5 x 21.5 cm (6 ½ x 8 ½ in.)
84.XM.956.110
MARKS & INSCRIPTIONS: (Verso) at center, partial Evans stamp A; at l. left, in pencil, Crane no. *L78.46(Evans)*.

175
[*Mast of the "Cressida," Voyage to Tahiti*], 1932
Image: 21.5 x 12.4 cm (8 ⁷/₁₆ x 4 ⁷/₈ in.); original mount: 34.2 x 25.6 cm (13 ½ x 10 ⅛ in.)
84.XM.956.111
MARKS & INSCRIPTIONS: (Recto, mount) signed and dated at l. right, in pencil, by Evans, *Walker Evans 1932*; (verso, mount) at u. center, in pencil, by Evans, *Cressida, 1932/ Kodak snapshot, enlarged*; (recto, mat) at l. left, in pencil, Crane no. *L78.47(Evans)*.

176
[*Male Portrait, Tahiti*], 1932
15.7 x 11.8 cm (6 ³/₁₆ x 4 ²¹/₃₂ in.)
84.XM.956.253
MARKS & INSCRIPTIONS: (Verso) at l. right, Evans stamp A; at l. left, Crane no. *L66.31*.
REFERENCES: WEAW, p. 76, (variant).

177
[*Two Chairs*], ca. 1932
20.5 x 15.3 cm (8 ¹/₁₆ x 6 in.)
84.XM.956.95
MARKS & INSCRIPTIONS: (Verso) at center, partial Evans stamp K; (recto, mat) at l. left, in pencil, Crane no. *L65.10 (Evans)*.

178
[*Two Stainless Steel Lamps*], ca. 1932
Image: 18.4 x 24 cm (7 ¼ x 8 ⁷/₁₆ in.); sheet: 20.4 x 25.4 cm (8 ¹/₁₆ x 9 ¹⁵/₁₆ in.)
84.XM.129.2
MARKS & INSCRIPTIONS: (Verso) at u. left, in pencil, *p.51*; at l. left, by Evans, *#847 Lamps*; at center, *p51*; at l. right, *E17*; at r. center, Lunn Gallery stamp, and within boxes, in pencil, *XII* and *#847*.
PROVENANCE: Lunn Gallery; Volker Kahmen and Georg Heusch.
REFERENCES: WEBR, p. 14, no. 17 (titled in German and dated, *Lampen, New York*, 1932).
EXHIBITIONS: *Walker Evans*, Bahnhof Rolandseck, West Germany, Oct. 5–Nov. 30, 1978.

179

180

182

183

179
[*Cary Ross's Bedroom, New York**],
1932; printed later
Image: 21.3 x 16.3 cm (6 ⅜ x 6 ⅞ in.);
sheet: 20.2 x 25.2 cm (8 x 9 ¹⁵/₁₆ in.)
84.XM.129.3
MARKS & INSCRIPTIONS: (Recto) at right
edge, in negative, *EASTMAN-SAFETY-
KODAK 130*; (verso) at l. left, in pencil:
M-38; at l. right, *11* [circled]/*E15*; at
l. right, Lunn Gallery stamp, and
within boxes, in pencil, *II* and *36*.
PROVENANCE: Lunn Gallery; Volker
Kahmen and Georg Heusch.

REFERENCES: *MoMA, p. 37; WEBR,
p. 14, no. 15 (titled in German and
dated, *Schlafzimmer von Cary Ross,
New York*, 1932).
EXHIBITIONS: *Walker Evans*, Bahnhof
Rolandseck, West Germany, Oct. 5–
Nov. 30, 1978.

180
[*Jennings Carriages*]/[*Detail of a
Jennings Carriage Wagon Wheel*], 1933
Image: 21 x 15.7 cm (8 ¼ x 6 ³/₁₆ in.);
sheet: 24.6 x 19.2 cm
(9 ²³/₃₂ x 7 ¹⁹/₃₂ in.)
84.XM.956.104

MARKS & INSCRIPTIONS: (Verso) at right
center, partial Evans stamp A; at
l. left, in pencil, Crane no. *L78.55*.

181
Jennings Carriages/[*High-Angle View
of Buckboard-Style Carriage*], 1933
Image: 15 x 19.8 cm (5 ²⁹/₃₂ x 7 ¾ in.);
mount: 30.3 x 25.4 cm (11 ¹⁵/₁₆ x 10 in.)
[Note: mount hinged to no. 185]
84.XM.956.105
MARKS & INSCRIPTIONS: (Verso, mount)
titled at u. center, in pencil, by Evans,
JENNINGS/CARRIAGES.

182
[*Jennings Carriages*]/[*Detail of a
Coach?*], 1933
Image: 19.6 x 14.8 cm (7 ¾ x 5 ²⁷/₃₂ in.)
[on original mount trimmed to image];
original second mount: 30.4 x 25.9 cm
(12 x 10 ⅛ in.) [Note: mount hinged to
nos. 183–84]
84.XM.956.106
MARKS & INSCRIPTIONS: (Verso, mount)
at l. left, in pencil, Crane no. *L78.50*
(*Evans*).

181

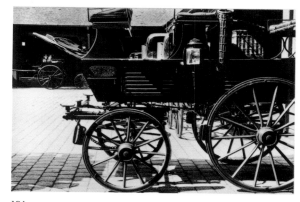

184

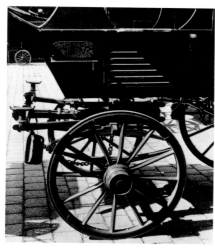

185

183
[*Jennings Carriages*]/[*View of a Jennings Carriage*], 1933
Image: 15.2 x 15.4 cm (6 x 6 1/16 in.); mount: 30.2 x 25.5 cm
(12 x 10 1/16 in.) [Note: image mounted with no. 184. and hinged to no. 182]
84.XM.956.107
MARKS & INSCRIPTIONS: (Recto, mount) signed and dated at l. right, in pencil, by Evans, *Walker Evans 1933*; (verso, mount) at l. left, in pencil, Crane no. *L78.51–52*.

184
[*Jennings Carriages*]/[*Detail of a Coupé Style Carriage: Two Side Wheels*], 1933
Image: 13.3 x 19.7 cm (5 1/4 x 7 3/4 in.); mount: 30.2 x 25.5 cm (12 x 10 1/16 in.) [Note: image mounted with no. 183 and mount hinged to no. 182]
84.XM.956.108 [JGPM negative no. 189]
MARKS & INSCRIPTIONS: (Recto, mount) signed at l. right, in pencil, by Evans, *Walker Evans 1933*; (verso, mount) at l. left, in pencil, Crane no. *L78.51–52*.

185
[*Jennings Carriages*]/[*Detail of a Coupé Style Carriage: Front Left Wheel*], 1933
Image: 18.3 x 15.3 cm (7 7/32 x 6 1/32 in.) [on original mount trimmed to image]; original second mount: 30.3 x 25.5 cm (11 15/16 x 10 1/16 in.) [Note: mount hinged to no. 181]
84.XM.956.109 [JGPM negative no. 186]
MARKS & INSCRIPTIONS: (Recto, mount) signed and dated at l. right, in pencil, by Evans, *Walker Evans 1933*; (verso, mount) at l. left, in pencil, Crane no. *L78.53(Evans)*.

186
[*Jennings Carriages*]/[*Detail of a Jennings Carriage: Front Left Wheel*], 1933
MEDIUM: Negative
21.3 x 16.2 cm (8 3/8 x 6 3/8 in.)
84.XG.963.1 [JGPM print no. 185]
MARKS & INSCRIPTIONS: (Verso) embossed at bottom edge, *166* [inverted]; on white label affixed to plastic sleeve, in pencil, Crane no. *L81.1/Evans*.
NOTE: Not illustrated.

187
[*Jennings Carriages*]/[*Detail of a Jennings Carriage: Carriage Seats*], 1933
MEDIUM: Negative
21.3 x 16.2 cm (8 3/8 x 6 3/8 in.)
84.XG.963.2
MARKS & INSCRIPTIONS: (Verso) embossed at bottom edge, *166* [inverted]; on white label affixed to plastic sleeve, in pencil, Crane no. *L81.2/Evans*.
NOTE: Not illustrated.

188
[*Jennings Carriages*]/[*Detail of a Jennings Carriage: Lamp and Two Side Wheels*], 1933
MEDIUM: Negative
21.3 x 16.2 cm (8 3/8 x 6 3/8 in.)
84.XG.963.3
MARKS & INSCRIPTIONS: (Verso) embossed at l. left edge, *166* [inverted]; on white label affixed to plastic sleeve, in pencil, Crane no. *L81.3/Evans*.
NOTE: Not illustrated.

189
[*Jennings Carriages*]/[*Detail of a Jennings Carriage: Two Side Wheels*], 1933
MEDIUM: Negative
16.2 x 21.3 cm (6 3/8 x 8 3/8 in.)
84.XG.963.4 [JGPM print no. 184]
MARKS & INSCRIPTIONS: (Verso) embossed at l. left edge, *166* and *EAST-MAN*; on white label affixed to plastic sleeve, in pencil, Crane no. *L81.4*.
NOTE: Not illustrated.

190
[*Jennings Carriages*]/[*Detail of Carriage from Above*], 1933
MEDIUM: Negative
16.2 x 21.3 cm (6 3/8 x 8 3/8 in.)
84.XG.963.5
MARKS & INSCRIPTIONS: (Verso) embossed at u. right edge, *303*; on white label affixed to plastic sleeve, in pencil, Crane no. *L81.6/Evans*.
NOTE: Not illustrated.

192

194

193

191
[*Jennings Carriages*]/[*Detail of a Jennings Carriage: Two Side Wheels, Basket and Lamp*], 1933
MEDIUM: Negative
21.3 x 16.2 cm (8 ⅜ x 6 ⅜ in.)
84.XG.963.6
MARKS & INSCRIPTIONS: (Verso) embossed at bottom edge, *166* [inverted]; on white label affixed to plastic sleeve, in pencil, *Crane no. L81.5/Evans*.
NOTE: Not illustrated.

192
[*A Bench in the Bronx on Sunday**], 1933
13.2 x 19.5 cm (5 ⁷⁄₃₂ x 7 ¹¹⁄₁₆ in.)
84.XM.956.493
MARKS & INSCRIPTIONS: (Verso) at left center, Evans stamp D; at l. left, Evans stamp F; at u. center, in pencil, *I-12*; at right center, in china marker, *Agfa W5/12 s plus man's f——*[cut off]/ *5s*; (recto, mat) at l. left, in pencil, *Crane no. L68.9(Evans)*.
REFERENCES: *AMP, Part I, no. 12 (variant).

193
[*A Bench in the Bronx on Sunday**], 1933
Image: 18.8 x 17.3 cm (7 ⅜ x 6 ¾ in.); original mount: 23.0 x 18.1 (9 ¹⁄₁₆ x 7 ⅛ in.)
94.XM.27.2
MARKS & INSCRIPTIONS: (Verso, mount) at u. right, in pencil, *L-123*; at l. right, in pencil, *136*.
PROVENANCE: Estate of James Agee; Light Gallery; Unidentified Private Collector; Carole Thompson.
REFERENCES: *AMP, Part I, no. 12 (variant).

194
[*Gingerbread, Pump House, Kennebunk, Maine*]/[*Maine Pump*]/[*Pump, Wedding-Cake House, Kennebunkport, Maine**], 1933
18.9 x 14.5 cm (7 ⁷⁄₁₆ x 5 ¹¹⁄₁₆ in.)
[mounted on Masonite trimmed to image]
84.XM.956.440
MARKS & INSCRIPTIONS: (Verso, mount) at l. right, Evans stamp F; at center, in pencil, *#65* [partially covered by MoMA label]; at l. center, in pencil, *II-32*; at l. left, in pencil, *CUT 8* [8 circled] 4 ¾″ [arrow pointing upward within rectan-

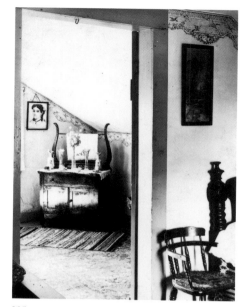

195

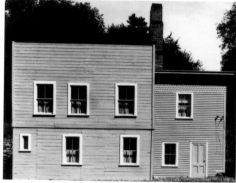

196

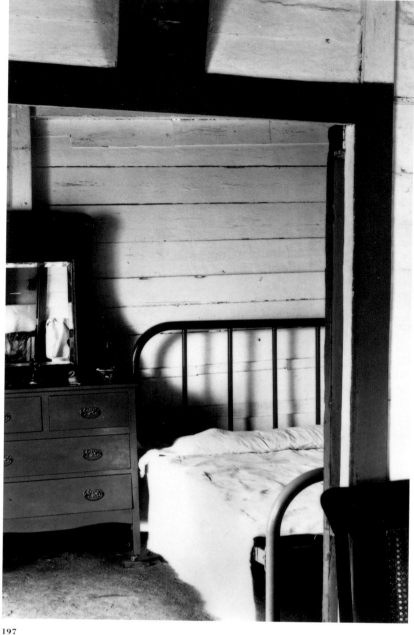

197

gle] *HIGH*; at l. right, in pencil, *64.5 25-185*; typed on MoMA label, *EVANS/ MAINE PUMP, 1933/65/38.2377*; at u. left, in pencil, *#120*; at u. center, in pencil, *A.P. II-32*; at center, in ink, *[KENNEBUNKPORT]*; at l. right, in pencil, *197* [sideways]; at l. right, in ink, *GR II*; in pencil, diagonal line from u. left to l. right; at center, Crane stamp; at l. left, in pencil, Crane no. *L69.12 (Evans)*.
REFERENCES: *AMP Part II, no. 32 (variant); SP, pl. 2 (variant); CRANE, no. 118; APERTURE, p. 47 (variant).

195
[New York County Town Bedroom]/ [Interior Near Copake, New York],* 1933
19.2 x 14.2 cm (7 ⅝ x 5 ¹⁹/₃₂ in.) [mounted on Masonite trimmed to image]
84.XM.956.450
MARKS & INSCRIPTIONS: (Verso, mount) signed at l. center, in pencil, by Evans, *Walker Evans*; at center, in pencil, *3049/106* [sideways]; typed on MoMA label, *EVANS/N.Y. COUNTY TOWN BEDROOM/106/38.3049*; at l. right, in black ink, *GR.IV*; at l. left, in pencil, Crane no. *L69.14(Evans)*.
REFERENCES: *MoMA, p. 75 (variant).

196
[Connecticut Frame House]*, 1933
Image: 11.1 x 13.8 cm (4 ⅜ x 5 ⁷/₁₆ in.); original hole-punched mount: 27.9 x 21.6 cm (11 x 8 ½ in.)
84.XM.956.487
MARKS & INSCRIPTIONS: (Recto, mount) at center right, in pencil, *SS*; at l. right, in pencil, *70*; at l. right, in red pencil, *S*; (verso, mount) at center, Evans stamp A; at l. right, in pencil, *H2416-86/86/NO* [within a box] *150 h*; at l. right, in pencil, *70*; (recto, mat) at l. center, in pencil, *CONNECTICUT FRAME HOUSE, 1933/(AMERICAN PHOTO-*

GRAPHS p. 146); at l. left, in pencil, Crane no. *L68.49(Evans)*.
REFERENCES: *AMP, Part II, no. 20.

197
[View of a Bedroom Through a Doorway], ca. 1933
Image: 19.9 x 12.5 cm (7 ¹³/₁₆ x 4 ⅞ in.); original mount: 23.4 x 14.5 cm (9 ¼ x 5 ¹¹/₁₆ in.)
84.XM.956.76
MARKS & INSCRIPTIONS: (Recto, mount) signed at l. right, in pencil, by Evans, *Walker Evans*; (recto, mat) at l. left, in pencil, Crane no. *L65.90(Evans)*.

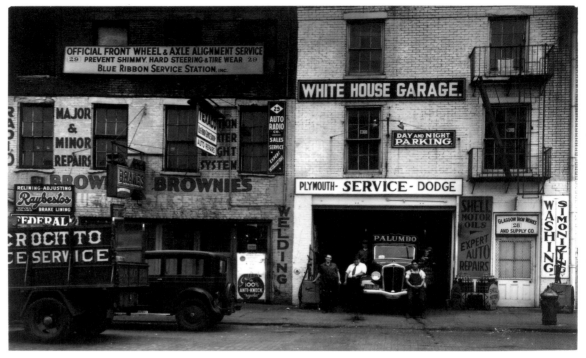

198

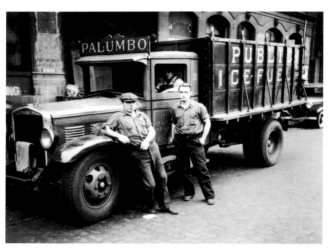

199

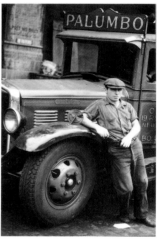

200

198
[*White House Garage, New York*],
ca. 1934
14.4 x 23.0 cm (5 ¹¹⁄₁₆ x 9 ¹⁄₃₂ in.)
84.XM.956.67
MARKS & INSCRIPTIONS: (Verso) at
u. right, Evans stamp B; at l. right,
Crane stamp; (recto, mat) at l. right, in
pencil, *122*; at l. left, in pencil, Crane
no. *L65.106(Evans)*.

199
[*Palumbo Public Ice-Fuel Corp. Truck,
New York*], ca. 1934
Image: 17.8 x 23.4 cm (7 x 9 ¼ in.);
original mount: 44.7 x 34.5 cm
(17 ¹¹⁄₁₆ x 13 ¹¹⁄₁₆ in.)
84.XM.488.19
MARKS & INSCRIPTIONS: (Recto, mount)
signed at l. right below print, in pen-
cil, by Evans, *Walker Evans*; (verso,
mount) at l. right, in pencil, Wagstaff
no. *W. Evans 21*.
PROVENANCE: George Rinhart; Samuel
Wagstaff, Jr.
REFERENCES: FAL, p. 61.

200
[*Mechanic with Palumbo Public Ice-
Fuel Corp. Truck, New York*], ca. 1934
15 x 9.5 cm (5 ¹⁵⁄₁₆ x 3 ¾ in.) [on origi-
nal mount trimmed to image]
84.XM.956.59
MARKS & INSCRIPTIONS: (Verso) at l. cen-
ter, Evans stamp B; at l. left, in pencil,
Crane no. *L65.102(Evans)*.
REFERENCES: FAL, p. 61 (variant).

201
[*Used Clothing Store Facade with
"Fist" Sign, New York*], ca. 1934
13.9 x 8.8 cm (5 ¹⁵⁄₃₂ x 3 ¹⁵⁄₃₂ in.)
84.XM.956.374
MARKS & INSCRIPTIONS: (Verso) at l. cen-
ter, Evans stamp A; at l. left, in pencil,
Crane no. *L67.87(Evans)*.

203

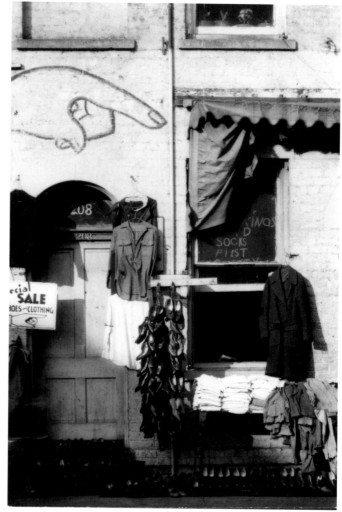

201

202

202
South Street, New York City, 1934
18.8 x 14.5 cm (7 ⅜ x 5 ¾ in.)
84.XM.956.93
MARKS & INSCRIPTIONS: (Verso) titled
and dated at center, in pencil, by
Evans, *South St NYC, 1934*; at l. center,
Evans stamp A; (recto, mat) at l. left,
in pencil, Crane no. *L65.86(Evans)*.

203
*[Abandoned Building with Movie
Posters]*, 1934; printed later
Image: 18.5 x 15.5 cm (7 ½ x 6 ¼ in.);
sheet: 25.2 x 19.8 cm (9 ⅞ x 7 ¾ in.)
84.XM.956.54
MARKS & INSCRIPTIONS: (Verso) at l. cen-
ter, Evans stamp A; at l. left edge, in
pencil, *2* [space] *23 ½* and at l. left,
Crane no. *L65.85(Evans)*.

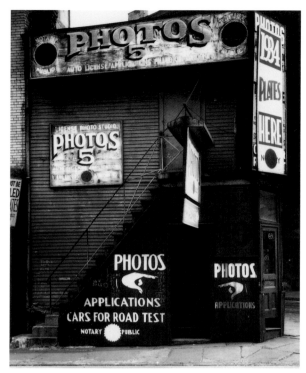

205

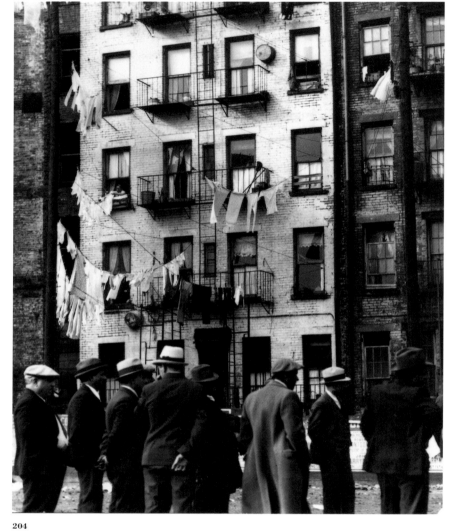

204

206

204
[*Men Gathered on a New York City Street*], 1934
25.2 x 20.2 cm (9 ¹⁵⁄₁₆ x 7 ³¹⁄₃₂ in.)
84.XM.956.1077
MARKS & INSCRIPTIONS: (Verso) at l. center, Evans stamp A; at l. right, in pencil, *b*; at l. left, in pencil, Crane no. *L78.25*.

205
[*License Photo Studio, New York**], 1934
Image: 18.2 x 14.4 cm
(7 ³⁄₁₆ x 5 ¹¹⁄₁₆ in.); original hole-punched mount: 27.9 x 21.6 cm
(11 x 8 ½ in.)
84.XM.956.456
MARKS & INSCRIPTIONS: (Mount, recto) below print, in black ink, *Part I no. 1 License Photo Studio/New York, 1934*; at l. right, in pencil, *S.S*; (verso, mount) at l. center, Evans stamp B; at l. left, in pencil, *H24/6-86/86/No 150*

h; at l. left, in pencil, Crane no. *L68.1 (Evans)*.
REFERENCES: **AMP*, Part I, no. 1; APER-TURE, p. 27 (variant).
EXHIBITIONS: *Neither Speech Nor Language: Photography and the Written Word*, J. Paul Getty Museum, Malibu, Calif., Feb. 28–May 12, 1991.

206
Massachusetts Town, 1934
15 x 19.6 cm (5 ²⁹⁄₃₂ x 7 ²³⁄₃₂ in.)
84.XM.956.61
MARKS & INSCRIPTIONS: (Verso) titled and dated at center, in pencil, by Evans, *Massachusetts Town 1934*; at l. right, Evans stamp A; at l. left, in pencil, Crane no. *L65.104(Evans)*.

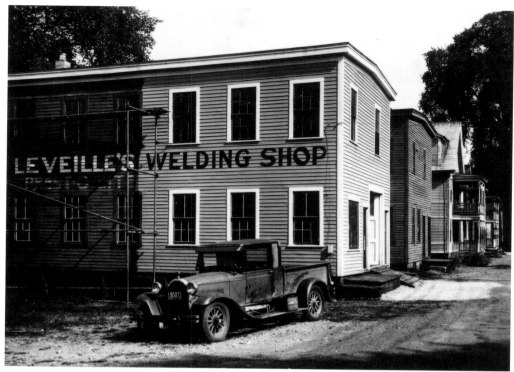

207

208

209

207
[*Massachusetts Town*]/[*Leveille's Welding Shop*], 1934
Image: 14.3 x 19.4 cm
(5 ⅝ x 7 ²¹/₃₂ in.); original mount:
18.9 x 25.3 cm (7 ⁷/₁₆ x 9 ¹⁵/₁₆ in.)
84.XM.956.133
MARKS & INSCRIPTIONS: (Recto, mount)
signed at l. right, in pencil, by Evans,
Walker Evans; at l. left, in pencil,
Crane no. *L65.105*.

208
[*Hotel Billboard and Sign Painters,
Florida*], 1934
18.9 x 22 cm (7 ⁷/₁₆ x 8 ²¹/₃₂ in.)
84.XM.956.99
MARKS & INSCRIPTIONS: (Verso) signed at
right center, in pencil, by Evans,
*WALKER EVANS/441 E. 92nd ST./NEW
YORK CITY; at l. center, Evans stamp B;
at l. right, Crane stamp; at u. left, in
pencil, 2/3*; at l. left, in pencil, Crane
no. *L78.56*.
REFERENCES: LUNN, p. 10 (variant).

209
[*Shells*], ca. 1934
Image: 16.2 x 11.4 cm (6 ⅜ x 4 ½ in.);
original mount: 27.8 x 11.4 cm
(10 ¹⁵/₁₆ x 8 ¹⁵/₁₆ in.)
84.XM.488.18
MARKS & INSCRIPTIONS: (Recto, mount)
signed at l. right below print, in pen-
cil, by Evans, *Walker Evans*; (verso,
mount) at l. left, in pencil, *600*;
at l. right, in pencil, Wagstaff
no. *Evans 4*.
PROVENANCE: George Rinhart; Samuel
Wagstaff, Jr.
REFERENCES: WEAW, p. 67 (variant).

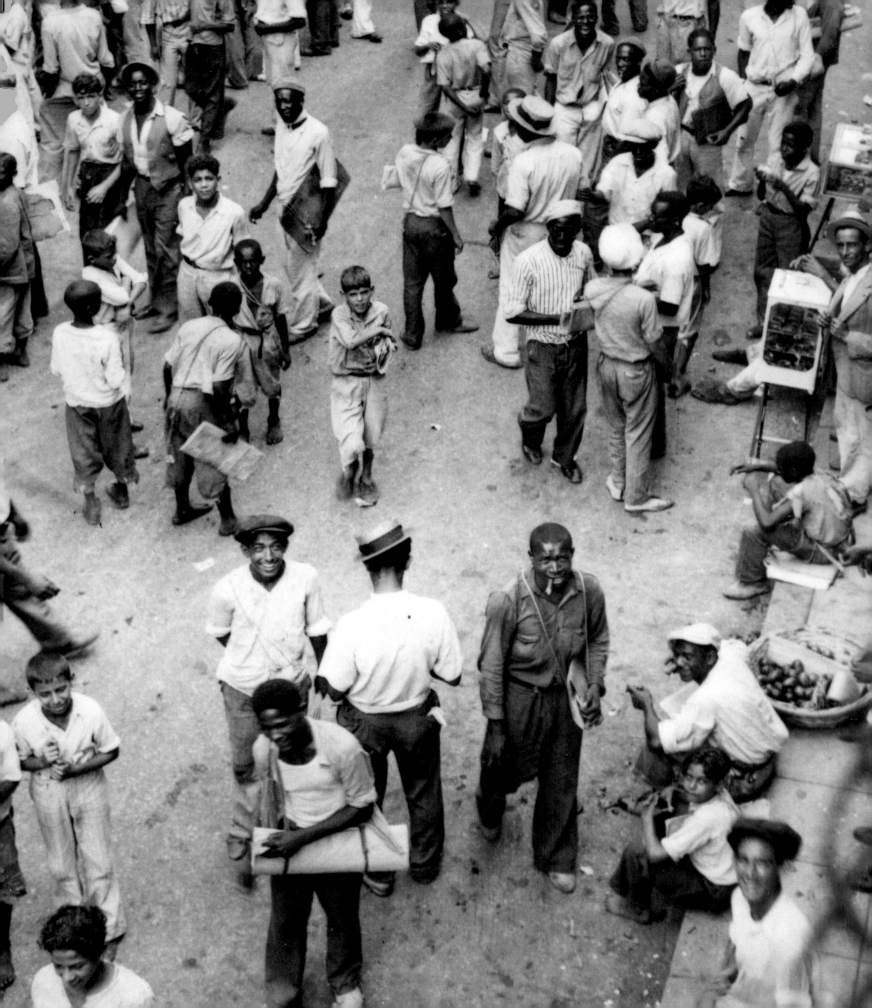

CUBA

Except for certain morning shopping hours, Havana is still largely a male city.

Carleton Beals, *The Crime of Cuba*, 1933[1]

During the Depression, culture and politics, especially leftist politics, were close comrades; in the thirties, Socialist writer Upton Sinclair would be a serious candidate for governor of California and the painter Barnett Newman would run for mayor of New York City. This revived interest in the relationship between art and the public good focused attention on Latin America, especially the murals, workshops, and other creative enterprises of artists in Mexico. Encouraged by grants from the Guggenheim Foundation, many artists—painters, filmmakers, and photographers—found themselves traveling in Central and South America, including Josef Albers, Andrew Dasburg, Philip Guston, Marsden Hartley, Stefan Hirsch, Yasuo Kuniyoshi, Sergei Eisenstein, Paul Strand, Laura Gilpin, Anton Bruehl, and Henri Cartier-Bresson. Others, in their search for a simpler way of life, something closer to paradise, went to the South Pacific; filmmakers Robert Flaherty and F. W. Murnau produced *Tabu* there, and Walker Evans traveled with movie camera to Tahiti. Evans seems to have been disappointed with the resulting footage and, judging

Walker Evans. *Havana Street* (detail), 1933 [no. 212].

from the lack of surviving vintage prints, with the small number of still photographs he made.

The year following his Tahiti voyage, the photographer was asked by the publisher J. B. Lippincott, through the influence of his author-editor friend Ernestine Evans, to produce photographs for a book about Cuba by the radical journalist Carleton Beals. Beals, who had spent the fall of 1932 in Havana, had already published three books on Mexico and had a reputation as a defender of the oppressed in Latin America. Gilles Mora's 1989 essay for the book *Walker Evans: Havana 1933* and the recent Beals biography by John Britton both discuss the preparations of the photographer and writer, working independently, for the fall 1933 publication *The Crime of Cuba*.[2] Neither of these sources, however, makes mention of the small cultural revolution taking place in New York on the eve of Evans's departure for another center of unrest.

Diego Rivera, Mexican painter and muralist, was also a Communist and made no excuses for his use of art as propaganda. The Museum of Modern Art gave him a one-man show in 1931, the same year he was asked to create a mural for the San Francisco Art Institute. In 1932, he was invited to Detroit to paint a fresco cycle on the subject of the automotive industry for the great hall of the Institute of Arts. In the spring of 1933, he returned to New York to

begin his commission for the RCA Building, the center-piece of the massive Rockefeller Center complex. Rivera's popularity as an artist and activist was a sign of the times.

Less than a month after it began, Rivera's work on his Rockefeller Center mural, *Man at the Crossroads*, was disrupted by his patrons because the artist had included in its iconography a portrait of Lenin. In May, as Evans was preparing to leave for nearly a month in Cuba, the huge, partially finished mural was boarded up. Rivera was paid and asked to leave. This highly publicized controversy inspired demonstrations and petition-signing, with artists and intellectuals such as Rockwell Kent, H. L. Mencken, Lewis Mumford, John Sloan, Niles Spencer, and Walter Pach, as well as Evans's friends Lou Block, Ben Shahn, and Ernestine Evans, involved in the protests.[3] Shahn, in fact, had been one of the artists assisting Rivera, and Evans's interest in the progress of this project went well beyond following it in the New York press. A note of April 20, 1933, to fellow photographer and poet Hans Skolle, reflects his enthusiasm for Rivera's public art: "Shahn is working with Rivera on a mural (fresco) in Radio City, and that *is* exciting. I go up often and watch the procedure."[4] Appearing in the mural next to the inflammatory portrait of Lenin was a large, individualized head of a laborer who, though representing the ideal Soviet citizen, also seemed to possess the qualities of Rivera's central figure, a young man in overalls operating an unidentified machine of overwhelming proportions. In a prospectus for the ill-fated mural that would be knocked to rubble in early 1934, the muralist described this figure as Man "expressed in his triple aspect": "the Peasant who develops from the Earth the products which are the origin and base of all the riches of mankind, the Worker of the cities who transforms and distributes the raw material given by the earth, and the Soldier who, under the Ethical Force that produces martyrs in religions and wars, represents Sacrifice."[5]

Rivera's imagery, dominated by the Latin male peasant or laborer, was, no doubt, a vivid memory for Evans as he began photographing in the streets of a city on the brink of revolt. Appropriately, pictures of a wreath-laying ceremony in Havana's Central Park (nos. 227–28) may be among the first he made, the ritual in question possibly being a commemoration of revolutionary hero José Martí's violent death on May 19, 1895. This politically loaded, subtly composed photograph is not one of the thirty-one pictures finally selected for the portfolio of photographs that appeared in the last pages of Beals's 1933 book *The Crime of Cuba*.[6] A good number of the portfolio images do, nonetheless, echo the author's scathing indictment of the regime of Cuban President Gerardo Machado (1925–33) and the long-standing exploitation of this vulnerable country by its powerful North American neighbor. Most explicit of these would be the last six plates (represented at the Getty by no. 211, a variant of the book's pl. 31) that include three pictures from local newspaper files, appropriated by Evans and credited as *Anonymous Photograph*.[7] But the majority of the published Evans images do present Cuba's widespread poverty, thus reflecting in a more general, indirect way the imperialistic policies of which Beals was so critical. Plate twenty-two, *Unofficial Village of Havana Poor*, is a strong example of Evans's attention to this side of Cuban society and served as ammunition for one reviewer, who declared that the United States had made the country "an economic fief."[8] (See no. 327 for a similar view of the same community.) This, in fact, was the front-page image accompanying the review by Harold Denny published on August 20, 1933, in the *New York Times Book Review*, which began: "Seldom has a tale of greed, misery, bloodshed and futility been placed between the covers of a book as is told in this new volume by Mr. Beals."[9] Denny goes on to give Beals credit for breadth as well as depth in his ambitious coverage of present-day conditions and his depiction of centuries of Cuban history:

He tells a sufficiently full history of Cuba from the days of the Spanish conquerors who exterminated the Indians and brought in Negroes to slave in the fields and mines through the many revolts of the Cubans against their Spanish masters and the grotesquely managed war by which the United States expelled the Spanish, on down through the "Dance of the Millions," the collapse of sugar, and the desperate efforts of Machado to remain in the saddle. With his factual and interpretative material, Mr. Beals has included brilliant character sketches, illuminating incidents, and some acute observations on the intellectual and social behavior of the Cubans.[10]

After recounting how Beals outlines the damage done by the notorious Platt Amendment of 1901, which insured United States control over the island's economic as well as foreign policy, and the State Department's determination to maintain the status quo at whatever cost to the Cuban people, Denny praises Beals for not offering a glib solution for this country's woes and ends with a special mention of Evans's work, saying that the photographs "form an appendix of thirty views of Cuban life, including two or three dreadful mementos of the horror."[11] On the same day that Denny's column appeared, the *New York Herald Tribune Books* section presented another review of *The Crime of Cuba*, this one by Ernest Gruening, who faulted Beals for evidence of hasty research but then discounted his own criticisms, noting the understandable urgency in getting the book out. (Gerardo Machado's regime, previously supported by the United States government, was toppled on August 12, 1933.)[12] Gruening mentions Evans's contribution early on, stating in his second paragraph: "Amply buttressed by four hundred pages of text, the effect of which is heightened by some thirty-one aquatone illustrations from photographs by Walker Evans, Mr. Beals develops his thesis that the United States has made Cuba what she is

Figure 1. E. H. Suydam (American, 1885–1940). *Scene in Havana* from *New York Herald Tribune*, August 20, 1933. Halftone from block print, 11.8 x 8.4 (4 9/16 x 3 5/16 in.).

today."[13] His acknowledgment of Evans notwithstanding, the subject of Gruening's text is represented by an ink drawing of an intense-looking Beals and a block print by E. H. Suydam, entitled *Scene in Havana* (fig. 1), rather than by a photograph from the book. Suydam's composition is a broadly drawn impressionistic representation of a "typical" Latin city street scene, looking more nineteenth- than twentieth-century, with heavy palm leaves draping the foreground and women, burros, sombreroed men, and large quantities of woven baskets filling the arched portals in the background. This romanticized, and probably completely fictional, view of life in Havana was to be expected from a printmaker/illustrator of numerous

travel books on the southern United States, the Southwest, and Mexico, but it was the antithesis of what mattered to Gruening, Beals, or Evans.[14] In stark contrast to the mood of this hand-drawn image is a "typical" Evans street scene, a Havana shop front for a general store (no. 262). The type of merchandise offered is spelled out plainly in large, highlighted letters, in simply stylized drawings, in exaggerated replicas, and in the display of the objects themselves at the wide entryways. Two men in ubiquitous straw Panamas pass the time in front of the shop but do not interrupt our view of, or Evans's fascination with, this clearly presented information. The facades of small shops—their signs and often empty doorways—were a favorite subject in Evans's Havana work (such as nos. 261, 264, 272, 276, 280). Another of his preferred themes from the streets of Havana was the movie house and its posters and marquees.

A composition built around this subject appears as plate eight in *The Crime of Cuba* (no. 269 represents a variant of the negative, less cropped than the book image). Prominent in the picture are posters for two American dramas, one starring the gangster hero Edward G. Robinson; the car, a well-kept luxury model conspicuous in the foreground, is a great rarity in the Havana pictures. Another theater front appears in several negatives and is found at the Getty in a print entitled *Havana Cinema* (no. 268). Near the center of the composition is a poster for *Adios a las Armas (A Farewell to Arms)*, the American film based on the 1929 novel by Ernest Hemingway and starring Helen Hayes and Hemingway's American friend Gary Cooper. James Mellow, one of Hemingway's biographers, has suggested that the Hemingway connection is no coincidence.[15] In Havana, Evans spent considerable time with Hemingway (who, like Evans, had grown up in a Chicago suburb); Evans may even have received financial aid from Hemingway in order to extend his stay. Whatever the case, Evans's documentation of this theater would seem to be a memento of the two men's friendship.

It seems probable that Hemingway and his writing exerted a considerable influence on the photographer's work at that time. Already acclaimed for his terse, unembellished style, in 1933 Hemingway was living in Key West and doing most of his writing in Havana. He would publish his third collection of short fiction, *Winner Take Nothing*, that year, and he was collecting Cuban material for the Harry Morgan stories that would finally appear together in 1937 as *To Have and Have Not*, as well as adventures of deep-sea fishing that he would later retell in *The Old Man and the Sea* (1952). The year before Evans's visit, Hemingway's encyclopedic work on the bullfight, *Death in the Afternoon*, was issued with sixty-four photographic illustrations, including five images of dead or wounded matadors.[16] In the first chapter of this chronicle covering every aspect of the ancient but "impermanent" art of the bullfight, Hemingway explains that he went to Spain because "I was trying to learn to write, commencing with the simplest things, and one of the simplest things of all and the most fundamental is violent death."[17] He continues: "So I went to Spain to see bullfights and to try to write about them for myself. I thought they would be simple and barbarous and cruel and that I would not like them."[18] Evans may have admired not only Hemingway's style of reporting his response to the bullfight but the pictures he chose to represent his subject. The brutal image of the heroic Joselito dead of a goring in the ring, or the frenzied crowd scene of an amateur fight in Pamplona, might have influenced the photographer's thinking while watching the public spectacles of Havana and combing its newspaper files for evidence of political terror.

Evans's fondness for Hemingway as a friend and author would come out in the seventies in several published interviews. In trying to explain to Paul Cummings why he thought some writers were "unconscious photographers," he described James Joyce as a realist and "partly a reporter," going on to say: "Photography is reporting, too. . . . I am interested in reporting, but I think that

reporting at its worst is journalism. But Hemingway was a hell of a good reporter, did it to begin with, and was always grounded in that."[19] In the same interview, in a discussion of photographic portraiture and why he disapproved of photographing celebrities, he again spoke of Hemingway: "I was around Hemingway a little bit, but I would never bring out a camera and photograph him, out of regard for him really, as too obvious a thing to do."[20] In 1974, remembering how he had avoided all Americans, especially the "big names," when he was a timid young man in Paris in the twenties, Evans brought up Hemingway as a peer of F. Scott Fitzgerald's, but one, unlike Fitzgerald, whose work and personality he liked: "I met Hemingway later and became friends with him, and was interested in and close to his experiences. And I thought he was a sensitive and superior man. When I met him he was nice to me; he knew exactly who I was and what I was doing."[21] Such lines as the one that introduces the author's "Banal Story" (issued in 1927 in the collection *Men Without Women*)— "So he ate an orange, slowly spitting out the seeds"[22]— would certainly have appealed to the photographer who reminisced that in the early thirties he was "doing some things that I thought were too plain to be works of art. I began to wonder. I knew I wanted to be an artist, but I wondered if I really was an artist."[23] Hemingway went to Spain to learn to write; for Evans it was on the streets of Havana that his style and subject meshed and he found his own way as a photographer. Havana was Spain for Evans. As we shall see, it was also his Paris.

He had escaped to Paris in 1926 after leaving Williams College, rejecting the United States for all things French and hoping to indulge his literary aspirations; as he recalled, he was at that time "almost a pathological bibliophile."[24] In 1933, he was not in search of the French but of a city that he could take on as a subject in the same way Eugène Atget had approached Paris, documenting it between the 1890s and his death in 1927. It is hard to say how much of

the French photographer's work Evans had seen before his Havana assignment, but we do know that he was quite familiar with the 1930 publication *Atget: Photographe de Paris,* which he reviewed along with five other new photography books for *Hound & Horn* in the fall of 1931.[25] Evans portrays Atget as a kind of isolated, naive artist, who in his obliviousness "worked right through a period of utter decadence in photography."[26] He points out, possibly in response to the Surrealists' promotion of Atget as one of their own, that it is possible to read into Atget's work "things he may never have formulated to himself." But Evans's reading of the photographs is that they offer "a lyrical understanding of the street, trained observation to it, special feeling for patina, eye for revealing detail," all presented with the stamp of Atget's personal poetry.[27]

Since that 1930 volume appeared, Atget's oeuvre has been much more thoroughly analyzed; his systematic business of recording Vieux Paris for the files of artists, architects, designers, antiquarians, museums, and libraries has been researched and reassembled. His style, too, has been dissected, with the conclusion of recent scholarship being very close to that of the German critic Walter Benjamin, who in his own 1931 analysis of Atget's photographs stated that "the remarkable thing about these pictures, however, is their emptiness. . . . They are not lonely, but they lack atmosphere; the city in these pictures is empty in the manner of a flat which has not yet found a new occupant."[28] But Benjamin goes on to categorize this special quality as Surrealist, where contemporary historians tend to attribute it to Atget's desire to create the look or the style of a "document," or what Molly Nesbit has called the "authorial document."[29] These images—which could be employed as information or background detail— served as the starting point for still other narratives. According to Nesbit, Atget's documents were "meant to be incomplete."[30] This element of emptiness or absence, ubiquitous in Atget's Paris series, Nesbit points to as particularly significant in his work documenting modernity, that

Figure 2. Eugène Atget (French, 1857–1927).
Kiosque de fleurs, n.d. Toned gravure from *Atget:*
Photographe de Paris (Paris: H. Jonquières;
New York: E. Weyhe, 1930), pl. 74.
21 x 16.6 cm (8¼ x 6¹⁷⁄₃₂ in.).

is, the *mœurs* of twentieth-century Paris. Of such series as the "Intérieurs parisiens" and "La Voiture à Paris," both begun about 1910, she says: "The development of emptiness was the precondition for Atget's work on modern life."[31] In his last work on what Nesbit calls the "third city" of Paris—that is, the Paris inhabited by ragpickers, street peddlers, and barge laborers—this sense of emptiness would be exacerbated, as Atget increasingly presented modernity "as vacant hollow space."[32]

The characteristic emptiness of Atget's modern document (whether intended for the archive or not) permeates much of Evans's Havana work, as does the earlier photographer's antiquarian sense. The many series that made up Atget's study of Old Paris—"Environs de Paris," "Topographie du Vieux Paris," "Paris pittoresque," "L'Art dans le

Vieux Paris"—as well as his pictures of modern life—including the shop fronts, window displays, and signage of "Métiers, boutiques et étalages de Paris" and "Enseignes et vieilles boutiques de Paris"— were reflected in the posthumous volume *Photographe de Paris* (1930), as was the series on "Fortifications de Paris" and the "Zoniers" about the *chiffonniers* (or ragpickers) and their surroundings. In the ninety-six plates of *Photographe de Paris*, which we know Evans had at hand, may be found the inspiration for many of the Havana subjects: the sidewalk displays of small tradesmen (such as no. 270); the signage of urban store fronts (no. 275); the abundant street offerings of fresh produce (no. 256); the decorative balconies of old housefronts (no. 287); the vacant entryways and courtyards of private buildings (no. 259); the many studies of archaic, horse-drawn wagons and carriages isolated from automobile traffic (no. 248); the portraits of women who appear to be prostitutes (no. 306)—all subjects equally accessible to a street photographer in Havana or in Paris.

Another relevant image from this first retrospective of the late photographer's work (who died, it should be remembered, in 1927, the year Evans began photographing in New York) is plate 74 from Atget's book (fig. 2). This photograph fits, no doubt, into Atget's category of *petits métiers*, but it is more interesting for our purposes because it seems to anticipate Evans's own intent observation of the habits of men on city streets. It may be compared to a group of pictures Evans made at a street-corner newsstand in Havana (nos. 233–36), the finest of which is a composition (no. 233; fig. 3) featuring a tall black man in a linen suit and Panama hat, a sophisticated, nonchalant figure set against a backdrop of movie magazines, shoeshine boys, and the grand, classical columns of an old Havana arcade (perhaps that of the Prado). This *Havana Citizen*, as the photographer titled the image, might be seen as Evans's updating of Charles Baudelaire's dandy, someone "whose solitary profession is elegance," who is "blasé, or pretends to be so," or even stoic, whose natural element is the

crowd, and who represented for the Frenchman, as well as perhaps for this twentieth-century American, "the last spark of heroism amid decadence."[33] Evans, himself trying to live up to Baudelaire's expectations for the ideal *flâneur*, captured in this anonymous portrait, as well as in many others not eventually included in *The Crime of Cuba*, the extraordinary mixing of races present in Cuban culture that is the subject of "Pattern," Part I of Beals's book.[34] Before he launches into a recounting of Cuba's long struggle for independence, the journalist vividly describes the inhabitants of "Black Cuba" and "White Cuba," and in interviews with residents of African, Amer-Indian, and Spanish heritage, he discusses contemporary Cuban society. Among other characteristics, he reports on the masculine quality of Havana's streets: "Except for certain morning shopping hours, Havana is still largely a male city. The tide of pedestrians along narrow Obispo Street, with its cavernous cool dark stores, or under the Prado portals, wall-papered with magazines and multicolored lottery tickets, the idlers in the open-air cafes—nearly all are men in white linen, now and then a bright tie under a dark chin shaded by a straw hat tilted effectively."[35]

Beals's observations could certainly be confirmed by the one hundred and thirty-eight Cuban pictures contained in the Getty collection, the majority of which, when they do contain signs of life, feature the male population—street vendors with their carts; lottery-ticket sellers conversing; the Havana bums Hemingway wrote about, asleep in the early morning sun; the stevedores whom Evans portrayed both en masse and as individuals; the newsboys; military men solemnly decorating Martí's monument; the craftsmen and civil servants, barbers, cobblers, trolley conductors, and farmers; the crowd at a *Public Spectacle*, which is so overwhelmingly male. The images of women are scarce—a young mother begging with three children; women who are probably prostitutes, shown behind barred windows; and members of a breadline. This emphasis on the male subject may have been an appropriate reflection

Figure 3. Walker Evans. *Havana Citizen*, 1933 [no. 233].

of street life in Havana, as suggested by Beals's narrative; it may to some extent come from the images of Rivera's heroic laborers and Hemingway's gallery of soldiers, boxers, matadors, and gangsters. Whatever the source, male imagery suited Evans's needs, and his style flourished in its presence.

Havana Citizen (nos. 233–34), though not among the thirty-one illustrations in *The Crime of Cuba*, proved to be one of Evans's favorite Havana images. The role it played in other projects of the thirties is a gauge of the picture's importance to Evans and his evolving style. To celebrate Machado's long-anticipated downfall, the July–

September 1934 issue of *Hound & Horn* ran a portfolio, "Cuba Libre: Photos," consisting of three Evans pictures (see nos. 227, 233, 237, for close variants of the three plates); *Havana Citizen* was one of them. When in 1938 he made selections for a one-man show at the Museum of Modern Art to be exhibited under the title *American Photographs*, Evans again chose this Cuban image to appear in both the exhibition and the accompanying book (which presented a sequence of photographs quite different than that presented in the galleries; see Appendix B).[36] At the museum, *Citizen in Downtown Havana*, as it was now called, appeared in a grouping with another newsstand image of four young men in Panamas (no. 237, variant cropping) and a single stevedore portrait (no. 295). Also included in the show were the *Village of Havana Poor* or *Squatters' Village* (no. 327), the picture *Family* (no. 317) that appeared in the 1933 volume, and a young girl, possibly a prostitute, in *Cuban Girl Looking Through Window Bars* (no. 309). The last three photographs were installed among images of the rural American South and city dwellers in the Bronx sunning themselves. According to museum loan numbers and labels found on five other Getty prints, Havana pictures of a breadline family (*Country Family*, no. 313), a beggar (no. 322), another of the coal dockworkers (no. 293), a Havana courtyard containing an iron jockey (no. 257), and a vacant, two-story facade entitled simply *Housefront, Havana* (no. 275) were at one point among the prints being considered for hanging.[37] The group of eighty-seven plates making up the published volume *American Photographs* was a substantially different selection, but, as he did for the exhibition, Evans assimilated the man in Havana into his image of Main Street America, inserting *Citizen in Downtown Havana* (pl. 20 of *American Photographs*), as well as two other distinctive portraits of Cuban types—*Havana Policeman* (pl. 30; no. 298) and *Coal Dock Worker* (pl. 33; no. 292)—among his American Legionnaires, Civil War sculptures, and images from the rural South.[38]

By 1938, Cuba had apparently become, as far as Evans was concerned, a part of the American Scene, that popular Depression-era theme. His inclusion of these faces from a small, impoverished country, ninety miles off the coast of Florida, which most New Yorkers thought of only as a vacation spot, may also have been intended as a tribute to the people of Havana and an acknowledgment of their predicament.[39] The title of *Havana Citizen* might well be somewhat ironic, referring as it does to a member of a disenfranchised population that, according to Beals, felt like exiles in their own land. The man-of-the-world Evans portrays, then, can be said to represent an idea rather than a reality. Cuban natives, and even longtime resident aliens like Graham Greene's Jim Wormold, British vacuum-cleaner salesman and unorthodox secret agent, longed for the self-assured composure and peace of mind embodied in Evans's remarkable dandy. In Greene's cold-war novel *Our Man in Havana*, the naive, blundering Wormold, on a rare visit to the exclusive Havana Club, achieves his ultimate goal: "In the club he felt himself, as in the Wonder Bar, a citizen of Havana."[40]

The lessons of Rivera, Hemingway, and, particularly, Atget that Evans put into practice during his brief stay in Cuba proved to be excellent preparation for a bigger assignment: to document the details of "Middletown U. S. A.," or at least a southeastern version of it, for the federal government. Evans would take full advantage of the New Deal's resources to refine this unblinking style of observation as he traveled through the rural South. But before he was offered the opportunity to apply his mature style in a free-ranging way, he would need to sustain himself with a very different commission, one closely connected to his interest in the black culture of Cuba. Photographing the major survey *African Negro Art* at the Museum of Modern Art in 1935 would put him back into the studio and test his skills as an interpreter of others' art.

NOTES

1. Carleton Beals, *The Crime of Cuba*, with 31 photographs by Walker Evans (Philadelphia: J. B. Lippincott, 1933), 76.

2. Gilles Mora, "Havana, 1933: A Seminal Work," in Gilles Mora and John Hill, *Walker Evans: Havana 1933* (New York: Pantheon Books, 1989), 8–23, and John A. Britton, *Carleton Beals: A Radical Journalist in Latin America* (Albuquerque: University of New Mexico Press, 1987), 103–22. Mora and Hill reproduce in quite small dimensions the complete portfolio for *The Crime of Cuba* and in text illustrations and large plates another selection (some duplicating images in the 1933 book) of some ninety-two posthumous prints, made (usually full-plate) for this new publication from the Evans negatives still held by the Walker Evans Estate.

3. Ernestine Evans, author of *The Frescoes of Diego Rivera* (New York: Harcourt, Brace, 1929), is listed as "Ernestina Evans" in the *New York Times* (May 28, 1933), in an article regarding a letter sent by artists and writers to John D. Rockefeller opposing his treatment of Rivera, quoted in Irene Herner de Larrea, *Diego Rivera: Paraiso Perdido en Rockefeller Center* (Mexico, D.F.: Edicupes, 1986), 124.

4. Evans to Skolle, Apr. 20, 1933, quoted in *Walker Evans at Work*, with an essay by Jerry L. Thompson (New York: Harper and Row, 1982), 95.

5. *Diego Rivera: A Retrospective* (New York: Founders Society Detroit Institute of Arts, in association with W. W. Norton, 1986), 295.

6. Twenty-one prints in the Getty collection are from negatives used for the thirty-one illustrations that finally accompanied Beals's text for *The Crime of Cuba*: nos. 211–12, 214, 225–26, 239, 243, 259, 269, 296, 308, 311, 312 (variant of 311), 313, 317, 322, 325–26, 333, 336, and 339. According to Mora and Hill (*Walker Evans: Havana 1933*, 9) and Evans/Beals correspondence quoted in their foreword, in taking this commission, Evans required that he be allowed to select and sequence the images used and that he be permitted to submit twice the number of pictures to be used, sixty-four prints, thirty-two of which he expected to be reproduced. Only thirty-one were included in the book; it is not known whether the publisher honored Evans's contract in terms of

the final sequencing of those that do appear. Among the Getty prints are sixteen photographs not included in the published portfolio that bear Evans's numbers in pencil at the upper center, verso. These prints, with numbers between 8 and 48, suggest that the photographer may have had another sequence in mind, whether it was that proposed to Lippincott or not. These designations would layout nos. 276, 274, 272, 273, and 242 as plates 8 through 12, respectively. Nos. 270, 227, and 236 would form another grouping as plates 22, 23, and 24. Other Getty prints that might have formed part of this original (or alternate) design are: nos. 256 (Evans "18"), 253 (Evans "19"), 318 (Evans "29"), 315 (Evans "30"), 324 (Evans "37"), 282 (Evans "42"), 332 (Evans "44"), and 219 (Evans "48").

7. See Beals, *Crime of Cuba*, pl. 26, *A Document of the Terror*; pl. 28, *Gonzalez Rubiera*; and pl. 30, *Terrorist Students in Jail*.

8. Harold N. Denny, "Cuba, The Crucified Republic: Carleton Beals Indicts the Machado Regime and American Penetration," *The New York Times Book Review*, Aug. 20, 1933, 1.

9. Ibid., 1 and 14.

10. Ibid., 1.

11. Ibid., 14.

12. Ernest Gruening, "How Cuba Became What She Is Today: Carleton Beals Lays Blame on the United States and the Platt Amendment," *New York Herald Tribune Books* 9:50 (Aug. 20, 1933), 3.

13. Ibid.

14. Edward Howard Suydam illustrated at least seventeen books, including Lyle Saxon's *Fabulous New Orleans* (1928) and *Old Louisiana* (1929), and *Hawaii: Isle of Enchantment* (1937) and *Pattern of Mexico* (1941) by Clifford Gessler, who reports the artist's then-recent death.

15. James Mellow, *Hemingway: A Life Without Consequences* (Boston: Houghton Mifflin, 1992), 425–26, and see the unpaginated plate section for a reproduction made from another negative documenting the same theater front. The Getty picture has not previously been published, but a variant of the Mellow image is found in *Walker Evans at Work*, 19.

16. Ernest Hemingway, *Death in the Afternoon* (New York: Charles Scribner's Sons, 1932). The photographic plates, identified as being by Vandel and Rodero, appear in unpaginated fashion after the main text and before the explanatory glossary.

17. Ibid., 2.

18. Ibid., 3.

19. "Walker Evans," a 1971 interview published in Paul Cummings, *Artists in Their Own Words: Conversations with Twelve American Artists* (New York: St. Martin's Press, 1979), 99.

20. Ibid., 97.

21. "A Visit with Walker Evans," in Bill Ferris and Carol Lynn Yellin, eds., *Images of the South: Visits with Eudora Welty and Walker Evans*, Southern Folklore Reports 1 (Memphis, Tenn.: Center for Southern Folklore, 1977), 29.

22. Ernest Hemingway, *Men Without Women* (New York: Charles Scribner's Sons, 1927; Scribner Classic/Collier Edition, 1986), 126.

23. Cummings, "Walker Evans," 99.

24. Ibid., 83.

25. Pierre MacOrlan, *Atget: Photographe de Paris* (Paris and Leipzig: Jonquières, 1930; New York: E. Weyhe, 1930). Evans's review of this and the recent publications *Steichen the Photographer*, *Die Welt ist Schön*, *Photo-Eye*, *Arts et Métiers Graphique*, and *Antlitz der Zeit* appeared under the title "The Reappearance of Photography" in *Hound & Horn*, Oct.–Dec. 1931, 125–28.

26. Ibid., 126.

27. Ibid.

28. Walter Benjamin, "A Short History of Photography," translated by Stanley Mitchell, *Screen* 10 (Spring 1972), 21. Benjamin's article first appeared in *Literarische Welt* in 1931 and seems to have been a review of five new books, including *Atget Lichtbilder*, the German edition of the MacOrlan book critiqued by Evans.

29. Molly Nesbit, *Atget's Seven Albums* (New Haven, Conn.: Yale University Press, 1992), 35. Nesbit's is one of the most complete accounts to date of Atget's methods; her interpretation of what the term *document* means in regard to Atget's images is exhaustive, and much of it could be applied to

Evans's work in a more lengthy study.

30. Ibid., 117.

31. Ibid., 133.

32. Ibid.

33. Charles Baudelaire, *The Painter of Modern Life and Other Essays*, translated and edited by Jonathan Mayne (London: Phaidon Press, 1964; Da Capo Press Paberback, 1986), with quoted phrases from pp. 26, 9, 28, respectively.

34. Beals, *Crime of Cuba*, 17–92.

35. Ibid., 76.

36. With the publication in Gilles Mora and John T. Hill, *Walker Evans: The Hungry Eye* (New York: Harry N. Abrams, 1993), 162–97, of a re-creation (based on Evans's own hastily made installation views) of the MoMA show, it is possible for the first time to see the selected images and the wall groupings of the exhibition and to compare them to those long known in the published work *American Photographs*.

37. See Appendix B for a complete listing of JPGM prints associated with the 1938 exhibition and book.

38. Walker Evans, *American Photographs*, with an essay by Lincoln Kirstein (New York: Museum of Modern Art, 1938).

39. The "all-inclusive" Havana cruises of the new ships *Morro Castle* and *Oriente* offered by the Ward Line were featured in streamlined advertisements in the early thirties; in 1937, when Walker Evans and James Agee prepared the article "Six Days at Sea . . . on a 'good average' cruise to Havana" for *Fortune* (vol. 16 [Sept. 1937], 117–20, 210–12, 214, 216, 219–20), the *Oriente*, their ship for the cruise, made fifty trips from New York to Havana each year, "carrying freight, mail, and passengers, of whom a strong preponderance are cruising."

40. Graham Greene, *Our Man in Havana* (London: William Heinemann, 1958; Penguin Books, 1991), 153. The 1991 edition displays one of Evans's Havana photographs on its cover (an image that is not in the Getty collection).

210

Cuba

All of the following photographs appear to have been made during Evans's 1933 trip to Cuba. The majority were made in Havana and are sequenced to introduce the reader to that urban environment through views of major monuments, like Columbus Cathedral and Morro Castle, followed by images of shop fronts, street vendors, balconied residences, and horse-and-carriage traffic in the city's narrow avenues. A group of portraits of Havana tradesmen and beggars precedes a final section of rural scenes made in the island's interior. Twenty-one of these prints (nos. 211, 212, 214, 225, 226, 239, 243, 259, 269, 296, 308, 311, 312 [variant of 311], 313, 317, 322, 325, 326, 333, 336, and 339) are from the negatives used for the thirty-one illustrations by Evans that accompanied Carleton Beals's text for *The Crime of Cuba* (1933).

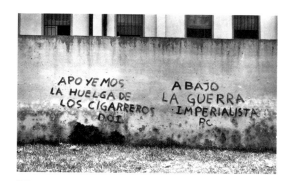

211

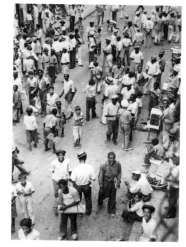

212

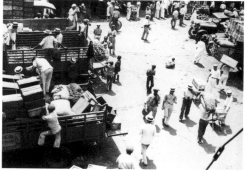

213

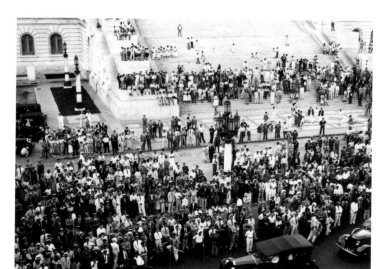

214

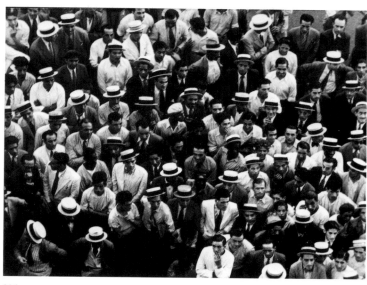

215

210
[Detail of an Ocean Liner, En Route to Havana], 1933
23.5 x 14.2 cm (9 ⁹/₃₂ x 5 ¹⁹/₃₂ in.)
84.XM.956.698
MARKS & INSCRIPTIONS: (Verso) at l. right, Evans stamp B; at l. left, in pencil, Crane no. L78.14(Evans).

211
[Wallwriting. We Support the Strike of the Cigar Workers. Down with the Imperialist War.*], 1933
14.5 x 23.2 cm (5 ¾ x 9 ³/₁₆ in.)
84.XM.956.162

MARKS & INSCRIPTIONS: (Verso) at right center, Evans stamp H; at l. left, in pencil, Crane no. L66.83(Evans).
REFERENCES: *CUBA, pl. 31 (variant); HAVANA, p. 111 (variant).

212
[Havana Street*], 1933
23.5 x 15.8 cm (9 ¼ x 6 ¼ in.)
84.XM.956.152
MARKS & INSCRIPTIONS: (Verso) signed at center, in pencil, by Evans, Walker Evans; at l. left, in pencil, Crane no. L66.68(Evans).
REFERENCES: *CUBA, pl. 1 and front cover of dust jacket (variant).

213
[Produce Trucks at Market], 1933
18.5 x 25.3 cm (7 ⁵/₁₆ x 9 ¹⁵/₁₆ in.)
84.XM.956.170
MARKS & INSCRIPTIONS: (Verso) at right, Evans stamp A; at l. left, in pencil, Crane no. L66.93(Evans).

214
[Public Spectacle*], 1933
17.4 x 23.2 cm (6 ⅞ x 9 ³/₁₆ in.)
84.XM.956.156
MARKS & INSCRIPTIONS: (Verso) at l. right, Evans stamp A; at l. left, in pencil, Crane no. L66.78(Evans).
REFERENCES: *CUBA, pl. 17 (variant).

215
[Spectacle, Capital Steps, Possibly Independence Day, May 20*], 1933
19.7 x 25.3 cm (7 ¾ x 9 ³¹/₃₂ in.)
84.XM.956.231
MARKS & INSCRIPTIONS: (Verso) signed at right center, in pencil, by Evans, Walker Evans; at l. left, in pencil, Crane no. L66.60(Evans).
REFERENCES: *HAVANA, pp. 26–27 (variant).

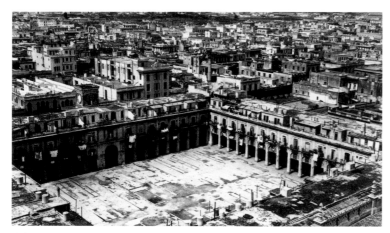

216

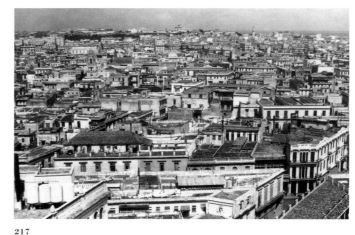

217

218

219

220

216
View of Havana/[Plaza del Vapor, Market Area, Havana]*, 1933
14.3 x 23.6 cm (5 ⁵⁄₈ x 9 ⁹⁄₃₂ in.) [on original mount trimmed to image]
84.XM.956.278
MARKS & INSCRIPTIONS: (Verso) titled and signed at center, in black ink, by Evans, *VIEW OF HAVANA/Walker Evans*; (recto, mat) at l. right, in pencil, *75*; at l. left, in pencil, Crane no. *L66.2 (Evans)*.
REFERENCES: *HAVANA, pp. 36–37 (variant).

217
View of Havana from the New Telephone Company Tower, 1933
15.5 x 23.6 cm (6 ⅛ x 9 ⁵⁄₁₆ in.) [on original mount trimmed to image]
84.XM.956.191
MARKS & INSCRIPTIONS: (Verso) titled and signed at center, in black ink, by Evans, *VIEW OF HAVANA/FROM THE NEW TELEPHONE CO. TOWER/Walker Evans/ 23 Bethune St.*; at l. left, in pencil, Crane no. *L66.92(Evans)*.

218
[Havana Street with Topiaries], 1933
23.2 x 14.8 cm (9 ⅛ x 5 ¹³⁄₁₆ in.) [on original mount trimmed to image]
84.XM.956.843
MARKS & INSCRIPTIONS: (Verso) at l. center, Evans stamp A; at l. left, in pencil, Crane no. *L66.104(Evans)*.

219
[Detail: The Cathedral, Havana]/ [Detail: Columbus Cathedral (La Catedral de la Virgen María de la Concepción)], 1933
16 x 14.7 cm (6 ⁵⁄₁₆ x 5 ¹³⁄₁₆ in.) [on original mount trimmed to image]

84.XM.956.238
MARKS & INSCRIPTIONS: (Verso) signed at center, in pencil, by Evans, *Walker Evans*; at u. center, in pencil, by Evans, *48.*; at l. left, in pencil, Crane no. *L66.117(Evans)*.

220
[Detail: The Cathedral, Havana]/ [Detail: Columbus Cathedral (La Catedral de la Virgen María de la Concepción)], 1933
19.2 x 25.1 cm (7 ⁹⁄₁₆ x 9 ²⁹⁄₃₂ in.)
84.XM.956.186
MARKS & INSCRIPTIONS: (Verso) at right

221

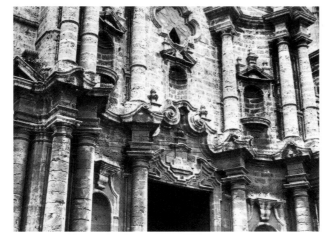

223

224

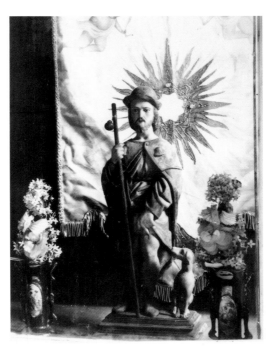

225

center, Evans stamp A; at l. left, in pencil, Crane no. *L66.114(Evans).*

221
[*Detail: The Cathedral, Havana*]/
[*Detail: Columbus Cathedral (La Catedral de la Virgen María de la Concepción)*], 1933
24.5 x 18.2 cm (9 ⅝ x 7 ³⁄₁₆ in.) [on original mount trimmed to image]
84.XM.956.185
MARKS & INSCRIPTIONS: (Verso) at right center, partial Evans stamp A; at l. left, in pencil, Crane no. *L66.115 (Evans).*

222
[*Detail: The Cathedral, Havana*]/
[*Detail: Columbus Cathedral (La Catedral de la Virgen María de la Concepción)*], 1933
Image: 25.2 x 19.8 cm
(9 ⅞ x 7 ¹³⁄₁₆ in.); sheet: 25.3 x 20 cm
(9 ³¹⁄₃₂ x 7 ⅞ in.)
84.XM.956.182
MARKS & INSCRIPTIONS: (Verso) at u. left, partial Evans stamp A; at l. right, in pencil, by Arnold Crane, *Cuba/AHC* and *Withdrawn 12/71 AHC*; at right center, Crane stamp; at l. left, in pencil, Crane no. *L66.116(Evans).*

NOTE: Not illustrated; variant of no. 221.

223
[*The Cathedral, Havana*]/[*Columbus Cathedral (La Catedral de la Virgen María de la Concepción)*], 1933
18.8 x 24.4 cm (7 ⁷⁄₁₆ x 9 ⅝ in.)
84.XM.956.187
MARKS & INSCRIPTIONS: (Verso) at right center, Evans stamp A; at l. left, in pencil, Crane no. *L66.113(Evans).*

224
[*Cuban Religious Shrine*], 1933
Image: 18.8 x 11.3 cm
(7 ¹³⁄₃₂ x 4 ¹⁵⁄₃₂ in.); original mount:
22.8 x 15.6 cm (8 ³¹⁄₃₂ x 6 ⁵⁄₃₂ in.)
84.XM.956.216
MARKS & INSCRIPTIONS: (Verso mount) at center, Evans stamp B; at l. left, in pencil, Crane no. *L66.105(Evans).*

225
[*Patron Saint**]/[*Patron Saint, St. Rock***], 1933
Image: 20.1 x 15.3 cm
(7 ¹⁵⁄₁₆ x 6 ¹⁄₁₆ in.); original mount:
23.2 x 18.6 cm (9 ⅛ x 7 ⅜ in.)
84.XM.956.149
MARKS & INSCRIPTIONS: (Recto, mount) signed at l. right, in pencil, by Evans, *Walker Evans*; (verso, mount) at l. right, Evans stamp A; at l. left, in pencil, Crane no. *L66.70(Evans).*
REFERENCES: *CUBA, pl. 3 (variant); FAL, p. 45; **HAVANA, p. 71.

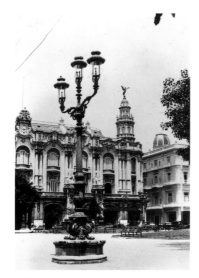

226

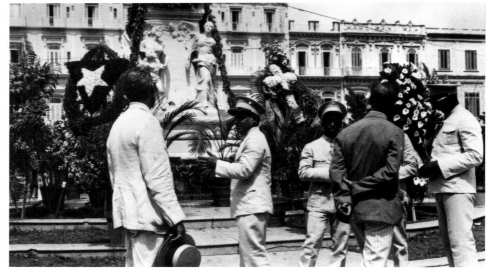

227

228

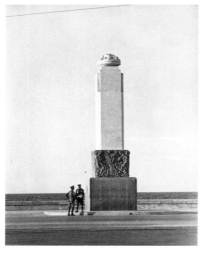

229

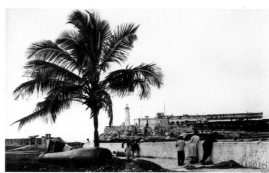

230

226
[Parque Central I]/[Parque Central, Galician Center in Background**]/ [National Opera House and the Inglaterra Hotel, Havana]*, 1933
22.5 x 14.6 cm (8 13/16 x 5 3/4 in.)
84.XM.956.150
MARKS & INSCRIPTIONS: (Verso) at right center, Evans stamp A; at l. left, in pencil, Crane no. *L66.73(Evans)*.
REFERENCES: **CUBA*, pl. 6 (variant); ***HAVANA*, p. 88 (variant).

227
Public Ceremony, Havana, Central Park/[Wreathlaying, Havana]/ [Wreathlaying at the José Martí Statue, Havana]*, 1933
13.3 x 22.9 cm (5 1/4 x 9 1/32 in.)
84.XM.956.188
MARKS & INSCRIPTIONS: (Verso) titled and signed at center, in black ink, by Evans, *PUBLIC CEREMONY, HAVANA, CENTRAL PARK/Walker Evans/23 Bethune St.*; at u. center, in pencil, by Evans, *23*; at l. left, in pencil, Crane no. *L66.111(Evans)*.
REFERENCES: **"Cuba Libre," Hound &*

Horn, vol. 7, no. 4 (July–Sept. 1934), n.p. (variant); HAVANA, pp. 30–31 (variant).

228
[Wreathlaying, Havana]/[Wreathlaying, Hotel Inglaterra in Background**]/[Wreathlaying at the José Martí Statue, Havana]*, 1933
22.5 x 19.3 cm (5 7/8 x 7 5/8 in.)
84.XM.956.155
MARKS & INSCRIPTIONS: (Verso) at l. right, Evans stamp A; at l. left, in pencil, Crane no. *L66.112(Evans)*.
REFERENCES: **"Cuba Libre," Hound &*

Horn, vol. 7, no. 4 (July–Sept. 1934), n.p. (variant); ***HAVANA*, pp. 30–31 (variant).

229
[Two Cubans in Uniform Standing Beside a Havana Monument], 1933
25.3 x 19.4 cm (9 31/32 x 7 21/32 in.)
84.XM.956.217
MARKS & INSCRIPTIONS: (Verso) at l. right, Evans stamp A; at l. left, in pencil, Crane no. *L66.102(Evans)*.

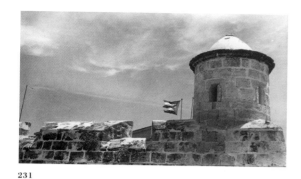

231

232

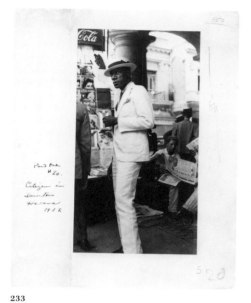

233

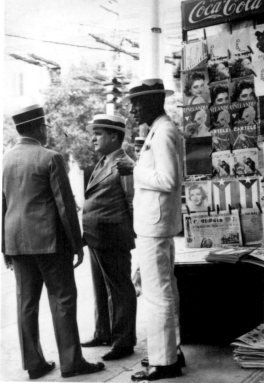

234

MARKS & INSCRIPTIONS: (Recto, mount) at l. left, in black ink, *Part One/#20./ Citizen in/Downtown/Havana/1932*; at u. right, in pencil, *95.0*; at right, in pencil, *8 ¼* [with lengthwise line along side]; at l. right, in pencil, *20*; at l. right, in red pencil, *S*; (verso, mount) at center, in pencil, *I-20*; at l. center, Evans stamp B; at l. right, in pencil, *20*; at l. right, in pencil, *H2416-86/86/NO* [within in a box] *150 h*; (recto, mat) at l. right, in pencil, *97*; at l. left, in pencil, Crane no. *AP48/ L68.61(Evans)*.

REFERENCES: *"Cuba Libre," *Hound & Horn*, vol. 7, no. 4 (July–Sept. 1934), n.p. (variant); AMP, Part I, no. 20 (variant); FAL, p. 32; APERTURE, p. 33 (variant); WEAW, p. 88; HAVANA, p. 85.

234
[Havana Citizen]*, 1933
24.2 x 15.7 cm (9 ½ x 6 ³⁄₁₆ in.) [on original mount trimmed to image]
84.XM.956.264
MARKS & INSCRIPTIONS: (Verso) at center, Evans stamp K; at l. right, Crane stamp; (recto, mat) at l. left, in pencil, Crane no. *L66.58(Evans)*.
REFERENCES: WEAW, p. 88 (variant, left); *HAVANA, p. 14 (variant).

230
Morro Castle, Havana, 1933
14.5 x 22.5 cm (5 ¹¹⁄₁₆ x 8 ⅞ in.) [on original mount trimmed to image]
84.XM.956.214
MARKS & INSCRIPTIONS: (Verso) titled at center, in black ink, by Evans, *MORRO CASTLE, HAVANA*; at l. right, Evans stamp A; at l. left, in pencil, Crane no. *L66.123(Evans)*.

231
"La Fuerza" Havana Fortress, 1933
14.3 x 23.8 cm (5 ⅝ x 9 ⅜ in.) [on original mount trimmed to image]

84.XM.956.171
MARKS & INSCRIPTIONS: (Verso) titled and signed at center, in black ink, by Evans, *"LA FUERZA" HAVANA FORTRESS/ Walker Evans/23 Bethune St.*; at l. left, in pencil, Crane no. *L66.97(Evans)*.

232
Havana Fortress, 1933
17.2 x 22.8 cm (6 ¹³⁄₁₆ x 9 in.) [on original mount trimmed to image]
84.XM.956.276
MARKS & INSCRIPTIONS: (Verso) titled and signed at l. center, in black ink,

by Evans, *HAVANA FORTRESS/ Walker Evans/23 Bethune St.*; (recto, mat) at l. left, in pencil, Crane no. *L66.17(Evans)*; at bottom on white paper taped to mat, in pencil, *LA FUERZA (The Fortress)*.

233
[Havana Citizen]/[Citizen in Downtown Havana]*, 1933
Image: 22.3 x 11.8 cm (8 ¾ x 4 ⅝ in.); original hole-punched mount: 27.9 x 29.6 cm (11 x 8 ½ in.)
84.XM.956.484

235

236

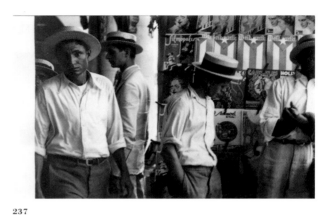

237

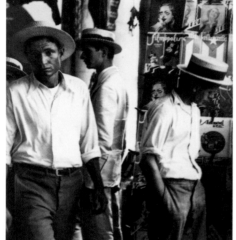

238

239

235
Havana Shopping District, 1933
24.4 x 15.5 cm (9 ⅝ x 6 ³⁄₃₂ in.) [on original mount trimmed to image]
84.XM.956.215
MARKS & INSCRIPTIONS: (Verso) titled and signed at u. center, in black ink, by Evans, *HAVANA SHOPPING DISTRICT/ Walker Evans/23 Bethune St.*; at l. left, in pencil, Crane no. *L66.57(Evans)*.
REFERENCES: WEAW, p. 88.

236
Bootblack Stand, Havana, 1933
22.8 x 13.6 cm (8 ³¹⁄₃₂ x 5 ⅜ in.) [on original mount trimmed to image]
84.XM.956.210
MARKS & INSCRIPTIONS: (Verso) titled at u. center, in black ink, by Evans, *BOOTBLACK STAND, HAVANA*; at u. center, in pencil, by Evans, *24.*; at l. right, Evans stamp A; at l. left, in pencil, Crane no. *L66.56(Evans)*.

237
[*People in Downtown Havana**]/
[*People in Downtown Havana,

*Shoeshine Newsstand***], 1933
Image: 12.7 x 18.4 cm (5 x 7 ¼ in.); sheet: 12.7 x 20.1 cm (5 x 7 ²⁹⁄₃₂ in.)
84.XM.956.192
MARKS & INSCRIPTIONS: (Verso) at l. right, Evans stamp A; at l. left, in pencil, Crane no. *L66.62(Evans)*.
REFERENCES: *"Cuba Libre," *Hound & Horn*, vol. 7, no. 4 (July–Sept. 1934), n.p. (variant); FAL, p. 41 (variant); **HAVANA, pp. 82–83 (variant).

238
[*People in Downtown Havana**]/
[*People in Downtown Havana Shoeshine Newsstand***], 1933

Image: 18 x 13.5 cm (7 ⅛ x 5 ⁵⁄₁₆ in.); original mount: 20.6 x 13.8 cm (8 ⅛ x 5 ⅞ in.)
84.XM.956.226
MARKS & INSCRIPTIONS: (Recto, mount) signed at l. right, in pencil, by Evans, *Walker Evans*; (verso, mount) signed at l. center, in pencil, *Walker Evans*; at l. left, in pencil, Crane no. *L66.61(EVANS)*.
REFERENCES: *"Cuba Libre," *Hound & Horn*, vol. 7, no. 4 (July–Sept. 1934), n.p. (variant); FAL, p. 41 (variant); **HAVANA, pp. 82–83 (variant).

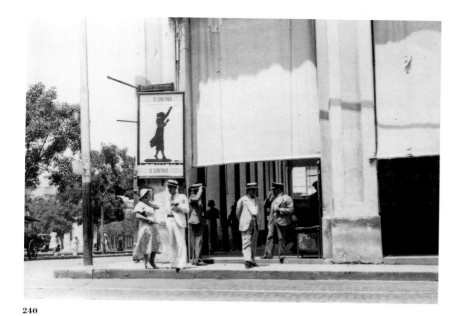

240

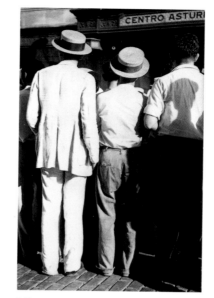

241

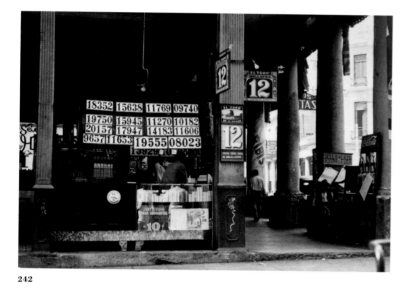

242

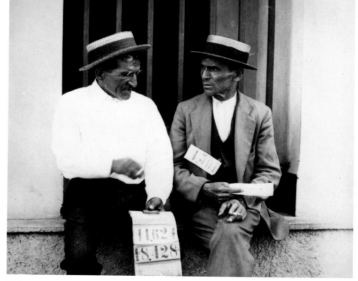

243

239
[*City People**]/[*City People, Trolley Stop***], 1933
17.7 x 22.9 cm (6 ³¹/₃₂ x 9 ¹/₃₂ in.)
84.XM.956.244
MARKS & INSCRIPTIONS: (Verso) signed at center, in black ink, by Evans, *Walker Evans*; at l. left, in pencil, Crane no. *L66.42*.
REFERENCES: *CUBA, pl. 13 (variant); **HAVANA, pp. 56–57 (variant).

240
[*Havana Street Corner, Pedestrians Under Ninth Symphony Poster*], 1933

18.3 x 25.2 cm (7 ⅓ x 9 ¹⁵/₁₆ in.)
84.XM.956.153
MARKS & INSCRIPTIONS: (Verso) at right, Evans stamp A; at l. left, in pencil, Crane no. *L66.96(Evans)*.
REFERENCES: HAVANA, p. 20 (variant).

241
[*Asturian Center**]/[*Three Men on a Havana Street*], 1933
24.8 x 15.2 cm (9 ¾ x 6 in.) [on original mount trimmed to image]
84.XM.956.229
MARKS & INSCRIPTIONS: (Verso) at l. right, Evans stamp B; at l. left, in

pencil, Crane no. *L66.59(EVANS)*.
REFERENCES: *HAVANA, p. 28 (variant).

242
Colonnade Shop, Havana, 1933
17 x 23.7 cm (6 ¹¹/₁₆ x 9 ⁵/₁₆ in.) [on original mount trimmed to image]
84.XM.956.266
MARKS & INSCRIPTIONS: (Verso) titled and signed at center, in black ink, by Evans, *COLONNADE SHOP, HAVANA/ Walker Evans/23 Bethune St.*; at l. right, Evans stamp A; at u. center, in pencil, by Evans, *12*; (recto, mat)

at l. right, in pencil, *80*; at l. left, in pencil, Crane no. *L66.12(Evans)*.

243
[*Lottery Ticket Vendors**], 1933
19.5 x 22.2 cm (7 ¹¹/₁₆ x 8 ¾ in.)
84.XM.956.157
MARKS & INSCRIPTIONS: (Verso) at right, Evans stamp A twice; at l. left, in pencil, Crane no. *L66.72(Evans)*.
REFERENCES: *CUBA, pl. 5 (variant).

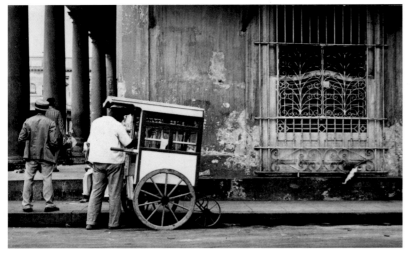

244

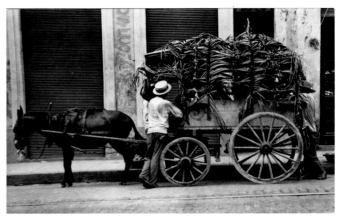

245

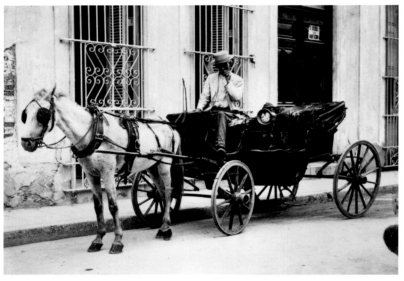

246

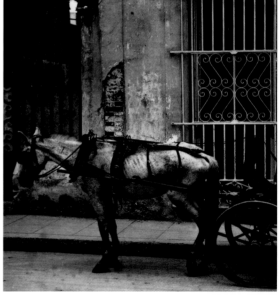

247

244
Havana, 1933
14.6 x 22.6 cm (5 ¾ x 8 ²⁹⁄₃₂ in.) [on
original mount trimmed to image]
84.XM.956.249
MARKS & INSCRIPTIONS: (Verso) titled
and signed at center, in black ink, by
Evans, *HAVANA/WALKER EVANS; signed
at right center, in pencil, by Evans,
Walker Evans*; at l. left, in pencil,
Crane no. *L66.38.*

245
[*Mule, Wagon, and Two Men, Havana*],
1933
13.8 x 21 cm (5 ⁷⁄₁₆ x 8 ⁵⁄₃₂ in.) [on origi-
nal mount trimmed to image]
84.XM.956.247
MARKS & INSCRIPTIONS: (Verso) signed
at center, in pencil, by Evans, *Walker
Evans* [sideways]; at l. left, in pencil,
Crane no. *L66.41.*
REFERENCES: HAVANA, p. 92 (variant).

246
[*Mule, Carriage, and Driver, Havana*],
1933

12.7 x 17.7 cm (5 x 6 ³¹⁄₃₂ in.)
84.XM.956.274
MARKS & INSCRIPTIONS: (Verso) signed
at right center, in pencil, by Evans,
Walker Evans [inverted]; (recto, mat) at
l. left, in pencil, Crane no. *L66.18
(Evans).*

247
[*Mule Harnessed to Carriage, Havana*],
1933
13.7 x 12.2 cm (5 ⅜ x 4 ²⁵⁄₃₂ in.)
84.XM.956.206
MARKS & INSCRIPTIONS: (Verso) titled
and signed at l. center, in black ink,

by Evans [first part cut off]—*MAN,
HAVANA/Walker Evans*; at l. center,
in pencil, Crane no. *L66.19(Evans)*;
at l. right, in pencil, *E 5* [number
circled]; at u. left, in pencil, *14.*

248
[*Horse Carriage, Havana**], 1933
13.4 x 21.3 cm (5 ¼ x 8 ¹³⁄₃₂ in.) [on
original mount trimmed to image]
84.XM.956.240
MARKS & INSCRIPTIONS: (Verso) at
u. right, Evans stamp I; at u. left, in
pencil, *#86/HORSE CARRIAGES, HAVANA/
1932*; at l. left, in pencil, *CUT 21 6″*

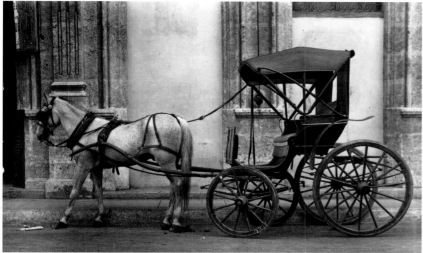

248

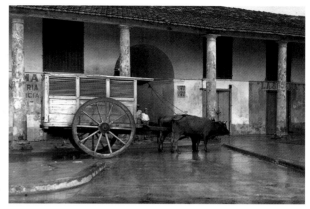

249

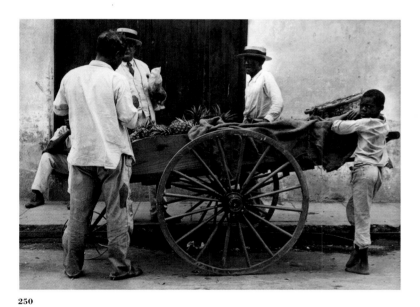

250

[arrow pointing to the right] *WIDE;* in
pencil [diagonal line from
u. left to l. right]; at l. left, in pencil,
Crane no. *L66.40.*
REFERENCES: *CRANE, no. 84.

249
Cuban Village, 1933
16.5 x 23.5 cm (6 ½ x 9 ¼ in.) [on origi-
nal mount trimmed to image]
84.XM.956.272
MARKS & INSCRIPTIONS: (Verso) titled
and signed at center, in black ink, by
Evans, *CUBAN VILLAGE/Walker Evans;*
(recto, mat) at l. left, in pencil, Crane
no. *L66.15(Evans).*

250
Havana Street Vendors, 1933
17.5 x 23.6 cm (6 ²⁹/₃₂ x 9 ⁹/₃₂ in.) [on
original mount trimmed to image]
84.XM.956.230
MARKS & INSCRIPTIONS: (Verso) titled
and signed at center, in black ink, by
Evans, *HAVANA STREET VENDORS/
Walker Evans/23 Bethune St;* at l. left,
in pencil, Crane no. *L66.50(Evans).*
REFERENCES: WEAW, p. 92 (variant,
bottom left image).

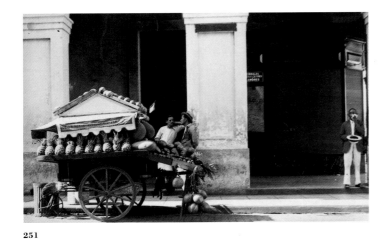

251

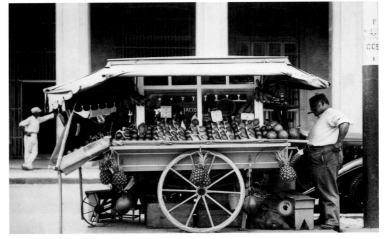

252

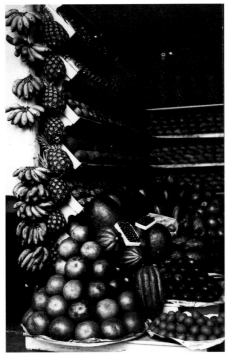

253

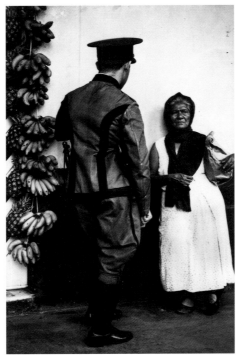

254

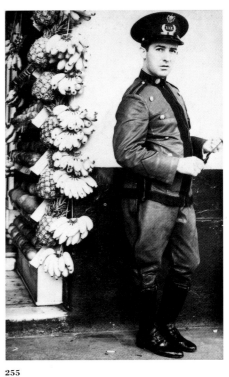

255

251
[Fruit Vendor's Wagon, Havana Street],
1933
14.7 x 23.1 cm (5 ¾ x 9 ¹⁄₁₆ in.) [on orig-
inal mount trimmed to image]
84.XM.956.218
MARKS & INSCRIPTIONS: (Verso) signed at
center, in pencil, by Evans, *Walker
Evans* [sideways]; at l. left, in pencil,
Crane no. *L66.49(EVANS)*.

252
[Havana Fruit Vendor with Cart], 1933
14.6 x 22.6 cm (5 ¾ x 8 ⅞ in.) [on origi-
nal mount trimmed to image]

84.XM.956.248
MARKS & INSCRIPTIONS: (Verso) signed at
center, in pencil, by Evans,
Walker Evans [sideways]; at l. left, in
pencil, Crane no. *L66.39*.

253
Havana Fruitstand, 1933
23.5 x 14.1 cm (9 ¼ x 5 ¹⁷⁄₃₂ in.) [on
original mount trimmed to image]
84.XM.956.232
MARKS & INSCRIPTIONS: (Verso) signed at
center, in pencil, by Evans, *Walker
Evans*; titled at u. center, in black ink,
by Evans, *HAVANA FRUITSTAND*; at u.

center, in pencil, by Evans, *19*. [this
number appears to have been changed
from 17.]; at l. left, in pencil, Crane
no. *L66.52(Evans)*.
REFERENCES: FAL, p. 28 (variant);
WEAW, p. 92 (variant, u. left image).

254
Havana Policeman, 1933
24.4 x 15.3 cm (9 ⅝ x 6 ¹⁄₃₂ in.) [on orig-
inal mount trimmed to image]
84.XM.956.227
MARKS & INSCRIPTIONS: (Verso) titled
and signed at center, in black ink, by
Evans, *HAVANA POLICEMAN/Walker

Evans/23 Bethune St.*; at l. left, in pen-
cil, Crane no. *L66.53(EVANS)*.

255
Havana Police, 1933
23.1 x 13.8 cm (9 ¹⁄₁₆ x 5 ⁷⁄₁₆ in.) [on
original mount trimmed to image]
84.XM.956.228
MARKS & INSCRIPTIONS: (Verso) signed at
center, in pencil, by Evans, *Walker
Evans*; titled at u. center, in black ink,
by Evans, *HAVANA POLICE*; at l. left, in
pencil, Crane no. *L66.55(Evans)*; at
l. right, Crane stamp.

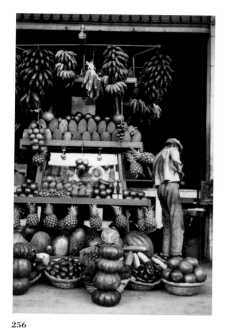

256

257

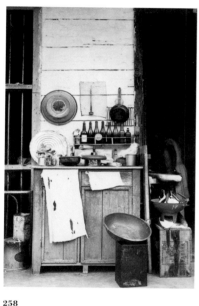

258

259

256
Havana Fruitstand, 1933
22.3 x 14.8 cm (9 3/16 x 5 13/16 in.)
84.XM.956.225
MARKS & INSCRIPTIONS: (Verso) titled
and signed at u. center, in black ink,
by Evans, *HAVANA FRUITSTAND/
Walker Evans/23 Bethune St.*; at u. cen-
ter, in pencil, by Evans, *18.*; at l. left,
in pencil, Crane no. *L66.54(Evans)*.
REFERENCES: WEAW, p. 92 (variant,
u. center image).

257
[Havana Courtyard], 1933
24.3 x 17 cm (9 9/16 x 6 23/32 in.) [on origi-
nal mount trimmed to image]
84.XM.956.268
MARKS & INSCRIPTIONS: (Verso) signed at
l. right, in pencil, by Evans, *Walker
Evans*; at u. center, in pencil, MoMA
no. *38.2300*; (recto, mat) at l. right, in
pencil, *77*; at l. left, in pencil, Crane
no. *L66.9(Evans)*.

258
[Cuban Courtyard Kitchen], 1933
23 x 15 cm (9 1/16 x 5 7/8 in.)

84.XM.956.270
MARKS & INSCRIPTIONS: (Verso) signed at
u. center, in pencil, by Evans, *Walker
Evans* [inverted]; (recto, mat) at
l. right, in pencil, *71*; at l. left, in pen-
cil, Crane no. *L66.13(Evans)*.
REFERENCES: HAVANA, p. 58 (variant).

259
[Patio]/[Patio, Tenement**]*, 1933
19.2 x 14.8 cm (7 9/16 x 5 13/16 in.) [on
original mount trimmed to image]
84.XM.956.165
MARKS & INSCRIPTIONS: (Verso) at

u. right, Evans stamp A; at u. center,
in pencil, MoMA no. *38.2359/Evans*; at
l. left, in pencil, Crane no. *L66.79
(Evans)*.
REFERENCES: *CUBA, pl. 19 (variant);
**HAVANA, p. 38 (variant).

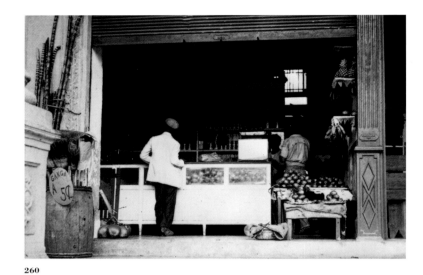

260

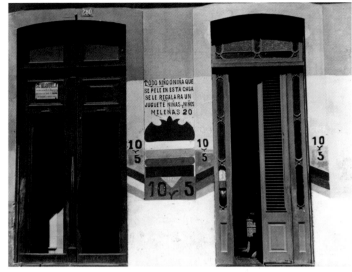

261

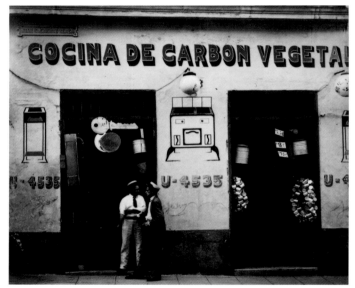

262

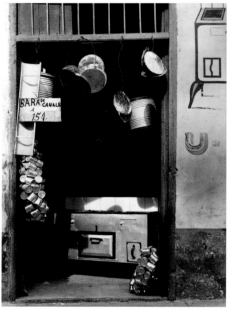

263

260
Havana Shop, 1933
14.3 x 21.4 cm (5 $^{21}/_{32}$ x 8 $^{7}/_{8}$ in.) [on original mount trimmed to image]
84.XM.956.193
MARKS & INSCRIPTIONS: (Verso) titled and signed at center, in black ink, by Evans, *HAVANA SHOP/Walker Evans/23 Bethune St.*; at l. left, in pencil, Crane no. *L66.108(Evans)*.

261
[*Two Cuban Doorways*], 1933
15.3 x 19.1 cm (6 $^{1}/_{16}$ x 7 $^{17}/_{32}$ in.) [on original mount trimmed to image]
84.XM.956.221

MARKS & INSCRIPTIONS: (Verso) signed at u. right, in pencil, by Evans, *Walker Evans* [inverted]; at l. left, in pencil, Crane no. *L66.106(Evans)*.

262
Havana, 1933
Image: 15.4 x 17.9 cm
(6 $^{1}/_{16}$ x 7 $^{1}/_{16}$ in.); original mount:
18.5 x 19.3 cm (7 $^{1}/_{4}$ x 7 $^{5}/_{8}$ in.)
84.XM.956.146
MARKS & INSCRIPTIONS: (Recto, mount) signed at l. right, in pencil, by Evans, *Walker Evans*; (verso, mount) titled and dated at u. center, in pencil, by

Evans, *Havana 1933*; at l. left, in pencil, Crane no. *L66.95 (Evans)*.

263
[*Doorway with Hanging Pots, Kitchenware Shop, Havana*], 1933
23.5 x 16.5 cm (9 $^{1}/_{4}$ x 6 $^{1}/_{2}$ in.)
84.XM.956.148
MARKS & INSCRIPTIONS: (Verso) signed at center, in pencil, by Evans, *Walker Evans* [sideways]; at l. left, in pencil, Crane no. *L66.86(Evans)*.

264
Havana Shopfront, 1933
14.8 x 23.2 cm (5 $^{27}/_{32}$ x 9 $^{5}/_{32}$ in.) [on original mount trimmed to image]
84.XM.956.189
MARKS & INSCRIPTIONS: (Verso) titled and signed at center, in black ink, by Evans, *HAVANA SHOPFRONT/ Walker Evans/23 Bethune St.*; at l. left, in pencil, Crane no. *L66.110(Evans)*.

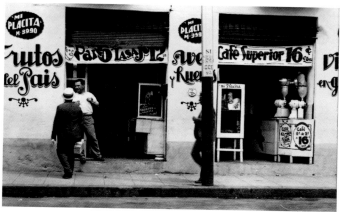

264

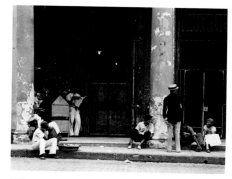

265

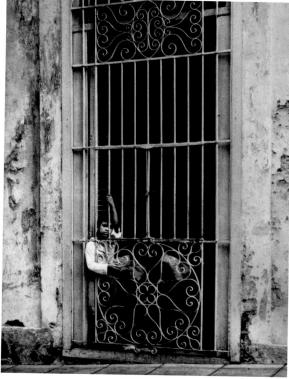

266

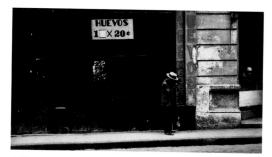

267

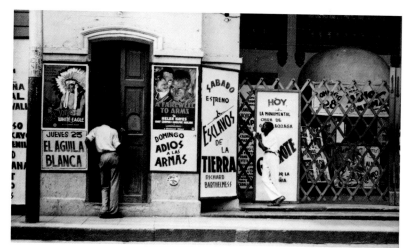

268

265
Havana Street, 1933
11.4 x 14.1 cm (4 ½ x 5 ¹⁷/₃₂ in.)
84.XM.956.245
MARKS & INSCRIPTIONS: (Verso) titled
and signed at center, in black ink,
by Evans, *HAVANA STREET/Walker
Evans/23 Bethune St.*; at l. left, in
pencil, Crane no. *L66.45.*

266
[*Cuban Children*], 1933
22.5 x 16.5 cm (8 ⅞ x 6 ½ in.) [on origi-
nal mount trimmed to image]
84.XM.956.144

MARKS & INSCRIPTIONS: (Verso) signed
at center, in pencil by Evans, *Walker
Evans*; at l. left, in pencil, Crane
no. *L66.94(Evans).*

267
Havana, 1933
10.7 x 18.1 cm (4 ⁷/₃₂ x 7 ⅛ in.) [on orig-
inal mount trimmed to image]
84.XM.956.205
MARKS & INSCRIPTIONS:(Verso) titled and
signed at center, in black ink, by
Evans, *HAVANA/Walker Evans*; at l. left,
in pencil, Crane no. *L66.124(Evans).*

268
Havana Cinema, 1933
14.7 x 23.4 cm (5 ¹³/₁₆ x 9 ¼ in.) [on
original mount trimmed to image]
84.XM.956.142
MARKS & INSCRIPTIONS: (Verso) signed at
center, in pencil, by Evans, *Walker
Evans*; titled at l. center, in black ink,
by Evans, *HAVANA CINEMA*; at l. left, in
pencil, Crane no. *L66.109(Evans).*

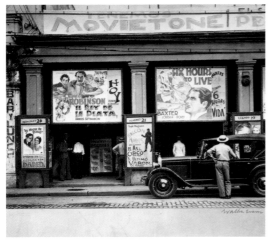

269

270

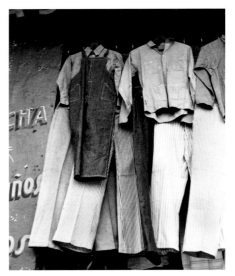

271

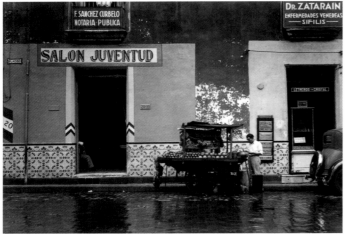

272

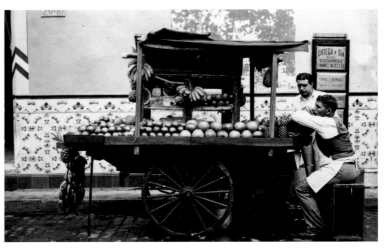

273

269
[*Cinema**], 1933
Image: 14.4 x 17.4 cm
(5 ¹¹⁄₁₆ x 6 ⅞ in.); original mount:
16.5 x 17.6 cm (6 ½ x 7 ¹⁵⁄₁₆ in.)
84.XM.956.158
MARKS & INSCRIPTIONS: (Recto, mount)
signed at l. right, in pencil, by Evans,
Walker Evans; (verso, mount) at u. left,
Evans stamp A; at l. left, Crane stamp
and in pencil, Crane no. *L66.75*
(*Evans*).
REFERENCES: **CUBA*, pl. 8 (variant);
HAVANA, p. 33 (variant).

270
Shopfront Detail, Havana Suburb, 1933
22.6 x 14.8 cm (8 ⅞ x 5 ¹³⁄₁₆ in.) [on
original mount trimmed to image]
84.XM.956.267
MARKS & INSCRIPTIONS: (Verso) titled at
u. center, in black ink, by Evans,
SHOPFRONT DETAIL, HAVANA SUBURB;
signed at l. center, in pencil, by
Evans, *Walker Evans*; at u. center, in
pencil, by Evans, *22*; (recto, mat) at
l. right, in pencil, *78*; at l. left, in
pencil, Crane no. *L66.10*(*Evans*).
REFERENCES: WEAW, p. 85 (variant,
u. right image).

271
[*Shopfront Detail, Havana Suburb*],
1933
18.3 x 14.6 cm (7 ³⁄₁₆ x 5 ¾ in.)
84.XM.956.174
MARKS & INSCRIPTIONS: (Verso) signed at
center, in pencil, by Evans,
Walker Evans [inverted]; at l. left, in
pencil, Crane no. *L66.11*(*Evans*).
REFERENCES: WEAW, p. 85 (variant,
u. right image).

272
Havana Shopfronts, 1933
17.1 x 24 cm (6 ¾ x 9 ¹⁵⁄₃₂ in.) [on origi-
nal mount trimmed to image]

84.XM.956.259
MARKS & INSCRIPTIONS: (Verso) titled
and signed at center, in black ink, by
Evans, *HAVANA SHOPFRONTS/
Walker Evans/23 Bethune St.*; at u. cen-
ter, in pencil, by Evans, *10.*; (recto,
mat) at l. right, in pencil, *79*; at l. left,
in pencil, Crane no. *L66.1*(*Evans*).
REFERENCES: HAVANA, p. 23 (variant).

273
Fruitcart, Havana, 1933
15 x 22.8 cm (5 ²⁹⁄₃₂ x 9 in.) [on original
mount trimmed to image]
84.XM.956.211

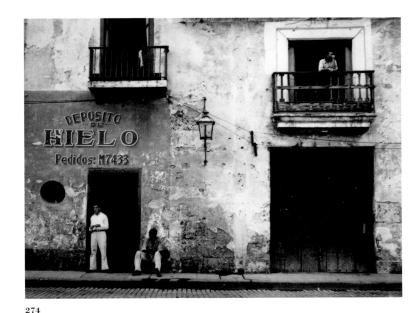

274

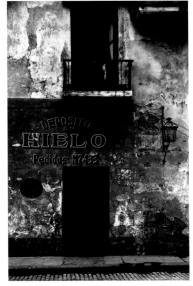

275

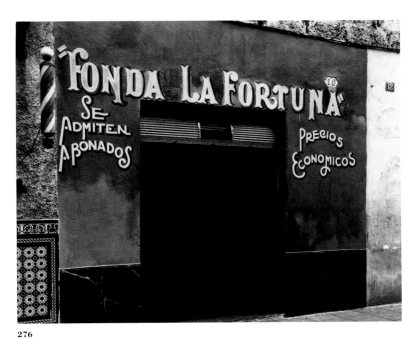

276

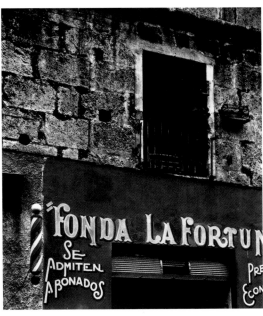

277

MARKS & INSCRIPTIONS: (Verso) titled and signed at right center, in black ink, by Evans, *FRUITCART, HAVANA/ Walker Evans/23 Bethune St*; at u. center, in pencil, by Evans, *11.* at l. left, in pencil, Crane no. *L66.51(Evans)*.
REFERENCES: WEAW, p. 92, (variant, center left image).

274
Old Havana Housefronts, 1933
17.7 x 22.7 cm (6 ¹⁵/₁₆ x 8 ¹⁵/₁₆ in.)
84.XM.956.258
MARKS & INSCRIPTIONS: (Verso) titled

and signed at center, in black ink, by Evans, *OLD HAVANA HOUSE-FRONTS/Walker Evans/23 Bethune St.*; at right center, Evans stamp K; at u. center, in pencil, by Evans, *9.*; at l. left, in pencil, Crane no. *L66.37*.

275
Housefront, Havana, 1933
19.8 x 12.5 cm (7 ¹³/₁₆ x 4 ²⁹/₃₂ in.) [on original mount trimmed to image]
84.XM.956.250
MARKS & INSCRIPTIONS: (Verso) titled and signed at u. center, in black ink, by Evans, *2. HOUSEFRONT,*

HAVANA/Walker Evans/23 Bethune St.; at right, in pencil, MoMA no. *38.2395*; at left, in pencil, *3*; at l. left, in pencil, Crane no. *L66.36*.

276
Small Restaurant, Havana, 1933
15.3 x 18.6 cm (6 ¹/₃₂ x 7 ¹¹/₃₂ in.)
84.XM.956.261
MARKS & INSCRIPTIONS: (Verso) titled and signed at center, in black ink, by Evans, *SMALL RESTAURANT, HAVANA/ Walker Evans*; at u. center, in pencil, by Evans, *8.*; (recto, mat) at l. right, in

pencil, *81*; at l. left, Crane no. *L66.5 (Evans)*.
REFERENCES: WEAW, p. 84 (variant, l. left image); HAVANA, p. 21 (variant).

277
[*Small Restaurant, Havana*], 1933
18.3 x 15.2 cm (7 ¹/₃ x 5 ¹⁵/₁₆ in.)
84.XM.956.172
MARKS & INSCRIPTIONS: (Verso) at center, Evans stamp B; at l. left, in pencil, Crane no. *L66.7(Evans)*.

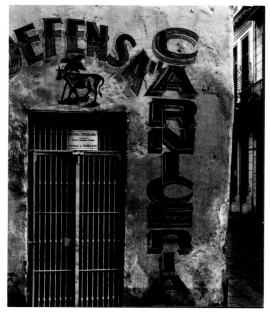

278

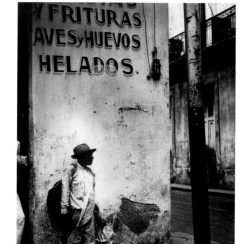

280

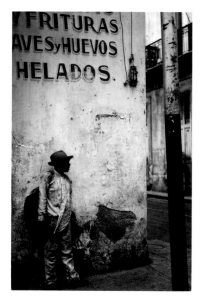

281

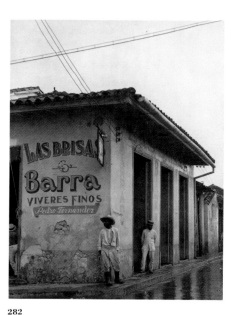

282

278
[*Small Restaurant, Havana*], 1933
Image/Sheet: 18.4 x 12.1 cm;
(7 ¼ x 4 ²⁵/₃₂ in.); original mount:
23.9 x 17.2 cm (9 ⁷/₁₆ x 6 ²⁵/₃₂ in.)
84.XM.956.209
MARKS & INSCRIPTIONS: (Mount, recto)
signed at l. right, in pencil, by Evans,
Walker Evans; (mount, verso) at l. left,
in pencil, Crane no. *L66.6(Evans)*.

279
[*Butcher Shop**], 1933
19.1 x 15.4 cm (7 ½ x 6 ¹/₁₆ in.)
84.XM.956.141
MARKS & INSCRIPTIONS: (Verso) at center,
Evans stamp K; at u. center, in pencil,
by Arnold Crane, *withdrawn/ AH
Crane* [inverted]; at l. left, in pencil,
Crane no. *L66.84(Evans)*.
REFERENCES: *CUBA, pl. 14 (different
neg.).

280
[*Havana Corner*], 1933
20 x 15.2 cm (7 ⅞ x 5 ³¹/₃₂ in.)
84.XM.956.262

MARKS & INSCRIPTIONS: (Verso) signed
at l. right, in pencil, by Evans, *Walker
Evans*; (recto, mat) at l. right, in pen-
cil, *82*; at l. left, in pencil, Crane
no. *L66.3(Evans)*.

281
Havana Corner, 1933
19.6 x 12.3 cm (7 ¾ x 4 ⅞ in.) [on origi-
nal mount trimmed to image]
84.XM.956.168
MARKS & INSCRIPTIONS: (Verso) titled
and signed at center, in black ink, by
Evans, *HAVANA CORNER/Walker Evans*;
at l. left, in pencil, Crane no. *L66.4
(Evans)*.

282
Cuban Country Town, 1933
23.7 x 17.3 cm (9 ¹¹/₃₂ x 6 ¹³/₁₆ in.) [on
original mount trimmed to image]
84.XM.956.181
MARKS & INSCRIPTIONS: (Verso) titled
and signed at center, in black ink, by
Evans, *CUBAN COUNTRY TOWN/
Walker Evans/23 Bethune St.*; at u. cen-
ter, in pencil, by Evans, *42*; at l. left,
in pencil, Crane no. *L66.101(Evans)*.

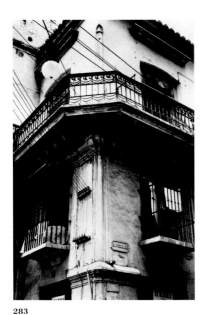

283

284

285

286

283
[*Corner of Havana Building with Decorative Iron Grillwork*], 1933
24 x 14.9 cm (9 7/16 x 5 7/8 in.)
84.XM.956.275
MARKS & INSCRIPTIONS: (Verso) signed at u. right, in pencil, by Evans, *Walker Evans* [inverted]; (recto, mat) at l. left, in pencil, Crane no. *L66.16(Evans)*.

284
Cuban Small Town Doorway, 1933
12.6 x 12.7 cm (5 x 5 in.) [on original mount trimmed to image]
84.XM.956.208
MARKS & INSCRIPTIONS: (Verso) titled and signed at top, in black ink, by Evans, *CUBAN SMALL TOWN DOORWAY/ WALKER EVANS*; at u. right, in pencil, by Evans, *1932*; at l. right, in pencil, *W 5* [number circled] at l. left, in pencil, Crane no. *L66.85(Evans)*.

285
[*Facades of Two Buildings with Balconies, Havana*], 1933
Image: 10.8 x 18.2 cm (4 1/4 x 7 5/32 in.); original mount: 13.4 x 19.1 cm (5 5/16 x 7 17/32 in.)
84.XM.956.235
MARKS & INSCRIPTIONS: (Recto, mount) signed at l. right, in pencil, by Evans, *Walker Evans*; (verso, mount) at l. right, in pencil, MoMA no. *38.2321/ Evans*; at l. left, in pencil, Crane no. *L66.22(Evans)*.

286
[*Interior of Plaza del Vapor**], 1933
Image/Sheet: 17.2 x 24.7 cm (4 17/32 x 7 5/16 in.); original mount: 17.2 x 24.7 cm (6 3/4 x 9 11/16 in.)
84.XM.956.184
MARKS & INSCRIPTIONS: (Recto, mount) signed at l. right, in pencil, by Evans, *Walker Evans*; (verso, mount) at l. left, in pencil, Crane no. *L66.20(Evans)*.
REFERENCES: *HAVANA, p. 39 (variant).

287

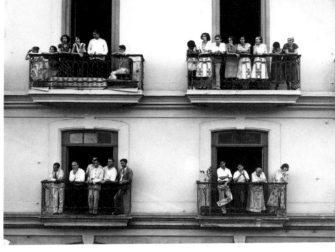

288

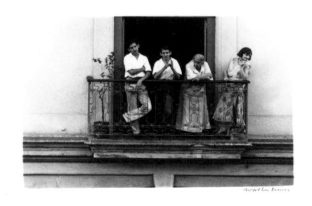

289

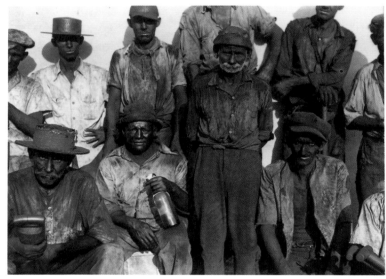

290

287
[*Building Facade, Havana*], 1933
12.1 x 17.1 cm (4 ¹³⁄₁₆ x 6 ¾ in.) [on
original mount trimmed to image]
84.XM.956.236
MARKS & INSCRIPTIONS: (Mount, verso)
signed at right center, in pencil, by
Evans, *Walker Evans*; at l. left, in pen-
cil, Crane no. *L66.21*(*Evans*).

288
[*Balcony Spectators**], 1933
20.2 x 25.2 cm (7 ¹⁵⁄₁₆ x 9 ¹⁵⁄₁₆ in.)
84.XM.956.159
MARKS & INSCRIPTIONS: (Recto) at l. left,

in pencil, *6-5*; (verso) at right, Evans
stamp A; at l. left, in pencil, Crane
no. *L66.87*(*Evans*).
REFERENCES: *HAVANA, p. 29 (variant).

289
[*Balcony Spectators, Detail*], 1933
Image: 10.1 x 14.3 cm (4 x 6 ¹⁄₁₆ in.);
sheet: 13 x 20.2 cm (5 ⅛ x 7 ¹⁵⁄₁₆ in.)
84.XM.956.160
MARKS & INSCRIPTIONS: (Recto) signed at
l. right, in pencil, by Evans, *Walker
Evans*; (verso) signed at center, in pen-
cil, by Evans, *Walker Evans*; at l. left,

in pencil, Crane no. *L66.88*(*Evans*).
REFERENCES: HAVANA, p. 29 (variant).

290
[*Coal Dockworkers, Havana*], 1933
Image: 15.6 x 21 cm (6 ⅛ x 8 ⁵⁄₁₆ in.);
original mount: 20.2 x 22.4 cm
(7 ¹⁵⁄₁₆ x 8 ¹³⁄₁₆ in.)
84.XM.956.167
MARKS & INSCRIPTIONS: (Recto, mount)
signed at l. right, in pencil, by Evans,
Walker Evans; (verso mount) at l. left,
in pencil, Crane no. *L66.33*(*Evans*).
REFERENCES: WEAW, p. 80 (variant,
middle left image).

291
[*Coal Dockworkers, Havana*], 1933
12.7 x 17.7 cm (5 x 6 ³¹⁄₃₂ in.)
84.XM.956.257
MARKS & INSCRIPTIONS: (Verso) signed at
center, in pencil, by Evans, *Walker
Evans* [sideways]; at l. left, in pencil,
Crane no. *L66.28*.
REFERENCES: WEAW, p. 80 (variant,
middle left image).

292
Coal Loader, Havana, 1933
17.1 x 12.2 cm (6 ¾ x 4 ¹³⁄₁₆ in.)
84.XM.956.474

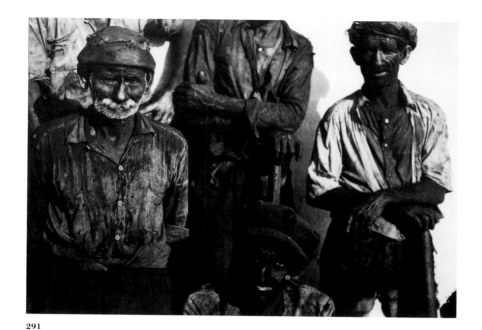
291

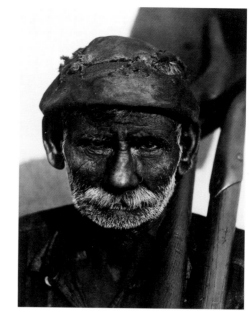
292

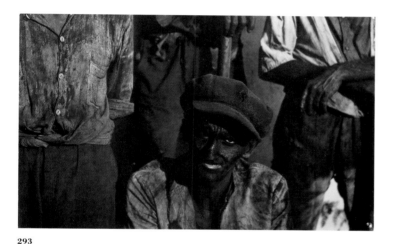
293

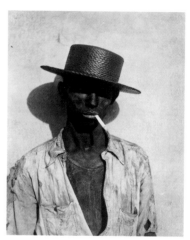
294

295

MARKS & INSCRIPTIONS: (Verso) titled and dated at u. center, in pencil, by Evans, *COAL LOADER, HAVANA/1932*; at u. center and l. center, Evans stamp B; at left edge, Crane stamp; at center, in pencil, *I-33*; at l. left, in pencil, Crane no. *L68.22*.
REFERENCES: AMP, Part I, no. 33; FOUR-TEEN, p. 5 (variant); WEAW, p. 80 (variant, l. right image); HAVANA, p. 77 (variant).

293
[*Coal Dockworker, Havana*], 1933
8.7 x 13.7 cm (3 ¹³⁄₁₆ x 5 ⅜ in.)

[on postcard stock]
84.XM.956.256
MARKS & INSCRIPTIONS: (Verso) signed at center, in pencil, by Evans, *Walker Evans*; at l. right, typed on imprinted MoMA label, *38.2288/Evans* at l. left, in pencil, Crane no. *L66.27*.
REFERENCES: MoMA, p. 55 (variant); WEAW, pp. 80–81 (variant).

294
Havana Stevedore, 1933
23.7 x 15.3 cm (9 ⅜ x 6 ¹⁄₁₆ in.) [on original mount trimmed to image]
84.XM.956.263

MARKS & INSCRIPTIONS: (Verso) signed at center, in pencil, by Evans, *Walker Evans*; titled at u. center, in black ink, by Evans, *HAVANA STEVEDORE*; (recto, mat) at l. left, in pencil, Crane no. *L66.32(Evans)*.

295
Coal Stevedore, Havana/[Dockworker, Havana], 1933
20.1 x 15.3 cm (7 ¹⁵⁄₁₆ x 6 in.)
84.XM.956.242
MARKS & INSCRIPTIONS: (Verso) titled and signed at center, in black ink, by Evans, *COAL STEVEDORE, HAVANA/*

Walker Evans; signed at center, in pencil, by Evans, *Walker Evans*; at u. center, in pencil, by Evans, *36.*; at l. right, in pencil, *E 8* [number 8 is circled]; at l. left, in pencil, Crane no. *L66.138* and Crane stamp.
REFERENCES: FAL, p. 83; *APERTURE, p. 35 (dated 1932); WEAW, p. 83 (variant); HAVANA, p. 79 (variant).

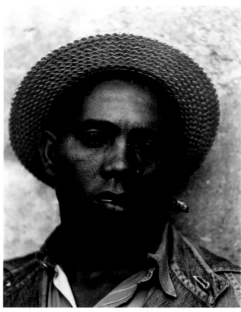

296

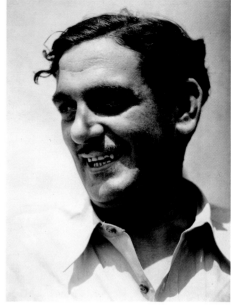

297

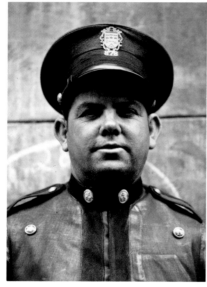

298

299

296
[*Stevedore**], 1933
20.1 x 15.1 cm (7 ²⁹⁄₃₂ x 5 ¹⁵⁄₁₆ in.)
84.XM.956.243
MARKS & INSCRIPTIONS: (Verso) signed
and dated at l. center, in pencil, by
Evans, *Walker Evans/1932*; at l. right,
in pencil, *E 3* [3 crossed out] and *E 2*
[2 circled]; at l. left, in pencil, Crane
no. *L66.139* and Crane stamp.
REFERENCES: *CUBA, pl. 25 (variant);
FAL, p. 26 (variant); HAVANA, p. 78.

297
[*Male Portrait, Cuba*], 1933
17.7 x 12.7 cm (7 x 5 in.)
84.XM.956.254
MARKS & INSCRIPTIONS: (Verso) at
l. right, Evans stamp A; at l. left,
Crane no. *L66.30.*

298
[*Havana Policeman**], 1933
19.5 x 13.2 cm (7 ¹¹⁄₁₆ x 5 ⁷⁄₃₂ in.) [on
original mount trimmed to image]
84.XM.956.465
MARKS & INSCRIPTIONS: (Verso) at l. cen-
ter, Evans stamp F; at center, Evans

stamp B; at u. center, in pencil, *I-30*;
at l. left, in pencil, Crane no. *L68.19*
(*Evans*).
REFERENCES: *AMP, Part I, no. 30;
HAVANA, p. 32 (variant).

299
Cuban Farmer, 1933
13.7 x 20 cm (5 ³⁄₈ x 7 ⁷⁄₈ in.) [on origi-
nal mount trimmed to image]
84.XM.956.255
MARKS & INSCRIPTIONS: (Verso) titled
and signed at center, in black ink,
by Evans, *CUBAN FARMER/Walker
Evans*; at right center, Evans stamp A;
at l. left, in pencil, Crane no. *L66.29.*

300
Cuban Sugarcane Worker, 1933
12 x 19.8 cm (4 ³⁄₄ x 7 ²⁵⁄₃₂ in.) [on origi-
nal mount trimmed to image]
84.XM.956.203
MARKS & INSCRIPTIONS: (Verso) titled
and signed at center, in black ink,
by Evans, *CUBAN SUGARCANE WORKER/
Walker Evans*; at l. left, in pencil,
Crane no. *L66.89*(*Evans*).

301
[*Man in Cuban Shoe Repair Shop*],
1933
14.9 x 24.8 cm (5 ⁷⁄₈ x 9 ³⁄₄ in.)

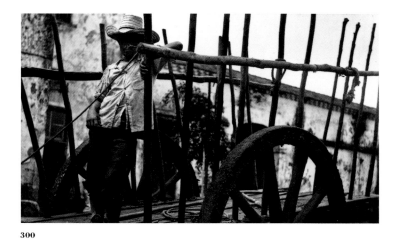

300

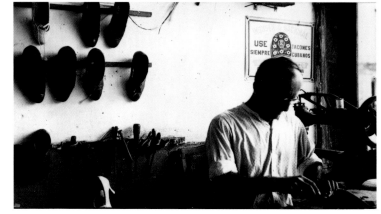

301

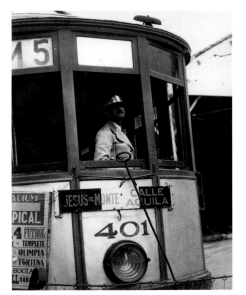

302

303

305

84.XM.956.220
MARKS & INSCRIPTIONS: (Verso) signed at
right center, in pencil, by Evans,
Walker Evans; at l. left, in pencil,
Crane no. *L66.118(Evans)*.

302
[*Streetcar, Havana*], 1933
24.8 x 19.2 cm (9 ¾ x 7 ¹⁷⁄₃₂ in.)
84.XM.956.271
MARKS & INSCRIPTIONS: (Verso) at
l. right, Evans stamp A; (recto, mat)
at l. right, in pencil, *85*; at l. left, in
pencil, Crane no. *L66.14(Evans)*.

303
[*Havana Barbershop*], 1933
20.1 x 18.7 cm (7 ¹⁵⁄₁₆ x 7 ¹¹⁄₃₂ in.)
84.XM.956.323
MARKS & INSCRIPTIONS: (Verso) signed
at center, in pencil, by Evans, *Walker
Evans*; at l. right, Evans stamp A; at
l. left, in pencil, Crane no. *L67.95*.

304
[*Havana Barbershop*], 1933
19.6 x 18 cm (7 ¾ x 7 ⅛ in.) [on origi-
nal mount trimmed to image]
84.XM.956.340
MARKS & INSCRIPTIONS: (Verso) at

l. right, Evans stamp A; at l. right, in
pencil, *95A*; at l. left, in pencil, Crane
no. *L67.83(Evans)*.
NOTE: Not illustrated; variant of
no. 303.

305
[*Woman on the Street, Havana*], 1933
24.6 x 14.7 cm (9 ¹¹⁄₁₆ x 5 ¾ in.) [on
original mount trimmed to image]
84.XM.956.145
MARKS & INSCRIPTIONS: (Verso) at center,
Evans stamp B; at l. left, in pencil,
Crane no. *L66.47(Evans)*.

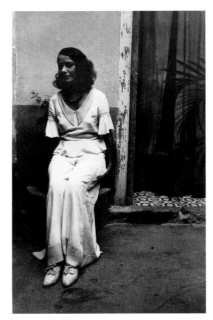

306

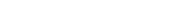

307

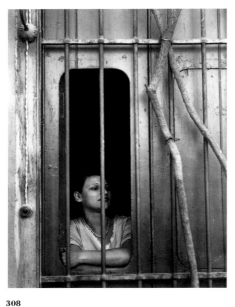

308

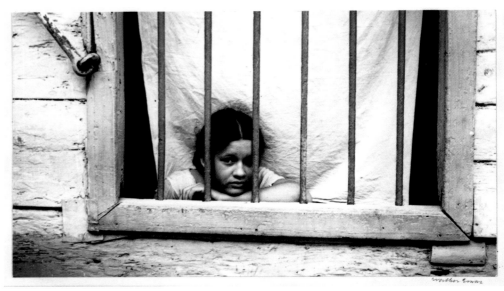

309

306
[*Woman in a Courtyard**], 1933
25.3 x 16.2 cm (9 ³¹⁄₃₂ x 6 ³⁄₈ in.)
84.XM.956.196
MARKS & INSCRIPTIONS: (Verso) at
l. right, Evans stamp A; at l. left, in
pencil, Crane no. *L66.48(Evans)*.
REFERENCES: **HAVANA, p. 44 (variant).

307
[*Seated Well-Dressed Young Woman*],
1933
24.7 x 15.1 cm (9 ²³⁄₃₂ x 5 ¹⁵⁄₁₆ in.)
84.XM.956.195

MARKS & INSCRIPTIONS: (Verso) at
l. right, Evans stamp A; at l. left, in
pencil, Crane no. *L66.46(Evans)*.

308
Courtyard in Havana/[*Girl in Window,
Havana**], 1933
19.7 x 14.8 cm (7 ³⁄₄ x 5 ¹³⁄₁₆ in.)
84.XM.956.265
MARKS & INSCRIPTIONS: (Verso) signed
at center, in pencil, by Evans, *Walker
Evans*; titled and dated at top, in
pencil, by Evans, *COURTYARD IN
HAVANA/1932*; (recto, mat) at l. left, in
pencil, *93* and Crane no. *L66.69
(Evans)*.

REFERENCES: CUBA, pl. 2 (variant);
LUNN, p. 5 (variant); FAL, p. 37 (vari-
ant); *APERTURE (variant, dated 1932);
HAVANA, p. 40 (variant).

309
[*Cuban Girl Looking Through Window
Bars*], 1933
Image: 13.7 x 23.9 cm
(5 ³⁄₈ x 9 ¹³⁄₁₆ in.); original mount:
14.7 x 25.3 cm (5 ¹³⁄₁₆ x 9 ¹⁵⁄₁₆ in.)
84.XM.956.175
MARKS & INSCRIPTIONS: (Recto, mount)
signed at l. right, in pencil, by Evans,
Walker Evans; (verso, mount) signed

at center, in pencil, by Evans, *Walker
Evans*; at l. left, in pencil, Crane
no. *L66.23(Evans)*.

310
Breadline, Havana, 1933
18 x 22.6 cm (7 ¹⁄₁₆ x 8 ¹⁵⁄₁₆ in.)
84.XM.956.163
MARKS & INSCRIPTIONS: (Verso) at right
center, Evans stamp A; titled and
signed at center, in black ink, by
Evans, *BREADLINE, HAVANA/
Walker Evans/23 Bethune St.*; at l. left,
in pencil, Crane no. *L66.67(Evans)*.

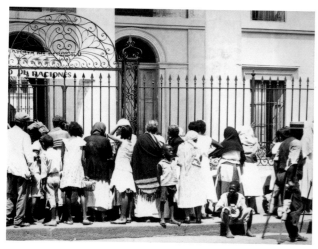

310

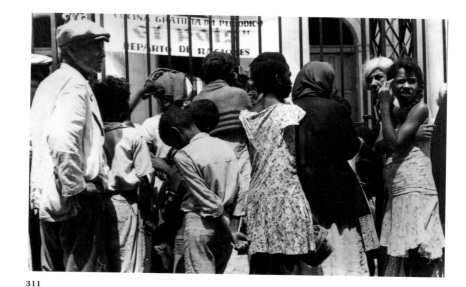

311

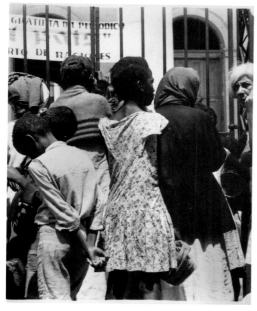

312

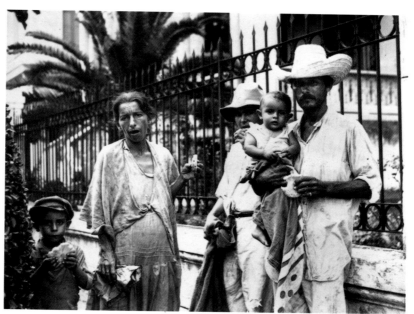

313

311
[Breadline, Havana], 1933
15 x 23.1 cm (5 15/16 x 9 3/32 in.)
84.XM.956.237
MARKS & INSCRIPTIONS: (Verso) at
l. right, Evans stamp A; at l. left,
in pencil, Crane no. L66.65(Evans).
REFERENCES: CUBA, pl. 18 (variant);
HAVANA, p. 15 (variant, top image).

312
[Breadline, Havana], 1933
Image: 19.7 x 15.9 cm (7 3/4 x 6 9/32 in.);
sheet: 20.2 x 15.9 cm (7 31/32 x 6 9/32 in.)
84.XM.956.223

MARKS & INSCRIPTIONS: (Verso) signed at
center, in pencil, by Evans, Walker
Evans; at l. left, in pencil, Crane
no. L66.66(Evans).
REFERENCES: CUBA, pl. 18 (variant);
HAVANA, p. 15 (variant, top image).

313
[Havana: Country Family*], 1933
17.8 x 22.5 cm (7 x 8 7/8 in.) [on original
mount trimmed to image]
84.XM.956.239
MARKS & INSCRIPTIONS: (Verso) signed
at right center, in pencil, by Evans,
Walker Evans; at l. right, in pencil,

MoMA no. 38.2426/Evans; at l. right,
Crane stamp twice; at l. left, in pencil,
Crane no. L66.63(EVANS).
REFERENCES: *CUBA, pl. 16 (variant);
HAVANA, pp. 90–91 (variant).

314

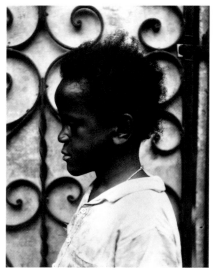

315

316

317

314
[*Negro Child, Havana*], 1933
Image: 19.8 x 13.2 cm
(7 ¹³⁄₁₆ x 5 ³⁄₁₆ in.); original mount:
23.6 x 15.3 cm (9 ⁵⁄₁₆ x 6 ¹⁄₃₂ in.)
84.XM.956.269
MARKS & INSCRIPTIONS: (Recto, mount)
signed at l. right, in pencil, by Evans,
Walker Evans; (recto, mat) at l. left, in
pencil, Crane no. *L66.24(Evans)*.

315
Negro Child, Havana, 1933
19.5 x 14.7 cm (7 ¹¹⁄₁₆ x 5 ¹³⁄₁₆ in.) [on
original mount trimmed to image]

84.XM.956.147
MARKS & INSCRIPTIONS: (Verso) titled at
center, in black ink, by Evans, *NEGRO
CHILD, HAVANA*; at u. center, in pencil,
by Evans, *30* [appears to have been
written over the partially erased "24"];
at l. center, Evans stamp K; at l. right,
88 [circled]; at l. left, in pencil, Crane
no. *L66.25(Evans)*.

316
[*Two Women Sleeping on a Havana
Park Bench*], 1933
13.8 x 19.4 cm (5 ⁷⁄₁₆ x 7 ¹¹⁄₁₆ in.)

84.XM.956.161
MARKS & INSCRIPTIONS: (Verso) signed at
center, in pencil, by Evans, *Walker
Evans*; at l. left, in pencil, Crane
no. *L66.100(Evans)*.
REFERENCES: WEAW, p. 91 (variant,
u. right image).

317
[*Family**]/[*Woman and Children,
Havana***], 1933
7.5 x 14.5 cm (2 ¹⁵⁄₁₆ x 5 ¾ in.); original
mount [Royal Crest board]:
16.8 x 20.3 cm (6 ⅝ x 8 in.)
84.XM.956.260
MARKS & INSCRIPTIONS: (Recto, mount)

signed at right, in pencil, by Evans,
Walker Evans; at l. right, Evans stamp
A; (verso, mount) at center, in pencil,
by Arnold Crane, *Abandoned family,
Havana/1932/AHC*; (recto, mat) at
l. right, in pencil, *107*; at l. left, in
pencil, Crane no. *L66.77(Evans)*.
REFERENCES: *CUBA, pl. 11 (variant);
**MoMA, p. 51 (variant); HAVANA,
p. 89.

318

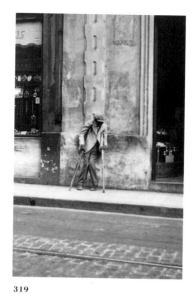

319

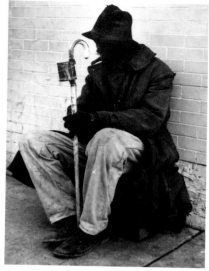

320

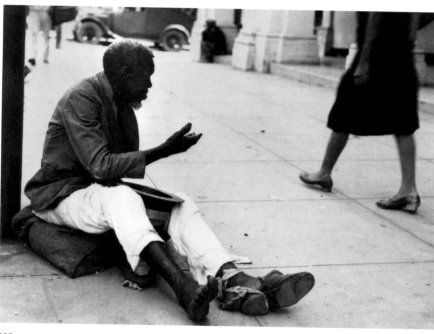

322

318
Havana Peddler, 1933
24.5 x 14.1 cm (9 ¹¹⁄₁₆ x 5 ⁹⁄₁₆ in.) [on original mount trimmed to image]
84.XM.956.183
MARKS & INSCRIPTIONS: (Verso) at u. center, in pencil, by Evans, *29.*; titled at u. center, in ink, by Evans, *HAVANA PEDDLER*; at center, Evans stamp K; at l. left, in pencil, Crane no. *L66.104 (Evans)*.

319
[*Man on Crutches, Cuba*], 1933
20.4 x 12.7 cm (8 ¹⁄₁₆ x 5 in.) [on original mount trimmed to image]

84.XM.956.143
MARKS & INSCRIPTIONS: (Verso) signed at l. center, in pencil, by Evans, *Walker Evans*; at l. left, in pencil, Crane no. *L66.107(Evans)*.

320
[*Seated Beggar with Cup Attached to Walking Cane*], 1933
22.1 x 16 cm (8 ¹¹⁄₁₆ x 6 ⁵⁄₁₆ in.)
84.XM.956.179
MARKS & INSCRIPTIONS: (Verso) at l. right, Evans stamp A; at l. left, in pencil, Crane no. *L66.126(Evans)*; at l. center, in pencil, [arrow pointing to right] *Evans*.

321
[*Seated Beggar with Cup Attached to Walking Cane*], 1933
22.8 x 16.9 cm (8 ³¹⁄₃₂ x 6 ²¹⁄₃₂ in.)
84.XM.956.180
MARKS & INSCRIPTIONS: (Verso) at u. right, Evans stamp C; at l. left, in pencil, Crane no. *L66.127(Evans)*; at l. right, in pencil, [arrow pointing to right] *Evans*.
NOTE: Not illustrated; duplicate of no. 320.

322
[*Beggar**], 1933
18.3 x 23.9 cm (7 ³⁄₁₆ x 9 ¹³⁄₃₂ in.) [on original mount trimmed to image]
84.XM.956.273
MARKS & INSCRIPTIONS: (Verso) at right center, Evans stamp B; at u. left, in pencil, MoMA no. *38.2419/Evans*; at l. left, in pencil, *3*; (recto, mat) at l. right, in pencil, *98*; at l. left, in pencil, Crane no. *L66.76(Evans)*.
REFERENCES: *CUBA, pl. 9 (variant); HAVANA, pp. 68–69 (variant).

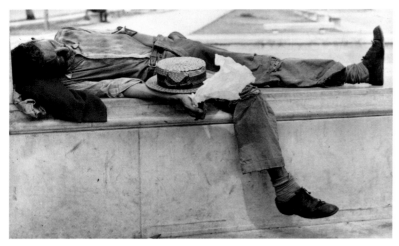

323

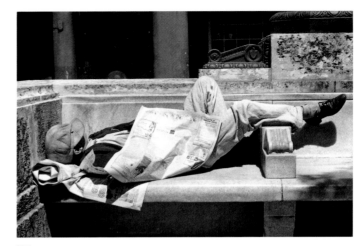

324

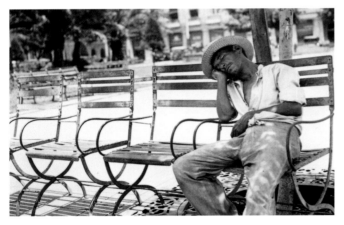

325

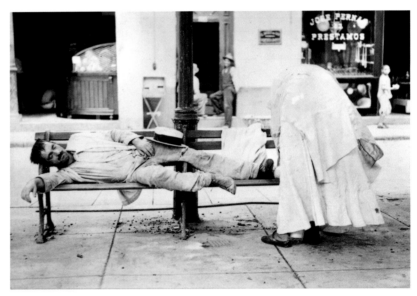

326

323
Havana Beggar, 1933
14.7 x 22.8 cm (5 ¹³⁄₁₆ x 8 ¹⁵⁄₁₆ in.) [on
original mount trimmed to image]
84.XM.956.177
MARKS & INSCRIPTIONS: (Verso) titled
and signed at u. center, in black ink,
by Evans, *HAVANA BEGGAR/Walker
Evans/23 Bethune St*; at l. left, in pen-
cil, Crane no. *L66.125(Evans)*.
REFERENCES: HAVANA, p. 15 (variant,
center left image).

324
Vagrant in the Prado of Havana, 1933
17.2 x 23.6 cm (6 ¾ x 9 ⁹⁄₃₂ in.)
84.XM.956.222
MARKS & INSCRIPTIONS: (Verso) titled
and signed at center, in black ink, by
Evans, *VAGRANT IN THE PRADO OF
HAVANA/Walker Evans/23 Bethune St.*;
at u. center, in pencil, by Evans, *37.*;
at l. left, in pencil, Crane
no. *L66.64(EVANS)*.
REFERENCES: WEAW, p. 91 (variant);
HAVANA, p. 15 (variant).

325
[*Parque Central II**], 1933
15 x 23 cm (5 ¹⁵⁄₁₆ x 9 ¹⁄₁₆ in.)
84.XM.956.166
MARKS & INSCRIPTIONS: (Verso) at right
center, Evans stamp A; at l. left, in
pencil, Crane no. *L66.74(Evans)*.
REFERENCES: *CUBA, pl. 7 (variant);
WEAW, p. 90 (variant, middle right
image); HAVANA, p. 65 (variant).

326
[*Public Square**], 1933
16.7 x 23 cm (6 ⁹⁄₁₆ x 9 ¹⁄₁₆ in.)
84.XM.956.169
MARKS & INSCRIPTIONS: (Verso) at right
center, Evans stamp A; at l. left, in
pencil, Crane no. *L66.71(Evans)*.
REFERENCES: *CUBA, pl. 4 (variant);
WEAW, p. 91 (variant); HAVANA, p. 67
(variant).

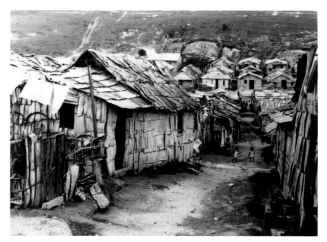

327

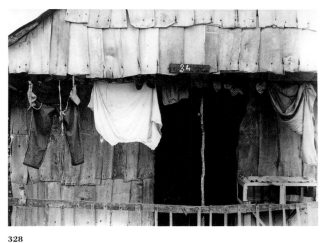

328

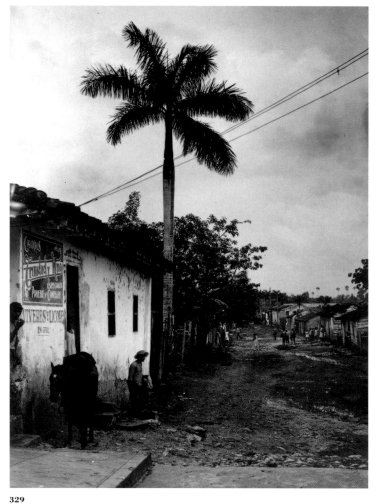

329

327
[*Village of Havana Poor*], 1933
18.9 x 24.6 cm (7 ¹⁵⁄₁₆ x 9 ¹¹⁄₁₆ in.)
84.XM.956.277
MARKS & INSCRIPTIONS: (Verso) signed at
l. right, in pencil, by Evans, *Walker
Evans* [slanted]; (recto, mat) at l. right,
in pencil, *76*; at l. left, in pencil,
Crane no. *L66.8(Evans)*.

328
[*Porch with Drying Laundry, Village of
Havana Poor*], 1933
17.7 x 24.1 cm (7 x 9 ½ in.)
84.XM.956.241
MARKS & INSCRIPTIONS: (Verso) at center
right, Evans stamp A; at l. left, in pen-
cil, Crane no. *L66.26*.

329
Typical Town, Interior of Cuba, 1933
17.7 x 12.6 cm (6 ³¹⁄₃₂ x 4 ³¹⁄₃₂ in.)
84.XM.956.252
MARKS & INSCRIPTIONS: (Verso) titled
and signed at u. center, in black ink,
by Evans, *TYPICAL TOWN INTERIOR OF
CUBA/Walker Evans/23 Bethune St.*; at
l. left, in pencil, Crane no. *L66.34*.

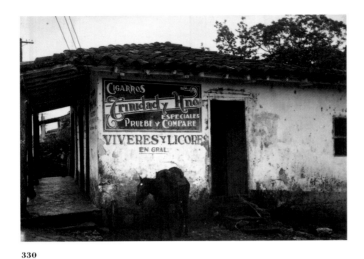

330

331

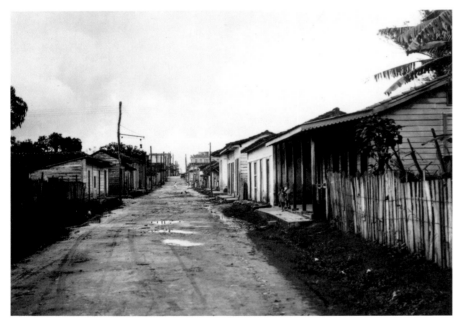

332

333

330
Country Store, Cuba, 1933
12.7 x 17.7 cm (5 x 6 ³¹/₃₂ in.)
84.XM.956.251
MARKS & INSCRIPTIONS: (Verso) signed at
center, in pencil, by Evans, *Walker
Evans*; titled at u. center, in black ink,
by Evans, *COUNTRY STORE CUBA*; at
l. left, in pencil, Crane no. *L66.35.*

331
Cuban Country Town, 1933
11.8 x 16.8 cm (4 ²¹/₃₂ x 6 ⁵/₈ in.)
84.XM.956.204

MARKS & INSCRIPTIONS: (Verso) signed at
l. center, in pencil, by Evans, *Walker
Evans*; titled at u. center, in black ink,
by Evans, *CUBAN COUNTRY TOWN*; at
left, in pencil, Crane no. *L66.90
(Evans).*

332
Cuban Country Town, 1933
12.3 x 16.8 cm (4 ⅞ x 6 ⅝ in.) [on origi-
nal mount trimmed to image]
84.XM.956.190
MARKS & INSCRIPTIONS: (Verso) titled
and signed at center, in black ink, by
Evans, *CUBAN COUNTRY TOWN/*

Walker Evans/23 Bethune St; at u. cen-
ter, in pencil, by Evans, *44*; at l. left,
in pencil, Crane no. *L66.91 (Evans).*

333
[Bohio]*, 1933
15.1 x 18.5 cm (5 ¹⁵/₁₆ x 7 ⁵/₁₆ in.)
84.XM.956.176
MARKS & INSCRIPTIONS: (Verso) at right
center, Evans stamp A; at l. left, in
pencil, Crane no. *L66.82 (Evans).*
REFERENCES: *CUBA, pl. 23 (variant);
HAVANA, p. 104.

334
Cuban Bohio, 1933
13.5 x 20 cm (5 ⁵/₁₆ x 7 ⅞ in.) [on origi-
nal mount trimmed to image]
84.XM.956.173
MARKS & INSCRIPTIONS: (Verso) titled
and signed at center, in black ink, by
Evans, *CUBAN BOHIO/Walker Evans*; at
l. left, in pencil, Crane no. *L66.98
(Evans).*

335
Cuban Farmers and Bohios, 1933
16.1 x 23.2 cm (6 ⅜ x 9 ³/₁₆ in.) [on orig-
inal mount trimmed to image]

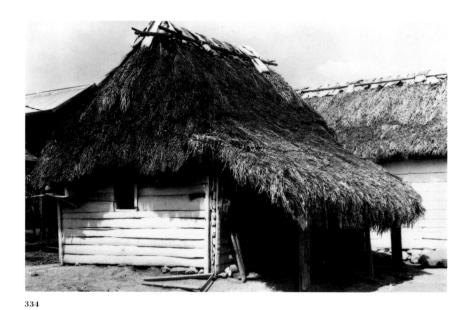

334

335

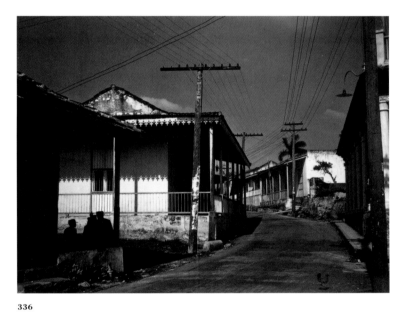

336

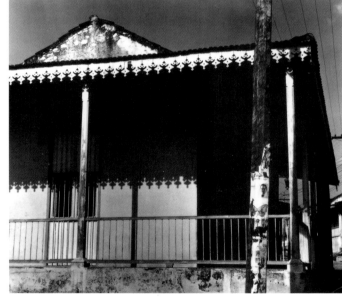

337

84.XM.956.154
MARKS & INSCRIPTIONS: (Verso) signed at right center, in pencil, by Evans, *Walker Evans*; titled at u. center, in black ink, by Evans, *CUBAN FARMERS AND BOHIOS*; at l. left, in pencil, Crane no. *L66.99(Evans)*.

336
[*Country Town**]/[*Small Village, Regla***], 1933
15 x 19.4 cm (5 ⅞ x 7 ⅝ in.)
84.XM.956.164
MARKS & INSCRIPTIONS: (Verso) signed at right center, in pencil, by Evans,

Walker Evans; at l. left, in pencil, Crane no. *L66.81(Evans)*.
REFERENCES: *CUBA, pl. 21 (variant); CRANE, no. 235; FAL, p. 42 (variant); **HAVANA, pp. 98–99 (variant).

337
[*House, Regla, Cuba*], 1933
13.7 x 15 cm (5 ¹³⁄₁₆ x 5 ²⁹⁄₃₂ in.)
84.XM.956.224
MARKS & INSCRIPTIONS: (Verso) signed at center, in pencil, by Evans, *Walker Evans* [sideways]; at l. left, in pencil, Crane no. *L66.133(EVANS)*.

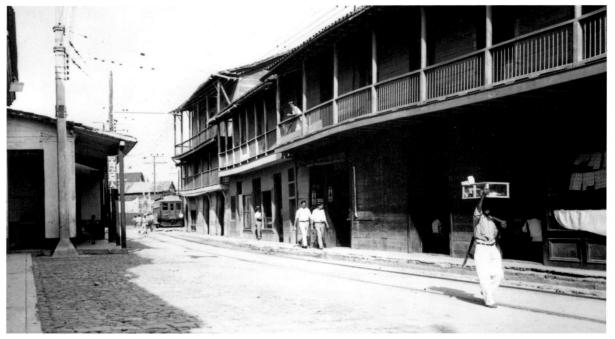

338

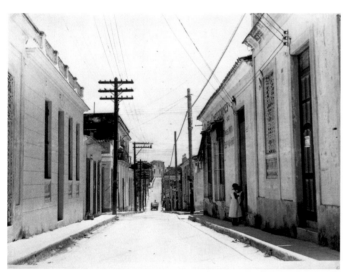

339

340

338
[*Harbor Side Street, Casablanca, Cuba*], 1933
14 x 23.8 cm (5 ½ x 9 ¹¹/₃₂ in.) [on original mount trimmed to image]
84.XM.956.234
MARKS & INSCRIPTIONS: (Verso) at right center, Evans stamp A; at l. left, Crane no. *L66.134(EVANS)*.

339
[*Small Town**], 1933
20.3 x 25.2 cm (8 x 9 ¹⁵/₁₆ in.)
84.XM.956.151
MARKS & INSCRIPTIONS: (Verso) at right center, Evans stamp A; at l. left, in pencil, *L66.80(Evans)*.
REFERENCES: *CUBA, pl. 20 (variant).

340
[*Cuban Country Town*], 1933
12.7 x 17.7 cm (5 x 6 ³¹/₃₂ in.)
84.XM.956.233
MARKS & INSCRIPTIONS: (Verso) signed at right center, in pencil, by Evans, *Walker Evans*; at l. left, in pencil, Crane no. *L66.135(EVANS)*.

341
[*Central Conchita, Wall Painting by Adolfo Gálvez*], 1933
Image: 12.1 x 18.9 cm (4 ¾ x 7 ⁷/₁₆ in.); original mount: 24.9 x 19.8 cm (9 ¹³/₁₆ x 7 ¹³/₁₆ in.)
84.XM.956.140
MARKS & INSCRIPTIONS: (Recto, mount) signed at right, in pencil, by Evans, *Walker Evans*; (verso, mount) at l. center, Evans stamp A; at l. left, in pencil, Crane no. *L66.128(Evans)*.

342
Havana Mural Painting/[*Watercolor Copy by Adolfo Gálvez of Central Conchita Mural Painting*]/[*Central Conchita, Painting by A. Galvez**], 1933
8.4 x 15.6 cm (3 ¼ x 6 ⅛ in.) [on original mount trimmed to image]
84.XM.956.207
MARKS & INSCRIPTIONS: (Verso) titled and signed at center, in black ink, by Evans, *HAVANA MURAL PAINTING/ Walker Evans*; at l. left, in pencil, Crane no. *L66.119(Evans)*.
REFERENCES: *HAVANA, p. 106 (variant).

341

342

343

343
[*Central Conchita, Painting by A. Gálvez**], 1933
19.6 x 24.7 cm (7 23/32 x 9 23/32 in.)
84.XM.956.213
MARKS & INSCRIPTIONS: (Recto) in negative, at l. edge, *EASTMAN-SAFETY-KO[DAK]* [reversed]; (verso) at l. right, Evans stamp A; at u. left, in pencil, *4/5* [inverted]; at l. left, in pencil, Crane no. *L66.121(Evans)*.
REFERENCES: *HAVANA, p. 106 (variant).

344
[*Central Conchita, Painting by A. Galvez**], 1933
18.2 x 23.2 cm (7 3/16 x 9 1/8 in.)
84.XM.956.212
MARKS & INSCRIPTIONS: (Recto) in negative, at l. edge, *EASTMAN-SAFETY-KO[DAK]* [reversed]; (verso) at right center, Evans stamp A; at l. right, in pencil, *11* [space] *7.;* at l. left, in pencil, Crane no. *L66.122(Evans)*.
REFERENCES: *HAVANA, p. 106 (variant).
NOTE: Not illustrated; duplicate of no. 343.

345
[*Central Conchita, Painting by A. Gálvez**], 1933
18.1 x 22.9 cm (7 1/8 x 9 in.)
84.XM.956.197
MARKS & INSCRIPTIONS: (Recto) at left center, *EASTMAN-SAFETY-KO[DAK]* [reversed]; (verso) at u. right, Evans stamp B; at l. left, in pencil, Crane no. *L66.120(Evans)*.
REFERENCES: *HAVANA, p. 106 (variant).
NOTE: Not illustrated; duplicate of no. 343.

346

350

347

351

346
[*Picador and Matador Mural by Adolfo Gálvez*], 1933
15.6 x 23.4 cm (6 ⅛ x 9 ¼ in.) [on original mount trimmed to image]
84.XM.956.199
MARKS & INSCRIPTIONS: (Verso) at l. right, Evans stamp A; at l. left, in pencil, Crane no. *L66.129(Evans)*.

347
[*Picador, from a Mural by Adolfo Gálvez*], 1933
20.8 x 10.2 cm (8 ³⁄₁₆ x 4 ¹⁄₃₂ in.)
84.XM.956.200

MARKS & INSCRIPTIONS: (Verso) at l. right, Evans stamp A; at l. left, in pencil, Crane no. *L66.131(Evans)*.

348
[*Picador, from a Mural by Adolfo Gálvez*], 1933
20.8 x 10.1 cm (8 ³⁄₁₆ x 3 ³¹⁄₃₂ in.)
84.XM.956.202
MARKS & INSCRIPTIONS: (Verso) at u. center, Evans stamp B; at center, in pencil, *Cuba '33*; at l. center, Crane stamp, in pencil, below Crane stamp, by Arnold Crane, *withdrawn/12/71/ AHC*; at l. left, in pencil, Crane

no. *L66.137(Evans)*.
NOTE: Not illustrated; duplicate of no. 347.

349
[*Picador, from a Mural by Adolfo Gálvez*], 1933
20.5 x 13.8 cm (8 ¹⁄₁₆ x 5 ⁷⁄₁₆ in.)
84.XM.956.198
MARKS & INSCRIPTIONS: (Verso) at l. right, Evans stamp A; at l. left, in pencil, Crane no. *L66.130(Evans)*.
NOTE: Not illustrated; variant of no. 347.

350
[*Matador, from a Mural by Adolfo Gálvez*], 1933
20.3 x 19.4 cm (8 x 7 ²¹⁄₃₂ in.)
84.XM.956.201
MARKS & INSCRIPTIONS: (Verso) at right center, Evans stamp A; at l. left, in pencil, Crane no. *L66.132(Evans)*.

351
[*Roast Pork, Country Style**]/ [*Self-Portrait*], 1933
Image: 25.2 x 15.8 cm (9 ¹⁵⁄₁₆ x 6 ³⁄₁₆ in.); sheet: 25.3 x 18.4 cm (9 ¹⁵⁄₁₆ x 7 ¼ in.)
84.XM.956.219
MARKS & INSCRIPTIONS: (Verso) at l. center, Evans stamp A; at l. left, in pencil, Crane no. *L66.103(Evans)*.
REFERENCES: *HAVANA, frontispiece.

1935–1938

African Negro Art

American Photographs: Evans in Middletown

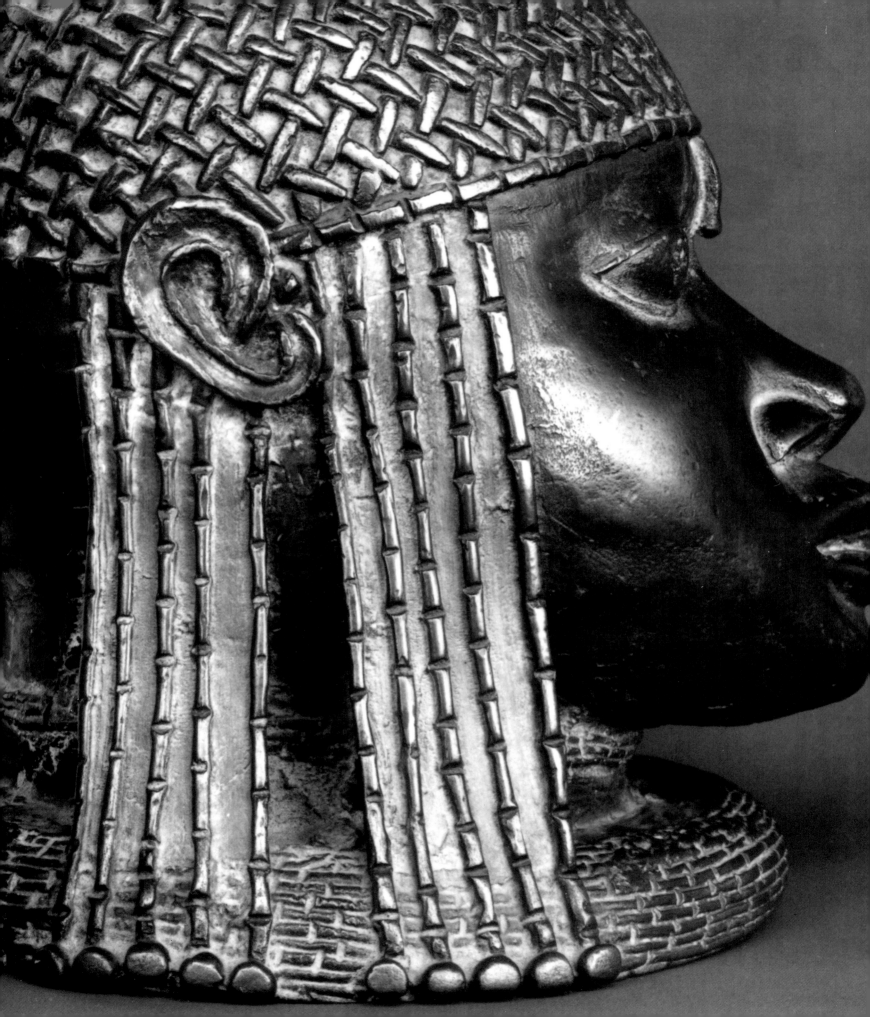

AFRICAN NEGRO ART

*"How old are these things" is the question most often asked by visitors to the
exhibition. It is impossible to give a very definite answer.*

Alfred H. Barr, Jr., on the antiquity of African sculpture, 1935[1]

During the summer of 1933, after Evans returned from Havana, the Mexican muralist Diego Rivera began work on a series of sixteen panels to decorate the New Workers School of New York, choosing to use his fee from the aborted Rockefeller Center project on paintings for the city's citizens. Evans's friend Ben Shahn was again assisting the muralist, and Evans observed with his camera; some of his photographs appeared the next year in Rivera's book *Portrait of America*, which illustrated these as well as the artist's murals in Detroit, in California, and those shown in 1931 at the Museum of Modern Art.[2]

Nineteen thirty-four would prove to be a year of varied, if not lucrative, commissions and publications for the photographer. In addition to providing illustrations for *Fortune*'s September essay on the Communist Party, Evans photographed a private collection of carriages (nos. 180–85), probably that of Mr. Oliver Jennings, who financed his filmmaking trip to Tahiti, and he traveled to Florida to photograph the deluxe Island Inn, recently acquired by an acquaintance.[3] Three Havana pictures and two of his portraits of Hart Crane were featured in the

July–September issue of *Hound & Horn* and at least one of his images of tourist-camp vernacular accompanied James Agee's piece on "The Great American Roadside" for *Fortune* that fall.[4]

The careful details Evans made of Rivera's murals were most likely done on his own time; he was clearly interested in the process and the style, since he spent part of the spring as well as the summer watching the artist's team at work. In Cuba, Evans had photographed more modest and naive murals (nos. 341, 346), whether landscapes or portraits of bullfighters, wherever he found them, in addition to recording the anonymous sculptures decorating cathedrals, such as the figure of St. Roche seen in a Getty collection print (no. 225).

Like his contemporary Charles Sheeler, Evans also did work for hire in galleries and museums. Some of this work he enjoyed, as he told a poet friend in a letter of 1933: "The work I have been doing for cash wouldn't interest you any more than it does me. At the moment, though, there is a lot of 50 copies to be made for the Downtown Gallery, of American folk paintings and objects, and that job not so bad. . . . I could support myself copying paintings I think but don't relish the work."[5]

Evans's early connections with MoMA, principally through his friend Lincoln Kirstein and the *Hound & Horn*

Walker Evans. *Head. Benin,
British Nigeria* (detail), 1935 [no. 395].

103

circle, have already been discussed, and there seems to be evidence that he photographed objects, particularly sculpture, on display there during the first year of the museum's existence. A Getty print representing a portion of the German sculptor Wilhelm Lehmbruck's undated *Torso of a Woman* (no. 126) seems to be from a group of photographs Evans made of the Lehmbruck pieces on exhibition at MoMA in the spring of 1930.[6] This forty-inch sculpture from the collection of Smith College was on loan to the exhibition *Wilhelm Lehmbruck—Sculpture—Aristide Maillol* and is represented in a full-length frontal view in the MoMA catalogue.[7] The Getty image, which eliminates the lower half of the figure and the fragmentary neck created by the artist to suggest a ruined antique piece, emphasizes the bust area, almost suggesting a face, with the small round breasts as eyes. Evans has also chosen to highlight the rough surface of the "composition" or *Kunststein* medium, which a Smith College collection catalogue describes as having been worked over "previous to the final hardening" of the material.[8] The 1930 MoMA catalogue does not credit the illustrations, and Evans's role in interpreting this sculpture is unexplained, as is his dating of the Getty image to 1929.[9] It is interesting, nevertheless, not only as perhaps the closest thing to a female nude known by him, but as an early example of Evans's involvement with sculpture and with the documentation of works of art.

The studies Evans made of Lehmbruck's sculpture, and the copy work he did at the Downtown Gallery and elsewhere, were good preparation for the large commission MoMA bestowed upon him in 1935. The occasion was an exhibition organized for the museum by James Johnson Sweeney entitled *African Negro Art,* held at the museum between March 18 and May 19, 1935. A groundbreaking show of 603 objects selected with the assistance of director Alfred H. Barr, Jr., from ethnographic museums in Germany and France, as well as from private collections of artists and scholars, *African Negro Art* attempted to present art from Africa on purely aesthetic terms. In his catalogue essay, Sweeney argued that "Picturesque or exotic features as well as historical and ethnographic considerations have a tendency to blind us" to the true value of what he called "Negro art."[10] Emphasizing by choice and display the all-important plastic qualities of the work, the exhibition sought to justify Sweeney's declaration that "the art of Negro Africa is a sculptor's art. As a sculptural tradition in the last century it has had no rival. It is as sculpture we should approach it."[11]

In a 1991 article for the journal *African Arts*, Virginia-Lee Webb lays out the history of this exhibition and the evolution of Evans's essential participation in making it available to an even wider audience than the one thousand daily visitors recorded during its two-month run.[12] She quotes from Barr's proposal to the General Education Board of the Rockefeller Foundation for funding to employ a photographer:

> *The exhibition of African Negro Art assembled for the Museum . . . is the most important of its kind ever held. . . . It would be a great waste were this exhibition to be dispersed without adequate documentation. Following the precedent of the Photographic Corpus of Theatre Art prepared by the Museum in 1934 it is proposed to photograph about 450 of the 600 objects in the exhibition.*[13]

MoMA had already produced a small catalogue with an essay by Sweeney, a brief listing of all of the pieces and their lenders, and selected illustrations made from photographs supplied by lenders or those made by the museum's official photographer, Soichi Sunami. What Barr wanted Evans to do was to photograph the exhibition while it was installed at MoMA—he would work in the evenings with the help of Dorothy Miller, then an assistant curator—so that a portfolio of these images could be put together before the objects were again dispersed throughout Europe

and the United States. The museum's plan was to donate sets of these photographs to African American colleges and libraries; a few others would be sold to ethnographic museums and libraries, as well as the exhibition organizers. The museum would retain one set for its records. In addition, a selection of seventy-five enlargements would be assembled for a circulating exhibition that was able to travel more extensively than the original show.

The Board of General Education approved both the portfolio and exhibition projects. Evans and Miller worked in the galleries about six hours every night after closing; John Cheever (the future author of *The Wapshot Chronicle*), Peter Sekaer, and J. Russack were employed to assist with the printmaking at Evans's Bethune Street studio. Eventually, seventeen sets of 477 prints were assembled in both mounted and unmounted formats, contained in blue-gray portfolio covers or bound in four volumes, such as the set found at MoMA.[14] Miller also prepared what amounted to a second catalogue for the exhibition—one that was to accompany Evans's photographs—entitled *African Negro Art: A Corpus of Photographs by Walker Evans*.[15] Highly detailed and existing only in typescript form, Miller's listing follows a different order than that of the published catalogue, with the numbers of the first book cross-referenced in each entry. Although Webb reports that the pieces comprising the MoMA show, *African Negro Art*, were not scheduled for travel, the MoMA Archives show that the exhibition did circulate to seven sites in 1935–36, including San Francisco, Chicago, Cleveland, and Baltimore.[16] *Photographs of African Negro Art by Walker Evans*, on the other hand, toured to sixteen venues between 1935 and 1937, visiting a number of Southern colleges. According to MoMA Archives records, this exhibition finally consisted of twenty-five enlargements and fifty small photographs. The Photography Department at MoMA still possesses at least three of these large exhibition prints, ranging from $18\frac{5}{8}$ x $13\frac{7}{8}$ to $21\frac{7}{8}$ x $10\frac{1}{2}$ inches.[17]

Miller recollects that Evans's attitude toward this massive job was one of dedicated meticulousness: "Evans was crazy about the objects. He was crazy about the job. . . . He was very fussy when setting up each piece."[18] She remembers that he liked to use "movable paper stands and a medium-tone seamless paper" for the background on some pieces.[19] He also wanted to avoid creating strong sharp shadows around a piece; the light source, in other words, should be ambiguous. Therefore, according to John Hill, a photographer and Evans Estate executor, he used the technique of continuously moving the lights in a circular motion while the shutter was open (no. 393).[20] Miller reports that his work, all done with an 8 x 10-inch camera, progressed slowly, taking many weeks; the contact printing of hundreds of negatives by Evans and his colleagues went on for many months. The work was still going on in the summer of 1935, when John Carter, head of the Information Division of the Resettlement Administration (RA), contracted with Evans to do some photographing in West Virginia and Pennsylvania. Evans undertook this work in June and July but wrote to Carter in frustration in August, saying his work at MoMA had kept him so "fully occupied" he had not been able to continue with the RA series, which he was keenly interested in and which would, some years later, overshadow his work with the African art show, not to mention everything else he had done up to that point.[21] Evans was officially employed by the RA in September of 1935 and was making trips through the South for Roy Stryker that fall; back in New York, Sekaer, Cheever, Russack, and E. Deis continued to print and spot the thousands of photographs that would make up the final portfolios.[22]

The Getty collection of prints from this project is not a complete portfolio but is rather a miscellaneous selection of sixty-five images (plus four duplicate prints) from two different sources. Among the ten photographs from the collection of Samuel Wagstaff, Jr., are untrimmed, unmounted contact prints; the remaining fifty-five, which Arnold Crane obtained from Evans himself, are all

mounted on lightweight, off-white board measuring 12 7/16 x 10 3/16 inches, with one exception on a 12 x 10-inch mount. The prints from Crane entered the Getty collection with one of the blue-gray portfolio cases (12 3/4 x 10 3/4 inches). Each image, originally from an 8 x 10-inch negative, has been trimmed to some extent, sometimes closing in quite severely on the pictured object and eliminating most vestiges of background space.

Webb remarks upon Evans's preference for stark frontal, rear, or profile views, rather than the more subtle three-quarter view often employed by photographers to enhance the curves or sharp corners of a carved piece. Getty prints illustrating this practice include three images of wooden ancestral figures identified as coming from the French Sudan and the Southern Cameroon region (nos. 352–53, 398).[23] Prints exemplifying the "edge-to-edge parallel placement" that Webb points out as another characteristic of Evans's style are also contained in the Getty group.[24] Among the Wagstaff photographs are the magnificent bronze head from Benin thought to be a portrait of a queen mother (no. 395), a wooden mask from the Ivory Coast that was lent by the artist Paul Guillaume (no. 361), and a twenty-inch-long bronze head of a serpent or crocodile, also from Benin (no. 396). Although there are many examples of this tight, in-camera framing among the Getty prints, the image of the cedar mask once owned by the art critic Roger Fry (no. 420) represents perhaps the most effective use of the technique, making this twenty-inch piece seem monumental indeed.

Other striking illustrations of Evans's sympathetic but sometimes unorthodox manner of communicating the "third-dimensional effect" that Barr praised when he first recommended the photographer can be found in prints such as the *Mask, Surmounted by Bird* (no. 356), a photograph displaying soft shadows and a radiant, solarized appearance that suggests light emanating from the mask itself or some other typically inscrutable source.[25] A print exhibiting a bronze, fourteen-inch Benin bell (no. 378),

though photographed straight on, shows off not only the volume of the conical shape but the hard, shiny, well-worn surface of this elegantly decorated piece. It is reminiscent in some ways of the series of pictures Evans did for his *Fortune* photo-essay "Beauties of the Common Tool" (July 1955), represented at the Getty by twenty-five prints (see no. 1080 and other images in the chapter "At *Fortune*," below).[26] Often the African pieces he photographed in 1935 seem to float against a blank background, a white void that destroys all sense of scale and context (nos. 359, 363–64). He would use this ingenious combination of lighting, background, and darkroom manipulation again with the "ordinary hand tools" he would lovingly portray as proto-Minimalist sculpture in the 1955 essay for *Fortune* (nos. 1077, 1087, 1093).

Evans's pictures from the MoMA project should be compared to the *African Negro Sculpture* portfolio of Charles Sheeler that is also in the Getty collection.[27] This group of twenty photographs, bound into a deluxe book of fewer than twenty-five copies, was put together in 1918 to document the exhibition presented by Marius de Zayas's Modern Gallery and entitled *African Negro Sculpture*. De Zayas had previously collaborated with Alfred Stieglitz at his 291 gallery on the show *Statuary in Wood by African Savages: The Roots of Modern Art*, held in 1914.[28] Both Stieglitz and de Zayas continued to show African art, alternating it as well as combining it with the work of European painters, such as Picasso, in their galleries during the 1910s. Stieglitz himself photographed the installations held at 291, recording the resemblances between European and African art and certain natural configurations, like the wasps' nest seen in a Getty print (fig. 1). Sheeler, who continued to do a substantial business in documenting art for collectors and dealers after de Zayas's gallery had closed, approached the African pieces as he did his work as a painter. One critic has pointed out that he "seems to have been the first American photographer to use African art as a vehicle for abstraction;"[29] in his ren-

Figure 1. Alfred Stieglitz (American, 1864–1946). *The Picasso Exhibition at "291" (Detail)*, January 1915. Platinum print, 19.5 x 24.8 cm (7 $^{11}/_{16}$ x 9 ¾ in.). JPGM 86.XM.622.2.

Figure 2. Charles Sheeler (American, 1883–1965). *Unidentified African Sculpture*, 1918. Toned gelatin silver print from *African Negro Sculpture* (New York: Marius de Zayas and Charles Sheeler, 1918), pl. 9. 23 x 17 cm (9 $^1/_{16}$ x 6 $^{11}/_{16}$ in.). JPGM 88.XB.23.9.

dering of fractured, overlapping shadows to create more ephemeral geometric shapes—which are counterpoised to the solid, wooden pieces reflecting the harsh artificial light—his debt to analytic Cubism seems clear (fig. 2).[30] The well-defined shadows produced by the raking light on two masks from that 1918 show give the sculpture and its silhouette a hard-edged definition that echoes Sheeler's Precisionist style in painting.[31] In his introduction to the *African Negro Sculpture* portfolio, de Zayas, referring to the Cubist innovations of circa 1907, gives African sculpture much of the credit for this revolution in Western art: "Negro sculpture has been the stepping stone for a fecund evolution in our art. It brought to us a new form of expres-

sion and a new expression of form." And he cites Sheeler as the one who made evident these qualities: "Sheeler has used the light to project the Negro vision. He photographs Negro sculpture in its plurality of form and effect."[32]

In contrast to Sheeler's rarefied, limited-edition book of twenty prints meant to be contemplated by artists and collectors, Evans's immense production based on the MoMA exhibition constituted a file of documents meant to be put to use in libraries, colleges, museums, and archives, such as the Photograph Study Collection in the Department of the Arts of Africa, Oceania, and the Americas at the Metropolitan Museum. As Virginia-Lee Webb, the archivist of that collection, has said, experts still

Figure 3. Walker Evans. *Figure. Hammered Brass. Abomey, Dahomey*, 1935 [no. 371].

consider the objects brought together for the 1935 show the canon of African art; Evans's pictures are, therefore, still in demand as a tool for the study of these important cultural artifacts.[33] It may seem a little odd, then, that the 477 prints are available only in those institutions holding the sets commissioned by MoMA the year of the exhibition. Though the photographs have never been reproduced in their entirety, they were employed in illustrating the 1952 *African Folktales and Sculpture*, coauthored by Paul Radin, Elinore Marvel, and James Johnson Sweeney. By placing his essay "African Negro Sculpture" in the same volume with a retelling of folktales, Sweeney was acknowledging a change of attitude in terms of the proper study of this art: "If we are serious in our effort to enjoy African art with any degree of discernment, our view of it must combine ethnographic and aesthetic considerations, not rely on one or the other in isolation."[34]

Although critical of his own earlier approach, as

well as that of the first painter-amateurs who looked at African art, Sweeney apparently still thought highly of Evans's 1935 work; nearly three-quarters of the plates selected for *African Folktales and Sculpture* came from his MoMA portfolio. Among them are two Getty images (nos. 370–71) that reflect Evans's special talent for animating these revered figures in wood and metal. Portraying a 41 ¼-inch hammered brass "god of war" from the treasure of Behanzin, last king of Dahomey, Evans first allowed the standing figure to fill the entire frame of his large negative; he turned it slightly to one side so that it would appear to be in motion, walking forward.[35] For a second view of the same piece (fig. 3), Evans approached the figure from the back and close up, so that the form and surface of its shoulders, neck, and head are experienced in a shallow space, confronting the viewer as hyper-real and at the same time appearing to move away from the picture plane where Evans's camera has seized it.

The use of Evans's photographs of objects that, though artful, were very much a part of the everyday ritual of life and death in Africa seems completely appropriate in a book that also considers the importance of folktales on that continent. Evans was probably equally satisfied by an event that took place at United States Customs when the African loans first arrived in New York for the 1935 exhibition. As would be the case with a number of pieces in MoMA's *Cubism and Abstract Art* exhibition of the next year, many of the African loans were refused the free entrance usually accorded works of art. Referring to the latter incident of 1936, Thomas Mabry explained:

These difficulties were not new to the Museum. Many objects in its exhibition of African Negro Art had been refused free entrance because it was impossible to prove that certain sculptures were not more than second replicas, or because the artist's signature could not be produced, or because no date of manufacture could be found, or because ancient

bells, drums, spoons, necklaces, fans, stools and head rests were considered by the examiners to be objects of utility and not works of art.[36]

Like the African artisan, Evans was not interested in making a distinction between a work of art and a utilitarian object. His photographs of the next two years, made in

the employ of the New Deal's Resettlement Administration, would reflect a preoccupation with the ordinary details of day-to-day living. Twenty years later, in the 1955 *Fortune* essay mentioned above, he would turn his 8 x 10-inch view camera on trowels, wrenches, chisels, and tin snips. The result would be an even more austere and plainspoken affirmation of the value of handwork.

NOTES

1. A. H. B., Jr. [Alfred H. Barr], "Antiquity of African Sculpture," *Bulletin of the Museum of Modern Art* 2:6–7 (Mar.–Apr. 1935), n.p.

2. See Diego Rivera, *Portrait of America* (New York: Covici, Friede, 1934), with an "Explanatory Text" by Bertram D. Wolfe, director of the New Workers' School of New York.

3. The *Fortune* essay was "The Communist Party," *Fortune* 10 (Sept. 1934), 69–74, 154, 156, 159–60, 162. The Jennings carriages may have belonged to the family of Oliver Jennings, head of Bethlehem Steel Corporation. I am grateful to Belinda Rathbone for this information about Evans's Florida commission in 1934.

4. See Walker Evans, "Cuba Libre: Photos" and "Hart Crane: Brooklyn: 1929" (two portraits) accompanying Hart Crane, "'The Bridge': Letters," both in *Hound & Horn* III:4 (July–Sept., 1934), n.p. James Agee, "The Great American Roadside," *Fortune* 10 (Sept. 1934), 58–63, 172, 174, 177.

5. Evans's letter to Hans Skolle of Apr. 20, 1933, quoted in *Walker Evans at Work* (New York: Harper and Row, 1982), 95.

6. For related prints by Evans see MoMA, Photography Department 506.80, 507.80, 508.80, and 509.80. All of these appear to be photographs Evans made in about 1930 of Lehmbruck sculpture in the MoMA exhibition; 509.80 is another view of the torso seen in the Getty print.

7. *Wilhelm Lehmbruck—Sculpture—Aristide Maillol* (New York: Museum of Modern Art, 1930), pl. 7, cat. no. 7.

8. *Smith College Museum of Art Catalogue* (Northampton, Mass.: Smith College Museum of Art, 1937), 35.

9. Evans may have signed and dated this piece at a much later time, incorrectly assigning it to 1929. The inscription on the verso of the mount correctly gives the sculpture's title and creator and refers to the catalogue number in the 1930 MoMA catalogue. Coincidentally, after its showing at MoMA, the piece was sent on to the Harvard Society for Contemporary Art, a venue overseen by Evans's friend Lincoln Kirstein and the site of an exhibition that included Evans's own work that same year.

10. James Johnson Sweeney, ed., *African Negro Art* (New York: Museum of Modern Art, 1935), 21.

11. Ibid.

12. See Virginia-Lee Webb, "Art as Information: The African portfolios of Charles Sheeler and Walker Evans," *African Arts* XXIV:1 (Jan. 1991), 56–63, 103. I am grateful to Ms. Webb of the Photograph Study Collection, Department of the Arts of Africa, Oceania, and the Americas, the Metropolitan Museum, for her valuable essay, as well as for her assistance with my research into this part of the Getty collection. I would also like to thank her assistant Thomas Frontini for his help in the spring of 1993. Information on attendance during the run of *African Negro Art* was gleaned from the *Bulletin of the Museum of Modern Art* 2:6–7 (Mar.–Apr. 1935), n.p.

13. Webb, "Art as Information," 58.

14. See Webb, "Art as Information," 103, fn. 22, for the final distribution of these sets. The unmounted set once owned by Robert Goldwater, who assisted with various aspects of assembling the cataloguing data, is now at the Metropolitan Museum in the Photograph Collection of the Department of

the Arts of Africa, Oceania, and the Americas. The Photography Department at MoMA possesses a set bound in four volumes.

15. Miller's forty-five-page listing with 477 entries is available at the Metropolitan Museum and at MoMA.

16. For this and the following information about the itinerary for both shows, see the following MoMA files: The Museum of Modern Art Archives, New York: Department of Circulating Exhibitions, II.1/33 (2) and II.1/91 (7).

17. See MoMA 382.41, 383.41, and 384.41.

18. Webb, "Art as Information," 59.

19. Ibid., 60.

20. Ibid., 60 and 103, fn. 19.

21. Evans to John Carter, Aug. 17, 1935, in *Roy Stryker Papers (1912–1972)*, edited by David Horvath (University of Louisville Photographic Archives, 1982). [Microfilm edition by Chadwick-Healey; reel 1.]

22. *Walker Evans at Work*, 117, quotes from Sekaer correspondence with Evans and lists an "E. Deis" among those requiring a salary for his work on the project.

23. For the purposes of this book, descriptive information about the title, date, and geographical derivation of the African pieces seen in Evans's images is based on the 1935 catalogues (both Sweeney and Miller), that is, on attributions from the time of the photographs. The difference between Evans's direct approach to the object and the more traditionally accepted dramatization of a piece is made clear if one compares his rendering of a wooden sculpture thought in 1935 to represent an ancestral figure of a her-

maphrodite (no. 352) to that of a more recent photographer, who supplied the illustration of the same piece for the 1984 MoMA catalogue *"Primitivism" in Twentieth-Century Art* (see vol. II, pl. 436).

24. Webb, "Art as Information," 59.

25. Ibid.

26. See Walker Evans, "Beauties of the Common Tool," *Fortune* 52 (July 1955), 103–7. This figure of twenty-five photographs at the Getty includes two duplicate prints.

27. See JPGM 88.XB.23.1–20. The Getty book is number seven in the edition of twenty-two.

28. See Webb, "Art as Information," 56, as well as *Camera Work* 48 (1916) for this collaboration.

29. Webb, "Art as Information," 57.

30. Ibid.

31. See *African Negro Sculpture*, JPGM 88.XB.23.8 and .18.

32. M. de Zayas, introduction to *African Negro Sculpture*, 1918, n.p.

33. In conversation with the author, Apr. 5, 1993.

34. *African Folktales and Sculpture* (New York: Pantheon Books, 1952; second printing, 1953), 325.

35. See Sweeney, *African Negro Art*, pl. 238, for a completely different interpretation of this "god of war."

36. T. D. M., "The United States Government and Abstract Art," *Bulletin of the Museum of Modern Art* 3:1 (Apr. 1936), 2. This April issue was entitled "The Government Defines Art."

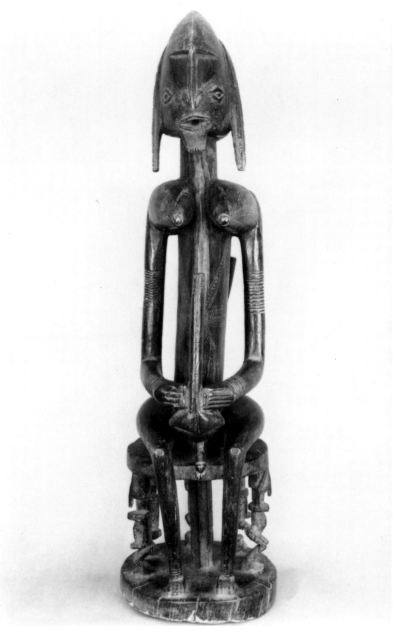

352

African Negro Art

The sixty-nine Getty prints related to Evans's 1935 commission to document the *African Negro Art* exhibition are sequenced here in keeping with the listing of 477 objects found in the typescript catalogue originally prepared by Dorothy Canning Miller to accompany a complete set of Evans's photographs. This unpublished catalogue is referred to in the following entries as ANA-WE.

352
[*Ancestral Figure Representing Hermaphrodite; French Sudan, Region of Bandiagara. Dogon. Front View.**]/ [*Figure of Hermaphrodite. Dogon, Region of Bandiagara.***], 1935
23.1 x 14.2 cm (9 3/32 x 5 9/16 in.) [on original mount trimmed to image]
84.XM.956.400
MARKS & INSCRIPTIONS: (Verso) at center, in pencil, by Evans, *PL2/C1*; at l. left, Evans stamp A; at l. left, in pencil, Crane no. *L73.9(Evans)*.
REFERENCES: *ANA-WE, no. 2 (**ANA-JJS, no. 1).

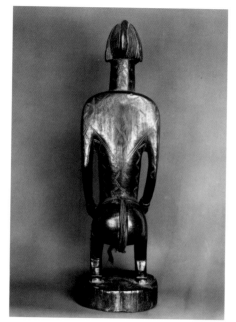

353

354

355

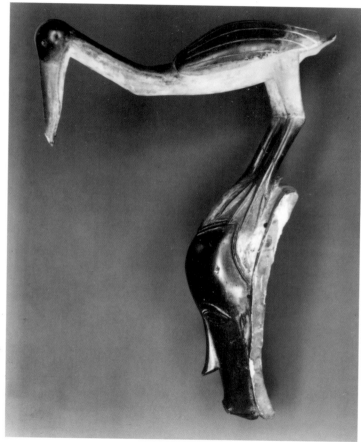

356

353
[Ancestral Figure. French Sudan.*],
1935
Image: 23.3 x 15.6 cm (9 3/16 x 6 1/8 in.);
original mount: 31.4 x 25.9 cm
(12 7/16 x 10 3/16 in.)
84.XM.956.380
MARKS & INSCRIPTIONS: (Verso, mount)
at l. right, in pencil, by Evans,
PL8/C4; at l. left, in pencil, Crane
no. *L72.20(Evans)*.
REFERENCES: *ANA-WE, no. 8
(ANA-JJS, no. 4).

354
[Mask Representing an Animal. French
Sudan. Dogon.*], 1935
Image: 24.2 x 18.2 cm
(9 17/32 x 7 3/16 in.); original mount:
31.5 x 26 cm (12 7/16 x 10 1/4 in.)
84.XM.956.391
MARKS & INSCRIPTIONS: (Verso, mount)
at l. left, Evans stamp A; at l. left, in
pencil, Crane no. *L73.12(Evans)*.
REFERENCES: *ANA-WE, no. 26
(ANA-JJS, no. 27).

355
[Mask Representing Animal with Horn.
Possibly Sudan.*], 1935
Image: 22.7 x 12.8 cm
(8 15/16 x 5 1/32 in.); original mount:
31.5 x 25.9 cm (12 7/16 x 10 3/16 in.)
84.XM.956.381
MARKS & INSCRIPTIONS: (Verso, mount)
at l. right, in pencil, by Evans, *pl. 31/
CAT.30*; at l. left, in pencil, Crane
no. *L72.9(Evans)*.
REFERENCES: *ANA-WE, no. 31
(ANA-JJS, no. 30).

356
[Mask, Surmounted by Bird. French
Sudan near Ivory Coast. Senufo (?)*],
1935
23.6 x 18.7 cm (9 5/16 x 7 3/8 in.)
84.XM.488.23
MARKS & INSCRIPTIONS: (Verso) at center,
in pencil, *33* [sideways]; at center,
Lunn Gallery stamp, and within boxes,
in pencil, *XX* and *33*; at l. right, in
pencil, Wagstaff no. *Evans 31*.
PROVENANCE: Lunn Gallery/Graph-
ics International, Ltd.; Samuel
Wagstaff, Jr.
REFERENCES: *ANA-WE, no. 35
(ANA-JJS, no. 33).

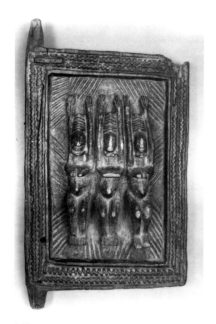

357

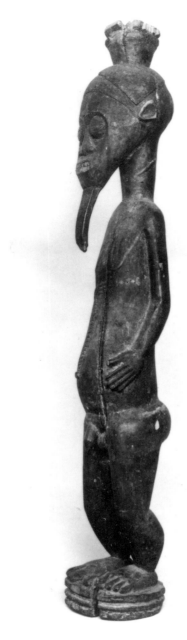

358

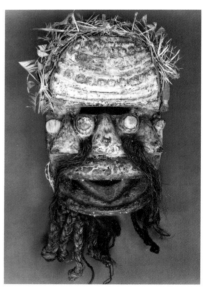

359

360

357
[*Door, Probably of a Granary; French Sudan. Dogon.*]/[Door. Wood. Dogon. French Sudan***], 1935
Image: 24.2 x 15.3 cm
(9 ⁹⁄₁₆ x 6 ¹⁄₃₂ in.); original mount:
31.5 x 25.9 cm (12 ⁷⁄₁₆ x 10 ³⁄₁₆ in.)
84.XM.956.413
MARKS & INSCRIPTIONS: (Recto, mount)
at l. left, in pencil, *P*; at l. right, in pencil, *35*; (verso, mount) at l. left, in pencil, Crane no. *L72.33(Evans)*.
REFERENCES: *ANA-WE, no. 39
(ANA-JJS, no. 35); **AFAS, no. 44.

358
[*Figure. Ivory Coast. Baule*]/[Figure of Man. Baoulé.***], 1935
Image: 24.5 x 8.8 cm (9 ⁵⁄₈ x 3 ¹⁵⁄₃₂ in.); original mount: 31.5 x 25.9 cm (12 ⁷⁄₁₆ x 10 ³⁄₁₆ in.)
84.XM.956.402
MARKS & INSCRIPTIONS: (Recto, mount)
at u. right, in pencil, *Discard ?*; at l. left, in pencil, *Discard/73/69*; (verso, mount) at l. left, in pencil, Crane no. *L72.28(Evans)*.
REFERENCES: *ANA-WE, no. 72
(**ANA-JJS, no. 69).

359
[*Mask. Ivory Coast.*]/[Mask with Horns***], 1935
Image: 24.1 x 11.4 cm
(9 ½ x 4 ¹⁵⁄₃₂ in.); original mount: 31.5 x 25.9 cm (12 ⁷⁄₁₆ x 10 ³⁄₁₆ in.)
84.XM.956.407
MARKS & INSCRIPTIONS: (Verso, mount)
at l. right, in pencil, by Evans, *pl 79/CAT.74*; at l. left, in pencil, Crane no. *L72.44(Evans)*.
REFERENCES: *ANA-WE, no. 79
(**ANA-JJS, no. 74).

360
[*Mask. Ivory Coast. Dan.*]/[Mask with Three Noses. "Man."***], 1935
Image: 24.1 x 16.5 cm
(9 ¹⁵⁄₃₂ x 6 ¹⁵⁄₃₂ in.); original mount: 31.5 x 25.9 cm (12 ⁷⁄₁₆ x 10 ³⁄₁₆ in.)
84.XM.956.421
MARKS & INSCRIPTIONS: (Verso, mount)
at l. left, in pencil, Crane no. *L72.3 (Evans)*.
REFERENCES: *ANA-WE, no. 93
(**ANA-JJS, no. 85).

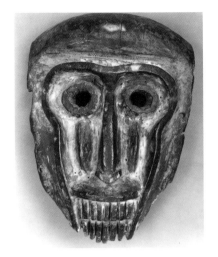

361

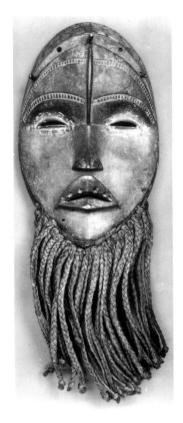

362

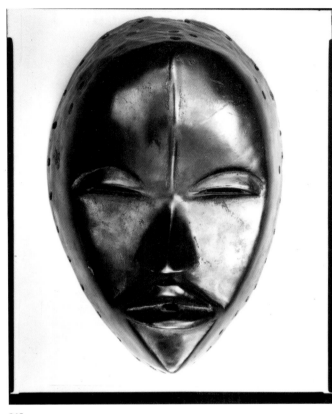

363

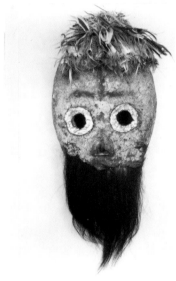

364

361
[*Mask. Ivory Coast.**], 1935
24.3 x 18.8 cm (9 %6 x 7 13/16 in.)
84.XM.488.22
MARKS & INSCRIPTIONS: (Verso) at center,
in pencil, *G2/blue tinted;* at l. center,
in pencil, *2-10 + 4-25* [inverted];
at center, Lunn Gallery stamp, and
within boxes, in pencil, *XX* and
96; at l. right, in pencil, Wagstaff
no. *Evans 32.*
PROVENANCE: Lunn Gallery/Graph-
ics International, Ltd.; Samuel
Wagstaff, Jr.
REFERENCES: *ANA-WE, no. 97
(ANA-JJS, no. 96).

362
[*Mask. Ivory Coast. Dan.**], 1935
Image: 23.8 x 9.2 cm (9 ⅜ x 3 ⅝ in.);
original mount: 31.5 x 25.9 cm
(12 ⅞6 x 10 3/16 in.)
84.XM.956.430
MARKS & INSCRIPTIONS: (Recto, mount)
at l. left, in pencil, *100;* (verso, mount)
at l. left, in pencil, Crane no. *L72.21
(Evans).*
REFERENCES: *ANA-WE, no. 100
(ANA-JJS, no. 89).

363
[*Mask. Ivory Coast. Dan.**], 1935
25.3 x 20.3 cm (9 31/32 x 7 31/32 in.)
84.XM.488.28
MARKS & INSCRIPTIONS: (Recto) in pen-
cil [lines to mark cropping]; (verso)
at center, in pencil, *123;* at l. center,
Lunn Gallery stamp, and within boxes,
in pencil, *XX* and *123;* at l. right,
in pencil, Wagstaff no. *Evans 33.*
PROVENANCE: Lunn Gallery/Graph-
ics International, Ltd.; Samuel
Wagstaff, Jr.
REFERENCES: *ANA-WE, no. 101
(ANA-JJS, no. 123); AFAS, no. 5.

364
[*Mask. Ivory Coast.**]/[*Mask with
Feather Beard***], 1935
Image: 23.7 x 14.1 cm
(9 11/32 x 5 %6 in.); original mount:
31.5 x 25.9 cm (12 ⅞6 x 10 3/16 in.)
84.XM.956.431
MARKS & INSCRIPTIONS: (Verso, mount) at
l. right, in pencil, by Evans, *pl.113/
CAT.73* at l. left, in pencil, Crane
no. *L72.8(Evans).*
REFERENCES: *ANA-WE, no. 113
(**ANA-JJS, no. 73).

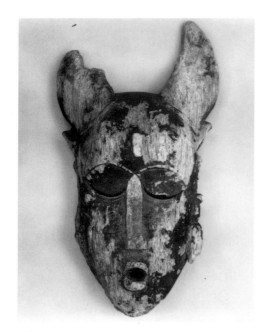

365

366

368

367

365
[Mask. Ivory Coast. Baule.]/[Mask with Horns. Baoulé.**]*, 1935
Image: 24.1 x 18 cm (9 ½ x 7 ³/₃₂ in.);
original mount: 31.5 x 25.9 cm
(12 ⁷/₁₆ x 10 ³/₁₆ in.)
84.XM.956.419
MARKS & INSCRIPTIONS: (Verso, mount) at
l. left, in pencil, Crane no. *L72.4
(Evans).*
REFERENCES: *ANA-WE, no. 114
(**ANA-JJS, no. 92).

366
[Two Bobbins. Ivory Coast. Baule.]*,
1935
Image: 18.8 x 21.2 cm
(7 ⁷/₁₆ x 8 ¹¹/₃₂ in.); original mount:
31.5 x 25.9 cm (12 ⁷/₁₆ x 10 ³/₁₆ in.)
84.XM.956.375
MARKS & INSCRIPTIONS: (Recto, mount)
at l. left, in pencil, *P*; at l. right, in
pencil, *63.126*; (verso, mount) at l. left,
in pencil, Crane no. *L72.27(Evans).*
REFERENCES: *ANA-WE, no. 129
(ANA-JJS, left to right, nos. 126, 63).

367
[Two Bobbins; Ivory Coast]*, 1935
18.9 x 22 cm (7 ⁷/₁₆ x 8 ¹¹/₁₆ in.)
84.XM.488.25
MARKS & INSCRIPTIONS: (Verso) at center,
in pencil, *135–41* [inverted]; at center,
Lunn Gallery stamp, and within boxes,
in pencil, *XX* and *135–41*.
PROVENANCE: Lunn Gallery/Graph-
ics International, Ltd.; Samuel
Wagstaff, Jr.
REFERENCES: *ANA-WE, no. 133 (ANA-
JJS, nos. 135, 141); AFAS, nos. 57–58.

368
*[Box with Equestrian Figure on Cover.
Gold Coast. Ashanti.*]/[Box with Ani-
mal on Cover. Ashanti. Gold Coast.**]*,
1935
Image: 20.1 x 13.8 cm
(7 ¹⁵/₁₆ x 5 ⁷/₁₆ in.); original mount:
31.5 x 25.9 cm (12 ⁷/₁₆ x 10 ³/₁₆ in.)
84.XM.956.416
MARKS & INSCRIPTIONS: (Verso, mount)
at l. left, in pencil, Crane no. *L72.41
(Evans)*; at u. left, in pencil,
CH3-1758.
REFERENCES: *ANA-WE, no. 146
(**ANA-JJS, no. 166).

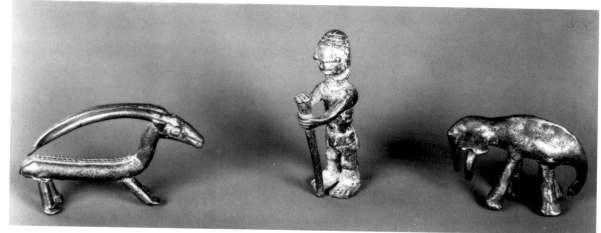

369

370

371

369
[*Three Weights for Measuring Gold Dust. Ivory Coast (Baule) or Gold Coast (Ashanti)*], 1935
Image: 9.5 x 23.8 cm (3 ²³⁄₃₂ x 9 ⅜ in.); original mount: 26 x 31.5 cm (10 ¼ x 12 ⅜ in.)
84.XM.956.388
MARKS & INSCRIPTIONS: (Recto) at u. right, in pencil, *S-L*; (mount, verso) at left center, Evans stamp A [sideways]; (mat, recto) at u. left, in pencil, Crane no. *L73.4(Evans)*.
REFERENCES: *ANA-WE, no. 160 (ANA-JJS, nos. 188–90).

370
[*Figure, So-Called God of War. Dahomey. Abomey.**]/[*Figure. Hammered Brass. Abomey, Dahomey***], 1935
Image: 21.6 x 12.5 cm (8 ¹⁷⁄₃₂ x 4 ¹⁵⁄₁₆ in.); original mount: 31.5 x 25.9 cm (12 ⁷⁄₁₆ x 10 ³⁄₁₆ in.)
84.XM.956.426
MARKS & INSCRIPTIONS: (Verso, mount) at l. right, in pencil, by Evans, *pl.169/CAT.238*; at l. left, in pencil, Crane no. *L72.16(Evans)*.
REFERENCES: *ANA-WE, no. 169 (ANA-JJS, no. 238); **AFAS, no. 112.

371
[*Figure, So-Called God of War. Dahomey. Abomey.**]/[*Figure. Hammered Brass. Abomey, Dahomey***], 1935
23.6 x 19.1 cm (9 ⅜ x 7 ½ in.)
84.XM.956.386
MARKS & INSCRIPTIONS: (Verso) at u. left, in pencil, *62/2S/238 [space] M75*.
REFERENCES: *ANA-WE no. 170 (ANA-JJS, no. 238), **AFAS, no. 113.
EXHIBITIONS: . . . *images that yet/Fresh images beget . . .*, J. Paul Getty Museum, Malibu, Calif., Sept. 15–Nov. 15, 1987.

372
[*Figure, So-Called God of War. Dahomey. Abomey.**]/[*Figure. Hammered Brass. Abomey, Dahomey***], 1935
25.2 x 20.2 cm (9 ¹⁵⁄₁₆ x 7 ³¹⁄₃₂ in.)
84.XM.488.30
MARKS & INSCRIPTIONS: (Verso) at u. center, in pencil, *238* and *C2/1 S/M75*; at l. center, Lunn Gallery stamp, and within boxes, in pencil, *XX* and *238*; at l. right, in pencil, Wagstaff no. *Evans 35*.
PROVENANCE: Lunn Gallery/Graphics International, Ltd.; Samuel Wagstaff, Jr.
REFERENCES: *ANA-WE, no. 170 (ANA-JJS, no. 238); **AFAS, no. 113.
NOTE: Not illustrated; variant of no. 371.

373

374

375

377

373
[Equestrian Figure. Dahomey. Yoruba.*]/[Polychrome Equestrian Figure. Yoruba**]/[Equestrian Figure. Polychrome Wood. Yoruba, Dahomey.***], 1935
Image: 23.9 x 17.6 cm
(9 13/32 x 6 15/16 in.); original mount: 31.5 x 25.9 cm (12 7/16 x 10 3/16 in.)
84.XM.956.409

MARKS & INSCRIPTIONS: (Recto, mount) at l. right, in pencil, by Evans, *PL172/ CAT 239*; (verso, mount) at center, in pencil, by Evans, *Pl 172* [underlined]/ *Cat 239* [within a box]; at l. left, in pencil, Crane no. *L72.42 (Evans)*.
REFERENCES: *ANA-WE, no. 172 (**ANA-JJS, no. 239); ***AFAS, no. 59.

374
[Kneeling Figure. Dahomey. Yoruba*/ [Kneeling Woman (Top of Sceptre). Yoruba.**], 1935
Image: 23.4 x 12.5 cm (9 7/32 x 4 15/16 in.); original mount: 31.5 x 25.9 cm
(12 7/16 x 10 3/16 in.)
84.XM.956.394

MARKS & INSCRIPTIONS: (Recto, mount) at l. left, in pencil, *176*; (verso, mount) at l. center, Evans stamp A; at l. left, in pencil, *L73.3(Evans)*.
REFERENCES: *ANA-WE, no. 176 (**ANA-JJS, no. 243).

375
[Figure of a Trumpeter. Benin, British Nigeria.*]/[Figure. Bronze. Benin, Nigeria. Full view, Front.**], 1935
Image: 23.3 x 14.7 cm (9 3/16 x 5 13/16 in.); original mount: 31.5 x 25.9 cm
(12 7/16 x 10 3/16 in.)
84.XM.956.422

MARKS & INSCRIPTIONS: (Verso, mount) at l. right, in pencil, by Evans, *pl.196/ CAT.272*; at l. left, in pencil, Crane no. *L72.2(Evans)*.
REFERENCES: *ANA-WE, no. 196 (ANA-JJS, no. 272); **AFAS, no. 128.

376

379

378

376
[*Relief with Hunter. Benin. British Nigeria**]/[*Plaque: Hunter. Bronze. Benin, Nigeria***], 1935
Image: 23.3 x 17 cm (9 ³/₁₆ x 6 ²³/₃₂ in.); original mount: 31.5 x 25.9 cm (12 ⁷/₁₆ x 10 ³/₁₆ in.)
84.XM.956.408
MARKS & INSCRIPTIONS: (Verso, mount) at l. right, in pencil, by Evans, *pl. 201/ CAT.255(253?)*; at l. left, in pencil, Crane no. *L72.45(Evans)*.
REFERENCES: *ANA-WE, no. 201 (ANA-JJS, no. 255); **AFAS, no. 116.

377
[*Leopard. Benin. British Nigeria.**], 1935
Image: 16.3 x 22.6 cm (6 ¹³/₃₂ x 8 ²⁹/₃₂ in.); original mount: 31.5 x 25.9 cm (12 ⁷/₁₆ x 10 ³/₁₆ in.)
84.XM.956.384
MARKS & INSCRIPTIONS: (Verso, mount) at l. right, in pencil, by Evans, *PL212/ CAT.280*; at l. left, in pencil, Crane no. *L72.35(Evans)*.
REFERENCES: *ANA-WE, no. 212 (ANA-JJS, no. 280).

378
[*Bell. Benin, British Nigeria**], 1935
25.3 x 20.1 cm (9 ³¹/₃₂ x 7 ¹⁵/₁₆ in.)
84.XM.488.29
MARKS & INSCRIPTIONS: (Verso) at u. left, in pencil, *2/4/2S*; at u. center, in pencil, *273*; at l. center, Lunn Gallery stamp, and within boxes, in pencil, *XX* and *273*; at l. left, in pencil, Wagstaff no. *Evans 38*.
PROVENANCE: Lunn Gallery/Graphics International, Ltd.; Samuel Wagstaff, Jr.
REFERENCES: *ANA-WE, no. 220 (ANA-JJS, no. 273).

379
[*Belt Ornament in Form of Leopard. Benin, British Nigeria.**], 1935
Image: 12.1 x 23 cm (4 ²⁵/₃₂ x 9 ¹/₁₆ in.); original mount: 31.5 x 25.9 cm (12 ⁷/₁₆ x 10 ³/₁₆ in.)
84.XM.956.425
MARKS & INSCRIPTIONS: (Recto, mount) at l. left, in pencil, *p*; at l. right, *287*; (verso, mount) at l. left, in pencil, Crane no. *L72.6(Evans)*.
REFERENCES: *ANA-WE, no. 226 (ANA-JJS, no. 287).

380

382

381

380
[Necklet. Benin, British Nigeria.*]/
[Collar. Benin.**], 1935
Image: 11.2 x 21.7 cm (4 ¹³⁄₃₂ x 8 ⁵⁄₁₆ in.);
original mount: 31.5 x 25.9 cm
(12 ⁷⁄₁₆ x 10 ³⁄₁₆ in.)
84.XM.956.418
MARKS & INSCRIPTIONS: (Verso, mount) at
l. right, in pencil, by Evans, PL.227/
CAT.289; at l. left, in pencil, Crane
no. L72.40(Evans).
REFERENCES: *ANA-WE, no. 227
(**ANA-JJS, no. 289).

381
[Seat with Figures. Cameroon. Yoko.*],
1935
Image: 16.1 x 14.2 cm
(6 ¹¹⁄₃₂ x 5 ¹⁹⁄₃₂ in.); original mount:
31.5 x 25.9 cm (12 ⁷⁄₁₆ x 10 ³⁄₁₆ in.)
84.XM.956.414
MARKS & INSCRIPTIONS: (Recto, mount)
at l. left, in pencil, E; at l. right, in
pencil, 336; (verso, mount) at l. left,
in pencil, Crane no. L72.24(Evans).
REFERENCES: *ANA-WE, no. 288
(ANA-JJS, no. 336); AFAS, no. 69.

382
[Necklet. Benin. British Nigeria*],
1935
Image: 11.9 x 21.5 cm
(4 ²³⁄₃₂ x 8 ⁷⁄₁₆ in.); original mount:
31.5 x 25.9 cm (12 ⁷⁄₁₆ x 10 ³⁄₁₆ in.)
84.XM.956.405
MARKS & INSCRIPTIONS: (Verso, mount) at
l. right, in pencil, by Evans, PL.228/
CAT.291; at l. left, in pencil, Crane
no. L72.36(Evans).
REFERENCES: *ANA-WE, no. 228
(ANA-JJS, no. 291).

383
[Armlet. Benin. British Nigeria*], 1935
Image: 12.2 x 16.6 cm
(4 ¹³⁄₁₆ x 6 ⁹⁄₁₆ in.); original mount:
31.5 x 25.9 cm (12 ⁷⁄₁₆ x 10 ³⁄₁₆ in.)
84.XM.956.404
MARKS & INSCRIPTIONS: (Verso, mount) at
l. right, in pencil, by Evans, pl.229/
CAT.288; at l. left, in pencil, Crane
no. L72.38(Evans).
REFERENCES: *ANA-WE, no. 229
(ANA-JJS, no. 288).

383

384

385

387

384
[*Armlet. Benin. British Nigeria.**],
1935
Image: 13.9 x 17.6 cm (5 ½ x 6 ¹⁵⁄₁₆ in.);
original mount: 31.5 x 25.9 cm
(12 ⁷⁄₁₆ x 10 ³⁄₁₆ in.)
84.XM.956.383
MARKS & INSCRIPTIONS: (Verso, mount) at
l. right, in pencil, by Evans, *pl. 230/*
CAT.290; at l. left, in pencil, Crane
no. *L72.37(Evans)*.
REFERENCES: *ANA-WE, no. 230
(ANA-JJS, no. 290).

385
[*Head. (Plaster Reproduction). Ife, British Nigeria. Yoruba.**]/[*Plaster Cast of
Terra Cotta Head. Yoruba.***], 1935
Image: 30.1 x 16.4 cm (7 ¹⁵⁄₁₆ x 6 ⁷⁄₁₆ in.);
original mount: 31.5 x 25.9 cm
(12 ⁷⁄₁₆ x 10 ³⁄₁₆ in.)
84.XM.956.406
MARKS & INSCRIPTIONS: (Recto, mount)
at l. left, in pencil, *236*; (verso, mount)
at l. left, in pencil, Crane no. *L72.43*
(Evans).
REFERENCES: *ANA-WE, no. 236
(**ANA-JJS, no. 294).

386
[*Head (Plaster Reproduction); Ife, British Nigeria; Yoruba**]/[*Plaster Cast of
Terracotta Head; Yoruba***], 1935
Image: 20.1 x 16.4 cm (7 ¹⁵⁄₁₆ x 6 ⁷⁄₁₆ in.);
original mount: 31.5 x 25.9 cm
(12 ⁷⁄₁₆ x 10 ³⁄₁₆ in.)
84.XM.956.399
MARKS & INSCRIPTIONS: (Recto, mount)
at l. left, in pencil, *236*; (verso, mount)
at l. center, Evans stamp A; at l. left,
in pencil, Crane no. *L73.6(Evans)*.
REFERENCES: *ANA-WE, no. 236
(**ANA-JJS, no. 294).
NOTE: Not illustrated; duplicate of
no. 385.

387
[*Head. (Plaster Reproduction). Ife, British Nigeria. Yoruba.**], 1935
Image: 20.3 x 12.4 cm (8 x 4 ⅞ in.);
original mount: 31.4 x 26 cm
(12 ⅜ x 10 ⁷⁄₃₂ in.)
84.XM.956.389
MARKS & INSCRIPTIONS: (Recto) at
u. right, in pencil, *L*; (verso, mount)
at l. center, Evans stamp A; at l. left,
in pencil, Crane no. *L73.10(Evans)*.
REFERENCES: *ANA-WE, no. 239
(ANA-JJS, no. 296); WEAW, p. 116
(variant, u. right image).

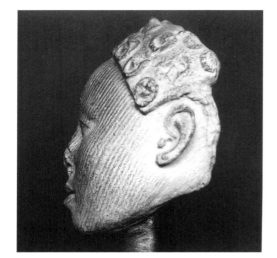

388

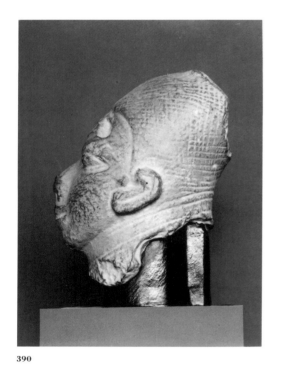

390

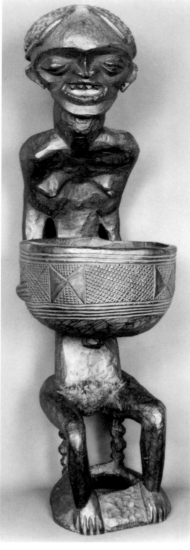

392

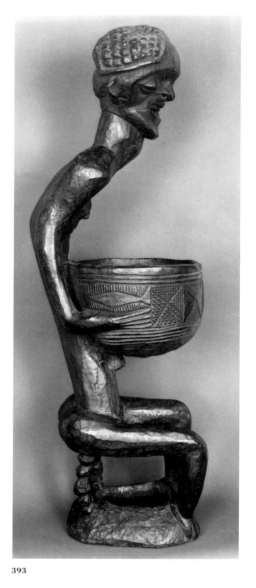

393

388
[*Head. (Plaster Reproduction). Ife, British Nigeria. Yoruba. Profile View**]/
[*Plaster Cast of Terra Cotta Head. Yoruba.***], 1935
Image: 18.1 x 17.5 cm (7 ⅛ x 6 ⅞ in.); original mount: 31.5 x 25.9 cm (12 ⁷⁄₁₆ x 10 ³⁄₁₆ in.)
84.XM.956.420
MARKS & INSCRIPTIONS: (Verso, mount) at l. right, in pencil, by Evans, *PL.240/CAT.296* at l. left, in pencil, Crane no. *L72.39(Evans).*
REFERENCES: *ANA-WE, no. 240 (**ANA-JJS, no. 296).

389
[*Head. (Plaster Reproduction). Ife, British Nigeria. Yoruba. Profile View**]/
[*Plaster Cast of Terra Cotta Head. Yoruba.***], 1935
Image: 21 x 16.4 cm (8 ⁹⁄₃₂ x 6 ¹⁵⁄₃₂ in.); original mount: 31.5 x 25.9 cm (12 ⁷⁄₁₆ x 10 ³⁄₁₆ in.)
84.XM.956.398
MARKS & INSCRIPTIONS: (Recto, mount) at l. left, wet stamp, *240*; (verso, mount) at u. center, Evans stamp A; at l. center, in pencil, Crane no. *L73.7 (Evans).*

REFERENCES: *ANA-WE, no. 240 (**ANA-JJS, no. 296).
NOTE: Not illustrated; variant of no. 388.

390
[*Head. (Plaster Reproduction); Ife, British Nigeria; Yoruba**]/[*Plaster Cast of Terra Cotta Head; Yoruba***], 1935
Image: 18.6 x 13.6 cm (7 ¹¹⁄₃₂ x 5 ¹¹⁄₃₂ in.); original mount: 31.5 x 25.9 cm (12 ⁷⁄₁₆ x 10 ³⁄₁₆ in.)
84.XM.956.397

MARKS & INSCRIPTIONS: (Recto, mount) at l. left, in pencil, *242*; (verso, mount) at l. center, Evans stamp A; at l. left, in pencil, Crane no. *L73.8(Evans).*
REFERENCES: *ANA-WE, no. 242 (**ANA-JJS, no. 297).

391
[*Head. (Plaster Reproduction). Ife, British Nigeria. Yoruba. Profile View.**]/
[*Plaster Cast of Terra Cotta Head. Yoruba.***]
1935

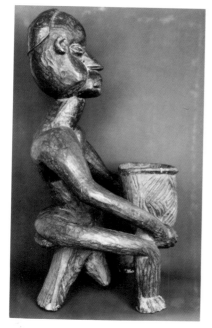

394

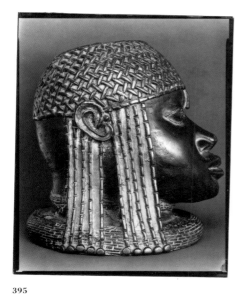

395

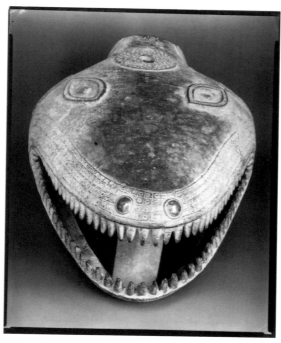

396

MARKS & INSCRIPTIONS: (Recto, mount) at l. left, in pencil, *323*; (verso, mount) at l. left, in pencil, Crane no. *L72.30 (Evans)*.
REFERENCES: *ANA-WE, no. 261 (**ANA-JJS, no. 323); ***AFAS, no. 66.

394
[*Seated Figure with Bowl. Cameroon. Bamileke. Profile View.**], 1935
Image: 23.3 x 13.8 cm (9 ³/₁₆ x 5 ⁷/₁₆ in.); original mount: 31.5 x 25.9 cm (12 ⁷/₁₆ x 10 ³/₁₆ in.)
84.XM.956.427
MARKS & INSCRIPTIONS: (Recto, mount) at l. left, in pencil, *264*; (verso, mount) at l. left, in pencil, Crane no. *L72.15 (Evans)*.
REFERENCES: *ANA-WE, no. 264 (ANA-JJS, no. 320).

395
[*Head. Benin. British Nigeria**], 1935
25.3 x 20.1 cm (9 ³¹/₃₂ x 7 ²⁹/₃₂ in.)
84.XM.488.24
MARKS & INSCRIPTIONS: (Verso) at center, in pencil, *264/6* [sideways]; at right center, Lunn Gallery stamp, and within boxes, in pencil, *XX* and *264*; at l. right, in pencil, Wagstaff no. *Evans 37*.
PROVENANCE: Lunn Gallery/Graphics International, Ltd.; Samuel Wagstaff, Jr.
REFERENCES: *ANA-WE, no. 191 (ANA-JJS, no. 264); AFAS, no. 126.

396
[*Head of Serpent or Crocodile. Benin, British Nigeria**]/[*Reptile Head. Bronze. Benin, Nigeria***], 1935
25.2 x 20.2 cm (9 ¹⁵/₁₆ x 7 ³¹/₃₂ in.)
84.XM.488.31
MARKS & INSCRIPTIONS: (Recto) in negative, at u. left top edge, *DEFENDER SAFETY BASE*; (verso) at l. right, in pencil, Lunn Gallery stamp, and within boxes, in pencil, *XX* and *250* and Wagstaff no. *Evans.36*.
PROVENANCE: Lunn Gallery/Graphics International, Ltd.; Samuel Wagstaff, Jr.
REFERENCES: *ANA-WE, no. 214 (ANA-JJS, no. 250); **AFAS, no. 121.

Image: 18.6 x 13.8 cm (7 ⁵/₁₆ x 5 ⁷/₁₆ in.); original mount: 31.5 x 25.9 cm (12 ⁷/₁₆ x 10 ³/₁₆ in.)
84.XM.956.432
MARKS & INSCRIPTIONS: (Verso, mount) at l. left, in pencil, Crane no. *L72.17 (Evans)*.
REFERENCES: *ANA-WE, no. 242 (**ANA-JJS, no. 297).
NOTE: Not illustrated; duplicate of no. 390.

392
[*Seated Figure with Bowl. Cameroon. Bangwa.**]/[*Seated Figure of Woman. Bangwa.***]/[*Mendicant Figure with a Bowl, Bangwa, French Cameroons. Front View.****], 1935
Image: 23.8 x 8.1 cm (9 ¹³/₃₂ x 3 ³/₁₆ in.); original mount: 31.5 x 25.9 cm (12 ⁷/₁₆ x 10 ³/₁₆ in.)
84.XM.956.412
MARKS & INSCRIPTIONS: (Recto, mount) at l. left, in pencil, *323*; (verso, mount) at l. left, in pencil, Crane no. *L72.31 (Evans)*.

REFERENCES: *ANA-WE, no. 260 (**ANA-JJS, no. 323); ***AFAS, no. 67.

393
[*Seated Figure with Bowl. Cameroon. Bangwa. Profile View.**]/[*Seated Figure of Woman. Cameroon.***]/[*Mendicant Figure with Bowl. Wood. Bangwa. French Cameroons***], 1935
Image: 23.6 x 9.6 cm (9 ⁵/₁₆ x 3 ²⁵/₃₂ in.); original mount: 31.5 x 25.9 cm (12 ⁷/₁₆ x 10 ³/₁₆ in.)
84.XM.956.411

397

400

398

401

397
[*Mask. British Nigeria.**]/[*Polychrome Mask.***], 1935
Image: 24.4 x 17.2 cm (9 ⅝ x 6 ²⁵⁄₃₂ in.); original mount: 31.5 x 25.9 cm (12 ⁷⁄₁₆ x 10 ³⁄₁₆ in.)
84.XM.956.424
MARKS & INSCRIPTIONS: (Recto, mount) at l. left, in pencil, *p*; at l. right, in pencil, *304*; (verso, mount) at l. left, in pencil, Crane no. *L72.10*(*Evans*).
REFERENCES: *ANA-WE, no. 249 (**ANA-JJS, no. 304).

398
[*Ancestral Figure, Southern Cameroon, Border of Gabun. Profile View.**], 1935
Image: 24 x 10.7 cm (9 ½ x 4 ⁷⁄₃₂ in.); original mount: 31.5 x 25.9 cm (12 ⁷⁄₁₆ x 10 ³⁄₁₆ in.)
84.XM.956.376
MARKS & INSCRIPTIONS: (Recto, mount) at l. left, in pencil, *P*; at l. right, in pencil, *322*; (verso, mount) l. left, in pencil, Crane no. *L72.25*(*Evans*).
REFERENCES: *ANA-WE, no. 268 (ANA-JJS, no. 322).

399
[*Ancestral Figure. Southern Cameroon, Border of Gabun. Profile View.**], 1935
Image: 23.6 x 8.9 cm (9 ⁹⁄₃₂ x 3 ½ in.); original mount: 31.5 x 25.9 cm (12 ⁷⁄₁₆ x 10 ³⁄₁₆ in.)
84.XM.956.423
MARKS & INSCRIPTIONS: (Recto, mount) at l. left, in pencil, *268*; (verso, mount) at l. left, in pencil, Crane no. *L72.1* (*Evans*).
REFERENCES: *ANA-WE, no. 268 (ANA-JJS, no. 322).
NOTE: Not illustrated; duplicate of no. 398.

400
[*Head. Cameroon.**]/[*Head with Traces of Polychrome.***], 1935
Image: 18.5 x 18.8 cm (7 ⁹⁄₃₂ x 7 ⅜ in.); original mount: 31.5 x 25.9 cm (12 ⁷⁄₁₆ x 10 ³⁄₁₆ in.)
84.XM.956.401
MARKS & INSCRIPTIONS: (Recto, mount) at l. right, in pencil, *317*; (verso, mount) at l. left, in pencil, Crane no. *L72.26*(*Evans*).
REFERENCES: *ANA-WE, no. 269 (**ANA-JJS, no. 317).

402

403

404

405

401

[Mask. Cameroon.], 1935
Image: 23.8 x 16.2 cm (9 ⅜ x 6 ⁷⁄₁₆ in.);
original mount: 31.5 x 26 cm
(12 ⁷⁄₁₆ x 10 ¼ in.)
84.XM.956.393
MARKS & INSCRIPTIONS: (Verso) at l. center, Evans stamp A; at l. left, in pencil, Crane no. *L73.2(Evans)*.
REFERENCES: *ANA-WE, no. 277
(ANA-JJS, no. 328).

402

[Janus Head. Cross River. Cameroon. Ekoi.], 1935
24 x 18.1 cm (9 ½ x 7 ⅛ in.)
84.XM.488.26
MARKS & INSCRIPTIONS: (Verso) at l. center, in pencil, *a2, 12s, 25 w* [inverted]; at right center, Lunn Gallery stamp, and within boxes, in pencil, *XX* and *332*; at l. right, in pencil, Wagstaff no. *Evans 39*.
PROVENANCE: Lunn Gallery/Graphics International, Ltd.; Samuel Wagstaff, Jr.
REFERENCES: *ANA-WE, no. 282
(ANA-JJS, no. 332).

403

[Janus Head. Cameroon.]/[*Janus Mask.***], 1935
Image: 24.9 x 13.2 cm (9 ¹³⁄₃₂ x 5 ⁷⁄₃₂ in.); original mount: 31.5 x 25.9 cm
(12 ⁷⁄₁₆ x 10 ³⁄₁₆ in.)
84.XM.956.410
MARKS & INSCRIPTIONS: (Recto, mount) at l. left, in pencil, *325*; (verso, mount) at l. left, in pencil, Crane no. *L72.32 (Evans)*.
REFERENCES: *ANA-WE, no. 284
(**ANA-JJS, no. 325).

404

[Pipe Bowl. Cameroon. Bamum (?)]/ [*Pipe Bowl in Form of Head***], 1935
Image: 24.2 x 14.5 cm
(9 ¹⁷⁄₃₂ x 5 ²³⁄₃₂ in.); original mount: 31.5 x 25.9 cm (12 ⁷⁄₁₆ x 10 ³⁄₁₆ in.)
84.XM.956.415
MARKS & INSCRIPTIONS: (Recto, mount) at l. left, in pencil, *P*; at l. right, in pencil, *341*; (verso, mount) at l. left, in pencil, Crane no. *L72.34(Evans)*.
REFERENCES: *ANA-WE, no. 295
(**ANA-JJS, no. 341).

405

[Ancestral Figure. Gabun. Pahouin (Fan).], 1935
Image: 23.5 x 8.9 cm (9 ¼ x 3 ½ in.); original mount: 31.5 x 25.9 cm
(12 ⁷⁄₁₆ x 10 ³⁄₁₆ in.)
84.XM.956.396
MARKS & INSCRIPTIONS: (Recto) at u. right, in pencil, *S*; (verso, mount) at l. center, Evans stamp A; at l. left, in pencil, Crane no. *L73.11(Evans)*.
REFERENCES: *ANA-WE, no. 307
(ANA-JJS, no. 357).

406

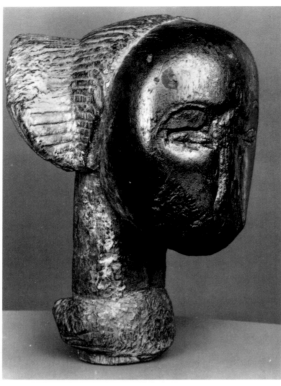

407

408

411

406
[*Ancestral Figure. Head. Gabun. Pahouin (Fan).**], 1935
Image: 23.4 x 13.9 cm (9 ¼ x 5 ¹⁵⁄₃₂ in.); original mount: 31.5 x 25.9 cm (12 ⁷⁄₁₆ x 10 ³⁄₁₆ in.)
84.XM.956.428
MARKS & INSCRIPTIONS: (Recto, mount) at l. left, in pencil, *313*; (verso, mount) at l. left, in pencil, Crane no. *L72.14 (Evans)*.
REFERENCES: *ANA-WE, no. 313 (ANA-JJS, no. 363).

407
[*Ancestral Figure, Head. Gabun. Pahouin (Fan).**], 1935
Image: 22.4 x 16.2 cm (8 ²⁷⁄₃₂ x 6 ¹¹⁄₃₂ in.); original mount: 31.5 x 25.9 cm (12 ⁷⁄₁₆ x 10 ³⁄₁₆ in.)
84.XM.956.377
MARKS & INSCRIPTIONS: (Verso, mount) at l. right, in pencil, by Evans, *PL.314/ CAT.365* at l. left, in pencil, Crane no. *L72.18(Evans)*.
REFERENCES: *ANA-WE, no. 314 (ANA-JJS, no. 365).

408
[*Necklet. Gabun. Pahouin (Fan).**], 1935
Image: 12.4 x 18 cm (4 ⁷⁄₈ x 7 ³⁄₃₂ in.); original mount: 25.4 x 30.5 cm (10 x 12 in.)
84.XM.956.387
MARKS & INSCRIPTIONS: (Verso, mount) at right center, Evans stamp A; (recto, mat) at l. left, in pencil, Crane no. *L73.5(Evans)*.
REFERENCES: *ANA-WE, no. 334 (ANA-JJS, no. 390).

409
[*Mask/ French Congo**]/[*Mask. Polychrome Wood. French Middle Congo***], 1935
Image: 18.3 x 19.3 cm (7 ³⁄₁₆ x 7 ⁹⁄₁₆ in.); original mount: 31.4 x 25.8 cm (12 ³⁄₈ x 10 ³⁄₁₆ in.)
84.XM.956.379
MARKS & INSCRIPTIONS: (Recto, mount) at l. left, in pencil, *414*; (verso, mount) at l. left, in pencil, Crane no. *L72.11(Evans)*.
REFERENCES: *ANA-WE, no. 358 (ANA-JJS, no. 414); **AFAS, no. 21.

409

410

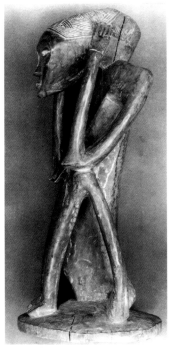

412

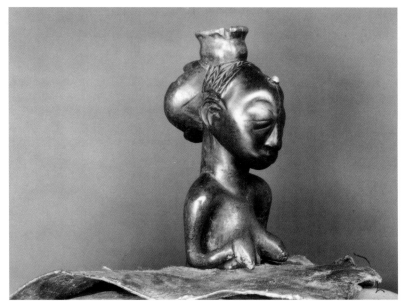

413

410
[*Four Musical Instruments. French Congo. Loango (?)**], 1935
Image:, 19.6 x 19.2 cm (7 ¾ x 7 ⁷⁄₁₆ in.); original mount: 31.5 x 25.9 cm (12 ⁷⁄₁₆ x 10 ³⁄₁₆ in.)
84.XM.956.403
MARKS & INSCRIPTIONS: (Verso, mount) at l. left, in pencil, Crane no. *L72.29 (Evans).*
REFERENCES: *ANA-WE, no. 363 (ANA-JJS, nos. 424–27).

411
[*Figure Stuck with Nails. Belgian Congo. Region of Cabinda.**]/[*Figure Studded with Nails, Called "Konde." Cabinda Region.***], 1935
Image: 24.2 x 10.4 cm (9 ⁹⁄₁₆ x 4 ¹⁄₁₆ in.); original mount: 31.5 x 25.9 cm (12 ⁷⁄₁₆ x 10 ³⁄₁₆ in.)
84.XM.956.433
MARKS & INSCRIPTIONS: (Recto, mount) at l. left, in pencil, *E* [crossed out]; at l. right, in pencil, *436;* at l. left, in pencil, Crane no. *L72.23(Evans).*
REFERENCES: *ANA-WE, no. 376 (**ANA-JJS, no. 436).

412
[*Figure. Belgian Congo. Badjok. Profile View.**]/[*Figure of Woman. Possibly From Vimbundu. Southern Angola.***], 1935
Image: 23.8 x 11.3 cm (9 ⅜ x 4 ¹⁵⁄₃₂ in.); original mount: 31.4 x 25.9 cm (12 ⅜ x 10 ³⁄₁₆ in.)
84.XM.956.390
MARKS & INSCRIPTIONS: (Verso, mount) at l. center, Evans stamp A; at l. right, in pencil, *Pl466? (pref)/CAT.586;* at l. left, in pencil, Crane no. *L73.14(Evans)* [number 4 partially erased].
REFERENCES: *ANA-WE, no. 380 (**ANA-JJS, no. 586).

413
[*Figure, Surmounting a Calabash. Belgian Congo. Urua.**]/[*Figure. Wood. Surmounting a Calabash, with Shells. Warua, Belgian Congo***], 1935
18.2 x 23.3 cm (7 ³⁄₁₆ x 9 ³⁄₁₆ in.)
84.XM.488.27
MARKS & INSCRIPTIONS: (Verso) at center, in pencil, *489;* at center, Lunn Gallery stamp, and within boxes, in pencil, *XX* and *489.*
PROVENANCE: Lunn Gallery/Graphics International, Ltd.; Samuel Wagstaff, Jr.
REFERENCES: *ANA-WE, no. 382 (ANA-JJS, no. 489); **AFAS, no. 96.

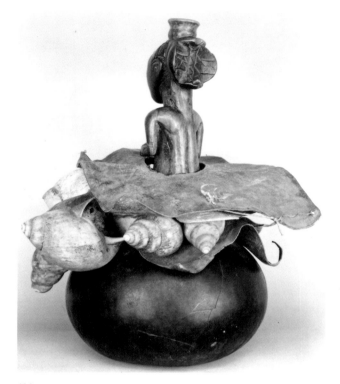

414

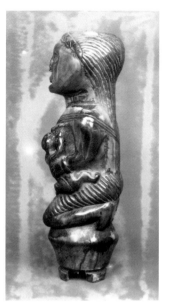

415

416

417

414
[*Figure, Surmounting a Calabash. Belgian Congo. Urua. Back View.**], 1935
Image: 24.3 x 19.2 cm (9 ⁹⁄₁₆ x 7 ⁷⁄₁₆ in.);
original mount: 31.5 x 25.9 cm
(12 ⁷⁄₁₆ x 10 ³⁄₁₆ in.)
84.XM.956.378
MARKS & INSCRIPTIONS: (Verso, mount) at
l. right, in pencil, by Evans, *PL.383/
CAT.489* at l. left, in pencil, Crane
no. *L72.7(Evans).*
REFERENCES: *ANA-WE, no. 383
(ANA-JJS, no. 489); AFAS, no. 97.

415
[*Woman and Child. Belgian Congo.
WaRegga. Profile View.**], 1935
Image: 20.1 x 10.6 cm (7 ²⁹⁄₃₂ x 4 ³⁄₁₆ in.);
original mount: 31.5 x 25.9 cm
(12 ⁷⁄₁₆ x 10 ³⁄₁₆ in.)
84.XM.956.395
MARKS & INSCRIPTIONS: (Recto, mount)
at l. left, in pencil, *400*; (verso, mount)
at u. center, Evans stamp B and Crane
stamp; at center, in pencil, by Arnold
Crane, *African Primitive Art/1936*; at
u. center, in pencil by Arnold Crane,
withdrawn/12/71/AHC [all erased];
at l. left, in pencil, Crane no. *L73.1
(Evans).*

REFERENCES: *ANA-WE, no. 400
(ANA-JJS, no. 516).

416
[*Head. Belgian Congo. WaRegga.**]/
[*Head. Ivory. Warega. Belgian
Congo***], 1935
Image: 17.7 x 12.3 cm (7 x 4 ²⁷⁄₃₂ in.);
original mount: 31.5 x 25.9 cm
(12 ⁷⁄₁₆ x 10 ³⁄₁₆ in.)
84.XM.956.385
MARKS & INSCRIPTIONS: (Recto, mount)
at l. right, in pencil, *515*; (verso,
mount) at l. left, in pencil, Crane
no. *L72.22(Evans).*

REFERENCES: *ANA-WE, no. 404
(ANA-JJS, no. 515); **AFAS, no. 157.

417
[*Mask. Belgian Congo.**]/[*Polychrome
Mask.***]/[*Mask. Polychrome Wood.
Basonge Mino, Belgian Congo****]/
[*Mask. Teke. People's Republic of the
Congo*], 1935
Image: 19.2 x 18.6 cm
(7 ⁹⁄₁₆ x 7 ⁵⁄₁₆ in.); original mount:
31.5 x 25.9 cm (12 ⁷⁄₁₆ x 10 ³⁄₁₆ in.)
84.XM.956.417
MARKS & INSCRIPTIONS: (Verso, mount) at
l. right, in pencil, by Evans, *PL.410/*

418

419

420

CAT.458; at l. left, in pencil, Crane no. L72.5(Evans).
REFERENCES: *ANA-WE, no. 410 (**ANA-JJS, no. 458); ***AFAS, no. 29.

418
[Mask. Belgian Congo. BaYaka. Profile View.*], 1935
Image: 16.6 x 22.1 cm
(6 17/32 x 8 23/32 in.); original mount: 31.5 x 25.9 cm (12 7/16 x 10 3/16 in.)
84.XM.956.382
MARKS & INSCRIPTIONS: (Verso, mount) at l. right, in pencil, by Evans, PL.423/

CAT.417 at l. left, in pencil, Crane no. L72.19(Evans).
REFERENCES: *ANA-WE, no. 424 (ANA-JJS, no. 417).

419
[Cylindrical Box with Cover. Belgian Congo. Mangbetu.*]/[Box with Woman's Head on Cover. Mangbetu.**], 1935
Image: 24.2 x 11.7 cm
(9 17/32 x 4 5/8 in.); original mount: 31.5 x 25.9 cm (12 7/16 x 10 3/16 in.)
84.XM.956.429
MARKS & INSCRIPTIONS: (Recto, mount) at l. right, in pencil, 502; (verso,

mount) at l. left, in pencil, Crane no. L72.13(Evans).
REFERENCES: *ANA-WE, no. 446 (**ANA-JJS, no. 502).

420
[Mask. British East Africa. Tanganyika Lake District. Three-Quarter View.*], 1935
Image: 24 x 17.2 cm (9 15/32 x 6 3/4 in.); original mount: 31.5 x 25.9 cm (12 7/16 x 10 3/16 in.)
84.XM.956.392
MARKS & INSCRIPTIONS: (Verso, mount) at l. center, Evans stamp A; at l. right,

in pencil, by Evans, PL.471.3/4 view/ CAT.592; at l. left, in pencil, Crane no. L73.13(Evans).
REFERENCES: *ANA-WE, no. 472 (ANA-JJS, no. 592).

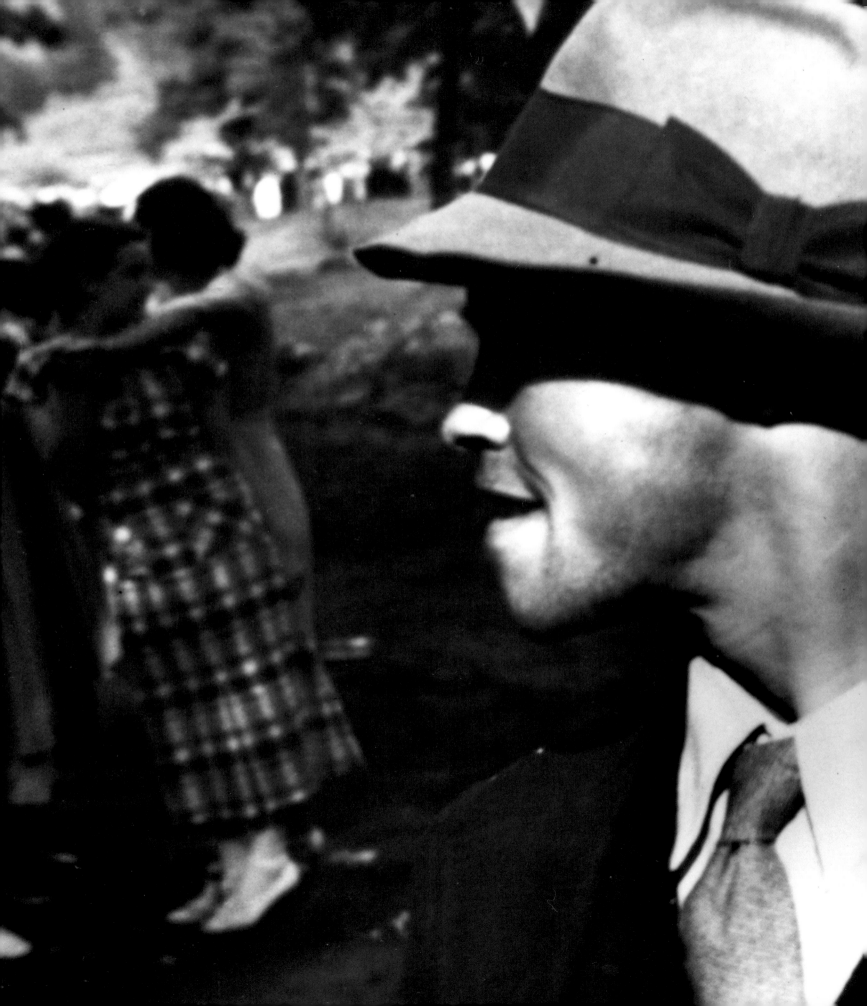

AMERICAN PHOTOGRAPHS[1]: EVANS IN MIDDLETOWN

Tom Mabry of the Museum of Modern Art was in my place the other day looking at pictures and he said he would like to have some he picked out simply as a group of photographs for the Museum to have in its collection. Among the choices were about twenty prints of work I have done at Resettlement. I thought that would be OK by you, but just let me know, will you. It's not very important as the pictures will not travel or be exhibited, just be there for anyone who is interested.

Walker Evans to Roy Stryker, April 12, 1938[2]

The Museum of Modern Art was very interested indeed in Walker Evans's work, and things happened quickly for him there. The files of the registrar at the museum reveal that a little more than two weeks after the above communication between Evans and Stryker, Thomas Mabry, then Executive Director, wrote to Lincoln Kirstein, reminding him that he had agreed to prepare an essay on Evans's work. Mabry also offered rather specific suggestions as to the content of that promised piece:

> *You know much more about Walker's work than I do. However I should think that you might want to define as simply and clearly as possible the difference between Walker's work and the majority of photographers both "documentary" and "lyric." Also I think that the article should not have an* in memoriam *flavor. The canonization of the commonplace that documentary photography has turned into*

Walker Evans. *Independence Day, Terra Alta, West Virginia* (detail), 1935 [no. 432].

(Margaret Bourke-White, "Life" photographers, and much of the Federal Art Project photography) is just as bad to me as any kind of Herald Tribune beautiful baby contest photography. Also, turning the commonplace into something precious, exquisite, etched and fabulous (Weston and Strand, to a degree) is equally bad. Incidentally, I think that some of Stieglitz's early work is very good.[3]

Kirstein, then director of the American Ballet Company, is often credited with orchestrating the book and exhibition that have become known as *American Photographs*.[4] However, it would seem that Mabry, another member of Evans's circle, was actually the moving force behind MoMA's sponsorship of these two important events of 1938. A Harvard-educated Tennessean who had contributed poetry and book reviews to Kirstein's *Hound & Horn*, Mabry was associated with the Marie Sterner Galleries and was a cofounder of the John Becker Gallery before joining the Museum's staff in 1935. He would be a lifelong friend of Evans's; his efforts to promote the photographer's work in 1938 were a watershed.[5] In an article on the exhibition

that Mabry himself prepared for the November 1938 issue of *Harper's Bazaar*, he boldly predicted the power of this venue:

> *During the month of October, the Museum of Modern Art opened its first one-man show of photography: the work of the American photographer, Walker Evans. Until recently known only to comparatively few people, Evans possesses perhaps the purest "eye" of any photographer of our generation. The exhibition at the Museum, which has attracted an unusual amount of interest among diverse types of people, is also accompanied by the production of a book of Evans's work, "American Photographs," which more than anything else will acquaint the public with the unique quality of his photographs.*[6]

The director had also, apparently over Evans's objections, submitted a biographical sketch to *Harper's* that emphasized his Midwestern upbringing and Mabry's belief that, although he had spent time in Europe, Evans "never for a moment became Europeanized" or tried to "identify himself with the European mind."[7] In his November article, Mabry dwells on the American characteristics of Evans's pictures, particularly those of architecture, pointing to the "unique American buildings, not the skyscraper (you won't find a skyscraper here) but the wooden ones" such as "the series of wooden churches," "those elaborate New England Gothic memories," and the "Louisiana Greek revival long lost."[8]

For Evans, these events at MoMA meant an opportunity to exhibit and publish his photographs, especially those made since 1935 for the United States Resettlement Administration (RA), in a format of his own choosing.[9] In a June 1938 letter to Roy Stryker, his former boss at the RA—a letter that, surprisingly, does not mention the *American Photographs* exhibition—Evans expresses his delight in this possibility: "The Mus. Mod. Art wants to publish me covering the range of ten years work. I am accepting although the book has to be arranged quickly. I have most of the Resettlement prints I want included here, no time to come to Washington about it. I told them to write to you about it, for permission, etc. It's a good idea, good as corrective. Hope you'll like it."[10]

When Evans was officially hired in October 1935 as an Information Specialist by the Historical Section of the Resettlement Administration, his duties were described as follows: "Under the general supervision of the Chief of the Historical Section with wide latitude for the exercise of independent judgement and decision as Senior Information Specialist to carry out special assignments in the field; collect, compile and create photographic material to illustrate factual and interpretive news releases and other informational material upon all problems, progress and activities of the Resettlement Administration."[11] Evans was to make liberal use of his right to exercise "independent judgement" during his time with the RA, and he perpetually resisted the idea that his purpose there was to gather illustrations for the promotion of the RA's (that is, the federal government's New Deal) programs. While considering a position with the RA in the spring of 1935, he jotted down those things he would require of his employer, including the "guarantee of one-man performance," and what he would provide, adding that he should not be asked to do anything more in the way of political propaganda: "[I] Mean never [to] make photographic statements for the government or do photographic chores for gov or anyone in gov, no matter how powerful—this is pure record not propaganda. The value and, if you like, even the propaganda value for the government lies in the record itself which in the long run will prove an intelligent and farsighted thing to have done. NO POLITICS whatever."[12]

Because his pictures had been issued by the

agency with policy-approved captions for the past three years, Evans felt the need in 1938 to distance himself from that establishment, as well as the world of commercial publishing, by prefacing *American Photographs* with this statement: "The responsibility for the selection of the pictures used in this book has rested with the author, and the choice has been determined by his opinion: therefore they are presented without sponsorship or connection with the policies, aesthetic or political, of any of the institutions, publications or government agencies for which some of the work has been done."[13] Stryker's business was to provide informative images to the mass media, and he and Evans would always disagree about the most appropriate vehicle for the latter's photographs, as well as the definition of "documentary." But when the photography project of the RA began, the two men were able to agree on its primary subject: American history as exemplified by life in the average American town. Evans's vision for documenting American life had begun to form much earlier; a letter drafted to his friend Ernestine Evans, an editor at J. B. Lippincott, in February of 1934, makes clear his aspirations:

> *What do I want to do? . . . I know now is the time for picture books. An American city is the best, Pittsburgh better than Washington. I know more about such a place. I would want to visit several besides Pittsburgh before deciding. Something perhaps smaller. Toledo, Ohio, maybe. Then I'm not sure a book of photos should be identified locally. American city is what I'm after. . . .*
>
> *People, all classes, surrounded by bunches of the new down-and-out.*
>
> *Automobiles and the automobile landscape.*
>
> *Architecture, American urban taste, commerce, small scale, large scale, the city street atmosphere, the street smell, the hateful stuff,*

women's clubs, fake culture, bad education, religion in decay. . . .[14]

Evans no doubt shared ideas like these with Stryker during their first conversations. The former Columbia University economics student recalls that soon after he came to Washington, he met with Evans: "I saw his pictures, I walked at night with him and I talked to him. He told me about what the photographer was for, what a photographer should do, and he gave me his rationale for pictures. It was extremely interesting because it was opening up a whole new field of ideas."[15]

The two men could find common ground in part due to the widespread influence of the 1929 publication *Middletown: A Study in Modern American Culture* by Robert and Helen Lynd, professors of sociology at Columbia and Sarah Lawrence, respectively. A 550-page field investigation by social anthropologists with subject headings including "What Middletown does to get its living" and "The houses in which Middletown lives," this pioneering project attempted an objective analysis of life in a small Midwestern American city (Muncie, Indiana). The Lynds' study was hailed as a very accessible report that was most appealing because it made "no attempt to prove anything" but simply recorded "what was observed."[16] The Lynds introduced their topic by saying their goal "was to study synchronously the interwoven trends that are the life of a small American city. A typical city, strictly speaking, does not exist, but the city studied was selected as having many features in common to a wide group of communities."[17]

The "Outline Memorandum" that Evans prepared in October 1935, probably at Stryker's request, laying out plans for an eight-week automobile trip through the Southeast, makes reference to *Middletown* and presents thoughts similar to the photographer's musings of 1934:

First objective, Pittsburgh and vicinity, one week; photography, documentary in style, of industrial subjects, emphasis on housing and home life of working-class people. . . .

Ohio Valley: rural architecture, including the historical, contemporary "Middletown" subjects; Cincinatti [sic] housing; notes on style of Victorian prosperous period. . . .

Indiana, Kentucky, Illinois river towns, gather typical documents, main streets, etc., in passing. Ditto Mississippi river towns. Select one of these towns, such as Hannibal, Missouri, for more thorough treatment, if time allows.[18]

This document goes on to list antebellum plantation architecture in Natchez, Mississippi; small rural French towns in Teche Parish, Louisiana; industrial themes in Birmingham, Alabama; and a cotton plantation in South Carolina, as objectives of the proposed trip for gathering still photography of a "general sociological nature." In early 1936, one of *Middletown*'s authors had a chance to directly affect the RA's Photography Section: Stryker showed Robert Lynd, a former Columbia colleague, some RA pictures and asked for his opinion while lunching with him in New York. The result was a "shooting script" for "things which should be photographed as American Background," issued by Stryker to his team of photographers. The script contains an extensive listing of items like "People on and off the job," "How do people look?," "The wall decoration in homes as an index to the different income groups and their reactions," and "A photographic study of use of leisure time in various income groups."[19]

Evans's work for the RA actually began in the summer of 1935, when John Carter, who preceded Stryker, contracted with the photographer to travel to West Virginia and Pennsylvania to photograph some of the Farm Security Administration's Subsistence Homestead Projects and

gather related material.[20] On this early assignment, he photographed miners' homes, local residents at an Independence Day celebration, and main streets (examples of which are seen in nos. 422, 430, and 432). Once Evans was officially on staff, his first trip under Stryker's direction seems to have been an extended fall visit to Bethlehem, Pennsylvania, where steel mills, workers' housing, parading legionnaires, and elaborate gravestones (nos. 437–39, 442) were his subjects. Between November 1935 and April 1936, Evans made two lengthy road trips that would account for the bulk of his entire production for the RA and many of the 169 mid-thirties pictures that follow this essay. From November to mid-January, he returned to industrial centers in Pennsylvania, finally spending some time in Pittsburgh, and went on to Ohio, Kentucky, Tennessee, Alabama, Mississippi, and Louisiana, following to some extent the course outlined in the memorandum above. In February 1936, he left again, with a completely Southern itinerary that would take him through many small cities, some of them renowned for antebellum architecture and Civil War battles, in Louisiana, Mississippi, Alabama, Georgia, Florida, the Carolinas, and Virginia.

In the spring of 1936, funds were evidently scarce for Stryker's photographic forays: a two-week trip to West Virginia, Pennsylvania, New Jersey, and Maryland was authorized for Evans in mid-June, but it is unclear from Stryker's papers whether this assignment was ever completed. A visit to New England was also in the works for that summer, but the trip was canceled. Instead, Stryker approved a furlough for Evans to work on a *Fortune* story with James Agee. This leave for mid-July through mid-September allowed Evans to return to the "middle south" with Agee to prepare "an article on cotton tenantry in the United States, in the form of a photographic and verbal record of the daily lives and environment of an average white family of tenant farmers" (nos. 530–67). [21] According to the terms of Stryker's arrangement with *Fortune*'s art edi-

tor, the pictures Evans produced on this job would become the property of the RA after the magazine had run the finished essay in a fall issue.

Once Evans returned from this trip south, during which he and Agee documented the lives of the Burroughs, Fields, and Tengle families in Alabama, he spent September and October printing his pictures and preparing presentations for both *Fortune* and Stryker.[22] Stryker again talked about a New England trip, on which he planned to accompany the photographer, but it did not materialize, and Evans was once more sent to the South, this time to photograph the catastrophe of flooding in Arkansas and Tennessee. An unusual and demanding assignment for Evans, this trip of late January and February 1937 was made with another RA photographer, Edwin Locke, and required that he spend considerable time in the affected area, photographing the flood victims and their temporary shelters (nos. 576–81).

Although stricken with flu while in Arkansas, Evans apparently spent time in Kentucky, Virginia, and West Virginia towns before completing this trip. This would be his last travel for the RA, an agency that was absorbed into the Farm Security Administration at about this time.[23] Evans's contributions to the RA's documentation of Depression-era America had essentially been obtained between the summer of 1935 and the spring of 1936, a period of less than a year. The Alabama pictures made while on leave to *Fortune* would become his best-known photographs and, ironically, those most closely identified with his work as a New Deal photographer.

The events generated by the Museum of Modern Art in the fall of 1938 could be viewed as the culmination of a highly productive period made possible by the patronage of the federal government. The sequences of images that appeared in the exhibition and book of *American Photographs*, though composed of different selections and gleaned from a decade of the photographer's work, might

just as appropriately have appeared under the title of "Middletown." In fact, Kirstein refers to the Lynds' *Middletown* in his *American Photographs* essay, suggesting that, although Evans's work should not be considered merely "illustrative accompaniment," a study such as theirs "might have been more effective had it also been plotted in visual terms."[24] An article by Anthony West entitled "Middletown and Main Street," one of the most insightful contemporary comments on Evans's subject matter, appeared in *Architectural Review* to mark the publication of *American Photographs*.[25]

Evans's RA images were actually supplied with three prominent vehicles for exposure by the Museum of Modern Art's decision to mount this first one-man show of photographs in 1938. *Walker Evans: American Photographs*, an exhibition of one hundred pictures, was presented at MoMA between September 28 and November 18, 1938; the book, *American Photographs*, a selection of eighty-seven images, thirty-three of which were not seen in the show, was published simultaneously by the museum; and *American Photographs by Walker Evans*, a circulating exhibition of eighty-eight prints, sixteen of which did not appear at MoMA, traveled to ten venues across the country after the show closed in New York.[26] (See Appendix B for a listing of Getty prints involved in each event.)

When one examines the makeup of each of these productions—the installation sequence of the MoMA show now available in the 1993 monograph *Walker Evans: The Hungry Eye*; the groupings designated for the circulating show selections accessible in MoMA files; and the book (reissued in a 1989 anniversary edition)—the complexities of carrying out the entire project become obvious. Intriguing questions of the influence of Mabry, Kirstein, and possibly Beaumont Newhall, then librarian at MoMA, on the installation of the shows and the sequencing of the book, are likewise multiplied.[27] But Evans's original exhibition prints should not be lost sight of in an attempt to sort out the intense activity of 1938.

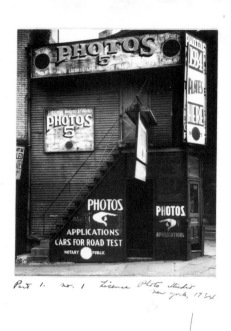

*Part 1. no. 1 License Photo Studio
new york, 1934*

Figure 1. Walker Evans. *License Photo Studio, New York*, 1934 [no. 205].

Within the Getty collection, it is possible to examine at least forty-one of the prints, identified by their MoMA loan numbers and/or labels, created by Evans for the New York show or the traveling exhibition. Based on the images published by Hill and Mora and the installation list for the circulating show contained in MoMA files, it would appear that at least twenty-three of these pictures were finally included in the New York venue, and eighteen of them (such as nos. 498 and 530) were also part of the circulating show. Three other prints were among those inserted into the group to circulate when the exhibition was trimmed in size and reconfigured (with the purpose, it seems, of adding more New York and New England images), but it has not been determined how or whether the remaining fifteen prints were used while on loan to MoMA. Although lacking loan numbers, an additional

group of three Getty prints bear other inscriptions that suggest they were on loan to MoMA in 1938.[28]

Regarding production of the publication *American Photographs*, another selection of thirty-two prints on 11 x 8 1/2-inch, three-hole mounts (fig. 1), with ink inscriptions in an unidentified hand designating the title, date, book part, and plate number, are found at the Getty. Acquired from the photographer by Arnold Crane, these prints seem to be part of the book dummy first assembled to indicate the sequence and captioning of the planned publication. They probably also served as the images from which the reproduction plates were made.

A closer look at two little-known RA images—one that appeared in both exhibition formats and one that appeared only in the book—provides a glimpse of how much the exhibitions and publication differed and of the way in which Evans went about editing his own work. Appearing almost in the very middle of the New York installation of *American Photographs* were two 1937 images of Arkansas flood refugees. One of them—a young African American woman asleep under a quilt in a heavy, metal-frame bed—is found in an almost square Getty print bearing an incomplete MoMA loan number (no. 577). A second image of almost the same size—a person who looks more like an African American man, partially concealed behind a boldly patterned makeshift curtain—is also found at the Getty (no. 576; fig. 2), but this print, apparently of the same vintage, does not possess a loan number or label. Both images have been severely cropped from the original negative.[29] Prints of the two images hung as pendants in the New York show between a photograph of a poor Cuban family from 1933 and a picture of the Tengle family in Hale County, Alabama, singing hymns. The installation list for the circulating version of *American Photographs* calls for these two images to appear together, only this time toward the end of the show, in group XV (of eighteen groupings specified), where they would be part of a larger selection of seven pictures, including three Ala-

Figure 2. Walker Evans. *Flood Refugee,*
Forrest City, Arkansas, 1937 [no. 576].

bama tenant farmer images, two Cuban pictures of working
men and women, and views of factories in Louisiana and
wooden stores in Mississippi.

For the book, however, Evans chose a vertically
oriented print from another negative of the sleeping
woman seen in no. 577. This image (no. 578), which might
seem more invasive than intimate, is even more startling
and unorthodox than the first. It presents the weary flood
victim at bedside level, awake but nestled under the quilt.
Below her on the floor of the old cotton warehouse that is
supplying emergency shelter are a few items of clothing
and a bedpan. Occurring at almost the exact center of the
book—that is, as plate forty-four in a sequence of eighty-
seven images—it falls between a van Gogh-like interior
entitled *Hudson Street Boarding House Detail, New York*
(no. 136) and a portrait of three working-class neighbors
passing the time together in *People in Summer, New York
State Town* (no. 143). As comparative material from this
winter of 1937 Arkansas assignment, three other prints in

the the Getty collection depict African American women
displaced by the flood and huddled in or near a bed due to
cold and illness (nos. 579–81). Like the two images chosen
for the MoMA show, these three reflect substantial cropping
of the negatives in an effort to close in on a single figure
and eliminate the barnlike interior of this uncomfortable
temporary home.[30] Always after portraits of "the anony-
mous people" of Middletown, Evans seems to have taken
full advantage of the unusual vulnerability of these resi-
dents of Forrest City, Arkansas.

Evans had company on this RA assignment, which
must have been one of the hardest emotionally as well as
technically of his career. The report submitted to Stryker
by his more communicative colleague, Edwin Locke, gives
an immediate picture of the conditions the two men found
and the way they attempted to record them. It also con-
firms Evans's perfectionist nature, his persistent determi-
nation to get the right picture, and the reasons why Roy
Stryker, like Tom Mabry, valued his work so highly. The
handwritten letter on hotel stationery reads in part:

> *My God, we are tired tonight! Got up at 6 this morn-*
> *ing, worked until 5:30 PM, made the 6:20 PM train*
> *back to Memphis, having covered the refugee camps*
> *as well as we could without flashes. And now a word*
> *about the camps:*
>
> *1. White camp (about 2 miles away from Negro*
> *camp—we covered this twice on foot with equip-*
> *ment): well run, adequate tent space, good (regular*
> *army) food. A detachment of soldiers from Fort*
> *Leavenworth are running the outfit along with*
> *the CCC. . . .*
>
> *2. The Negro camp: Overcrowded. There are*
> *many more negroes than whites affected by flood*
> *in this area. Found 11 in one tent. They are not*
> *"happy-go-lucky" about it, but dazed, apathetic,*
> *and hopeless. There is a good deal of illness: excruci-*
> *ating coughs, pneumonia and influenza cases lay-*

ing in a dark cotton warehouse. I shot in there with the Leica, but Walker said it was too dark. He bought photoflashes and shot with the 4 x 5, but is afraid that the exposures were wrong. He will undoubtedly want to go back. . . .[31]

Evans and Stryker parted ways, mostly because of the bureaucratic requirements that Stryker adhered to. Working under difficult conditions was certainly not something the photographer shied away from, particularly when he was after the archetypal portrait of "Everyman" that he treasured. In pursuit of this goal, for his next major series Evans would contrive to photograph only by remote shutter release while riding the New York subway in winter.

NOTES

1. Although it has become known simply as *American Photographs*, the exhibition held at MoMA in the fall of 1938 was originally titled *Walker Evans: American Photographs*; the circulating exhibition, of a slightly different composition, was called *American Photographs by Walker Evans*. The book published by MoMA to accompany the two exhibitions was listed by some contemporary reviewers as *Walker Evans: American Photographs*; librarians sometimes catalogue the book as *Walker Evans, American Photographs*. The title page of the book presents Evans's name in slightly smaller type above the words "American Photographs," thus making the exact reading of the title ambiguous and contributing to the continuing controversy over Evans's authorial role. But the book is recorded in the *National Union Catalogue* as *American Photographs*, with Walker Evans given as the author. Throughout this chapter and in the rest of this catalogue, the MoMA exhibition, book, and related traveling exhibition will all be referred to as *American Photographs*.

2. Walker Evans to Roy Stryker, Apr. 12, 1938, in *Roy Stryker Papers (1912–1972)*, edited by David Horvath (University of Louisville, Photographic Archives, 1982). Microfilm edition by Chadwick-Healy, reel 1. Hereafter referred to as *Stryker Papers*.

3. Thomas Mabry to Lincoln Kirstein, Apr. 29, 1938. A letter in the exhibition files for *American Photographs by Walker Evans*, used by permission of the Office of the Registrar, Museum of Modern Art, New York.

4. By virtue of the postscript essay he contributed to *American Photographs*, Kirstein has always been associated

with the show, and Russell Lynes in *Good Old Modern: An Intimate Portrait of the Museum of Modern Art* (New York: Athenaeum, 1973), 158, credits him and Thomas Mabry with putting the exhibition together (saying Beaumont Newhall was not involved in any way). Recent scholarship has tended to emphasize Kirstein's role. In "Walker Evans' American Photographs," an unpublished 1983 thesis for the University of California at Berkeley, Amanda Wick Bowen calls Kirstein the "moving force behind Evans' 1938 show" and goes on to state that Kirstein played a major part in the initiation of the show and in the final selection and installation. Bowen also suggests that it is Kirstein's vision that is reflected in the sequencing of plates in the book. *By With To & From: A Lincoln Kirstein Reader*, edited by Nicholas Jenkins (New York: Farrar, Straus & Giroux, 1991), simply states in the introduction that Kirstein was the organizer of the 1938 show. Douglas R. Nickel in a 1992 article, "*American Photographs* Revisited" (*American Art* 6:2 [Spring 1992], 78–97), does not mention Mabry but credits Kirstein with assisting Evans in the installation of the show at MoMA. More importantly, in focusing on the issue of collaboration in Evans's oeuvre, Nickel calls Kirstein the coauthor of *American Photographs* and reports that he was "largely responsible for the image selection and distinctive pictorial sequencing long credited exclusively to Evans." Citing Director Mabry's support for Kirstein's project, Mora and Hill in *Walker Evans: The Hungry Eye* (New York: Harry N. Abrams, 1993), 160, again name Kirstein as the force behind the show. However, Mora and Hill give Newhall

the responsibility for organizing and initially installing the show; Evans receives sole authorship of the complete last-minute rehanging.

5. Mabry (1903–1969) would leave MoMA the next year, finding employment in the 1940s and 1950s in the Office of War Information, at Time, Inc., and as a teacher at the Iowa Writers' Workshop. Four of his short stories from this period are collected in *The White Hound: Stories by Ward Dorrance and Thomas Mabry* (Columbia: University of Missouri Press, 1959). A brief biography in *The White Hound* states that in the late fifties Mabry was living on a farm near Allensville, Kentucky, and raising cattle, hogs, and tobacco. His daughter, Eliza, would eventually be named by Evans as a beneficiary of his estate. I am grateful to Belinda Rathbone for sharing with me the year of Mabry's death as well as other details of his education, time spent in Europe, and early career in New York.

6. Thomas Dabney Mabry, "Walker Evans's Photographs of America," *Harper's Bazaar* 71 (Nov. 1, 1938), 84.

7. Thomas Mabry to George Davis at *Harper's Bazaar*, Oct. 6, 1938. A letter in the exhibition files for *American Photographs by Walker Evans*, used by permission of the Office of the Registrar, Museum of Modern Art, New York.

8. Mabry, "Walker Evans's Photographs of America," 140.

9. The workings of the Historical Section-Photographic of the New Deal's Resettlement Administration (later part of the Farm Security Administration) and Evans's involvement

with it have been described in a multitude of general histories including: Maren Stange, *Symbols of Ideal Life: Social Documentary Photography in America, 1890–1950* (New York: Cambridge University Press, 1989); Carl Fleischhauer and Beverly Brannan, eds., *Documenting America* (Berkeley: University of California Press, 1988); Hank O'Neal, ed., *A Vision Shared: A Classic Portrait of America and Its People, 1935–1943* (New York: St. Martin's Press, 1976); Roy Stryker and Nancy Wood, eds., *In This Proud Land: America, 1935–1942, As Seen in the FSA Photographs* (Greenwich, Conn.: New York Graphic Society, 1973); William Stott, *Documentary Expression and Thirties America* (New York: Oxford University Press, 1973); F. Jack Hurley, *Portrait of a Decade: Roy Stryker and the Development of Documentary Photography in the Thirties* (Baton Rouge: Louisiana State University Press, 1972); and Thomas Garver, ed., *Just Before the War* (New York: October House, 1968). The only publication devoted entirely to Evans's work for the FSA is the 1973 volume *Walker Evans: Photographs for the Farm Security Administration, 1935–1938*, illustrating the negatives contained in the Farm Security Administration-Office of War Information collection, Prints and Photographs Division, Library of Congress. A private enterprise, this incomplete catalogue of the Library of Congress' Evans collection contains a brief introduction by Jerald Maddox, then curator of photography at the library, and was intended to be as much a guide to purchasing prints from the library's negatives as an instructive account of FSA photography.

10. Walker Evans to Roy Stryker, letter of June 15, 1938, *Stryker Papers*.

11. Memorandum from Roy E. Stryker, Division of Information, Resettlement Administration, to Miss McKinney, Division of Information, Oct. 9, 1935, *Stryker Papers*.

12. Memorandum draft by Walker Evans, reproduced in *Walker Evans at Work*, (New York: Harper and Row, 1982), 112.

13. Walker Evans, *American Photographs* (New York: Museum of Modern Art 1938), n.p.

14. Walker Evans to Ernestine Evans, unfinished two-page letter in black ink on hotel stationery, dated Feb. 1934, first published in *Walker Evans at Work*, 98. This letter is part of the Evans Collection at the Getty (JPGM 84.XG.963.42).

15. Garver, *Just Before the War*, n.p.

16. From a review by W. B. Shaw, quoted in *Book Review Digest: Books of 1929* (New York: H. W. Wilson, 1930), 591.

17. Robert S. Lynd and Helen Merrell Lynd, *Middletown: A Study in American Culture* (San Diego: Harcourt Brace Jovanovich, 1929; reprint, Harvest/HBJ, 1956), 3.

18. Walker Evans to Roy Stryker, "Outline Memorandum," ca. Oct. 1935, *Stryker Papers*. Also published in *Walker Evans at Work*, 113.

19. Roy Stryker to all FSA (then RA) photographers, outline for "Suggestions recently made by Robert Lynd for things which should be photographed as 'American Background,'" dated by Stryker to early 1936, first published in Garver, *Just Before the War*, n.p.

20. Information for the following chronology of Evans's work for the Resettlement Administration was taken primarily from letters and memoranda documenting authorizations and travel expenses contained in the *Stryker Papers* for 1935–38. *Walker Evans: Photographs for the Farm Security Administration* (New York: Da Capo Press, 1973) was also a source in determining the dating of Evans's travels for the RA, but because it is organized by state (or city) rather than by trip, it presents a more fractured and somewhat misleading view of Evans's brief, but intense, term of employment with this federal agency.

21. James Agee and Walker Evans, *Let Us Now Praise Famous Men: Three Tenant Families* (Boston: Houghton Mifflin, 1941), viii. This book, the final result of the Agee-Evans collaboration, was reviewed widely upon publication (see bibliography); numerous later interpretations have appeared, including those in William Stott, *Documentary Expression and Thirties America* (New York: Oxford University Press, 1973); J. A. Ward, *American Silences: The Realism of James Agee, Walker Evans, and Edward Hopper* (Baton Rouge and London: Louisiana State University Press, 1985); and James Curtis, *Mind's Eye, Mind's Truth: FSA Photography Reconsidered* (Philadelphia: Temple University Press, 1989). Thirty-one pictures were included in the first edition of *Let Us Now Praise Famous Men*, sixty-two in the 1960 edition. For a more extensive look at the images Evans brought back from the *Fortune* assignment, see nos. 530–67 in this volume; *Walker Evans: Photographs for the Farm Security Administration, 1935–1938*; and the Evans collection at the Harry Ransom Humanities Research Center, University of Texas at Austin.

22. For more background on this Alabama series and a discussion of two photograph albums in the collection of the Prints and Photographs Division of the Library of Congress thought to be Evans's "first draft" for *Fortune*, see Judith Keller and Beverly Brannan, "Walker Evans: Two Albums in the Library of Congress," *History of Photography* 19:1 (Spring 1995).

23. A summer 1938 series on New York tenements in the current Farm Security Administration-Office of War Information files in the Library of Congress is attributed to Evans, but there is still some skepticism among scholars as to his authorship of these images. The architectural views in particular seem atypical of his work of the time. If these street photographs are indeed by Evans, then they may not be up to his usual standards simply because he took less interest in this New York assignment than he did in his travels in the South.

24. Lincoln Kirstein, "Photographs of America: Walker Evans," *American Photographs* (New York: Museum of Modern Art, 1938), 196.

25. Anthony West, "Middletown and Main Street," *Architectural Review* 85 (May 1939), 218–20.

26. The itinerary for *American Photographs* is found in the Museum of Modern Art Archives: P.I. Scrapbook 112. It lists the following as venues: the Chouinard School, Los Angeles; Smith College Museum of Art, Northampton; Society of Arts and Crafts, Detroit; Duke University, Durham; The Garret Club, Buffalo; Honolulu Academy of Art; Brown University, Providence; Kauffmann Department Stores, Inc., Pittsburgh; Harvard University, Cambridge; University of Louisiana, Baton Rouge. The installation list for the reduced version of the show that circulated is available in the Office of the Registrar and is recorded in the MoMA archives as: The Museum of Modern Art Archives, New York: Department of Circulations Exhibition Records, II. 1/34(12).

27. Mora and Hill, *Walker Evans: The Hungry Eye*, 160, report that Newhall (librarian at MoMA from 1935 to 1942) first installed the show, but Evans, unhappy with that arrangement, "turned Newhall's initial hanging of the show inside out." In conversation with the author, May 17, 1991, Newhall recounted the genesis of the exhibition in different terms, stating that he had nothing to do with it (he had organized a major survey exhibition, *Photography, 1839–1937*, for the museum the year before) and that Evans had agreed to the idea of the show only if he could hang it himself. The photographer worked at night in the gallery, an interim space in the subterranean levels of Rockefeller Center, in the company of a museum technician. He asked for a paper cutter and cropped his prints, some of them severely, there in the gallery before attaching them to the walls. Newhall also recalled that once the show was up he received a letter from Edward Weston, saying he was anxious to obtain a copy of *American Photographs* and voicing his longstanding admiration for Evans's work: "When I see a picture I like, it is usually by Walker Evans."

28. See nos. 489, 503, 562.

29. See Maddox, *Walker Evans: Photographs for the Farm Security Administration, 1935–1938*, ill. nos. 432–33.

30. See Maddox, 429–31, for a more complete look at these three negatives.

31. Edwin Locke to Roy Stryker, six-page letter on hotel stationery, Feb. 4, 1937, *Stryker Papers*. Seven days after this letter, the two photographers are still in Memphis; Locke notifies Stryker that Evans is ill with a serious case of the flu but refuses to be taken to the hospital. Locke to Stryker, two-page letter on notecards, Feb. 11, 1937, *Stryker Papers*.

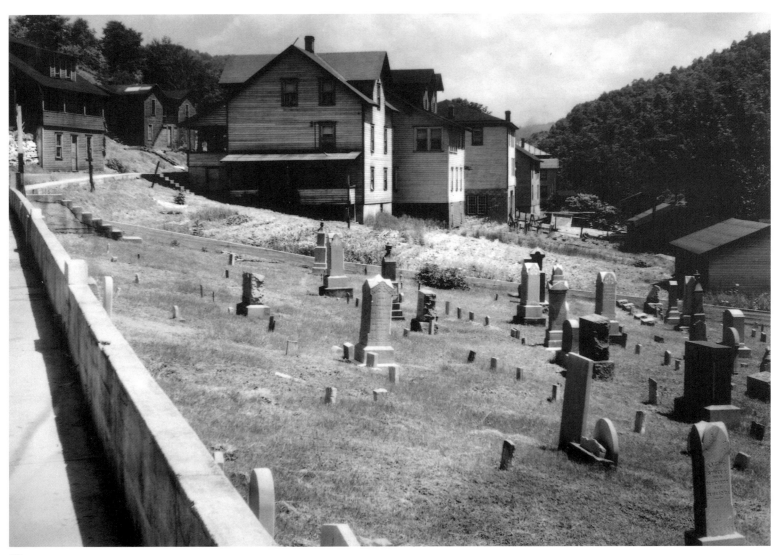

421

***American Photographs*: Evans in Middletown**

In this section of images dating from 1935 to 1938, the prints have been arranged chronologically and geographically according to Evans's travels of the period. His first two trips in the employ of the Resettlement Administration (RA), to West Virginia and Pennsylvania, are followed by pictures of 1935–36 from Louisiana and Mississippi made during a privately funded project to record southern antebellum architecture and on assignment for the federal government; these photographs are sequenced primarily by subject. Other RA trips to Georgia, South Carolina, Ala-bama, Tennessee, and Arkansas appear according to Evans's itineraries and Jerald Maddox's 1973 publication of his RA/FSA work in the Library of Congress collection (see FSA in references). Within the Alabama section, those images made in the Hale County area of three tenant-farmer families are organized by family (Burroughs, Fields, or Tengle), with a few prints (of such subjects as farm animals and graves) falling into a more general category. Eight miscellaneous pictures, seemingly outside the RA work and in a few cases identified as New York images, close this section.

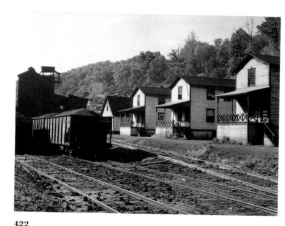

422

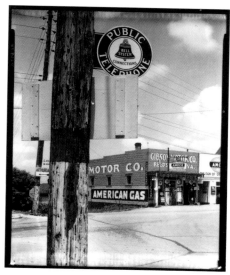

424

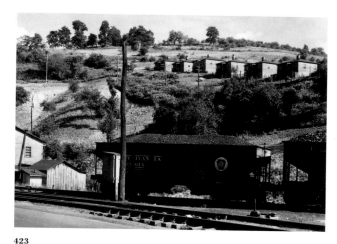

423

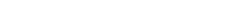

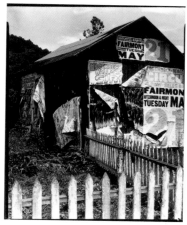

425

423
[*Mining Camp, Osage, West Virginia**],
1935
14.9 x 20.6 cm (5 ⅞ x 8 ⅛ in.)
84.XM.956.296
MARKS & INSCRIPTIONS: (Verso) at
l. right, Evans stamp A; at u. right,
in pencil, *20*; at l. center, in pencil, *20*
[circled]; at l. left, in pencil, *C3/1/25/_*
5W; at l. right, *WALKER EVANS* [box
around name]; typed on white label, at
u. center, [text lacking] *O. SCOTT'S*
RUN, MINING [text lacking] *AR MORGAN-*
TOWN W. VA./View near Osage. [text
lacking] *5*; (recto, mat) at l. left, in pen-
cil, Crane no. *L67.46(Evans)*.
REFERENCES: *FSA, no. 13 (variant, neg-
ative dated July 1935).

424
[*Highway Corner, Reedsville, West*
*Virginia**], 1935
25.4 x 20.6 cm (10 x 8 ⅛ in.)
84.XM.129.5
MARKS & INSCRIPTIONS: (Verso) at
l. right, Lunn Gallery stamp and
within boxes, in pencil, *II* and *116*; at
u. left, in pencil, *d-18(FSA)*; at l. left,
in pencil, *E2*; at l. right, in pencil, *23*
[circled].
PROVENANCE: Lunn Gallery; Volker
Kahmen and Georg Heusch.
REFERENCES: *FSA, no. 21 (negative
dated June 1935); WEBR, p. 5, no. 2
(titled and dated in German, *Tanks-*
telle, Reedsville [*West Virginia*], June
1935).
EXHIBITIONS: *Walker Evans*, Bahnhof
Rolandseck, West Germany, Oct. 5–
Nov. 30, 1978; *Art of Photography*,
Museum of Fine Art, Houston, Tex.,
Feb. 11–Apr. 30, 1989.

425
[*Roadside Barn, Monongalia County,*
*West Virginia**], June 1935
25.2 x 20 cm (9 ¹⁵⁄₁₆ x 7 ²⁹⁄₃₂ in.)
84.XM.956.308
MARKS & INSCRIPTIONS: (Verso) at center,
in black crayon, by Evans, *9.*; at l. cen-
ter, Evans stamp J [three times]; at
l. left, in pencil, Crane no. *L67.32*.
REFERENCES: *FSA, no. 19 (variant,
negative dated June 1935).

421
Rowlesburg, Preston County, West
Virginia, June 1935
17 x 23.3 cm (6 ¹¹⁄₁₆ x 9 ⅛ in.)
84.XM.956.318
MARKS & INSCRIPTIONS: (Verso) titled
and dated at center, in pencil, by
Evans, *Rowlesburg/Preston Co./W. Va/*
June, 1935/FSA; at right edge, Evans
stamp A; at left of center, in pencil,
14A [circled]; at right center, in pencil,
14A; at l. left, in pencil, *C2/105/*
75W; at l. left, in pencil, Crane
no. *L67.28*; typed on white label
[partially destroyed], at u. center,

_____*LESBURG, PRESTON COU___/_une,*
1935.
REFERENCES: FSA, no. 22 (variant).

422
[*Company Houses, Scott's Run, West Vir-*
*ginia**]/[*Company Houses for Miners,*
*Osage, West Virginia***], 1935
Image: 18 x 23.1 cm (7 ¹⁄₁₆ x 9 ³⁄₃₂ in.);
original hole-punched mount:
31.3 x 25.8 cm (12 ⅜ x 10 ³⁄₁₆ in.)
84.XM.956.488
MARKS & INSCRIPTIONS: (Recto, mount)
at u. right, in pencil, *79.4* [beside a

right angle]; at l. center, -7 ¹⁄₈-; at
l. right, *63*; at l. right, in red pencil, *S*;
(verso, mount) signed at center, in pen-
cil, by Evans, *Walker Evans*; at l. right,
in pencil, *H2416-86/86/NO* [within a
box] *150 h* and *63*; (recto, mat) at
l. right, in pencil, *130*; at l. left, Crane
no. *L68.43 (Evans)*.
REFERENCES: *AMP, Part II, no. 13;
**FSA, no. 14 (variant, negative dated
July 1935).

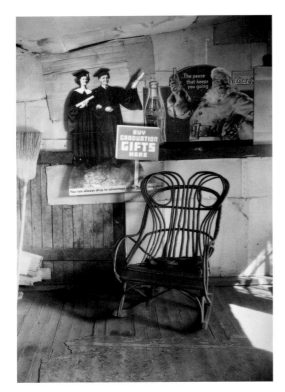

426

427

428

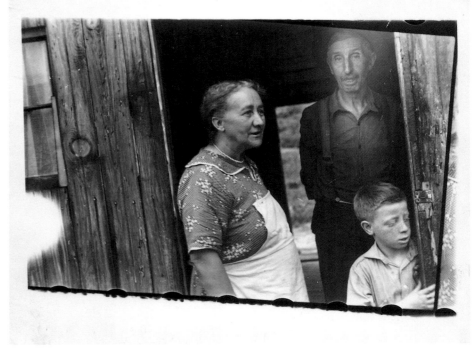

429

426
[*Interior Detail, West Virginia Coal Miner's House**]/[*Coal Miner's House, Scotts Run, West Virginia***], 1935
23.6 x 16 cm (9 5/16 x 6 9/32 in.)
84.XM.956.518
MARKS & INSCRIPTIONS: (Verso) at l. center, Evans stamp H; at u. center, in pencil, *Interior Detail, West Viriginia/ Coal Miner's House, 193_/(cropped/ part 9 5/8" x 7 5/8",/Walker Evans*; at right center, in pencil, *Reproduced p. 54/Museum of Modern/ Walker Evans/Am Photographs c. 193_*; at l. center, in pencil, *23*

[circled]; at l. right, in pencil, *C2/____* [sideways]; at l. left, in pencil, Crane no. *L68.16*.
REFERENCES: *AMP, Part I, no. 23 (variant); FSA, no. 15 (variant, negative dated July 1935); FAL, p. 113 (variant); **APERTURE, p. 79 (variant).

427
[*Residential Area, Morgantown, West Virginia**], 1935
Image: 16.4 x 22.4 cm
(6 15/32 x 8 13/16 in.); original mount: 19.5 x 24.8 cm (7 21/32 x 9 25/32 in.)
84.XM.956.355

MARKS & INSCRIPTIONS: (Recto, mount) signed at l. right, in pencil, by Evans, *Walker Evans*; (verso mount) at center right, Evans stamp B; at l. left, in pencil, Crane no. *L67.55(Evans)*.
REFERENCES: *FSA, no. 3 (variant, negative dated June 1935).

428
[*Main Street Faces**]/[*Street Scene, Morgantown, West Virginia***], 1935
14.8 x 17.7 cm (5 27/32 x 6 15/16 in.) [on Masonite trimmed to image]
84.XM.956.438

MARKS & INSCRIPTIONS: (Verso, mount) signed on MoMA label, at u. right, in pencil, by Evans, *Walker Evans*; at u. left, Evans stamp C; at l. left, Evans stamp H; on MoMA label, wet stamp, at l. left, in black ink, *RIGHTS RESERVED*; typed on MoMA label, *EVANS/MAIN STREET FACES, 1935/33/38.2273*; on MoMA label, in black ink, at l. right, *GR V*; at l. left, in pencil, Crane no. *L69.4(Evans)*.
REFERENCES: *AMP, Part I, no. 39 (variant); **FSA, no. 8 (variant, negative dated July 1935).

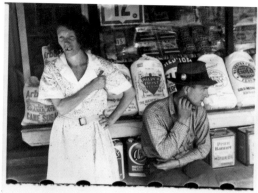

430

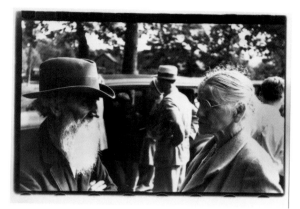

431

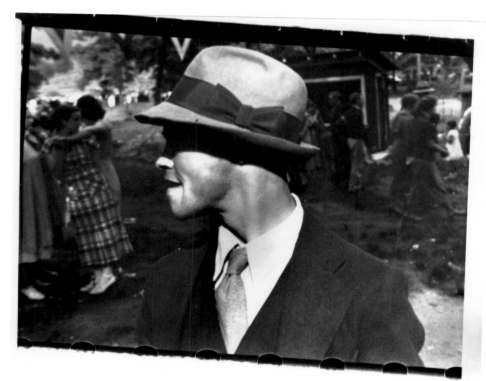

432

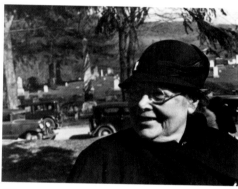

433

429

[*Mining Camp Residents, Morgantown, West Virginia*], 1935
20.1 x 25.1 cm (7 ¹⁵⁄₁₆ x 9 ⅞ in.)
94.XM.6.2
MARKS & INSCRIPTIONS: (Verso) at
u. right, in pencil, *L-9*; at l. left corner,
in pencil, *no. 2*; at l. right, Lunn Gal-
lery stamp, and within boxes, in
pencil, *III* and *6*.
PROVENANCE: George Rinhart and Tom
Bergen; Harry H. Lunn, Jr.

430

*Main Street at Kingwood, West
Virginia*, June 1935
20.1 x 25.2 cm (7 ⅞ x 9 ⅞ in.)
94.XM.7
MARKS & INSCRIPTIONS: (Verso) at center,
in pencil, by Evans, *Main Street at
Kingwood W. Va June 1935*; at center,
in pencil, *23* [circled]; at l. left corner,
in pencil, *#1353*; at right center, Lunn
Gallery stamp, and within boxes, in
pencil, *W, 111* and *17*.
PROVENANCE: George Rinhart; Harry
H. Lunn, Jr.; Bonni Benrubi.
REFERENCES: FSA, no. 17 (negative
dated July 1935).

431

[*Independence Day, Terra Alta, West
Virginia**], 1935
Image: 15.3 x 22.8 cm (6 ¹⁄₁₆ x 9 in.);
sheet: 18.9 x 24.5 cm (7 ½ x 9 ⅝ in.)
84.XM.956.352
MARKS & INSCRIPTIONS: (Verso) at right
center, Evans stamp B, at l. left, in
pencil, Crane no. *L67.77(Evans)*.
REFERENCES: *FSA, no. 25 (variant,
negative dated July 4, 1935); WEAW,
p. 115 (variant).

432

[*Independence Day, Terra Alta, West
Virginia*], 1935
20.1 x 25.1 cm (7 ¹⁵⁄₁₆ x 9 ⅞ in.)
93.XM.40
MARKS & INSCRIPTIONS: (Verso) at u. left
corner, in pencil, *BL 743*; at bottom left
corner, in pencil, *EHG/0.89* [sideways];
at bottom right corner, in pencil, *#1*
[sideways]; at right center, Lunn Gal-
lery stamp [sideways], and within two
boxes, in pencil, *III* and *24A*.
PROVENANCE: George Rinhart; Harry H.
Lunn, Jr., New York; Bonni Benrubi.

433

[*Woman with Black Hat, Possibly Terra
Alta, West Virginia*], 1935
14.7 x 18.6 cm (5 ¹³⁄₁₆ x 7 ⁵⁄₁₆ in.) [on
original mount trimmed to image]
84.XM.956.916
MARKS & INSCRIPTIONS: (Verso) signed
at center, in pencil, by Evans, *Walker
Evans*; at l. left, in pencil, *S* [or pos-
sibly the letter "P"] and Crane
no. *L76.47(Evans)*.

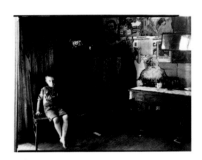

434

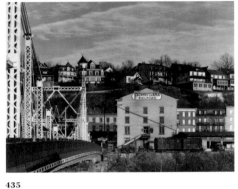

435

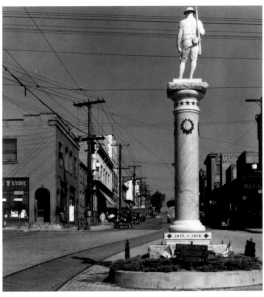

436

437

438

434
[*Coal Miner's House, Scott's Run, West Virginia**]/[*A Miner's House, Vicinity Morgantown, West Virginia***], 1935
Image: 19.3 x 24 cm (7 ⅝ x 9 ½ in.); sheet: 20.1 x 25.2 cm (7 ¹⁵⁄₁₆ x 9 ¹⁵⁄₁₆ in.)
84.XM.956.322
MARKS & INSCRIPTIONS: (Verso) signed at center, in pencil, by Evans, *Walker Evans* [sideways]; at l. right, in pencil, *2.7*; at l. left, in pencil, Crane no. *L67.29*; at right edge, Crane stamp twice [one partial].
REFERENCES: *MoMA, p. 127 (variant, dated 1936); **FSA, no. 10 (variant,

negative dated July 1935); FAL, pl. 112 (variant); APERTURE, p. 77 (variant).

435
[*Part of Phillipsburg, New Jersey**], 1935
Image: 18.5 x 23.3 cm (7 ⁹⁄₃₂ x 9 ³⁄₁₆ in.); original hole-punched mount: 31.3 x 25.8 cm (12 ⅜ x 10 ³⁄₁₆ in.)
84.XM.956.496
MARKS & INSCRIPTIONS: (Recto, mount) at l. left, in black ink, *Part Two/#3*; at l. center, in black ink, *Part of Phillipsburg, N.J., 1936*; at u. right, in

pencil, *78.5* [within a box]; at l. left, in pencil, *9 ⅛ x 7 ¼* and *7 ⅛ x 5 ⅝*; at l. right, in pencil, *53*; (verso, mount) signed at center, in pencil, by Evans, *Walker Evans*; at l. center, *H2416-86/ 86/NO* [within a box] *150 h*; at l. right, in pencil, *53*; (recto, mat), at l. right, in pencil, *135*; at l. left, in pencil, Crane no. *L68.35(Evans)*.
REFERENCES: *AMP, Part II, no. 3 (variant, dated 1936); FSA, no. 48 (variant, negative dated Nov. 1935); FAL, p. 117 (variant, dated 1936); APERTURE, p. 81 (variant, dated 1936).

436
[*Main Street of Pennsylvania Town**]/ [*World War I Monument on Main St., Mt. Pleasant, Pennsylvania***], 1935
Image: 20.4 x 17.8 cm (8 ¹⁄₃₂ x 7 in.); original hole-punched mount: 27.1 x 21.6 cm (10 ²¹⁄₃₂ x 8 ½ in.)
84.XM.956.491
MARKS & INSCRIPTIONS: (Recto, mount) at l. left, in black ink, *Part One/#28*; at l. center, in black ink, *Main Street of Penna. Town/1935*; at l. center, in pencil, *SS*; at l. right, in pencil, *28*; in red pencil, at l. right, *S*; (verso, mount) at center, Evans stamp B; at u. left, in pencil, *#124/Main Street, Pa 1935*; at

439

440

441

center, in pencil, *I-28*; at l. left, in pencil, *CUT 1* [circled] *7″* [arrow pointing to right] *WIDE*; at l. center, in pencil, *H2416–86/86 NO* [within a box] *150 h*; at l. right, *28* (over *29*); at l. center, Crane stamp; also, [pencil lines defining outer edge of print and one diagonal line from u. left to l. right corner]; (recto, mat) at l. right, in pencil, *124*; at l. left, in pencil, Crane no. *L68.17 (Evans)*.
REFERENCES: *AMP, Part I, no. 28; **FSA, no. 35 (variant, negative dated July 1935); CRANE, no. 122.

437
[*American Legionnaire*], 1935
18.9 x 17.2 cm (7 ¹⁵/₃₂ x 6 ²⁵/₃₂ in.) [on original mount trimmed to image; originally on a second larger mount that has been cut down]
84.XM.956.466
MARKS & INSCRIPTIONS: (Verso, mount) signed at l. center, in pencil, by Evans, *Walker Evans*; in black ink on paper from original second mount now taped down, *Part One/#32/* [space] *American Legionnaire/1936*; at l. left, in pencil, Crane no. *L68.21(Evans)*; at l. center, Crane stamp.

438
[*American Legionnaire*], 1935
Image: 14.9 x 22.3 cm
(5 ⅞ x 8 ¹³/₁₆ in.); sheet: 20.2 x 25.0 cm
(7 ¹⁵/₁₆ x 9 ⅞ in.)
94.XM.27.1
MARKS & INSCRIPTIONS: (Verso) at u. left, in pencil, *L-48*; at l. right, in pencil, *134/$500.00*.
PROVENANCE: Estate of James Agee; Light Gallery; Unidentified Private Collector; Carole Thompson.
REFERENCES: *AMP, Part I, no. 32 (variant, dated 1936); FSA, no. 65 (variant, negative dated Nov. 1935).

REFERENCES: *AMP, Part I, no. 32 (dated 1936); FSA, no. 65 (variant, negative dated Nov. 1935).

439
[*Sons of the American Legion, Bethlehem, Pennsylvania**], 1935
Image: 16.6 x 18.3 cm
(6 ⁹/₁₆ x 7 ⁷/₃₂ in.); original hole-punched mount: 27.9 x 21.6 cm
(11 x 8 ½ in.)
84.XM.956.459
MARKS & INSCRIPTIONS: (Recto, mount) signed at l. right, in pencil, by Evans, *Walker Evans*; at u. right, in pencil, *98/5*; at l. right, in pencil, *31*; at l. center, in pencil, —*7 ⅛*— [mostly erased]; at l. center, in pencil, *1 ⅛ OK* [mostly erased]; below print, in black ink, *Part One/#31* and *Sons of the American Legion/1936*; (verso, mount) at l. center, Evans stamp A; at l. right, in pencil, *31*; at l. right, in pencil, *H2416-86/86/NO* [within a box] *150 h*; at right center, Crane stamp; at l. left, in pencil, Crane no. *L68.20(Evans)*.
REFERENCES: *AMP, Part I, no. 31 (dated 1936); FSA, no. 66 (variant, negative dated Nov. 1935).

440
[*Window Display, Bethlehem, Pennsylvania**], 1935
Image: 22.5 x 17.2 cm
(8 ⅞ x 6 ²⁵/₃₂ in.); original mount: 25.5 x 19.2 cm (10 x 7 ¹⁷/₃₂ in.)
84.XM.956.282
MARKS & INSCRIPTIONS: (Recto, mount) signed at l. right, in pencil, by Evans, *Walker Evans*; (recto, mat) at l. right, *126*; at l. left, in pencil, Crane no. *L67.40(Evans)*.
REFERENCES: *FSA, no. 64 (negative dated Nov. 1935).

441
[*Graveyard, Houses and Steel Mill, Bethlehem, Pennsylvania**], 1935; printed later
20.3 x 25.3 cm (8 x 19 ¹⁵/₁₆ in.)
84.XM.129.7
MARKS & INSCRIPTIONS: (Verso) at l. right, in pencil, Kahmen/Heusch no. *E 7*; at l. left, in pencil, *#811 Bethlehem, Pennsylvania, 1936*; at l. right, Lunn Gallery stamp and in pencil, *II* and *142–3*; below boxes, in pencil, *III* and *61*.
PROVENANCE: Lunn Gallery; Volker Kahmen and Georg Heusch.
REFERENCES: *FSA, no. 61 (negative dated Dec. 1935); WEBR, p. 9, no. 7 (titled and dated, *Bethlehem [Pennsylvania]*, Nov. 1935); WEAW, p. 122 (middle image).

442

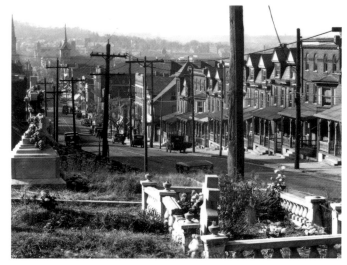

443

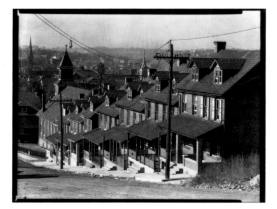

444

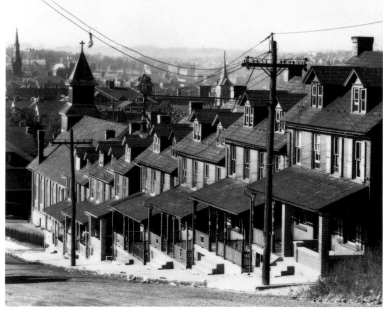

445

442
Bethlehem, Pennsylvania, 1935
Image: 19.8 x 17.6 cm
(7 ¾ x 6 ¹⁵⁄₁₆ in.); mount: 43.1 x 38 cm
(17 x 15 in.)
84.XM.956.334
MARKS & INSCRIPTIONS: (Recto, mount)
signed at l. right below print, in pen-
cil, by Evans, *Walker Evans*; (verso,
mount) titled and dated at center, in
pencil, by Evans, *Bethlehem, Pa.,*

1936; at center, Evans stamp C; at
l. left, in pencil, *75* and Crane no.
L67.88(Evans).
REFERENCES: FSA, no. 62 (negative
dated Nov. 1935).

443
[*Street and Graveyard in Bethlehem,
Pennsylvania**], 1935
Image: 18.9 x 23.9 cm (7 ⁷⁄₁₆ x 9 ⅜ in.);
original hole-punched mount:
31.3 x 25.8 cm (12 ⅜ x 10 ³⁄₁₆ in.)
84.XM.956.512
MARKS & INSCRIPTIONS: (Recto, mount)
at l. left, in black ink, *Part Two/#5*; at

l. center, *Street and Graveyard in Beth-
lehem/Penna., 1936*; at u. right, in
pencil, *76.5* [underlined]; at l. left,
in pencil, *7 ⅛ x 5 ⅝*; at l. center,
—*7 ⅛*—; at l. right, in pencil, *55*;
(verso, mount) at l. center, Evans
stamp B; at l. right, in pencil, *H2416-
86/86/NO* [within a box] *150 h*; at
l. right, in pencil, *55*; at l. left, in
pencil, Crane no. *L68.36*.
REFERENCES: *AMP, Part II, no. 5 (dated
1936); FSA, no. 52 (negative dated Nov.
1935); WEAW, p. 122 (variant, u. left
image, dated 1936).

444
[*Two-Family Houses in Bethlehem,
Pennsylvania**], 1935; printed later
20.3 x 25.2 cm (8 x 9 ¹⁵⁄₁₆ in.)
84.XM.129.6
MARKS & INSCRIPTIONS: (Verso) at l. left,
in pencil, Kahmen/Heusch no. *E6*; at
u. left, in pencil, *50*; at l. center, Lunn
Gallery stamp, and within boxes, in
pencil, *I* and *122*.
PROVENANCE: Lunn Gallery; Volker
Kahmen and Georg Heusch.
REFERENCES: *AMP, Part II, no. 6 (vari-
ant, dated 1936); FSA, no. 53 (variant,
negative dated Nov. 1935); WEBR, p. 9,

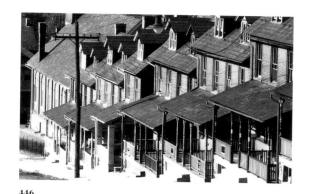

446

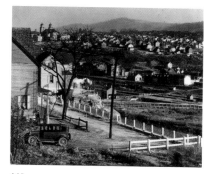

448

449

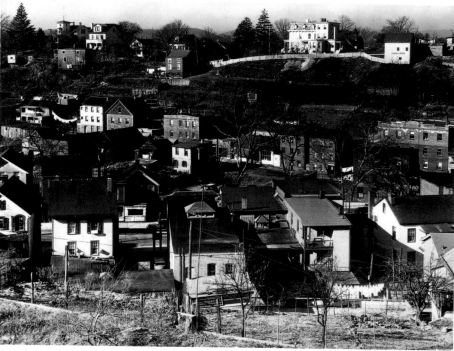

447

no. 6 (titled in German and dated, *Zweifamilienhäuser in Bethlehem* [*Pennsylvania*], Nov. 1935); WEAW, p. 123 (variant, u. left image).
EXHIBITIONS: *Walker Evans*, Bahnhof Rolandseck, West Germany, Oct. 5–Nov. 30, 1978.

445
[*Two-Family Houses in Bethlehem, Pennsylvania**], 1935
Image: 17.9 x 20.9 cm (7 ¹⁄₃₂ x 8 ¼ in.); original hole-punched mount: 31.3 x 26.8 cm (12 ⅜ x 10 ³⁄₁₆ in.)
84.XM.956.485

MARKS & INSCRIPTIONS: (Recto, mount) at l. left, in black ink, *Part Two/#6*; at center, in black ink, *Two-Family Houses in/Bethelehem, Pa., 1936*; at u. left, l. left, u. right, and l. right, check mark; at l. right, in pencil, *56* [crossed out]; at l. right, in red pencil, *s* [crossed out]; at u. right, in china marker, *49-2* [crossed out]; at l. center, wet stamp, in black ink, *ART* [circled] (verso, mount) at l. center, Evans stamp A; at l. right, wet stamp, in red ink, *OCT 2-1938*; at l. right, in pencil, *H2416-86/86/NO* [in a box] *150 h*; at l. right, in pencil, *56* [crossed out]; (recto, mat) at l. right, in pencil, *136*;

at l. left, in pencil, Crane no. *L68.67 (Evans)* and *AP122*; on white label taped to l. center [unrelated to this image], in pencil, *Pier-1929/Illustrated in magazine/HOUND & HORN*.
REFERENCES: *AMP, Part II, no. 6 [dated 1936]; FSA, no. 53 (variant, negative dated Nov. 1935); WEAW, p. 123 (variant, u. left image).

446
Bethlehem, Pennsylvania, Street, 1935
Image: 8.6 x 13.3 cm (3 ⅜ x 5 ¼ in.) [on postcard stock]; original mount: 11.7 x 17.2 cm (4 ⅝ x 6 ¾ in.)
84.XM.956.470

MARKS & INSCRIPTIONS: (Recto, mount) at l. left, in pencil, by Evans, *II-6*; (verso, mount) at l. right, Evans stamp B; at center, in pencil, by Evans, *II-6/ Bethlehem Pa. Street/1935*; at l. left, in pencil, Crane no. *L68.37(Evans)*.
REFERENCES: AMP, Part II, no. 6 (variant); FSA, no. 53 (variant, negative dated Nov. 1935); WEAW, p. 123 (variant, u. left image).

447
[*Miners' Town, Pennsylvania*], 1935
13.2 x 16.6 cm (5 ³⁄₁₆ x 6 ⁹⁄₁₆ in.) [on original mount trimmed to image]
84.XM.956.281

MARKS & INSCRIPTIONS: (Verso) at right center, Evans stamp B; at center, in pencil, MoMA no. *38.304/Evans*; (recto, mat) at l. left, in pencil, Crane no. *L67.48(Evans)*.

448
[*View of Easton, Pennsylvania*], 1935
17.7 x 20.4 cm (6 ¹⁵⁄₁₆ x 8 ¹⁄₁₆ in.) [on Masonite trimmed to image]
84.XM.956.451

MARKS & INSCRIPTIONS: (Verso, mount) typed on MoMA label: *EVANS/VIEW OF EASTON, PENNSYLVANIA, 1936/98/ 38.2254*; at l. right, in black ink on MoMA label, *GR.X*; at l. left, in pencil, Crane no. *L69.18(Evans)*.
REFERENCES: FSA, no. 46 (variant).

449
"Joe's Auto Graveyard," Pennsylvania, 1935
10.3 x 12.9 cm (4 ¹⁄₁₆ x 5 ¹¹⁄₁₆ in.)
84.XM.956.469

MARKS & INSCRIPTIONS: (Verso) at center, in pencil, by Evans, *Walker Evans/ please return to/"JOE'S AUTO GRAVE-YARD," (Pennsylvania)*; at right edge, Evans stamp A; at left, in pencil, *125*

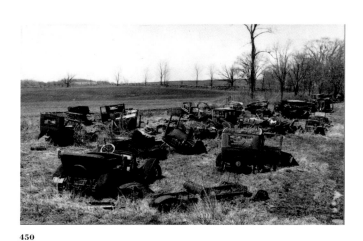

450

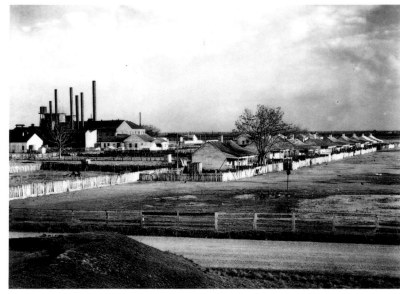

451

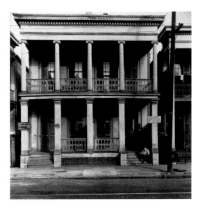

452

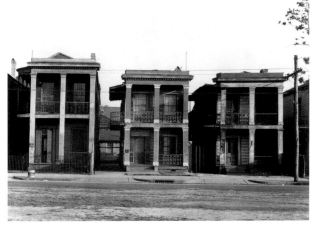

453

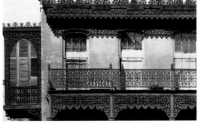

454

[crossed out]; at l. right, in pencil, *146+*; at l. right corner, in pencil, *EVANS/53.495*; at l. left, in pencil, Crane no. *L68.6 (Evans)*.
REFERENCES: AMP, Part I, no. 7 (variant, dated 1936); FOURTEEN, p. 4 (variant); FSA, no. 50 (variant, negative Nov. 1935); FAL, p. 103 (variant, dated 1936).

450
[*"Joe's Auto Graveyard," Vicinity of Easton, Pennsylvania*], 1935
13.6 x 20.9 cm (5 ⅜ x 8 ¼ in.)
84.XM.956.358

MARKS & INSCRIPTIONS: (Verso) at u. left, Evans stamp B; at l. right, Crane stamp; at center, in pencil, *90*; at l. left, in pencil, Crane no. *L67.76 (Evans)*.

451
[*Louisiana Factory and Houses**], 1935
Image: 17.2 x 22.4 cm
(6 ²⁵⁄₃₂ x 8 ²⁷⁄₃₂ in.); original hole-punched mount: 31.3 x 25.8 cm
(12 ⅜ x 10 ³⁄₁₆ in.)
84.XM.956.497
MARKS & INSCRIPTIONS: (Recto, mount) at u. right, in pencil, *81.5* [beside a right angle]; at l. left, in pencil,

7 ⅛ x 5 ½; at l. center, in pencil, —*7 ⅛"*— ; at l. right, *10/60* [60 has been crossed out]; at l. right, in red pencil, *S*; (verso, mount) signed at center, in pencil, by Evans, *Walker Evans*; at l. right, in pencil, *H2416-86/86/NO* [within a box] *150 h* and *60*; at u. right, *P*; (recto, mat) at l. left, in pencil, Crane no. *L68.41 (Evans)*.
REFERENCES: *AMP, Part II, no. 10.

452
[*New Orleans Boardinghouse*], 1935
Image: 18.6 x 17 cm (7 ¹¹⁄₃₂ x 6 ¹¹⁄₁₆ in.); original hole-punched mount:

27.9 x 21.6 cm (11 x 8 ½ in.)
84.XM.956.482

MARKS & INSCRIPTIONS: (Recto, mount) at l. left, in black ink, *Part One/#37*; at l. center, in black ink, *New Orleans Boarding House/1935*; at l. center, in pencil, *SS*; at right, in pencil, *37*; at l. right, in red pencil, *S*; (verso, mount) at l. center, Evans stamp A; at l. center, in pencil, *H2416-86/86/NO* [within a box] *150 h*; at l. right, in pencil, *37*; (recto, mat) at l. right, in pencil, *132*; at l. left, in pencil, Crane no. *L68.26 (Evans)*.
REFERENCES: AMP, Part I, no. 37.

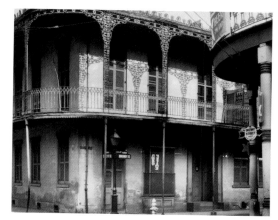

455

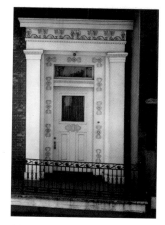

456

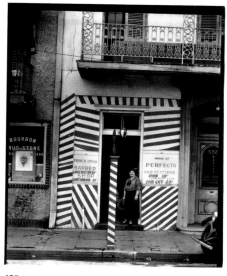

458

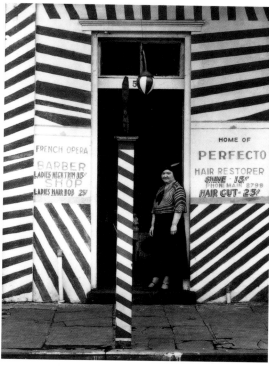

459

REFERENCES: *AMP, Part II, no. 36 (variant).

456
[*Doorway, New Orleans*], 1935
15.1 x 10.1 cm (5 �5/16 x 4 in.)
84.XM.956.17
MARKS & INSCRIPTIONS: (Verso) at l. right, partial Evans stamp A; at center, in pencil, *40s/303/25W*; at l. left, in pencil, Crane no. *L65.87(Evans)*.

457
[*Doorway, New Orleans*], 1935
13.6 x 9 cm (5 ⅜ x 3 9/16 in.)
84.XM.956.98
MARKS & INSCRIPTIONS: (Verso) at center, in pencil, *30/1303/317*; at l. center, Evans stamp A; at l. left, in pencil on white label, Crane no. *L65.88Evans*; (recto, mat) at l. left, in pencil, Crane no. *Mpls/L65.88(Evans)*.
REFERENCES: FAL, p. 46.
NOTE: Not illustrated; variant of no. 456.

458
[*Sidewalk and Shopfront, New Orleans**], 1935
25.2 x 20.2 cm (9 ¹⁵/16 x 7 ³¹/32 in.)
84.XM.956.453
MARKS & INSCRIPTIONS: (Verso) at center, Evans stamp B [sideways]; at l. left, in pencil, *FRENCH BARBER SHOP ca. 1936/withdrawn/Arnold H. Crane*; at u. right, in pencil, on white label, *1* [space] *5*; at u. right, in pencil, *2/2 ½*; at l. left, in pencil, *Cut 18* [circled] *4* [arrow in box] *½" HIGH*; at l. left edge, in pencil, *47.S 27–187*; in pencil, lines defining the outer perimeter with two lines crossing diagonally at center; at l. left, Crane no. *L68.4(Evans)*.
REFERENCES: *AMP, Part I, no. 5 (variant); FOURTEEN, p. 11 (variant); CRANE, no. 234; FAL, p. 122; APERTURE, p. 85, (variant).

459
[*Sidewalk and Shop Front, New Orleans*], 1935
15.4 x 10.9 cm (6 ⅛ x 4 9/32 in.)
84.XM.956.476
MARKS & INSCRIPTIONS: (Verso) at u. right, Evans stamp A; at left of center, in pencil, *C4/105/75W*; at right edge, Crane stamp; at l. left, in pencil, Crane no. *L68.5(Evans)*.
EXHIBITIONS: *Art of Photography*, Museum of Fine Arts, Houston, Tex., Feb. 11–Apr. 30, 1989.

453
[*New Orleans Houses**], 1936
Image: 13.8 x 17.5 cm (5 ⁷/16 x 6 ⅞ in.); original hole-punched mount: 28 x 21.6 cm (11 x 8 ½ in.)
84.XM.956.502
MARKS & INSCRIPTIONS: (Recto, mount) at center right, in pencil, *SS*; at l. right, in pencil, *74*; (mount, verso) at l. center, Evans stamp A, at l. center, in pencil, *H2416-86/86/NO* [within a box] *150h*; at l. right, in pencil, *74*; (recto, mat) at l. right, in pencil, *147*; at l. left, in pencil, Crane no. *L68.53 (Evans)*.

REFERENCES: *AMP, Part II, no. 24 (dated 1935); FSA, no. 74 (variant, negative dated Feb. 1936).

454
[*House with Cast Iron Grill Work, New Orleans, Louisiana**], 1936
8.7 x 13.1 cm (3 ⁷/16 x 5 ⁵/32 in.)
84.XM.956.366
MARKS & INSCRIPTIONS: (Verso) initialled at center, in pencil, by Evans, *WE*; at l. left, in pencil, Crane no. *L67.82 (Evans)*.
REFERENCES: *FSA, no. 75 (variant, negative dated Jan. 1936).

455
[*French Quarter House in New Orleans**], 1935
17.2 x 21.1 cm (6 ²⁵/32 x 8 ⁵/16 in.) [on Masonite board trimmed to image]
84.XM.956.449
MARKS & INSCRIPTIONS: (Verso, mount) signed at l. right, in pencil, by Evans, *Walker Evans*; at l. right, Evans stamp F; at l. center, in pencil, *AP II-36*; typed on MoMA label: *EVANS/FRENCH QUARTER HOUSE IN NEW/ORLEANS, 1935/72/38.2950*; at l. right, in black ink, on MoMA label, *GR II*; at l. left, in pencil, Crane no. *L69.13(Evans)*.

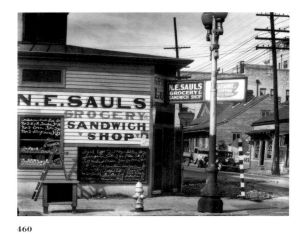

460

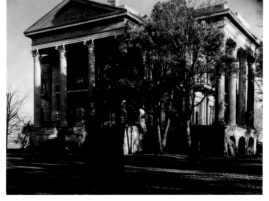

462

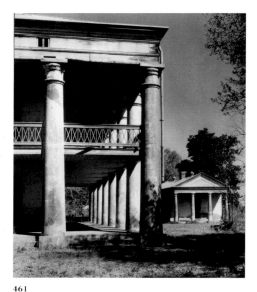

461

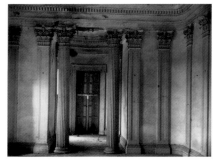

463

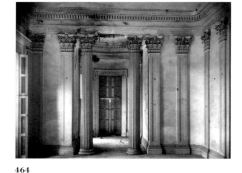

464

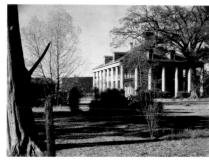

465

460
[*Street Scene, New Orleans*], 1935; printed later
20.7 x 25.4 cm (8 ³/₁₆ x 10 in.)
84.XM.129.8
MARKS & INSCRIPTIONS: (Recto) in negative, at u. right edge, *RA-1273-A* [*reversed*]; (verso) at u. right, in pencil, *d-21* (FSA); along bottom edge, in pencil, *#797 Street Scene, New Orleans, La. December 1935*; at l. right, in pencil, *E5*; at l. left edge, Lunn Gallery stamp, and within boxes, in pencil, *III* and *72* [check mark].
PROVENANCE: Lunn Gallery; Volker Kahmen and Georg Heusch.

REFERENCES: WEBR, p. 8, no. 5 (titled in German and dated, *Straβenszene, New Orleans* [*Louisiana*], Dezember 1935).
EXHIBITIONS: *Walker Evans*, Bahnhof Rolandseck, West Germany, Oct. 5–Nov. 30, 1978; *Neither Speech Nor Language: Photography and the Written Word*, J. Paul Getty Museum, Malibu, Calif., Feb. 28–May 12, 1991.

461
[*Uncle Sam Plantation, Convent, Louisiana*], 1935
21.9 x 18.1 cm (8 ⅝ x 7 ⅛ in.)
84.XM.956.315

MARKS & INSCRIPTIONS: (Verso) at center, Evans stamp A; at l. right, in pencil, *s 4* [number circled]; at u. right, in

black ink, *81.* [crossed out in pencil]; at l. left, in pencil, Crane no. *L67.80* (*Evans*).
REFERENCES: WEAW, p. 109 (variant).

462
[*Belle Grove Plantation, Near New Orleans*], 1935
15.7 x 19.3 cm (6 ³/₁₆ x 7 ⅝ in.)
84.XM.956.357
MARKS & INSCRIPTIONS: (Verso) signed at center, in pencil, by Evans, *Walker Evans* [inverted]; at center, Evans stamp A [sideways]; at l. right, in pencil, *3 ½ + ⁷/₁₆/ E* [crossed out] *s 1* [1 circled].

463
[*Breakfast Room at Belle Grove Plantation, White Chapel, Louisiana**], 1935
17 x 21.8 cm (6 ¹¹/₁₆ x 8 ⁹/₁₆ in.)
84.XM.129.4
MARKS & INSCRIPTIONS: (Verso) at l. left, in pencil, Kahmen/Heusch no. *E 14*; at u. left, in pencil, *16* [circled]; at center, in pencil, *No number/Evans*; at l. right, Lunn Gallery stamp; in pencil, *II* and *76*.

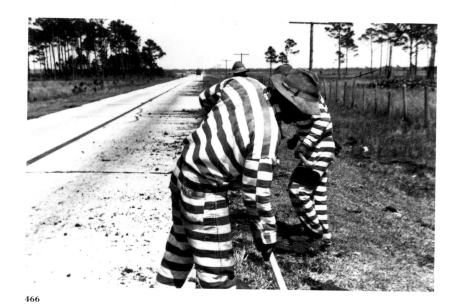

466

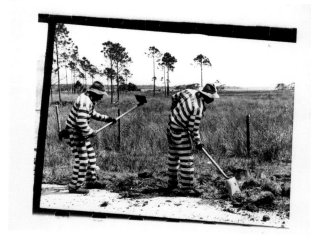

467

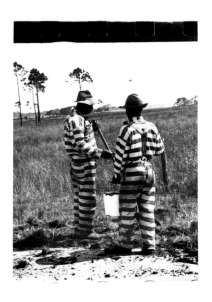

468

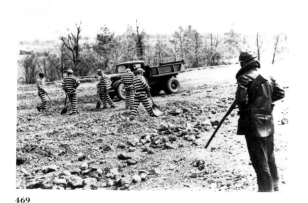

469

13.1 x 19.4 cm (5 ³/₁₆ x 7 ²¹/₃₂ in.)
84.XM.956.891
MARKS & INSCRIPTIONS: (Verso) at u. left,
Evans stamp A [sideways]; at l. center,
in pencil, *48 ¹/₂/16*; at l. right, in pen-
cil, *E3*; at l. left, in pencil, Crane
no. *L76.123(Evans)*.

467
*[Two Members of a Prison Work Gang,
Possibly Louisiana]*, ca. 1935
Image: 15.6 x 20.4 cm (6 ⁷/₃₂ x 8 in.);
sheet: 19.7 x 24.9 cm
(7 ²⁵/₃₂ x 9 ¹³/₁₆ in.)
84.XM.956.892
MARKS & INSCRIPTIONS: (Verso) at center,
Evans stamp K; at l. left, in pencil,
Crane no. *L76.122(Evans)*.

468
*[Two Members of a Prison Work Gang,
Possibly Louisiana]*, ca. 1935
Image: 14 x 10.4 cm (5 ¹/₂ x 4 ³/₃₂ in.);
sheet: 17.8 x 11.4 cm (7 x 4 ¹/₂ in.)
84.XM.956.847
MARKS & INSCRIPTIONS: (Verso) at
l. right, Evans stamp A; at l. left, in
pencil, Crane no. *L76.120(Evans)*.

469
*[Guard and Five Members of a Prison
Work Gang]*, ca. 1935
14.5 x 19.4 cm (5 ²³/₃₂ x 7 ⁵/₈ in.) [on
remnant of original mount]
84.XM.956.893
MARKS & INSCRIPTIONS: (Verso) at center,
Evans stamp A; at l. left, in pencil,
Crane no. *L76.121(Evans)*.

PROVENANCE: Lunn Gallery; Volker
Kahmen and Georg Heusch.
REFERENCES: MFTI, pl. 3 (variant);
*MoMA, p. 77 (variant); SP, pl. 3 (vari-
ant); FAL, p. 125 (variant); WEBR,
p. 18, no. 14 (titled in German and
dated, *Frühstückszimmer, Belle Grove
Plantation, White Chapel [Louisiana]*,
März 1935); WEAW, p. 110 (variant).
EXHIBITIONS: *Walker Evans*, Bahnhof
Rolandseck, West Germany, Oct. 5–
Nov. 30, 1978.

464
The Breakfast Room at Belle Grove,
1935
18.2 x 23.9 cm (7 ⁵/₃₂ x 9 ⁷/₁₆ in.)
84.XM.956.330
MARKS & INSCRIPTIONS: (Verso) along left
edge, Evans stamp B; at center, in
pencil, by Evans, *THE BREAKFAST
ROOM AT BELLE GROVE/935*; at
l. center, in pencil, *Cl 75 W/D 73*; at
l. left, in pencil, Crane no. *L67.30*.
REFERENCES: MFTI, pl. 3 (variant);
MoMA, p. 77 (variant); SP, pl. 3 (vari-
ant); FAL, p. 125 (variant); WEAW,
p. 110 (variant).

465
*[Seven Oaks Plantation Near New
Orleans]*, 1935
18.5 x 23.8 cm (7 ⁹/₃₂ x 9 ³/₈ in.)
84.XM.956.285
MARKS & INSCRIPTIONS: (Verso) signed
at center, in pencil, *Walker Evans*; at
l. center, Evans stamp A [inverted];
at u. right, in pencil, *2/20/25 W*
[inverted]; (recto, mat) at l. left, in
pencil, Crane no. *L67.47(Evans)*.

466
*[Three Members of a Prison Work
Gang, Possibly Louisiana]*, ca. 1935

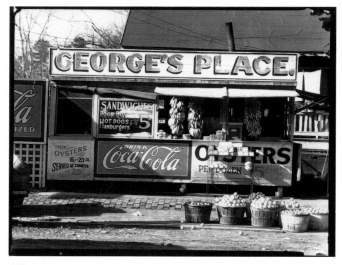

470

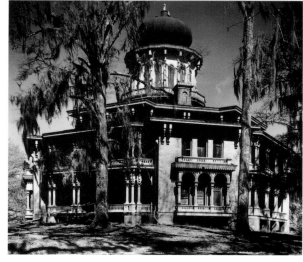

471

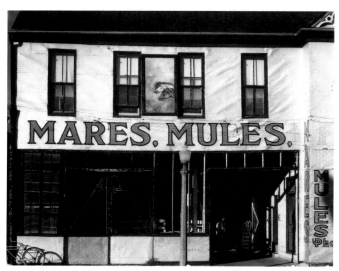

472

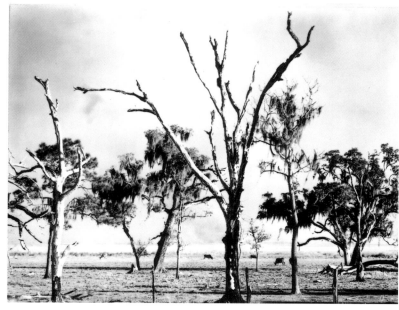

473

470
[*Roadside Sandwich Shop, Poncha-toula, Louisiana*], 1936
20.2 x 25.3 cm (7 ¹⁵/₁₆ x 9 ³¹/₃₂ in.)
84.XM.129.14
MARKS & INSCRIPTIONS: (Verso) at
l. right, in pencil, Kahmen/Heusch
no. *E 4*; at l. left, in pencil, *#808 ca.
1936*; at l. center, Lunn Gallery stamp,
and within boxes, in pencil, *IX* and *I*.
PROVENANCE: Lunn Gallery; Volker
Kahmen and Georg Heusch.
REFERENCES: Lunn Gallery, cat. no. 5,
no. 130; WEBR, p. 8, no. 4 (titled and
dated, *George's Place* [*Mississippi*],
1936); WEAW, p. 11 (variant, bottom
image).

EXHIBITIONS: *Walker Evans*, Bahnhof
Rolandseck, West Germany, Oct. 5–
Nov. 30, 1978.

471
[*Longwood Plantation, Near Natchez,
Mississippi*], ca. 1935
16.5 x 18.2 cm (6 ½ x 7 ⁵/₃₂ in.)
84.XM.956.915
MARKS & INSCRIPTIONS: (Verso) at
u. right, in black ink, by Evans, *119.*;
at center and l. right, Evans stamp A;
at l. right, Crane stamp; at l. left, in
pencil, Crane no. *L76.46(Evans)*.

472
[*Stable, Natchez, Mississippi*], 1935
17.5 x 20.9 cm (6 ⅞ x 8 ¼ in.) [on origi-
nal mount trimmed to image]
84.XM.956.332
MARKS & INSCRIPTIONS: (Verso) at right
center, Evans stamp A; at u. left, in
pencil, MoMA no. *38.2357/Evans*;
at l. left, in pencil, *horse - front* and
Crane no. *L67.22*.

473
Mississippi Gulf Coast Landscape, 1935
Image: 19 x 23.9 cm (7 ⁷/₁₆ x 9 ¹³/₃₂ in.);
original mount: 19.9 x 27.3 cm
(7 ⅞ x 10 ¾ in.)
84.XM.956.342
MARKS & INSCRIPTIONS: (Recto, mount)
signed at l. right, in pencil, by Evans,
Walker Evans; (verso) titled and dated
at center, in pencil, by Evans, *Missis-
sippi, Gulf Coast landscape/1935*; at
l. left, in pencil, Crane no. *L67.91
(Evans)*.
REFERENCES: MoMA, p. 145.

475

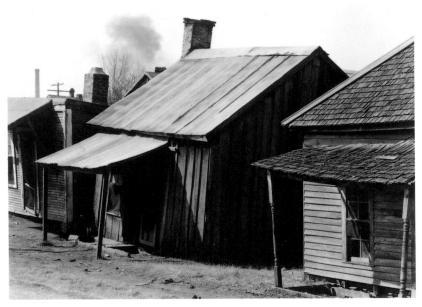

476

477

7 ⅛ x 5 ⁷/₁₆; (verso, mount) signed at right center, in pencil, by Evans, *Walker Evans*; at l. right, in pencil, *H2416.86/86/NO* [within a box] *150 h*; at l. right, in pencil, *21*; (recto, mat) at l. center, in pencil, *AP50*; at l. left, in pencil, Crane no. *L68.14(Evans)*.
REFERENCES: *AMP, Part I, no. 21; FSA, no. 125 (negative dated Mar. 1936); APERTURE, p. 57.

474
Mississippi Gulf Coast Landscape, 1935
19.3 x 25.1 cm (7 ⅝ x 9 ⅞ in.); original mount: 19.3 x 27 cm (7 ⅝ x 10 ⅝ in.)
84.XM.956.338
MARKS & INSCRIPTIONS: (Verso) titled at l. right, in black ink, by Evans, *Mississippi Gulf Coast Landscape*; (recto, mount) at l. left, Evans stamp A; at u. center, in pencil, MoMA no. *38.2262/Evans*; at right center, in pencil, *1935* [underlined]; at l. left, in pencil, Crane no. *L67.61(Evans)*.
REFERENCES: MoMA, p. 145.
NOTE: Not illustrated; variant of no. 473.

475
Mississippi Gulf Coast Landscape, 1935
19.6 x 25.3 cm (7 ¹¹/₁₆ x 9 ³¹/₃₂ in.); original mount: 19.6 x 26.7 cm (7 ¹¹/₁₆ x 10 ¹⁷/₃₂ in.)
84.XM.956.337
MARKS & INSCRIPTIONS: (Verso) titled and dated at center, in pencil, by Evans, *Mississippi Gulf Coast landscape/1935*; at u. center, in pencil, MoMA no. *38.2285/Evans*.

476
[*Houses in Negro Quarter of Tupelo, Mississippi**], 1936
Image: 18.3 x 23.3 cm (7 ³/₁₆ x 9 ³/₁₆ in.); original hole-punched mount: 31.3 x 25.8 cm (12 ⅜ x 10 ³/₁₆ in.)
84.XM.956.500
MARKS & INSCRIPTIONS: (Recto, mount) at l. left, in black ink, *Part One/#21*; at center, in pencil, *Houses in Negro Quarter of/Tupelo, Miss. 1936*; at u. right, in pencil, *78.5* [beside a right angle]; at l. right, in pencil, *21*; at l. left, in pencil, *9 ⅛ x 7 ³/₁₆/*

477
[*Butcher Sign, Mississippi**], 1936
8.6 x 13.7 cm (3 ¹³/₃₂ x 5 ⅜ in.) [on AZO postcard stock]
84.XM.956.372
MARKS & INSCRIPTIONS: (Verso) at l. right, Evans stamp A; at u. right, in pencil, by Evans, *Mr. Barth/Resdt of/VA 34676/Mrs. Hoover*; at l. center, in pencil, by Arnold Crane, *withdrawn/A H Crane*; at l. left, Crane no. *L67.89(Evans)*.
REFERENCES: *AMP, Part II, no. 31 (variant); FSA, no. 116 (variant, negative dated Mar. 1936).

478

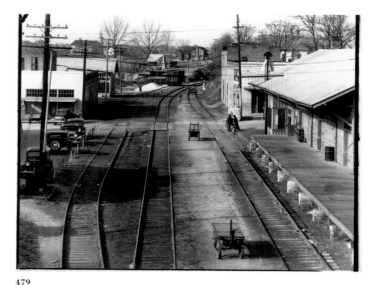

479

480

481

478
[*Butcher Sign, Mississippi**], 1936
17.6 x 19.8 cm (6 15/16 x 7 25/32 in.) [on
Masonite trimmed to image]
84.XM.956.446
MARKS & INSCRIPTIONS: (Verso, mount)
signed on MoMA label, at right center,
in pencil, by Evans, *Walker Evans*; at
right center, Evans stamp F; at center,
in pencil, *A-P II-31*; at u. left, on
manila card, *#92*; at center, on manila
card, *38.2424/Evans*; at top center,
typed on MoMA label, *EVANS/BUTCHER
SIGN, MISSISSIPPI, 1936/92/38.2424*; at
u. right, in pencil, *AP II-31*; at l. right,

in black ink, *GR VI*; at l. left, in pencil,
Crane no. *L69.11 (Evans)*.
REFERENCES: *AMP, Part II, no. 31 (vari-
ant); FSA, no. 116 (variant).
EXHIBITIONS: "*. . . images that yet/
Fresh images beget . . .*" J. Paul Getty
Museum, Malibu, Calif., Sept. 15–
Dec. 15, 1987.

479
[*Railroad Station, Edwards, Missis-
sippi**], 1936
19.8 x 25.2 cm (7 13/16 x 9 15/16 in.) [pos-
sibly a RA/FSA print]
84.XM.956.311

MARKS & INSCRIPTIONS: (Verso) at
l. right, Evans stamp C; at center, on
label, in pencil, *59* [circled]; at center,
on label, in blue pencil, *61* [circled];
at center, typed on white label,
*Walker Evans/c/o Fortune Magazine/
Time & Life Building/9 Rockefeller
Plaza/New York, New York*; at l. center,
in pencil, *59* [circled]; at u. center, in
blue pencil, *61* [circled and crossed
out]; at right center, in pencil, *4 15/16 h*;
at center, in pencil, *sideways*; at right
center, in red pencil, *65%*; at right cen-
ter, in blue ink, *65*; at u. right, wet
stamp, in purple ink, *x 395* [inverted];
at l. left, in pencil, Crane no. *L67.1*.

REFERENCES: *FSA, no. 109 (variant,
negative dated Feb. 1936).

480
[*Storefronts, Edwards, Mississippi**],
1936
8.7 x 13.7 cm (3 7/16 x 5 13/32 in.) [on AZO
postcard stock]
84.XM.956.367
MARKS & INSCRIPTIONS: (Verso) at
l. right, Evans stamp A; at l. left, in
pencil, Crane no. *L67.65 (Evans)*.
REFERENCES: *FSA, no. 112 (variant,
negative dated Mar. 1936).

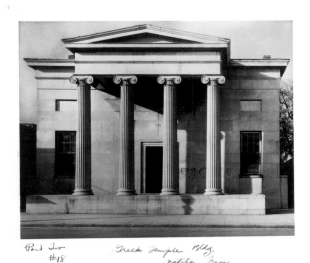

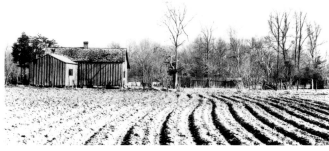

483

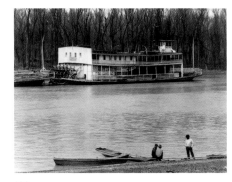

484

485

482

481
[*Storefronts, Edwards, Mississippi**], 1936
13.7 x 8.7 cm (5 ¹³⁄₃₂ x 3 ¹³⁄₃₂ in.) [on AZO postcard stock]
84.XM.956.365
MARKS & INSCRIPTIONS: (Verso) at l. right, Evans stamp A twice; at l. left, in pencil, Crane no. *L67.64* (*Evans*).
REFERENCES: *FSA, no. 112 (variant, negative dated Mar. 1936).

482
[*Greek Temple Building, Natchez, Mississippi**]/[*Old Commercial Build-ing, Erected 1809, 206 Main Street, Natchez, Mississippi*], 1936
Image: 16 x 19.7 cm (6 ⁵⁄₁₆ x 7 ¾ in.); original hole-punched mount: 27.9 x 21.6 cm (11 x 8 ½ in.)
84.XM.956.492
MARKS & INSCRIPTIONS: (Recto, mount) at l. left, in black ink, *Part Two*/*#18*; at l. center, in pencil, *Greek Temple Bldg.*/*Natchez, Miss.*/*1936*; at u. right, in pencil, *92.7* [beside a right angle]; at u. left, in pencil, *X*; at l. center, in pencil, *R-7/8*; at l. right, in pencil, *68*; (verso) mount) at l. center, Evans stamp B; at l. center, in pencil, *H2416-86/86/NO* [within a box] *150h*; (recto,

mat) at l. right, in pencil, *145*; at l. left, in pencil, Crane no. *L68.46* (*Evans*).
REFERENCES: *AMP, Part II, no. 18.

483
[*Mississippi Land**]/[*Farm Scene, Jackson, Mississippi***], 1936
Image: 13.3 x 22.1 cm (5 ¼ x 8 ²³⁄₃₂ in.); original hole-punched mount: 21.8 x 25.9 cm (8 ⁹⁄₁₆ x 10 ³⁄₁₆ in.)
84.XM.956.457
MARKS & INSCRIPTIONS: (Recto, mount) at l. left, in black ink, *Part Two*/*#9*; at center, in black ink, *Mississippi Land*/*1936*; at l. right, in pencil, *II-9*; at u. right, in pencil, *82.7* [next to a right angle]; (verso, mount) at right center, Evans stamp A; at u. right, in pencil, *P*; at center, in pencil, *II-9*; at l. left, in pencil, Crane no. *L68.40*(*Evans*).
REFERENCES: *AMP, Part II, no. 9; **FSA, no. 108 (variant, negative dated Mar. 1936).

484
[*Mississippi Sternwheeler at Vicksburg, Mississippi*], 1936
Image: 18.9 x 23.4 cm (7 ¹⁵⁄₃₂ x 9 ³⁄₁₆ in.); original hole-punched mount: 31.2 x 25.8 cm (12 ¼ x 10 ⅛ in.)

84.XM.956.514
MARKS & INSCRIPTIONS: (Recto, mount) at l. left, in black ink, *Part Two*/*#15*; at l. center, in black ink, *Mississippi Sternwheeler at*/*Vicksburg, Penna.*/ *1936*; at l. right, in pencil, by Evans, [indecipherable inscription]; at u. right, in pencil, *78.4* [with a right angle drawn to the side]; at l. right, *65*; (verso, mount) signed at center, in pencil, by Evans, *Walker Evans*; at u. right, in pencil, *P*; at l. right, in pencil, *65*; at l. right, in pencil, *H2416–86/86/No* [within a box] *150h*; at right center, Crane stamp; at l. left, in pencil, Crane no. *L68.63*.
REFERENCES: AMP, Part II, no. 15 (variant, incorrectly titled *Mississippi Sternwheeler at Vicksburg, Pennsylvania*, but corrected in errata).

485
[*Ferry Landing, Vicksburg, Missis-sippi**], 1936
8.5 x 13.7 cm (3 ⅜ x 5 ⅜ in.) [on post-card stock]
84.XM.956.284
MARKS & INSCRIPTIONS: (Verso) at l. right, Evans stamp B; (recto, mat) in pencil, *144*; at l. left, in pencil, Crane no. *L67.41*(*Evans*).
REFERENCES: *FSA, no. 148 (variant, negative dated Feb. 1936).

486

487

488

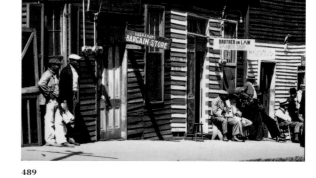

489

486
[*Seed Store, Interior, Vicksburg, Missis-
sippi**], 1936; printed later
24 x 19.2 cm (9 ⁷⁄₁₆ x 7 ⁹⁄₁₆ in.)
84.XM.956.309
MARKS & INSCRIPTIONS: (Verso) signed
and dated at center, in pencil, by
Evans, *Walker Evans/1936*; at l. left,
in pencil, Crane no. *L67.33*.
REFERENCES: *FSA, no. 135 (variant,
negative dated Mar. 1936).

487
[*Street Scene, Vicksburg, Mississippi*],
1936
14.3 x 18.9 cm (5 ¹¹⁄₁₆ x 7 ¹⁵⁄₃₂ in.) [on
original mount trimmed to image]
84.XM.956.289
MARKS & INSCRIPTIONS: (Verso) at right
center, Evans stamp B; at u. center, in
pencil, MoMA no. *38.2412/Evans/#75*;
(recto, mat) at l. left, in pencil, Crane
no. *L67.43(Evans)*.
REFERENCES: WEAW, p. 140 (variant,
l. left image).

488
[*Street Scene, Vicksburg, Mississippi*],
1936
12.1 x 18 cm (4 ¾ x 7 ³⁄₃₂ in.)
84.XM.956.369
MARKS & INSCRIPTIONS: (Verso) at l. left,
Evans stamp A; at l. left, in pencil,
Crane no. *L67.70(Evans)*.

489
*Mississippi Town Negro Street/[Street
Scene, Vicksburg, Mississippi**], 1936
8.7 x 13.8 cm (3 ¹³⁄₃₂ x 5 ¹³⁄₃₂ in.) [on
postcard stock]
84.XM.956.305

MARKS & INSCRIPTIONS: (Verso) initialled
and inscribed at u. center, in black
ink, by Evans, *W.E./c/o Mr. Mabry/
Museum of Modern Art*; at l. left, in
black ink, by Evans, *8. Mississippi
Town negro street*; at l. left, in pencil,
Crane no. *L67.25*.
REFERENCES: *FSA, no. 133 (variant,
negative dated Mar. 1936).

490
[*Sidewalk Portrait of Three Men, Vicks-
burg, Mississippi*], 1936
Image: 17.7 x 24 cm (7 x 9 ⁷⁄₁₆ in.); orig-
inal mount: 18.2 x 24 cm
(7 ⁵⁄₃₂ x 9 ¹⁵⁄₁₆ in.)
84.XM.956.303

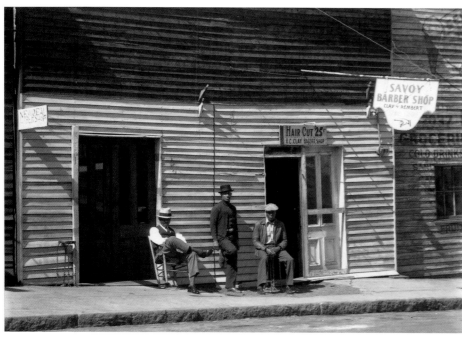

490

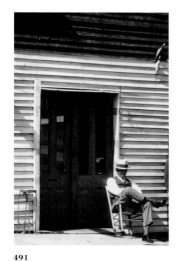

491

492

493

MARKS & INSCRIPTIONS: (Verso, mount) at l. center, Evans stamp B; at center, in black crayon, *44*; at l. left, in pencil, Crane no. *L67.27*.

EXHIBITIONS: *Neither Speech Nor Language: Photography and the Written Word*, J. Paul Getty Museum, Malibu, Calif., Feb. 28–May 12, 1991.

491
[*Barbershop Facade, Vicksburg, Mississippi*], 1936
13.8 x 8.6 cm (5 ⁷/₁₆ x 3 ¹³/₃₂ in.) [on postcard stock]
84.XM.956.306

MARKS & INSCRIPTIONS: (Verso) at right center, Evans stamp B; at l. left, in pencil, Crane no. *L67.26*.

492
[*Savoy Barber Shop, Vicksburg, Mississippi*], 1936
13.2 x 11.4 cm (5 ³/₁₆ x 4 ½ in.) [on original mount trimmed to image]
84.XM.956.304

MARKS & INSCRIPTIONS: (Verso, mount) at u. center, Evans stamp B; at l. left, in pencil, Crane no. *L67.24*.

EXHIBITIONS: *Neither Speech Nor Language: Photography and the Written*

Word, J. Paul Getty Museum, Malibu, Calif., Feb. 28–May 12, 1991.

493
Vicksburg Battlefield Monument/[*Brigadier General Lloyd Tilghman, Killed May 16, 1863, The Battle of Champions Hill, Mississippi*], 1936
18 x 17.5 cm (7 ¹/₁₆ x 6 ⅞ in.) [on original mount trimmed to image]
84.XM.956.468

MARKS & INSCRIPTIONS: (Verso, mount) titled and dated at center, in blue ink, by Evans, *VICKSBURG BATTLEFIELD MONUMENT/1935*; at left center, Evans

stamp F; at right center, Evans stamp A; at u. right, in pencil, on white label, *I 29*; at l. left, in pencil, Crane no. *L68.18(Evans)*.

REFERENCES: AMP, Part I, no. 29 (variant, titled and dated *Battle field Monument, Vicksburg, Pennsylvania* [sic], *1936*); FSA, no. 160 (variant, negative dated Mar. 1936).

494

495

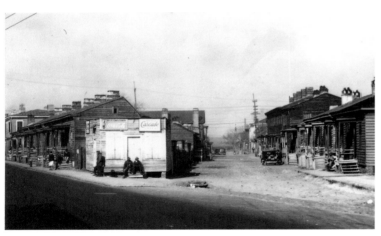

496

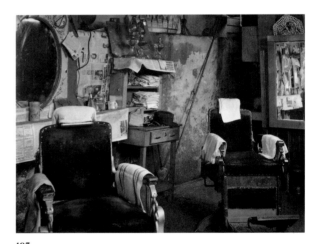

497

494
[*Battlefield Monument, Vicksburg, Mississippi**]/[*Rhode Island Monument, Vicksburg National Military Park*], 1936
22.4 x 15 cm (8 ²⁷⁄₃₂ x 5 ²⁹⁄₃₂ in.) [on original mount trimmed to image]
84.XM.956.343
MARKS & INSCRIPTIONS: (Verso) at left center, Evans stamp A; at u. left, in pencil, [indecipherable]/*LE4* [space] *7433/5:45* [space] *32* [space] *Tues*; at center, in pencil, *Vicksburg*; at l. left, in pencil, Crane no. *L67.78(Evans)*.
REFERENCES: *FSA, no. 159 (variant, negative dated Mar. 1936).

495
[*Battlefield Monument, Vicksburg, Mississippi**]/[*Ohio Monument, Vicksburg National Military Park*], 1936
18.1 x 17.9 cm (7 ⅛ x 7 ¹⁄₁₆ in.) [on original mount trimmed to image]
84.XM.956.347
MARKS & INSCRIPTIONS: (Verso) at l. right, Evans stamp A; at l. left in pencil, Crane no. *L67.68*.
REFERENCES: *FSA, no. 161 (negative dated Mar. 1936).

496
[*Savannah Negro Quarter**], 1936
Image: 10.2 x 16.8 cm (4 ¹⁄₃₂ x 6 ⅝ in.);
original hole-punched mount:
27.9 x 21.6 cm (11 x 8 ½ in.)
84.XM.956.508
MARKS & INSCRIPTIONS: (Recto, mount) at l. left, in black ink, *Part One/#36*; at l. center, in black ink, *Savannah Negro Quarter/1935*; at l. center, in pencil, *SS*; at l. right, in pencil, *36*; (verso, mount) signed at center, in pencil, by Evans, *Walker Evans*; at l. center, in pencil, *H2416-86/86/NO* [within a box] *150 h*; at l. right, in pencil, *36*; (recto, mat) at l. right, in pencil, *149*; at l. left, in pencil, Crane no. *L68.25(Evans)*.

REFERENCES: *AMP, Part I, no. 36 (dated 1935).

497
[*Negro Barbershop Interior, Atlanta**], 1936
18.3 x 23.4 cm (7 ¼ x 9 ¼ in.) [on Masonite trimmed to image]
84.XM.956.434
MARKS & INSCRIPTIONS: (Verso, mount) at u. left, Evans stamp C; at l. right, Evans stamp F and Evans stamp H; at center, typed on MoMA label, *EVANS/ NEGRO BARBERSHOP INTERIOR/ ATLANTA, 1936/26/38.233*; at u. right,

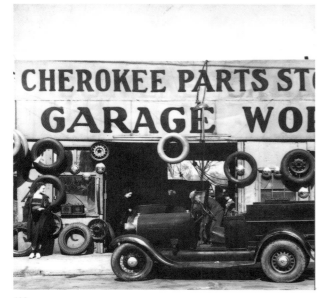

498

500

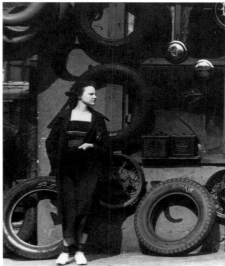

499

signed in pencil on MoMA label, by Evans, *Walker Evans*; at center, in pencil, on MoMA label, *AP I-6* and *OA18690*; at l. right, in ink, on MoMA label, *GR VIII*; at center, in pencil, *#26*; at l. left, in pencil, *I-6*; at l. center, wet stamp, *RIGHTS RESERVED*; at l. right, in pencil, Crane no. *L69.1* (*Evans*).
REFERENCES: *AMP, Part I, no. 6 (variant); FSA, no. 170 (variant, negative dated Mar. 1936).

498
[*Garage in Southern City Outskirts**]/
[*Garage, Atlanta, Georgia***], 1936
17.4 x 17.6 cm (6 $^{27}/_{32}$ x 6 $^{15}/_{16}$ in.) [on Masonite trimmed to image]
84.XM.956.447
MARKS & INSCRIPTIONS: (Verso, mount) at center, typed on MoMA label: *EVANS/ GARAGE IN SOUTHERN CITY OUTSKIRTS/ 68/38.2258*; at right center, in ink, on MoMA label, *1936*; at l. right, in black ink, on MoMA label, *GR X*; at l. left, in pencil, Crane no. *L69.3*(*Evans*).
REFERENCES: *AMP, Part I, no. 25 (vari-

ant); SP, pl. 7 (variant); **FSA, no. 171 (variant); FAL, p. 97 (variant).

499
[*Garage in Southern City Outskirts*]/
[*Garage, Atlanta, Georgia*], 1936
Image: 34 x 25.1 cm (13 $^{3}/_{8}$ x 9 $^{7}/_{8}$ in.); sheet: 35.3 x 27.8 cm
(13 $^{7}/_{8}$ x 10 $^{15}/_{16}$ in.)
90.XM.69
MARKS & INSCRIPTIONS: (Verso) at l. right, Lunn Gallery stamp, and within boxes, in pencil, *1* and *58* [check mark].

PROVENANCE: Swann Galleries; Daniel Wolf.
REFERENCES: WEAW, p. 138 (variant).

500
[*Garage in Southern City Outskirts*]/
[*Garage, Atlanta, Georgia*], 1936
25.2 x 20.3 cm (9 $^{15}/_{16}$ x 7 $^{31}/_{32}$ in.)
84.XM.956.319
MARKS & INSCRIPTIONS: (Verso) at l. left, Evans stamp A; at center, in pencil, *I-25*; at l. left, in pencil, Crane no. *L67.14*.
REFERENCES: WEAW, p. 138 (variant).

501

504

506

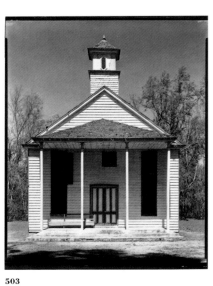

503

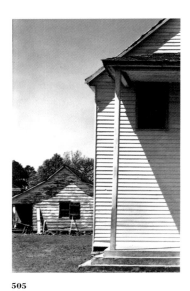

505

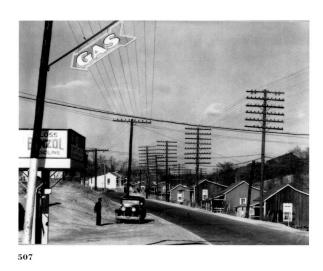

507

501
[*Wooden Church, South Carolina**],
1936
20.9 x 18.2 cm (8 ⁷⁄₃₂ x 7 ³⁄₁₆ in.) [on
Masonite trimmed to image]
84.XM.956.448
MARKS & INSCRIPTIONS: (Verso, mount)
signed at l. right, in pencil, by Evans,
Walker Evans; at right center, Evans
stamp H; at u. left, in pencil, *AP.1:II
17*; at l. center, in pencil, *AP.1: II-17*; at
center, typed on MoMA label: *EVANS/
WOODEN CHURCH, SOUTH CAROLINA/31/
38.2369*; at center, in pencil, on MoMA
label, *AP1 II-17*; at l. right, in black

ink, on MoMA label, *GR XII*; at l. left, in
pencil, Crane no. *I.69.10(Evans)*.
REFERENCES: *AMP, Part II, no. 17 (vari-
ant); FOURTEEN, p. 7 (variant); FSA,
no. 196 (variant, negative dated Mar.
1936); FAL, p. 85 (variant); APERTURE,
p. 67 (variant).

502
[*Wooden Church, South Carolina**],
1936; printed later
Image: 22 x 19.5 cm (8 ⁵⁄₈ x 7 ²¹⁄₃₂ in.);
possibly original window mat [taped to
recto]: 25.6 x 24.2 cm (10 ¹⁄₁₆ x 9 ½ in.)
84.XM.956.454

MARKS & INSCRIPTIONS: (Verso) at u. cen-
ter, Evans stamp I; at l. center, Evans
stamp I; at center, Evans stamp G [sec-
ond line has been crossed out with
black marker]; at u. center, in pencil,
$150.00; at center right, in black
marker, *$150.00*; at l. left, on white
label, in pencil, *I.68.45/Evans*.
REFERENCES: *AMP, Part II, no. 17 (vari-
ant); FSA, no. 196 (variant, negative
dated Mar. 1936); FAL, p. 85 (variant);
APERTURE, p. 67.
NOTE: Not illustrated; duplicate of
no. 501.

503
[*Negroes' Church, South Carolina**]/
[*Country Church, South Carolina***],
1936
25.3 x 20 cm (9 ³¹⁄₃₂ x 7 ²⁹⁄₃₂ in.)
84.XM.956.320
MARKS & INSCRIPTIONS: (Recto) in nega-
tive, at u. left, *AGFA SAFTEY FILM*;
(verso) at u. left, partial Evans stamp
A; at u. right, in pencil, *c* [circled]/*this
was used/Am. Photographs/MMA 1938*;
at center, in pencil, *F: Walker Evans-
Credit/RE. Church Gallery-Dec.*; at
right center, in pencil, *S.S. POS.*; at
center, in blue pencil, *F7*; at l. right,
in red ink, *I.608*; at l. center, Crane

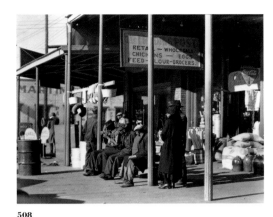

508

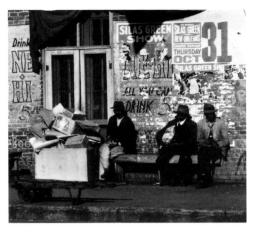

509

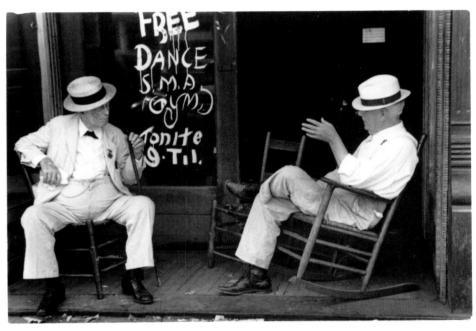

510

(7 ³/₁₆ x 8 ¹³/₁₆ in.); original hole-punched mount: 31.3 x 25.8 cm (12 ⁵/₁₆ x 10 ³/₁₆ in.)
84.XM.956.498
MARKS & INSCRIPTIONS: (Recto, mount) at l. left, in black ink, *Part Two/#7*; at l. center, in black ink, *Roadside View, Alabama Coal/Area Co. Town, 1936*; at u. right, *81.7* [beside a right angle]; at l. center, *8″* [space] *8 ½″*; at l. right, in pencil, *97* [circled]; at l. right, in pencil, *57* [crossed out]; (verso, mount) signed at center, in pencil, by Evans, *Walker Evans*; at l. right, in pencil, *H2416-86/86/NO* [within a box] *150 h* and *57* (*over 56*).
REFERENCES: *AMP, Part II, no. 7; FSA, no. 224 (variant, negative dated Nov. 1935); LUNN, p. 3 (variant); APERTURE, p. 75 (variant, dated 1936).
EXHIBITIONS: *Walker Evans: An Alabama Record*, J. Paul Getty Museum, Malibu, Calif., Apr. 7–June 21, 1992.

508
[*Sidewalk Scene, Selma, Alabama**], 1935
18.4 x 23.5 cm (7 ¼ x 9 ¼ in.)
84.XM.956.317
MARKS & INSCRIPTIONS: (Verso) at l. right, Evans stamp A; at u. left, in pencil, *A2/2 ½ s shade top w glacine/ 25 W* [inverted]; at l. left, in pencil, Crane no. *L67.12*.
REFERENCES: *FSA, no. 210 (variant, negative dated Dec. 1935).
EXHIBITIONS: *Walker Evans: An Alabama Record*, J. Paul Getty Museum, Malibu, Calif., Apr. 7–June 21, 1992.

509
The Paperdealers/[*Sidewalk Scene, Selma, Alabama**], 1935
8.9 x 9.7 cm (3 ½ x 3 ¹³/₁₆ in.) [on original mount trimmed to image]
84.XM.956.283
MARKS & INSCRIPTIONS: (Verso) at l. edge, in pencil, by Evans, *THE PAPERDEALERS*; at u. edge, in pencil, *Evans*; at center, in pencil, *#84*; at center, in pencil MoMA loan no. *38.2948/Walker Evans 1937*.
REFERENCES: *FSA, no. 205 (variant, negative dated Dec. 1935).
EXHIBITIONS: *Walker Evans: An Alabama Record*, J. Paul Getty Museum, Malibu, Calif., Apr. 7–June 21, 1992.

510
[*Two Elderly Men Conversing*], 1936
15.1 x 21.8 cm (5 ³¹/₃₂ x 8 ¹⁹/₃₂ in.)
84.XM.956.293
MARKS & INSCRIPTIONS: (Verso) signed at l. right, in black ink, by Evans, *WALKER EVANS/441 E. 92nd ST. N.Y.C.* ["N.Y.C." *crossed out in pencil*]; at l. right, Evans stamp C; at u. left, in pencil, *2.46* [circled];

stamp; at l. left, Crane no. *L67.17*.
REFERENCES: "Primitive Churches," *Architectural Forum*, Dec. 1961, p. 105 (variant); *FSA, no. 195 (variant, negative dated Mar. 1936); **APERTURE, p. 65 (variant).

504
[*Detail of Negroes' Church, South Carolina*], 1936
13.7 x 8.7 cm (5 ¹³/₃₂ x 3 ⁷/₁₆ in.) [on postcard stock]
84.XM.956.473
MARKS & INSCRIPTIONS: (Verso) at l. right, Evans stamp A; at l. left, in pencil, Crane no. *L68.47*(*Evans*).

REFERENCES: AMP, Part II, no. 19 (variant); FSA, no. 194 (variant, negative dated Mar. 1936).

505
[*Detail of Negroes' Church, South Carolina*], 1936
13.7 x 8.7 cm (5 ³/₈ x 3 ¹/₃₂ in.) [on postcard stock]
84.XM.956.475
MARKS & INSCRIPTIONS: (Verso) at l. right, Evans stamp I, at l. left, in pencil, Crane no. *L68.48*(*Evans*).
REFERENCES: AMP, Part II, no. 19 (variant); FSA, no. 194 (variant, negative dated Mar. 1936).

506
[*Gilded Pediment Eagle, Charleston, South Carolina*], 1936
8.7 x 13.7 cm (3 ⁷/₁₆ x 5 ¹³/₃₂ in.) [on AZO postcard stock]
84.XM.956.368
MARKS & INSCRIPTIONS: (Verso) at l. right, Evans stamp B; at l. left, in pencil, Crane no. *L67.63*(*Evans*).
REFERENCES: FSA, no. 199 (variant, negative dated Mar. 1936).

507
[*Roadside View, Alabama Coal Area Company Town**], 1935
Image: 18.3 x 22.4 cm

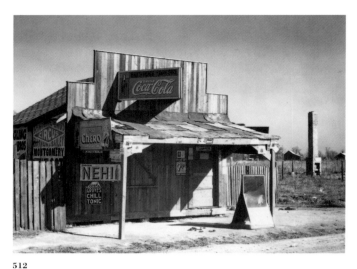

512

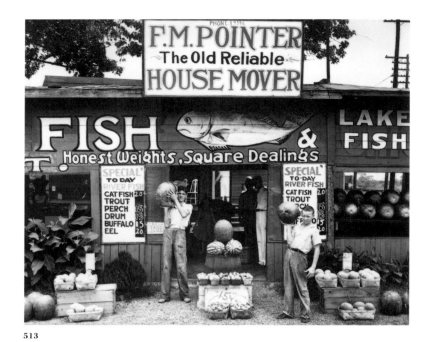

513

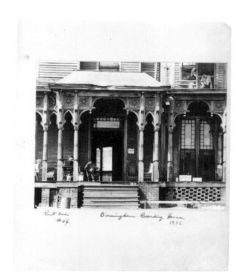

514

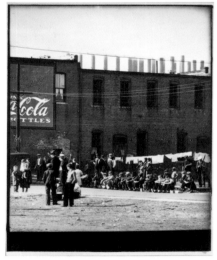

515

516

at u. center, *45794* [underlined]/*6* [underlined]/*2* [entire inscription crossed out]; at center, in pencil, *10″ wide*; at l. center, *E 85* [circled]; at u. right, Crane stamp.
REFERENCES: LUNPFM-60, no. 46 (variant).
EXHIBITIONS: *Walker Evans: An Alabama Record*, J. Paul Getty Museum, Malibu, Calif., Apr. 7–June 21, 1992.

511
[*Two Elderly Men Conversing*], 1936
Image: 15.7 x 23.1 cm
(6 3/16 x 9 1/16 in.); sheet: 18.1 x 24.2 cm
(7 1/8 x 9 9/16 in.)
84.XM.956.313

MARKS & INSCRIPTIONS: (Recto) at l. right, Evans stamp C; at l. right, in pencil, *2-46*; (verso) at right center, Evans stamp C; at center, in pencil, *2-46*; at l. left, in pencil, Crane no. *L67.8*.
REFERENCES: LUNPFM-60, pl. no. 46.
NOTE: Not illustrated; variant of no. 510.

512
[*Roadside Store, Near Selma, Alabama*], 1935
13.5 x 18.1 cm (5 5/16 x 7 1/8 in.) [on original mount trimmed to image]
84.XM.956.361

MARKS & INSCRIPTIONS: (Verso) at l. right, Evans stamp C; at l. left, in pencil, Crane no. *L67.57(Evans)*; at left of center, in black crayon, *2-49*; at right center, in black crayon, *10*.
REFERENCES: FSA, no. 207 (variant, negative dated Dec. 1935).
EXHIBITIONS: *Walker Evans: An Alabama Record*, J. Paul Getty Museum, Malibu, Calif., Apr. 7–June 21, 1992.

513
[*Roadside Stand Near Birmingham**]/
[*Roadside Store Between Tuscaloosa and Greensboro, Alabama***], 1936
18.4 x 22.4 cm (7 1/4 x 8 13/16 in.)
84.XM.956.519

MARKS & INSCRIPTIONS: (Verso) signed at u. center, in pencil, by Evans, arrow pointing to the right, *WALKER EVANS*; at center, in pencil, by Evans, *Alabama (Birmingham Suburb)*; at center, in red pencil, by Evans, *for FSA*; at center, Evans stamp B; at u. right, in pencil, on white label, *I 35*; at u. left, in pencil, *#155/Roadside Stand/ Birmingham, Ala. 1936*; at l. left, in pencil, *CROP*/[arrow pointing to left] [space] *CUT 26* [circled] *3 1/2″* [arrow pointing upward] *HIGH*; in pencil, [crop lines along left edge and diagonally from u. left to l. right]; at l. right,

517

518

519

Crane stamp; at l. left, in pencil, Crane no. *L68.24*.

REFERENCES: *AMP, Part I, #35 (variant); FOURTEEN, p. 9 (variant); FSA, no. 216 (variant); CRANE no. 153; FAL, p. 100 (variant); **APERTURE, p. 73 (variant).

EXHIBITIONS: *Walker Evans: An Alabama Record*, J. Paul Getty Museum, Malibu, Calif., Apr. 7–June 21, 1992.

514
[*Birmingham Boarding House**], 1936
Image: 18.4 x 22.9 cm (7 ¼ x 9 in.); original hole-punched mount: 31.3 x 25.8 cm (12 ⅜ x 10 3/16 in.)
84.XM.956.505
MARKS & INSCRIPTIONS: (Recto, mount) at l. left, in black ink, *Part One/#46*; at l. center, in pencil, *Birmingham Boarding House /1936*; at l. right, in pencil, *46*; (verso, mount) signed at l. center, in pencil, by Evans, *Walker Evans*; at u. left, in pencil, *#157*; at l. left, in pencil, *CUT 7* [7 circled] *5″* [arrow pointing to the right] *WIDE*; at

l. right, in pencil, *H2416-86/86/NO* [within a box] *150 h.*; at l. right, in pencil, *46*.
REFERENCES: *AMP, Part I, no. 46; FOURTEEN, p. 2 (variant); FSA, no. 228 (variant, negative dated Mar. 1936); CRANE no. 55.
EXHIBITIONS: *Walker Evans: An Alabama Record*, J. Paul Getty Museum, Malibu, Calif., Apr. 7–June 21, 1992.

515
[*Steel Millworkers, Birmingham, Alabama*], 1936
Image: 22.2 x 19 cm (8 ¾ x 7 ½ in.); sheet: 25 x 20 cm (9 ⅞ x 8 ⅞ in.); original mount: 26.6 x 20 cm (10 7/16 x 8 ⅞ in.)
84.XM.956.341
MARKS & INSCRIPTIONS: (Verso) at l. right, Evans stamp A; at u. center, in pencil, MoMA no. *38.2312/Evans*; at l. left, in pencil, Crane no. *L67.71 (Evans)*.
EXHIBITIONS: *Walker Evans: An Alabama Record*, J. Paul Getty Museum, Malibu, Calif., Apr. 7–June 21, 1992.

516
[*Houses and Cemetery, Birmingham, Alabama*], 1936
Image: 15.9 x 18 cm (6 9/32 x 7 ⅛ in.); original mount: 16.6 x 18.8 cm (6 17/32 x 7 7/16 in.)
84.XM.956.312
MARKS & INSCRIPTIONS: (Verso) at center, Evans stamp J; at l. right, Crane stamp; at l. left, in pencil, Crane no. *L67.19*.
REFERENCES: *FSA, no. 227 (variant, negative dated Mar. 1936).

EXHIBITIONS: *Walker Evans: An Alabama Record*, J. Paul Getty Museum, Malibu, Calif., Apr. 7–June 21, 1992.

517
[*Penny Picture Display, Savannah**]/ [*Photographer's Window Display, Birmingham, Alabama***]/[*Studio Portraits, Birmingham, Alabama****], 1936
25.6 x 19.9 cm (10 1/16 x 7 27/32 in.)
84.XM.956.477
MARKS & INSCRIPTIONS: (Verso) at u. center, in pencil, *1-2*; at l. center, Crane stamp.
REFERENCES: *AMP, Part I, no. 2 (variant); **FSA, no. 229 (negative dated Mar. 1936); SP, pl. 7 (variant); FAL, no. 127; ***APERTURE, p. 89 (variant).
EXHIBITIONS: "*. . . images that yet/ Fresh images beget . . . ,*" J. Paul Getty Museum, Malibu, Sept. 15–Nov. 15, 1987; *Neither Speech Nor Language: Photography and the Written Word*, J. Paul Getty Museum, Malibu, Calif., Feb. 28–May 12, 1991.

518
[*Penny Picture Display, Savannah**]/ [*Photographer's Window Display, Birmingham, Alabama***], 1936
20.2 x 25.4 cm (7 31/32 x 9 31/32 in.)
84.XP.208.21
MARKS & INSCRIPTIONS: (Verso) at u. left, in pencil, *L.C.229*; at u. right, in pencil, *L-135*; at l. left, in pencil, *4* [circled]; at l. right, in pencil, *83*; at l. right, in pencil, *$2000.—*; at l. center, in pencil, *Birmingham, Alabama: March 1936*.
PROVENANCE: Daniel Wolf.
REFERENCES: *AMP, Part I, no. 2 (variant); **FSA, no. 229 (variant, negative dated Mar. 1936); FAL, p. 127 (variant); APERTURE, p. 89 (variant).

519
Photographer's Window, Savannah/ [*Penny Picture Display, Savannah**]/ [*Photographer's Window Display, Birmingham, Alabama***], 1936
17.9 x 21.4 cm (7 1/16 x 8 7/16 in.) [on original mount trimmed to image]
84.XM.956.463
MARKS & INSCRIPTIONS: (Verso, mount) signed, titled and dated at u. left, in blue ink, by Evans, *Walker Evans/Photographers Window, Savannah/1936/*

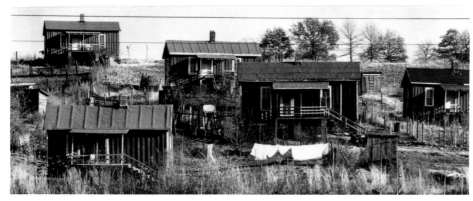

520

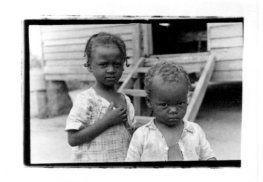

521

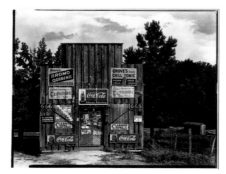

523

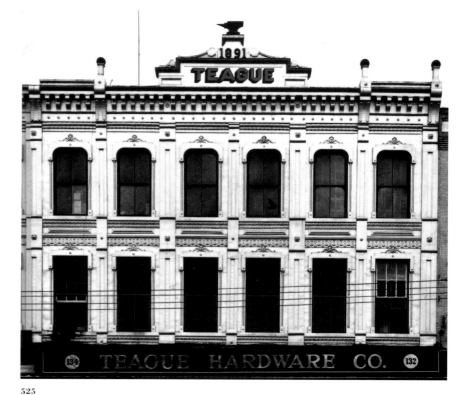

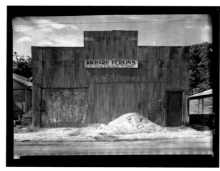

524

525

8 x 10 [crossed out] *this print for repro-duction*; at u. left, in pencil, *cat* ____ [missing]/*37.835* [crossed out]; at center, in pencil, *38.2949/Evans # 77* and *6 ¼* [with horizontal lines to either side]; at l. right, in pencil, *F 308*; at l. left, in pencil, Crane no. *L68.3 (Evans)*.
REFERENCES: *AMP, Part I, no. 2 (vari-ant); **FSA, no. 229 (variant, negative dated Mar. 1936); FAL, p. 127 (variant); APERTURE, p. 89 (variant).

520
[*Miners' Houses, Vicinity Birmingham, Alabama**], 1935
7.3 x 17.5 cm (2 ⅞ x 6 ⅞ in.)
84.XM.956.280
MARKS & INSCRIPTIONS: (Verso) at left, Evans stamp J.
REFERENCES: *FSA, no. 225 (variant, negative dated Dec. 1935).
EXHIBITIONS: *Walker Evans: An Ala-bama Record*, J. Paul Getty Museum, Malibu, Calif., Apr. 7–June 21, 1992.

521
[*Two Children, Probably Alabama*], ca. 1936

Image: 14.4 x 21.1 cm
(5 ²¹⁄₃₂ x 8 ⁵⁄₁₆ in.); sheet: 20.1 x 25.1 cm
(7 ²⁹⁄₃₂ x 9 ²⁹⁄₃₂ in.)
84.XM.956.295
MARKS & INSCRIPTIONS: (Verso) at center right, Evans stamp A; at u. right, in pencil, *Walker Evans*.
EXHIBITIONS: *Walker Evans: An Ala-bama Record*, J. Paul Getty Museum, Malibu, Apr. 7–June 21, 1992.

522
Greensboro, Alabama, 1936
20 x 25.3 cm (7 ⅞ x 9 ³¹⁄₃₂ in.)
84.XM.956.316

MARKS & INSCRIPTIONS: (Verso) titled and dated at u. center, in pencil, by Evans, *Greensboro, Ala. 1936*; at l. right, Evans stamp C; at l. left, in pencil, Crane no. *L67.16*.
EXHIBITIONS: *Walker Evans: An Ala-bama Record*, J. Paul Getty Museum, Malibu, Calif., Apr. 7–June 21, 1992.

523
[*Roadside Store Between Tuscaloosa and Greensboro, Alabama**], 1936; printed later
Image: 19.4 x 24.4 cm

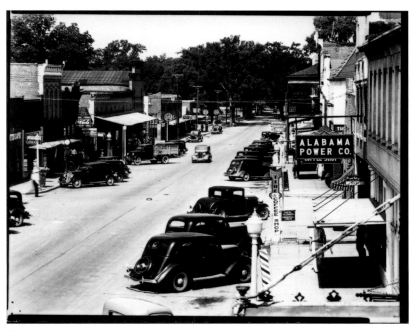

522

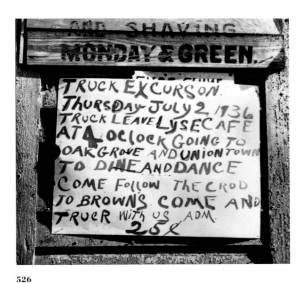

526

527

(7 ⅝ x 9 ¹⁹⁄₃₂ in.); sheet: 20.4 x 25.2 cm (8 x 9 ³¹⁄₃₂ in.)
84.XM.129.9
MARKS & INSCRIPTIONS: (Verso) at u. right, in pencil, *14.* [underlined]; at center, in pencil, *168*; at l. left, in pencil, *E3*; at l. right, in pencil, *25* [circled]; at l. right, Lunn Gallery stamp, and within boxes, in pencil, *II* and *114*.
PROVENANCE: Lunn Gallery; Volker Kahmen and Georg Heusch.
REFERENCES: *MoMA, p. 115; FSA, no. 369 (variant, negative dated Summer 1936); FAL, p. 101; WEBR, p. 7,

no. 3 (titled in German and dated, *Laden an der Straße zwischen Tuscaloosa und Greensboro* [*Alabama*], Sommer 1936).
EXHIBITIONS: *Walker Evans*, Bahnhof Rolandseck, West Germany, Oct. 5–Nov. 30, 1978.

524
[*Corrugated Tin Facade**]/[*Tin Building, Moundville, Alabama***], 1936
Image: 16.9 x 23.2 cm (6 ¹¹⁄₁₆ x 9 ⅛ in.); sheet: 20.3 x 25.2 cm (8 x 9 ¹⁵⁄₁₆ in.)
84.XM.129.10

MARKS & INSCRIPTIONS: (Recto) in negative, at u. right edge, *GFA SAFETY FILM* [reversed and lacking first letter]; at l. right edge, *RA-8160-A* [reversed]; (verso) at l. left, in pencil, Kahmen/Heusch no. *E8*; at l. right, in pencil, *35* [circled]; at l. center, Lunn Gallery stamp twice, and within two boxes of one stamp, in pencil, *II* and *102*.
PROVENANCE: Lunn Gallery; Volker Kahmen and Georg Heusch.
REFERENCES: *MoMA, p. 103 (variant); SP, pl. 13 (variant); **FSA, no. 241 (variant, negative dated Summer 1936); FAL, p. 96 (variant); WEBR, p. 6,

no. 8 (titled in German and dated, *Wellblechfassade, Moundville* [*Alabama*], Sommer 1936); APERTURE, p. 71 (variant).
EXHIBITIONS: *Walker Evans*, Bahnhof Rolandseck, West Germany, Oct. 5–Nov. 30, 1978.

525
[*Alabama City Block, Teague Hardware Company*], 1936
14 x 15.5 cm (5 ½ x 6 ³⁄₃₂ in.) [on original mount trimmed to image]
84.XM.956.349
MARKS & INSCRIPTIONS: (Verso) at u. center, Evans stamp A; at u. center, in pencil, *#83*; at u. right, in pencil, *Evans/38.2339*; at right center, on label, MoMA no. *no. 83/38.2339/Evans*; on label, at l. center, in black ink, by Evans, *COURTESY RESETTLEMENT ADMINISTRATION/ WASHINGTON*; typed on label, *Walker Evans/Alabama City Block/ 1936*; at l. left, in pencil, Crane no. *L67.69* (*Evans*).

526
[*Excursion Sign**], 1936
11.3 x 12.2 cm (4 ¹⁵⁄₃₂ x 4 ²⁵⁄₃₂ in.) [on original mount trimmed to image]
84.XM.956.373
MARKS & INSCRIPTIONS: (Verso) at center, Evans stamp B; at l. left, in pencil, Crane no. *L67.67*(*Evans*).
REFERENCES: *FSA, no. 362 (variant, negative Summer 1936).
EXHIBITIONS: *Walker Evans: An Alabama Record*, J. Paul Getty Museum, Malibu, Calif., Apr. 7–June 21, 1992.

527
[*Minstrel Show Bill**]/[*Minstrel Poster, Alabama***], 1936
19 x 16 cm (7 ½ x 6 ⁹⁄₃₂ in.)
84.XM.956.479
MARKS & INSCRIPTIONS: (Verso) at l. center, Evans stamp F; at top center, in blue pencil, *W. Evans/37-1054*; at l. left, in pencil, *AD#76*; at l. center, Crane stamp; at l. left, in pencil, Crane no. *L68.32*(*Evans*).
REFERENCES: *AMP, Part I, no. 34; SP, pl. 4 (variant); **FSA, no. 379 (variant); APERTURE, p. 51 (variant).
EXHIBITIONS: *Walker Evans: An Alabama Record*, J. Paul Getty Museum, Malibu, Calif., Apr. 7–June 21, 1992.

528

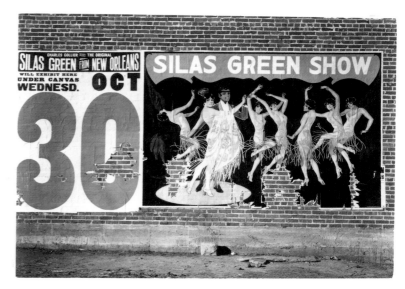

529

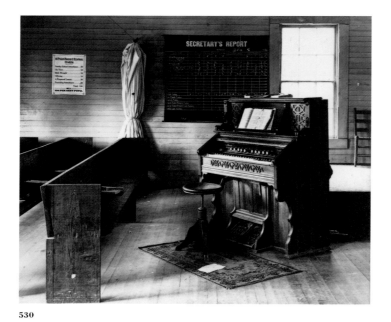

530

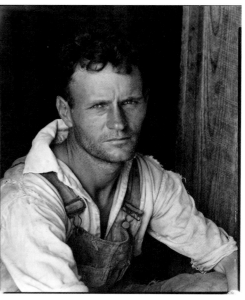

531

528
[*Mule Team and Poster, Demopolis, Alabama*], 1936
20.1 x 25.3 cm (7 ⅞ x 9 ¹⁵⁄₁₆ in.)
84.XM.956.354
MARKS & INSCRIPTIONS: (Verso) at l. right, Evans stamp A; at center, in pencil, *2-57*; at l. left, in pencil, Crane no. *L67.58(Evans).*
REFERENCES: LUNPFM-60, pl. no. 57 (variant); FSA, no. 384 (variant).

529
[*Show Bill, Demopolis, Alabama**]/ [*Poster, Alabama***], 1936
15.6 x 21.8 cm (6 ⅛ x 8 ⁹⁄₁₆ in.)
84.XM.956.294

MARKS & INSCRIPTIONS: (Verso) at u. right, Evans stamp A; at u. left, in pencil, *#154/Poster, Ala. 1936*; at l. left, in pencil, *6″* [arrow in box pointing to right] *WIDE/Cut 20*; at l. right, in pencil, *A2/20S/25W*; in pencil, line from u. left to l. right corners.
REFERENCES: *MoMA, p. 123 (variant); **FSA, no. 385 (variant); CRANE no. 152.

530
[*Church Organ with Pews*]/[*The Church Organ, Alabama**]/[*Church Interior, Alabama***], 1936
19 x 21.9 cm (7 ½ x 8 ⅝ in.) [on Masonite trimmed to image]

84.XM.956.452
MARKS & INSCRIPTIONS: (Verso, mount) signed at l. center, in pencil, by Evans, *Walker Evans*; at u. left, Evans stamp C; at l. center, Evans stamp I; at u. right, wet stamp, *RIGHTS RESERVED*; at u. center, typed on MoMA label, *EVANS/CHURCH ORGAN AND PEWS, 1936/23/38.2352*; at u. left, in pencil, on MoMA label, *#153*; at l. right, in black ink, on MoMA label, *GR23*; at l. left, in pencil, *CUT 3* [3 is circled] *8 ½* [arrow pointing to the right] *WIDE*; at l. left, in pencil, *98.5* [space] *11-186*; at l. left, in pencil, Crane

no. *L69.17(Evans).*
REFERENCES: *MFTI, pl. 5 (variant); LUNN, p. 10 (variant); **FAL, p. 89 (variant); CRANE no. 151; APERTURE, p. 69 (variant).
EXHIBITIONS: *Walker Evans: An Alabama Record*, J. Paul Getty Museum, Malibu, Calif., Apr. 7–June 21, 1992.

531
[*Floyd Burroughs, A Cotton Sharecropper, Hale County, Alabama**]/ [*George Gudger*], 1936
24.4 x 20 cm (9 ¹¹⁄₁₆ x 7 ⅞ in.)
84.XM.956.300

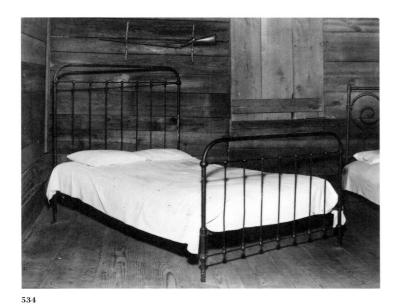

534

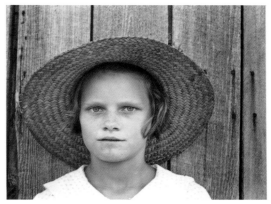

535

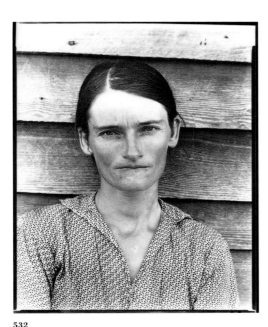

532

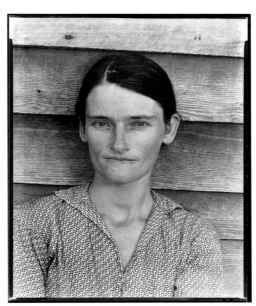

533

MARKS & INSCRIPTIONS: (Verso) at left center, Evans stamp B; at center, in pencil, *2-2/8138 A*; at l. right, Crane stamp; at l. left, in pencil, Crane no. *L67.11*.
REFERENCES: LUNPFM-41, pl. 2 (variant); LUNPFM-60, pl. 2 (variant); *FSA, no. 249 (negative dated Summer 1936); APERTURE, p. 53; WEAW, p. 126 (l. left image).

532
[*Allie Mae Burroughs, Wife of a Cotton Sharecropper, Hale County, Alabama*]/[*Annie Mae Gudger*], 1936

25.2 x 20.2 cm (9 ¹⁵⁄₁₆ x 7 ¹⁵⁄₁₆ in.)
84.XM.956.301
MARKS & INSCRIPTIONS: (Verso) at l. center, Evans stamp A; at center, typed on label, *Walker Evans/% Fortune Magazine/Time & Life Building/9 Rockefeller Plaza/New York, New York*; at l. right, wet stamp, in purple ink, *X 395*; at l. left, in pencil, *56* [sideways]; at u. center, in blue pencil, *3* [circled]; at l. center, *7 ⅝" h*; at l. left, in pencil, Crane no. *L67.15*; at l. center, on label, in pencil, *3* [circled]; at center, on label, in red pencil, *74%*.
REFERENCES: LUNPFM-41, pl. no. 3 (vari-

ant); LUNPFM-60, pl. no. 3 (variant); FOURTEEN, p. 12; APERTURE, p. 55 (variant).
EXHIBITIONS: *Walker Evans: An Alabama Record*, J. Paul Getty Museum, Malibu, Calif., Apr. 7–June 21, 1992.

533
[*Alabama Cotton Tenant Farmer Wife**]/[*Allie Mae Burroughs, Wife of a Sharecropper, Hale County, Alabama***]/[*Annie Mae Gudger*], 1936; printed later
24.9 x 20.2 cm (9 ²⁵⁄₃₂ x 7 ³¹⁄₃₂ in.)
84.XM.956.517

MARKS & INSCRIPTIONS: (Verso) at l. right, Evans stamp C; at l. left, in pencil, Crane no. *L68.10*.
REFERENCES: *AMP, Part I, no. 14 (variant); **FSA, no. 250 (negative dated Summer 1936); WEAW, p. 127 (u. left image).
EXHIBITION: *Walker Evans: An Alabama Record*, J. Paul Getty Museum, Malibu, Calif., Apr. 7–June 21, 1992.

534
[*Bed, Tenant Farmhouse, Hale County, Alabama**]/[*Floyd Burroughs' Bedroom, Hale County, Alabama***]/ [*The Rear Bedroom, the Gudger House*], 1936
17.8 x 22.2 cm (7 x 8 ¾ in.)
84.XM.956.350
MARKS & INSCRIPTIONS: (Verso) at center, in ink, *2-4*; at l. left, in pencil, Crane no. *L67.53(Evans)*.
REFERENCES: LUNPFM-60, pl. 4 (variant); *MoMA, p. 95 (variant); **FSA, no. 267 (variant, negative dated Summer 1936).
EXHIBITIONS: *Art of Photography*, Museum of Fine Arts, Houston, Tex., Feb. 11–Apr. 30, 1989; *Walker Evans: An Alabama Record*, J. Paul Getty Museum, Malibu, Calif., Apr. 7–June 21, 1992.

535
[*Lucille Burroughs, Hale County, Alabama**]/[*Maggie Louise Gudger*], 1936
Image: 17.8 x 22.8 cm (7 x 9 in.); fragmentary original hole-punched mount: 19.4 x 25.4 (7 ⅝ x 10 in.)
84.XM.488.32
MARKS & INSCRIPTIONS: (Recto, mount) at l. right, in pencil, *R-2050*; at u. left, in pencil, *2-6*; (verso, mount) at

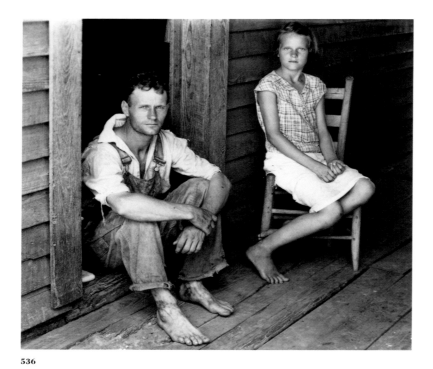

536

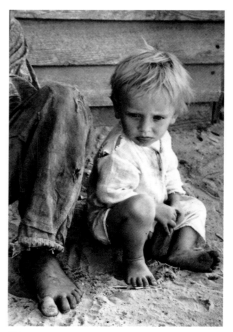

538

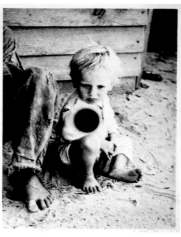

539

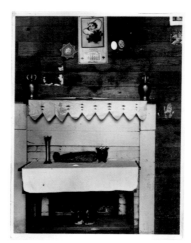

540

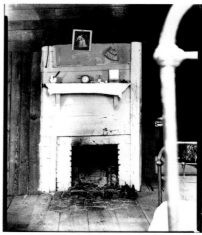

541

l. right, Evans stamp C; at u. left, in pencil, *7*; at center, in pencil, *2-6*; at l. right, in pencil, *R-2050*; at l. center, Lunn Gallery stamp, and within boxes, in pencil, *III* and *251*.
PROVENANCE: George Rinhart; Samuel Wagstaff, Jr.
REFERENCES: LUNPFM-41 and LUNPFM-60, pl. 6 (variants); *FSA, no. 251 (negative dated Summer 1936); WEAW, p. 131 (variant).
EXHIBITIONS: *Walker Evans: An Alabama Record*, J. Paul Getty Museum, Malibu, Calif., Apr. 7–June 21, 1992.

536
[Floyd and Lucille Burroughs, Hale County, Alabama]/[Floyd Burroughs and His Daughter, Hale County, Alabama]/[George and Maggie Louise Gudger]*, 1936
Image: 19.1 x 21.5 cm (7 ½ x 8 ⁷/₁₆ in.); mount: 44.5 x 36.7 cm
(17 ½ x 14 ½ in.)
84.XM.956.336
MARKS & INSCRIPTIONS: (Recto, mount) signed at right below print, in pencil, by Evans, *Walker Evans*; (verso, mount) at center, in pencil, *Alabama 1936*; at center, Evans stamp C; at l. left, in pencil, Crane no. *L67.49 (Evans)*.

REFERENCES: WEAW, p. 126 (variant); *APERTURE, cover.
EXHIBITIONS: *Art of Photography*, Museum of Fine Arts, Houston, Tex., Feb. 11–Apr. 30, 1989; *Walker Evans: An Alabama Record*, J. Paul Getty Museum, Malibu, Calif., Apr. 7–June 21, 1992.

537
[Floyd and Lucille Burroughs, Hale County, Alabama], 1936
19.8 x 24.8 cm (7 ¹³/₁₆ x 9 ²⁵/₃₂ in.)
84.XM.956.288

MARKS & INSCRIPTIONS: (Verso) at u. left, Evans stamp B [sideways]; at l. right, Crane stamp; at l. left, in pencil, Crane no. *L67.92(EVANS)*.
REFERENCES: WEAW, p. 126 (top image).
NOTE: Not illustrated; variant of no. 536.

538
Farmer's Child, Alabama/[Othel Lee (Squeakie) Burroughs, Hale County Alabama]/[Valley Few (Squinchy) Gudger]*, 1936
19.5 x 12.9 cm (7 ¹¹/₁₆ x 5 ¹/₁₆ in.)
84.XM.956.290

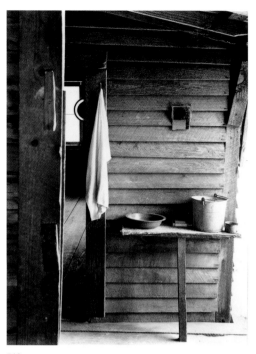

542

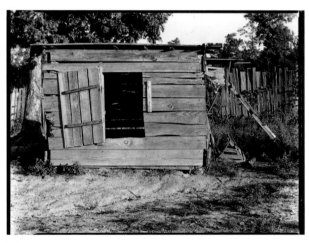

543

MARKS & INSCRIPTIONS: (Verso) titled and dated at center, in pencil, by Evans, *FARMER'S CHILD, ALABAMA/1936*; at l. right, Evans stamp C; at l. left, Crane stamp; at center, in pencil, *2-8*; at l. center, in pencil, *2-8*; at l. left, in pencil, Crane no. *L67.35(Evans)*.
REFERENCES: LUNPFM-41, pl. 5; LUNPFM-60, pl. 8; *FSA, no. 257 (variant, negative dated Summer 1936).
EXHIBITIONS: *Walker Evans: An Alabama Record*, J. Paul Getty Museum, Malibu, Calif., Apr. 7–June 21, 1992.

539
[Othel Lee (Squeakie) Burroughs, Hale County, Alabama]/[Valley Few (Squinchy) Gudger]*, 1936, printed later by The Library of Congress
Image: 24 x 18.2 cm (9 ¹⁵/₃₂ x 7 ⁵/₃₂ in.); sheet: 25.3 x 19.8 cm (10 x 7 ¹³/₃₂ in.)
84.XM.956.363
MARKS & INSCRIPTIONS: (Verso) at u. right, in pencil, *31334M/#4*; at u. center, wet stamp, in black ink, *This photograph is not known to be copyrighted/or restricted in [illegible]. However, it is not/accompanied by any [illegible] commercial/sense) [illegible]* *The Library of Congress/limits [illegible] to furnish/photographs [illegible] lieu of the/original. The Library can assume no responsibility/for the subsequent use of pictures so obtained.*; at l. left, in pencil, Crane no. *L67.36 (Evans)*.
REFERENCES: LUNPFM-41, pl. 5 (variant); LUNPFM-60, pl. 8 (variant); *FSA, no. 257 (variant, negative dated Summer 1936).

540
[Fireplace and Objects in a Bedroom of Floyd Burroughs' Home, Hale County, Alabama]/[In the Front Bedroom, the Gudger House]*, 1936
Image: 21.9 x 16.2 cm (8 ⅝ x 6 ⅜ in.); original mount: 22.8 x 16.9 cm (9 x 6 ²¹/₃₂ in.)
84.XM.956.279
MARKS & INSCRIPTIONS: (Verso, mount) at l. right, Evans stamp C; at center, typed on label, *Walker Evans/% Fortune Magazine/Time & Life Building/9 Rockefeller Plaza/New York, New York*; at u. right, in blue pencil, *9* [circled]; at center, in pencil, *4 ⅝″ W*; on label, in pencil, *9* [circled]; at center, in red pencil, *79+%*; at l. left, wet stamp, in purple ink, *X 395*; at l. right, on white label, in black ink, *9*.
REFERENCES: LUNPFM-41, pl. 8 (variant); LUNPFM-60, pl. 9 (variant); MoMA, p. 87 (variant); *FSA, no. 262 (variant, negative Summer 1936).
EXHIBITIONS: *Walker Evans: An Ala-*

bama Record, J. Paul Getty Museum, Malibu, Calif., Apr. 7–June 21, 1992.

541
[Alabama Country Fireplace]/[Fireplace, Burroughs House, Hale County, Alabama**]/[Interior, Gudger Home]*, 1936
24.4 x 20.2 cm (9 ⅝ x 7 ¹⁵/₁₆ in.)
84.XM.956.307
MARKS & INSCRIPTIONS: (Verso) at l. center, Evans stamp H; at u. center, in pencil, *Alabama Country Fireplace/1936, 9 ⅜″ x 7 ⅞″ (cropped/part)/Walker Evans/Reproduced # 9 in Message From the* [all underlined]/*Interior* [underlined] *by Mr. Evans-/Published in 1966/by the Eakins Press/in New York*; at l. left, in pencil, Crane no. *L67.21*.
REFERENCES: *MFTI, pl. 9 (variant); **FAL, p. 78 (variant).

542
Alabama/[Washroom in the Dog Run of Floyd Burroughs' Home, Hale County, Alabama]/[Burroughs' Kitchen, Hale County, Alabama**]/[In the Hallway, the Gudger House]*, 1936
Image: 23.5 x 16.7 cm (9 ¼ x 6 ½ in.); mount: 44.5 x 37 cm (17 ½ x 14 ⁹/₁₆ in.)
84.XM.956.335
MARKS & INSCRIPTIONS: (Recto, mount) signed at right below print, in pencil, by Evans, *Walker Evans*; at center, in pencil, by Evans, *Alabama 1936*; at center, Evans stamp C; at l. left, in pencil, Crane no. *L67.50(Evans)*; at l. left, Strathmore blindstamp.
REFERENCES: *FSA, no. 261 (variant, negative dated Summer 1936); **APERTURE, p. 61 (variant); WEAW, p. 128 (variant, u. left image).
EXHIBITIONS: *Art of Photography*, Museum of Fine Arts, Houston, Tex., Feb. 11–Apr. 30, 1989; *Walker Evans: An Alabama Record*, J. Paul Getty Museum, Malibu, Calif., Apr. 7–June 21, 1992.

543
[Chicken Coop on Floyd Burroughs' Farm, Hale County, Alabama]/[Chicken Coop, the Gudger Farm]*, 1936
20.1 x 25.3 cm (7 ¹⁵/₁₆ x 9 ¹⁵/₁₆ in.)
84.XM.956.326
MARKS & INSCRIPTIONS: (Verso) at l. right, Evans stamp C; at u. center, in pencil, *2-13*; at l. left, in pencil, Crane no. *L67.4*.
REFERENCES: LUNPFM-60, no. 13 (variant); *FSA, no. 268 (variant, negative dated Summer 1936).
EXHIBITIONS: *Walker Evans: An Alabama Record*, J. Paul Getty Museum, Malibu, Calif., Apr. 7–June 21, 1992.

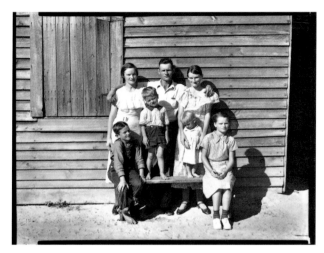

544

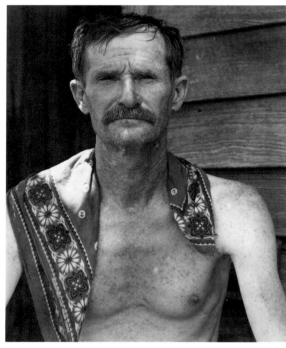

545

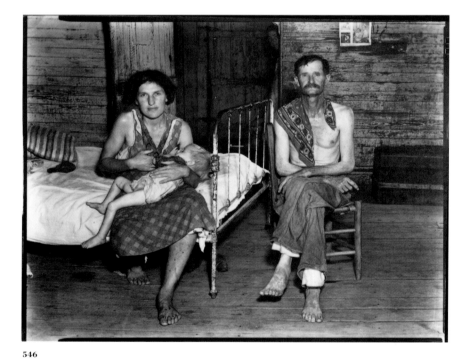

546

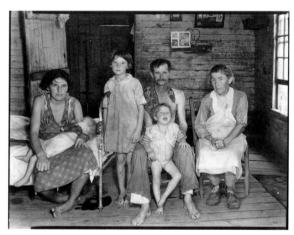

547

544
[*Sharecropper's Family, Hale County, Alabama**/[Burroughs Family, Hale County, Alabama***]/[*The Gudger Family*], 1936; printed later
Image: 19.1 x 24.1 cm (7 ⁹⁄₁₆ x 9 ½ in.); sheet: 20.3 x 25.2 cm (8 x 9 ¹⁵⁄₁₆ in.)
84.XM.129.12
MARKS & INSCRIPTIONS: (Verso) at l. left, in pencil, *#817/Floyd Burroughs Family/Hale County, Alabama 1936*; at l. right, pencil, *Kahmen/Heusch no. E 10*; at l. right, Lunn Gallery stamp, and within boxes, in pencil, *II* and *88*.

PROVENANCE: Lunn Gallery; Volker Kahmen and Georg Heusch.
REFERENCES: *MoMA, p. 89; **FAL, p. 75 (variant); WEBR, p. 10, no. 10 (titled in German and dated, *Landarbeiterfamilie, Hale County [Alabama]*, 1936).
EXHIBITIONS: *Walker Evans*, Bahnhof Rolandseck, West Germany, Oct. 5–Nov. 30, 1978; *Walker Evans: An Alabama Record*, J. Paul Getty Museum, Malibu, Calif., Apr. 7–June 21, 1992.

545
[*William Edward (Bud) Fields, A Cotton Sharecropper, Hale County, Alabama*]/[*Bud Woods, Tenant Farmer*], 1936
22.1 x 17.8 cm (8 ¹¹⁄₁₆ x 7 in.)
84.XM.956.321
MARKS & INSCRIPTIONS: (Verso) at center, Evans stamp H; at u. center, in pencil, *Alabama Cotton Tenant Farmer [all underlined]/1936, 8 ⅝" x 7"/Walker Evans*; at center Crane stamp; at l. left, in pencil, Crane no. *L67.18*.

546
[*Bud Fields with His Wife and Daughter, Hale County, Alabama**/ [*Bud Woods with Ivy and Ellen*], 1936
19.9 x 25.3 cm (7 ⅞ x 9 ¹⁵⁄₁₆ in.)
84.XM.956.302
MARKS & INSCRIPTIONS: (Verso) at l. right, Evans stamp B and Crane stamp; at l. left, in pencil, Crane no. *L67.20*.
REFERENCES: LUNPFM-41, pl. 14 (variant); *FSA, no. 326 (variant, negative dated Summer 1936).
EXHIBITIONS: *Walker Evans: An Alabama Record*, J. Paul Getty Museum, Malibu, Calif., Apr. 7–June 21, 1992.

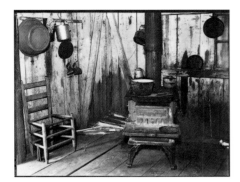

548

549

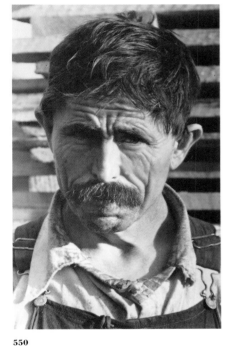

550

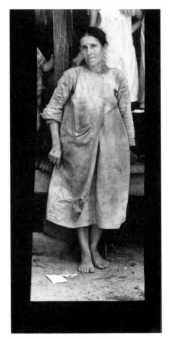

551

547
[*Sharecropper's Family, Hale County, Alabama**]/[*Bud Fields and His Family, Hale County, Alabama***]/[*Bud Woods and His Family*], 1936
20 x 24.7 cm (7 ⅞ x 9 ²³/₃₂ in.)
84.XM.956.299
MARKS & INSCRIPTIONS: (Verso) at l. right, Evans stamp C; at center, in pencil, *2 + 19*; at l. left, in pencil, Crane no. *L67-9.*
REFERENCES: LUNPFM-41, pl. 15 (variant); LUNPFM-60, pl. 19 (variant); *MoMA, p. 79; **FSA, no. 327 and cover image (variants, negative dated

Summer 1936); APERTURE, p. 59 (variant); WEAW, p. 133.
EXHIBITIONS: *Walker Evans: An Alabama Record*, J. Paul Getty Museum, Malibu, Calif., Apr. 7–June 21, 1992.

548
Alabama Tenant Farmer's Kitchen Near Moundville/[*Kitchen of Bud Fields' (Bud Woods) Home, Hale County, Alabama*], 1936
19.2 x 24.7 cm (8 ⁹/₁₆ x 9 ²³/₃₂ in.)
84.XM.956.310
MARKS & INSCRIPTIONS: (Verso) at right center, Evans stamp A; at l. right, Evans stamp C; at center, in pencil,

by Evans, *Alabama tenant farmer's kitchen/near Moundville/1936*; at l. center, in pencil, *2-20* [all circled]; at l. left, in pencil, Crane no. *L67.2.*
REFERENCES: LUNPFM-41, pl. 16 (variant); LUNPFM-60, pl. 20 (variant); FSA, no. 337 (variant, negative dated Summer 1936); WEAW, p. 129 (variant).

549
[*Kitchen Wall, Alabama Farmstead**]/ [*Kitchen Wall in Bud Fields' Home, Hale County, Alabama***]/[*Kitchen Wall in the Woods Home*], 1936
16.5 x 17.9 cm (6 ½ x 7 ³/₁₆ in.) [on Masonite trimmed to image]

84.XM.956.443
MARKS & INSCRIPTIONS: (Verso, mount) at right center, Evans stamp C; at u. center, typed on MoMA label, *EVANS/FARM KITCHEN WALL, Alabama, 1936/58/ 38.2358*; at l. right, on MoMA label, in blue ink, *GR IX*; at u. right, on MoMA label, in pencil, *2-30*; at l. left, in pencil, Crane no. *L69.16(Evans).*
REFERENCES: LUNPFM-41, pl. 17 (variant); LUNPFM-60, pl. 30 (variant); *MoMA, p. 100 (variant); SP, pl. 8 (variant); FSA, no. 338 (variant); **APERTURE, p. 63 (variant).
EXHIBITIONS: *Walker Evans: An Alabama Record*, J. Paul Getty Museum, Malibu, Calif., Apr. 7–June 21, 1992.

550
[*Frank Tengle, A Cotton Sharecropper, Hale County, Alabama**]/[*Fred Ricketts, Cotton Tenant Farmer*], 1936
19.9 x 12.3 cm (7 ¹³/₁₆ x 4 ²⁷/₃₂ in.)
84.XM.956.286
MARKS & INSCRIPTIONS: (Verso) at l. center, Evans stamp B; at u. center, in pencil, *#164/FRANK TENGLE/COTTON SHARECROPPER/HALE COUNTY, ALA./ 1936*; at left edge, in pencil, *64 13-173* [sideways along edge]; at l. left, in pencil, *CUT 22* [circled] *5″* [arrow pointing upward] *HIGH*; at u. left, Crane stamp.
REFERENCES: *FSA, no. 280 (variant, negative dated Summer 1936).
EXHIBITIONS: *Walker Evans: An Alabama Record*, J. Paul Getty Museum, Malibu, Calif., Apr. 7–June 21, 1992.

551
[*Sharecropper's Wife, Hale County, Alabama**]/[*Mrs. Frank Tengle, Wife of a Cotton Sharecropper, Hale County, Alabama***]/[*Sadie Ricketts*], 1936; printed later
Image: 19.6 x 7.3 cm (7 ²³/₃₂ x 2 ⅞ in.); sheet: 22.3 x 10.2 cm (8 ²⁵/₃₂ x 4 ¹/₃₂ in.)
84.XM.956.348
MARKS & INSCRIPTIONS: (Verso) at l. center, Evans stamp C; at u. left, in pencil, *RA 8178E*; at center, in pencil, *2-28*; at l. center, Crane stamp [three times]; at l. left, Crane no. *L67.60 (Evans).*
REFERENCES: LUNPFM-41, pl. 20 (variant); LUNPFM-60, pl. 28 (variant);*MoMA, p. 97 (variant); **FSA, no. 282 (variant, negative dated Summer 1936).
EXHIBITIONS: *Walker Evans: An Alabama Record*, J. Paul Getty Museum, Malibu, Calif., Apr. 7–June 21, 1992.

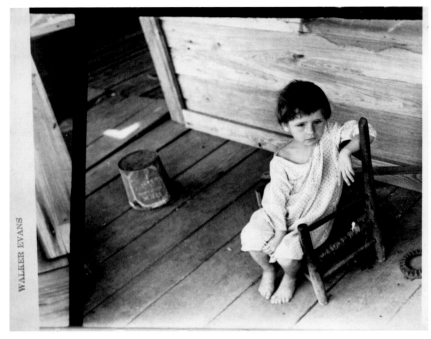

552

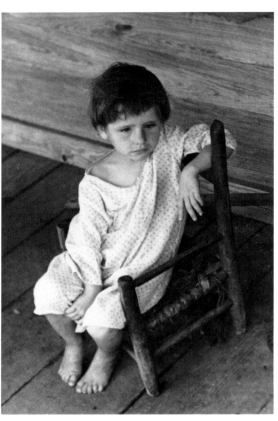

553

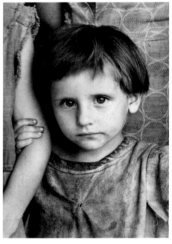

554

552
[*Laura Minnie Lee Tengle, Hale County, Alabama**]/[*Clair Bell Ricketts*], 1936
Image: 18.8 x 23 cm (7 7/16 x 8 27/32 in.); sheet: 20.1 x 25.1 cm (7 29/32 x 9 7/8 in.)
84.XM.956.359
MARKS & INSCRIPTIONS: (Recto) at left edge, Evans stamp C; (verso) at l. right, Evans stamp C; at center, in pencil, *2-31*; at l. left, in pencil, Crane no. *L67.79(Evans)*.
REFERENCES: LUNPFM-41, pl. 24; LUNPFM-60, pl. 31; *FSA, no. 298 (variant, negative dated Summer 1936).

EXHIBITIONS: *Walker Evans: An Alabama Record*, J. Paul Getty Museum, Malibu, Calif., Apr.–June 21, 1992.

553
[*Laura Minnie Lee Tengle, Hale County, Alabama**]/[*Clair Bell Ricketts*], 1936
16.6 x 11 cm (6 9/16 x 4 5/16 in.) [on original mount trimmed to image]
84.XM.956.291
MARKS & INSCRIPTIONS: (Verso, mount) at l. right, Evans stamp C and Evans stamp A; at center, in pencil, *2-31*; at u. center, Crane stamp.

REFERENCES: LUNPFM-41, pl. 24 (variant); LUNPFM-60, pl. 31 (variant); *FSA, no. 298 (variant, negative dated Summer 1936).
EXHIBITIONS: *Walker Evans: An Alabama Record*, J. Paul Getty Museum, Malibu, Calif., Apr. 7–June 21, 1992.

554
[*Laura Minnie Lee Tengle, Hale County, Alabama**]/[*Clair Bell Ricketts*], 1936
15.2 x 10.1 cm (5 31/32 x 3 31/32 in.) [on original mount trimmed to image]
84.XM.956.287

MARKS & INSCRIPTIONS: (Verso, mount) at u. left edge, Evans stamp A.
REFERENCES: LUNPFM-41, pl. 25 (variant); LUNPFM-60, pl. 32 (variant); *FSA, no. 313 (variant, negative dated 1936).
EXHIBITIONS: *Walker Evans: An Alabama Record*, J. Paul Getty Museum, Malibu, Calif., Apr. 7–June 21, 1992.

555
[*Elizabeth Tengle at the Kitchen Table*]/[*Paralee Ricketts Working in the Kitchen*], 1936
17.5 x 22.5 cm (6 7/8 x 8 7/8 in.)
84.XM.956.325

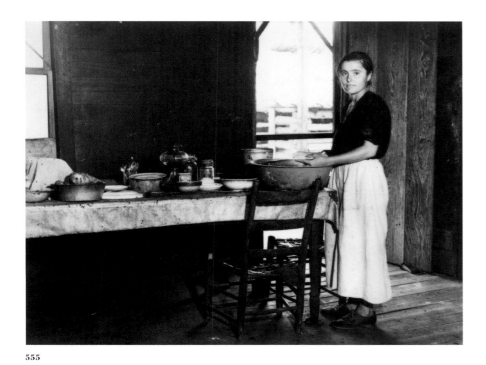

555

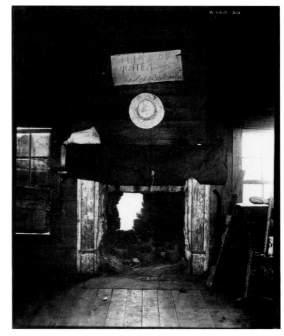

556

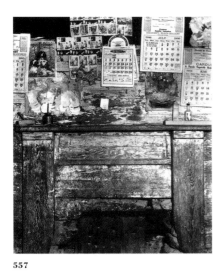

557

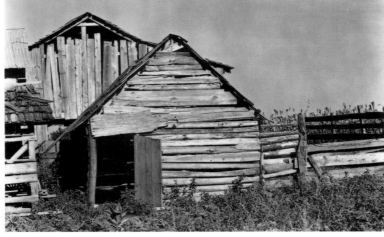

558

MARKS & INSCRIPTIONS: (Verso) at l. right, Evans stamp C; at u. left, in pencil, *Walker Evans/Let us Now Praise Famous Men/ c/o Readers Subscription/1140 Broadway* [inscription crossed out in pencil]; at center, in pencil, *2-39* [all circled]; at l. left, in pencil, Crane no. *67.5*.
REFERENCES: LUNPFM-60, pl. no. 39 (variant).
EXHIBITIONS: *Walker Evans: An Alabama Record*, J. Paul Getty Museum, Malibu, Calif., Apr. 7–June 21, 1992.

556
[*The Cotton Room at Frank Tengle's Farm, Hale County, Alabama**]/[*The Cotton Room, the Ricketts House*], 1936
25.2 x 20.2 cm (9 15/16 x 7 31/32 in.)
84.XM.956.353
MARKS & INSCRIPTIONS: (Recto) in negative, *RA-8151-A* [reversed]; (verso) at l. left, Evans stamp A; at l. left, in pencil, Crane no. *L67.59(Evans)*.
REFERENCES: LUNPFM-60, pl. no. 40 (variant); *FSA, no. 316 (negative dated Summer 1936).
EXHIBITION: *Walker Evans: An Alabama Record*, J. Paul Getty Museum, Malibu, Calif., Apr. 7–June 21, 1992.

557
[*Wall in Farmer's House, Alabama*]/ [*Fireplace in Frank Tengle's Home, Hale County, Alabama**]/[*Front Room, the Ricketts House*], 1936
23 x 18.5 cm (9 1/16 x 7 9/32 in.) [on Masonite trimmed to image]
84.XM.956.444
MARKS & INSCRIPTIONS: (Verso, mount) at l. center, Evans stamp C; at u. center, in pencil, *2nd-41*; at right center, in pencil, *2-41* [sideways]; at u. center, typed on MoMA label, *EVANS/WALL IN FARMER'S HOUSE,/Alabama, 1936/59/ 38.2368*; at l. right, in black ink, on

MoMA label, *GR XV*; at l. left, in pencil, Crane no. *L69.15(Evans)*.
REFERENCES: LUNPFM-60, pl. 41 (variant); *FSA, no. 315 (variant, negative dated Summer 1936).
EXHIBITIONS: *Walker Evans: An Alabama Record*, J. Paul Getty Museum, Malibu, Calif., Apr. 7–June 21, 1992.

558
[*Barns on Frank Tengle's Farm*]/[*Barns on the Ricketts Farm*], 1936
Image: 15.6 x 23.5 cm (6 3/16 x 9 9/32 in.); original mount: 16.2 x 24.1 cm (6 3/8 x 9 1/2 in.)
84.XM.956.351

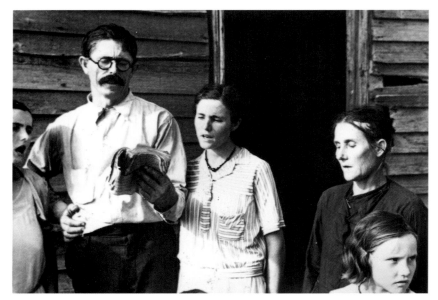

559

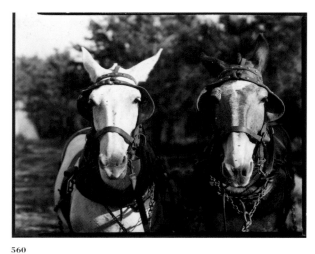

560

561

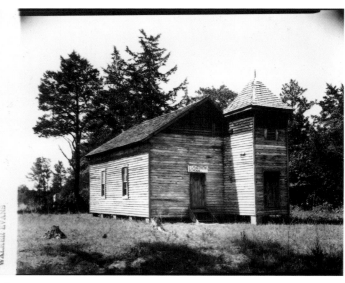

562

MARKS & INSCRIPTIONS: (Recto, mount) at l. right, Evans stamp A; (verso, mount) at center, Evans stamp A; at l. left, in pencil, Crane no. *L67.66 (Evans)*.
EXHIBITIONS: *Walker Evans: An Alabama Record*, J. Paul Getty Museum, Malibu, Calif., Apr. 7–June 21, 1992.

559
[*Alabama Tenant Farmer Family Singing Hymns**]/[*The Tengle Family, Hale County, Alabama*]/[*The Ricketts Family Singing Hymns*], 1936
13.4 x 18.6 cm (5 ¼ x 7 5/16 in.) [on original mount trimmed to image]
84.XM.956.507

MARKS & INSCRIPTIONS: (Verso) at u. left, in pencil, *I-22*; at l. right, Crane stamp.
REFERENCES: *AMP, Part I, no. 22.
EXHIBITIONS: *Walker Evans: An Alabama Record*, J. Paul Getty Museum, Malibu, Calif., Apr. 7–June 21, 1992.

560
[*Two Mules, Hale County, Alabama*], 1936
19.9 x 25.2 cm (7 ¾ x 9 15/16 in.)
84.XM.956.314

MARKS & INSCRIPTIONS: (Verso) at l. right, Evans stamp C; at center, in pencil, *2-47*; at l. left, in pencil, Crane no. *L67.7*.
REFERENCES: LUNPFM-60, pl. no. 47.
EXHIBITIONS: *Walker Evans: An Alabama Record*, J. Paul Getty Museum, Malibu, Calif., Apr. 7–June 21, 1992.

561
[*A Mule, Hale County, Alabama**], 1936; printed later
Image: 19 x 11.6 cm (7 ½ x 4 9/16 in.); sheet: 22.7 x 18.7 cm (8 15/16 x 7 ⅜ in.)
84.XM.956.356

MARKS & INSCRIPTIONS: (Verso) at l. center, Evans stamp C; at center, in pencil, *2-47*; at u. right, Crane stamp; at l. left, *L67.81(Evans)*.
REFERENCES: *FSA, no. 352 (variant, negative dated Summer 1936).

562
[*St. Matthew School, Alabama**], 1936
Image: 19.3 x 23.4 cm (7 19/32 x 9 7/32 in.); sheet: 20 x 25 cm (7 ⅞ x 9 27/32 in.); original mount: 20.3 x 28.8 cm (8 x 11 11/32 in.)
84.XM.956.339

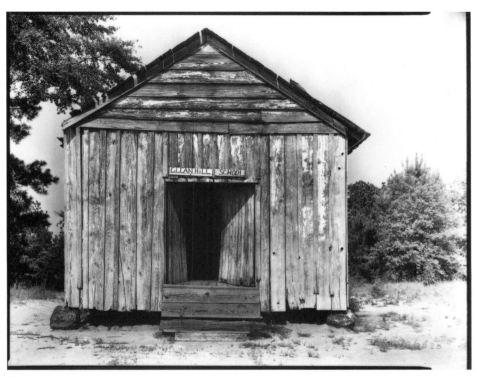

563

564

566

EXHIBITIONS: *Walker Evans: An Alabama Record*, J. Paul Getty Museum, Malibu, Calif., Apr. 7–June 21, 1992.

565
[*A Child's Grave, Hale County, Alabama**]/[*A Baptist Grave, Hale County*], 1936
Image: 20.1 x 25 cm (7 ¹⁵/₁₆ x 9 ⅞ in.); original mount: 20.2 x 27.8 cm (7 ¹⁵/₁₆ x 10 ¹⁵/₁₆ in.)
84.XM.956.329
MARKS & INSCRIPTIONS: (Recto, mount) at right edge, Evans stamp C; at l. right, in pencil, *2-61*; (verso, mount) at l. center, Evans stamp C; at u. center, in pencil, *No numbers/Evans*; at center, *2-61*; at l. right, in pencil, *w*; at l. left, in pencil, Crane no. *L67.10*.
REFERENCES: LUNPFM-60, pl. no. 61; *FSA, no. 345 (negative dated Summer 1936); FAL, p. 82.
NOTE: Not illustrated; variant of no. 564.

566
[*A Child's Grave, Hale County, Alabama**], 1936
Image: 18.7 x 23.8 cm (7 ¹¹/₃₂ x 9 ⁵/₁₆ in.); mount: 21.3 x 29.3 cm (8 ⅜ x 10 ¹⁷/₃₂ in.)
84.XM.129.11
MARKS & INSCRIPTIONS: (Verso) at u. left, in pencil, *1* [circled]; at l. right, in pencil, *RA8176A*; at l. right, in pencil, Kahmen/Heusch no. *E 13*; at l. right, Lunn Gallery stamp, and within boxes, in pencil, *III* and *346*; (verso, mount) at l. right, in pencil, Kahmen/Heusch no. *E 13*.
PROVENANCE: Lunn Gallery; Volker Kahmen and Georg Heusch.
REFERENCES: *FSA, no. 346 (negative dated Summer 1936); WEBR, p. 18, no. 13, (titled in German and dated, *Kindergrab, Hale County [Alabama]*, Sommer 1936).
EXHIBITIONS: *Walker Evans*, Bahnhof Rolandseck, West Germany, Oct. 5–Nov. 30, 1978; *Walker Evans: An Alabama Record*, J. Paul Getty Museum, Malibu, Calif., Apr. 7–June 21, 1992.

MARKS & INSCRIPTIONS: (Recto) at l. left edge, Evans stamp C; (recto, mount) at l. left edge, Evans stamp C; (verso, mount) at l. right, Evans stamp C; at u. center, in pencil, by MoMA staff, *No number/Evans*; at center, in pencil, by Evans, *2nd Ed./#54* [all circled]; at l. right, in pencil, *W*; at l. left, in pencil, Crane no. *L67.56(Evans)*.
REFERENCES: LUNPFM-60, pl. 54 (variant); *FSA, no. 368 (variant).
EXHIBITIONS: *Walker Evans: An Alabama Record*, J. Paul Getty Museum, Malibu, Calif., Apr. 7–June 21, 1992.

563
[*Gleanhill School House, Hale County, Alabama*], 1936
19.8 x 24.8 cm (7 ¹³/₁₆ x 9 ¾ in.)
84.XM.956.324
MARKS & INSCRIPTIONS: (Verso) at l. right, Evans stamp C; at center, in pencil, *2-58*; at l. right, in pencil, *4/5 ¼*; at l. left, in pencil, Crane no. *L67.6*.
REFERENCES: LUNPFM-60, pl. no. 58 (variant).
EXHIBITIONS: *Walker Evans: An Alabama Record*, J. Paul Getty Museum, Malibu, Calif., Apr. 7–June 21, 1992.

564
[*A Child's Grave, Hale County, Alabama**]/[*A Baptist Grave, Hale County*], 1936
15.6 x 22.5 cm (6 ⅛ x 8 ⅞ in.) [on Masonite trimmed to image]
84.XM.956.437
MARKS & INSCRIPTIONS: (Verso, mount) at center, in pencil, MoMA no. *38.2325/#54*; at l. left, on white label, in pencil, Crane no. *L69.19(Evans)*.
REFERENCES: LUNPFM-60, pl. no. 61 (variant); *FSA, no. 345 (variant, negative dated Summer 1936); FAL, p. 82 (variant).

567

568

571

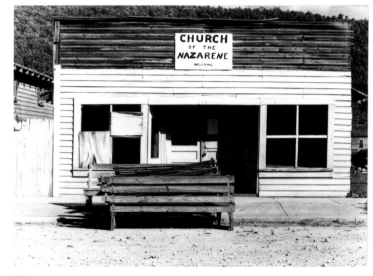

572

567
[*A Gourd Tree for Martins, Hale Co., Alabama**], 1936
25.1 x 20 cm (9 ²⁹⁄₃₂ x 7 ²⁹⁄₃₂ in.)
84.XM.956.298
MARKS & INSCRIPTIONS: (Recto) in negative, at u. right edge, *RA - 8169A* [reversed]; (verso), at l. center, Evans stamp A; at center, in pencil, *RA 8169A*; at l. left, in pencil, Crane no. *L67.3*.
REFERENCES: LUNPFM-60, pl. 62; *FSA, no. 350 (negative dated Summer 1936); WEAW, p. 137.
EXHIBITIONS: *Walker Evans: An Alabama Record*, J. Paul Getty Museum, Malibu, Calif., Apr. 7–June 21, 1992.

568
[*Frame Houses in Virginia**], 1936
Image: 15.8 x 20.3 cm (6 ¼ x 8 ⅜ in.); sheet: 19.3 x 24.9 cm (7 ⅝ x 9 ¹³⁄₁₆ in.)
[on original mount trimmed to sheet]
84.XM.956.515
MARKS & INSCRIPTIONS: (Verso) at center, Evans stamp F; at l. center, Evans stamp D; at u. right, in pencil, on white label, *II 23*; at u. center, in pencil, MoMA no. *38.2330/Evans*; at l. left, in pencil, Crane no. *L68.62*.
REFERENCES: *AMP, Part II, no. 23 (variant).

569
[*Frame Houses in Virginia**], 1936
Image: 11.5 x 20.4 cm (4 ½ x 8 ¹⁄₃₂ in.); original hole-punched mount: 31.3 x 25.8 cm (12 ⅜ x 10 ³⁄₁₆ in.)
84.XM.956.501
MARKS & INSCRIPTIONS: (Recto, mount) at l. left, in black ink, *Part Two/#23*; at l. center, in pencil, *Frame Houses in Virginia, 1936*; at u. right, in pencil, *89.5* [beside a right angle]; at l. right, in pencil, *73*; (mount, verso) at u. center, Evans stamp B; at l. right, in pencil, *H2416-86/86/NO* [within a box] *150h*; at l. right, in pencil, *73*; at u. right, in pencil, on white label, *II*

23; at center, Crane stamp; (recto, mat) at l. right, in pencil, *148*; at l. left, in pencil, Crane no. *L68.52*(*Evans*).
REFERENCES: *AMP, Part II, no. 23.

570
[*Frame Houses in Virginia**], 1936
13.7 x 8.7 cm (5 ¹³⁄₃₂ x 3 ¹³⁄₃₂ in.) [on AZO postcard stock]
84.XM.956.472
MARKS & INSCRIPTIONS: (Verso) at center, Evans stamp B [sideways]; at l. left, in pencil, Crane no. *L68.51*(*Evans*).
REFERENCES: *AMP, Part II, no. 22 (variant).

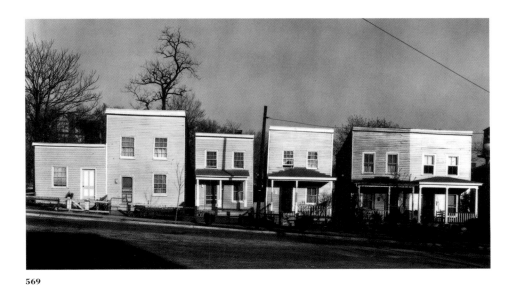

569

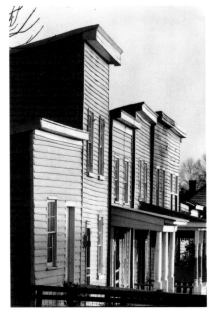

570

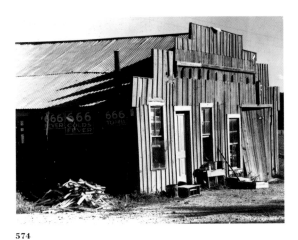

574

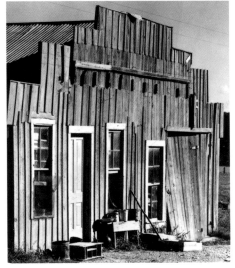

575

571
[*Shoeshine Sign in a Southern Town**]/
[*Shoeshine Stand Detail, Southeastern
U.S.***], 1936
20.3 x 25.2 cm (8 x 9 ¹⁵⁄₁₆ in.)
84.XM.956.327
MARKS & INSCRIPTIONS: (Recto) in nega-
tive, *AGFA SAFETY FILM* [in reverse];
(verso) at left center, Evans stamp B;
at center, in pencil, *4/2* [inverted]; at
l. left, in pencil, Crane no. *L67.23.*
REFERENCES: *MoMA, p. 122 (variant);
SP, pl. 5 (variant); **FSA, no. 389;
APERTURE, p. 93 (variant).

572
[*Church of the Nazarene, Tennessee**],
1936
Image: 18.3 x 23.2 cm (7 ³⁄₁₆ x 9 ⅛ in.);
fragmentary original hole-punched
mount: 19.4 x 24.1 cm (7 ⅝ x 9 ½ in.)
84.XM.956.510
MARKS & INSCRIPTIONS: (Recto, mount)
at l. left, in black ink, *Part Two
(cropped off)* [space] *Church of the
Nazarene* [space] *II 16*; (mount, verso)
at u. left, Evans stamp D; at center,
Evans stamp F; at u. center, in pencil,
CROP [arrow pointing upward]; at right
center, in pencil, *II 16*; at l. center, in
pencil, *#152/Country Church/Ten-
nessee 1936*; at l. left, in pencil, *CUT 4*
[arrow pointing upward] *HIGH/29*; in
pencil, [line from u. left to
l. right]; at l. left, in pencil, Crane
no. *L68.44.*
REFERENCES: *AMP, Part II, no. 16;
"Primitive Churches." *Architectural
Forum*, Dec. 1961, p. 102 (variant);
FSA, no. 396 (variant); CRANE no. 50.

573
[*Church of the Nazarene, Tennessee**],
1936
20.3 x 25.3 cm (8 x 9 ¹⁵⁄₁₆ in.)
84.XM.129.13

MARKS & INSCRIPTIONS: (Verso) at l. left,
in pencil, Kahmen/Heusch no. *E9.*
PROVENANCE: Lunn Gallery; Volker
Kahmen and Georg Heusch.
REFERENCES: *AMP, Part II, no. 16 (vari-
ant); "Primitive Churches."
Architectural Forum, Dec. 1961, p. 102
(variant); FSA, no. 396 (variant); WEBR,
p. 10, no. 9 (titled in German and
dated, *Landkirche* [*Tennessee*], 1936).
EXHIBITIONS: *Walker Evans*, Bahnhof
Rolandseck, West Germany, Oct. 5–
Nov. 30, 1978.
NOTE: Not illustrated; variant of
no. 572.

574
[*Tennessee Board-and-Batten*], 1936
17 x 21 cm (6 ¹¹⁄₁₆ x 8 ¼ in.)
84.XM.956.297
MARKS & INSCRIPTIONS: (Verso) at center,
Evans stamp I; (recto, mat) at l. left, in
pencil, Crane no. *L67.90(Evans).*

575
Tennessee Board-And-Batten, 1936;
printed 1937
14.5 x 12.1 cm (5 ¾ x 4 ¾ in.) [on origi-
nal mount trimmed to image]
84.XM.956.370
MARKS & INSCRIPTIONS: (Verso) dated at
l. right, in blue ink, by Evans, *1937*;
titled at center, in blue ink, by Evans,
TENNESSEE BOARD-AND-BATTEN; at
l. right, Evans stamp A; at l. left, in
pencil, Crane no. *L67.54(Evans).*

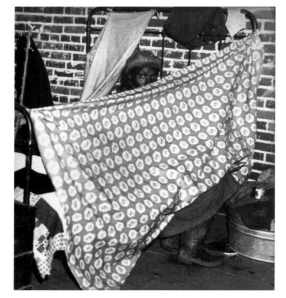

576

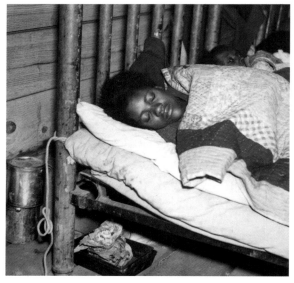

577

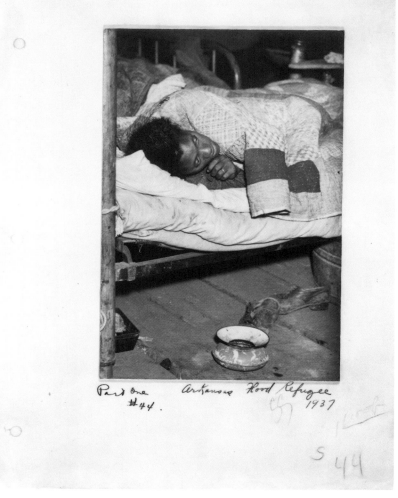

578

576
[*Flood Refugee, Forrest City, Arkansas**], 1937
19.9 x 17.5 cm (7 ¹³⁄₁₆ x 6 ²⁹⁄₃₂ in.) [on original mount trimmed to image]
84.XM.956.292
MARKS & INSCRIPTIONS: (Verso) signed at l. center, in pencil, by Evans, *Walker Evans*; at l. center, Crane stamp; at l. left, in pencil, Crane no. *L67.51(Evans)*; (recto, mat) at l. left, in pencil, Crane no. *L67.51 (Evans)*.
REFERENCES: *FSA, no. 433 (variant, negative dated Feb. 1937).

577
[*Flood Refugee, Forrest City, Arkansas**], 1937
18.2 x 17.8 cm (7 ³⁄₁₆ x 7 in.) [on original mount trimmed to image]
84.XM.956.344
MARKS & INSCRIPTIONS: (Verso, mount) at l. right, in pencil, on MoMA label, *Museum o____/LOAN*; at l. right, typed on MoMA label, *38.22___/Evans*; at l. left, in pencil, Crane no. *L67.72 (Evans)*.
REFERENCES: *FSA, no. 432 (variant, negative dated Feb. 1937).

578
[*Arkansas Flood Refugee**], 1937
Image: 19.5 x 12.9 cm (7 ¹¹⁄₁₆ x 5 ¹⁄₁₆ in.) [on original mount trimmed to image]; second original hole-punched mount: 27.9 x 21.6 cm (11 x 8 ½ in.)
84.XM.956.460
MARKS & INSCRIPTIONS: (Recto, mount) at l. left, in black ink, *Part One/#44*; at l. center, in black ink, *Arkansas Flood Refugee/1937*; at l. right, in pencil, *SS*; at l. right, in pencil, *1 Proof* [last word is underlined]; at l. right, in pencil, *44*; at l. right, in red pencil, *S*; (verso, mount) at l. center, Evans stamp A; at l. right, in pencil, *44*; at l. center, in pencil, *H2416–86/86/*[box] *150h*; at l. left, in pencil, Crane no. *L68.30(Evans)*.
REFERENCES: *AMP, Part I, no. 44.

579
[*Flood Refugee, Forrest City, Arkansas**], 1937
18.8 x 22.1 cm (7 ⁷⁄₁₆ x 8 ¹¹⁄₁₆ in.) [on original mount trimmed to image]
84.XM.956.345

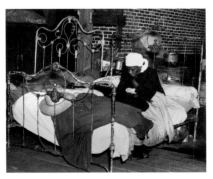

579

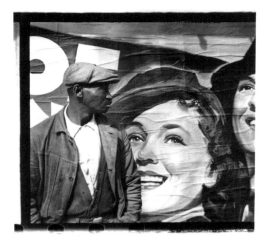

582

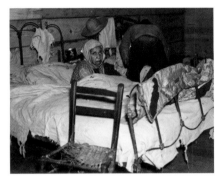

580

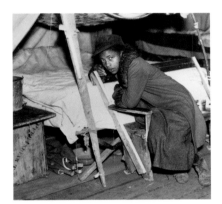

581

583

584

MARKS & INSCRIPTIONS: (Verso) at l. right, Evans stamp B; at l. left, in pencil, Crane no. *L67.75(Evans)*.
REFERENCES: *FSA, no. 430 (variant, negative dated Feb. 1937).

581
[*Flood Refugee, Forrest City, Arkansas**], 1937
17.3 x 17.8 cm (6 ²⁵⁄₃₂ x 6 ³¹⁄₃₂ in.) [on original mount trimmed to image]
84.XM.956.362
MARKS & INSCRIPTIONS: (Verso) at l. right, Evans stamp B; at l. left, in pencil, Crane no. *L67.74(Evans)*.
REFERENCES: *FSA, no. 429 (variant, negative dated Feb. 1937).

582
[*Street Scene, Southern City*], ca. 1936
Image: 15.6 x 16.8 cm (6 ⅛ x 6 ⅝ in.); sheet: 18.3 x 19 cm (7 ³⁄₁₆ x 7 ½ in.)

84.XM.956.328
MARKS & INSCRIPTIONS: (Verso) at u. left, Evans stamp A twice; at l. left, Crane stamp; at l. left, in pencil, Crane no. *L67.13*.

583
[*"Madam Adele," Palmistry Sign, Southern United States*], ca. 1936
14 x 18.8 cm (5 ½ x 3 ¹⁵⁄₃₂ in.) [on AGFA ANSCO postcard stock]
84.XM.956.371
MARKS & INSCRIPTIONS: (Verso) at l. center, Evans stamp A [sideways]; at l. left, in pencil, Crane no. *L67.85 (Evans)*.

584
[*"The Grand Man" Wall Mural*], ca. 1935
Image: 16.3 x 11.3 cm (6 ⁷⁄₁₆ x 4 ⁷⁄₁₆ in.); mount: 44.2 x 37.9 cm (17 x 14 ¹⁵⁄₁₆ in.)
84.XM.956.1074
MARKS & INSCRIPTIONS: (Verso) at center, Evans stamp C; at l. left, in pencil, Crane no. *L78.42(Evans)*.

580
[*Flood Refugee, Forrest City, Arkansas**], 1937
17.9 x 21 cm (7 ¹⁄₁₆ x 8 ⁹⁄₃₂ in.)
84.XM.956.360
MARKS & INSCRIPTIONS: (Verso) at l. right, Evans stamp A; at l. left, in pencil, Crane no. *L67.73(Evans)*.
REFERENCES: *FSA, no. 431 (variant, negative dated Feb. 1937).

585

587

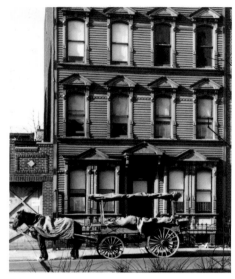

589

586

588

585
["Fresh and Smoked" Butcher's Sign],
ca. 1936
8.8 x 13.9 cm (3 ¹⁵/₃₂ x 5 ¹⁵/₃₂ in.) [on
AGFA ANSCO postcard stock]
84.XM.956.364
MARKS & INSCRIPTIONS: (Verso) at u. left,
Evans stamp B; at center right, Crane
stamp; at l. left, in pencil, Crane
no. L67.86(Evans).

586
[House on Fire in a Southern State],
ca. 1935
Image: 12.5 x 10 cm (4 ¹⁵/₁₆ x 3 ²⁹/₃₂ in.);

original mount: 18.2 x 26.9 cm
(7 ³/₁₆ x 10 ¹⁹/₃₂ in.)
84.XM.956.697
MARKS & INSCRIPTIONS: (Verso) at center,
Evans stamp A; at l. left, in pencil,
Crane no. L78.45(Evans).

587
[New York City*], 1937
22.2 x 15.4 cm (8 ¾ x 6 ¹/₁₆ in.)
84.XM.956.1078
MARKS & INSCRIPTIONS: (Verso) at u. cen-
ter, Evans stamp B.
REFERENCES: *FAL, p. 157 (variant).

588
Doorway, New York City, 1938
Image: 15.1 x 8.3 cm (5 ¹⁵/₁₆ x 3 ⁹/₃₂ in.);
[on mount trimmed to image affixed to
second mount] second mount:
44.4 x 36.8 cm (17 ½ x 14 ½ in.)
84.XP.459.2
MARKS & INSCRIPTIONS: (Recto, mount)
signed and dated below print, in pen-
cil, by Evans, Walker Evans 1938;
(verso, mount) at center, in pencil, by
Evans, Doorway, New York City, 1938;
at center, Evans stamp C; at right cen-
ter, in pencil, Doorway-1033; at l. left,
in pencil, #1033; at l. right, in pencil,

K1760 [space] #42; at u. left, typed on
white label, Doorway and Funeral
Wreath,/New York, 1938/photograph,
5 ¹⁵/₁₆" x 3 ⁵/₁₆"/by Walker Evans; at
l. right, Lunn Gallery stamp, and
within boxes, in pencil, X14 and 107;
(recto, mat) at left side, l. right, in
pencil, I2E.
PROVENANCE: Lunn Gallery; unidenti-
fied European collector; Sotheby's,
New York; Samuel Wagstaff, Jr.
EXHIBITIONS: Flower Show: Photo-
graphs from the J. Paul Getty Museum,
Selected by Sam Wagstaff, The Detroit
Institute of Art, Apr. 14–June 16,
1985.

589
[Street Scene with Horse-Drawn
Wagon, Possibly New York City],
ca. 1930s
14.8 x 11.8 cm (5 ²⁷/₃₂ x 4 ¹¹/₁₆ in.) [on
original mount trimmed to image]
84.XM.956.690
MARKS & INSCRIPTIONS: (Verso) at u. cen-
ter, Evans stamp J; at l. left, in pencil,
Crane no. L78.45(Evans).

1938–1941

The Making of *Many Are Called*

The Wheaton College Commission

On the West Coast of Florida

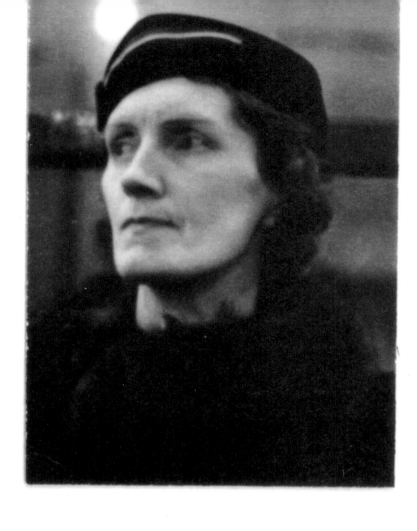

CITY HA

THE MAKING OF
MANY ARE CALLED[1]

Those who use the New York subways are several millions. The facts about them are so
commonplace that they have become almost as meaningless, as impossible to realize,
as death in war. These facts—who they are, and the particular thing that happens to
them in the subway—need brief reviewing, and careful meditation.

James Agee, introduction to *Many Are Called*[2]

In 1966, Walker Evans published a collection of eighty-nine photographs from negatives made in the subways of New York at least twenty-five years before. As Sarah Greenough reminds us in her 1991 exhibition catalogue *Walker Evans: Subways and Streets*, the appearance of this collection, *Many Are Called*, was accompanied that fall by an exhibition at the Museum of Modern Art of forty images from the same project.[3] The 223 Getty prints related to the circa 1940 subway project, including ten prints lent to MoMA for the 1966 show (nos. 620, 625, 636, 660, 677, 686, 722, 731, 736, 791), allow us to study the production of this series and the 1966 publication in great detail. Prints dating from the early forties to the sixties illustrate the numerous, sometimes radical croppings Evans applied to these negatives; verso inscriptions suggest the variety of individuals he might have photographed on any given day; and a set of prints evidently made in the sixties especially for reproduction in the book displays in final form his thinking about both subject and technique over a period of twenty-five years.[4] The startling, mysterious picture of a

Walker Evans. *Subway Portrait:*
Sixteen Women (detail), 1938–41;
probably assembled ca. 1959 [no. 775].

blind accordion player singing to a full car of disinterested passengers that closes the volume is represented in the Getty collection by four prints from two related negatives (nos. 771–74). Evans's treatment of this image, perhaps the most poignant and meaningful of the series, may serve to illustrate the complexity of his process while exhibiting the depth of the Getty collection.

Getty print no. 773 (fig. 1) presents the entire negative from which the book's final image (no. 771) was made. A third picture from this negative (no. 772) is a print from the 1940s, 3¾ x 7³¹⁄₃₂ inches on an 11 x 8½-inch mount, with three holes at the left edge for use in a loose-leaf binder. It gives us an indication of Evans's first meditations on the subject of the blind musician and his early intention to include it in a mock-up (thus the three-hole mount) for possible publication.[5] From no. 773, it is clear that Evans was attempting to take in the entire length and width of this particular subway car by standing at one end of the aisle and shooting from what seems to be higher than eye level toward the other end. The curvature of the car's ceiling, the one-point perspective of the camera's lens, and the shadow of the photographer's coat intruding on the image at the right all contribute to the making of a distinctively claustrophobic, tunnel-like interior. Although this aura of harsh light and

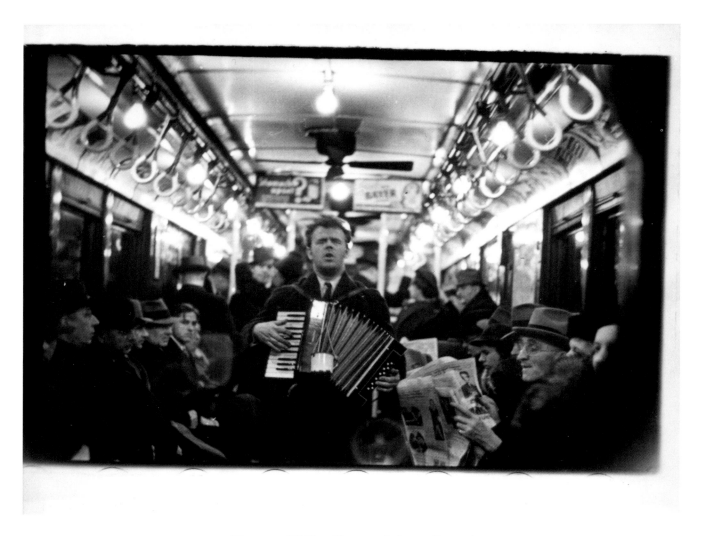

Figure 1. Walker Evans. *Subway Portrait*,
1938–41 [no. 773].

crowded quarters would seem an appropriate setting for our last glimpse of these subterranean travelers, Evans apparently preferred to direct our attention to individuals rather than atmosphere, and in a print made soon after the negative, he severely cropped the image on all sides, concentrating our view on the singing musician and a few passengers seated at his left who ignore him to focus on their newspapers (no. 772).

The same kind of concentration on anonymous, individual faces can be seen in two prints, one at the Getty (no. 774), from a second negative Evans managed to obtain from what must have been a fairly conspicuous stance in the center of the car. The Getty print allows for only bust-length views of passengers seated along the left side of the car, and the blind musician's body is truncated at the bottom edge of his accordion. This view seems to have been made from a more elevated and even less stable vantage point; the emphasis here is on the speed and constant side-to-side movement of the train rather than the close quarters in each car. Another print from this negative was exhibited in 1991 at the National Gallery of Art in Washington, D.C. It has been cropped substantially at the right side, so that the figure of the singing musician is now prominently featured in the immediate foreground; at

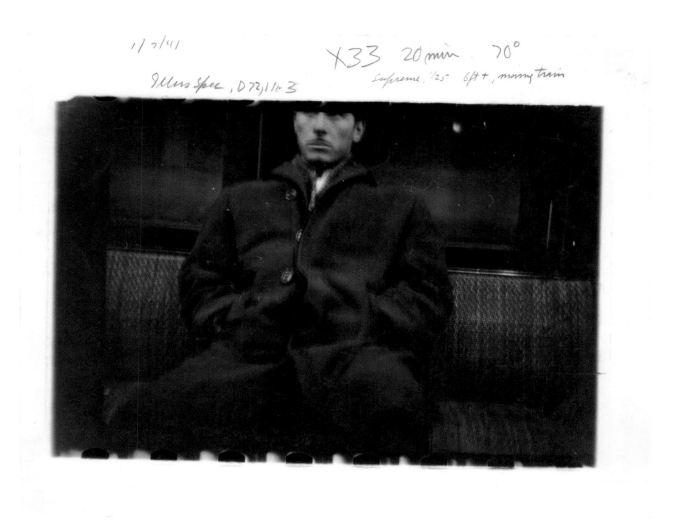

Figure 2. Walker Evans. *Subway Portrait*,
January 1941 [no. 811].

left, juxtaposed to him in uncomfortably tight quarters, are the heads of eight fellow travelers, one of whom actually appears to be attentively listening to the blind man's music.[6]

Evans also cropped this image radically at the top, with the result that, instead of seeing the overhead fans mounted in the car, the viewer's attention is on the harsh glare from several rows of overhead lightbulbs. The unattractive artificial illumination provided by the New York Transit Authority was all that was available to this photographer, who preferred working out on the street in natural light. But dealing with available light was just one of the difficulties Evans created for himself when he set out on this subway project; he was, from the beginning, "shooting blind."

A Getty print dated in the photographer's hand "1/7/41" is an especially good example of this self-imposed predicament and, because of other notations in the top margin, it is also an unusual piece of evidence about how Evans worked through the technical problems he was facing (no. 811; fig. 2). Additionally, this print may possibly suggest when the project began in earnest. Since it was clearly an experiment, this picture contains notes, such as "6ft+, moving train," that record the distance at

which Evans made the exposure while seated opposite an unsuspecting passenger. As Evans himself described it, his aim in going into the New York subway to photograph was to put into practice the purity of "the record method" by photographing a series of people who would unconsciously come "into range before an impersonal fixed recording machine during a certain time period."[7] The recording machine was "a hidden camera,"[8] a Contax camera concealed beneath his coat, "strapped to the chest and connected to a long wire strung down the right sleeve."[9] This print of January 7, 1941, appears to be the earliest among the subway pictures at the Getty to be dated by Evans; its date would indicate that he began serious work on the series just as a grant he had received from the Guggenheim Foundation took effect.[10] A winter date for the series seems completely appropriate, since the success of the project depended on a camera being concealed under heavy clothing.

The composition itself is, of course, less than masterful; the top of the subject's head has been cut off, and the seat he rests on seems to be tilting downhill. The picture, in addition to being very dark, is slightly out of focus. Evans's lack of control, at least in these first forays into the trains, is obvious here. Though he claimed that these portraits would, ideally, be made "without any human selection for the moment of lens exposure,"[11] the majority of the Getty pictures testify to the fact that over time the photographer became much more adept at manipulating his hidden camera and, in the darkroom, he took the selection process still further.

The subject of the blind musician and the idea of photographing those without sight was evidently much on Evans's mind at this time. As early as 1934, while in Florida, Evans had made several different portraits of an elderly man who appears to be blind, posed outside his home in Florida.[12] Now, in 1941, he not only captured the accordion player performing in the depths of the New York subway but, on excursions to Chicago and again to Florida,

he photographed blind couples he encountered on the street.

The pair of blind musicians he found in Chicago are represented in three Getty images (nos. 1013–15), one of them (no. 1015) titled simply *Chicago*, with a date stamped "Nov 2 1941."[13] While the man plays the guitar, his companion seems to be singing. They maintain their station next to a bridal shop, while pedestrians pass them on either side trying to ignore their tin cup (no. 1013). Two of these passers-by, who appear to be mother and daughter, have their eyes downcast in such a manner that they, too, appear to be blind. Not only is the subject once more a blind musician, but, according to Greenough, the November 2, 1941, date on the *Chicago* print is the same as that found on another photograph of the New York subway accordionist she has located in a private collection.[14] While she proposes that this may mean the accordionist picture was among the last made by Evans in the subway, the fact that prints of these two different images bear the same date might suggest that the date refers, not to the negative in either case, but rather to the day on which both prints were made.

Whatever the case, later in the fall of 1941, Evans traveled to Florida on commission to produce illustrations for *The Mangrove Coast*, a book by Karl Bickel published the next year.[15] *Blind Couple in Tampa City Hall Square* (no. 959) appears to have been prepared by Evans for submission to the publishers; it is a severely cropped version of a print that also exists in the Getty collection in an almost square format (no. 960). In this version, the man and woman are seen in the larger context of the public space; they are seated on the sidewalk behind a small table, with a corner of the city hall and its well-manicured lawns visible in the background. Although thirty-two photographs, including at least six sidewalk scenes with acquaintances or relations deep in conversation, did finally appear in *The Mangrove Coast*, the *Blind Couple* is not among them.

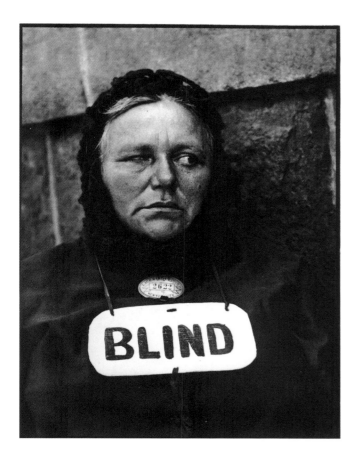

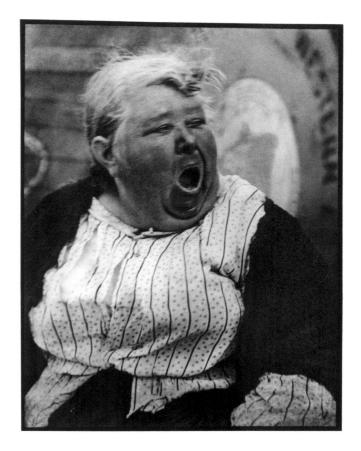

Figure 3. Paul Strand (American, 1890–1976). *New York*, 1916. Photogravure from *Camera Work*, nos. 49–50 (June 1917), pl. 3. 22.4 x 16.8 cm (8 $^{13}/_{16}$ x 6 $^{19}/_{32}$ in.). JPGM 93.XB.26.51.3.

Figure 4. Paul Strand (American, 1890–1976). *New York*, 1916. Photogravure from *Camera Work*, nos. 49–50 (June 1917), pl. 1. 22.5 x 16.8 cm (8 $^{27}/_{32}$ x 6 $^{5}/_{8}$ in.). JPGM 93.XB.26.51.1.

If, at the time of the subway project, Evans seems to have been pursuing sightless subjects for his lens, he also seems to have expected encounters with the blind to be a predictable part of his rapid-transit experience. In one pre-1966 draft of an introductory text for his subway portraits, Evans included "the inevitable familiar inventive blind man making his way down the rocking aisle" in a list of experiences—like "the noise, sense of speed, useful motion, the smell"—that, in retrospect, he felt passengers of 1941 actually enjoyed about their time on the train.[16] But the way in which he chose to use the image of the blind accordionist as the summation of a long and powerful progression of anonymous faces and the fact that

its composition is so entirely different from that of the eighty-eight preceding images of seated passengers, all of whom are presented individually (as seen in no. 590) or in selective groups of twos or threes, give this picture special significance.

In a discussion of Evans's subway pictures, Peter Conrad has called this concluding image an "homage to Strand," seeing it as a reference to Paul Strand's 1916 picture of a blind newspaper vendor (fig. 3).[17] In an interview in 1971, Evans himself admitted to the wrenching effect of Strand's photograph: "I remember coming across Paul Strand's *Blind Woman* when I was very young, and that really bowled me over. I'd already been in that and wanted

to do that. It's a very powerful picture. I saw it in the New York Public Library file of *Camera Work*, and I remember going out of there overstimulated."[18] A Strand portrait of a yawning woman (fig. 4) also appeared in the June 1917 issue of *Camera Work*. Conrad suggests that a second plate in *Many Are Called* (no. 682), which humorously presents a man yawning directly into Evans's camera while a somber young man sits beside him, may be yet another knowing reference to this same, and final, issue of *Camera Work*.[19]

Evans may well have had Strand's work in mind when he rode the New York subway or, later, as he labored over his negatives in the darkroom. Some of the individual female portraits, such as the first plate of *Many Are Called* (no. 590) or the Getty's sixteen small, closely cropped heads of female passengers (mounted together for an earlier maquette [no. 775]), are quite reminiscent of Strand's blind newspaper vendor. But it is perhaps too easy to attribute this brutal last image to Evans's appreciation of the earlier Strand picture. Evans's close involvement with Hart Crane and James Agee may in fact have inspired the image of the blind accordionist, and the subway project of which it is a part.

It is more than likely that—in addition to creating many views of the Brooklyn Bridge that Crane good-naturedly commandeered for his epic poem, *The Bridge*— Evans discussed the poet's ambitious project with him. The first edition of this poem, published in Paris in 1930 by Harry and Caresse Crosby's Black Sun Press, was accompanied by three of Evans's photographs printed in gravure. (See chapter one, "Circa 1930: New York and New England," for a discussion of Getty prints related to the Brooklyn Bridge subject.) There were 275 copies of this deluxe publication printed; of the eight additional special copies marked A to H, the Getty possesses copy C, which bears the imprint on the colophon page: "Special Copy for Walker Evans."[20]

A poem in eight parts, *The Bridge* includes a sev-

enth section entitled "The Tunnel" that describes a nightmarish ride on the subway. Writing to his patron Otto Kahn in 1926, Crane divided the subject matter of *The Bridge*, an immensely complex work, into seven topics, the sixth of which was: "Subway—The encroachment of machinery on humanity; a kind of purgatory in relation to the open sky of last section."[21] This section, of course, was to be about the Brooklyn Bridge itself as a "symbol of consciousness spanning time and space."[22] Around 1929, Evans had photographed this structure from many angles, then made views of the city and the river as seen from its span. Crane's harrowing vision may have planted an idea in Evans's mind so that, by the end of the thirties, he felt himself ready to take on the subject of the subway. Far beneath the Brooklyn Bridge, the subway represented the antithesis of Crane's heroic symbol of Modernism.

Alan Trachtenberg has proposed that "The Tunnel" or subway section of *The Bridge* "seems to deliver damnation," with a presiding spirit that Crane calls "the Daemon" and Trachtenberg reads as a symbol of "the omnipresence of evil."[23] Though a daemon may be a superhuman power of either good or evil, Crane's character appears to be definitely maleficent: "Whose hideous laughter is a bellows mirth/Or the muffled slaughter of a day in birth."[24] Although Evans may not have intended such ominous overtones for his subway sequence as published in *Many Are Called*, the cumulative impact of this extensive series of trancelike faces is to suggest a journey toward death, if not damnation, a macabre apparition, not unlike the vision of the dead Edgar Allan Poe that appears to Crane's protagonist in this section of *The Bridge*:

> *Whose head is swinging from the swollen strap?*
> *Whose body smokes along the bitten rails,*
> *Bursts from a smoldering bundle far behind*
> *In back forks of the chasms of the brain,—*
> *Puffs from a riven stump far out behind*
> *In interborough fissures of the mind . . . ?*

And why do I often meet your visage here,
Your eyes like agate lanterns—on and on
Below the toothpaste and the dandruff ads ?
—And did their riding eyes right through your side,
And did their eyes like unwashed platters ride?
And Death, aloft,—gigantically down
Probing through you—toward me, O evermore![25]

Standing alone with his music, the blind accordionist commands attention, bizarrely taking on the role of a leader who may himself be blind to his followers' impending doom. "Let them alone; they are blind guides. And if a blind man leads a blind man, both will fall into a pit," reads the Gospel of Matthew (15:14), the same New Testament book from which Evans borrowed the final title for his project, *Many Are Called.*

Similar imagery, sinister and at times surreal, fills "Rapid Transit," a poem published by James Agee in 1937:

> *Squealing under city stone*
> > *The millions on the millions run,*
> *Every one a life alone,*
> > *Every one a soul undone:*
>
> *There all the poisons of the heart*
> > *Branch and abound like whirling*
> > > *brooks*
> *And there through every useless art*
> > *Like spoiled meats on a butcher's*
> > > *hooks*
>
> *Pour forth upon their frightful kind*
> > *The faces of each ruined child:*
> *The wrecked demeanors of the mind*
> > *That now is tamed, and once was wild.*[26]

That Evans had discussed this project with James Agee seems certain. The extent of their collaboration is less clear. By early 1937, when Agee published his poem, the two men were close friends. They had recently completed the Hale County, Alabama, project for *Fortune* and, since the journal had rejected their work, were awaiting the release of that material so they could begin planning for a larger undertaking: the book-length *Let Us Now Praise Famous Men,* finally issued in 1941. It cannot be assumed that Agee discussed all of his writing projects with Evans, but, given their regular communication and many mutual interests, it is not unlikely that Evans was aware of the publication of "Rapid Transit." In 1956, for example, Evans's portfolio of eight subway pictures included in the *i.e. The Cambridge Review*'s posthumous tribute to Agee appeared under the same title.[27] In addition, these selected subway images, the first of the series to be made public, were accompanied by a short essay written by Agee.[28]

Although published with the date "October 1940," the Agee essay begins with the statement that these subway photographs were made "during the late thirties and early forties."[29] This assertion, and the fact that the essay did not appear until long after its completion, has caused its dating to remain somewhat controversial. Sarah Greenough speculates that the essay may have been prepared "in support of Evans's application in late 1940 to renew his Guggenheim fellowship."[30] It may also be the case that Evans and Agee, as they worked on the final stages of *Let Us Now Praise Famous Men,* were putting together a possible publication about the subway pictures. If the two men had plans to publish their work in the early forties, soon after Evans had produced a body of prints, the onset of World War II and Evans's concern about adverse reactions from some of his unsuspecting sitters caused them to defer the idea indefinitely.

However, after Agee's death, Evans was to use his friend's essay in two of the three forms in which he chose to publish his subway photographs, the first being the "Rapid Transit" portfolio of 1956 and the second being the 1966 book *Many Are Called,* which Evans dedicated "To

James Agee (1909–1955)." It must be taken as significant that, although he himself drafted at least six different introductory texts and jotted down at least nine different titles between 1956 and 1966, Evans ultimately chose for this book to reuse Agee's earlier text and to use as his title a biblical quotation that may have originated with the deeply religious writer.[31]

The quotation is taken from the parable of the marriage feast in the Gospel of Matthew, in which Jesus says: "The kingdom of heaven may be compared to a king who gave a marriage feast for his son, and sent his servants to call those who were invited to the marriage; but they would not come" (Matthew 22:1–3). Although the king makes several attempts to attract the invited guests, not only are they indifferent and ungrateful, but they respond by killing the king's messengers. In retaliation, the king sends his troops to destroy the wedding guests' city. Then he dispatches his servants a second time, now with these orders: "'The wedding is ready, but those invited were not worthy. Go therefore to the thoroughfares, and invite to the marriage feast as many as you find.' And those servants went out into the streets and gathered all whom they found, both bad and good; so the wedding hall was filled with guests" (Matthew 22:8–10). Upon encountering a man "who has no wedding garment," the king asks how he got into the wedding celebration, but the man has no answer. The king then has him ejected from the hall and thrown "into the outer darkness," because, Jesus explains, "many are called, but few are chosen" (Matthew 22:14).

Like this biblical parable, Evans's book gathers unknown faces from the cities' thoroughfares and confronts them (us) with their inevitable mortality. It is probably no accident that the final image in this volume, the blind accordionist, recalls another passage from this same Gospel, the parable of the blind leading the blind.[32] When applied to Evans's twentieth-century image, the parable adds moral and political significance to this important photograph. As Evans suggests in one of his own introductory drafts for *Many Are Called*, speculation about the faces on these pages is the prerogative of the reader, who is free to draw her or his own conclusions, including the possibility that "what America needs is a political revolution."[33]

NOTES

1. This essay appeared in an expanded version as "Walker Evans and *Many Are Called*: Shooting Blind," in *History of Photography* XVII:2 (Summer 1993), 152–65.

2. James Agee, introduction to Walker Evans, *Many Are Called* (Boston: Houghton Mifflin, 1966), n.p.

3. Sarah Greenough, *Walker Evans: Subways and Streets* (Washington, D.C.: National Gallery of Art, 1991). Greenough's essay "Many Are Called and Many Are Chosen: Walker Evans and the Anonymous Portrait" provides the first lengthy discussion in print of the subway series, with special emphasis on the relevant drafts, maquettes, and publishing efforts that preceded the release of the book in 1966. Sidney Tillim's review of the MoMA exhibition *Walker Evans: Photography as Representation* for *Artforum* 5 (Mar. 1967, 14–18), devotes more time to Evans's work in general than to the subway series on display. Information provided by Sarah Greenough made possible the determination that five of the ten Getty prints with 1966 loan numbers were displayed in the MoMA show: nos. 620, 636, 660, 686, and 722.

4. After conferring with John Szarkowski, John Hill, Jim Dow, Lee Friedlander, Jerry Thompson, Virginia Hubbard, and Isabelle Storey, I have not been able to determine who, if not Evans, created this group of prints, each bearing directions to the Houghton Mifflin printers. John Szarkowski suggested that Evans's intent in producing this new set of prints was to avoid using vintage material in the book-production process. Correspondence with the author, April–May 1994.

5. The Getty collection includes some thirty-two prints intended for the 1938 volume *American Photographs* that are affixed to similar three-hole mounts bearing title, date, and plate number information. These appear to have been part of a working maquette put together as the book's sequence evolved (see Appendix B).

6. See Greenough, *Walker Evans*, "Subway Portrait, 1941," pls. 51, 98.

7. See Walker Evans, "Unposed Photographic Records of People," manuscript in the Getty collection (84.XG.953.50.2); first published in *Walker Evans at Work* (New York: Harper and Row, 1982), 160.

8. Walker Evans, "The Unposed Portrait," *Harper's Bazaar* 95 (Mar. 1962), 120–25, in Greenough, *Walker Evans*, 127.

9. Walker Evans, "Twenty Thousand Moments under Lexington Avenue: A Superfluous Word," first published in Greenough, *Walker Evans*, 127. The author thanks Jerry Thompson for his letter of August 30, 1993, identifying the camera used in this project as a Contax, which Mr. Thompson subsequently inherited. Painted a flat black by the photographer himself, the Contax, according to Mr. Thompson, would have been preferable to a Leica for this difficult project because the Contax opens up to f/1.5, almost a full stop faster than the f/2 possible with Leicas at that time, and because the Contax has a shutter-speed setting of $\frac{1}{25}$ second, whereas the settings of the older Leicas used by Evans go from $\frac{1}{20}$ to $\frac{1}{30}$ second.

10. The thirty Getty pictures from the subway series that have decipherable dates, beginning with this image of January 7, 1941, break down as follows: January 9, one image; January 13, four; January 17, four; January 21,

eight; January 22, one; January 25, three; January 26, one; February (no date), one; March 16, one; May 27, one. John Hill, in conversation with the author, May 31, 1991, reported that Evans was unable, due to illness, to use his 1940 Guggenheim grant for a proposed project in Savannah, Georgia, and so reapplied for a grant to be used on a subway series in 1941. See also Greenough, *Walker Evans*, 20 and 44, fn. 35.

11. See Evans, "Unposed Photographic Records of People," 160.

12. The Evans Estate in 1982 reprinted three of these images from Evans's negatives. See *Walker Evans at Work*, 99.

13. A third Getty print from this image (no. 1014), with cropping very similar to fig. 6, is titled on the verso *Chicago, Halsted Street, 1941.*

14. Greenough, *Walker Evans*, 44, fn. 23.

15. Karl A. Bickel, *The Mangrove Coast: The Story of the West Coast of Florida*, photographs by Walker Evans (New York: Coward-McCann, 1942).

16. Walker Evans, "Subway," first published in *Walker Evans at Work*, 161.

17. Peter Conrad, *The Art of the City: Views and Versions of New York* (New York and Oxford: Oxford University Press, 1984), 164.

18. Leslie Katz, "An Interview with Walker Evans" (1971), in *Photography in Print*, edited by Vicki Goldberg (New York: Simon and Schuster, 1981), 366–67.

19. Conrad, *Art of the City*, 162. Also see *Camera Work* 49/50 (June 1917), ills. I and III.

20. JPGM 84.XB.1143.

21. Hart Crane, "Two letters on 'The Bridge,'" *Hound & Horn* V–VII, no. 4 (July–Sept. 1934), 678.

22. Ibid.

23. Alan Trachtenberg, *Brooklyn Bridge: Fact and Symbol* (New York: Oxford University Press, 1965), 156.

24. Brom Weber, ed., *The Complete Poems and Selected Letters and Prose of Hart Crane* (Garden City, N.Y.: Anchor Books, 1966), 111.

25. Weber, *Hart Crane*, 110.

26. This is the complete poem as published by Agee in *Forum and Century* 97 (Feb. 1937), 115.

27. Walker Evans, "Rapid Transit: Eight Photographs," *i.e. The Cambridge Review* (Mar. 1956), 16–24.

28. James Agee, "A Note on Photography," *i.e. The Cambridge Review* (Mar. 1956), 25.

29. Ibid., 25.

30. Greenough, *Walker Evans*, 44, fn. 35.

31. For Evans's drafts of introductory titles and texts, see Evans manuscripts in the Getty collection (JPGM 84.XG.963.50.1–.7 and 84.XG.963.49.5); *Walker Evans at Work*, 152 and 160–61; and Greenough, *Walker Evans*, 125–27. Agee's essay appears in *Many Are Called* under the title "Introduction." In a June 1993 discussion with the author about the subway project, Jane Sargeant, Evans's wife in 1941, said she thought that Alice Morris, a friend and an editor at *Harper's Bazaar* for many years, suggested the title "Many Are Called."

32. Matthew 15:14. Pieter Brueghel's 1568 painting *The Parable of the Blind* (Museo-Galleria Nazionale di Capodimonte, Naples) might be another source for Evans's choice of the blind musician as a figure who unwittingly determines the fate of his apathetic companions. The author would like to thank Dawson W. Carr, Associate Curator in the Department of Paintings at the Getty Museum, for his mention of the Brueghel work in a discussion about the occurrence of blind subjects in paintings of the sixteenth and seventeenth centuries.

33. See Evans manuscript in the Getty collection (JPGM 84.XG.963.49.5); revised version first published in *Walker Evans at Work*, 161.

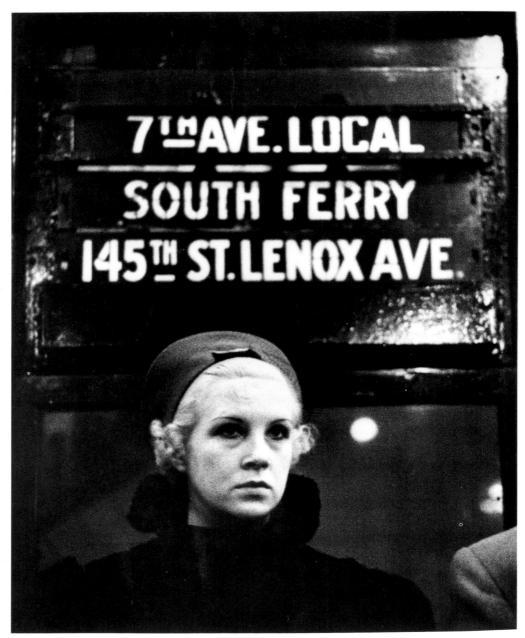

590

The Making of *Many Are Called*

The first 185 entries in this section of images made in the New York subway follow the sequencing established by Evans for his 1966 book *Many Are Called*, with the exception of nos. 708 and 732, which follow related images that fall earlier in the published sequence of plates. The entries include the eighty-nine photographs (each displaying printer's marks) made circa 1955–65 to illustrate

this publication. These prints occasionally differ in minor ways from the published image (and, therefore, are referred to as variants), owing simply to the trimming that took place as part of the book production process. The prints have been assembled here in book order with their related images, usually 1940s prints of different croppings from the same negative or photographs from different negatives of the same subject, inserted after them for immedi-

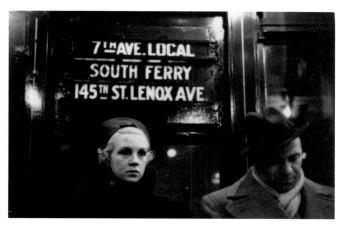

591

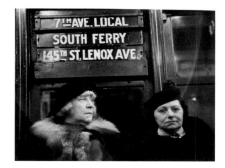

592

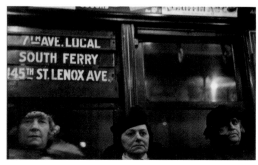

593

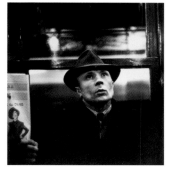

594

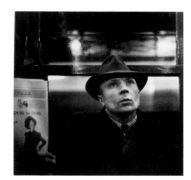

595

ate reference or comparison. The last thirty-eight subway entries fall outside of Evans's 1966 book selection and are organized arbitrarily by subject, with women preceding men. Two other portraits, one of the photographer's first wife from the year of their marriage, ends this catalogue section.

590
[*Subway Portrait*], 1938–41; printed ca. 1965
Image: 25.2 x 20 cm (10 x 7 ⅞ in.); sheet: 35.4 x 28 cm (14 x 11 ¹⁄₁₆ in.) [mounted to second sheet]
84.XM.956.562
MARKS & INSCRIPTIONS: (Recto) signed below image, in ink, by Evans, *Walker Evans*; at l. right, Evans stamp I; in pencil, *185/12* [horizontal line]/*73* and at l. right center, in pencil, *66 ½*; (verso, mount) at center, Evans stamp I; at l. left, in pencil, Crane no. *L71.1* (*Evans*).

REFERENCES: MAC, p. 1; WEAW, p. 154 (variant, middle right image).

591
[*Subway Portrait*], 1938–41
Image: 12.5 x 19.2 cm
(4 ¹⁵⁄₁₆ x 7 ⁹⁄₁₆ in.); sheet: 20 x 24.8 cm
(7 ⅞ x 9 ¾ in.)
84.XM.956.654
MARKS & INSCRIPTIONS: (Verso) at l. right, Evans stamp B; at l. right, in pencil, *XX*; at l. left in pencil, Crane no. *L70.67*(*Evans*).
REFERENCES: MAC, p. 1 (variant); WEAW, p. 154 (variant, middle right image).

592
[*Subway Portrait*], 1938–41; printed ca. 1965
Image: 20 x 25.6 cm (7 ⅞ x 10 ¹⁄₁₆ in.); sheet: 35.3 x 28 cm (13 ¹⁵⁄₁₆ x 11 ¹⁄₁₆ in.) [mounted to second sheet]
84.XM.956.563
MARKS & INSCRIPTIONS: (Recto) signed at l. right below image, in ink, by Evans, *Walker Evans*; at l. right, Evans stamp I; at l. right, in pencil, *170/13* [horizontal line] /*57*; (verso, mount) at center, Evans stamp I; at l. center, in pencil, *2* [circled]/*50% off/2" HEAD*; at l. left, in pencil, Crane no. *L71.2* (*Evans*).
REFERENCES: MAC, p. 3.

593
[*Subway Portrait*], 1938–41
14.8 x 23.5 cm (5 ¹³⁄₁₆ x 9 ¼ in.)
84.XM.956.786
MARKS & INSCRIPTIONS: (Verso) at u. right, Evans stamp A; at l. left, in pencil, Crane no. *L70.76*.
REFERENCES: WEAW, pp. 152 and 156 (variants).

594
[*Subway Portrait*], 1938–41; printed ca. 1955–65
Image: 17 x 15.6 cm (6 ¹¹⁄₁₆ x 6 ⁵⁄₃₂ in.); original mount: 32 x 25.5 cm
(12 ⅝ x 10 ¹⁄₁₆ in.)
84.XM.956.564
MARKS & INSCRIPTIONS: (Recto, mount) signed at l. right below print, in ink, by Evans, *Walker Evans*; at l. right, Evans stamp I; at l. center, in pencil, *180-10-170*; at l. right, in pencil, *90*; (verso, mount) at center, Evans stamp I; at l. center, in pencil, *3* [circled]/ *5 ½" WIDE/ 1 ½" HEAD*; at l. left, in pencil, Crane no. *L71.3*(*Evans*).
REFERENCES: MAC, p. 5; WEAW, p. 153 (variant, top image).

595
[*Subway Portrait*], 1938–41
Image: 12.2 x 12.1 cm
(4 ¹³⁄₁₆ x 4 ¾ in.); original mount:
28.7 x 21.4 cm (11 ⁵⁄₁₆ x 8 ⁷⁄₁₆ in.)

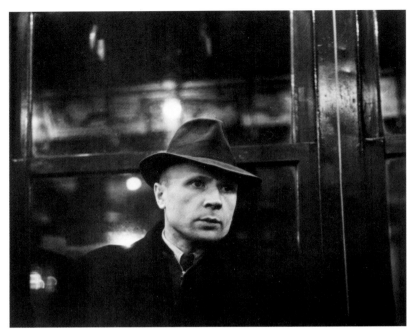

596

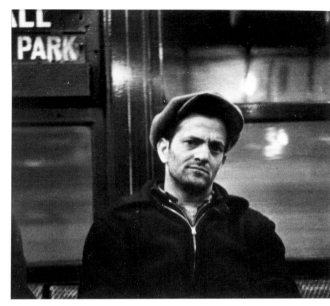

597

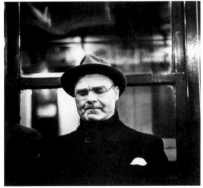

600

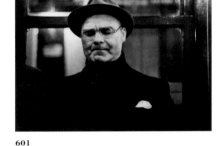

601

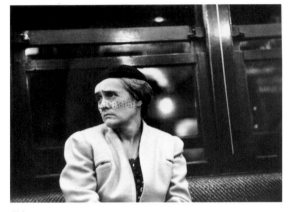

602

84.XM.956.681
MARKS & INSCRIPTIONS: (Recto, mount)
signed at l. right, in pencil, by Evans,
Walker Evans; (verso, mount) at center,
Evans stamp I; at l. left, in pencil,
Crane no. *L70.40(Evans)*.
REFERENCES: MAC, p. 5 (variant); WEAW,
p. 153 (variant, top image).

596
[*Subway Portrait*], 1938–41
Image: 12 x 13.9 cm (4 ²³⁄₃₂ x 5 ⁷⁄₁₆ in.);
original mount: 28.7 x 21.3 cm
(11 ⁵⁄₁₆ x 8 ¹³⁄₃₂ in.)
84.XM.956.706

MARKS & INSCRIPTIONS: (Recto, mount)
signed at l. right, in pencil, by Evans,
Walker Evans; (verso, mount) at center,
Evans stamp I; at center, in red ink,
return this print to [arrow]; at l. left, in
pencil, Crane no. *L70.45(Evans)*.

597
[*Subway Portrait*], 1938–41; printed
ca. 1955–65
Image: 16.9 x 18.3 cm
(6 ¹¹⁄₁₆ x 7 ⁷⁄₃₂ in.); original mount:
32.2 x 25.4 cm (12 ¾ x 10 in.)
84.XM.956.565

MARKS & INSCRIPTIONS: (Recto, mount)
signed below print, in ink, by Evans,
Walker Evans; at l. right, Evans stamp
I; at l. right, in pencil, *188/12* [under-
lined]/*176*; (verso, mount) at center,
Evans stamp I; at l. center, in pencil, *4*
[circled]/*1/4 OFF/1 ½" HEAD*; at l. left,
in pencil, Crane no. *L71.4(Evans)*.
REFERENCES: "Rapid Transit: Eight
Photographs," *i.e. The Cambridge
Review*, Mar. 1956, p. 22 (variant);
MAC, p. 7.

598
[*Subway Portrait*], 1938–41
Image: 12 x 10.5 cm (3 ¾ x 4 ⅛ in.);
original mount: 28.7 x 21.3 cm
(11 ⁵⁄₁₆ x 8 ⁷⁄₁₆ in.)
84.XM.956.768
MARKS & INSCRIPTIONS: (Recto, mount)
signed at l. right below print, in pen-
cil, by Evans, *Walker Evans*; (verso,
mount) at center, Evans stamp I;
(recto, mat) at l. left, in pencil, Crane
no. *L70.26(Evans)*.
REFERENCES: "Rapid Transit: Eight
Photographs," *i.e. The Cambridge
Review*, Mar. 1956, p. 22 (variant);
MAC, p. 7 (variant).

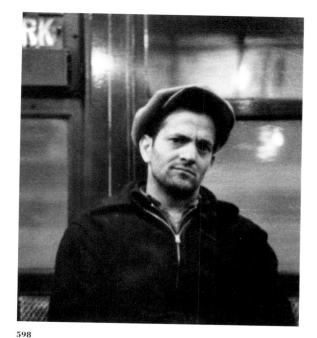

598

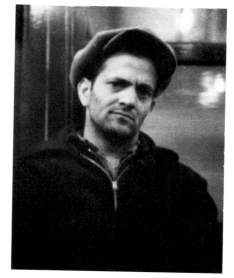

599

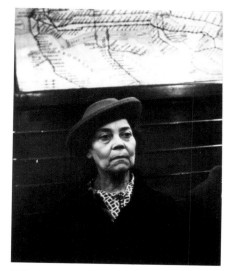

603

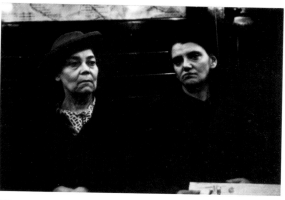

604

center, in pencil, *J18* [illegible]; (recto, mat) at l. left, in pencil, Crane no. *L70.91(Evans)*.
REFERENCES: MAC, p. 9 (variant); WEAW, p. 154 (variant, u. left image).

602
[*Subway Portrait*], 1938–41; printed ca. 1955–65
Image: 15.6 x 20.9 cm (6 ⅛ x 8 ¼ in.); original mount: 32 x 25.5 cm (12 ⅝ x 10 ⅟₁₆ in.)
84.XM.956.567
MARKS & INSCRIPTIONS: (Recto, mount) signed below print, in ink, by Evans, *Walker Evans*; at l. right, Evans stamp I; at center, in pencil, *180/11* [underlined]/*179*; (verso, mount) at center, Evans stamp I; at center, in pencil, *6* [circled]*¼ OFF/1 ¾" HEAD*; at l. left, in pencil, Crane no. *L71.6(Evans)*.
REFERENCES: MAC, p. 11 (variant).

603
[*Subway Portrait*], 1938–41; printed ca. 1955–65
Image: 18.3 x 14.8 cm (7 ³⁄₁₆ x 5 ¹³⁄₁₆ in.); original mount: 32.5 x 25.4 cm (12 ¹³⁄₁₆ x 10 in.)
84.XM.956.568
MARKS & INSCRIPTIONS: (Recto, mount) signed below print, in ink, by Evans, *Walker Evans*; at l. right, Evans stamp I; at l. center, in ink, *80%*; at l. right, in pencil, *166/12* [underlined]/*154* [all erased]; (verso, mount) at center, Evans stamp I; at center, in pencil, *7* [circled]/*10% OFF/¾" HEAD*; at l. left, in pencil, Crane no. *L71.7(Evans)*.
REFERENCES: MAC, p. 13 (variant).

604
[*Subway Portrait*], 1938–41
Image: 10.9 x 15.6 cm (4 ¼ x 6 ³⁄₁₆ in.); original mount: 11.6 x 16.1 cm (4 ⁹⁄₁₆ x 6 ⅝ in.)
84.XM.956.715
MARKS & INSCRIPTIONS: (Verso, mount) at right edge, Evans stamp A; at l. left, in pencil, Crane no. *L70.17(Evans)*.
REFERENCES: MAC, p. 13 (variant); WEAW, pp. 152 and 156 (variants).

599
[*Subway Portrait*], 1938–41
10 x 7.7 cm (3 ¹⁵⁄₁₆ x 3 in.) [on original mount trimmed to image]
84.XM.956.747
MARKS & INSCRIPTIONS: (Verso, mount) at l. center, Evans stamp A; at u. center, in ink, by Evans, *B #18*; (recto, mat) at l. right, in pencil, *207, 208*; at l. left, in pencil, Crane nos. *L70.57-58(Evans)*.
REFERENCES: "Rapid Transit: Eight Photographs," i.e. *The Cambridge Review*, Mar. 1956, p. 22 (variant); MAC, p. 7 (variant).

600
[*Subway Portrait*], 1938–41; printed ca. 1955–65
Image: 16 x 16 cm (6 ⁵⁄₁₆ x 6 ⁵⁄₁₆ in.); original mount: 30.8 x 25.4 cm (12 ⅛ x 10 in.)
84.XM.956.566
MARKS & INSCRIPTIONS: (Recto, mount) signed at l. right below print, in ink, by Evans, *Walker Evans*; at l. right, Evans stamp I; at l. left, in pencil, *195/13*; at l. right below print, in pencil, *183/10*; at l. edge, in pencil, *175-13-182*; (verso, mount) at center, Evans stamp I; at l. center, in pencil, *5* [circled]/*SAME SIZE/1" HEAD*; at l. left, in pencil, Crane no. *L71.5(Evans)*.
REFERENCES: MAC, p. 9; WEAW, p. 154 (variant, u. left image).

601
[*Subway Portrait*], 1938–41
Image: 10.3 x 12.4 cm (4 ⅟₁₆ x 4 ⅞ in.); mount: 27.1 x 21.1 cm (10 ¹¹⁄₁₆ x 8 ⁵⁄₁₆ in.)
84.XM.956.755
MARKS & INSCRIPTIONS: (Recto, mount) signed at right below print, in pencil, by Evans, *Walker Evans*; (verso, mount) at center, Evans stamp I; at

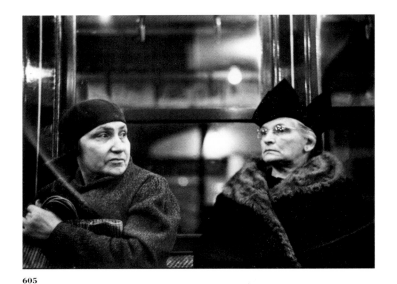

605

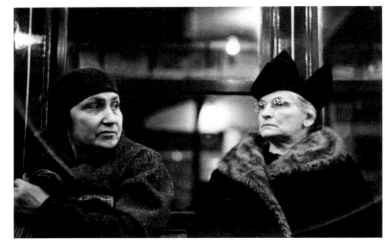

606

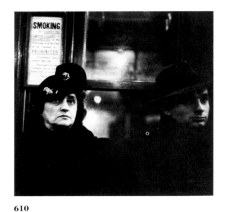

610

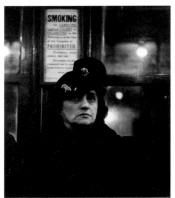

611

612

605
[*Subway Portrait*], 1938–41; printed
ca. 1965
Image: 19 x 25.5 cm (7 ½ x 10 ⅟15 in.);
sheet: 35.3 x 28 cm (13 ¹⁵/₁₆ x 11 ¹/₁₆ in.)
[mounted to second sheet]
84.XM.956.569
MARKS & INSCRIPTIONS: (Recto) signed at
right below image, in ink, by Evans,
Walker Evans; at l. right, Evans stamp
I; at l. right, in pencil, *191/10* [under-
lined]/*181*; (verso, mount) at center,
Evans stamp I; at l. center, in pencil, *8*
[circled]/*6″ WIDE/2″ HEAD*; at l. left, in
pencil, Crane no. *L71.8(Evans)*.
REFERENCES: MAC, p. 15.

606
[*Subway Portrait*], 1938–41
Image: 11.1 x 17 cm (4 ⅜ x 6 ¹¹/₁₆ in.);
original mount: 28.8 x 21.4 cm
(11 ⁵/₁₆ x 8 ⁷/₁₆ in.)
84.XM.956.750
MARKS & INSCRIPTIONS: (Recto, mount)
signed at right below sheet, in pencil,
by Evans, *Walker Evans*; (verso,
mount) at center, Evans stamp I;
(recto, mat) at l. left, in pencil, Crane
no. *L70.88(Evans)*.
REFERENCES: MAC, p. 15 (variant).

607
[*Subway Portrait*], January 17, 1941;
printed ca. 1955–65
Image: 17 x 15.3 cm (6 ¾ x 6 in.); origi-
nal mount: 30.7 x 25.5 cm
(12 ⅛ x 10 ⅛ in.)
84.XM.956.570
MARKS & INSCRIPTIONS: (Recto, mount)
signed at l. right below print, in ink,
by Evans, *Walker Evans*; at l. right,
Evans stamp I; at l. right, in pencil,
196/13 [underlined]/*183*; (verso,
mount) at center, in pencil, *9* [circled]/
10% OFF/1″ HEAD; at l. left, in pencil,
Crane no. *L71.9(Evans)*.

REFERENCES: MAC, p. 17; WEAW, p. 157
(variant, center right image).

608
[*Subway Portrait*], 1941
Image: 13.4 x 9.6 cm (5 ¼ x 3 ¾ in.);
original mount: 28.6 x 21.6 cm
(11 ¼ x 8 ½ in.)
84.XM.956.770
MARKS & INSCRIPTIONS: (Recto, mount)
signed at l. right below print, by
Evans, *Walker Evans*; (verso, mount) at
center, in ink, by Evans, *1-17 #24*; at
center, Evans stamp I; (recto, mat) at
l. left, in pencil, Crane no. *L70.96*
(*Evans*).

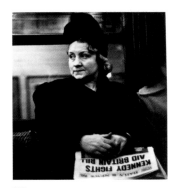

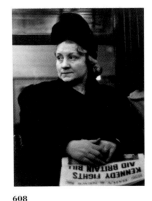

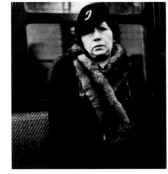

607 608 609

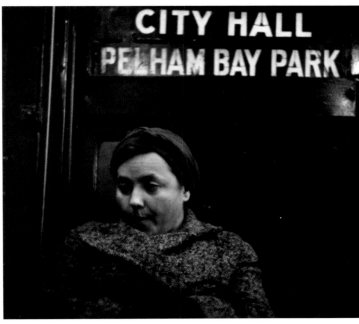

613

pencil, *11* [circled]/*20% OFF/1 ¼″
HEAD*; at l. left, in pencil, Crane
no. *71.11*(*Evans*).
REFERENCES: MAC, p. 21; WEAW, p. 152
and 156 (variants).

611
[*Subway Portrait*], 1938–41
Image: 12.7 x 11 cm (5 x 4 ¹¹⁄₃₂ in.);
original mount: 28.7 x 21.2 cm
(11 ⁵⁄₁₆ x 8 ⅜ in.)
84.XM.956.703
MARKS & INSCRIPTIONS: (Recto, mount)
signed at l. right, in pencil, by Evans,
Walker Evans; (verso, mount) at center,
Evans stamp I; at l. left, in pencil,
Crane no. *L70.33*(*Evans*).
REFERENCES: MAC, p. 21 (variant);
WEAW, pp. 152, 156 (variants).

612
[*Subway Portrait*], 1941; printed
ca. 1965
Image: 17.4 x 25.6 cm
(6 ⅞ x 10 ¹⁄₁₆ in.); sheet: 35.3 x 28 cm
(13 ¹⁵⁄₁₆ x 11 ¹⁄₁₆ in.) [mounted on sec-
ond sheet]
84.XM.956.573
MARKS & INSCRIPTIONS: (Recto) signed at
right below image, in ink, by Evans,
Walker Evans; at l. right, Evans stamp
I; at l. right, in pencil, *193/13* [under-
lined]/*180*; (verso, mount) at l. right,
Evans stamp H; at l. center,
in pencil, *12* [circled]/*40% OFF/2″
HEAD*; at l. left, in pencil, Crane
no. *L71.12*(*Evans*).
REFERENCES: MAC, p. 23.

REFERENCES: "Rapid Transit: Eight
Photographs," *i.e. The Cambridge
Review*, Mar. 1956, p. 24 (variant);
MAC, p. 17 (variant); WEAW, p. 157 (cen-
ter right image).

609
[*Subway Portrait*], 1938–41; printed
ca. 1955–65
Image: 16.7 x 15 cm (6 ⁹⁄₁₆ x 5 ¹⁵⁄₁₆ in.);
original mount: 31.2 x 25.4 cm
(12 ¹⁵⁄₁₆ x 10 ¹⁄₁₆ in.)
84.XM.956.571

MARKS & INSCRIPTIONS: (Recto, mount)
signed at l. right below print, in ink,
by Evans, *Walker Evans*; at l. right,
Evans stamp I; at l. right, in pencil,
178/12 [underlined]/*166*; (verso,
mount) at center, Evans stamp I; at
l. center, in pencil, *10* [circled]/*10%
OFF/1″ HEAD*; at l. left, in pencil,
Crane no. *L71.10*(*Evans*).
REFERENCES: MAC, p. 19; WEAW,
pp. 152, 156 (variants).

610
[*Subway Portrait*], 1938–41; printed
ca. 1955–65
Image: 16.9 x 17.8 cm (6 ¹¹⁄₁₆ x 7 in.);
original mount: 31.5 x 25.4 cm
(12 ½ x 10 in.)
84.XM.956.572
MARKS & INSCRIPTIONS: (Recto, mount)
signed at right below print, in ink, by
Evans, *Walker Evans*; at l. right, Evans
stamp I; at l. right, in pencil, *179/11*
[underlined]/*168*; (verso, mount) at
l. right, Evans stamp I; at l. center, in

613
[*Subway Portrait*], 1941
Image: 11.4 x 12.6 cm
(4 ½ x 4 ¹⁵⁄₁₆ in.); original mount:
28.8 x 21.4 cm (11 ⁵⁄₁₆ x 8 ⅜ in.)
84.XM.956.769
MARKS & INSCRIPTIONS: (Recto, mount)
signed at l. right below print, in pen-
cil, by Evans, *Walker Evans*; (verso,
mount) at center, in ink, by Evans,
1-21 #22; at center, Evans stamp I;
(recto, mat) at l. right, in pencil, *203*;
at l. left, in pencil, Crane no. *L70.95*
(*Evans*).
REFERENCES: MAC, p. 23 (variant).

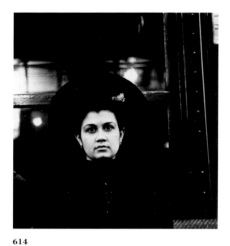

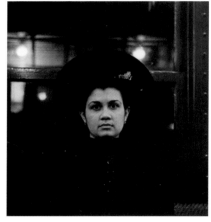

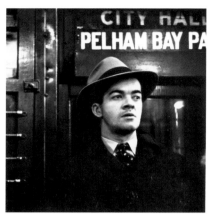

614

615

616

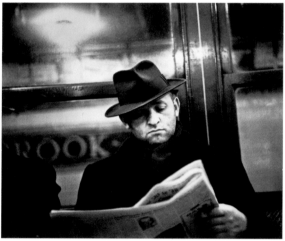

619

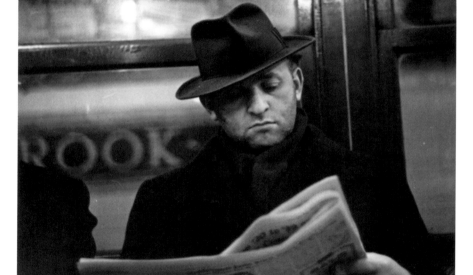

620

614
[*Subway Portrait*], 1938–41; printed ca. 1955–65
Image: 16.9 x 15.3 cm (6 ⅝ x 6 in.); original mount: 31.2 x 25.3 cm (12 ⁵⁄₁₆ x 10 in.)
84.XM.956.574
MARKS & INSCRIPTIONS: (Recto, mount) signed at right below print, in ink, by Evans, *Walker Evans*; at l. right, Evans stamp I; (verso, mount) at center, Evans stamp I; at l. center, in pencil, *13* [circled]/*1/6 OFF/1 ¼″ HEAD*; at l. left, in pencil, Crane no. *L71.12 (Evans)*.

REFERENCES: "Walker Evans: The Unposed Portrait," *Harper's Bazaar*, Mar. 1962, p. 125 (variant); MAC, pl. 25; WEAW, p. 157 (variant).

615
[*Subway Portrait*], 1938–41
Image: 12.6 x 11.6 cm (4 ¹⁵⁄₁₆ x 4 ⁹⁄₁₆ in.); original mount: 27.3 x 20.7 cm (10 ¾ x 8 ⅛ in.)
84.XM.956.756
MARKS & INSCRIPTIONS: (Recto, mount) signed at right below print, in pencil, by Evans, *Walker Evans*; (verso, mount) at center, Evans stamp I; at

center, in pencil, *II/24* [*??*]; (recto, mat) at l. left, in pencil, Crane no. *L70.107(Evans)*.
REFERENCES: "Walker Evans: The Unposed Portrait," *Harper's Bazaar*, Mar. 1962, p. 125 (variant); MAC, p. 25 (variant); WEAW, p. 157.

616
[*Subway Portrait*], 1941; printed ca. 1955–65
Image: 16.6 x 15.3 cm (6 ½ x 6 ¹⁄₁₆ in.); original mount: 31.2 x 25.6 cm (12 ⁵⁄₁₆ x 10 in.)
84.XM.956.575

MARKS & INSCRIPTIONS: (Recto, mount) signed at l. right below print, in ink, by Evans, *Walker Evans*; at l. right, Evans stamp I; at l. left, in pencil, *37 ½ %*; (verso, mount) at center, Evans stamp I; at l. center, in pencil, *14* [circled]/*¹⁄₆ OFF/1 ¼″ HEAD*; at l. left, in pencil, Crane no. *L71.14 (Evans)*.
REFERENCES: MAC, p. 27.

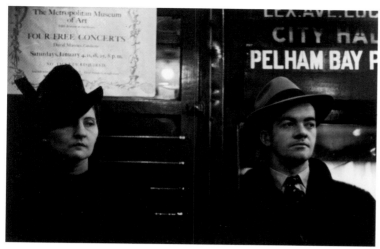

617

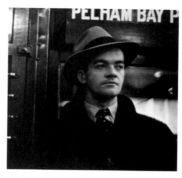

618

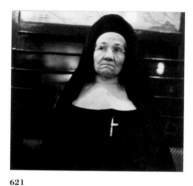

621

622

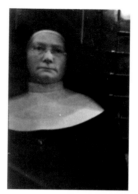

623

617
[*Subway Portrait*], 1941
Image: 12.9 x 19.7 cm (5 ¹/₁₆ x 7 ¾ in.);
original mount: 34 x 25.5 cm
(13 ³/₈ x 10 ¹/₁₆ in.)
84.XM.956.761
MARKS & INSCRIPTIONS: (Recto, mount)
signed at right below print, in pencil,
by Evans, *Walker Evans*; (verso,
mount) at center, Evans stamp I; at
center, in ink, by Evans, *1-25* [space]
#28-39; (recto, mat) on a piece of
paper taped to mount, in pencil, *1939-
40/N.Y. Subway*; at l. right, in pencil,
186; at l. left, in pencil, Crane
no. *L70.109(Evans)*.

618
[*Subway Portrait*], 1941
Image: 17 x 17.5 cm (6 ¹¹/₁₆ x 6 ⅞ in.);
original mount: 31.5 x 23 cm
(12 ⁷/₁₆ x 9 ¹/₁₆ in.)
84.XM.956.684
MARKS & INSCRIPTIONS: (Recto, mount)
signed at l. right, in pencil, by Evans,
Walker Evans; (verso, mount) at center,
Evans stamp I; at center, in ink, by
Evans, *1-25 #28-29*; at l. left, in
pencil, Crane no. *L70/29(Evans)*.

619
[*Subway Portrait*], 1938–41; printed
ca. 1955–65
Image: 16.8 x 19.3 cm (6 ⅝ x 7 ⅝ in.);
original mount: 31 x 25.5 cm
(12 ¼ x 10 ⅛ in.)
84.XM.956.576
MARKS & INSCRIPTIONS: (Recto, mount)
signed at l. right, in ink, by Evans,
Walker Evans; at l. right, Evans stamp
I; at l. center, in pencil, *178-11-167*
[erased]; at l. right, in pencil, *72%*;
(verso, mount) at center, Evans stamp
I; at l. center, in pencil, *15* [circled]/
5 ½ WIDE/2″ HEAD and *28% OFF*;
at l. left, in pencil, Crane no. *L75.15
(Evans)*.
REFERENCES: MAC, p. 29; WEAW, p. 153
(variant, bottom right image).

620
[*Subway Portrait*], 1938–41
Image: 17.4 x 22.3 cm (6 ⅞ x 8 ¾ in.);
original mount: 33 x 24.8 cm
(13 x 9 ²⁵/₃₂ in.)
84.XM.956.685
MARKS & INSCRIPTIONS: (Verso, mount) at
center, Evans stamp I; at u. right, in

pencil, MoMA loan no. *66.1121*; at
l. center, in pencil, *30*; at l. left, in
pencil, Crane no. *L70.83(Evans)*.
REFERENCES: MAC, p. 29 (variant);
WEAW, p. 153.
EXHIBITIONS: *Walker Evans' Subway*,
Museum of Modern Art, New York,
Oct. 5–Dec. 11, 1966.

621
[*Subway Portrait*], 1938–41; printed
ca. 1955–65
Image: 16.3 x 17.2 cm
(6 ½ x 6 ¹³/₁₆ in.); original mount:
31 x 25.3 cm (12 ¼ x 10 in.)
84.XM.956.577
MARKS & INSCRIPTIONS: (Recto, mount)
signed at l. right, in ink, by Evans,
Walker Evans; at l. right, Evans stamp
I; at l. right, in pencil, *202/10* [under-
lined] *192*; at right next to print, in
pencil, *81.5*; (verso, mount) at center,
Evans stamp I; at l. center, in pencil,
16 [circled]/*5 ½ WIDE/1 ¼″ HEAD*;
at l. left, in pencil, Crane no. *L71.16
(Evans)*.
REFERENCES: MAC, p. 31.

622
[*Subway Portrait*], 1938–41
Image: 15.8 x 14 cm (6 ¼ x 5 ½ in.);
original mount: 17.7 x 14.4 cm
(6 ¹⁵/₁₆ x 5 ¹¹/₁₆ in.)
84.XM.956.763
MARKS & INSCRIPTIONS: (Verso, mount) at
l. center, Evans stamp A; at u. center,
in pencil, *2/2* [with 3 written over] *8*;
(recto, mat) at l. left, in pencil, Crane
no. *L70.51(Evans)*.
REFERENCES: MAC, p. 31 (variant).

623
[*Subway Portrait*], 1938–41
10 x 6.5 cm (3 ¹⁵/₁₆ x 2 ⁹/₁₆ in.)
84.XM.956.721
MARKS & INSCRIPTIONS: (Verso) at l. left,
in pencil, Crane no. *L70.14(Evans)*.

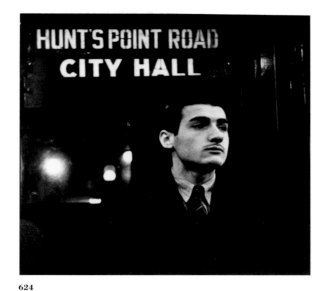

624

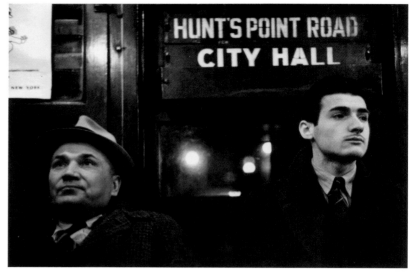

625

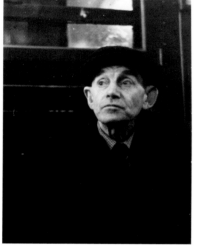

628

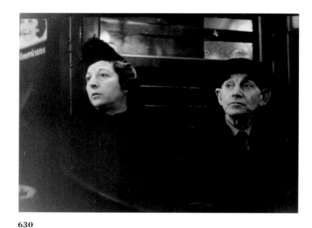

630

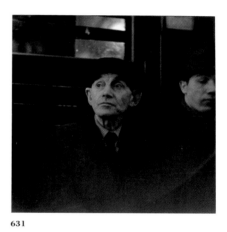

631

624
[*Subway Portrait*], 1941; printed
ca. 1955–65
Image: 15.7 x 17 cm (6 ¼ x 6 ¾ in.);
original mount: 31 x 25.5 cm
(12 ¼ x 10 ¹/₁₆ in.)
84.XM.956.578
MARKS & INSCRIPTIONS: (Recto, mount)
signed below print, in ink, by Evans,
Walker Evans; at l. right, Evans stamp
I; at l. margin, in pencil, *193/12*
[underlined]/*181*; (verso, mount) at
center, Evans stamp I; at l. center, in
pencil, *17* [circled]/*5 ½ WIDE/1 ½″
HEAD*; at l. left, in pencil, Crane

no. *L71.17(Evans)*.
REFERENCES: MAC, p. 33.

625
[*Subway Portrait*], 1941
Image: 12 x 17.6 cm (4 ¾ x 6 ¹⁵/₁₆ in.);
original mount: 28.8 x 21.3 cm
(11 ⅜ x 8 ⁷/₁₆ in.)
84.XM.956.776
MARKS & INSCRIPTIONS: (Recto, mount)
signed at l. right below print, in pen-
cil, by Evans, *Walker Evans*; (verso,
mount) at center, Evans stamp I;
at u. left, in pencil, MoMA loan
no. *66.1135*; at center, Crane stamp;

(recto, mat) at l. left, in pencil, Crane
no. *L70.93(Evans)*.
REFERENCES: MAC, p. 33 (variant).

626
[*Subway Portrait*], 1941
Image: 18.6 x 15.6 cm
(7 ¹¹/₃₂ x 6 ⁵/₃₂ in.); original mount:
28.5 x 24.6 cm (11 ³/₁₆ x 9 ¹¹/₁₆ in.)
84.XM.956.707
MARKS & INSCRIPTIONS: (Recto, mount)
signed at l. right, in pencil, by Evans,
Walker Evans; (verso, mount) at center,
Evans stamp I; at l. center, in ink, by
Evans, *1-26 #24a*; at l. left, in pencil,
Crane no. *L70.30(Evans)*.

627
[*Subway Portrait*], 1941
Image: 12.8 x 12 cm (5 ¹/₃₂ x 4 ²³/₃₂ in.);
original mount: 38.9 x 21.5 cm
(11 ⅜ x 8 ¹⁵/₃₂ in.)
84.XM.956.671
MARKS & INSCRIPTIONS: (Recto, mount)
signed at l. right below print, in pen-
cil, by Evans, *Walker Evans*; (verso,
mount) at center, Evans stamp I; at
l. left, in pencil, Crane no. *L70.37
(Evans)*.

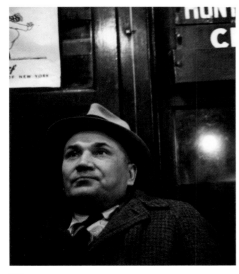

626

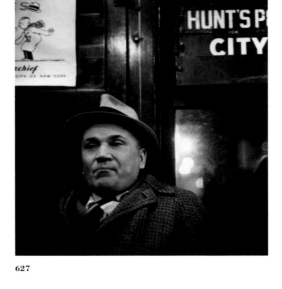

627

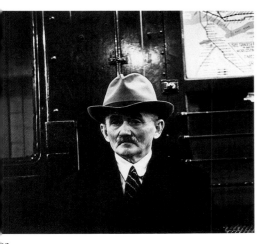

2

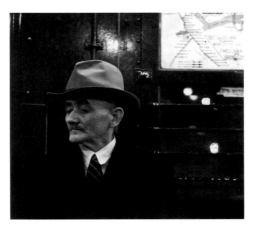

634

628
[*Subway Portrait*], 1938–41; printed
ca. 1955–65
Image: 16.3 x 12 cm (6 ½ x 4 ¾ in.);
original mount: 32 x 25.5 cm
(12 ⅝ x 10 in.)
84.XM.956.579
MARKS & INSCRIPTIONS: (Recto, mount)
signed at right below print, in ink, by
Evans, *Walker Evans*; at l. right, Evans
stamp I; at l. right, in pencil, *193/12*
[underlined]/*181*; (verso, mount) at
center, Evans stamp I; at l. center, in
pencil, *18* [circled]/*SAME SIZE/1"*

HEAD; at l. left, in pencil, Crane
no. *L71.18(Evans)*.
REFERENCES: MAC, p. 35.

629
[*Subway Portrait*], 1938–41
Image: 14.8 x 9.7 cm
(5 ¹³⁄₁₆ x 3 ¹³⁄₁₆ in.); original mount:
15.9 x 10.5 cm (6 ¼ x 4 ⅛ in.)
84.XM.956.711
MARKS & INSCRIPTIONS: (Verso, mount) at
l. right, Evans stamp A [sideways];
at center, in pencil, *2/38* (over *28*)
and Crane no. *L70.121(Evans)*.

REFERENCES: MAC, p. 35 (variant).
NOTE: Not illustrated; variant of
no. 628.

630
[*Subway Portrait*], 1938–41
18.1 x 24.3 cm (7 ⅛ x 9 ⁹⁄₁₆ in.)
84.XM.956.651
MARKS & INSCRIPTIONS: (Verso) at right
of center, Evans stamp A; at l. left, in
pencil, Crane no. *L70.123(Evans)*.
REFERENCES: MAC, p. 35 (variant).

631
[*Subway Portrait*], 1938–41
Image: 12.7 x 12.6 cm (5 x 5 in.); sheet:
15.6 x 12.7 cm (6 ⅛ x 5 in.)
84.XM.956.746
MARKS & INSCRIPTIONS: (Verso) at l. center, Evans stamp A; at l. center, in
pencil, *W5/4 1/2 s* [inverted] (recto,
mat) at l. left, in pencil, Crane
no. *L70.53(Evans)*.
REFERENCES: MAC, p. 35 (variant).

632
[*Subway Portrait*], 1938–41; printed
ca. 1955–65
Image: 16 x 18 cm (6 ⅜ x 7 ⅛ in.); original mount: 31.8 x 25.5 cm
(12 ½ x 10 ¹⁄₁₆ in.)
84.XM.956.580
MARKS & INSCRIPTIONS: (Recto, mount)
signed at right below print, in ink, by
Evans, *Walker Evans*; at l. right, Evans
stamp I; at l. right, in pencil, *186/12*
[underlined]/*174*; (verso, mount) at
center, Evans stamp H; at l. center, in
pencil, *19* [circled]/*¼ OFF/1 ¾" HEAD*;
at l. left, in pencil, Crane no. *L71.19*
(Evans).
REFERENCES: "Rapid Transit: Eight
Photographs," i.e. *The Cambridge
Review*, Mar. 1956, p. 21 (variant);
MAC, p. 37; WEAW, p. 159 (variant,
bottom image).

633
[*Subway Portrait*], 1938–41
Image: 12.1 x 14.1 cm (4 ¾ x 5 ⁹⁄₁₆ in.);
original mount: 33.2 x 24.3 cm
(13 ½ x 10 in.)
84.XM.956.759
MARKS & INSCRIPTIONS: (Recto, mount)
signed at right below print, in pencil,
by Evans, *Walker Evans*; (verso,
mount) at center, Evans stamp I; at
center, in pencil, *1* [underlined twice]/
36; at l. left, in pencil, *S*; (recto, mat)
at l. right, in pencil, *189*; at l. left, in
pencil, Crane no. *L70.111(Evans)*.
REFERENCES: "Walker Evans: The
Unposed Portrait," *Harper's Bazaar*,
Mar. 1962, p. 124 (variant); MAC, p. 37
(variant); WEAW, p. 159 (variant, bottom image).
NOTE: Not illustrated; variant of
no. 632.

634
[*Subway Portrait*], 1938–41
Image: 11.4 x 12.5 cm (4 ½ x 4 ¹⁵⁄₁₆ in.);
original mount: 34.2 x 25.3 cm
(13 ½ x 9 ³¹⁄₃₂ in.)
84.XM.956.702
MARKS & INSCRIPTIONS: (Recto, mount)
signed at l. right, in pencil, by Evans,
Walker Evans; (verso, mount) at center,
Evans stamp I; at l. right, in pencil,
N.Y. Subway/1939–40; at l. left, in pencil, *S*; at center, Crane stamp; at l. left,
in pencil, Crane no. *L70.19(Evans)*.

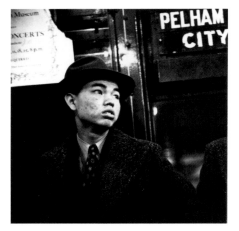

635

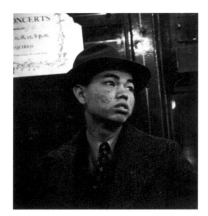

636

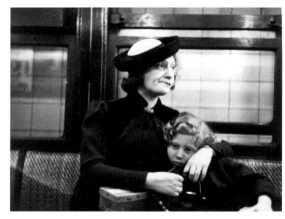

637

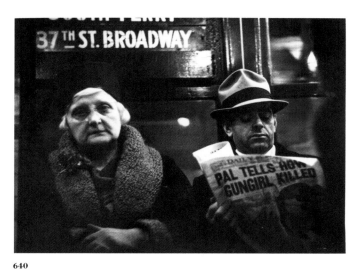

640

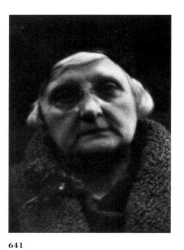

641

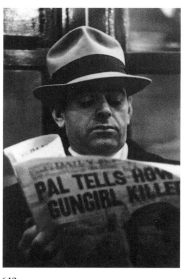

642

635
[*Subway Portrait*], 1941; printed
ca. 1955–65
Image: 16.7 x 16.3 cm (6 ⅝ x 6 ⁷⁄₁₆ in.);
original mount: 31.7 x 25.5 cm
(12 ½ x 10 ¹⁄₁₆ in.)
84.XM.956.581
MARKS & INSCRIPTIONS: (Recto, mount)
signed at right below print, in ink, by
Evans, *Walker Evans*; at l. right, Evans
stamp I; at l. right, in pencil, *181/11*
[underlined]/*170*; (verso, mount) at
center, Evans stamp I; at l. center, in
pencil, *20* [circled] *5 ½" WIDE/1 ¼"*

HEAD and *15% ± OFF*; at l. left, in pen-
cil, Crane no. *L71.20(Evans)*.
REFERENCES: "Rapid Transit: Eight
Photographs," *i.e. The Cambridge
Review*, Mar. 1956, p. 21 (variant);
MAC, p. 39.

636
[*Subway Portrait*], 1941
Image: 17.6 x 16 cm (6 ¹⁵⁄₁₆ x 6 ¼ in.);
original mount: 33 x 24.8 cm
(13 x 9 ¾ in.) [laid into 1966 MoMA win-
dow mat]
84.XM.956.778

MARKS & INSCRIPTIONS: (Recto, mount)
at right, in pencil, *4*; (verso, mount) at
center right, Evans stamp I; at l. cen-
ter, in pencil, *36*; at u. right, in pencil,
MoMA loan no. *66.1128*; at l. left,
Crane no. *L70.81(Evans)*.
REFERENCES: "Rapid Transit: Eight
Photographs," *i.e. The Cambridge
Review*, Mar. 1956, p. 21 (variant);
MAC, p. 39 (variant).
EXHIBITIONS: *Walker Evans' Subway*,
Museum of Modern Art, New York,
Oct. 5–Dec. 11, 1966.

637
[*Subway Portrait*], 1938–41; printed
ca. 1965
Image: 20.1 x 25.5 cm (8 x 10 ¹⁄₁₆ in.);
sheet: 35.2 x 28 cm (13 ⅞ x 11 ¹⁄₁₆ in.)
[mounted to second sheet]
84.XM.956.582
MARKS & INSCRIPTIONS: (Recto) signed at
l. right below image, in ink, by Evans,
Walker Evans; at l. center, Evans
stamp I; at l. right, in pencil, *194/13*
[underlined]/*181*; (verso, mount) at
center, Evans stamp I; at l. center, in
pencil, *21* [circled] *40% OFF/1 ½"*

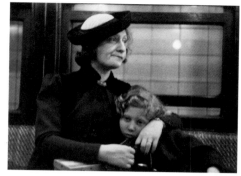

638

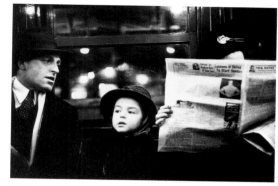

639

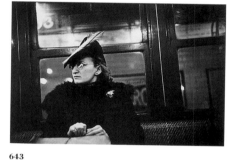

643

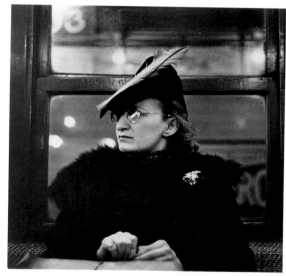

644

HEAD; at l. left, in pencil, Crane
no. *L71.21(Evans)*.
REFERENCES: MAC, p. 41; LUNN, p. 11
(variant); WEAW, p. 157 (variant, bottom left image).

638
[*Subway Portrait*], 1938–41
Image: 11 x 14.5 cm (4 �5/16 x 5 ¹¹/16 in.);
original mount: 28.7 x 21.4 cm
(11 ⁵/16 x 8 ⁷/16 in.)
84.XM.956.774
MARKS & INSCRIPTIONS: (Recto, mount)
signed at l. right below print, in pencil, by Evans, *Walker Evans*; (verso, mount) at center, Evans stamp I; at

center, Crane stamp; (recto, mat) at
l. right, in pencil, *204*; at l. left, in
pencil, Crane no. *L70.106(Evans)*.
REFERENCES: MAC, p. 41 (variant);
WEAW, p. 157 (bottom left image).

639
[*Subway Portrait*], 1938–41; printed
ca. 1965
Image: 17.5 x 25.6 cm
(6 ¹⁵/16 x 10 ⅛ in.); sheet: 35.3 x 28 cm
(14 x 11 ¹/16 in.) [mounted to second
sheet]
84.XM.956.583

640
[*Subway Portrait*], February 15, 1938;
printed ca. 1965
Image: 19 x 25.5 cm (7 ½ x 10 ¹/16 in.);

MARKS & INSCRIPTIONS: (Recto) signed at
l. right below image, in ink, by Evans,
Walker Evans; at l. center, in pencil,
179/12 [underlined]/*167*; (verso,
mount) at center, Evans stamp I; at
l. center, in pencil, *22* [circled]/*40%
OFF/1 ½" HEAD*; at l. left, in pencil,
Crane no. *L71.22(Evans)*.
REFERENCES: MAC, p. 43; WEAW, p. 158
(variant, center left image).

sheet: 35.3 x 28 cm (14 x 11 in.)
[mounted to second sheet]
84.XM.956.584
MARKS & INSCRIPTIONS: (Recto) signed at
right below image, in ink, by Evans,
Walker Evans; at l. right, Evans stamp
I; at l. right, in pencil, *171/12* [underlined] *159*; (verso, mount) at center,
Evans stamp I; at l. center, in pencil,
23 [circled]/*40% OFF/2" HEAD*; at
l. left, in pencil, Crane no. *L71.23
(Evans)*.
REFERENCES: MAC, p. 45 (variant).

641
[*Subway Portrait*], 1938
6.9 x 5 cm (2 ¾ x 1 ¹⁵/16 in.)
84.XM.956.723
MARKS & INSCRIPTIONS: (Verso) at u. center, Evans stamp A; at l. left, in pencil,
Crane no. *L70.4 (Evans)*.
REFERENCES: MAC, p. 45 (variant).

642
[*Subway Portrait*], 1938
9.9 x 6.4 cm (3 ⅞ x 2 ½ in.)
84.XM.956.744
MARKS & INSCRIPTIONS: (Verso) at center,
Evans stamp A; (recto, mat) at l. right,
in pencil, *209, 210, 211*; at l. left, in
pencil, Crane nos. *L70.54-56(Evans)*.
REFERENCES: MAC, p. 45 (variant).

643
[*Subway Portrait*], 1941; printed
ca. 1965
Image: 17.5 x 25.5 cm
(6 ¹⁵/16 x 10 ¹/16 in.); sheet:
35.5 x 27.9 cm (14 x 11 in.) [mounted
to second sheet]
84.XM.956.585
MARKS & INSCRIPTIONS: (Recto) signed at
right below image, in ink, by Evans,
Walker Evans; at l. right, Evans stamp
I; at l. center, in pencil, *192/12* [underlined]/*180*; (verso, mount) at center,
Evans stamp I; at l. center, in pencil,
24 [circled] *40% OFF/2" HEAD*; at
l. left, in pencil, Crane no. *L71.24
(Evans)*.
REFERENCES: MAC, p. 47.

644
[*Subway Portrait*], 1941
Image: 12.2 x 12.2 cm
(4 ¹³/16 x 4 ¹³/16 in.); original mount:
28.8 x 21.3 cm (11 ⅜ x 8 ⅜ in.)
84.XM.956.760
MARKS & INSCRIPTIONS: (Recto, mount)
signed at right below print, in pencil,
by Evans, *Walker Evans*; (verso,
mount) at center, Evans stamp I; at
center, in ink, by Evans, *1-17 #22*;

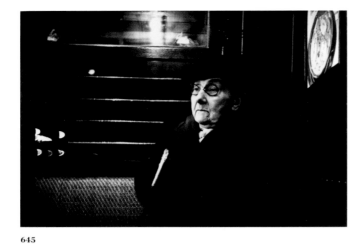

645

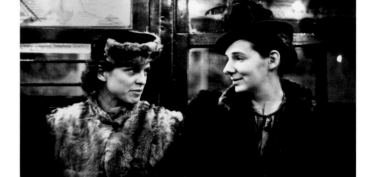

646

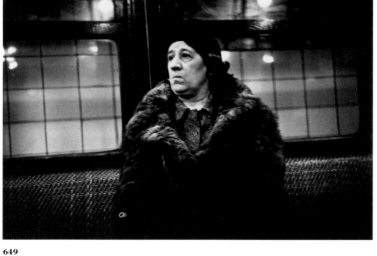

649

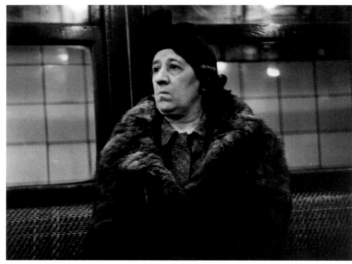

650

at center, Crane stamp; (recto, mat) at l. center, on torn white paper taped to mat, in pencil, *1939-40/N.Y. Subway*; at l. right, in pencil, *192*; at l. left, in pencil, Crane no. *L70.112(Evans)*.
REFERENCES: MAC, p. 47 (variant).

645
[*Subway Portrait*], 1938; printed ca. 1965
Image: 17.5 x 25.5 cm
(6 ¹⁵⁄₁₆ x 10 ¹⁄₁₆ in.); sheet: 35.3 x 28 cm
(13 ¹⁵⁄₁₆ x 11 in.) [mounted to second sheet]
84.XM.956.586

MARKS & INSCRIPTIONS: (Recto) signed at right below image, in ink, by Evans, *Walker Evans*; at l. right, Evans stamp I; at l. center, in pencil, *184/12* [underlined]/*172*; (verso, mount) at center, Evans stamp I; at l. center, in pencil, *25* [circled]/*40% OFF/2″ HEAD*; at l. left, in pencil, Crane no. *L71.25(Evans)*.
REFERENCES: MAC, p. 49; WEAW, p. 156 (variant).

646
[*Subway Portrait*], 1938–41; printed ca. 1965
Image: 17.5 x 25.5 cm
(6 ¹⁵⁄₁₆ x 10 ¹⁄₁₆ in.); sheet: 35.4 x 28 cm
(14 x 11 ¹⁄₁₆ in.) [mounted to second sheet]
84.XM.956.587
MARKS & INSCRIPTIONS: (Recto) signed at right below image, in ink, by Evans, *Walker Evans*; at l. right, Evans stamp I; at l. right, in pencil, *180/12* [underlined]/*168*; (verso, mount) at center, Evans stamp I; at l. center, in pencil, *26* [circled] *40% OFF/2″*

HEAD; at l. left, in pencil, Crane no. *L71.26(Evans)*.
REFERENCES: MAC, p. 51.

647
[*Subway Portrait*], 1938–41
7 x 5 cm (2 ¾ x 1 ¹⁵⁄₁₆ in.)
84.XM.956.734
MARKS & INSCRIPTIONS: (Verso) at u. center, Evans stamp A; at l. left, in pencil, Crane no. *L70.99(Evans)*.
REFERENCES: MAC, p. 51 (variant).

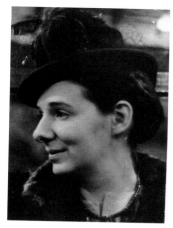

647

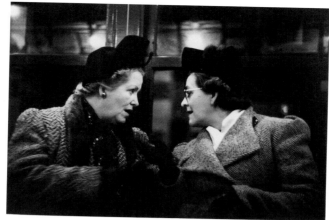

648

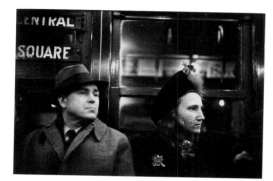

651

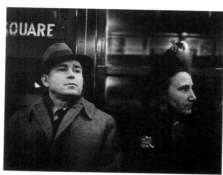

652

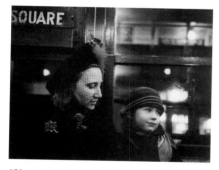

653

648
[*Subway Portrait*], 1938–41; printed
ca. 1965
Image: 17.5 x 25.5 cm (6 ¹⁵⁄₁₆ x 10 in.);
sheet: 35.3 x 28 cm (13 ¹⁵⁄₁₆ x 11 in.)
[mounted to second sheet]
84.XM.956.588
MARKS & INSCRIPTIONS: (Recto) signed at
l. right below image, in ink, by Evans,
Walker Evans; at l. right, Evans stamp
I; at l. center, in pencil, *164/12* [under-
lined]/*152*; (verso, mount) at center,
Evans stamp I; at l. center, in pencil,
27 [circled] *40% OFF/2" HEAD*; at

l. left, in pencil, Crane no. *L71.27
(Evans)*.
REFERENCES: MAC, p. 53.

649
[*Subway Portrait*], 1938–41; printed
ca. 1965
Image: 17.5 x 25.5 cm
(6 ¹⁵⁄₁₆ x 10 ⅛ in.); sheet: 35.4 x 28 cm
(14 x 11/16 in.) [mounted to second
sheet]

84.XM.956.589
MARKS & INSCRIPTIONS: (Recto) signed at
l. right, in ink, by Evans, *Walker Evans*;
at l. right, Evans stamp I; (verso,
mount) at center, Evans stamp I; at
l. center, in pencil, *36* [circled]/*40%
OFF/2" HEAD*; at l. left, in pencil,
Crane no. *L71.36(Evans)*.
REFERENCES: MAC, p. 55 (variant).

650
[*Subway Portrait*], 1938–41
Image: 11.2 x 14.6 cm (4 ⅜ x 5 ¾ in.);
original mount: 16.8 x 24.7 cm
(6 ⅝ x 9 ¾ in.)
84.XM.956.663
MARKS & INSCRIPTIONS: (Recto, mount)
signed at l. right, in pencil, by Evans,
Walker Evans; in left margin, Evans
stamp I; (verso, mount) at left,
Evans stamp I; at l. left, in pencil,
Crane no. *L70.61(Evans)*.
REFERENCES: MAC, p. 55 (variant).

651
[*Subway Portrait*], 1938–41; printed
ca. 1965
Image: 17.5 x 25.5 cm
(6 ¹⁵⁄₁₆ x 10 ¹⁄₁₆ in.); sheet: 35.3 x 28 cm
(13 ¹⁵⁄₁₆ x 11 in.) [mounted to second
sheet]
84.XM.956.590
MARKS & INSCRIPTIONS: (Recto) signed at
l. right, in ink, by Evans, *Walker Evans*;
at l. right, Evans stamp I; at l. right, in
pencil, *191/11* [underlined]/*180*;
(verso, mount) at center, Evans stamp
I; at l. center, in pencil, *29* [circled]/
40% OFF/2" HEAD; at l. left, in pencil,
Crane no. *L71.29(Evans)*.
REFERENCES: "Walker Evans: The
Unposed Portrait," *Harper's Bazaar*,
Mar. 1962, p. 121 (variant); MAC, p. 57
(variant); WEAW, p. 157 (variant,
u. left image).

652
[*Subway Portrait*], 1938–41
Image: 13 x 16.8 cm (5 ⅛ x 6 ⅝ in.);
original mount: 22.9 x 25.2 cm
(9 x 9 ¹⁵⁄₁₆ in.)
84.XM.956.680
MARKS & INSCRIPTIONS: (Recto, mount)
signed at right below print, in pencil,
by Evans, *Walker Evans*; (verso,
mount) at center, Evans stamp I; at
l. left, in pencil, Crane no. *L70.39
(Evans)*.

653
[*Subway Portrait*], 1938–41
12.2 x 15.6 cm (4 ¾ x 6 ⅛ in.)
84.XM.956.716
MARKS & INSCRIPTIONS: (Verso) at l. left,
Evans stamp A twice; at l. left, in
pencil, Crane no. *L70.15(Evans)*.

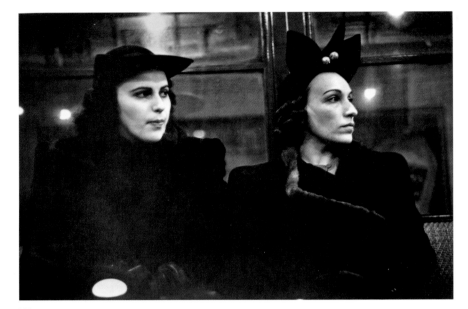

654

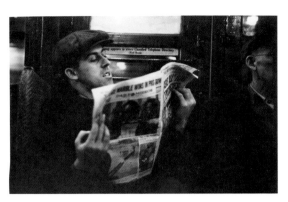

655

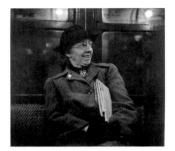

660

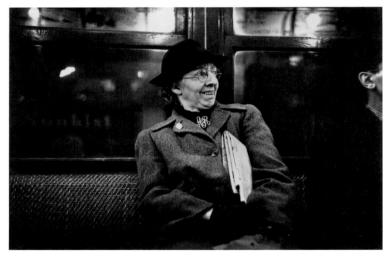

659

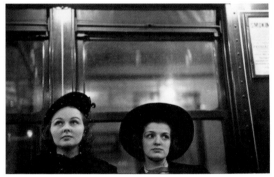

661

654
[*Subway Portrait*], 1938–41; printed
ca. 1965
Image: 17.5 x 25.5 cm
(6 ¹⁵⁄₁₆ x 10 ¹⁄₁₆ in.); sheet: 35.3 x 28 cm
(14 x 11 in.) [mounted to second sheet]
84.XM.956.591
MARKS & INSCRIPTIONS: (Recto) signed at
l. right, in ink, by Evans, *Walker Evans*;
at l. right, Evans stamp I; (verso,
mount) at center, Evans stamp I; at
l. center, in pencil, *30* [circled]/*40%
OFF/2″ HEAD*; at l. left, in pencil,
Crane no. *L71.30(Evans)*.

REFERENCES: "Walker Evans: The
Unposed Portrait," *Harper's Bazaar*,
Mar. 1962, p. 123 (variant, top image);
MAC, p. 59; WEAW, p. 158 (variant,
l. right image).

655
[*Subway Portrait*], 1938–41; printed
ca. 1965
Image: 17.5 x 25.5 cm
(6 ¹⁵⁄₁₆ x 10 ¹⁄₁₆ in.); sheet: 35.3 x 28 cm
(14 x 11 in.) [mounted to second sheet]
84.XM.956.592

MARKS & INSCRIPTIONS: (Recto) signed at
l. right, in ink, by Evans, *Walker Evans*;
at l. right, Evans stamp I; (verso,
mount), at center, Evans stamp I; at
l. center, in pencil, *31* [circled]/*40%
OFF/2″ HEAD*; at l. left, in pencil,
Crane no. *L71.31(Evans)*.
REFERENCES: MAC, p. 61.

656
[*Subway Portrait*], 1938–41
Image: 12 x 12 cm (4 ¾ x 4 ¾ in.);
original mount: 28.6 x 21.4 cm
(11 ¼ x 8 ⁷⁄₁₆ in.)
84.XM.956.758

MARKS & INSCRIPTIONS: (Recto, mount)
signed at right below print, in pencil,
by Evans, *Walker Evans*; (verso,
mount) at center, Evans stamp I; at
center, in ink, by Evans, *S-40 #17*;
(recto, mat) at l. right, in pencil, *187*;
at l. left, in pencil, Crane no. *L70.110
(Evans)*.
REFERENCES: MAC, p. 61 (variant).

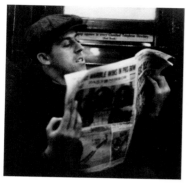

656

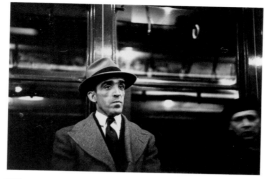

657

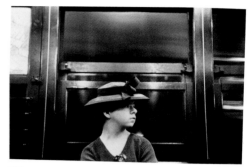

658

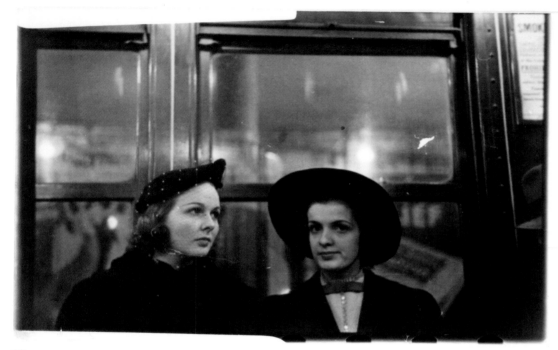

662

660
[*Subway Portrait*], 1941
Image: 13 x 13.8 cm (5 ⅛ x 5 ⁷⁄₁₆ in.);
original mount: 25.6 x 21.4 cm
(10 ¹⁄₁₆ x 8 ⁷⁄₁₆ in.) [laid into 1966 MoMA
mat]
84.XM.956.686
MARKS & INSCRIPTIONS: (Verso, mount) at
center, in ink, by Evans, *1-13 #20*;
at l. center, in pencil, *7*; at l. right, in
pencil, MoMA loan no. *66.1116*; at
l. left, in pencil, Crane no. *L70.84
(Evans)*; (recto, MoMA mat) at l. right,
in pencil, by Evans, *Walker Evans*;
(verso, mat) at l. left, in pencil,
[*MOMA?*].
REFERENCES: MAC, p. 67 (variant).
EXHIBITIONS: *Walker Evans' Subway*,
Museum of Modern Art, New York,
Oct. 5–Dec. 11, 1966.

661
[*Subway Portrait*], 1938–41; printed
ca. 1965
Image: 17.2 x 25.5 cm
(6 ¹³⁄₁₆ x 10 ⅛ in.); sheet:
35.3 x 27.9 cm (13 ¹⁵⁄₁₆ x 11 in.)
[mounted to second sheet]
84.XM.956.596
MARKS & INSCRIPTIONS: (Recto) signed at
l. right below image, in ink, by Evans,
Walker Evans; at l. right, Evans stamp
I; (verso, mount) at center, Evans
stamp I; at l. center, in pencil, *35*
[circled]/*40% OFF/2″ HEAD*; at l. left,
in pencil, Crane no. *L71.35(Evans)*.
REFERENCES: MAC, p. 69 (variant);
WEAW, pp. 152 and 156 (variants).

662
[*Subway Portrait*], 1938–41
12.7 x 20.1 cm (5 x 7 ¹⁵⁄₁₆ in.)
84.XM.956.741
MARKS & INSCRIPTIONS: (Verso) at
l. right, Evans stamp A; (recto, mat)
at l. left, in pencil, Crane no. *L70.52
(Evans)*.

657
[*Subway Portrait*], 1938–41; printed
ca. 1965
Image: 17.5 x 25.5 cm
(6 ¹⁵⁄₁₆ x 10 ¹⁄₁₆ in.); sheet: 35.3 x 28 cm
(14 x 11 in.) [mounted to second sheet]
84.XM.956.593
MARKS & INSCRIPTIONS: (Recto) signed
below print, in ink, by Evans,
Walker Evans; at l. right, Evans stamp
I; (verso, mount) at center, Evans
stamp I; at l. center, in pencil, *32*
[circled]/*40% OFF/2″ HEAD*; at l. left,
in pencil, Crane no. *L71.32(Evans)*.
REFERENCES: MAC, p. 63; WEAW, p. 153
(variant, l. left image).

658
[*Subway Portrait*], 1938–41; printed
ca. 1965
Image: 17.5 x 25.5 cm
(6 ¹⁵⁄₁₆ x 10 ⅛ in.); sheet: 35.3 x 28 cm
(14 x 11 in.) [mounted to second sheet]
84.XM.956.594
MARKS & INSCRIPTIONS: (Recto) signed at
l. right below image, in ink, by Evans,
Walker Evans; at l. right, Evans stamp
I; (verso, mount) at center, Evans
stamp I; at l. center, in pencil, *34* [cir-
cled]/*40% OFF/2″ HEAD*; at l. left, in
pencil, Crane no. *L71.33(Evans)*.
REFERENCES: MAC, p. 65.

659
[*Subway Portrait*], 1941; printed
ca. 1965
Image: 17.5 x 25.5 cm (6 ⅞ x 10 ⅛ in.);
sheet: 35.3 x 28 cm (14 x 11 in.)
[mounted to second sheet]
84.XM.956.595
MARKS & INSCRIPTIONS: (Recto) signed at
l. right, in ink, by Evans, *Walker Evans*;
at l. right, Evans stamp I; (verso,
mount) at center, Evans stamp H; at
l. center, in pencil, *34* [circled]/*40%
OFF/2″ HEAD*; at l. left, in pencil,
Crane no. *L71.34(Evans)*.
REFERENCES: MAC, p. 67 (variant).

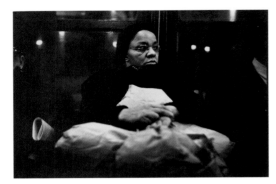

663

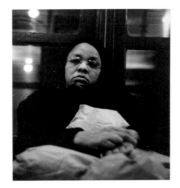

664

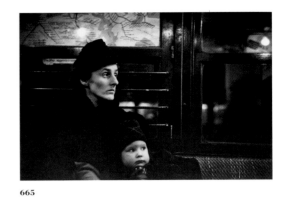

665

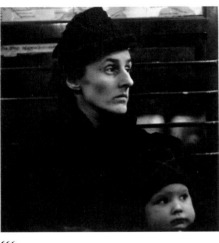

666

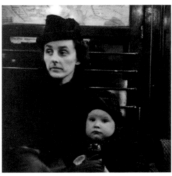

667

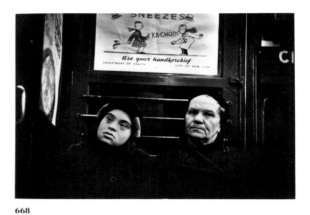

668

663
[*Subway Portrait*], 1941; printed
ca. 1965
Image: 17.5 x 25.5 cm
(6 ¹⁵/₁₆ x 10 ¹/₁₆ in.); sheet: 35.4 x 28 cm
(14 x 11 in.) [mounted to second sheet]
84.XM.956.597
MARKS & INSCRIPTIONS: (Recto) signed at
l. right below image, in ink, by Evans,
Walker Evans; at l. right, Evans stamp
I; at l. center, in pencil, *160/12* [under-
lined]*/148*; (verso, mount) at center,
Evans stamp I; at l. center,
in pencil, *28* [circled] *40% OFF/2″*

HEAD; at l. left, in pencil, Crane
no. *L71.28(Evans)*.
REFERENCES: MAC, p. 71.

664
[*Subway Portrait*], 1941
Image: 11.1 x 9.9 cm (4 ⅜ x 3 ²⁹/₃₂ in.);
original mount: 28.8 x 21.5 cm
(11 ¹¹/₃₂ x 8 ¹⁵/₃₂ in.)
84.XM.956.708
MARKS & INSCRIPTIONS: (Recto, mount)
signed at l. right, in pencil, by Evans,
Walker Evans; (verso, mount) at center,
Evans stamp I; at center, in ink, by
Evans, *1-9 #33*; at l. left, in pencil,
Crane no. *L70.42(Evans)*.

665
[*Subway Portrait*], 1941; printed
ca. 1965
Image: 17.5 x 25.5 cm
(6 ¹⁵/₁₆ x 10 ¹/₁₆ in.); sheet: 35.3 x 28 cm
(14 x 11 in.) [mounted to second sheet]
84.XM.956.598
MARKS & INSCRIPTIONS: (Recto) signed at
l. right below image, in ink, by Evans,
Walker Evans; at l. right, Evans stamp
I; at l. center, in pencil, *37* [cir-
cled]*/40% OFF/2″ HEAD*; at l. left, in
pencil, Crane no. *L71.37(Evans)*.
REFERENCES: MAC, p. 73 (variant);
WEAW, p. 159 (variant, u. left image).

666
[*Subway Portrait*], 1941
Image: 17 x 15.7 cm (6 ¹¹/₁₆ x 6 ³/₁₆ in.);
original mount: 33 x 24.8 cm
(13 x 9 ¾ in.)
84.XM.956.682
MARKS & INSCRIPTIONS: (Recto, mount)
signed at l. right, in pencil, by Evans,
Walker Evans; (verso, mount) at center,
Evans stamp I; at u. right, in pencil,
#72; at l. left, in pencil, Crane
no. *L70.25(Evans)*.
REFERENCES: MAC, p. 73 (variant);
WEAW, p. 159.

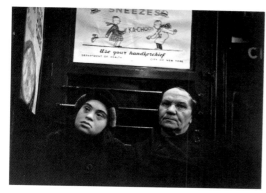

669

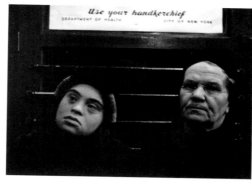

670

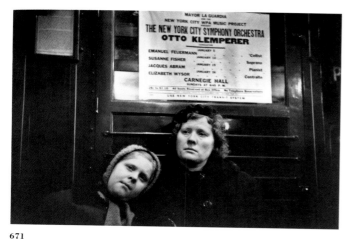

671

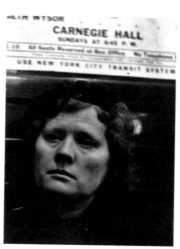

672

Walker Evans; (verso, mount) at center, Evans stamp I; at center, Crane stamp; at l. left, in pencil, *S*; at l. left, in pencil, Crane no. *L70.116(Evans)*.
REFERENCES: "Rapid Transit: Eight Photographs," *i.e. The Cambridge Review*, Mar. 1956, p. 18 (variant); MAC, p. 75 (variant); WEAW, p. 157 (variant, u. right image).

670
[*Subway Portrait*], 1941
14.5 x 20.2 cm (5 ²³⁄₃₂ x 7 ³¹⁄₃₂ in.); original mount: 31.4 x 25.5 cm
(12 ³⁄₈ x 10 ¹⁄₁₆ in.)
84.XM.956.675
MARKS & INSCRIPTIONS: (Recto, mount) signed at l. right below print, in pencil, by Evans, *Walker Evans*; (verso, mount) at center, Evans stamp I; at center, in ink, by Evans, *1-22 #10*; at center left, in pencil, *#74*; at l. left, in pencil, Crane no. *L70.46(Evans)*.
REFERENCES: "Rapid Transit: Eight Photographs," *i.e. The Cambridge Review*, Mar. 1956, p. 18 (variant); MAC, p. 75 (variant); WEAW, p. 157 (variant, u. right image).

671
[*Subway Portrait*], 1941; printed ca. 1965
Image: 17.5 x 25.5 cm
(6 ¹⁵⁄₁₆ x 10 ¹⁄₁₆ in.); sheet: 35.3 x 28 cm
(14 x 11 in.) [mounted to second sheet]
84.XM.956.600
MARKS & INSCRIPTIONS: (Recto) signed at right below image, in ink, by Evans, *Walker Evans*; at l. right, Evans stamp I; (verso, mount) at l. right, Evans stamp I; at l. right, Evans stamp I; at l. center, in pencil, *40 [circled]/40% OFF/2″ HEAD*; at l. left, in pencil, Crane no. *L71.39(Evans)*.
REFERENCES: MAC, p. 77.

672
[*Subway Portrait*], 1941
6.9 x 4.9 cm (2 ³⁄₄ x 1 ¹⁵⁄₁₆ in.) [on original mount trimmed to image]
84.XM.956.724
MARKS & INSCRIPTIONS: (Verso) at u. center, Evans stamp A; at l. left, in pencil, Crane no. *L70.5(Evans)*.
REFERENCES: MAC, p. 77 (variant).

667
[*Subway Portrait*], 1941
Image: 12.9 x 12.4 cm (5 ¹⁄₁₆ x 4 ⁷⁄₈ in.); original mount: 34.1 x 25.3 cm
(13 ½ x 10 in.)
84.XM.956.767
MARKS & INSCRIPTIONS: (Recto, mount) signed at l. right below print, in pencil, by Evans, *Walker Evans*; (verso, mount) at center, in ink, by Evans, *1-21 #28*; at center, Evans stamp I; at l. left, in pencil, *S*; (recto, mat) at l. left, in pencil, Crane no. *L70.24 (Evans)*.

668
[*Subway Portrait*], 1941; printed ca. 1965
Image: 17.5 x 25.5 cm
(6 ¹⁵⁄₁₆ x 10 ¹⁄₈ in.); sheet: 35.5 x 28.1 cm (14 x 11 ¹⁄₈ in.)
[mounted to second sheet]
84.XM.956.599
MARKS & INSCRIPTIONS: (Recto) signed at l. right below image, in ink, by Evans, *Walker Evans*; at l. right, Evans stamp I; (verso, mount) at center, Evans stamp I; at l. center, in pencil, *38 [circled]/40% OFF/2″ HEAD*; at l. left, in pencil, Crane no. *L71.38(Evans)*.

REFERENCES: "Rapid Transit: Eight Photographs," *i.e. The Cambridge Review*, Mar. 1956, p. 18 (variant); MAC, p. 75 (variant); WEAW, p. 157 (variant).

669
[*Subway Portrait*], 1941
Image: 13.1 x 17.9 cm
(5 ⁵⁄₃₂ x 7 ¹⁄₁₆ in.); original mount: 34.2 x 25.3 cm (13 ⁷⁄₁₆ x 9 ¹⁵⁄₁₆ in.)
84.XM.956.687
MARKS & INSCRIPTIONS: (Recto, mount) signed at l. right, in pencil, by Evans,

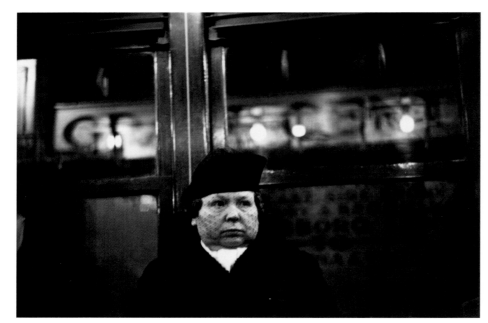

673

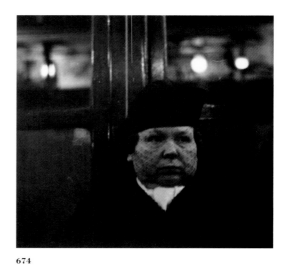

674

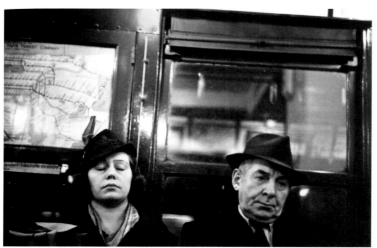

676

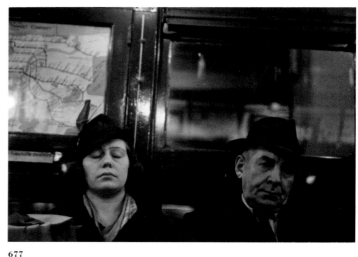

677

673
[*Subway Portrait*], 1938–41; printed
ca. 1965
Image: 17.5 x 25.5 cm
(6 ¹⁵⁄₁₆ x 10 ⅛ in.); sheet: 35.4 x 28 cm
(14 x 11 in.) [mounted to second sheet]
84.XM.956.601
MARKS & INSCRIPTIONS: (Recto) signed
at right below image, in ink, by Evans,
Walker Evans; at l. right, Evans stamp
I twice; (verso, mount) at center,
Evans stamp I; at l. center, in pencil,
40 [circled] *40% OFF/2″ HEAD*; at
l. left, in pencil, Crane no. *L71.40*
(*Evans*).

REFERENCES: MAC, p. 79; WEAW, p. 158
(variant).

674
[*Subway Portrait*], 1938–41
Image: 16.5 x 17.5 cm (6 ½ x 6 ⅞ in.);
original mount: 28.7 x 21.4 cm
(11 ⁵⁄₁₆ x 8 ¹³⁄₃₂ in.)
84.XM.956.678
MARKS & INSCRIPTIONS: (Recto, mount)
signed at l. right, in pencil, by Evans,
Walker Evans; (verso, mount) at center,
Evans stamp I; at l. center, in pencil,
"Subway Series"; at l. left, in pencil,
Crane no. *L70.80*(*Evans*).

REFERENCES: MAC, p. 79 (variant);
WEAW, p. 158 (variant).

675
[*Subway Portrait*], 1938–41; printed
ca. 1965
Image: 17.5 x 25.5 cm
(6 ¹⁵⁄₁₆ x 10 ⅛ in.); sheet: 35.4 x 28 cm
(14 x 11 in.) [mounted to second sheet]
84.XM.956.602
MARKS & INSCRIPTIONS: (Recto) signed at
right below image, in ink, by Evans,
Walker Evans; at l. right, Evans stamp
I; (verso, mount) at center, Evans
stamp I; at l. center, in pencil, *41*

[circled]/*40% OFF/2″ HEAD*; at l. left,
in pencil, Crane no. *L71.41*(*Evans*).
REFERENCES: MAC, p. 81 (variant);
WEAW, pp. 152 and 156 (variants).

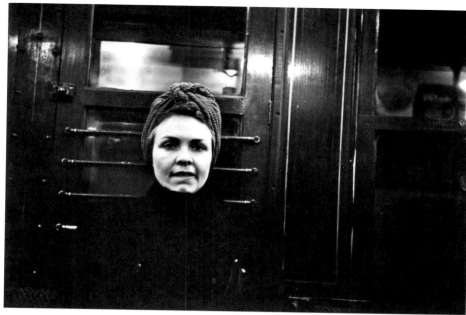

675

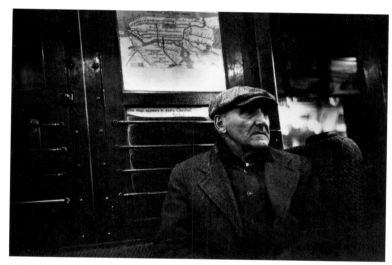

678

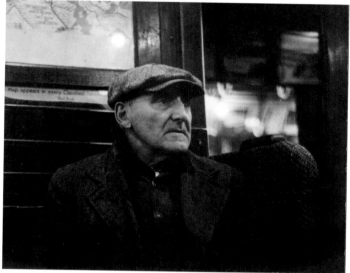

679

676
[*Subway Portrait*], 1938–41; printed
ca. 1965
Image: 17.1 x 25.5 cm
(6 ¹³⁄₁₆ x 10 ¹⁄₁₆ in.); sheet: 35.4 x 28 cm
(14 x 11 in.) [mounted to second sheet]
84.XM.956.603
MARKS & INSCRIPTIONS: (Recto) signed
at right below image, in ink, by Evans,
Walker Evans; at l. right, Evans stamp
I; (verso, mount) at center, Evans
stamp I; at l. center, in pencil, *42* [cir-
cled]/*40% OFF/2″ HEAD*; at l. left, in
pencil, Crane no. *L71.42(Evans)*.
REFERENCES: MAC, p. 83 (variant).

677
[*Subway Portrait*], 1938–41
Image: 12.3 x 17.6 cm
(4 ¹³⁄₁₆ x 6 ¹⁵⁄₁₆ in.); original mount:
28.8 x 21.4 cm (11 ⁵⁄₁₆ x 8 ⁷⁄₁₆ in.)
84.XM.956.771
MARKS & INSCRIPTIONS: (recto, mount)
signed at l. right below print, by
Evans, *Walker Evans*; (verso, mount) at
center, Evans stamp I; at u. right, in
pencil, MoMA loan no. *66.1136* (recto,
mat) at l. left, in pencil, Crane
no. *L70.97(Evans)*.
REFERENCES: MAC, p. 83 (variant).

678
[*Subway Portrait*], 1941; printed
ca. 1965
Image: 17.5 x 25.5 cm
(6 ¹⁵⁄₁₆ x 10 ¹⁄₈ in.); sheet: 35.4 x 28 cm
(14 x 11 in.) [mounted to second sheet]
84.XM.956.604
MARKS & INSCRIPTIONS: (Recto) signed at
right below image, in ink, by Evans,
Walker Evans; at l. right, Evans stamp
I; (verso, mount) at center, Evans
stamp I; at l. center, in pencil, *43* [cir-
cled]/*40% OFF/2″ HEAD*; at l. left, in
pencil, Crane no. *L71.43(Evans)*.
REFERENCES: MAC, p. 85.

679
[*Subway Portrait*], 1941
15.3 x 18.9 cm (6 ¹⁄₃₂ x 7 ⁷⁄₁₆ in.) [on
original mount trimmed to image]
84.XM.956.659
MARKS & INSCRIPTIONS: (Verso) at
l. right, Evans stamp A; at center, wet
stamp, in black ink, *JAN 13 1941*; at
center, in ink, by Evans, *1-13 #12-13*;
at l. left, in pencil, Crane no. *L70.71
(Evans)*.
REFERENCES: MAC, p. 85 (variant).

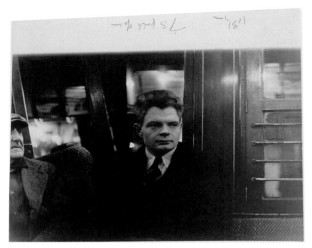

680

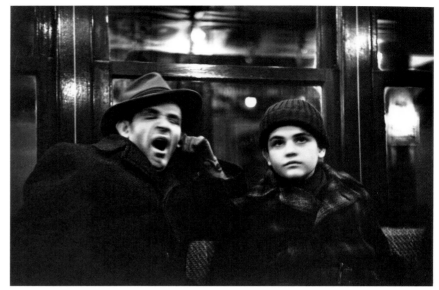

682

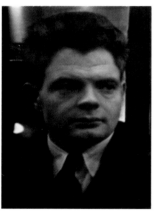

681

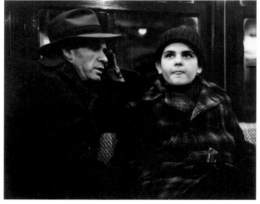

683

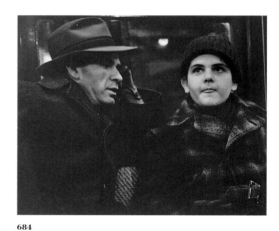

684

680
[*Subway Portrait*], 1941
Image: 13.8 x 20.3 cm (5 ⁷/₁₆ x 8 in.);
sheet: 16.5 x 20.3 cm (6 ½ x 8 in.)
84.XM.956.660
MARKS & INSCRIPTIONS: (Recto) at u. mar-
gin, in pencil, by Evans, *11 ¾*
[illegible] 7s full open [inverted];
(verso) at u. right, Evans stamp A; at
l. left, in pencil, Crane no. *L70.69*
(*Evans*).

681
[*Subway Portrait*], 1941
6.9 x 4.9 cm (2 ¾ x 1 ¹⁵/₁₆ in.) [on origi-
nal mount trimmed to image]
84.XM.956.736
MARKS & INSCRIPTIONS: (Verso, mount)
signed at l. left, in ink, by Evans,
Walker Evans [first letter cut off]; at
u. right, Evans stamp A; at l. left,
in pencil, Crane no. *L70.9*(*Evans*).

682
[*Subway Portrait*], 1941; printed
ca. 1965
Image: 17.5 x 25.5 cm
(6 ¹⁵/₁₆ x 10 ¹/₁₆ in.); sheet:
17.5 x 25.5 cm (14 x 11 in.) [mounted
to second sheet]
84.XM.956.605
MARKS & INSCRIPTIONS: (Recto) signed at
right below image, in ink, by Evans,
Walker Evans; at l. right, Evans stamp
I; (verso, mount) at center, Evans
stamp I; at l. center, in pencil, *44* [cir-
cled]/*40% OFF/2″ HEAD*; at l. left, in
pencil, Crane no. *L71.44*(*Evans*).
REFERENCES: MAC, p. 87.

683
[*Subway Portrait*], 1941
12.4 x 14.9 cm (4 ⅞ x 5 ⅞ in.) [on origi-
nal mount trimmed to image]
84.XM.956.718
MARKS & INSCRIPTIONS: (Verso, mount) at
center, Evans stamp A; at center, wet
stamp, *JAN 26 1941*; at center, in ink,
by Evans, *1-26 #17*; at l. left, in pen-
cil, Crane no. *L70.120*(*Evans*).

684
[*Subway Portrait*], 1941
18.2 x 20.9 cm (7 ⅛ x 8 ¼ in.)
84.XM.956.780

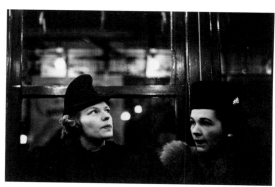

685

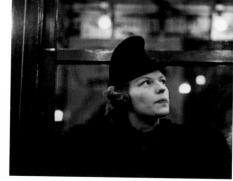

686

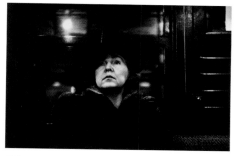

687

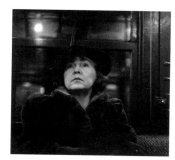

688

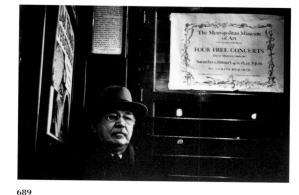

689

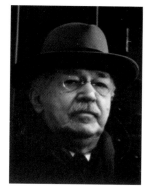

690

MARKS & INSCRIPTIONS: (Recto) signed at right below image, in ink, by Evans, *Walker Evans*; at l. right, Evans stamp I; (verso, mount) at center, Evans stamp I; at l. center, in pencil, *46* [circled]/*40% TOP/2″ HEAD*; at l. left, in pencil, Crane no. *L71.46(Evans)*.
REFERENCES: "Rapid Transit: Eight Photographs," *i.e. The Cambridge Review*, Mar. 1956, p. 20 (variant); MAC, p. 91; WEAW, p. 157 (variant, center left image).

688
[*Subway Portrait*], 1938–41
Image: 12 x 12.7 cm (4 ¾ x 5 in.); mount: 28.9 x 21.5 cm (11 ⅜ x 8 ½ in.)
84.XM.956.752
MARKS & INSCRIPTIONS: (Recto, mount) signed at right below print, in pencil, by Evans, *Walker Evans*; (verso, mount) at center, Evans stamp I; (recto, mat) at l. left, in pencil, Crane no. *L70.90(Evans)*.
REFERENCES: "Rapid Transit: Eight Photographs," *i.e. The Cambridge Review*, Mar. 1956, p. 20 (variant); MAC, p. 91 (variant); WEAW, p. 157 (center left image).

689
[*Subway Portrait*], 1941; printed ca. 1965
Image: 17.5 x 25.5 cm (6 ¹⁵/₁₆ x 10 ⅛ in.); sheet: 35.4 x 28 cm (14 x 11 in.) [mounted to second sheet]
84.XM.956.608
MARKS & INSCRIPTIONS: (Recto) signed at right below image, in ink, by Evans, *Walker Evans*; at l. right, in pencil, *188/ 14* [underlined]/*174*; (verso, mount) at center, Evans stamp I; at l. center, in ink, *#90/replace shot/on page facing 92*; at l. left, in pencil, Crane no. *L71.90 (Evans)*.
REFERENCES: MAC, p. 93.

690
[*Subway Portrait*], 1941
6.9 x 5 cm (2 ¹¹/₁₆ x 1 ¹⁵/₁₆ in.)
84.XM.956.728
MARKS & INSCRIPTIONS: (Verso) at u. center, Evans stamp A; across left edge, in pencil, Crane no. *L70.7(Evans)*.
REFERENCES: MAC, p. 93 (variant).

MARKS & INSCRIPTIONS: (Verso) at l. center, Evans stamp B; at l. left, in pencil, Crane no. *L70.77*.

685
[*Subway Portrait*], 1941; printed ca. 1965
Image: 17.2 x 25.5 cm (6 ¹³/₁₆ x 10 ¹/₁₆ in.); sheet: 35.4 x 28 cm (14 x 11 in.) [mounted to second sheet]
84.XM.956.606
MARKS & INSCRIPTIONS: (Recto) signed at right below image, in ink, by Evans, *Walker Evans*; at l. right, Evans stamp I; (verso, mount) at center, Evans

stamp I; at l. center, in pencil, *45* [circled]/*40% OFF/2″ HEAD*; at l. left, in pencil, Crane no. *L71.45(Evans)*.
REFERENCES: MAC, p. 89.

686
[*Subway Portait*], 1941
Image: 16.9 x 20.2 cm (6 ⅝ x 7 ¹⁵/₁₆ in.); original mount: 33.6 x 22.8 cm (13 ¼ x 9 in.) [laid into 1966 MoMA mat]
84.XM.956.777
MARKS & INSCRIPTIONS: (Verso) at center, in ink, by Evans, *1-26 #13*; at center, Evans stamp I; at l. center, in pencil,

25; at u. left, in pencil, MoMA loan no. *66.1126*; at l. left, in pencil, Crane no. *L70.82(Evans)*.
REFERENCES: MAC, p. 89 (variant).
EXHIBITIONS: *Walker Evans' Subway*, Museum of Modern Art, New York, Oct. 5–Dec. 11, 1966.

687
[*Subway Portrait*], 1938–41; printed ca. 1965
Image: 17.3 x 25.5 cm (6 ¹³/₁₆ x 10 ¹/₁₆ in.); sheet: 17.3 x 25.5 cm (14 x 11 in.)
84.XM.956.607

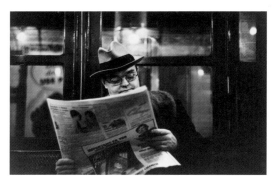
691

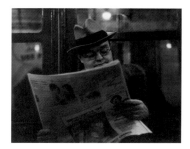
692

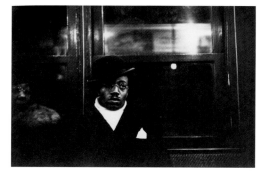
694

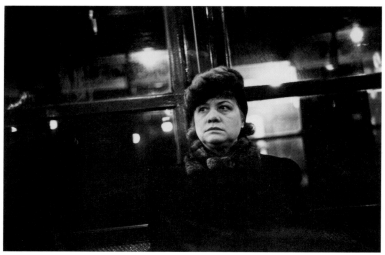
697

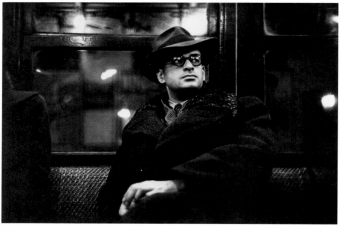
698

691
[*Subway Portrait*], 1938–41; printed
ca. 1965
Image: 17.4 x 25.6 cm (6 ⅞ x 10 ⅛ in.);
sheet: 35.4 x 28 cm (14 x 11 in.)
[mounted to second sheet]
84.XM.956.609
MARKS & INSCRIPTIONS: (Recto) signed at
right below image, in ink, by Evans,
Walker Evans; at l. right, Evans stamp
I; (verso, mount) at center, Evans
stamp I; at l. center, in pencil, *48* [cir-
cled]/*40% OFF/2″ HEAD*; at l. left, in
pencil, Crane no. *L71.48(Evans)*.
REFERENCES: MAC, p. 95 (variant).

692
[*Subway Portrait*], 1938–41
Image: 11.7 x 14.2 cm (4 ⅝ x 5 ⅝ in.);
original mount: 28.7 x 21.3 cm
(11 ⁵⁄₁₆ x 8 ⅜ in.)
84.XM.956.757
MARKS & INSCRIPTIONS: (Recto, mount)
signed at right below print, in pen-
cil, by Evans, *Walker Evans*; (verso,
mount) at center, Evans stamp I;
(recto, mat) at l. left, in pencil,
Crane no. *L70.113(Evans)*.
REFERENCES: MAC, p. 95 (variant).

693
[*Subway Portrait*], 1938–41
Image: 14.4 x 18.6 cm
(5 ¹¹⁄₁₆ x 7 ⁵⁄₁₆ in.); sheet: 15.2 x 18.6 cm
(6 x 7 ⁵⁄₁₆ in.)
84.XM.956.783
MARKS & INSCRIPTIONS: (Verso) at l. left,
Evans stamp A twice; at l. left, in pen-
cil, Crane no. *L70.74*.
REFERENCES: MAC, p. 95 (variant).
NOTE: Not illustrated; variant of
no. 692.

694
[*Subway Portrait*], 1941; printed
ca. 1965
Image: 17.5 x 25.5 cm (6 ⅞ x 10 ⅛ in.);
sheet: 35.4 x 28 cm (14 x 11 in.)
[mounted to second sheet]
84.XM.956.610
MARKS & INSCRIPTIONS: (Recto) signed at
right below image, in ink, by Evans,
Walker Evans; at l. right, Evans stamp
I; at l. right, Evans stamp I; (verso,
sheet) at center, Evans stamp I; at
l. center, in pencil, *49* [circled]/*40%
OFF/2″ HEAD*; at l. left, in pencil,
Crane no. *L71.49(Evans)*.

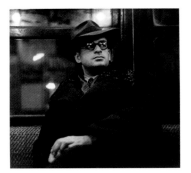

695

699

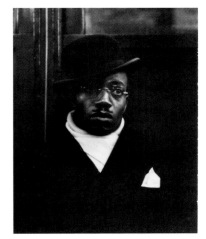

696

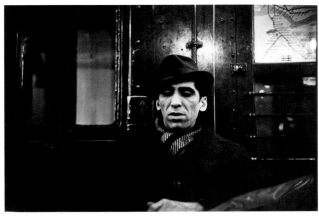

700

MARKS & INSCRIPTIONS: (Recto) signed at right below image, in ink, by Evans, *Walker Evans*; at l. right, Evans stamp I; (verso, mount) at center, Evans stamp I; at l. center, in pencil, *50* [circled]/*40% OFF/2″ HEAD*; at l. left, in pencil, Crane no. *L71.50(Evans)*.
REFERENCES: MAC, p. 99.

698
[*Subway Portrait*], 1941; printed ca. 1965
Image: 17.5 x 25.6 cm (6 ⅞ x 10 ⅟₁₆ in.); sheet: 35.4 x 28 cm (14 x 11 in.) [mounted to second sheet]
84.XM.956.612
MARKS & INSCRIPTIONS: (Recto) signed at right below image, in ink, by Evans, *Walker Evans*; at l. right, Evans stamp I; (verso, mount) at center, Evans stamp I; at l. center, in pencil, *51* [circled]/*40% OFF/2″ HEAD*; at l. left, in pencil, Crane no. *L71.51(Evans)*.
REFERENCES: MAC, p. 101.

699
[*Subway Portrait*], 1941
Image: 12.5 x 12.7 cm (4 ⅟₁₆ x 5 in.); original mount: 28.8 x 21.3 cm (11 ⁵⅟₁₆ x 8 ⅜ in.)
84.XM.956.668
MARKS & INSCRIPTIONS: (Recto, mount) signed at right below print, in pencil, by Evans, *Walker Evans*; (verso, mount) at center, Evans stamp I; at center, in ink, by Evans, *1-17 #13* [underlined]; at l. left, in pencil, Crane no. *L70.47(Evans)*.
REFERENCES: MAC, p. 101 (variant).

700
[*Subway Portrait*], 1938–41; printed ca. 1965
Image: 17.5 x 25.5 cm (6 ¹⁵⁄₁₆ x 10 ⅛ in); sheet: 35.4 x 28 cm (14 x 11 in.) [mounted to second sheet]
84.XM.956.613
MARKS & INSCRIPTIONS: (Recto) signed at right below image, in ink, by Evans, *Walker Evans*; at l. right, Evans stamp I; (verso, mount) at center, Evans stamp I; at l. center, in pencil, *52* [circled]/*40% OFF/2″ HEAD*; at l. left, in pencil, Crane no. *L71.52(Evans)*.
REFERENCES: MAC, p. 103 (variant); WEAW, p. 155 (variant, top right image).

REFERENCES: "Rapid Transit: Eight Photographs," *i.e. The Cambridge Review*, Mar. 1956, p. 17 (variant); MAC, p. 97; WEAW, p. 153 (variant, center right image).

695
[*Subway Portrait*], 1941
12 x 17.9 cm (4 ¾ x 7 ⅟₁₆ in.)
84.XM.956.653
MARKS & INSCRIPTIONS: (Verso) at center, Evans stamp B; at left edge, partial Crane stamp; at l. left, in pencil, Crane no. *L70.119(Evans)*.

REFERENCES: "Rapid Transit: Eight Photographs," *i.e. The Cambridge Review*, Mar. 1956, p. 17 (variant); MAC, p. 97 (variant); WEAW, p. 153 (variant, center right image).

696
[*Subway Portrait*], 1941
10.1 x 7.9 cm (4 x 3 ⅛ in.) [on original mount trimmed to image]
84.XM.956.743
MARKS & INSCRIPTIONS: (Verso, mount) at top, Evans stamp B; at l. center, wet stamp, in black ink, *JAN 13 1941*; at center, in ink, by Evans, *1-13 #26*;

(recto, mat) at l. left, in pencil, Crane nos. *L70.54-56(Evans)*.
REFERENCES: "Rapid Transit: Eight Photographs," *i.e. The Cambridge Review*, Mar. 1956, p. 17 (variant); MAC, p. 97 (variant); WEAW, p. 153 (center right image).

697
[*Subway Portrait*], 1938; printed ca. 1965
Image: 17.5 x 25.5 cm (6 ¹⁵⁄₁₆ x 10 ⅛ in.); sheet: 35.4 x 28 cm (14 x 11 in.) [mounted to second sheet]
84.XM.956.611

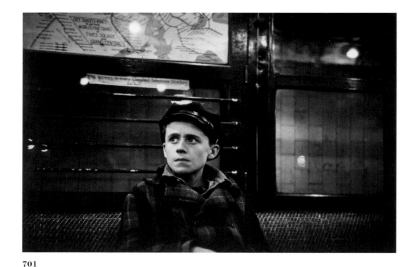

701

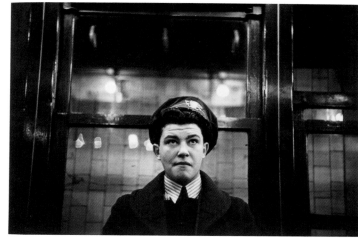

702

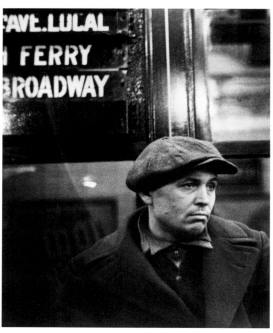

705

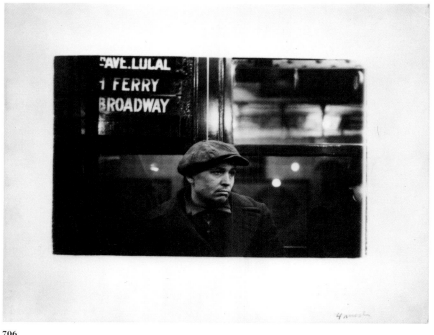

706

701
[*Subway Portrait*], 1938–41; printed
ca. 1965
Image: 17.5 x 25.5 cm (6 ⅞ x 10 ⅟₁₆ in.);
sheet: 35.4 x 28 cm (14 x 11 in.)
[mounted to second sheet]
84.XM.956.614
MARKS & INSCRIPTIONS: (Recto) signed at
right below image, in ink, by Evans,
Walker Evans; at l. right, Evans stamp
I; (verso, mount) at center, Evans
stamp I; at l. center, in pencil, *53*
[circled]/*40% OFF/2″ HEAD*; at l. left,
in pencil, Crane no. *L71.53(Evans)*.
REFERENCES: "Rapid Transit: Eight

Photographs," *i.e. The Cambridge
Review*, Mar. 1956, p. 19 (variant);
MAC, p. 105.

702
[*Subway Portrait*], 1938–41; printed
ca. 1965
Image: 17.5 x 25.5 cm
(6 ¹⁵⁄₁₆ x 10 ⅛ in.); sheet: 35.4 x 28 cm
(14 x 11 in.) [mounted to second sheet]
84.XM.956.615
MARKS & INSCRIPTIONS: (Recto) signed at
right below image, in ink, by Evans,
Walker Evans; at l. right, Evans stamp
I; (verso, mount) at center, Evans
stamp I; at l. center, in pencil, *54*

[circled]/*40% OFF/2″ HEAD*; at l. left,
in pencil, Crane no. *L71.54(Evans)*.
REFERENCES: MAC, p. 107; WEAW, p. 154
(variant, center left image).

703
[*Subway Portrait*], 1941; printed
ca. 1965
Image: 17.5 x 25.5 cm
(6 ¹⁵⁄₁₆ x 10 ⅟₁₆ in.); sheet: 35.4 x 28 cm
(14 x 11 in.) [mounted to second sheet]
84.XM.956.616
MARKS & INSCRIPTIONS: (Recto) signed at
right below image, in ink, by Evans,
Walker Evans; at l. right, Evans stamp
I; (verso, mount) at center, Evans
stamp I; at l. center, in pencil, *55*

[circled]/*40% OFF/2″ HEAD*; at l. left,
in pencil, Crane no. *L71.55(Evans)*.
REFERENCES: MAC, p. 109 (variant).

704
[*Subway Portrait*], 1941
Image: 12.7 x 11.6 cm (5 x 4 ⁹⁄₁₆ in.);
original mount: 28.9 x 21.4 cm
(11 ⅜ x 8 ⁷⁄₁₆ in.)
84.XM.956.754
MARKS & INSCRIPTIONS: (Recto, mount)
signed at right below print, in pencil,
by Evans, *Walker Evans*; (verso,
mount) at center, Evans stamp I; at
center, in ink, by Evans, *1-25 #47*;

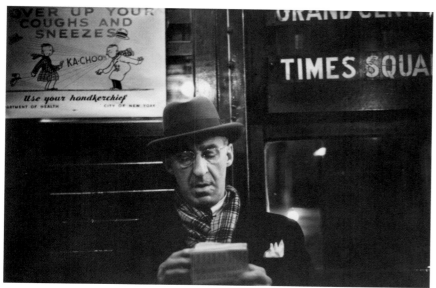

703

704

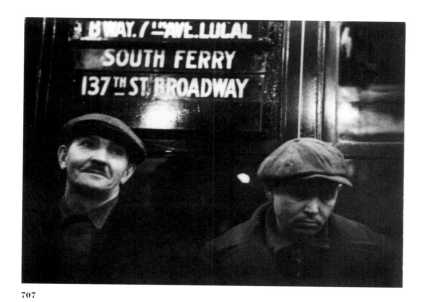

707

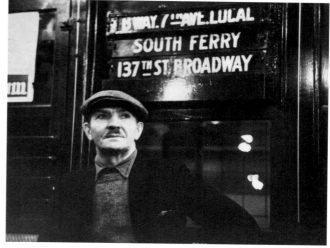

708

(recto, mat) at l. left, in pencil, Crane no. *L70.94(Evans)*.
REFERENCES: MAC, p. 109 (variant).

705
[*Subway Portrait*] 1938–41; printed ca. 1965
Image: 25.2 x 20 cm (9 ¹⁵⁄₁₆ x 7 ⅞ in.); sheet: 35.4 x 28 cm (14 x 11 in.) [mounted to second sheet]
84.XM.956.617
MARKS & INSCRIPTIONS: (Recto) signed at right below image, in ink, by Evans, *Walker Evans*; at l. right, Evans stamp I twice; (verso, mount) at center,

Evans stamp I; at l. center, in pencil, *56 [circled]/40% TOP/5/8″ HEAD*; at l. left, in pencil, Crane no. *L71.56 (Evans)*.
REFERENCES: MAC, p. 111.

706
[*Subway Portrait*], 1938–41
Image: 12.3 x 18.7 cm (4 ¹³⁄₁₆ x 7 ⅜ in.); sheet: 19.8 x 25.2 cm (7 ¹³⁄₁₆ x 9 ¹⁵⁄₁₆ in.)
84.XM.956.655
MARKS & INSCRIPTIONS: (Recto) at l. right, in pencil, by Evans, *4 mesh*; (verso) at right edge, Evans stamp A; at l. left, in pencil, Crane no. *L70.66 (Evans)*.
REFERENCES: MAC, p. 111 (variant).

707
[*Subway Portrait*], 1938–41
Image: 11.7 x 15.9 cm (4 ⅝ x 6 ¼ in.); original mount: 12.3 x 16.9 cm (4 ⅞ x 6 ⅝ in.)
84.XM.956.713
MARKS & INSCRIPTIONS: (Verso, mount) at center, Evans stamp B; at l. left, in pencil, Crane no. *L70.59(Evans)*.

708
[*Subway Portrait*], 1938–41; printed ca. 1965
Image: 17.5 x 25.5 cm (6 ¹⁵⁄₁₆ x 10 ¹⁄₁₆ in.); sheet: 35.4 x 28 cm (14 x 11 in.) [mounted to second sheet]
84.XM.956.626
MARKS & INSCRIPTIONS: (Recto) signed at right below image, in ink, by Evans, *Walker Evans*; at l. right, Evans stamp I; (verso, mount) at center, Evans stamp I; at l. center, in pencil, *65 [circled]/40% OFF/1 ½″ HEAD*; at l. left, in pencil, Crane no. *L71.65(Evans)*.
REFERENCES: MAC, p. 129 (variant).

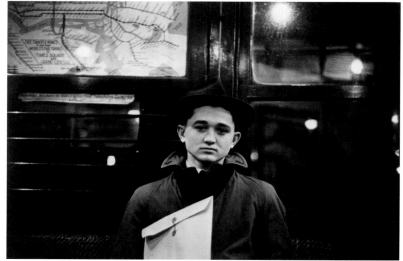

709

710

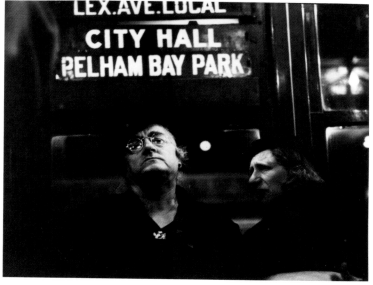

713

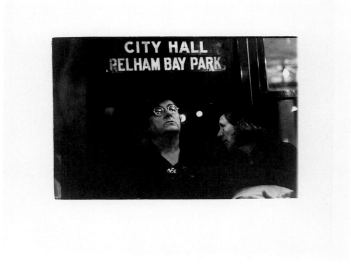

714

709
[*Subway Portrait*], 1938–41; printed
ca. 1965
Image: 25.5 x 17.5 cm
(6 15/16 x 10 1/8 in.); sheet: 35.4 x 28 cm
(14 x 11 in.) [mounted to second sheet]
84.XM.956.618
MARKS & INSCRIPTIONS: (Recto) signed at
right below image, in ink, by Evans,
Walker Evans; at l. right, Evans stamp
I; (verso, mount) at l. right, Evans
stamp I; at l. center, in pencil, *57* [cir-
cled]/*40% OFF/2″ HEAD*; at l. left, in
pencil, Crane no. *L71.57(Evans)*.
REFERENCES: MAC, p. 113 (variant).

710
[*Subway Portrait*], 1938–41
18.2 x 22.5 cm (7 1/8 x 8 7/8 in.)
84.XM.956.782
MARKS & INSCRIPTIONS: (Verso) at l. left,
in pencil, Crane no. *L70.72*.
REFERENCES: MAC, p. 113 (variant).

711
[*Subway Portrait*], 1941; printed
ca. 1965
Image: 17.5 x 25.5 cm
(6 15/16 x 10 1/16 in.); sheet: 35.4 x 28 cm
(14 x 11 in.)
84.XM.956.619

MARKS & INSCRIPTIONS: (Recto) signed at
right below image, in ink, by Evans,
Walker Evans; at l. right, Evans stamp
I; (verso, mount) at center, Evans
stamp I; at l. center, in pencil, *58* [cir-
cled]/*40% OFF/2″ HEAD*; at l. left, in
pencil, Crane no. *L71.58(Evans)*.
REFERENCES: MAC, p. 115.

712
[*Subway Portrait*], 1941
Image: 12.3 x 15.2 cm (4 27/32 x 6 in.);
original mount: 28.8 x 21.4 cm
(11 5/16 x 8 7/16 in.)
84.XM.956.700

MARKS & INSCRIPTIONS: (Recto, mount)
signed at l. right, in pencil, by Evans,
Walker Evans; (verso, mount) at center,
Evans stamp I; at center, in ink, by
Evans, *1-21 #21*; at l. left, in pencil,
Crane no. *L70.34(Evans)*.
REFERENCES: MAC, p. 115 (variant).

713
[*Subway Portrait*], 1938–41; printed
ca. 1965
Image: 20 x 25.5 cm (7 15/16 x 10 1/16 in.);
sheet: 35.4 x 28 cm (14 x 11 in.)
[mounted to second sheet]
84.XM.956.620

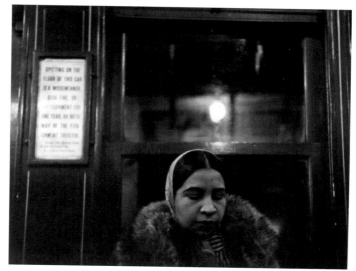

711

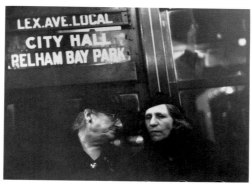

712

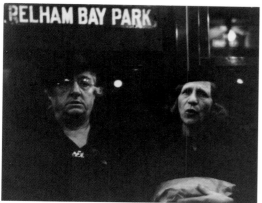

715

716

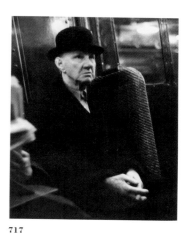

717

MARKS & INSCRIPTIONS: (Recto) signed at right below image, in ink, by Evans, *Walker Evans*; at l. right, Evans stamp I; (verso, mount) at center, Evans stamp I; at l. center, in pencil, *59* [circled]/*40% OFF/2″ HEAD*; at l. left, in pencil, Crane no. *L71.59(Evans)*.
REFERENCES: MAC, p. 117.

714
[*Subway Portrait*], 1938–41
Image: 12.5 x 18.3 cm (4 ¹⁵⁄₁₆ x 7 ³⁄₁₆ in.); sheet: 19.7 x 24.8 cm (7 ¾ x 9 ¾ in.)
84.XM.956.656

MARKS & INSCRIPTIONS: (Verso) at l. right, Evans stamp A; at center, in pencil, *83S/31/2S/WS*; at l. left, in pencil, Crane no. L70.65(Evans).

715
[*Subway Portrait*], 1938–41
12.1 x 14.9 cm (4 ¾ x 5 ⅞ in.) [on original mount trimmed to image]
84.XM.956.712
MARKS & INSCRIPTIONS: (Verso, mount) at l. right, Evans stamp A; at l. left, in pencil, Crane no. *L70.60(Evans)*.

716
[*Subway Portrait*], 1938–41; printed ca. 1965
Image: 18.9 x 25.6 cm
(7 ⁷⁄₁₆ x 10 ¹⁄₁₆ in.); sheet: 35.5 x 28 cm
(14 x 11 in.) [mounted back-to-back with no. 717]
84.XM.956.794
MARKS & INSCRIPTIONS: (Recto) at l. left, on label, in pencil, Crane no. *L85.3 (Evans)*.

717
[*Subway Portrait*], 1938–41; printed ca. 1965
Image: 25.2 x 20 cm (9 ¹⁵⁄₁₆ x 7 ⅞ in.); sheet: 35.5 x 28 cm (14 x 11 in.)
[mounted back-to-back with no. 716]
84.XM.956.793

MARKS & INSCRIPTIONS: (Recto) at l. left, on label, in pencil, Crane no. *L85.4 (Evans)*.

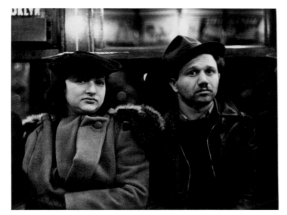

718

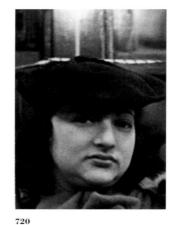

720

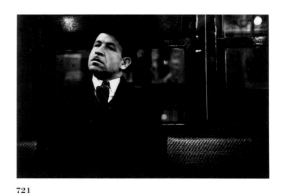

721

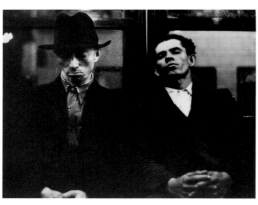

723

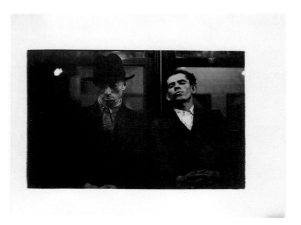

724

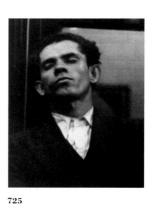

725

718
[*Subway Portrait*], 1938–41; printed
ca. 1965
Image: 20.2 x 25.5 cm (8 x 10 ¹⁄₁₆ in.);
sheet: 35.4 x 28 cm (14 x 11 in.)
[mounted to second sheet]
84.XM.956.621
MARKS & INSCRIPTIONS: (Recto) signed at
right below image, in ink, by Evans,
Walker Evans; at l. right, Evans stamp
I; (verso, mount) at center, Evans
stamp I; at l. center, in pencil, *60*
[circled]/*40% OFF/2″ HEAD*; at l. left,
in pencil, Crane no. *L71.60(Evans)*.
REFERENCES: MAC, p. 119.

719
[*Subway Portrait*], 1938–41
Image: 11.3 x 13.5 cm
(4 ⁷⁄₁₆ x 5 ⁵⁄₁₆ in.); original mount:
12.4 x 16.3 cm (4 ⅞ x 6 ⅜ in.)
84.XM.956.717
MARKS & INSCRIPTIONS: (Verso) at center,
Evans stamp A; at l. left, in pencil,
Crane no. *L70.18(Evans)*.
REFERENCES: MAC, p. 119 (variant).
NOTE: Not illustrated; variant of
no. 718.

720
[*Subway Portrait*], 1938–41
6.9 x 5 cm (2 ¹¹⁄₁₆ x 1 ¹⁵⁄₁₆ in.) [on origi-
nal mount trimmed to image]
84.XM.956.727
MARKS & INSCRIPTIONS: (Verso) at top
center, Evans stamp A; at l. left, in
pencil, Crane no. *L70.12(Evans)*.
REFERENCES: MAC, p. 119 (variant).

721
[*Subway Portrait*], 1941; printed
ca. 1965
Image: 17.5 x 25.5 cm
(6 ¹⁵⁄₁₆ x 10 ¹⁄₁₆ in.); sheet:

17.5 x 25.5 cm (14 x 11 in.) [mounted
to second sheet]
84.XM.956.622
MARKS & INSCRIPTIONS: (Recto) signed at
right below image, in ink, by Evans,
Walker Evans; at l. right, Evans stamp
I; (verso, mount) at center, Evans
stamp I; at l. center, in pencil, *61* [cir-
cled]/*40% OFF/2″ HEAD*; at l. left, in
pencil, Crane no. *L71.61(Evans)*.
REFERENCES: MAC, p. 121; WEAW, p. 155
(variant, bottom left image).

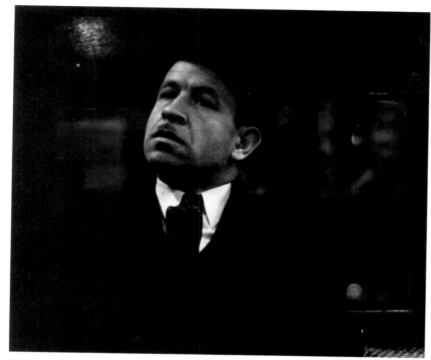

722

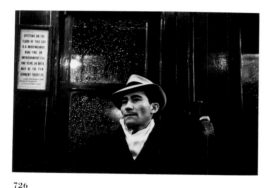

726

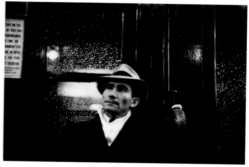

727

724
[*Subway Portrait*], 1938–41
Image: 12.7 x, 19.4 cm (5 x 7 ⅝ in.);
sheet: 19 x 24.2 cm (7 ½ x 9 ⁹⁄₁₆ in.)
84.XM.956.661
MARKS & INSCRIPTIONS: (Verso) at center,
in pencil, *832/2+2+3/W5*; at l. left,
in pencil, Crane no. *L70.68(Evans)*.
REFERENCES: "Walker Evans: The
Unposed Portrait," *Harper's Bazaar*,
Mar. 1962, p. 120 (variant); MAC,
p. 123 (variant); WEAW, p. 158 (variant,
bottom left image).

725
[*Subway Portrait*], 1938–41
10.3 x 8 cm (4 ¹⁄₁₆ x 3 ⅛ in.) [on origi-
nal mount trimmed to image]
84.XM.956.748
MARKS & INSCRIPTIONS: (Verso) at u. cen-
ter, Evans stamp A.
REFERENCES: "Walker Evans: The
Unposed Portrait," *Harper's Bazaar*,
Mar. 1962, p. 120 (variant); MAC,
p. 123 (variant); WEAW, p. 158 (variant,
bottom left image).

726
[*Subway Portrait*], 1938–41; printed
ca. 1965
Image: 17.5 x 25.5 cm
(6 ¹⁵⁄₁₆ x 10 ¹⁄₁₆ in.); sheet: 35.4 x 28 cm
(14 x 11 in.) [mounted to second sheet]
84.XM.956.624
MARKS & INSCRIPTIONS: (Recto) signed at
right below image, in ink, by Evans,
Walker Evans; at l. right, Evans stamp
I; (verso, mount) at center, Evans
stamp I; at l. center, in pencil, *63*
[circled]/*40% OFF/2″ HEAD*; at l. left,
in pencil, Crane no. *L71.63(Evans)*.
REFERENCES: MAC, p. 125; WEAW, p. 155
(variant, center right image).

727
[*Subway Portrait*], 1938–41; printed
ca. 1965
Image: 17.5 x 25.6 cm (6 ⅞ x 10 ¹⁄₁₆ in.);
sheet: 35.4 x 28 cm (13 ¹⁵⁄₁₆ x 11 in.)
[mounted to second sheet]
84.XM.956.787
MARKS & INSCRIPTIONS: (Recto) signed at
l. right below image, in ink, by Evans,
Walker Evans; at l. right, Evans stamp
I; (verso, mount) at center, Evans
stamp I; at center, in pencil, *47* [cir-
cled]/*40% off/2″ HEAD*; at l. left, in
pencil, Crane no. *L71.42(Evans)*.

722
[*Subway Portrait*], 1941
Image: 17.6 x 20.4 cm (6 ¹⁵⁄₁₆ x 8 in.);
original mount: 20.4 x 25.9 cm
(8 ¹⁄₁₆ x 10 ³⁄₁₆ in.) [laid into 1966
MoMA window mat]
84.XM.956.779
MARKS & INSCRIPTIONS: (Recto, mount)
at l. right, Evans stamp I; (verso,
mount) at l. center, in ink, by Evans,
1-26 #39; at center, Evans stamp I; at
l. center, in pencil, *28*; at u. right, in
pencil, MoMA loan no. *66.1111*; at
l. left, in pencil, Crane no. *L70.85
(Evans)*.

REFERENCES: MAC, p. 121 (variant);
WEAW, p. 155 (variant, bottom right
image).
EXHIBITIONS: *Walker Evans' Subway*,
Museum of Modern Art, New York,
Oct. 5–Dec. 11, 1966.

723
[*Subway Portrait*], 1938–41; printed
ca. 1965
Image: 20 x 25.5 cm
(7 ¹⁵⁄₁₆ x 10 ¹⁄₁₆ in.); sheet: 35.4 x 28 cm
(14 x 11 in.) [mounted to second sheet]
84.XM.956.623

MARKS & INSCRIPTIONS: (Recto) signed at
right below image, in ink, by Evans,
Walker Evans; at l. right, Evans stamp
I; (verso, mount) at center, Evans
stamp I; at l. center, in pencil, *62*
[circled]/*40% OFF/2″ HEAD*; at l. left,
in pencil, Crane no. *L71.62(Evans)*.
REFERENCES: "Walker Evans: The
Unposed Portrait," *Harper's Bazaar*,
Mar. 1962, p. 120 (variant); MAC,
p. 123; WEAW, p. 158 (variant, bottom
left image).

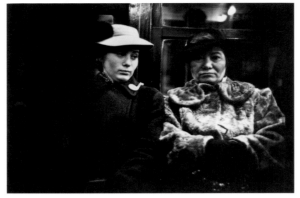

728

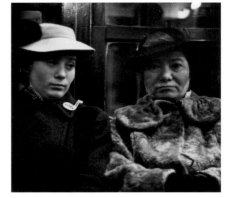

729

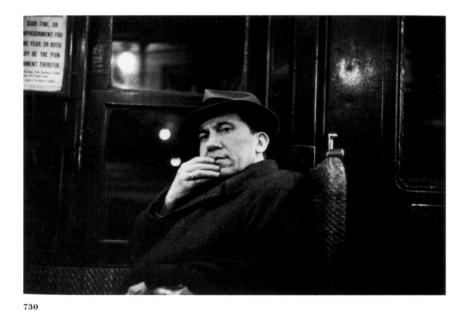

730

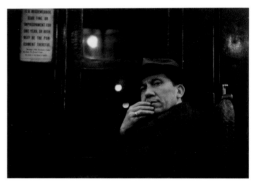

731

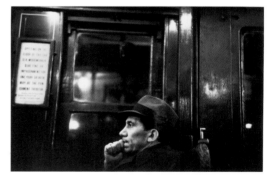

732

728
[*Subway Portrait*], 1941; printed
ca. 1965
Image: 17.5 x 25.5 cm
(6 ¹⁵/₁₆ x 10 ¹/₁₆ in.); sheet: 35.4 x 28 cm
(14 x 11 in.) [mounted to second sheet]
84.XM.956.625
MARKS & INSCRIPTIONS: (Recto) signed at
right below image, in ink, by Evans,
Walker Evans; at l. right, Evans stamp
I; (verso, mount) at center, Evans
stamp I; at l. center, in pencil, *61*
[circled]/*40% OFF/2″ HEAD*; at l. left,
in pencil, Crane no. *L71.64*(*Evans*).
REFERENCES: MAC, p. 127.

729
[*Subway Portrait*], 1941
10.2 x 10.9 cm (4 x 4 ¼ in.) [on original
mount trimmed to image]
84.XM.956.742
MARKS & INSCRIPTIONS: (Verso, mount) at
u. center, Evans stamp A; at center, in
ink, by Evans, *1-26 #19a*; at center,
wet stamp, *JAN 26 1941*; (recto, mat) at
l. left, in pencil, Crane no. *L70.90*
(*Evans*).
REFERENCES: MAC, p. 127 (variant).

730
[*Subway Portrait*], 1941; printed
ca. 1965
Image: 17.5 x 25.5 cm
(6 ¹⁵/₁₆ x 10 ¹/₁₆ in.); sheet: 35.4 x 28 cm
(14 x 11 in.)
84.XM.956.627
MARKS & INSCRIPTIONS: (Recto) signed at
right below image, in ink, by Evans,
Walker Evans; at l. right, Evans stamp
I; (verso, mount) at center, Evans
stamp I; at l. center, in pencil, *66*
[circled]/*40% OFF/2″ HEAD*; at l. left,
in pencil, Crane no. *L71.66*(*Evans*).
REFERENCES: MAC, p. 131 (variant).

731
[*Subway Portrait*], 1941
Image: 12.3 x 16.8 cm
(4 ¹³/₁₆ x 6 ⅝ in.); original mount:
28.7 x 21.3 cm (11 ⁵/₁₆ x 8 ⅜ in.)
84.XM.956.673
MARKS & INSCRIPTIONS: (Recto, mount)
signed at l. right, in pencil, by Evans,
Walker Evans; (verso, mount) at center,
Evans stamp I; at center, in ink, by
Evans, *1-25 #32*; at u. right, in pencil,
MoMA loan no. *66.1134*; at l. left, in
pencil, Crane no. *L70.44*(*Evans*).
REFERENCES: MAC, p. 131 (variant).

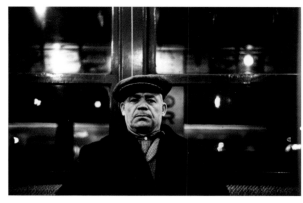

733

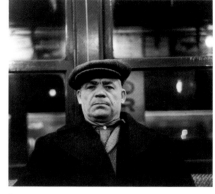

734

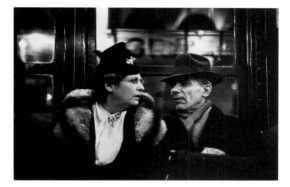

735

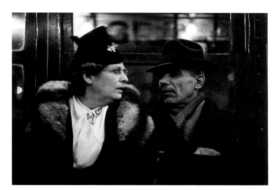

736

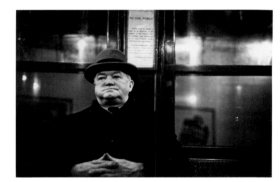

737

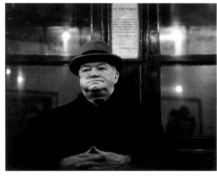

738

732
[*Subway Portrait*], 1941; printed
ca. 1965
Image: 17.5 x 25.5 cm
(6 ¹⁵/₁₆ x 10 ¹/₁₆ in.); sheet: 35.4 x 28 cm
(14 x 11 in.) [mounted to second sheet]
84.XM.956.636
MARKS & INSCRIPTIONS: (Recto) signed at
right below image, in ink, by Evans,
Walker Evans; at l. right, Evans stamp
I; (verso, mount) at center, Evans
stamp I; at l. center, in pencil, *75*
[circled]/*40% OFF/2″ HEAD*; at l. left,
in pencil, Crane no. *L71.75(Evans)*.
REFERENCES: MAC, p. 149.

733
[*Subway Portrait*], 1941; printed
ca. 1965
Image: 17.5 x 25.5 cm
(6 ¹⁵/₁₆ x 10 ¹/₁₆ in.); sheet: 35.4 x 28 cm
(14 x 11 in.) [mounted to second sheet]
84.XM.956.628
MARKS & INSCRIPTIONS: (Recto) signed at
right below image, in ink, by Evans,
Walker Evans; at l. right, Evans stamp
I; (verso, mount) at center, Evans
stamp I; at l. center, in pencil, *67*
[circled]/*40% OFF/2″ HEAD*; at l. left,
in pencil, Crane no. *L71.67(Evans)*.
REFERENCES: MAC, p. 133 (variant);
WEAW, p. 155 (variant, center left
image).

734
[*Subway Portrait*], 1941
Image: 12.6 x 12.9 cm (5 x 5 ⅛ in.):
original mount 28.9 x 21.4 cm
(11 ⅜ x 8 ⅞ in.)
84.XM.956.764
MARKS & INSCRIPTIONS: (Recto, mount)
signed below print, in pencil, by
Evans, *Walker Evans*; (verso, mount) at
center, in ink, by Evans, *1-17-7*; at cen-
ter, Evans stamp I; (recto, mat)
at l. left, in pencil, Crane no. *L70.28*
(*Evans*).
REFERENCES: MAC, p. 133 (variant);
WEAW, p. 155 (variant, center left
image).

735
[*Subway Portrait*], 1941; printed
ca. 1965
Image: 17.5 x 25.5 cm
(6 ¹⁵/₁₆ x 10 ¹/₁₆ in.); sheet: 35.4 x 28 cm
(14 x 11 in.) [mounted to second sheet]
84.XM.956.629
MARKS & INSCRIPTIONS: (Recto) signed at
right below image, in ink, by Evans,
Walker Evans; at l. right, Evans stamp
I; (verso, mount) at center, Evans
stamp I; at l. center, in pencil, *68*
[circled]/*40% OFF/2″ HEAD*; at l. left,
in pencil, Crane no. *L71.68(Evans)*.
REFERENCES: MAC, p. 135 (variant).

736
[*Subway Portrait*], 1941
Image: 11.9 x 16.9 cm
(4 ¹¹/₁₆ x 6 ²¹/₃₂ in.); original mount:
28.7 x 21.5 cm (11 ¼ x 8 ½ in.)
84.XM.956.704
MARKS & INSCRIPTIONS: (Recto, mount)
signed at l. right, in pencil, by Evans,
Walker Evans; (verso, mount) at center,
Evans stamp I; at center, in ink, by
Evans, *1-21 #12*; at u. right, in pencil,
MoMA loan no. *66.1137* at l. left, in pen-
cil, Crane no. *L70.31(Evans)*.
REFERENCES: MAC, p. 135 (variant).

737
[*Subway Portrait*], 1938–41; printed
ca. 1965
Image: 17.5 x 25.5 cm
(6 ¹⁵/₁₆ in. × 10 ¹/₁₆) sheet: 35.4 x 28 cm
(14 x 11 in.) [mounted to second sheet]
84.XM.956.630
MARKS & INSCRIPTIONS: (Recto) signed at
right below image, in ink, by Evans,
Walker Evans; at l. right, Evans stamp
I; (verso, mount) at center, Evans
stamp I; at l. center, in pencil, *69*
[circled]/*40% OFF/2″ HEAD*; at l. left,
in pencil, Crane no. *L71.69(Evans)*.
REFERENCES: "Walker Evans: The
Unposed Portrait," *Harper's Bazaar*,
Mar. 1962, p. 122 (variant, bottom
image); MAC, p. 137; WEAW, p. 154
(variant, top right image).

738
[*Subway Portrait*], 1938–41
Image: 13.1 x 16.1 cm (5 ³/₁₆ x 6 ⁵/₁₆ in.);
original mount: 28.7 x 21.4 cm
(11 ⁵/₁₆ x 8 ⁷/₁₆ in.)
84.XM.956.762
MARKS & INSCRIPTIONS: (Recto, mount)
signed at l. right below print, in pen-
cil, by Evans, *Walker Evans*; (verso,
mount) at center, Evans stamp I; at
u. center, in pencil, *#188/N.Y. Subway,
1941*; at center, in pencil, [crop marks
outlining print and with diagonal line
from u. left to l. right of periphery];

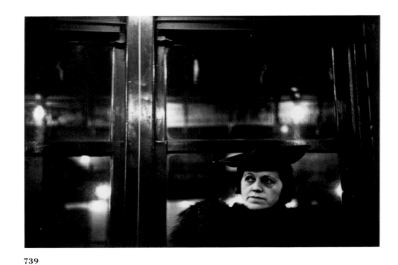

739

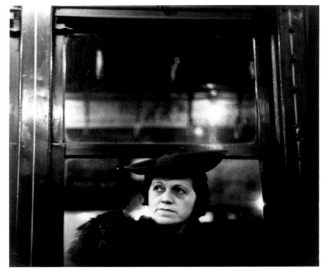

740

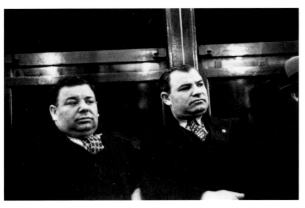

741

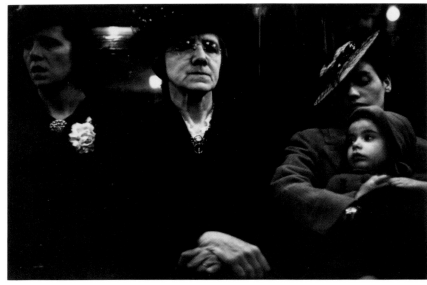

742

at center left, in ink, *CROP* [with
arrow pointing to the right]; at l. left
below crop marks, in pencil, *CUT 23*
[circled] *3 ¾″* [arrow pointing up
within a box] *HIGH*; (recto, mat) at
l. right, in pencil, *188*; at l. left, in pen-
cil, Crane no. *L70.108(Evans)*.
REFERENCES: "Walker Evans: The
Unposed Portrait," *Harper's Bazaar*,
Mar. 1962, p. 122 (variant); MAC,
p. 137 (variant); CRANE no. 185; WEAW,
p. 154 (variant, top right image).

739
[*Subway Portrait*], 1938–41; printed
ca. 1965
Image: 17.5 x 25.5 cm
(6 ¹⁵⁄₁₆ x 10 ¹⁄₁₆ in.); sheet: 35.4 x 28 cm
(14 x 11 in.) [mounted to second sheet]
84.XM.956.631
MARKS & INSCRIPTIONS: (Recto) signed at
right below image, in ink, by Evans,
Walker Evans; at l. right, Evans stamp
I; (verso, mount) at center, Evans
stamp I; at l. center, in pencil, *70*
[circled]/*40% OFF/2″ HEAD*; at l. left,
in pencil, Crane no. *L71.70(Evans)*.
REFERENCES: MAC, p. 139 (variant).

740
[*Subway Portrait*], 1938–41
Image: 13.2 x 15 cm (5 ³⁄₁₆ x 5 ¹⁵⁄₁₆ in.);
original mount: 25.4 x 20.2 cm
(10 ⅛ x 7 ¹⁵⁄₁₆ in.)
84.XM.956.665
MARKS & INSCRIPTIONS: (Verso, mount)
at l. center, Evans stamp A; at l. left,
in pencil, Crane no. *L70.63(Evans)*.
REFERENCES: MAC, p. 139 (variant).

741
[*Subway Portrait*] 1938–41; printed ca.
1965
Image: 17.5 x 25.5 cm

(6 ¹⁵⁄₁₆ x 10 ¹⁄₁₆ in.); sheet: 35.4 x 28 cm
(14 x 11 in.) [mounted to second sheet]
84.XM.956.632
MARKS & INSCRIPTIONS: (Recto) signed at
right below image, in ink, by Evans,
Walker Evans; at l. right, Evans stamp
I; (verso, sheet) at center, Evans stamp
I; at l. center, in pencil, *71* [circled]/
40% OFF/2″ HEAD; at l. left, in pencil,
Crane no. *L71.71(Evans)*.
REFERENCES: MAC, p. 141.

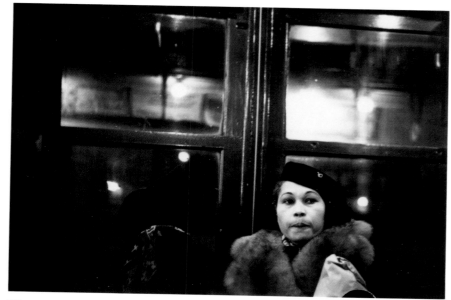

743

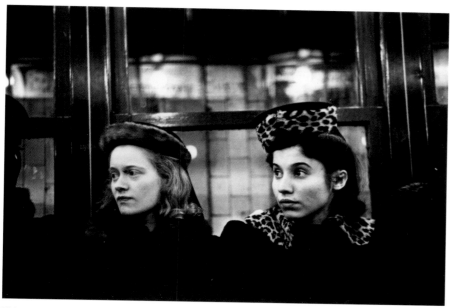

744

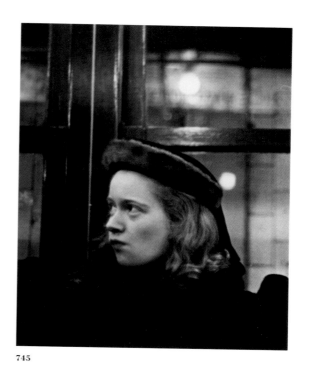

745

742
[*Subway Portrait*], 1938–41; printed ca. 1965
Image: 17.5 x 25.5 cm
(6 ¹⁵⁄₁₆ x 10 ¹⁄₁₆ in.); sheet: 35.4 x 28 cm (14 x 11 in.) [mounted to second sheet] 84.XM.956.633
MARKS & INSCRIPTIONS: (Recto) signed at right below image, in ink, by Evans, *Walker Evans*; at l. right, Evans stamp I; (verso, mount) at center, Evans stamp I; at l. center, in pencil, *72* [circled]/*40% HEAD/2″ HEAD*; at l. left, in pencil, Crane no. *L71.72(Evans)*.
REFERENCES: MAC, p. 143.

743
[*Subway Portrait*], 1938–41; printed ca. 1965
Image: 17.5 x 25.5 cm
(6 ¹⁵⁄₁₆ x 10 ¹⁄₁₆ in.); sheet: 35.4 x 28 cm (14 x 11 in.) [mounted to second sheet] 84.XM.956.634
MARKS & INSCRIPTIONS: (Recto) signed at right below image, in ink, by Evans, *Walker Evans*; at l. right, Evans stamp I; (verso, mount) at center, Evans stamp I; at l. center, in pencil, *73* [circled]/*40% OFF/2″ HEAD*; at l. left, in pencil, Crane no. *L71.73(Evans)*.
REFERENCES: MAC, p. 145.

744
[*Subway Portrait*], 1941; printed ca. 1965
Image: 17.5 x 25.5 cm
(6 ¹⁵⁄₁₆ x 10 ¹⁄₁₆ in.); sheet: 35.4 x 28 cm (14 x 11 in.) [mounted to second sheet] 84.XM.956.635
MARKS & INSCRIPTIONS: (Recto) signed at right below image, in ink, by Evans, *Walker Evans*; at l. right, Evans stamp I; (verso, mount) at center, Evans stamp I; at l. center, in pencil, *74* [circled]/*40% OFF/2″ HEAD*; at l. left, in pencil, Crane no. *L71.74(Evans)*.
REFERENCES: MAC, p. 147.

745
[*Subway Portrait*], 1941
Image: 10.9 x 8.7 cm (4 ⁹⁄₃₂ x 3 ⁷⁄₁₆ in.); original mount: 28.7 x 21.4 cm (11 ⁵⁄₁₆ x 8 ⁷⁄₁₆ in.)
84.XM.956.669
MARKS & INSCRIPTIONS: (Recto, mount) signed at l. right, in pencil, by Evans, *Walker Evans*; (verso, mount) at center, Evans stamp I; at center, in ink, by Evans, *1-26 #29*; at l. left, in pencil, Crane no. *L70.48(Evans)*.

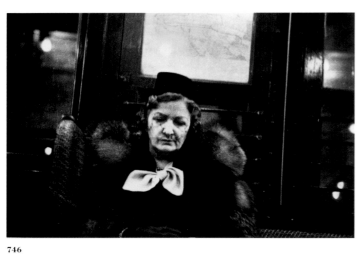

746

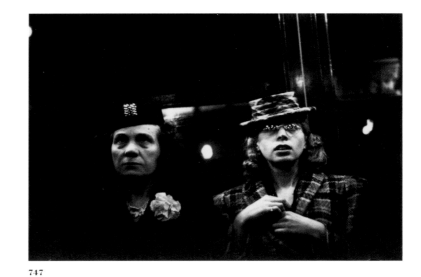

747

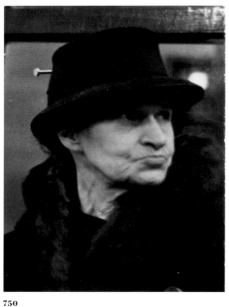

750

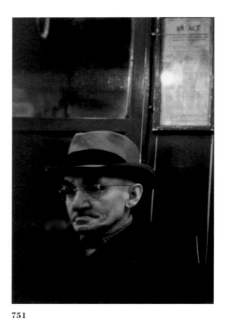

751

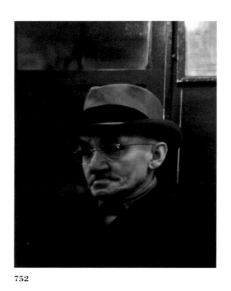

752

746
[*Subway Portrait*], 1938–41; printed
ca. 1965
Image: 17.5 x 25.5 cm
(6 ¹⁵⁄₁₆ x 10 ¹⁄₁₆ in.); sheet: 35.4 x 28 cm
(14 x 11 in.) [mounted to second sheet]
84.XM.956.637
MARKS & INSCRIPTIONS: (Recto) signed at
right below image, in ink, by Evans,
Walker Evans; at l. right, Evans stamp
I; (verso, mount) at center, Evans
stamp I; at l. center, in pencil, *76* [cir-
cled]/*40% OFF/2″ HEAD*; at l. left, in
pencil, Crane no. *L71.76(Evans)*.
REFERENCES: MAC, p. 151 (variant).

747
[*Subway Portrait*], 1938–41; printed
ca. 1965
Image: 17.5 x 25.5 cm
(6 ¹⁵⁄₁₆ x 10 ¹⁄₁₆ in.); sheet: 35.4 x 28 cm
(14 x 11 in.) [mounted to second sheet]
84.XM.956.638
MARKS & INSCRIPTIONS: (Recto) signed at
right below image, in ink, by Evans,
Walker Evans; at l. right, Evans stamp
I; (verso, mount) at center, Evans
stamp I; at l. center, in pencil, *77*
[circled]/*40% OFF/2″ HEAD*; at l. left,
in pencil, Crane no. *L71.77(Evans)*.
REFERENCES: MAC, p. 153 (variant).

748
[*Subway Portrait*], 1938–41
10.7 x 7.7 cm (4 ³⁄₁₆ x 3 in.) [on original
mount trimmed to image]
84.XM.956.720
MARKS & INSCRIPTIONS: (Verso, mount)
at l. center, partial Evans stamp A; at
l. left, in pencil, Crane no. *L70.1
(Evans)*.
REFERENCES: MAC, p. 153 (variant).

749
[*Subway Portrait*], 1938–41; printed
ca. 1965
Image: 17.5 x 25.5 cm

(6 ¹⁵⁄₁₆ x 10 ¹⁄₁₆ in.); sheet: 35.4 x 28 cm
(14 x 11 in.) [mounted to second sheet]
84.XM.956.639
MARKS & INSCRIPTIONS: (Recto) signed at
right below image, in ink, by Evans,
Walker Evans; at l. right, Evans stamp
I; (verso, mount) at center, Evans
stamp I; at l. center, in pencil, *78*
[circled]/*40% OFF/2″ HEAD*; at l. left,
in pencil, Crane no. *L71.78(Evans)*.
REFERENCES: MAC, p. 155.

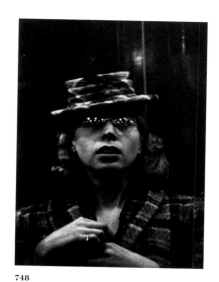

748

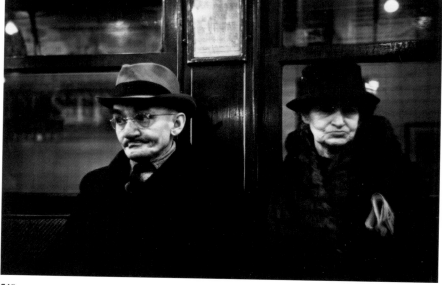

749

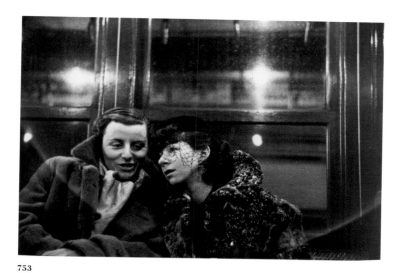

753

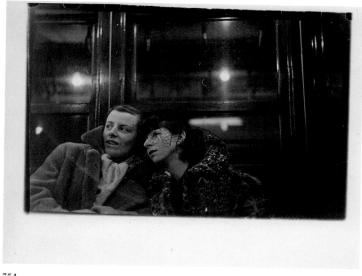

754

750
[*Subway Portrait*], 1938–41
6.9 x 5 cm (2 ¹¹⁄₁₆ x 2 in.) [on original
mount trimmed to image]
84.XM.956.725
MARKS & INSCRIPTIONS: (Verso) at center
and l. left, Evans stamp A [inverted];
at l. left, in pencil, Crane no. *L70.8*
(*Evans*).

751
[*Subway Portrait*], 1938–41
Image: 12.7 x 8.4 cm (5 x 3 ⁵⁄₁₆ in.);
original mount: 28.7 x 21.3 cm
(11 ⁵⁄₁₆ x 8 ³⁄₈ in.)

84.XM.956.689
MARKS & INSCRIPTIONS: (Recto, mount)
signed at l. right, in pencil, by Evans,
Walker Evans; (verso, mount) at center,
Evans stamp I; at l. left, in pencil,
Crane no. *L70.21* (*Evans*).

752
Subway Portrait], 1938–41
Image: 9.6 x 7.5 cm (3 ¹³⁄₁₆ x 2 ¹⁵⁄₁₆ in.);
original mount: 16.2 x 12 cm
(6 ³⁄₈ x 4 ³⁄₄ in.)
84.XM.956.710
MARKS & INSCRIPTIONS: (Recto, mount)
signed at l. right below print, in pen-

cil, by Evans, *Walker Evans*; at l. left,
Evans stamp I; (verso, mount) at left
edge, fragments of two Evans stamp I;
at l. left, in pencil, Crane no. *L70.114*
(*Evans*).

753
[*Subway Portrait*], 1938–41; printed
ca. 1965
Image: 17.5 x 25.5 cm
(6 ¹⁵⁄₁₆ x 10 ¹⁄₁₆ in.); sheet: 35.4 x 28 cm
(14 x 11 in.) [mounted to second sheet]
84.XM.956.640
MARKS & INSCRIPTIONS: (Recto) signed at
right below image, in ink, by Evans,
Walker Evans; at l. right, Evans stamp

I; (verso, mount) at center, Evans
stamp I; at l. center, in pencil, *79*
[circled]/*40% OFF/2″ HEAD*; at l. left,
in pencil, Crane no. *L71.79* (*Evans*).
REFERENCES: MAC, p. 157 (variant).

754
[*Subway Portrait*], 1938–41
Image: 14.9 x 22.1 cm
(5 ¹³⁄₁₆ x 8 ¹¹⁄₁₆ in.); sheet:
19.6 x 24.6 cm (7 ¹¹⁄₁₆ x 9 ¹¹⁄₁₆ in.)
84.XM.956.784
MARKS & INSCRIPTIONS: (Verso) at l. left,
in pencil, Crane no. *L70.75*.
REFERENCES: WEAW, p. 158 (variant,
center right image).

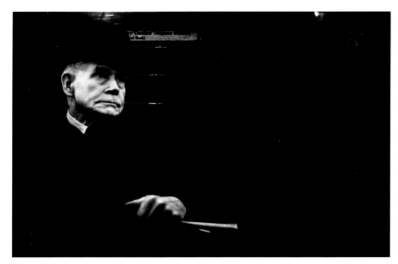

755

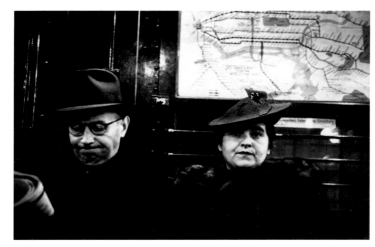

756

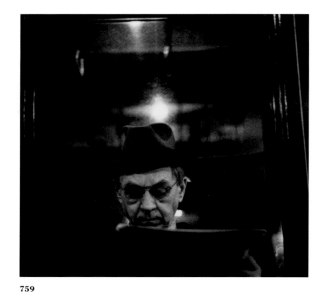

759

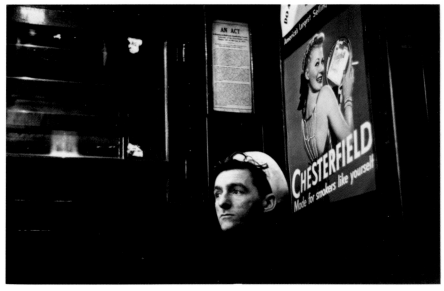

760

755
[*Subway Portrait*], 1938–41; printed
ca. 1965
Image: 17.5 x 25.5 cm
(6 ¹⁵⁄₁₆ x 10 ¹⁄₁₆ in.); sheet: 35.4 x 28 cm
(14 x 11 in.) [mounted to second sheet]
84.XM.956.641
MARKS & INSCRIPTIONS: (Recto) signed at
right below image, in ink, by Evans,
Walker Evans; at l. right, Evans stamp
I; (verso, sheet) at center, Evans stamp
I; at l. center, in pencil, *80* [circled]/
40% OFF/2″ HEAD; at l. left, in pencil,
Crane no. *L71.80(Evans)*.
REFERENCES: MAC, p. 159; WEAW, p. 153
(variant, center left image).

756
[*Subway Portrait*], 1941; printed
ca. 1965
Image: 17.5 x 25.5 cm
(6 ¹⁵⁄₁₆ x 10 ¹⁄₁₆ in.); sheet: 35.4 x 28 cm
(14 x 11 in.) [mounted to second sheet]
84.XM.956.642
MARKS & INSCRIPTIONS: (Recto) signed at
right below image, in ink, by Evans,
Walker Evans; at l. right, Evans stamp
I; (verso, mount) at center, Evans
stamp I; at l. center, in pencil, *81*
[circled]/*40% OFF/2″ HEAD*; at l. left,
in pencil, Crane no. *L71.81(Evans)*.
REFERENCES: MAC, p. 161.

757
[*Subway Portrait*], 1941
Image: 13 x 18.1 cm (5 ⅛ x 7 ⅛ in.);
original mount: 28.7 x 21.3 cm
(11 ⁹⁄₃₂ x 8 ⅜ in.)
84.XM.956.672
MARKS & INSCRIPTIONS: (Recto, mount)
signed at l. right, in pencil, by Evans,
Walker Evans; (verso, mount) at center,
Evans stamp I; at center, in ink, by
Evans, *1-26#1*; at l. left, in pencil,
Crane no. *L70.38(Evans)*.
REFERENCES: MAC, p. 161 (variant).

758
[*Subway Portrait*], 1938–41; printed
ca. 1965
Image: 17.5 x 25.5 cm
(6 ¹⁵⁄₁₆ x 10 ¹⁄₁₆ in.); sheet: 35.4 x 28 cm
(14 x 11 in.) [mounted to second sheet]
84.XM.956.643
MARKS & INSCRIPTIONS: (Recto) signed
at right below image, in ink, by Evans,
Walker Evans; at l. right, Evans stamp
I; (verso, mount) at center, Evans
stamp I; at l. center, in pencil, *82*
[circled]/*40% OFF/2″ HEAD*; at l. left,
in pencil, Crane no. *L71.82(Evans)*.

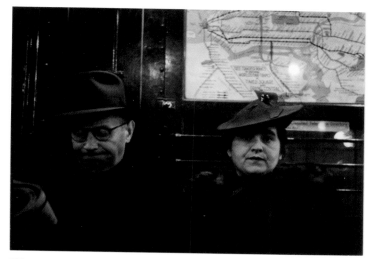

757

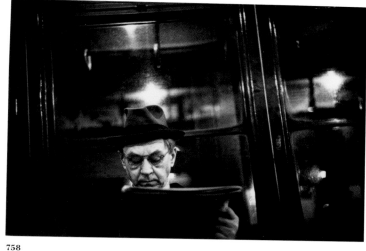

758

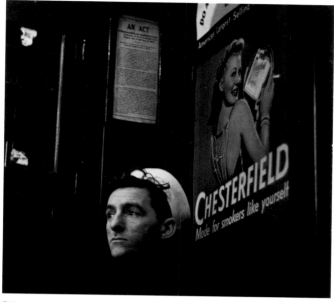

761

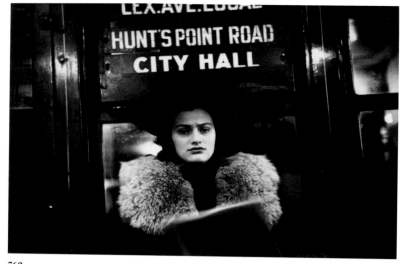

762

REFERENCES: MAC, p. 163; WEAW, p. 155 (variant, u. left image).

759
[*Subway Portrait*], 1938–41
Image: 12 x 12.7 cm (4 ¾ x 5 in.); original mount: 28.8 x 21.4 cm
(11 ⁵⁄₁₆ x 8 ⁷⁄₁₆ in.)
84.XM.956.749
MARKS & INSCRIPTIONS: (Recto, mount) signed at right below sheet, in pencil, by Evans, *Walker Evans*; (verso, mount) at center, Evans stamp I; (recto, mat) at l. left, in pencil, Crane no. *L70.87(Evans)*.

REFERENCES: MAC, p. 163 (variant); WEAW, p. 155 (variant, u. left image).

760
[*Subway Portrait*], 1941; printed ca. 1965
Image: 17.5 x 25.5 cm
(6 ¹⁵⁄₁₆ x 10 ¹⁄₁₆ in.); sheet: 35.4 x 28 cm (14 x 11 in.) [mounted to second sheet]
84.XM.956.644
MARKS & INSCRIPTIONS: (Recto) signed at right below image, in ink, by Evans, *Walker Evans*; at l. right, Evans stamp I; (verso, mount) at center, Evans stamp I; at l. center, in pencil, *83*

[circled]/*40% OFF/2" HEAD*; at l. left, in pencil, Crane no. *L71.83(Evans)*.
REFERENCES: MAC, p. 165.

761
[*Subway Portrait*], 1941
12.1 x 12.9 cm (4 ¾ x 5 ¹⁄₁₆ in.)
84.XM.956.775
MARKS & INSCRIPTIONS: (Verso) at u. center, Evans stamp A; at center, wet stamp, in black ink, *Jan 25, 1941*; at center, in ink, by Evans, *I-25 #23*.
REFERENCES: MAC, p. 165 (variant).

762
[*Subway Portrait*], 1938–41; printed ca. 1965
Image: 17.5 x 25.5 cm
(6 ¹⁵⁄₁₆ x 10 ¹⁄₁₆ in.); sheet: 35.4 x 28 cm (14 x 11 in.) [mounted to second sheet]
84.XM.956.645
MARKS & INSCRIPTIONS: (Recto) signed at right below image, in ink, by Evans, *Walker Evans*; at l. right, Evans stamp I; (verso, mount) at center, Evans stamp I; at l. center, in pencil, *84* [circled]/*40% OFF/2" HEAD*; at l. left, in pencil, Crane no. *L71.84(Evans)*.
REFERENCES: MAC, p. 167; WEAW, p. 152 and 156 (variants).

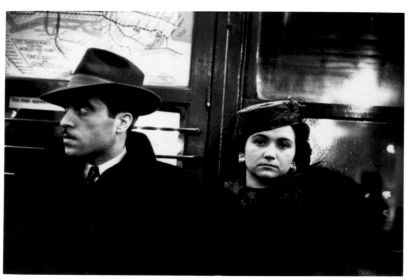

763

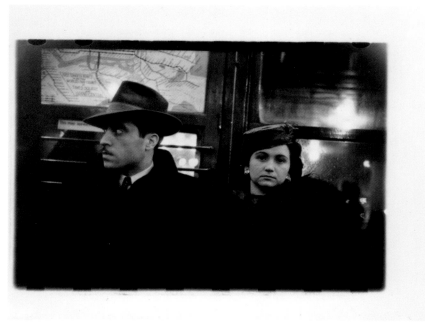

764

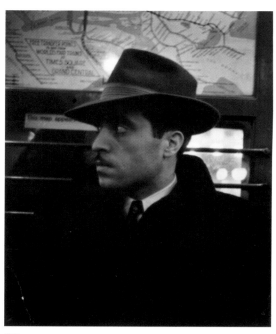

765

763
[*Subway Portrait*], 1938–41; printed
ca. 1965
Image: 17.5 x 25.5 cm
(6 ¹⁵/₁₆ x 10 ¹/₁₆ in.); sheet: 35.4 x 28 cm
(14 x 11 in.) [mounted to second sheet]
84.XM.956.646
MARKS & INSCRIPTIONS: (Recto) signed at
right below image, in ink, by Evans,
Walker Evans; at l. right, Evans stamp
I; (verso, mount) at center, Evans
stamp I; at l. center, in pencil, *85*
[circled]/*40% OFF/2″ HEAD*; at l. left,
in pencil, Crane no. *L71.85(Evans)*.
REFERENCES: MAC, p. 169; WEAW,
pp. 152 and 156 (variants).

764
[*Subway Portrait*], 1938–41
Image: 14.9 x 21.3 cm (5 ⅞ x 8 ⅜ in.);
sheet: 19.7 x 24.4 cm (7 ¾ x 9 ⅝ in.)
84.XM.956.781
MARKS & INSCRIPTIONS: (Verso) at l. left,
in pencil, Crane no. *L70.73*.
REFERENCES: MAC, p. 169 (variant);
WEAW, pp. 152 and 156 (variants).

765
[*Subway Portrait*], 1938–41
12 x 9.8 cm (4 ¾ x 3 ⅞ in.)
84.XM.956.719
MARKS & INSCRIPTIONS: (Verso) at
l. right, Evans stamp A; at l. left, in
pencil, Crane no. *L70.126*.
REFERENCES: MAC, p. 169 (variant).

766
[*Subway Portrait*], 1938–41; printed
ca. 1965
Image: 17.5 x 25.3 cm
(6 ¹⁵/₁₆ x 10 ¹/₁₆ in.); sheet: 35.4 x 28 cm
(14 x 11 in.) [mounted to second sheet]

84.XM.956.647
MARKS & INSCRIPTIONS: (Recto) signed at
right, in ink, by Evans, *Walker Evans*;
(verso, mount) at center, Evans stamp
I; at l. center, in pencil, *86* [circled]/
40% OFF/2″ HEAD; at l. left, in pencil,
Crane no. *L71.86(Evans)*.
REFERENCES: MAC, p. 171; WEAW,
pp. 152 and 156 (variants).

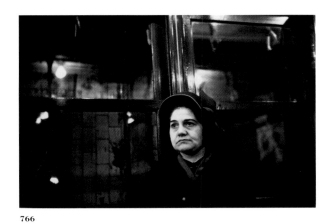

766

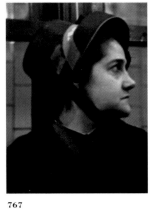

767

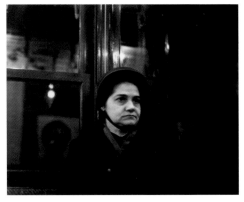

768

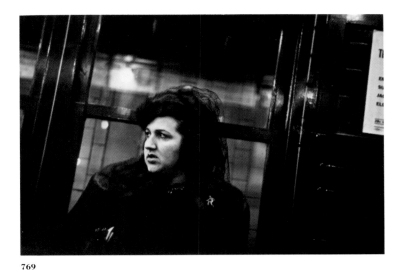

769

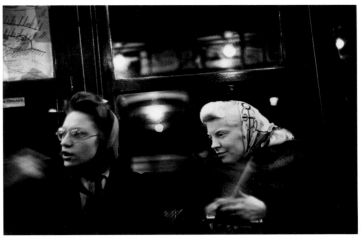

770

767
[*Subway Portrait*], 1938–41
6.9 x 5 cm (2 ¹¹⁄₁₆ x 1 ¹⁵⁄₁₆ in.)
84.XM.956.730
MARKS & INSCRIPTIONS: (Verso) at l. center, Evans stamp A; at l. left, in pencil, Crane no. *L70.98(Evans)*.

768
[*Subway Portrait*], 1938–41
Image: 12.6 x 14.2 cm
(4 ¹⁵⁄₁₆ x 5 ⅝ in.); original mount:
28.8 x 21.3 cm (11 ⅜ x 8 ⅜ in.)
84.XM.956.667

MARKS & INSCRIPTIONS: (Recto, mount) signed below print, in pencil, by Evans, *Walker Evans*; (verso, mount) at center, Evans stamp I; at l. left, in pencil, Crane no. *L70.50(Evans)*.

769
[*Subway Portrait*], 1938–41; printed ca. 1965
Image: 17.5 x 25.5 cm
(6 ¹⁵⁄₁₆ x 10 ¹⁄₁₆ in.); sheet: 35.4 x 28 cm (14 x 11 in.) [mounted to second sheet]
84.XM.956.648

MARKS & INSCRIPTIONS: (Recto) signed at right below image, in ink, by Evans, *Walker Evans*; (verso, mount) at center, Evans stamp I; at center, Evans stamp I; at l. center, in pencil, *87* [circled]/ *40% OFF/2″ HEAD*; at l. right, in pencil, *170/11* [underlined]/*159* at l. left, in pencil, Crane no. *L71.87(Evans)*.
REFERENCES: MAC, p. 173 (variant).

770
[*Subway Portrait*], 1938–41; printed ca. 1965
Image: 17.5 x 25.5 cm (6 ⅞ x 10 ⅛ in.); sheet: 35.4 x 28 cm (14 x 11 in.) [mounted to second sheet]

84.XM.956.649
MARKS & INSCRIPTIONS: (Recto) signed at right, in ink, by Evans, *Walker Evans*; (verso, mount) at center, Evans stamp I; at l. center, in pencil, *88* [circled]/ *40% OFF/2″ HEAD*; at l. right, in pencil, *188/12* [underlined]/*176*; at l. left, in pencil, Crane no. *L71.88(Evans)*.
REFERENCES: MAC, p. 175.

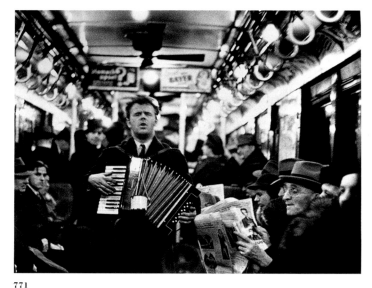

771

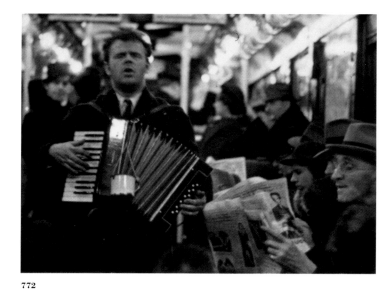

772

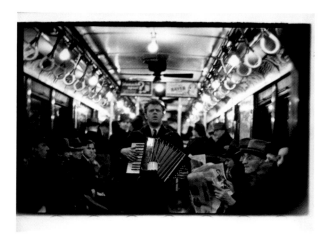

773

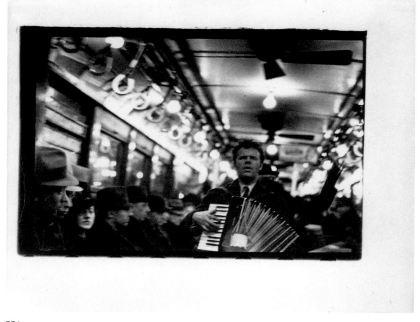

774

771
[*Subway Portrait*], 1938–41; printed
ca. 1965
Image: 20.5 x 25.5 cm
(7 ¹⁵/₁₆ x 10 ¹/₁₆ in.); sheet: 35.4 x 28 cm
(14 x 11 in.) [mounted to second sheet]
84.XM.956.650
MARKS & INSCRIPTIONS: (Recto) signed at
right below image, in ink, by Evans,
Walker Evans; (verso, mount) at center,
Evans stamp I; at l. center, in pencil,
89 [circled]/*40% OFF/1 ¾" HEAD*; at
l. right, in pencil, *198/11* [underlined]/
187; at l. left, in pencil, Crane
no. *L71.89(Evans)*.
REFERENCES: MAC, p. 177 (variant).

772
[*Subway Portrait*], 1938–41
Image: 9.6 x 12.6 cm (3 ¾ x 7 ³¹/₃₂ in.);
original hole-punched mount:
27.9 x 21.6 cm (11 x 8 ½ in.)
84.XM.956.679
MARKS & INSCRIPTIONS: (Verso, mount)
at center, Evans stamp B; at center,
Crane stamp; at l. left, in pencil,
Crane no. *L70.79(Evans)*.
REFERENCES: MAC, p. 177 (variant).

773
[*Subway Portrait*], 1938–41
Image: 16.5 x 24.2 cm (6 ½ x 9 ½ in.)
sheet: 19.6 x 25.1 cm (7 ¾ x 9 ⅞ in.)
84.XM.956.785
MARKS & INSCRIPTIONS: (Verso) at
l. right, Evans stamp B; at l. left, in
pencil, Crane no. *L70.124*.
REFERENCES: MAC, p. 177 (variant).

774
[*Subway Portrait*], 1938–41
Image: 14.8 x 21.3 cm (5 ¹³/₁₆ x 8 ⅜ in.);
sheet: 20.1 x 25.1 cm (7 ¹⁵/₁₆ x 9 ⅞ in.)
84.XM.956.662

MARKS & INSCRIPTIONS: (Verso) at right,
Evans stamp B; at l. left, in pencil,
Crane no. *L70.78(Evans)*.

775
[*Subway Portrait: Sixteen Women*],
1938–41; probably assembled ca. 1959
Each image: 6.7 x 4.7 cm (2 ⅝ x 1 ⅞ in.);
original mount: 33 x 21.8 cm
(13 x 8 ⁹/₁₆ in.)
84.XM.956.792
MARKS & INSCRIPTIONS: (Recto, mount)
signed at l. left, in pencil, by Evans,
Walker Evans; at l. right below prints,
Evans stamp H; (verso, mount) at cen-

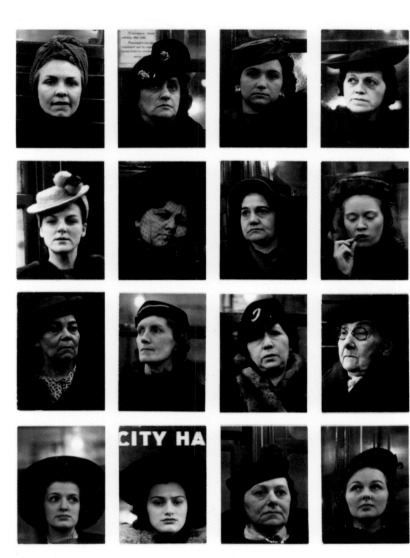

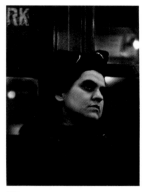

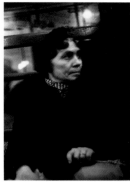

775

776 777

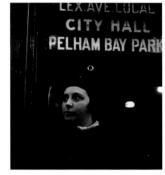

778

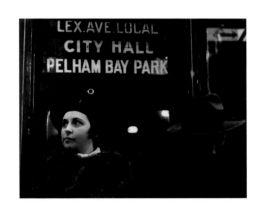

779

ter, Evans stamp H twice; at l. right, Crane stamp; at l. left, in pencil, Crane no. *L70.127–142*.
REFERENCES: WEAW, p. 156 (variant).

776
[*Subway Portrait*], 1938–41
Image: 13.2 x 9.1 cm (5 ³⁄₁₆ x 3 ¹⁹⁄₃₂ in.); original mount: 23.3 x 18 cm (9 ³⁄₁₆ x 7 ³⁄₃₂ in.)
84.XM.956.664
MARKS & INSCRIPTIONS: (Verso, mount) at l. left, Evans stamp A; at l. left, in pencil, Crane no. *L70.62(Evans)*.

777
[*Subway Portrait*], 1938–41
Image: 10.2 x 7.2 cm (4 x 2 ¹³⁄₁₆ in.); original mount: 28.8 x 21.4 cm (11 ³⁄₈ x 8 ¹³⁄₃₂ in.)
84.XM.956.666
MARKS & INSCRIPTIONS: (Recto, mount) signed at l. right, in pencil, by Evans, *Walker Evans*; (verso, mount) at center, Evans stamp I; at l. left, in pencil, Crane no. *L70.36(Evans)*.

778
[*Subway Portrait*], 1941
Image: 12.8 x 11.1 cm (5 x 4 ¹³⁄₃₂ in.); original mount: 28.7 x 21.5 cm (11 ⁹⁄₃₂ x 8 ¹⁵⁄₃₂ in.)
84.XM.956.683
MARKS & INSCRIPTIONS: (Recto, mount) signed at l. right below print, in pencil, by Evans, *Walker Evans*; (verso, mount) signed at center, in ink, by Evans, *Walker Evans*; at center, Evans stamp I; at center, in ink, by Evans, *1-21 #14*; at l. left, in pencil, Crane no. *L70.27(Evans)*.

779
[*Subway Portrait*], 1941
Image: 13 x 15.9 cm (5 ⅛ x 6 ¼ in.); original mount: 28.7 x 21.5 cm (11 ⁵⁄₁₆ x 8 ⁷⁄₁₆ in.)
84.XM.956.772
MARKS & INSCRIPTIONS: (Recto, mount) signed at l. right below print, in pencil, by Evans, *Walker Evans*; (verso, mount) at center, in ink, by Evans, *1-21 #14*; at center, Evans stamp I twice; (recto, mat) at l. left, in pencil, Crane no. *L70.104(Evans)*.

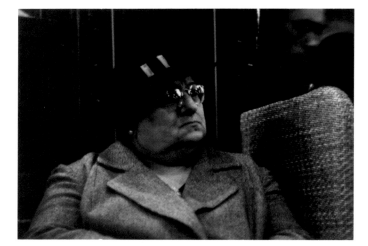

780

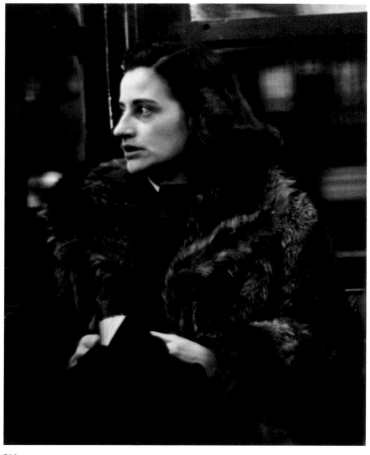

781

782

783

780
[*Subway Portrait*], 1941
Image: 8.7 x 12.3 cm (3 ⁷⁄₁₆ x 4 ¹³⁄₁₆ in.);
original mount: 28.8 x 21.5 cm
(11 ³⁄₈ x 8 ⁷⁄₁₆ in.)
84.XM.956.688
MARKS & INSCRIPTIONS: (Recto, mount)
signed at l. right, in pencil, by Evans,
Walker Evans; (verso, mount) at center,
Evans stamp I; at center, in ink, by
Evans, *5-27 #30*; at l. left, in pencil,
Crane no. *L70.118(Evans)*.

781
[*Subway Portrait*], 1938–41
Image: 12.3 x 9.7 cm (4 ¹³⁄₁₆ x 3 ¹³⁄₁₆ in.);
original mount: 28.8 x 21.4 cm
(11 ⁵⁄₁₆ x 8 ⁷⁄₁₆ in.)
84.XM.956.701
MARKS & INSCRIPTIONS: (Recto, mount)
signed at l. right, in pencil, by Evans,
Walker Evans; (verso, mount) at center,
Evans stamp I; at l. left, in pencil,
Crane no. *L70.35(Evans)*.

782
[*Subway Portrait*], 1938–41
6.9 x 5 cm (2 ¾ x 1 ¹⁵⁄₁₆ in.) [on original
mount trimmed to image]

84.XM.956.739
MARKS & INSCRIPTIONS: (Verso) at top,
Evans stamp A; at l. left, in pencil,
Crane no. *L70.6(Evans)*.

783
[*Subway Portrait*], 1938–41
6.9 x 5 cm (2 ¾ x 1 ¹⁵⁄₁₆ in.) [on original
mount trimmed to image]
84.XM.956.722
MARKS & INSCRIPTIONS: (Verso) at u. cen-
ter, Evans stamp A; at l. left, in pencil,
Crane no. *L70.3(Evans)*.

784
[*Subway Portrait*], 1941
Sheet: 12.5 x 10.5 cm (4 ¹⁵⁄₁₆ x 4 ⅛ in.);
original mount: 23.7 x 14.1 cm
(9 ⁵⁄₁₆ x 5 ⁹⁄₁₆ in.)
84.XM.956.740
MARKS & INSCRIPTIONS: (Recto, mount)
signed at l. right below print, in pen-
cil, by Evans, *Walker Evans*; at l. left,
in pencil, by Evans, *NOTE/This is some-
what off-square./SQUARE THIS TRULY*;
(verso, mount) at center, Evans stamp
I; at left edge, partial Evans stamp I
[cut off]; at left edge, in ink, by Evans,

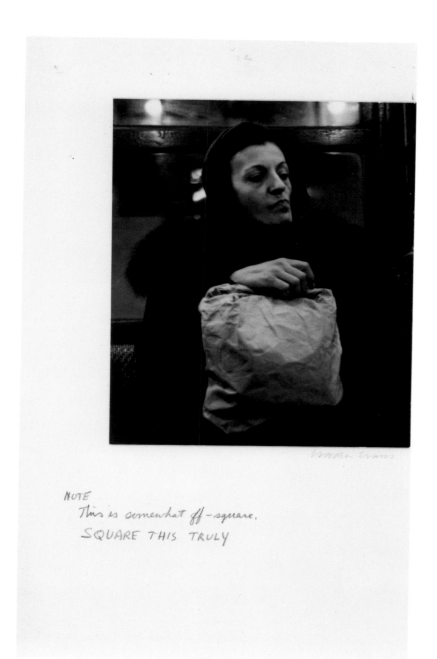

784

785

786

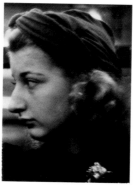

787

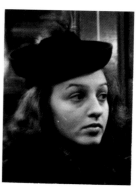

788

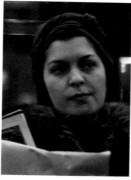

789

NOTE
This is somewhat off-square.
SQUARE THIS TRULY

13 #11; (recto, mat) at l. left, in pencil, Crane no. *L70.86(Evans)*.
REFERENCES: "Walker Evans: The Unposed Portrait," *Harper's Bazaar*, Mar. 1962, p. 122 (variant); WEAW, p. 159 (variant, u. right image).

785
[*Subway Portrait*], 1938–41
6.9 x 4.9 cm (2 ¹¹/₁₆ x 1 ¹⁵/₁₆ in.)
84.XM.956.738
MARKS & INSCRIPTIONS: (Verso) at l. center, Evans stamp A; at l. left, in pencil, Crane no. *L70.13(Evans)*.

786
[*Subway Portrait*], 1938–41
6.9 x 4.9 cm (2 ¹¹/₁₆ x 1 ¹⁵/₁₆ in.) [on original mount trimmed to image]
84.XM.956.737
MARKS & INSCRIPTIONS: (Verso) at u. center, Evans stamp A; at l. left, in pencil, Crane no. *L70.10(Evans)*.

787
[*Subway Portrait*], 1938–41
6.9 x 5 cm (2 ¾ x 1 ¹⁵/₁₆ in.)
84.XM.956.735
MARKS & INSCRIPTIONS: (Verso) at l. center, Evans stamp A; at l. left, in pencil, Crane no. *L70.2(Evans)*.

788
[*Subway Portrait*], 1938–41
7 x 4.9 cm (2 ¾ x 1 ¹⁵/₁₆ in.)
84.XM.956.732
MARKS & INSCRIPTIONS: (Verso) at l. center, Evans stamp A twice; at l. left, in pencil, Crane no. *L70.100(Evans)*.

789
[*Subway Portrait*], 1938–41
6.9 x 5 cm (2 ¹¹/₁₆ x 1 ¹⁵/₁₆ in.) [on original mount trimmed to image]
84.XM.956.729
MARKS & INSCRIPTIONS: (Verso) at u. center, Evans stamp A; at l. left, in pencil, Crane no. *L70.101(Evans)*.

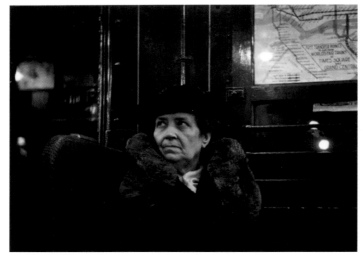

790

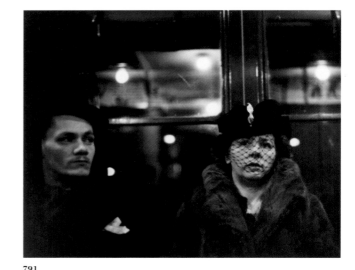

791

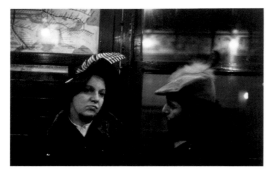

792

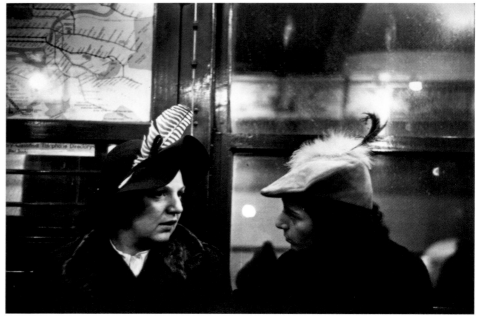

793

790
[*Subway Portrait*], 1941
Image: 12.3 x 16.6 cm (4 ¹³/₁₆ x 6 ⁹/₁₆ in.);
original mount: 28.5 x 21.5 cm
(11 ¼ x 8 ⁷/₁₆ in.)
84.XM.956.674
MARKS & INSCRIPTIONS: (Recto, mount)
signed below print, in pencil, by
Evans, *Walker Evans*; (verso, mount)
at center, Evans stamp I; at center, in
ink, by Evans, *1-25 #30-31*; at l.left, in
pencil, Crane no. *L70.43(Evans)*.

791
[*Subway Portrait*], 1941
Image: 12.6 x 15.4 cm (4 ³¹/₃₂ x 6 ¹/₁₆ in.);
original mount: 28.9 x 21.4 cm
(11 ⅜ x 8 ¹³/₃₂ in.)
84.XM.956.677
MARKS & INSCRIPTIONS: (Recto, mount)
signed at right below print, in pencil,
by Evans, *Walker Evans*; (verso,
mount) at center, Evans stamp I; at
center, in ink, by Evans, *1-21 #11*; at
u. right, in pencil, MoMA no. *66.1133*;
at l. left, in pencil, Crane no. *L70.41*
(*Evans*).

792
[*Subway Portrait*], 1938–41
Image: 11.9 x 18.3 cm (4 ¹¹/₁₆ x 7 ³/₁₆ in.);
original mount: 28.7 x 21.4 cm
(11 ⁵/₁₆ x 8 ⁷/₁₆ in.)
84.XM.956.751
MARKS & INSCRIPTIONS: (Recto, mount)
signed at right below print, in pencil,
by Evans, *Walker Evans*; (verso,
mount) at center, Evans stamp I;
(recto, mat) at l. left, in pencil, Crane
no. *L70.89(Evans)*.

793
[*Subway Portrait*], 1938–41; printed
ca. 1965
Image: 17.5 x 25.5 cm (6 ⅞ x 10 ¹/₁₆ in.);
sheet: 35.3 x 28 cm (13 ¹⁵/₁₆ x 11 in.)
84.XM.956.791
MARKS & INSCRIPTIONS: (Verso) at
l. right, Evans stamp B; at u. left, wet
stamp, in black ink, *1* [space] *18*
[inverted]; at center, in pencil, *46*
[inverted]; at l. left, in pencil, Crane
no. *L85.6(Evans)*.

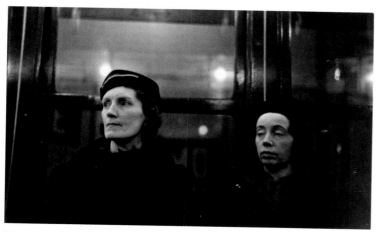

794

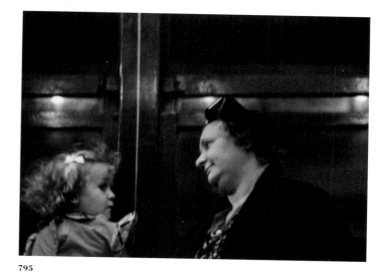

795

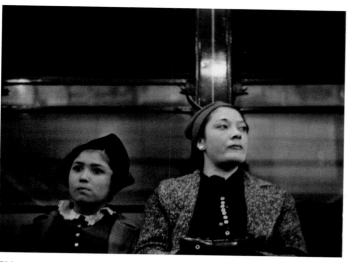

796

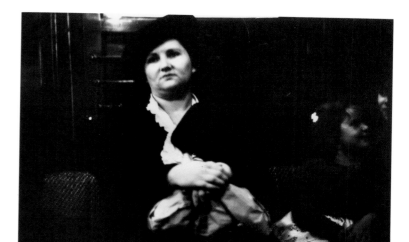

797

794
[*Subway Portrait*], 1938–41
Image: 10.7 x 17.5 cm (4 ³⁄₁₆ x 6 ⁷⁄₈ in.);
original mount: 11.5 x 18.1 cm
(4 ½ x 7 ⅛ in.)
84.XM.956.714
MARKS & INSCRIPTIONS: (Verso) at center
right, Evans stamp A; at l. left, in pen-
cil, Crane no. *L70.16(Evans)*.
REFERENCES: WEAW, pp. 152 and 156
(variants).

795
[*Subway Portrait*], 1938–41
Image: 11.1 x 15.1 cm (4 ⅜ x 5 ³¹⁄₃₂ in.);
original mount: 25.4 x 20.1 cm
(10 x 7 ¹⁵⁄₁₆ in.)
84.XM.956.652
MARKS & INSCRIPTIONS: (Verso) signed at
center, in blue ink, by Evans, *Walker
Evans*; at l. left, in pencil, Crane
no. *L70.122(Evans)*.

796
[*Subway Portrait*], 1938–41
Image: 14.6 x 19.4 cm (5 ¾ x 7 ⅝ in.);
original mount: 25.4 x 20.4 cm
(10 x 8 ¹⁄₁₆ in.)
84.XM.956.676
MARKS & INSCRIPTIONS: (Verso, mount)
signed at center, in blue ink, by
Evans, *Walker Evans*; at l. left, in
pencil, Crane no. *L70.64(Evans)*.

797
[*Subway Portrait*], 1938–41; printed
ca. 1965
Image: 17.5 x 25.6 cm
(6 ⅞ x 10 ¹⁄₁₆ in.); sheet: 35.4 x 28 cm
(13 ¹⁵⁄₁₆ x 11 in.)
84.XM.956.790
MARKS & INSCRIPTIONS: (Verso) at
l. right, Evans stamp B; at top, wet
stamp, in black ink, *1* [space] *18*
[inverted]; at center, in pencil, *40*
[inverted]; at l. left, in pencil, Crane
no. *L85.5(Evans)*.

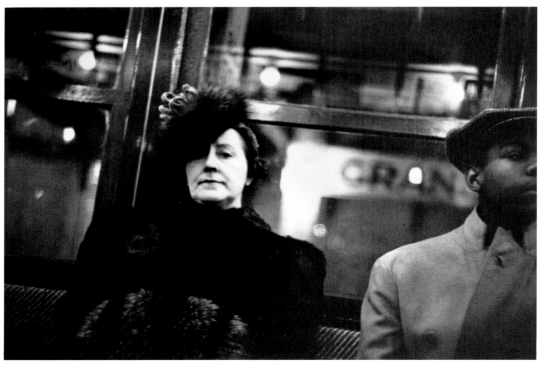

798

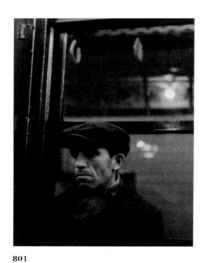

801

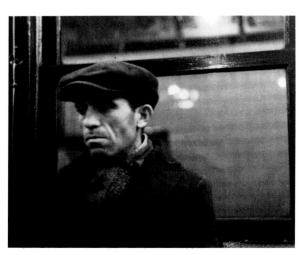

802

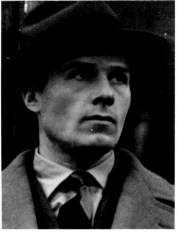

803

798
[*Subway Portrait*], 1938–41; printed
ca. 1965
Image: 17.5 x 25.5 cm
(6 ⅞ x 10 1/16 in.); sheet: 35.4 x 28 cm
(13 15/16 x 11 in.)
84.XM.956.789
MARKS & INSCRIPTIONS: (Verso) at
l. right, Evans stamp B; at center, in
pencil, *58*; at l. left, in pencil, Crane
no. *L85.2(Evans).*

799
[*Subway Portrait*], 1941
Image: 11.5 x 15.8 cm (4 ½ x 6 7/32 in.);

original mount: 28.7 x 21.4 cm
(11 5/16 x 8 13/32 in.)
84.XM.956.670
MARKS & INSCRIPTIONS: (Recto, mount)
signed at l. right, in pencil, by Evans,
Walker Evans; (verso, mount) at center,
Evans stamp I; at center, in ink, by
Evans, *1-13 #28*; at l. left, in pencil,
Crane no. *L70.49(Evans).*

800
[*Subway Portrait*], 1941
Image: 12.2 x 16.5 cm (4 13/16 x 6 ½ in.);
original mount: 28.9 x 21.4 cm
(11 ⅜ x 8 13/32 in.)

84.XM.956.705
MARKS & INSCRIPTIONS: (Recto, mount)
signed at l. right, in pencil, by Evans,
Walker Evans; (verso, mount) at center,
Evans stamp I; at center, in ink, by
Evans, *1-21 #31-32*; at l. left, in
pencil, Crane no. *L70.32(Evans).*

801
[*Subway Portrait*], 1938–41
Image: 12.6 x 9.5 cm
(4 31/32 x 3 23/32 in.); original mount:
34.2 x 25.3 cm (13 15/32 x 9 15/16 in.)
84.XM.956.709

MARKS & INSCRIPTIONS: (Recto, mount)
signed at l. right, in pencil, by Evans,
Walker Evans; (verso, mount) at center,
Evans stamp I; at l. left, in pencil, *S*
and Crane no. *L70.23(Evans).*

802
[*Subway Portrait*], 1938–41
Image: 12 x 14.3 cm (4 ¾ x 5 ⅝ in.);
original mount: 34.2 x 25.2 cm
(13 ½ x 9 15/16 in.)
84.XM.956.773

MARKS & INSCRIPTIONS: (Mount, recto)
signed at l. right below print, in pen-
cil, by Evans, *Walker Evans*; left and

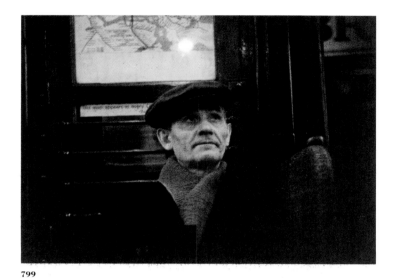

799

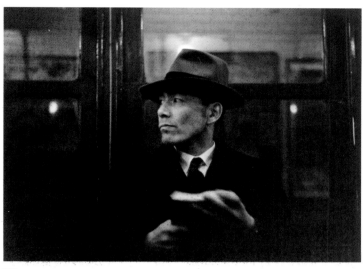

800

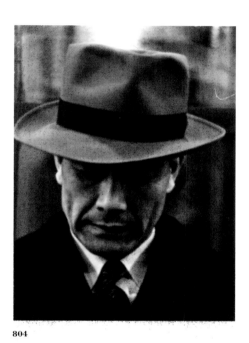

804

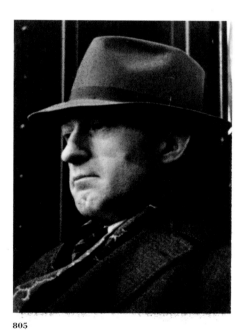

805

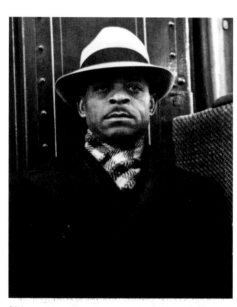

806

right l. corners, in pencil, *X*; (verso, mount) at center, Evans stamp I; at u. right, in pencil, *S131*; at l. right, in pencil, [illegible markings]; at l. left, in pencil, *S*; (recto, mat) at l. right, in pencil, *205*; at l. left, in pencil, Crane no. *L70.105(Evans)*.

803
[*Subway Portrait*], 1938–41
6.9 x 5 cm (2 ¾ x 2 in.)
84.XM.956.726
MARKS & INSCRIPTIONS: (Verso) at l. right, Evans stamp A; at l.left, in pencil, Crane no. *L70.11(Evans)*.

804
[*Subway Portrait*], 1938–41
6.9 x 5 cm (2 ¾ x 2 in.)
84.XM.956.731
MARKS & INSCRIPTIONS: (Verso) at u. center, Evans stamp A; at l. left, in pencil, Crane no. *L70.102(Evans)*.

805
[*Subway Portrait*], 1938–41
6.9 x 5 cm (2 ¾ x 2 in.)
84.XM.956.733
MARKS & INSCRIPTIONS: (Verso) at l. center, Evans stamp A; at l. left, in pencil, Crane no. *L70.103(Evans)*

806
[*Subway Portrait*], 1941
10 x 7.7 cm (3 ¹⁵⁄₁₆ x 3 in.) [on original mount trimmed to image]
84.XM.956.745
MARKS & INSCRIPTIONS: (Verso, mount) at bottom edge, Evans stamp A; at cen-

ter, wet stamp, in black ink, *JAN 17 1941*; at center, in ink, by Evans, *1-17 #1*; (recto, mat) at l. right, *209, 210, 211*; at l. left, in pencil, Crane nos. *L70.54–56*.
REFERENCES: "Rapid Transit: Eight Photographs," *i.e. The Cambridge Review*, Mar. 1956, p. 23 (variant).

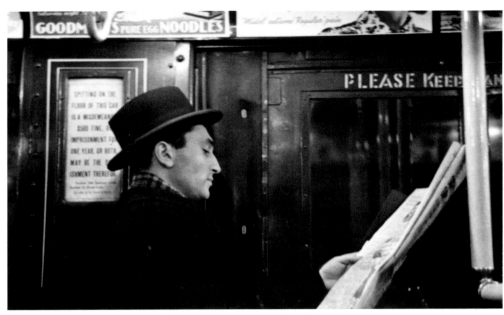

807

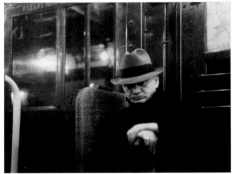

808

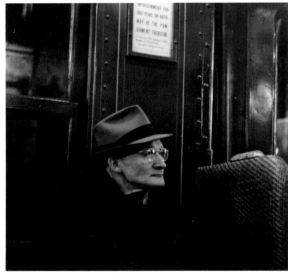

809

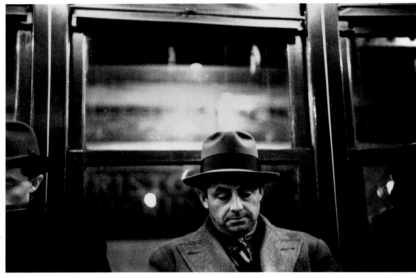

810

807
[*Subway Portrait*], 1941
Image: 12.4 x 16.1 cm (5 ½ x 6 ¾ in.);
original mount: 27.6 x 20.2 cm
(11 x 8 in.)
84.XM.956.753
MARKS & INSCRIPTIONS: (Recto, mount)
signed at right below print, in pencil,
by Evans, *Walker Evans*; (verso,
mount) at center, Evans stamp I; at
center, in ink, by Evans, *3-16 #22-23*;
(recto, mat) at l. right, in pencil, *206*;
at l. left, in
pencil, Crane no. *L70.22(Evans)*.

808
[*Subway Portrait*], 1938–41
Image: 10.6 x 17 cm (4 ³⁄₁₆ x 6 ¹¹⁄₁₆ in.);
original mount: 25.5 x 20.1 cm
(10 ¹⁄₁₆ x 7 ¹⁵⁄₁₆ in.)
84.XM.956.765
MARKS & INSCRIPTIONS: (Verso) signed at
center, in ink, by Evans, *Walker
Evans*; (recto, mat) at l. left, in pencil,
Crane no. *L70.125(Evans)*.

809
[*Subway Portrait*], 1938–41
Image: 12.9 x 13 cm (5 ¹⁄₁₆ x 5 ⅛ in.);
original mount: 28.8 x 21.4 cm
(11 ⁵⁄₁₆ x 8 ⁷⁄₁₆ in.)

84.XM.956.766
MARKS & INSCRIPTIONS: (Recto, mount)
signed at l. right below print, in pen-
cil, by Evans, *Walker Evans*; (verso,
mount) at center, in ink, by Evans, *#Y*;
at center, Evans stamp I; (recto, mat)
at l. right, in pencil, *195*; at l. left, in
pencil, Crane no. *L70.20(Evans)*.

810
[*Subway Portrait*], 1938–41; printed
ca. 1965
Image: 17.5 x 25.5 cm (6 ⅞ x 10 ¹⁄₁₆ in.);
sheet: 35.4 x 28 cm (13 ¹⁵⁄₁₆ x 11 in.)

84.XM.956.788
MARKS & INSCRIPTIONS: (Verso) at
l. right, Evans stamp B; at center, in
pencil, *47*; at l. left, wet stamp, in
black ink, *1* [space] *18*; at l. left,
in pencil, Crane no. *L85.1(Evans)*.

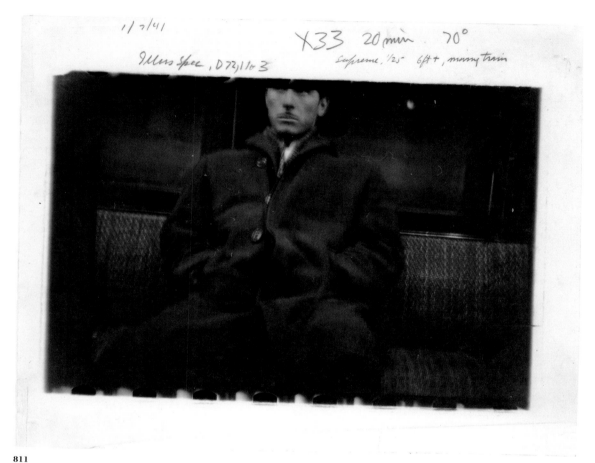

811

813

814

811
[*Subway Portrait*], 1941
Image: 15 x 21.8 cm (5 $^{15}/_{16}$ x 8 $^{9}/_{16}$ in.);
sheet: 20.1 x 25.2 cm (7 $^{7}/_{8}$ x 9 $^{15}/_{16}$ in.)
84.XM.956.657
MARKS & INSCRIPTIONS: (Recto) across
upper margin, in pencil, by Evans, at
left, *1/7/41/ Illus. Spec, D72, 1 to 3* , at
right, *X33 20 min. 70 °/Supreme, 1/25*
[space] *6 ft +, moving train*; (verso) at
l. left, in pencil, Crane no. *L70.70*
(Evans).

812
[*New York Subway Series: Film Frag-
ment, Frames 30–33*], January 1941
MEDIUM: Negative [see no. 811]
3.4 x 16.8 cm (1 $^{3}/_{8}$ x 6 $^{5}/_{8}$ in.) [irregular]
84.XM.956.658
MARKS & INSCRIPTIONS: at top edge,
frame nos. *30—31—32—33*; at bot-
tom edge below frame 31, *AGFA 29 R.*
NOTE: Not illustrated.

813
[*Portrait of Jane Smith Ninas*], Janu-
ary 13, 1941
Image: 8.8 x 8.5 cm (3 $^{15}/_{32}$ x 3 $^{11}/_{32}$ in.);

original mount: 25.2 x 20.4 cm
(9 $^{15}/_{16}$ x 8 in.)
84.XP.208.23
MARKS & INSCRIPTIONS: (Verso, mount)
at l. right, in black ink, by Evans,
#3/New York. 1-13-41; (recto, mat) at
l. left, in pencil, *Walker Evans*; at
l. right, in pencil, *TCI*; (verso, mat)
at l. right, in pencil, *PORTRAIT/
Wife/WALKER EVANS*; at l. right corner,
in pencil, *6623/1200.*
PROVENANCE: Jane Sargeant (the former
Jane Smith Ninas); Daniel Wolf.

814
[*Portrait of a Boy*], ca. 1940
13.0 x 9.1 cm (5 $^{3}/_{32}$ x 3 $^{19}/_{32}$ in.)
84.XM.956.1083
MARKS & INSCRIPTIONS: None.

THE WHEATON COLLEGE COMMISSION

Wheaton College is the only institution bearing a college charter within the limits of the original territory controlled by the Pilgrim Fathers and historically known as the Old Colony. Its earliest surviving building dates from 1835. Mary Lyon Hall was erected in 1849. In the years from 1900 to 1934 a series of buildings in the colonial style were grouped around the campus according to a prearranged plan, and in 1940 a new departure was made with the Student Alumnae Building, which was designed in accord with modern ideals of architecture.

From the foreword to *Wheaton College Photographs*[1]

The exhibition that preceded *Walker Evans: American Photographs* at the Museum of Modern Art in the summer and early fall of 1938 was *Competition for a Wheaton College Campus Art Center*, sponsored jointly by MoMA and the journal *Architectural Forum*.[2] Professor Esther Seaver, head of the Wheaton College Art Department and an advocate for modern architecture, had organized this competition with the hope that "a new departure," as the president's foreword termed it, would be made, appropriately enough in the form of an art building for the campus. After conferring with various art authorities (including Alfred Barr of MoMA), Ms. Seaver received approval from the Wheaton Trustees to proceed with the competition, which would involve an expert jury of architects (such as John Welborn Root, Jr., of Chicago and Edward Durell Stone of New York), with John McAndrew, newly appointed curator of architecture at MoMA, as chairman. Four firms described as "the most important modern architectural

firms of the century" were invited to submit designs; the competition, open to any American architect, was announced nationally by MoMA.[3] The judging of the 253 entries was held in May 1938 at Rockefeller Center, with second prize going to Walter Gropius, one of three fifth prizes going to Eero Saarinen, and one of seven honorable mentions to Richard Neutra. First prize was awarded to the young New York firm of Richard Bennett and Caleb Hornbostel, whose principals were then working for Edward Durell Stone and Norman Bel Geddes, respectively. From June to September, the winning drawings, plus non-prizewinning designs by four other architects (including Louis Kahn), were shown at MoMA. The exhibition then began a three-year tour, visiting numerous colleges and museums across the country.

At Wheaton, however, funds could not be found to implement the winning Bennett and Hornbostel design. The art-center project would have to be postponed. Professor Seaver, however, continued her campaign to bring Modernism to Wheaton. She set about lobbying the college to use the prizewinning firm for a more modest, already financed undertaking: the Student Alumnae

Walker Evans. *Wheaton College:
The Alumnae Parlor* (detail), 1941 [no. 847].

Building. Not surprisingly, the major donors to this long-nurtured fund were not former students—women who had attended the "oldest institution in America for 'the advanced education of Females'"—but two of their sons, Henry Crapo and Herbert Plimpton, who made their gifts in honor of their mothers, "Wheaton girls of the early Seminary days."[4] President J. Edgar Park offered Bennett and Hornbostel this new commission in the fall of 1939. By June of 1940, the Alumnae Association could make a formal gift of the building at a banquet held in the newly completed auditorium-ballroom wing named after Mrs. Plimpton. The art-center competition and Professor Seaver's persistent vision had resulted in one of the "earliest examples of Modernist architecture on an American college campus."[5]

Nineteen forty may seem a late date for Wheaton—or any college—to be considered a pioneer in modern design, but, in fact, colleges and universities, probably because of their conservative nature and institutional inertia, were among the last bastions to be invaded by the International Style.[6] Begun in 1834 as Wheaton Female Seminary, Wheaton College of Norton, Massachusetts, was, typically, a New England campus with a long tradition of building in what Thomas Mabry of MoMA referred to as "designs of ages past" in a 1938 press release.[7] The earliest structures, such as the house called "The Sem" of 1835 (no. 826), were built in the Federal and late Colonial styles. New Seminary Hall, later renamed Mary Lyon Hall, was a substantial addition to the campus in 1849 (nos. 817–18, 822). Constructed in the Greek Revival style, it was a "two-story templelike wooden structure," finished off with Italianate details.[8] This important classroom building was enlarged in 1878 (giving the building a cruciform shape) and an Italianate cupola was added; both additions were executed by the Boston architect Gridley Bryant. In the twentieth century, Mary Lyon Hall was given a "more 'classical' and 'colonial' appearance" when its trim was painted white and its walls a lighter shade of yellow.[9]

After 1900, Ralph Adams Cram, of the firm of Cram, Goodhue, and Ferguson, was the architect for this small women's school. His first commission—part of a larger scheme Cram submitted for a campus quadrangle—was a red-brick dormitory in the Georgian-Colonial style. With it, his firm set the tone for the appearance of the college over the next four decades. Between 1902 and 1907, two buildings, a gymnasium and a dormitory, were built on the campus by other Boston architects, but always in the Georgian mode. In 1907, Cram, Goodhue, and Ferguson were made the Supervising Architects of Buildings and Grounds; between 1911 and 1934, they completed ten more buildings for Wheaton, including a science building, a library, dormitories, and a chapel. These structures were grouped around the central courtyard or quadrangle first proposed by Cram in 1900. The quadrangle idea, one borrowed from the design of English colleges, was supposed to echo the arrangement of a New England village, "centered on a common with the church a dominant structure."[10] At Wheaton the dominant structure became the church, Cram's Cole Memorial Chapel of 1917 (nos. 815, 824, 828–30). Its disproportionate, three-tiered steeple not only overwhelms the Colonial brick church but towers above the other three- and four-story buildings of the campus. This chapel with its spire is the introductory image in Walker Evans's 1941 book, *Wheaton College Photographs*.[11] It reappears five times as an emblem of Cram's institutional style and, in a transitional image, provides a look back from the college's "new departure," its Student Alumnae Building (no. 837). The opening of this radically different structure, the first building ever given to the college, was probably the impetus behind the Evans book.

Evans had long wanted to do a book on architecture. His travels through New England with Lincoln Kirstein and John Wheelwright in the early 1930s had given him an opportunity to document historic regional architecture in some depth (see chapter one); his 1935 visit to New Orleans, sponsored by an ultimately unreliable

patron, Gifford Cochran, was intended to produce a book on the architecture of the antebellum South. Nearly half of the images contained in the MoMA publication *American Photographs* that accompanied his 1938 exhibition are on the subject of architecture. He originally planned to use his 1940 Guggenheim Fellowship for a return trip to Savannah to document the architecture of the area. That year, illness caused him to cancel his plans for the Savannah project; he reapplied to the Guggenheim Foundation, asking for funds to carry out a photographic project in the New York subway. His grant was extended, and he worked in the subway during the early months of 1941. His attention then turned to other matters; in this year before the country went to war, he would be very busy. Evans's first wife, Jane Sargeant (formerly Jane Smith Ninas), recalls that, in addition to the much-delayed appearance of *Let Us Now Praise Famous Men* and a summer assignment to Bridgeport, Connecticut, for *Fortune* magazine, Evans made visits in the spring and fall of 1941 to the Wheaton Campus in Norton and spent six weeks at the end of the year in Florida, gathering material for yet another book, *The Mangrove Coast*.[12]

Jane Sargeant, who accompanied Evans on one of his Boston/Wheaton trips, remembers that the couple had quite a sociable time, meeting many people, staying in a professor's Cambridge apartment, and having dinner with Wheaton's president, J. Edgar Park.[13] Some months after the Student Alumnae Building was completed, President Park released an announcement, itemizing "what the building had proved." This statement and, specifically, Park's first point, may suggest why Evans was hired: "1. That it is possible to erect on a college campus a building which satisfied the conscience and stimulates the genius of modern architecture without introducing into an ancient campus discordant motives . . . the new building, although entirely modern in essence, fits in beautifully."[14]

It might have been in defense of this recent capital project, or with an eye toward future fundraising, or possibly just as a memento for loyal alumnae, that Evans was engaged by the college to compile a book of photographs. And although we do not know what, if any, mandate he was given, it seems likely that Evans was asked to present the new building as an appropriate addition to the "ancient campus." Evans was not primarily known as an architectural photographer, but his interest in "ancient" American buildings, as well as his straightforward, view-camera style, were probably familiar to people like Park and Seaver, who had recently been in close contact with MoMA.[15] Whether the recommendation came through MoMA or through New England connections related to Evans's years at Andover and Williams College, the Wheaton alumnae must have been pleased: Evans's work reveals a sympathetic eye and is a successful attempt to represent as harmoniously as possible the Federal, Georgian Colonial, and Modernist styles mentioned by President Park in his foreword: "The college lends itself well to the talent of the photographer as three ages of architecture are here represented in buildings of real distinction, and the three styles meet here without disturbing the serenity and unity of the whole."[16] As found in a printer's proof in the Getty collection, this passage appears to have been corrected by Evans to read "medium" instead of "talent"; a note in the margin addressed to Evans confirms that the correction will be made. The foreword as published reflects this change.[17]

Also in the Getty collection are thirty-three photographs related to the Wheaton commission. Twenty-three prints in this group, most of them on Evans's original mounts, may have been the pictures used in preparing the plates for reproduction. They represent, in sometimes more inclusive croppings, all but one (pl. 15, *Everett Quadrangle*) of the twenty-four plates that make up the book. Six of the Getty photographs are duplicate printings. Among the variant croppings found in the Wheaton group, the most radical difference is seen in the two prints for plate 5 (nos. 822–23), a view of Mary Lyon Hall. For the

published version (no. 822), Evans cropped substantial portions of the negative at the left and at the bottom edge, coming in a little closer at the top and at the right as well. One end of a Cram building has been completely eliminated so that the revered Mary Lyon Hall nearly fills the frame, with just a suggestion of campus landscaping allowed at either side. The Getty variant of plate 20 (no. 842), an already severely cropped horizontal view of the Student Alumnae Building's Plimpton Hall wing, is a more successful composition than that published (no. 841), since it allows minor details (a drainpipe and three small windows) to balance the substantial architectural elements found in the two more prominent sections of this asymmetrical, three-part image. Although not sequenced to follow plate 16 (no. 837), which completes the picture of the back of the Alumnae Building, the unpublished Getty variant does take up where that view leaves off. In no. 837, Evans contrasts a broad, almost square, sparsely decorated wall of the Alumnae Building with the elegant upper portions of the Cole Chapel spire; in no. 842, he presents a more informative view of the long low span produced by Bennett and Hornbostel's design.

Evans's progression of twenty-four plates includes the representation of ten Cram buildings as well as views of Mary Lyon Hall and the Student Alumnae Building, but it is clear that he found Cole Memorial Chapel to be the most interesting, photographically, of Cram's works. In addition to opening the volume (no. 815), it appears in six plates, sometimes seen in the background and other times shown simply as a spire ascending above the treetops (no. 815), more a symbol of small-town serenity than of the academic search for wisdom and truth. A second favorite subject, also occurring in six plates, boldly manifests itself initially in plate 2 (no. 817): Mary Lyon Hall in its expanded and rejuvenated incarnation. This still-prominent campus fixture bears faint resemblance to its original (1849) character, and Evans chose to use the updating efforts to his advantage. The addition that

destroyed the symmetrical entrance on the first two-story facade provides another stackable geometric element that, in exaggerated foreshortening, the photographer plays off against the higher earlier gable and the 1878 Italianate crossing-tower. The dominance of these three elements increases with the two-dimensionality imparted by Evans's lens, but the short chimney and small skylight on either side of the tower make significant contributions to the composition, as does the barren tree (suggesting a date of very early spring 1941) in the right foreground. Mary Lyon Hall, or corners of that large edifice, are found juxtaposed with an even earlier campus monument, the President's House (built 1829), in three *Wheaton College* plates in the Getty collection (nos. 819–20, 827). The most interesting of these, *Main Street Entrance to College* (no. 827), pictures one side-bay of Mary Lyon Hall, with its highly stylized, brightly painted, Greek Revival elements—pilasters, entablature, and decorated windows—in the right foreground; in the background at left, set off against this brash exterior and looking almost humble by comparison, is the three-story home of the campus president, nestled in a grove of trees.

Although appearing only in the last third of the book, the real centerpiece of this effort, and, as mentioned above, probably its reason for existence, was the just-finished Student Alumnae Building of Bennett and Hornbostel. Evans includes four exterior and four interior views, supplying a more thorough look at this progressive, multipurpose building than he gave to the more traditional campus structures (nos. 837, 839–41, 843, 845–47). The offices of Student Government were to be housed here, as well as those of other student organizations, such as the undergraduate newspaper, the campus literary magazine, and the Camera Club. Space for lectures and banquets, for returning groups of alumnae gathering after Commencement, and, to answer a major need, for "the proper entertainment of men," was to be provided by the auditorium, parlors, and playrooms of this new building.[18] The site cho-

sen was the old tennis courts, a spot that was expected to feature "two of the most beautiful views of the campus . . . one looking over the hockey field to the lake beyond and the other looking down through the Pines."[19] Needless to say, Evans's approach to this structure had little to do with its strategic placement in attractive natural surroundings, although in plate 18 (no. 839) he did make good use of the birch trees in front of the campus entrance to the building. In this tightly cropped view, the stark, right-angle lines of the plain brick facade, with its three simple second-story windows, are relieved only by the curves of the birch tree branches and the potted shrubs. At the other end of the building, Evans did a "portrait" of the Plimpton Hall motor entrance (plate 19; no. 840). Composing as usual with line rather than space, he balances the gridded glass-brick window at the lower left with the heavy roof line at the upper right, an element accentuated by the strong shadow caught by Evans's camera. Here the right angles of restrained Modernism are eased by a more organic form, that of the sheltering roof extending from the glass doors to the driveway; now a motor entrance, this streamlined feature is a holdover from the days of carriage travel and the architect's porte cochere.

Evans also photographed the highly praised interior decoration of Ann Hatfield, recording in black and white what *Interiors* magazine hailed as "clear, pure, 'young' colors."[20] His interpretation of the so-called play-room (or game room), as well as his renderings of the parlors (nos. 843, 845, 847), might best be evaluated in the context of other illustrations published by the architectural press in early 1941. *Architectural Forum* and *Interiors* both carried favorable articles on the Student Alumnae Building featuring the photographs of Ezra Stoller.[21] About twenty-five years old at the time, Stoller had only been a professional architectural photographer for two years, but his widely known picture of the Chamberlain house by Gropius and Breuer had already created a demand for his work. As he would do after the war, when his reputation

Figure 1. Ezra Stoller (American, b. 1915). *Playroom*, ca. 1939. Gelatin silver print, 18.9 x 24.1 cm (7 7/16 x 9 15/32 in.). Ezra Stoller © Esto. All rights reserved.

escalated to the top of his field, Stoller approached the Wheaton assignment by working with both an experimental—or Contructivist—perspective (as in his stairway details) and in a factual style intended to provide clear information about the size, shape, and contents of buildings.[22]

The majority of Stoller's nineteen Alumnae Building illustrations presented by *Architectural Forum* are in the latter mode, with cars and people often included for purposes of scale and to make clear the functions of the different parts of the buildings. Evans's campus, on the other hand, seems to be uninhabited; this emptiness is felt most strongly in his Alumnae Building interiors, where the pristine condition of the space adds to the slightly surreal, showroom effect encouraged by the perfect detail of his large-format negatives. In addition to arranging students, plants, and furniture in model groups around the room, Stoller shoots the game room from one end, so that the fireplace in the brick wall opposite him becomes the center of attention (fig. 1). Unfortunately, the fireplace and all

Figure 2. Walker Evans. *Wheaton College:
The Game Room*, 1941 [no. 845].

ment about his unique talent for interpreting architecture. Harriet Hughes, author of the 1941 *Interiors* article, described this room as having light green walls, a maroon carpet, and drapery fabrics in complementary colors. The furnishings, she claimed, "please every age and taste."[23] Fitting out this seemingly incongruous room was apparently one of the decorator's biggest challenges:

> *The alumnae have not been neglected for the young things, you see, and as a matter of fact, it is in the Alumnae Parlor that Ann Hatfield's skill and discernment are perhaps best shown. In spite of alumnae espousal of modern style, it was felt that the decoration of the Alumnae Parlor would have to take into account that its furnishings would include heirloom pieces from the old Seminary parlors. So Ann Hatfield gave this room a Victorian flavor and charmingly harmonized the cherished old furniture with contemporary fabrics and lamps and colors.*[24]

the other components of the space are nearly overwhelmed in Stoller's picture by the loudly painted floor designs that create their own diagonal tension, adding to the overall clutter of his composition. Evans's *Game Room* (no. 845; fig. 2), which also appears as the book's plate 22, is another space altogether: there are no plants or people, and the Alvar Aalto chairs and couches are lined up against the walls or end to end in the immediate foreground. Evans has positioned himself at the fireplace end of the room, so that the view is toward the open doorway. Unlike Stoller's artificially lit tableau, Evans's photograph exploits the natural light coming from that open door as well as from the large side windows. It is a tranquil space, again constructed of hard right angles and displaying a fairly elaborate pattern of light and dark areas created by wall color, upholstery, and intense-to-subtle shadows.

Contrasting treatments of the Alumnae Parlor, the subject of Evans's last plate (fig. 3), offer a final state-

Stoller chose a three-quarter view of the parlor that shows off more of the furnishings, both heirloom and modern, yet tends to emphasize the undistinguished floral arrange-

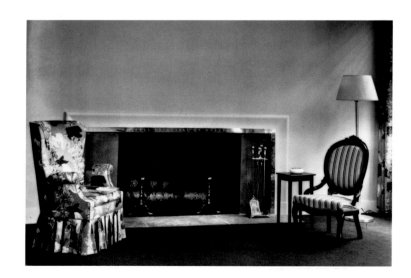

Figure 3. Walker Evans. *Wheaton College:
The Alumnae Parlor*, 1941 [no. 847].

ments of foreground and background.[25] Central to his composition is an ineffective, overlapping assemblage of chair, lamp, and drapes that, although in the opposite corner, appear to hover above the foreground blooms. Evans, instead, directs our attention to the fireplace, its accessories, and the two chairs that seem to stand guard. His viewpoint lowers the ceiling and creates a more intimate mood by eliminating much of the front wall, all of the side walls, and any foreground carpet that is not absolutely necessary. A thin slice of drapery at the right is the only contextual detail; it was included, no doubt, to offset the conspicuous floral pattern of the armchair at the left. In his concluding

plate—a minimal depiction of a pseudo-Victorian parlor in a nineteen-forties Modernist building on the oldest campus in America "for the advanced education of females"— Evans surpasses his task of making this newcomer to Wheaton "fit in beautifully." In doing so, he seems to have drawn inspiration from the simple interiors of the Alabama tenant-farmer homes he had photographed in 1936 (no. 548, for example). He may also have been looking forward to the collection of photographs of parlors and other well-worn places he would publish many years later as *Message from the Interior* (no. 1183).[26]

NOTES

1. J. Edgar Park, foreword to Walker Evans, *Wheaton College Photographs* (Norton, Mass.: Wheaton College, 1941), n.p.

2. For background on the Wheaton campus and information about the competition and exhibition, I have relied heavily on Thomas J. McCormick's "Wheaton College, Competition for an Art Center, February 1938–June 1938" in James D. Kornwolf, ed., *Modernism in America, 1937–1941: A Catalog and Exhibition of Four Architectural Competitions* (Williamsburg, Va.: Joseph and Margaret Muscarelle Museum of Art, College of William and Mary, 1985).

3. Ibid., 28.

4. Harriet E. Hughes, "Century Old Wheaton College Sponsors Modern," *Interiors* (Feb. 1941), 25, 28.

5. McCormick, "Wheaton College," 23.

6. In Paul Venable Turner's *Campus: An American Planning Tradition* (New York and Cambridge: Architectural History Foundation and MIT Press, 1984; paperback ed., 1987), 251. This phenomenon is discussed with a mention of the Wheaton competition and the role of *Architectural Forum* in fostering the acceptance of Modernism for campus design.

7. McCormick, "Wheaton College," 30.

8. Ibid., 24.

9. Ibid.

10. Ibid., 26.

11. See note 1.

12. Phone conversation with the author, June 29, 1993.

13. Ibid.

14. McCormick, "Wheaton College," 36.

15. In addition to his 1938 exhibition *Walker Evans: American Photographs*, Park and Seaver may have been aware of the 1933 MoMA exhibition *Walker Evans: Photographs of Nineteenth-Century Houses* that resulted from the Victorian house project he carried out with Kirstein and Wheelwright (see chapter one). Additionally, Evans was a close acquaintance of Thomas Mabry, an administrator at the museum from 1935 to 1939 and executive director at the time of the Wheaton competition show.

16. Park, foreword in a signed proof copy of *Wheaton College Photographs*, JPGM 84.XG.963.34.

17. Park, foreword to *Wheaton College Photographs*, n.p.

18. Hughes, "Wheaton College Sponsors Modern," 24–29, 44–48, and Kathleen Emerson Swan, "Student Alumnae Building," *Wheaton Alum-nae Quarterly* XVIII:4 (Aug. 1939), 3–6, are both informative sources for the proposed functions of the Alumnae Building; Swan mentions specifically the need for "Adequate facilities for the proper entertainment of men," p. 4.

19. Swan, "Student Alumnae Building," 4.

20. Hughes, "Wheaton College Sponsors Modern," 47.

21. See "Student Alumnae Building, Wheaton College, Norton, Mass., Caleb Hornbostel and Richard M. Bennett, Architects," *Architectural Forum* (Jan. 1941), 53–62, and Hughes, "Wheaton College Sponsors Modern." The *Architectural Forum* illustrations are credited to Stoller; though seemingly not credited, six of the eight views published in *Interiors* duplicate those found in *Architectural Forum*, indicating that the other two images are also Stoller's.

22. For Stoller's career, see Cervin Robinson and Joel Herschman, *Architecture Transformed: A History of the Photography of Buildings from 1839 to the Present* (New York and Cambridge: Architectural League of New York and MIT Press, 1987).

23. Hughes, "Wheaton College Sponsors Modern," 26.

24. Ibid., 47.

25. "Student Alumnae Building, Wheaton College, Norton, Mass.," 60 ("Alumnae Parlor").

26. Walker Evans, *Message from the Interior* (New York: Eakins Press, 1966).

815

The Wheaton College Commission

The thirty-three Getty prints on the subject of Wheaton College architecture are ordered here in keeping with the plates found in the 1941 publication for which they were commissioned, *Wheaton College Photographs*. They represent twenty-three of the twenty-four images that appeared in the book, as well as duplicates or variant croppings of those images.

815
[*Wheaton College: Cole Memorial Chapel (1917)*], 1941
Image: 21.3 x 17 cm (8 ⅜ x 6 ²³⁄₃₂ in.); original mount: 31.4 x 25.9 cm (12 ⅜ x 10 ³⁄₃₂ in.)
84.XM.956.540
MARKS & INSCRIPTIONS: (Recto, mount) signed at l. right, in pencil, by Evans, *Walker Evans*; in right mount margin, in pencil, - *7 ½″* -; at l. right, in black ink, by Evans, *9.15*; (verso, mount) at l. left, in pencil, *M*; at l. right, in pencil, *L-9876-24*; at l. left, in pencil, Crane no. *L75.1*(*Evans*).
REFERENCES: WCP, pl. 1.

817

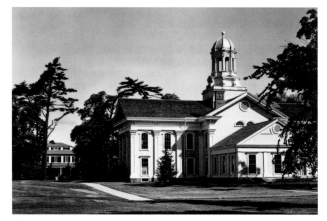

818

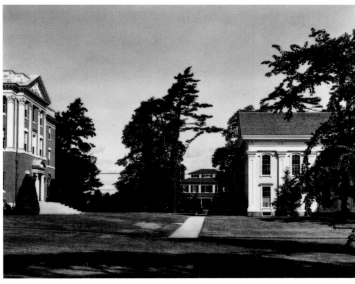

820

MARKS & INSCRIPTIONS: (Recto, mount) signed at l. right, in pencil, by Evans, *Walker Evans*; (verso, mount) at l. left, in pencil, by Arnold Crane, *Wheaton College/AHC*; at l. left, in pencil, Crane no. *L75.3(Evans).*
REFERENCES: WCP, pl. 3 (variant).

819
[*Wheaton College: Mary Lyon Hall and President's House (1829)*], 1941
16.6 x 23.1 cm (6 ⁹⁄₁₆ x 9 ³⁄₃₂ in.)
84.XM.956.529
MARKS & INSCRIPTIONS: (Verso) signed at center, in pencil, by Evans, *Walker* Evans; at l. right, in pencil, *2nd Print*; at l. left, in pencil, Crane no. *L75.26 (Evans).*
REFERENCES: WCP, pl. 3 (variant).
NOTE: Not illustrated; variant of no. 818.

820
[*Wheaton College: Administration Building (1934), President's House, and Mary Lyon Hall*], 1941
Image: 16.8 x 21 cm (6 ⁵⁄₈ x 8 ⁹⁄₃₂ in.); original mount: 31.4 x 25.9 cm (12 ³⁄₈ x 10 ³⁄₃₂ in.)
84.XM.956.537
MARKS & INSCRIPTIONS: (Recto, mount) signed at l. right, in pencil, by Evans, *Walker Evans*; at l. center, in pencil, -6″-; at l. right, in black ink, by Evans, *3.6*; (verso, mount) at l. right, in pencil, *L-9876-24*; at u. left, in pencil, *M*; at l. left, in pencil, Crane no. *L75.4 (Evans).*
REFERENCES: WCP, pl. 4.

821
[*Wheaton College: Administration Building (1934), President's House, and Mary Lyon Hall*], 1941
Image: 16.6 x 21.1 cm (6 ¹⁷⁄₃₂ x 8 ⁵⁄₁₆ in.); original mount: 31.4 x 25.9 cm (12 ³⁄₈ x 10 ³⁄₃₂ in.)
84.XM.956.558
MARKS & INSCRIPTIONS: (Recto, mount) signed at l. right, in pencil, by Evans, *Walker Evans*; at l. center, in pencil, -6″-; at l. left, in pencil, *C*; at l. center, in pencil, *4.*; at l. right, in pencil, *3 and 6* [circled]; (verso, mount) at l. right, in pencil, *L9876-24* [underlined]/*24/150sc*; at l. center, in pencil, by Arnold Crane, *Wheaton College/ AHC*; at l. left, in pencil, Crane no. *L75.29(Evans).*
REFERENCES: WCP, pl. 4.
NOTE: Not illustrated; duplicate of no. 820.

816
[*Wheaton College: Cole Memorial Chapel (1917)*], 1941
Image: 21.9 x 16.9 cm (8 ⁵⁄₈ x 6 ²¹⁄₃₂ in.); original mount: 31.4 x 25.9 cm (12 ³⁄₈ x 10 ³⁄₃₂ in.)
84.XM.956.556
MARKS & INSCRIPTIONS: (Recto, mount) signed at l. right, in pencil, by Evans, *Walker Evans*; in right mount margin, in pencil, -7 ¹⁄₂″-; at l. left, in pencil, *E*; at l. center, in pencil, *1.*; at l. right, *9 and 15* [circled]; (verso, mount) at l. left, in pencil, by Arnold Crane, *Wheaton College/AHC*; at l. center, in pencil, *L9876–24/24.*

REFERENCES: WCP, pl. 1.
NOTE: Not illustrated; duplicate of no. 815.

817
[*Wheaton College: Mary Lyon Hall*], 1941
Image: 19.9 x 14.7 cm (7 ²⁷⁄₃₂ x 5 ²⁵⁄₃₂ in.); original mount: 31.4 x 25.9 cm (12 ³⁄₈ x 10 ³⁄₃₂ in.)
84.XM.956.539
MARKS & INSCRIPTIONS: (Recto, mount) signed at l. right, in pencil, by Evans, *Walker Evans*; in left mount margin, in

pencil, -7 ¹⁄₂″- [sideways]; at l. left, in pencil, *19.*; at l. center, in pencil, *2.*; at l. right, *15 and 2* [circled] (verso, mount) at right center, in pencil, *L987624* [underlined]/*24*; at l. left, in pencil, Crane no. *L75.2(Evans).*
REFERENCES: WCP, pl. 2.

818
[*Wheaton College: Mary Lyon Hall and President's House (1829)*], 1941
Image: 14.9 x 21.4 cm (5 ⁷⁄₈ x 8 ⁷⁄₁₆ in.); original mount: 31.4 x 25.9 cm (12 ³⁄₈ x 10 ³⁄₃₂ in.)
84.XM.956.538

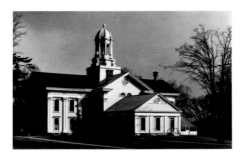

822

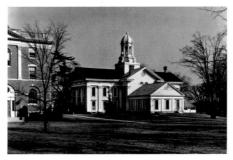

823

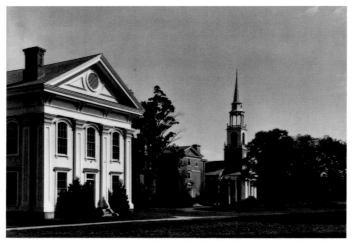

824

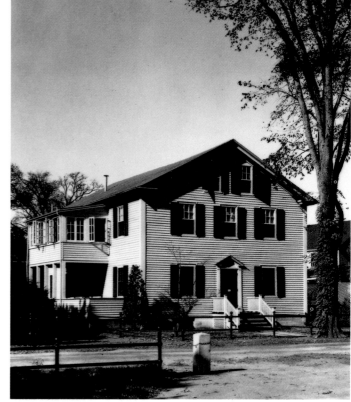

826

822
[*Wheaton College: Mary Lyon Hall from Campus*], 1941
Image: 11.6 x 17.8 cm (4 ⁹⁄₁₆ x 7 in.); original mount: 31.4 x 25.9 cm (12 ³⁄₈ x 10 ³⁄₃₂ in.)
84.XM.956.548
MARKS & INSCRIPTIONS: (Recto, mount) signed at l. right, in pencil, by Evans, *Walker Evans*; at l. center, in pencil, *5.*; at l. right, in pencil, *15* and *8* [circled]; (verso, mount) at l. right, in pencil, *L 9876-24* [underlined]/*24 150 sc*; at l. left, in pencil, Crane no. *L75.5 (Evans)*.
REFERENCES: WCP, pl. 5.

823
[*Wheaton College: View of Mary Lyon Hall*], 1941
17 x 24.2 cm (6 ¹¹⁄₁₆ x 9 ⁹⁄₁₆ in.)
84.XM.956.561
MARKS & INSCRIPTIONS: (Verso, mount) at l. left, Evans stamp A; at l. right, in pencil, by Arnold Crane, *Wheaton College/AHC*; at l. left, in pencil, Crane no. *L75.6(Evans)*.
REFERENCES: WCP, pl. 5 (variant).

824
[*Wheaton College: Mary Lyon Hall, Science Building (1911), and Chapel*],

1941
Image: 14.3 x 19.9 cm
(5 ⅝ x 7 ¹³⁄₁₆ in.); original mount: 31.4 x 25.9 cm (12 ⅜ x 10 ³⁄₃₂ in.)
84.XM.956.557
MARKS & INSCRIPTIONS: (Recto, mount) signed at l. right, in pencil, by Evans, *Walker Evans*; at l. center, in pencil, *-6″-*; at l. left, in pencil, *25.*; at l. center, in pencil, *6.*; at l. right, in pencil, *11* and *19B* [circled]; (verso, mount) at u. right, in pencil, *L9876.24* [underlined]/*24*; at l. left, in pencil, *MARY LYON HALL, SCIENCE BUILDING (1911), AND CHAPEL PLATE 6*; at l. left, in pen-

cil, by Arnold Crane, *Wheaton College/AHC*; at l. left, in pencil, Crane no. *L75.30(Evans)*.
REFERENCES: WCP, pl. 6.

825
[*Wheaton College: Mary Lyon Hall, Science Building (1911), and Chapel*], 1941
Image: 15.2 x 20.1 cm (6 x 7 ²⁹⁄₃₂ in.); original mount: 31.4 x 25.9 cm (12 ⅜ x 10 ³⁄₃₂ in.)
84.XM.956.547
MARKS & INSCRIPTIONS: (Recto, mount) signed at l. right, in pencil, by Evans,

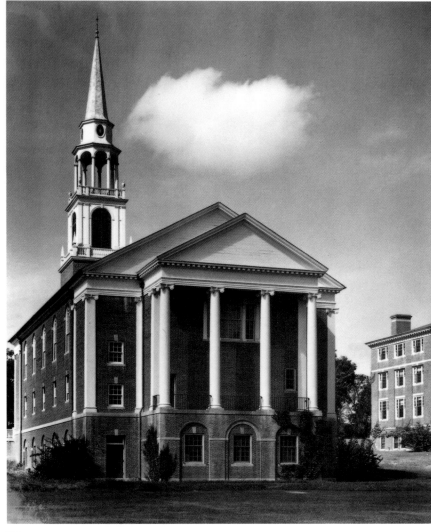

827

828

Walker Evans; at l. center, in pencil, -6″-; at l. right, in black ink, by Evans, *11.19B*; at u. right, in pencil, *76.5* [circled]; (verso, mount) at l. right, in pencil, *L. 9876-24*; at u. right, in pencil, *W (?)*; at l. left, in pencil, Crane no. *L75.7(Evans)*.

REFERENCES: WCP, pl. 6.

NOTE: Not illustrated; duplicate of no. 824.

826
[*Wheaton College: "The Sem" (1835)*], 1941
Image: 17.4 x 13.1 cm

(6 ²⁷/₃₂ x 5 ⅛ in.); original mount: 31.4 x 25.9 cm (12 ⅜ x 10 ³/₃₂ in.)
84.XM.956.546

MARKS & INSCRIPTIONS: (Recto, mount) signed at l. right, in pencil, by Evans, *Walker Evans*; at l. right, in black ink, *12.10*; in right mount margin, in pencil, *-7 ½″-* [sideways]; at u. right, in pencil, *89.0*; (verso, mount) at u. right, in pencil, *W (?)*; at l. right, in pencil, *L.9876-24*; at l. left, in pencil, Crane no. *L75.8(Evans)*.

REFERENCES: WCP, pl. 7.

827
[*Wheaton College: Main Street Entrance to College*], 1941
Image: 20.3 x 18.6 cm (8 x 7 ⁵/₁₆ in.); original mount: 31.4 x 25.9 cm (12 ⅜ x 10 ³/₃₂ in.)
84.XM.956.545

MARKS & INSCRIPTIONS: (Recto, mount) signed at l. right, in pencil, by Evans, *Walker Evans*; at l. center, in pencil, -6″-; at l. left, in pencil, by Evans, *23.*; at l. center, in pencil, *8.*; at l. right, in pencil, *3* and *2* [circled]; (verso, mount) at u. right, in pencil, *L 9876-24* [underlined]/*24*; at l. left, in pencil, Crane no. *L75.9(Evans)*.

REFERENCES: WCP, pl. 8.

828
[*Wheaton College: Chapel from the Athletic Field*], 1941
23.3 x 18.3 cm (9 ³/₁₆ x 7 ⁷/₃₂ in.)
84.XM.956.544

MARKS & INSCRIPTIONS: (Verso) signed at l. right center, in pencil, by Evans, *Walker Evans*; at center left, in pencil, *-7 ½″-*; at l. right, in pencil, *L-9876* [underlined]/*24* and *82.2* [circled and sideways]; at l. left, in pencil, Crane no. *L75.10(Evans)*.

REFERENCES: WCP, pl. 9.

829

830

831

832

829
[*Wheaton College: The Spire*], 1941
22.4 x 18.6 cm (8 ¹³⁄₁₆ x 7 ⁵⁄₁₆ in.)
84.XM.956.543
MARKS & INSCRIPTIONS: (Verso) at l. right center, Evans stamp A; at l. center, in pencil, *-6″-*; at l. left center, in pencil, *L-9876* [underlined]/*24*; at u. left, in pencil, *W (?)*; at u. right, in pencil, *82.5* [circled]; at l. right, in pencil, *W*; at l. left, in pencil, Crane no. *L75.11 (Evans)*.
REFERENCES: WCP, pl. 10.

830
[*Wheaton College: Science Building and Chapel*], 1941
18.2 x 14 cm (7 ³⁄₁₆ x 5 ¹⁷⁄₃₂ in.)
84.XM.956.542
MARKS & INSCRIPTIONS: (Verso) at l. center, Evans stamp A; at center, in pencil, *-7 ½″-*; at u. left, in pencil, *E 95.0″* [circled]; at right center, *L-9876* [underlined]/*24*; at l. left, in pencil, Crane no. *L75.12 (Evans)*.
REFERENCES: WCP, pl. 11.

831
[*Wheaton College: Campus from Main Street Entrance*], 1941

Image: 18.4 x 18.2 cm (7 ¼ x 7 ³⁄₁₆ in.); original mount: 31.4 x 25.9 cm (12 ³⁄₈ x 10 ³⁄₃₂ in.)
84.XM.956.541
MARKS & INSCRIPTIONS: (Recto, mount) signed at l. right, in pencil, by Evans, *Walker Evans*; at l. center, in pencil, *-6″-*; at l. left, in pencil, by Evans, *22.*; at l. center, in pencil, *12.*; at l. right, in pencil *15* and *12* [circled]; (verso, mount) at u. left, in pencil, *L 9876-24* [underlined]/*24* [inverted]; at l. left, in pencil, Crane no. *L75.13 (Evans)*.
REFERENCES: WCP, pl. 12.

832
[*Wheaton College: Campus from Main Street Entrance*], 1941
18.5 x 20.6 cm (7 ⁵⁄₁₆ x 8 ³⁄₃₂ in.)
84.XM.956.550
MARKS & INSCRIPTIONS: (Verso) at l. left, Evans stamp A; at l. right, in pencil, by Arnold Crane, *Wheaton College/ AHC*; at l. left, in pencil, Crane no. *L75.25 (Evans)*.
REFERENCES: WCP, pl. 12 (variant).

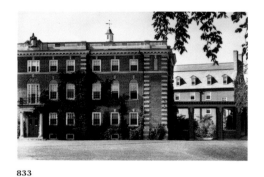

833

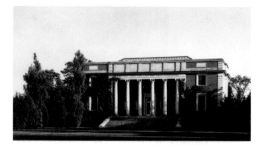

835

837

84.XM.956.553
MARKS & INSCRIPTIONS: (Recto, mount) signed at l. right, in pencil, by Evans, *Walker Evans*; at l. center, in pencil, *-6″-*; at l. left, in pencil, by Evans, *5.*; at l. center, in pencil, by Evans, *14.*; at l. right, in pencil, *11* and *5* [circled]; (verso, mount) at l. right, in pencil, *L9876-24* [underlined]/*24*; at l. left, in pencil, by Arnold Crane, *Wheaton College/AHC*; at l. left, in pencil, Crane no. *L75.33(Evans)*.
REFERENCES: WCP, pl. 14 (variant).

836
[*Wheaton College: The Library (1923)*], 1941
Image: 12.8 x 20.9 cm (5 ¹/₃₂ x 8 ⁷/₃₂ in.); original mount: 31.4 x 25.9 cm (12 ³/₈ x 10 ³/₃₂ in.)
84.XM.956.532
MARKS & INSCRIPTIONS: (Recto, mount) signed at l. right, in pencil, by Evans, *Walker Evans*; at l. center, in pencil, *-6″-*; at u. right, in pencil, *73.5* [circled]; at right, in ink, *11.5*; (verso, mount) at l. left, in pencil, *No (?)*; at l. right, in pencil, *L-9876-24*; at l. left, in pencil, Crane no. *L75.15(Evans)*.
REFERENCES: WCP, pl. 14 (variant).
NOTE: Not illustrated; duplicate of no. 835.

837
[*Wheaton College: The Spire from Student Alumnae Building (1940)*], 1941
Image: 16.9 x 21.2 cm (6 ⁵/₈ x 8 ³/₈ in.); mount: 31.4 x 25.9 cm (12 ³/₈ x 10 ³/₃₂ in.)
84.XM.956.531
MARKS & INSCRIPTIONS: (Recto, mount) signed at l. right, in pencil, by Evans, *Walker Evans*; at l. center, in pencil, *-6″-*; at l. left, in pencil, by Evans, *21.*; at l. center, in pencil, *16.*; at l. right, in pencil, *15* [space] *4* [last number circled]; (verso, mount) at l. center, in pencil, *L9876-24* [underlined]/*24/150 sc*; at l. center, in pencil, Crane no. *L75.16(Evans)*.
REFERENCES: WCP, pl. 16.

833
[*Wheaton College: Everett (1926) and Cragin (1911) Halls*], 1941
Image: 15.8 x 23.5 cm (6 ¼ x 9 ¼ in.); original mount: 31.4 x 25.9 cm (12 ³/₈ x 10 ³/₃₂ in.)
84.XM.956.535
MARKS & INSCRIPTIONS: (Recto, mount) signed at l. right, in pencil, by Evans, *Walker Evans*; at l. center, in pencil, *-6″-*; at l. right, in black ink, by Evans, *12.18*; at u. right, in pencil, *64.4/150 screen*; at u. right, in pencil, *65.0* [circled]; (verso, mount) at l. right, *L.9876.24* [underlined]/*150sc*; at l. left, in pencil, Crane no. *L75.14(Evans)*.
REFERENCES: WCP, pl. 13 (variant).

834
[*Wheaton College: Everett (1926) and Cragin (1911) Halls*], 1941
Image: 14.9 x 23.6 cm (5 ⁷/₈ x 9 ⁹/₃₂ in.); original mount: 31.4 x 25.9 cm (12 ³/₈ x 10 ³/₃₂ in.)
84.XM.956.555
MARKS & INSCRIPTIONS: (Recto, mount) signed at l. right, in pencil, by Evans, *Walker Evans*; at l. center, in pencil, *-6″-*; at l. left, in pencil, by Evans, *13.*; at l. center, in pencil, *13.*; at l. right,

in pencil, by Evans, *12* and *18* [circled]; (verso, mount) at l. right, in pencil, *L9876–24/24* [space] *150 sc*; at l. left, in pencil, by Arnold Crane, *Wheaton College/AHC*; at l. left, in pencil, Crane no. *L75.32(Evans)*.
REFERENCES: WCP, pl. 13.
NOTE: Not illustrated; variant of no. 833.

835
[*Wheaton College: View of the Library (1923)*], 1941
Image: 12.4 x 20.8 cm (4 ⁷/₈ x 8 ³/₁₆ in.); original mount: 31.4 x 25.9 cm (12 ³/₈ x 10 ³/₃₂ in.)

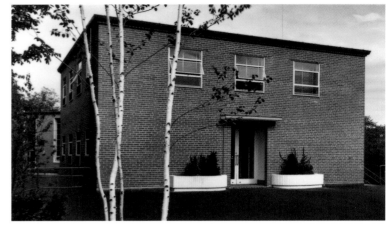

839

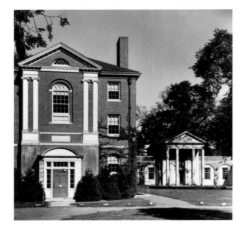

838

841

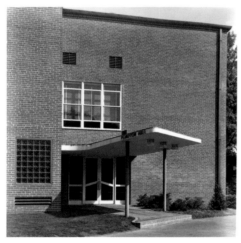

840

842

838
[*Wheaton College: Hebe Court (1932)*],
1941
Image: 18.4 x 18.2 cm (7 ¼ x 7 ³⁄₁₆ in.);
original mount: 31.4 x 25.9 cm
(12 ⅜ x 10 ³⁄₃₂ in.)
84.XM.956.530
MARKS & INSCRIPTIONS: (Recto, mount)
signed at l. right, in pencil, by Evans,
Walker Evans; at l. center, in pencil,
-6″-; at l. right, in black ink, by Evans,
12.13; (verso, mount) at l. right, in pen-
cil, *L-9876-24*; at u. left, in pencil,
W (?); at l. left, in pencil, Crane
no. *L75.17(Evans)*.
REFERENCES: WCP, pl. 17.

839
[*Wheaton College: Campus Entrance,
Student Alumnae Building*], 1941
Image: 13.2 x 22.2 cm (5 ³⁄₁₆ x 8 ¾ in.);
original mount: 31.4 x 25.9 cm
(12 ⅜ x 10 ³⁄₃₂ in.)
84.XM.956.549
MARKS & INSCRIPTIONS: (Recto, mount)
signed at l. right, in pencil, by Evans,
Walker Evans; at l. center, in pencil,
-6″-; at l. right, in black ink, *7.16*; at
u. right, in pencil, *68.5* [circled];
(verso, mount) at l. right, in pencil,
L-9876-24; at u. right, in pencil, *W (?)*;
at l. left, in pencil, Crane no. *L75.18
(Evans)*.
REFERENCES: WCP, pl. 18.

840
[*Wheaton College: Plimpton Entrance,
Student Alumnae Building*], 1941
Image: 19.2 x 18.4 cm (7 ⁹⁄₁₆ x 7 ¼ in.);
original mount: 31.4 x 25.9 cm
(12 ⅜ x 10 ³⁄₃₂ in.)
84.XM.956.551
MARKS & INSCRIPTIONS: (Recto, mount)
signed at l. right, in pencil, by Evans,
Walker Evans; at l. center, in pencil,
-6″-; at l. left, in pencil, by Evans, *7.*;
at l. center, in pencil, by Evans, *19.*; at
l. right, in pencil, *9 and 5* [circled];
(verso, mount) at l. right, in pencil,
L9876-24 [underlined]*/24*; at l. left, in
pencil, Crane no. *L75.19(Evans)*.
REFERENCES: WCP, pl. 19 (variant).

841
[*Wheaton College: Student Alumnae
Building from College Pines*], 1941
Image: 10 x 21.6 cm (3 ¹⁵⁄₁₆ x 8 ½ in.);
original mount: 31.4 x 25.9 cm
(12 ⅜ x 10 ³⁄₃₂ in.)
84.XM.956.552
MARKS & INSCRIPTIONS: (Recto, mount)
signed at l. right, in pencil, by Evans,
Walker Evans; at l. center, in pencil,
-6″-; at l. left, in pencil, *3.*; at l. center,
in pencil, by Evans, *20.*; at l. right, in

843

845

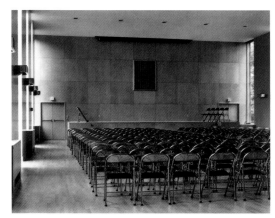

846

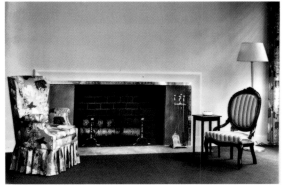

847

MARKS & INSCRIPTIONS: (Recto, mount) signed at l. right, in pencil, by Evans, *Walker Evans*; at l. center, in pencil, *-6″-*; at l. right, in black ink, *13.9*; at u. right, in pencil, *65.5* [circled]; (verso, mount) at u. right, in pencil, *W (?)*; at l. right, in pencil, *L-9876-24*; at l. left, in pencil, by Arnold Crane, *Wheaton College/AHC*; at l. left, in pencil, Crane no. *L75.28(Evans)*.
REFERENCES: WCP, pl. 21.
NOTE: Not illustrated; duplicate of no. 843.

845
[*Wheaton College: The Game Room*], 1941
Image: 18.4 x 19.8 cm (7 ⁷/₃₂ x 7 ²⁵/₃₂ in.); original mount: 31.4 x 25.9 cm (12 ³/₈ x 10 ³/₃₂ in.)
84.XM.956.533
MARKS & INSCRIPTIONS: (Recto, mount) signed at l. right, in pencil, by Evans, *Walker Evans*; at l. center, in pencil, *-6″-*; at l. left, in pencil, by Evans, *18.*; at l. right, in pencil, by Evans, *22.*; at l. right, in pencil, *7*; at l. right, in pencil, *5* [circled]; (verso, mount) at l. right, in pencil, *L9876.24* [underlined]/*24*; at l. left, in pencil, Crane no. *L75.22(Evans)*.
REFERENCES: WCP, pl. 22.

846
[*Wheaton College: Plimpton Hall*], 1941
Image: 17.8 x 21.5 cm (7 x 8 ⁷/₁₆ in.); original mount: 31.4 x 25.9 cm (12 ³/₈ x 10 ³/₃₂ in.)
84.XM.956.534
MARKS & INSCRIPTIONS: (Recto, mount) signed at l. right, in pencil, by Evans, *Walker Evans*; at l. center, in pencil, *-6″-*; at l. left, in pencil, by Evans, *16.*; at l. center, in pencil, by Evans, *23*; at l. right, in pencil, *13* [space] *11* [last number circled]; (verso, mount) at u. left, in pencil, *L9876.24* [underlined]/*24*; at l. left, in pencil, Crane no. *L75.23(Evans)*.
REFERENCES: WCP, pl. 23.

847
[*Wheaton College: The Alumnae Parlor*], 1941
Image: 16.9 x 24.2 cm (6 ¹¹/₁₆ x 9 ⁹/₁₆ in.); original mount: 31.4 x 25.9 cm (12 ³/₈ x 10 ³/₃₂ in.)
84.XM.956.536
MARKS & INSCRIPTIONS: (Recto, mount) signed at l. right, in pencil, by Evans, *Walker Evans*; at l. center, in pencil, *-6″-*; at l. right, in black ink, by Evans (?): *13.16*; at u. right, in pencil, *638* [circled]; (verso, mount) at l. right, in pencil, *L.9876-24*; at l. left, in pencil, Crane no. *L75.24(Evans)*.
REFERENCES: WCP, pl. 24.

pencil, *9* and *3* [circled]; (verso, mount) at l. right, in pencil, *L9876* [space] *24* [underlined]/*24* [space] *150 sc*; at l. left, in pencil, Crane no. *L75.20(Evans)*.
REFERENCES: WCP, pl. 20.

842
[*Wheaton College: Student Alumnae Building from College Pines*], 1941
Image: 10.7 x 24 cm (4 ⁷/₃₂ x 9 ⁷/₁₆ in.); original mount: 31.4 x 25.9 cm (12 ³/₈ x 10 ³/₃₂ in.)
84.XM.956.560
MARKS & INSCRIPTIONS: (Recto, mount)

signed at l. right, in pencil, by Evans, *Walker Evans*; (verso, mount) at l. left, in pencil, by Arnold Crane, *Wheaton College/AHC*; at l. left, in pencil, Crane no. *L75.27(Evans)*.
REFERENCES: WCP, pl. 20 (variant).

843
[*Wheaton College: The Yellow Parlor*], 1941
Image: 9.3 x 23.4 cm (3 ¹¹/₁₆ x 9 ³/₁₆ in.); original mount: 31.4 x 25.9 cm (12 ³/₈ x 10 ³/₃₂ in.)
84.XM.956.554
MARKS & INSCRIPTIONS: (Recto, mount) signed at l. right, in pencil, by Evans,

Walker Evans; at l. center, in pencil, *-6″-*; at l. left, in pencil, by Evans, *14.*; at l. center, in pencil, by Evans, *21.*; at l. right, in pencil, *13* and *9* [circled]; (verso, mount) at center, in pencil, *L9876.24/24* [inverted]; at l. left, in pencil, Crane no. *L75.21(Evans)*.
REFERENCES: WCP, pl. 21.

844
[*Wheaton College: The Yellow Parlor*], 1941
Image: 9.6 x 23.3 cm (3 ²⁵/₃₂ x 9 ³/₁₆ in.); original mount: 31.4 x 25.9 cm (12 ³/₈ x 10 ³/₃₂ in.)
84.XM.956.559

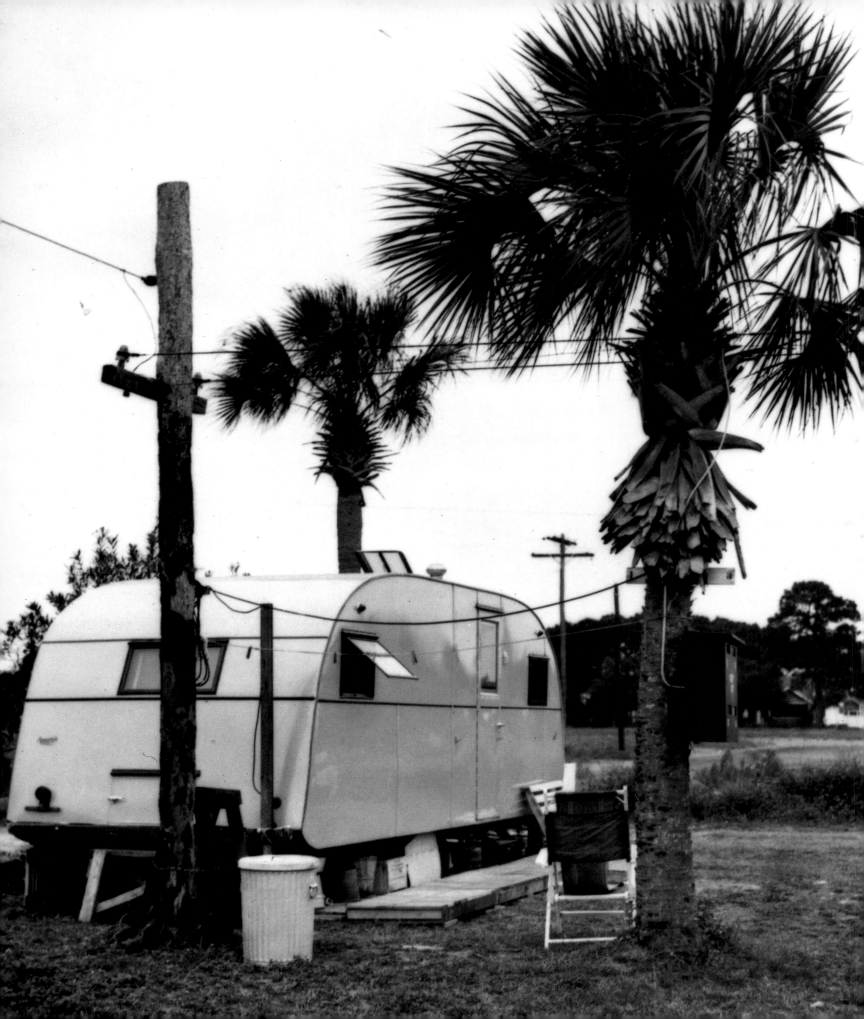

ON THE WEST COAST
OF FLORIDA

1940 . . . Resort areas have their most profitable tourist season in Florida history, as the second World War prevents travel to Europe.

From *Florida: A Guide to the Southernmost State*, published by the Works Progress Administration[1]

Longtime newspaperman Karl Bickel retired with his wife to Sarasota, Florida, in 1935. Bickel had been president of what was then called United Press Associations (now UPI) from 1923 to 1935, had written the book *New Empires: The Newspaper and the Radio* (1930), and, in 1932, had confidentially advised Charles Lindbergh on how to deal with the media during the ordeal of his son's kidnapping.[2] In the quiet resort town of Sarasota (population about 8,000), Bickel quickly became a community leader working toward economic as well as cultural improvements. During this very active retirement, Bickel also took up the hobby of researching the history of the west coast of Florida. The resulting book, brought out in 1942, ranges in undistinguished prose from the geology of the region to the legends of its explorers to the author's personal reminiscences about favorite fishing trips. Promoting the scope and variety of the book's contents, the dust jacket of the first edition describes the author's accomplishment as follows:

Playing one legend up, tearing another to tatters, studying the West Coast's many palm trees and the

Walker Evans. *Trailer in Camp (Sarasota)* [detail], 1941 [no. 913].

winds which blow good seed from the coasts of Latin America to the continent of North America, describing the big snakes of the glades, the vanished parakeets, laying out the story of the Seminole wars for the lessons there are in them still for those who go to war today, watching Andrew Jackson and his wife arrive in Tallahassee for the taking over for the USA, seeing the Rough Riders off to Cuba—Karl Bickel has caught completely the peculiar treasures of its history and its landscape.[3]

The Mangrove Coast: The Story of the West Coast of Florida concerns a stretch of the state along the Gulf of Mexico described by Bickel as extending "from Ancolote Anchorage to Sanibel Key and then tapering off from Sanibel southward to the distant mouth of the Shark."[4] In the book's epilogue, Bickel declares that the attraction of the Mangrove Coast is actually to be found, not in its past, but "in its intangibles: the gleam of white sand, the softness of southwest winds, pink and turquoise sunsets, and the abiding simplicity of its people."[5] Going on to explain the uncomplicated ways of the Mangrove Coast population, Bickel brings up the subject of the tourist:

From the first, the Mangrove Coast, besides being

hospitable and 'agin snobs,' saw there was a future in the business of entertaining the tourists who came in trailers. While other communities were passing ordinances forbidding trailers from parking within their city limits, Sarasota, for example, was making model arrangements for laundries and social halls and water and light for as many trailers as wanted to come. It boasts today of the finest municipal trailer camp in the world . . .[6]

Although the text is, for the most part, written in the style of straightforward journalism, one gets a glimpse of Bickel's good-humored, slightly sardonic view of contemporary life on Florida's west coast in his discussion of tourist habits:

By mid-December the tourists start rolling in from the Midwest and Ohio, down for Christmas. A month later, the New Yorkers, the rich and leisured, the government and corporation pensioners from Connecticut, Pennsylvania and New England come—come for the same reason as the robins do, to evade the cold and eat, to go gather in flocks and chatter in high voice. Down on the coast they say the robins come down to get drunk eating the fermented berry of the cabbage palm and point to them on the ground with their thin little legs in the air, helpless and oblivious. Tourists, of course, never touch the berries of the cabbage palm.[7]

In retrospect, it does seem strange that a photographer who consistently maintained that he found nature uninteresting was selected to provide illustrations for a book about the historical myths and natural beauty of the nation's vacationland, its southernmost state. Perhaps, as the above passage would suggest, the author actually viewed his subject with something of the same ironic eye Walker Evans turned on the banal themes he favored.

Whatever the reasons for the offer, Evans was happy to accept the job of illustrating Bickel's book, which involved a six-week trip to Florida and paid him a much-needed fee.[8] Evans's new bride, Jane Smith Ninas (now Sargeant), who accompanied him, recalls the approximate dates of their stay as being from Thanksgiving until Christmas 1941. Not surprisingly, they were based in Sarasota during this time and saw quite a lot of Karl Bickel. According to Evans's pictures and Ms. Sargeant's recollections, their travels within the state consisted of a trip from Jacksonville down to Sarasota, visits to cities near Sarasota (including Tampa, Tarpon Springs, and St. Petersburg), and a journey up the west coast to Tallahassee. Bickel's suggestions may have formed at least a part of that itinerary. Sargeant remembers that the author's tour of Sarasota included the John and Mable Ringling Museum of Art and the winter quarters of the Ringling Bros. and Barnum & Bailey Circus.[9] As Bickel was well aware, the circus entrepreneur had an enormous influence on the city's development; the photographs reveal that Evans, too, was charmed by the Ringling legacy and the circus's winter quarters.

The Mangrove Coast appeared in 1942 in a first edition that consisted of Bickel's text (with an epilogue written that January reflecting the recent effects of wartime on Florida's west coast), followed by a portfolio of thirty-two photographs by Evans, introduced with his captions.[10] The book proved to be very popular; a second impression was issued in the same year, without Evans's pictures.[11] In the past fifty years, *The Mangrove Coast* has been through four editions and more than twenty printings, but Evans's work has not reappeared.[12] It would seem more than coincidence that the number of images chosen for *The Mangrove Coast* was almost exactly that allowed for Evans's 1941 publication *Let Us Now Praise Famous Men* and the earlier *Crime of Cuba*, both of which contained thirty-one photographs.[13] These numbers probably have more to do with the current cost of reproduction than anything else; as with the other projects, we know that Evans made many more

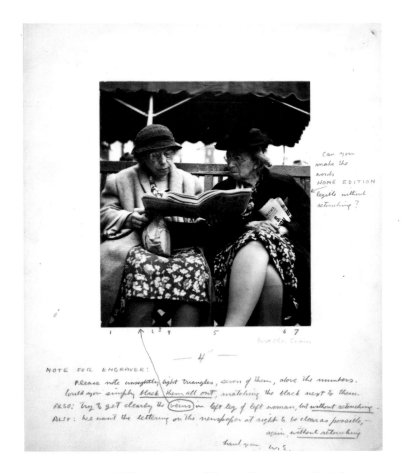

Figure 1. Walker Evans. *Winter Resorters, Florida*,
1941 [no. 963].

pictures and probably planned on a more extensive selection. The Getty collection contains at least 152 prints (including some duplicates) related to this Florida assignment, with twenty-nine of the thirty-two *Mangrove Coast* illustrations represented.[14] This group of pictures is possibly the least known of Evans's pre-1945 works and survives in very few 1940s prints, most of them now located at the Getty (fig. 1). Their importance seems to have been overshadowed by Evans's New York subway series of the same period, but they exhibit the photographer's eye in an equally exceptional way and, with more exposure, should be accepted as a significant phase in the development of Evans's mature documentary style, comparable to his 1933 work in Cuba and his later pictures "from the field" for the Resettlement Administration.

Most of the photographs in that rare first edition depict the habits and habitats of what Evans calls the Winter Resorters, the retirees (or as Bickel says, "the aged and infirm, the businessmen who have called it a day") who descend on the region each winter from the American Northeast and Midwest.[15] As he had earlier that year in the subways of New York, Evans once more sought out anonymous portraits, this time on the shuffleboard courts of Tampa, the municipal pier of Sarasota, and the bench-lined streets of St. Petersburg (see nos. 923, 945, and 972). He even acquiesced to undertake some landscape work, venturing into cypress swamps and onto the beach to obtain sometimes haunting, often humorous views, none of them destined for the walls of travel agencies (such as nos. 854 and 869). In an attempt to make marine life inter-

esting (for himself, if for no one else), Evans photographed murals of—and by—sponge divers (no. 882), sponge boats anchored at Tarpon Springs (no. 917), and the ubiquitous pelicans (no. 928) that he managed to render in the style of naive painting, majestically filling the frame and silhouetted against the bright Florida sky.

Many of these *Mangrove Coast* images are found in the Getty collection as vintage prints on original mounts, with the published caption inscribed in ink in the lower margin. Additional Getty images, apparently intended by Evans for the book but not finally included, exist in this format. One example is the *Blind Couple in Tampa City Hall Square* (no. 959). A second Getty print from the same negative (no. 960) reveals more about how Evans first composed this subject. It also shows, by way of comparison, what Evans was ultimately after, that is, an unusual portrait of a couple whose very public communication seems to be made private by the camera's exposure of their blindness. Interestingly, one of the few known images from Evans's previous trip to Florida, a 1934 visit on a commission to record a luxury hotel, is that of a seemingly blind African American preacher.[16] The photographer also posed this man with other members of his family and made views of the interior decoration of their modest home, but the preacher himself appears to have captivated Evans, as did the blind accordion player his hidden camera captured in the New York subway in the early months of 1941 (no. 771).

A Getty picture from this 1934 trip (no. 208) comes out of a series he made of sign painters preparing a billboard; it also provides a striking contrast to the Florida pictures he created seven years later. On his first trip, Evans was working on the southeast coast of the state and staying at Hobe Sound, just north of the West Palm Beach area. He wrote to a friend from the Island Inn there (the hotel that was employing him), expressing his ambivalent attitude about the area:

Florida is ghastly and very pleasant where I am, away from the cheap part. One feels good naturally, coming out of New York winter. . . . You ought to see West Palm Beach and die. There is among other things a walkathon, if you know what that is, going on at present. Oh, the Florida whites! Even the Negroes bad in Fla. Me I play tennis and drink ice tea in grateful seclusion.[17]

The photographer most likely derived more pleasure from documenting the sign-painting process than from photographing the hotel itself; in 1941, his interests ran to the failed efforts of hotel speculators rather than the luxurious resorts of Hobe Sound. *Unfinished Boomtime Hotel* (no. 898), a mounted print bearing Evans's inscribed title, is probably another of his rejected selections for the book. Surprisingly, Evans's commissioned treatment of the resort aspects of Florida is considerably less flattering than that of Farm Security Administration photographer Marion Post Wolcott, who documented the hotels and private clubs of Miami on one of several visits she made through the state from 1939 to 1941 at the request of Roy Stryker. Post Wolcott also recorded the working and living conditions of Florida's migrant laborers, another subject missing from Evans's selective view of the state.[18]

The abandoned hotel pictured in Evans's unpublished print (no. 898) is the Ritz Carlton, begun by John Ringling on Longboat Key, one of the millionaire's few unsuccessful projects for the Sarasota area. Buried in the middle of the *Mangrove Coast* illustrations are four other pictures related to the Ringlings and their circus's winter quarters; in the Getty collection, there are many more. *Mangrove Coast* plates 10 (no. 888) and 11 (no. 895), identified as *Uninhabited Seaside Residence near Sarasota* and *Coast Residence*, represent, respectively, views of the unoccupied mansion of John and Mable Ringling, then in probate with both Ringlings deceased, and the residence of John's brother Charles, then occupied only by his widow.

Plates 16 (no. 985) and 17 (see no. 974 for another view of the same wagon) display circus wagons and trains in what were then the yards of the Ringling Circus winter quarters at Sarasota (and have since become a subdivision, with the circus quarters relocating to Venice, Florida). Twenty-five different negatives by Evans concerning the circus animals and their trainers, the circus wagons and the trains, are represented in the Getty's collection (see nos. 974–1002). As mentioned above, it was apparently Bickel who first made Evans aware of the presence of the circus and Ringling's legacy in Sarasota. Given his predisposition for the American vernacular, the photographer must have been delighted to suddenly have access to the circus "at home." His decision to frequent the winter quarters and make the circus environment more than a subtheme of his Florida trip (although it suited the publisher's purposes to include only two of these compositions in Bickel's book) may have been stimulated by a source other than his well-connected Sarasota host.

One of the most widely appreciated, and lasting, contributions of the Federal Writers' Project established by the Federal Work Projects Administration during the Great Depression was the state guidebooks its writers compiled. One of them, *Florida: A Guide to the Southernmost State*, was first issued in 1939. In light of his involvement with the Resettlement Administration and his continuing acquaintance with artists and administrators of WPA projects, it seems likely that Evans would have known this series and, in preparation for his trip, might have obtained a copy of the Florida guide, possibly in the second printing of 1940. Of particular interest as he scanned the contents would have been the sections devoted to individual cities. Sarasota, his base of operations, receives six pages of coverage, half of which is dedicated to "Points of Interest." The highlights of this "clean-swept resort town" are, according to the guidebook: the Municipal Auditorium and park, offering forty shuffleboard courts, built by the WPA in 1938; the Sarasota Tourist Park on Ringling Boulevard

that, in years past, has hosted the annual convention of the Tin Can Tourists of the World, which always includes a parade of "new model trailers, house cars, and equipment"; the Sarasota Reptile Farm, where rattlesnake venom is extracted every Thursday; the John and Mable Ringling Museum of Art, "the largest in the state"; and the Ringling Bros. and Barnum & Bailey Circus Winter Quarters, open from 10:00 A.M. to 4:30 P.M. daily, December to April, admission twenty-five cents.[19]

John Ringling, the "circus king" who created the "Greatest Show on Earth" and at one point "controlled more circus property than any man since the sixth century B.C., when Lucius Tarquinius Priscus built the Circus Maximus for the people of Rome,"[20] first visited the Sarasota area around 1910. At that time, he and his wife bought a vacation cottage that had previously belonged to the manager of the Buffalo Bill Wild West Show. Ringling continued to buy real estate on his return trips to Florida and eventually owned about twenty-five percent of Sarasota.

In the twenties, the Ringlings settled permanently in the area, building their lavish, architect-designed home, Ca' d'Zan (pictured in Evans's photograph, no. 888), that was inspired by Ringling's admiration for the Doge's Palace in Venice and for McKim, Mead, and White's Madison Square Garden, where the Ringling circus opened its season each year. Before his death in 1936, the circus impresario also built a downtown hotel, a junior college, and a causeway connecting the city to the Longboat and Lido Keys, as well as an art museum. The art museum, begun in 1927 and dedicated in 1930, was designed by J. H. Phillips of New York in a "modified Italian Renaissance" style and, according to the WPA guidebook, contained seven hundred old-master works that the Ringlings had collected over thirty-five years. Ringling's largest contribution to Sarasota came, however, when he decided in 1927 to transfer the circus's winter quarters from Bridgeport, Connecticut, the home of P. T. Barnum (and, coincidentally, the site of Evans's 1941 assignment for *Fortune*) to

that warm-weather city.

Each year, the circus would come home to Sarasota in November, just as the first invasions of winter resorters were taking place. For this Florida town, suffering, like much of the state, from the collapse of the tremendous real-estate boom of 1924–26, watching the circus "at home" became another important tourist attraction, along with the excellent fishing and golfing. The Ringling circus quarters also offered something special for students of the art school that was initially associated with the Ringling museum: "the opportunity of studying old masters as well as an amazing assortment of wild animals." The WPA guide reports that a prosperous art colony had grown up around the museum and school; thanks to Ringling, it was "a common sight to see artists at work on the circus grounds."[21]

What these fenced-in grounds looked like in the early forties and why they held potential for students and artists like Evans is summarily described by the WPA author as follows:

> To the right of the long central road bisecting the area, the railroad yards form a huge triangle. Here the four show trains are repaired, refitted, and repainted during the winter.
>
> The group of buildings consists of animal quarters, utility buildings and workshops, dormitories for workmen, executive offices, and a dining hall. The main animal barn, to the right of the roadway, beyond the railroad yards, is lined with cages, the majority opening upon outside runways. In the larger runways, occupied by lions, tigers, leopards, kangaroos, and other animals, the "cats" are trained and put through their acts each afternoon at 2:30. On the upper floors are the tent, wardrobe, and harness-making departments. Canvas workers are employed the year round in the manufacture of 41 new tents required at the beginning of every season.
>
> South of the animal house are outdoor cages for polar and American brown bears, pongurs (dwarf mules), and giraffes. Adjoining are special barns for 30 elephants, including pigmy species, that are rehearsed and exercised daily. Near by are quarters for rhinoceroses, orangutans, chimpanzees, and smaller varieties of the monkey family. Opposite is an aviary housing exotic birds. At the east end of the grounds are stables for 700 horses and practice rings, where daily rehearsals are held. Adjoining are runways for dromedaries, camels, and zebras.[22]

A more suggestive depiction of the Ringling quarters is found in a *Harper's Bazaar* article of April 1942, "The Circus at Home," illustrated with three Evans images (only one of which, no. 998, is found at the Getty):

> Near the end of November, the ninety cars of circus train pull into the old Sarasota Fair Grounds outside the city, are shunted off in long lines to laze in the flat Florida sun. The animals' wagons roll off their flat-cars, rejoin the spaced-out rows of left behinds: the magnificent circus wagons of the past—heavily carved, adorned with caryatids and weathered paint—too old now, or too cumbersome, for the new, crack, streamlined, air-conditioned Greatest Show on Earth.[23]

Alice S. Morris, the author of this piece, goes on in a more impressionistic style to suggest the pace of activity on the winter grounds:

> Stretch of wagons and canvas tops . . . gleam of silver paint, red trim . . . smell of upturned turf and animals in the sun . . . screams, roars, barks, chatterings of beasts . . . stutter of tractors hauling cars and cages over the chabby [sic] grass . . . soft Indian cries of American trainers exhorting the elephants in the tongue they understand. In the

elephant kraal, trainer Walter McClain puts one of his pupils through difficult paces for the new elephant ballet—Balanchine choreography, Stravinsky music.[24]

From the Getty prints we know that Evans spent some time at the elephant kraal following these daily rehearsals and that he looked with a sympathetic eye into the cages of lions and monkeys and up at the always peculiar giraffes, whose long necks, in Evans's views, defy confinement. But for the most part, the Getty pictures reflect what is evident in two of the three *Harper's Bazaar* illustrations: that Evans was most intrigued with "the magnificent circus wagons of the past," those remnants of the circus's golden age (1870–1914) that were once brightly painted and heavily gilded for their prominent role in "the mile-long parade from the railroad yards to the big tent" that opened the circus show in each new town.[25] Few of these finely carved, nineteenth-century wagons, typically used as trap wagons for carrying heavy equipment, have survived. Their design was highly eclectic, depending on craftsmen trained in other fields, such as carriage making. Evans, with a sensitive eye to the best of folk art (and perhaps some urging from the circus's winter crew), chose to work most intensely with a large, nearly intact wooden wagon that he pictured at least once in a complete side-view, the one published by *Harper's Bazaar*. (For another view of the same wagon, see fig. 2.)[26] This wagon, bearing the characteristic three-quarter-life-size relief figures, is represented by detail views in plate 17 of *The Mangrove Coast* and in three Getty prints that focus on a front side panel that includes a fantastic, winged female creature (no. 975); a classically draped, dancing figure from a rear side panel (no. 974); and the deeply scrolled double doors at the rear of the wagon (no. 976).[27]

It is not surprising that Evans was drawn to this survivor of an anonymous, quite transient, but popular art. While investigating the west coast of Florida, he found

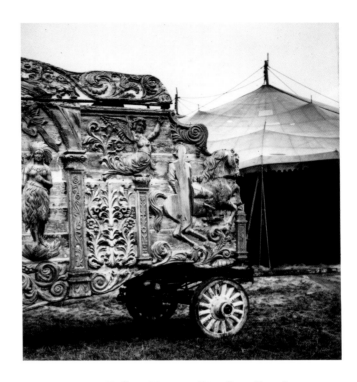

Figure 2. Walker Evans. *Ringling Bandwagon, Circus Winter Quarters, Sarasota*, 1941 [no. 975].

numerous examples of what some would call kitsch, and others, vernacular forms. The Getty collection presents photographs of a cast-concrete putto serving as a lawn decoration (no. 910), rows of painted coconut "heads" for sale at a fruit stand (no. 881), shell mosaics in the form of potted flowers embellishing a small concrete block building (no. 903), carved and painted elephant heads topping the animals' winter home, or kraal (no. 990), murals explaining the sponge industry and the dangers run by divers (no. 882), and, of course, the postcard stand boasting colorful views, for five cents, of Evans's own subjects (no. 879), like the circus elephants and the Ringling residence, Ca' d'Zan. However, in the case of the discarded circus wagon, Evans chose a motif that others before him had recognized and recorded as an important part of America's material culture.

Had Evans perused the section under "Art" in the 1940 WPA guide, he would have come across the informa-

tion that another WPA program, the Federal Art Project, was sponsoring a variety of public art works in the state. In addition, its Index of American Design had already copied hundreds of early regional textile, clothing, and carving designs, "and other manifestations of folk and popular art." This included circus-wagon design and decoration, "copied at the Ringling headquarters in Sarasota from famous old circuses that have long departed the American scene. The elaborate figures and ornamental carvings on this rapidly deteriorating equipment have been recorded on faithfully drawn colored plates."[28]

The Index, which carried out work in thirty-five states during the six years of its existence (1935–41), emphasized a meticulous, objective rendering of regional crafts; each representation, whether in oil or watercolor, was to be accurate enough to "stand as surrogate" for the object copied.[29] A drawing by an Index artist now in the National Gallery of Art's collection appears to reflect some "restoration" of Evans's wagon in the recording process; it also pictures the wagon's fanciful decoration as red, white, blue, and gold, giving a more faithful version of the wagon's original appearance.[30] On the other hand, Evans's black-and-white images point up the high relief employed by the wood-carvers in order to satisfy the long-distance gaze of parade crowds. In a 1972 survey of the Index collection of popular folk arts, the cataloguer highlights this wagon, based on a patriotic rather than a biblical or mythological theme, as a fine example of its type:

> The circus wagon United States *is one of the most magnificent examples of circus carving, replete with symbols of the American spirit. Figures and allegories proudly display the flag and eagle. In the central panel the Goddess of Liberty stands flanked by Indian maidens. Every square foot is covered with architectural framework, arches and pilasters, arabesques and storied details to instill patriotic fervor in the hearts of spectators, c. 1875.*[31]

Access to fine nineteenth-century craftsmanship allowed Evans to indulge his continuing passion for products of the 1800s, whether railroad cars or Victorian houses. Moreover, his time in Florida supplied material for a vision still inspired by Eugène Atget, who around 1910 had put together *La Voiture à Paris*, an album of photographs of sixty wagons and carriages he had found on Paris streets.[32] On assignment in Cuba in 1933 (see the chapter "Cuba," above), Evans produced many studies, twelve of them part of the Getty collection, of street vendors' wagons and horse-drawn carriages populating the streets of Havana. For a private commission the next year, he photographed the Jennings collection of carriages (possibly that of industrialist Oliver Jennings) as seen in six Getty prints (see the chapter "Circa 1930," above).

In Evans's later work, this interest in earlier forms of transportation seems to have been transferred to the twentieth-century Ford and to streamlined trains, such as that of the Ringling Brothers circus, which conveyed performers, animals, tents, and wagons from one town to another.[33] The train of circus cars had several roles, and Evans could appreciate them all. After years of service as rapid transportation, the cars were sometimes retired to the winter yards to provide lodging for members of the crew during the off-season months. In a quintessential Evans picture from this Florida series (no. 989), a train becomes a house. His "portrait" concentrates on the car's picture window and balcony, framed, appropriately, by a squat palm of the same proportions and the sunny Florida horizon. The car receives the same careful attention Evans devoted to the other transient homes he came across in Florida—the winter resorters' trailers (tin cans or house cars, as they were called [nos. 912–15])—and considerably more than he gave to the antebellum plantation house he photographed in Tallahassee (no. 900).

NOTES

1. The Federal Writers' Project of the Works Projects Administration (for the state of Florida), *Florida: A Guide to the Southernmost State* (New York: Oxford University Press, 1939; second printing, 1940), 551.

2. The details of Bickel's life were gleaned, for the most part, from the exhibition catalogue *Karl August Bickel, 1882–1972: An Exhibition to Honor His Many Contributions to the Ringling Museum and the State of Florida* (Sarasota: John and Mable Ringling Museum of Art, Oct. 25–Nov. 25, 1973).

3. Karl A. Bickel, *The Mangrove Coast: The Story of the West Coast of Florida*, photographs by Walker Evans (New York: Coward-McCann, 1942), dust jacket.

4. Ibid., 3.

5. Ibid., 296.

6. Ibid., 297.

7. Ibid., 298.

8. Details regarding the dates and itinerary for this commission were gathered from the author's conversations between 1990 and 1993 with Evans biographer Belinda Rathbone and with Evans's ex-wife, Jane Smith Ninas (now Jane Sargeant). Ms. Sargeant recalled for Ms. Rathbone the experience of being on the Florida beach with Evans the day Pearl Harbor was bombed.

9. The author would like to thank Jane Sargeant for sharing her reminiscences about this 1941 trip when we spoke by phone on June 29, 1993.

10. Bickel, *The Mangrove Coast*.

11. Ibid., second impression.

12. Deborah Walk, Archivist at the John and Mable Ringling Museum of Art, Sarasota, generously provided information about the printing history of the Bickel book, as well as identification of the Charles Ringling residence that appears in *The Mangrove Coast* and background material on John Ringling, the circus winter quarters, and the history of circus trains.

13. See the portfolio of Evans's photographs located at the back of Carleton Beals, *The Crimes of Cuba* (Philadelphia and London: J. B. Lippincott, 1933) and the group of thirty-one images placed at the front of James Agee and Walker Evans, *Let Us Now Praise Famous Men: Three Tenant Families* (Boston: Houghton Mifflin, 1941).

14. These twenty-nine negatives are represented at the Getty in fifty different prints (excluding duplicates), sometimes displaying several variant croppings of the published image: nos. 851, 854–62, 869, 873–76, 879–83, 888–89, 891, 893, 895–96, 899, 900, 909, 912–13, 917–18, 923, 928, 945–50, 955, 961–64, 972–73, 983, and 985.

15. Bickel, *The Mangrove Coast*, Evans's captions, 311–12, and Bickel's text, 299.

16. See *Walker Evans at Work* (New York: Harper and Row, 1982), 99–103, for images (selected from Evans's negatives) identified as Florida 1934. The information that Evans's 1934 commission came from an acquaintance who had recently purchased a luxury hotel, the Island Inn, was contributed by Belinda Rathbone in conversation with the author.

17. From an unfinished letter to Ernestine Evans in the Getty collection (84.XG.963.42), first published in *Walker Evans at Work*, 98.

18. See *Marion Post Wolcott: FSA Photographs*, introduction by Sally Stein (Carmel, Calif.: Friends of Photography, 1983), and Paul Hendrickson, *Looking for the Light: The Hidden Life and Art of Marion Post Wolcott* (New York: Alfred A. Knopf, 1992), for examples of Post Wolcott's Florida work of 1939–41; see also the microfilm files of the Farm Security Administration photographs in the Prints and Photographs Division of the Library of Congress for more complete representation of her Florida assignments.

19. *Florida: A Guide to the Southernmost State*, 268–73.

20. Mel Miller, *Ringling Museum of the Circus: The Collection and Its Relation to the History of the Circus* (Sarasota: John and Mable Ringling Museum of Art, 1963), n.p. Also see "Portrait of John," *Fortune* 1 (Apr. 1930), 44–45; *Ca' d'Zan: Ringling Residence* (Sarasota: John and Mable Ringling Museum of Art, n.d.); Robert Wernick, "The Greatest Show on Earth Didn't Compare to Home," *Smithsonian* 12:6 (Sept. 1981), 62–71; and Patricia Ringling Buck, *The John and Mable Ringling Museum of Art* (Sarasota: John and Mable Ringling Museum of Art, 1988; reprint 1991), for background information about the Ringlings' involvement with Sarasota and the building of their residence and art museum.

21. See *Florida: A Guide to the Southernmost State*, 161, for this quotation and the above description of Ringling's contributions to the education of artists.

22. Ibid., 272.

23. Alice S. Morris, "The Circus at Home," *Harper's Bazaar*, 75:2764 (Apr. 1942), 65.

24. Ibid., 65, 116.

25. Clarence P. Hornung, *Treasury of American Design: A Pictorial Survey of Popular Folk Arts Based upon Watercolor Renderings in the Index of American Design, at the National Gallery of Art*, vol. 2 (New York: Harry N. Abrams, 1972), 594.

26. Morris, "The Circus at Home," 65, top illus. This image is a radically cropped version of a 4 x 5-inch negative revealed in a more complete state in *First and Last* (New York: Harper and Row, 1978), 146. Another Evans composition based on this wagon appears in Giles Mora and John T. Hill, *Walker Evans: The Hungry Eye* (New York: Harry N. Abrams, 1993), 245. A posthumous photograph printed full frame from a 4 x 5-inch Estate negative, this image isolates the mythical winged, mermaid-like creature, who plays a more minor role in the Getty print mentioned below, where she is shown in the company of a Native American goddess and a Revolutionary soldier on horseback, her consorts at one end of the wagon.

27. The image from *The Mangrove Coast* (pl. 17) was selected by Evans in 1966 as the last of twelve plates making up the deluxe publication *Message from the Interior* (New York: Eakins Press, 1966). Of the twelve pictures he culled from three decades of work (1931–62), this is the only one that challenges the rubric of "interior."

28. *Florida: A Guide to the Southernmost State*, 161.

29. Holger Cahill, introduction to Erwin O. Chistensen, *The Index of American Design* (New York: MacMillan, in collaboration with the National Gallery of Art, Washington, D.C.), 1950, xiv. See Cahill's introduction for the history, philosophy, and techniques of the Index, as well as background on the appreciation of folk and popular art in the United States. A former national director of the Index, Cahill advised Abby Aldrich Rockefeller as she assembled her folk-art collection and was responsible for the exhibition *American Folk Art: The Art of the Common Man in America, 1750–1900* (which Evans, no doubt, saw) while serving as acting director of the Museum of Modern Art in 1933. In his introduction, Cahill mentions that the initial idea for the Index came from Romana Javitz, then head of the New York Public Library's picture collection and an early collector of Evans's work.

30. Hornung, *Treasury of American Design*, cat. no. 2144, double-page illus., 596–97.

31. Ibid., 597.

32. For illustrations and a discussion of this series (a complete album exists in the collection of the Museum of Modern Art), see Molly Nesbit, *Atget's Seven Albums* (New Haven and London: Yale University Press, 1992), 350–64.

33. During the thirties, especially while traveling on assignment for the Resettlement Administration, Evans photographed individual automobiles; another favorite subject was what he called "auto graveyards." In the fifties, he produced several stories for *Fortune* on the subject of railroads, including "Along the Right-of-Way" (Sept. 1950) and "The Last of Railroad Steam" (Sept. 1958). The silver-painted Ringling Bros. and Barnum & Bailey Circus train, which at one point consisted of one hundred railroad cars carrying 1,500 employees, is pictured in seven Getty prints (nos. 981–85, 988–89), usually serving as a backdrop for an elaborate circus wagon ornamented with fierce griffins and helmeted, charioteer-like female figureheads. Additional background about the general history of circus trains was gleaned from Freeman H. Hubbard, "100 Years of Circus Trains," *Railroad* (Apr. 1956), 12–27, supplied by Deborah Walk of the John and Mable Ringling Museum of Art.

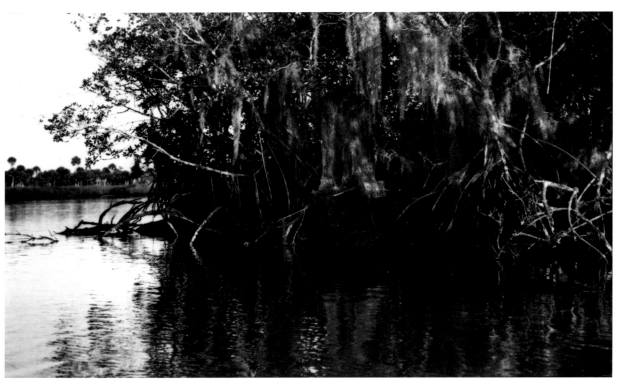

848

On the West Coast of Florida

Because the Getty collection includes nearly five times the number of Florida images finally used in *The Mangrove Coast*, the author has elected not to follow the published sequence but to organize the entries in this section—all pictures believed to have been made in the late fall of 1941—into seven informal categories: landscape, road pictures, scenes from tourist shops, regional architecture (the Ringling villas, resorters' trailers, etc.), action and wildlife on wharf and pier, people on the street and at shuffleboard, and, lastly, images from the Ringling Circus Winter Quar-

ters, arranged by subject (traditional circus wagons, trains, or trained animals). Of the thirty-two negatives employed for the plate section of *The Mangrove Coast*, twenty-nine are represented here, sometimes in several variant croppings, in fifty-two prints (excluding duplicates): nos. 851, 854–62, 869–71, 873– 876, 879–83, 888, 889, 891, 893, 895, 896, 899, 900, 909, 912, 913, 917, 918, 923, 928, 945–50, 955, 961–64, 972, 973, 983, and 985. The minor differences in cropping between the published image and the Getty print are sometimes attributable to trimming by designers or printers during the book production process.

849

850

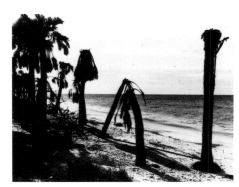

851

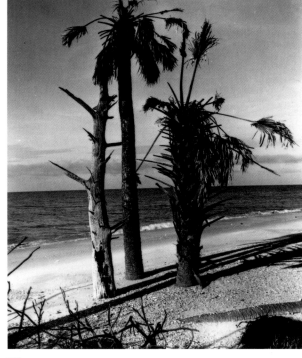

852

848
[*Mangroves at Water's Edge, Florida*],
1941
10.2 x 16.2 cm (4 x 6 ⅜ in.)
84.XM.956.846
MARKS & INSCRIPTIONS: (Verso) at right
edge, Evans stamp C; at l. left, in pen-
cil, Crane no. *L76.54(Evans)*.

849
[*Mangroves at Water's Edge, Florida*],
1941
12.8 x 16.6 cm (5 ¹/₃₂ x 6 ⁹/₁₆ in.)
84.XM.956.845
MARKS & INSCRIPTIONS: (Verso) at l. left,

Evans stamp A; at l. left, in pencil,
Crane no. *L76.53(Evans)*.

850
[*Coastal Landscape with Palms*], 1941
19.4 x 24.3 cm (7 ⅝ x 9 ⁹/₁₆ in.)
84.XM.956.919
MARKS & INSCRIPTIONS: (Verso) at right
edge, Evans stamp A; at left edge, in
pencil, [arrow pointing to the right]
Evans; at l. left, in pencil, Crane
no. *L76.50(Evans)*.

851
Long Boat Key/[*Long Boat Key and
the Gulf**], 1941
Image: 18.2 x 22.9 cm
(7 ⁵/₃₂ x 9 ¹/₃₂ in.); original mount:
20.7 x 25.6 cm (8 ⁵/₃₂ x 10 ³/₃₂ in.)
84.XM.956.902
MARKS & INSCRIPTIONS: (Recto, mount)
signed at l. right, in pencil, by Evans,
Walker Evans; at l. left, in black ink,
by Evans, *LONG BOAT KEY*; at l. center,
in pencil, *-5 ⅛-*; (verso, mount) at
right edge, Evans stamp C; at u. left,
in pencil, *val/093/29.20* [inverted]; at
l. right, in pencil, *57* [circled and

inverted]; at l. left, in pencil, Crane
no. *L76.20(Evans)*.
REFERENCES: *MANCO, pl. 23 (variant).

852
[*Three Palms on the Beach, Florida*],
1941
20.4 x 16.5 cm (8 ¹/₃₂ x 6 ½ in.)
84.XM.956.816
MARKS & INSCRIPTIONS: (Verso) at
l. right, Evans stamp A; at l. left, in
pencil, Crane no. *L76.39(Evans)*.

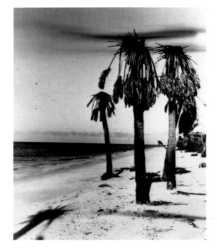

853

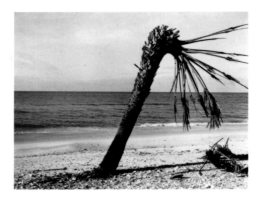

854

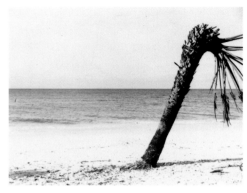

856

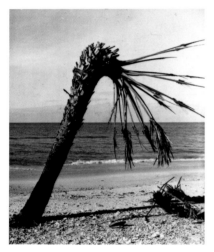

857

858

859

853
[*View of the Beach, Florida*], 1941
24.5 x 19 cm (9 ²¹⁄₃₂ x 7 ½ in.)
84.XM.956.817
MARKS & INSCRIPTIONS: (Verso) at
l. right, Evans stamp C [sideways]; at
l. left, in pencil, Crane no. *L76.38*
(*Evans*).

854
The Gulf of Mexico, 1941
Image: 15 x 18.9 cm (5 ¹⁵⁄₁₆ x 7 ⁷⁄₁₆ in.);
original mount: 24.9 x 20.9 cm
(9 ²⁵⁄₃₂ x 8 in.) [detached]
84.XM.956.931

MARKS & INSCRIPTIONS: (Verso) at l. left,
in pencil, Crane no. *L76.17*(*Evans*);
(recto, mount) signed at l. right, in pen-
cil, by Evans, *Walker Evans*; at l. left,
in pencil, by Evans, *THE GULF OF
MEXICO*; at l. center, in pencil, *-5 ¹⁄₈-*;
at l. left, in pencil, *Mangrove Coast*; at
l. right, in pencil, *133* [small letter o or
zero underlined]; at l. right, in pencil,
Frontis.; (verso, mount) at u. right, in
pencil, *78L* [circled and crossed out];
at u. right, in pencil, *val/093* [under-
lined]/*29-29* [all inverted]; at l. right,
in pencil, [arrow pointing to right]
Evans; at l. left, in pencil, *70* [circled];

at l. left, in pencil, Crane no. *L76.17*
(*Evans*).
REFERENCES: MANCO, pl. 20.

855
[*The Gulf of Mexico**], 1941
16.6 x 20.8 cm (6 ¹⁷⁄₃₂ x 8 ⁷⁄₃₂ in.)
84.XM.956.807
MARKS & INSCRIPTIONS: (Verso) at right
edge, Evans stamp A [sideways]; at
left edge, in pencil, [arrow pointing to
right] *Evans*; at l. left, in pencil, Crane
no. *L76.147*(*Evans*).
REFERENCES: *MANCO, pl. 20 (variant).
NOTE: Not illustrated; variant of
no. 854.

856
[*The Gulf of Mexico**], 1941
16.2 x 20.3 cm (6 ⅜ x 8 ¹⁄₃₂ in.)
84.XM.956.801
MARKS & INSCRIPTIONS: (Verso) at
u. right, Evans stamp A; at l. left, in
pencil, Crane no. *L76.112*(*Evans*).
REFERENCES: *MANCO, pl. 20 (variant).

857
[*Gulf of Mexico**], 1941
24.8 x 19.5 cm (9 ¾ x 7 ⅝ in.)
84.XM.956.881
MARKS & INSCRIPTIONS: (Verso) at u. cen-
ter, Evans stamp A [inverted]; at

860

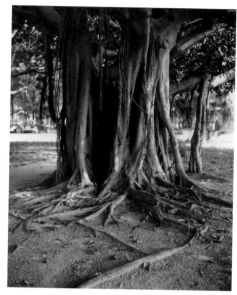

862

BANYAN TREE

861

864

l. right, in pencil, [arrow pointing to right] *Evans*; at l. left, in pencil, Crane no. *L76.111(Evans)*.
REFERENCES: *MANCO, pl. 20 (variant).

858
[*Inland Landscape**], 1941; printed later
Image: 18.9 x 15.7 cm (7 ¹⁵⁄₃₂ x 6 ³⁄₁₆ in.); sheet: 21.9 x 17.6 cm (8 ²¹⁄₃₂ x 6 ³¹⁄₃₂ in.)
84.XM.956.837
MARKS & INSCRIPTIONS: (Verso) at center, in pencil, [arrow pointing to right] *Evans*; at l. left, in pencil, no. *L76.91 (Evans)*.
REFERENCES: *MANCO, pl. 26 (variant).

859
[*Inland Landscape**], 1941
Image: 19.5 x 15.8 cm (7 ²¹⁄₃₂ x 6 ⁷⁄₃₂ in.); original mount: 25.5 x 20.5 cm (10 ¹⁄₃₂ x 8 ¹⁄₁₆ in.)
84.XM.956.898
MARKS & INSCRIPTIONS: (Recto, mount) signed at l. right below print, in pencil, by Evans, *Walker Evans*; (verso, mount) at u. right, Evans stamp C; at l. left, in pencil, Crane no. *L76.23 (Evans)*.
REFERENCES: *MANCO, pl. 26 (variant).

860
[*Vultures**], 1941
Image: 23.5 x 18.4 cm (9 ¼ x 7 ¼ in.); sheet: 24.7 x 18.9 cm (9 ¾ x 7 ¹³⁄₃₂ in.)
84.XM.956.804
MARKS & INSCRIPTIONS: (Recto) at l. right, in black ink, *30 30 29 30* [last three numbers crossed out in ink]; at l. right, incised, *31* [mainly erased]; (verso) at u. right, Evans stamp C; at l. left, in pencil, Crane no. *L76.27 (Evans)*.
REFERENCES: *MANCO, pl. 30 (variant).

861
Banyan Tree, 1941
Image: 10 ⅛ x 8 ¹⁄₃₂ in. (7 ⁹⁄₁₆ x 5 ⁵⁄₁₆ in.); original mount: 25.7 x 20.4 cm (10 ⅛ x 8 ¹⁄₃₂ in.)
84.XM.956.943
MARKS & INSCRIPTIONS: (Recto, mount) signed at l. right, in pencil, by Evans, *Walker Evans*; at l. left, in black ink, by Evans, *BANYAN TREE*; at l. center, in pencil, by Evans, *4 ½*; (verso, mount) at u. right center, Evans stamp C; at u. right, in pencil, *val/093* [underlined]/*29-14*; at l. right, in pencil, [arrow pointing to right] *Evans*; at l. right, *86* [circled and inverted].
REFERENCES: MANCO, pl. 3.

862
[*Banyan Tree**], 1941; printed later
22.3 x 17.5 cm (8 ²⁵⁄₃₂ x 6 ²⁹⁄₃₂ in.)
84.XM.956.799
MARKS & INSCRIPTIONS: (Verso) at l. left, in pencil, Crane no. *L76.3(Evans)*.
REFERENCES: *MANCO, pl. 3 (variant).

863
[*Banyan Tree**], 1941; printed later
22.4 x 17.7 cm (8 ¹³⁄₁₆ x 6 ³¹⁄₃₂ in.)
84.XM.956.800
MARKS & INSCRIPTIONS: (Verso) at center, Evans stamp C [sideways]; at l. left, in pencil, Crane no. *L76.2(Evans)*.
REFERENCES: *MANCO, pl. 3 (variant).
NOTE: Not illustrated; duplicate of no. 862.

864
[*Banyan Tree*], 1941; printed later
23.4 x 17.6 cm (9 ⁷⁄₃₂ x 6 ²⁹⁄₃₂ in.)
84.XM.956.857
MARKS & INSCRIPTIONS: (Verso) at center, Evans stamp C; at l. left, in pencil, Crane no. *L76.30(Evans)*.

865

869

870

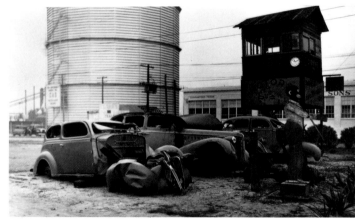

876

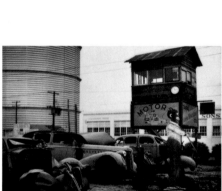

875

865
[*Cypress Swamp, Florida*], 1941
Image: 21.4 x 15.8 cm (8 7/16 x 6 7/32 in.);
original mount: 25.6 x 20.3 cm
(10 3/32 x 7 31/32 in.)
84.XM.956.895
MARKS & INSCRIPTIONS: (Recto, mount)
signed at l. right below print, in pen-
cil, by Evans, *Walker Evans*; (verso,
mount) at u. right, Evans stamp C; at
l. right, [arrow pointing to right]
Evans; at l. left, in pencil, Crane
no. *L76.109(Evans)*.

866
[*Cypress Swamp, Florida*], 1941;
printed later
Image: 22 x 17 cm (8 11/16 x 6 11/16 in.);
sheet: 22.9 x 18.3 cm (9 1/32 x 7 3/16 in.)
84.XM.956.865
MARKS & INSCRIPTIONS: (Verso) at u. left,
Evans stamp C; at l. left, in pencil,
Crane no. *L76.153(Evans)*.
NOTE: Not illustrated; variant of
no. 865.

867
[*Cypress Swamp, Florida*], 1941;
printed later
Image: 23.8 x 17.2 cm

(8 11/16 x 6 25/32 in.); sheet: 3.8 x 18.4 cm
(9 3/8 x 7 1/4 in.)
84.XM.956.880
MARKS & INSCRIPTIONS: (Verso) at u. left,
Evans stamp C; at l. left, in pencil,
Crane no. *L76.110(Evans)*.
NOTE: Not illustrated; duplicate of
no. 866.

868
[*Cypress Swamp, Florida*], 1941;
printed later
21.9 x 16.8 cm (8 5/8 x 6 5/8 in.)
84.XM.956.863
MARKS & INSCRIPTIONS: (Verso) at l. left,
Evans stamp C [inverted]; at l. left, in
pencil, Crane no. *L76.134(Evans)*.

NOTE: Not illustrated; duplicate of
no. 866.

869
A Cypress Swamp, 1941
Image: 21.5 x 15.9 cm (8 15/32 x 6 1/4 in.);
original mount: 25.5 x 20.3 cm
(10 1/32 x 8 in.)
84.XM.956.900
MARKS & INSCRIPTIONS: (Recto, mount)
signed at l. right, in pencil, by Evans,
Walker Evans; at l. left, in black ink,
by Evans, *A CYPRESS SWAMP*; at
l. center, in pencil, -5 1/8-; (verso,
mount) at u. center, Evans stamp C; at

871

873

877

MARKS & INSCRIPTIONS: (Recto, mount) signed at l. right, in pencil, by Evans, *Walker Evans*; (verso, mount) at u. right edge, in pencil, [arrow pointing to right] *Evans* [sideways]; at l. left, in pencil, Crane no. *L76.24 (Evans).*
REFERENCES: *MANCO, pl. 27 (variant).

874
[*Logging Landscape**], 1941
Image: 17.2 x 24 cm (6 ²⁵⁄₃₂ x 9 ⁷⁄₁₆ in.); sheet: 18.4 x 24.7 cm (7 ¼ x 9 ¾ in.)
84.XM.956.808
MARKS & INSCRIPTIONS: (Verso) at center, Evans stamp C; at l. left, in pencil, Crane no. *L76.141(Evans).*
REFERENCES: *MANCO, pl. 27 (variant).
NOTE: Not illustrated; variant of no. 873.

875
Auto Graveyard (at Tampa), 1941
Image: 14.5 x 18.3 cm (5 ¹¹⁄₁₆ x 7 ³⁄₁₆ in.); original mount: 29.1 x 23.8 cm (11 ½ x 9 ⅜ in.)
84.XM.956.944
MARKS & INSCRIPTIONS: (Recto, mount) signed at l. right below print, in pencil, *Walker Evans*; at l. left, in black ink, by Evans, *AUTO GRAVEYARD AT TAMPA* [last two words crossed out in pencil]; at l. center, in pencil, *-5 ⅛-*; (verso, mount) at u. right, in pencil, *val/093* [underlined]/*29-23*; at l. left, in pencil, *72* [circled]; at l. right, in pencil, [arrow pointing to the right] *Evans*; at l. right, in pencil, *30*; at l. left, in pencil, Crane no. *L76.150.*
REFERENCES: MANCO, pl. 13 (variant); FAL, p. 145 (variant).

876
[*Auto Graveyard**], 1941
15.2 x 23.8 cm (5 ³¹⁄₃₂ x 9 ⅜ in.)
84.XM.956.911
MARKS & INSCRIPTIONS: (Verso) at center, Evans stamp C [inverted]; at l. left, in pencil, Crane no. *L76.13(Evans).*
REFERENCES: *MANCO, pl. 13 (variant); FAL, p. 145 (variant).

877
[*Mystery Ship Roadside Bar*], 1941; printed later
Image: 16.7 x 21.2 cm (6 ⁹⁄₁₆ x 7 ³¹⁄₃₂ in.); sheet: 18.2 x 21.2 cm (7 ³⁄₁₆ x 8 ¹¹⁄₃₂ in.)
84.XM.956.936
MARKS & INSCRIPTIONS: (Verso) at u. right, Evans stamp C; (recto, mat) at l. right, in pencil, *238*; at l. left, in pencil, Crane no. *L76.124(Evans).*

u. left, in pencil, *NL/294* [underlined]/*2*; at l. right, [arrow pointing to right] *Evans*; at l. left, in pencil, Crane no. *L76.18(Evans).*
REFERENCES: MANCO, pl. 21.

870
[*Cypress Swamp, Florida*], 1941
Image: 22.8 x 16.8 cm (9 x 6 ⅝ in.); sheet: 24.3 x 18.2 cm (9 ⁹⁄₁₆ x 7 ³⁄₁₆ in.)
84.XM.956.879
MARKS & INSCRIPTIONS: (Verso) at u. right, Evans stamp C; at l. center, in pencil, [arrow pointing to right] *Evans*; at l. left, in pencil, Crane no. *L76.107(Evans).*

871
[*Cypress Swamp, Florida*], 1941
Image: 22.8 x 16.8 cm (8 ³¹⁄₃₂ x 6 ⅝ in.); sheet: 23.8 x 18.5 cm (9 ⅜ x 7 ¼ in.)
84.XM.956.862
MARKS & INSCRIPTIONS: (Verso) at l. center, Evans stamp A; at l. left, in pencil, Crane no. *L76.135(Evans).*

872
[*Cypress Swamp, Florida*], 1941
Image: 22.7 x 16.9 cm (8 ¹⁵⁄₁₆ x 6 ⅝ in.);- sheet: 24.8 x 18.7 cm (9 ²⁵⁄₃₂ x 7 ⅜ in.)
84.XM.956.894
MARKS & INSCRIPTIONS: (Recto) at l. center, in black ink, *-5 ⅛"-*; at lower right,

in ink, *21*; at l. right, in ink, *20* [crossed out]; at l. right, [indecipherable inscription crossed out in ink]; (verso) at l. center, Evans stamp A; at l. right, in pencil, *37A* [mainly erased]; at l. left, in pencil, Crane no. *L76.108 (Evans).*
NOTE: Not illustrated; variant of no. 871.

873
[*Logging Landscape**], 1941
Image: 15.5 x 23 cm (6 ¹⁄₁₆ x 9 ¹⁄₁₆ in.); original mount: 20.4 x 25.7 cm (8 x 10 ⅛ in.)
84.XM.956.899

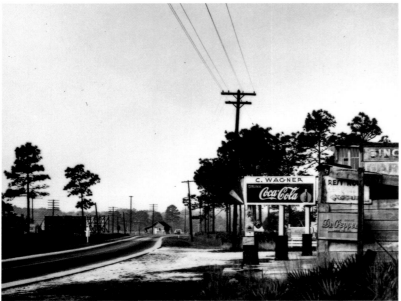

878

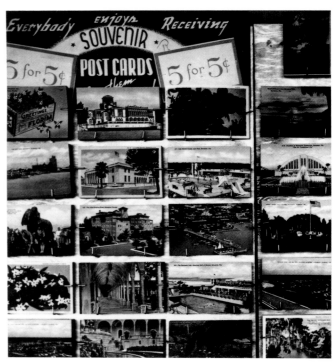

879

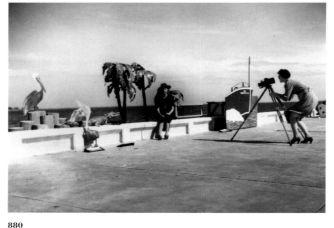

880

881

878
Upstate Roadside Landscape, 1941
Image: 12.9 x 16.4 cm (5 ¹/₁₆ x 6 ¹⁵/₃₂ in.);
original mount: 29.1 x 23.7 cm
(11 ½ x 9 ⁵/₁₆ in.)
84.XM.956.937
MARKS & INSCRIPTIONS: (Recto, mount)
signed at l. right below print, in
pencil, *Walker Evans*; at l. left, in
black ink, by Evans, *UPSTATE ROAD-
SIDE LANDSCAPE*; (verso, mount) at
l. right, in pencil, by Evans, *25*; (recto,
mat) at l. right, in pencil, *237*; at
l. left, in pencil, Crane no. *L76.125
(Evans)*.

879
Postcard Display, 1941
Image: 16.3 x 14.6 cm (6 ⁷/₁₆ x 5 ¾ in.);
original mount: 29.3 x 23.7 cm
(11 ½ x 9 ⁵/₁₆ in.)
84.XM.956.874
MARKS & INSCRIPTIONS: (Recto, mount)
signed at l. right below print, in pen-
cil, by Evans, *Walker Evans*; at l. left,
in black ink, by Evans, *POSTCARD DIS-
PLAY*; at l. center, in pencil, *-5 ⅛-*;
(verso, mount) at u. right, in pencil,
val./093 [underlined]/*29.27* [inverted];
at l. left, *89.5* [circled and sideways];
at l. center, in pencil, [arrow pointing

to right] *Evans*; at l. right, in pencil,
by Evans, *29*; at l. left, in pencil,
Crane no. *L76.29(Evans)*.
REFERENCES: MANCO, pl. 32.

880
[*Resort Photographer at Work**], 1941;
printed later
15.8 x 22.4 cm (6 ¼ x 8 ¹³/₁₆ in.)
84.XM.956.948
MARKS & INSCRIPTIONS: (Verso) at l. left,
Evans stamp C; at l. left, Crane
no. *L76.6*.
REFERENCES: *MANCO, pl. 6 (variant);
FAL, p. 142 (variant).

881
[*Souvenir Shop Display**], 1941;
printed later
17.5 x 20.3 cm (6 ²⁹/₃₂ x 8 in.)
84.XM.956.935
MARKS & INSCRIPTIONS: (Recto, mat) at
l. left, in pencil, Crane no. *L76.22
(Evans)*.
REFERENCES: *MANCO, pl. 25 (variant).

882
*Descriptive Painting by a Sponge-
Diver*/[*Painting of Sponge Divers at
Work, Possibly by C. Coolidge*], 1941

882

883

884

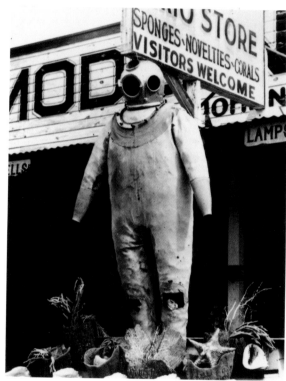

885

886

Image: 11.3 x 19.2 cm (4 ⁷/₁₆ x 7 ⁹/₁₆ in.); original mount: 29.2 x 23.4 cm (11 ½ x 9 ¼ in.)
84.XM.956.873
MARKS & INSCRIPTIONS: (Recto, mount) signed at right below print, in pencil, by Evans, *Walker Evans*; at l. left, in black ink, by Evans, *DESCRIPTIVE PAINTING BY A SPONGE-DIVER*; at l. center, in pencil, *-5 ⅛-*; (verso, mount) at u. right, in pencil, *val/093* [underlined]/*29-6*; at l. left, in pencil, *68* [encircled and sideways]; at l. right, in pencil, arrow pointing to the right, *Evans*; at l. right, in pencil, *6.*; at

l. left, in pencil, Crane no. *L76.25 (Evans)*.
REFERENCES: MANCO, pl. 28.

883
[*Descriptive Painting by a Sponge-Diver, Florida**]/ [*Painting of Sponge Divers at Work, Possibly by C. Coolidge*], 1941
15.6 x 23.8 cm (6 ⅛ x 9 ⅜ in.)
84.XM.956.878
MARKS & INSCRIPTIONS: (Verso) at l. right, Evans stamp A; at l. left, in pencil, Crane no. *L76.114(Evans)*.
REFERENCES: *MANCO, pl. 28 (variant).

884
[*Painting of Sponge Divers at Work, Possibly by C. Coolidge*], 1941
16.9 x 23.7 cm (6 ²¹/₃₂ x 9 ⁵/₁₆ in.)
84.XM.956.850
MARKS & INSCRIPTIONS: (Verso) at l. right, Evans stamp B; at l. left, in pencil, Crane no. *L76.113(Evans)*.

885
[*Sponge Diver's Suit, Tarpon Springs, Florida*], 1941
Image: 15.3 x 11.1 cm (6 ⅟₃₂ x 4 ⅜ in.); original mount: 29.3 x 23.5 cm (11 ¹⁷/₃₂ x 9 ¼ in.)

84.XM.956.924
MARKS & INSCRIPTIONS: (Recto, mount) signed at l. right below print, by Evans, *Walker Evans*; (verso, mount) at l. right, in pencil, *31*; at l. left, in pencil, Crane no. *L76.83(Evans)*.

886
Sponge Diver's Suit, Tarpon Springs, 1941
Image: 21.8 x 16 cm (8 ⁹/₁₆ x 6 ¼ in.); original mount: 25.6 x 20.4 cm (10 ³/₃₂ x 8 ⅟₃₂ in.)
84.XM.956.868
MARKS & INSCRIPTIONS: (Recto, mount) signed at l. right, in pencil, by Evans, *Walker Evans*; at l. left, in black ink, by Evans, *SPONGE DIVER'S SUIT, TARPON SPRINGS*; (verso, mount) at l. right, Evans stamp C; at l. left, in pencil, Crane no. *L76.82(Evans)*.

887
[*Sponge Diver's Suit, Tarpon Springs, Florida*], 1941
22.1 x 17.1 cm (8 ¹¹/₁₆ x 6 ¾ in.)
84.XM.956.813
MARKS & INSCRIPTIONS: (Verso) at u. right, Evans stamp C; at l. left, in pencil, Crane no. *L76.142(Evans)*.
NOTE: Not illustrated; duplicate of no. 886.

888

889

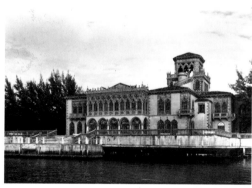

894

888

Uninhabited Seaside Residence Near Sarasota/[*Ca' d'Zan, The Ringling Residence (Built 1925–26, in Probate, ca. 1936–46)*], 1941
Image: 15.8 x 17.3 cm
(6 ¼ x 6 ²⁷⁄₃₂ in.); original mount:
25.7 x 20.3 cm (10 ³⁄₃₂ x 8 in.)
84.XM.956.886
MARKS & INSCRIPTIONS: (Recto, mount) signed at l. right, in pencil, by Evans, *Walker Evans*; at l. left, in black ink, by Evans, *UNINHABITED SEASIDE RESIDENCE NEAR SARASOTA*; at
l. center, in pencil, *5 ⅛*; (verso, mount) at u. right, Evans stamp C [inverted];

at u. right, in pencil, *val./093* [underlined]/*29.5*; at l. center, in pencil, arrow pointing to the right, *Evans*; at l. right, in pencil, *76* [circled and inverted]; at l. left, in pencil, Crane no. *L76.10(Evans)*.
REFERENCES: MANCO, pl. 10.

889

[*Uninhabited Seaside Residence near Sarasota**]/[*Ca' d'Zan, The Ringling Residence (Built 1925–26, in Probate, ca. 1936–46)*], 1941
17.6 x 22.5 cm (6 ¹⁵⁄₁₆ x 8 ⅞ in.)
84.XM.956.821

MARKS & INSCRIPTIONS: (Verso) at
u. right, Evans stamp C; at l. left, in pencil, Crane no. *L76.104(Evans)*.
REFERENCES: *MANCO, pl. 10 (variant).

890

[*Uninhabited Seaside Residence near Sarasota**]/[*Ca' d'Zan, The Ringling Residence (Built 1925–26, in Probate, ca. 1936–46)*], 1941
17.4 x 22.5 cm (6 ⅞ x 8 ⅞ in.)
84.XM.956.827
MARKS & INSCRIPTIONS: (Verso) at
u. right, Evans stamp C [inverted]; at l. left, in pencil, Crane no. *L76.103 (Evans)*.

REFERENCES: *MANCO, pl. 10 (variant).
NOTE: Not illustrated; variant of
no. 889.

891

[*Uninhabited Seaside Residence, Near Sarasota**]/[*Ca' d'Zan, The Ringling Residence (Built 1925–26, in Probate, ca. 1936–46)*], 1941
16.9 x 22.5 cm (6 ²¹⁄₃₂ x 8 ²⁷⁄₃₂ in.)
84.XM.956.795
MARKS & INSCRIPTIONS: (Verso) at right center, Evans stamp A; at l. left, in pencil, Crane no. *L76.152(Evans)*.
REFERENCES: *MANCO, pl. 10 (variant).
NOTE: Not illustrated; variant of
no. 889.

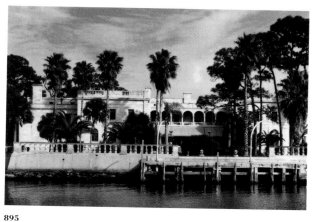

895

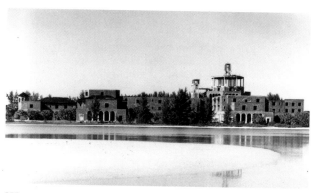

898

899

892

[*Uninhabited Seaside Residence near Sarasota**]/[Ca' d'Zan, The Ringling Residence (Built 1925–26, in Probate, ca. 1936–46)], 1941; printed later
Image: 17.8 x 22.8 cm
(7 1/32 x 8 31/32 in.); sheet: 18.9 x 23.7 cm
(7 7/16 x 9 5/16 in.)
84.XM.956.861
MARKS & INSCRIPTIONS: (Verso) at center,
Evans stamp C; at l. left, in pencil,
Crane no. *L76.136(Evans)*.
REFERENCES: *MANCO, pl. 10 (variant).
NOTE: Not illustrated; variant of
no. 889.

893

[*Uninhabited Seaside Residence Near Sarasota**]/*Ca' d'Zan, The Ringling Residence (Built 1925–26, in Probate, ca. 1936–46)], 1941
17.6 x 22.2 cm (6 15/16 x 8 23/32 in.)
84.XM.956.796
MARKS & INSCRIPTIONS: (Verso) at
u. right, Evans stamp C; at l. left, in
pencil, Crane no. *L96.105(Evans)*.
REFERENCES: *MANCO, p. 10 (variant).
NOTE: Not illustrated; variant of
no. 889.

894

[*View of Uninhabited Seaside Residence Near Sarasota, Florida*]/[*Ca' d'Zan, The Ringling Residence (Built 1925–26, in Probate, ca. 1936–46)*], 1941
14.1 x 19.1 cm (5 9/16 x 7 1/2 in.)
84.XM.956.826
MARKS & INSCRIPTIONS: (Verso) at bottom
edge, partial Evans stamp C; at l. left,
in pencil, Crane no. *L76.106(Evans)*.

895

Coast Residence/[*Ringling Residence, Home of Charles Ringling's Widow, Sarasota*], 1941
Image: 13.8 x 20 cm (5 7/16 x 7 7/8 in.);
original mount: 29.2 x 23.5 cm
(11 1/2 x 9 1/4 in.)
84.XM.956.928
MARKS & INSCRIPTIONS: (Recto, mount)
signed at l. right below print, in pencil, by Evans, *Walker Evans*; at l.
center, in pencil, *-5 3/4-*; at l. left, in
black ink, by Evans, *COAST RESIDENCE*; (verso, mount) at u. right, in
pencil, *val/093* [underlined]/*29-22*; at
l. left, in pencil, *74.5* [circled]; at
l. right, in pencil, arrow pointing to
the right, *Evans*; at l. right, in pencil,
8.; at l. left, in pencil, Crane
no. *L76.11(Evans)*.
REFERENCES: MANCO, pl. 11 (variant).

896

[*Coast Residence**]/[*Ringling Residence, Home of Charles Ringling's Widow, Sarasota*], 1941
16.9 x 20.7 cm (6 11/16 x 8 5/32 in.)
84.XM.956.812
MARKS & INSCRIPTIONS: (Verso) at right
center, partial Evans stamp C
[inverted]; at l. right, Crane stamp; at
l. right, in pencil, by Arnold Crane,
Withdrawn 12/71 AHC; at l. left, in pencil, Crane no. *L76.137(Evans)*.
REFERENCES: *MANCO, pl. 11 (variant).
NOTE: Not illustrated; variant of
no. 895.

897

[*Coast Residence**]/[*Ringling Residence, Home of Charles Ringling's Widow, Sarasota*], 1941
16.9 x 20.7 cm (6 21/32 x 8 3/16 in.)
84.XM.956.921
MARKS & INSCRIPTIONS: (Verso) at center
right, Evans stamp C; at l. left, in
pencil, Crane no. *L76.70(Evans)*.
REFERENCES: *MANCO, pl. 11 (variant).
NOTE: Not illustrated; duplicate of
no. 896.

898

Unfinished Boomtime Hotel, 1941
Image: 11.2 x 18.6 cm
(4 13/32 x 7 5/16 in.); original mount:
29.1 x 23.4 cm (11 7/16 x 9 7/32 in.)
84.XM.956.867
MARKS & INSCRIPTIONS: (Recto, mount)
signed at l. right, in pencil, by Evans,
Walker Evans; at l. left, in black ink,
by Evans, *UNFINISHED BOOMTIME HOTEL*; (verso, mount) at l. right, in
pencil, *18*; at l. left, in pencil, Crane
no. *L76.52(Evans)*.

899

Tampa University, 1941
Image: 19.6 x 12.4 cm
(7 23/32 x 4 7/8 in.); mount:
29.1 x 23.5 cm (11 15/32 x 9 1/4 in.)
84.XM.956.933
MARKS & INSCRIPTIONS: (Recto, mount)
signed at l. right below print, in
pencil, by Evans, *Walker Evans*; at
l. center, in pencil, *-4"-*; at l. left, in
black ink, by Evans, *TAMPA UNIVERSITY*; (verso, mount) at l. center, Evans
stamp A; at u. right, in pencil, *val/093*
[underlined]/*29.10*; at l. left, in pencil,
82.5 [circled]; at l. right, in pencil, *10*
and [arrow pointing to right] *Evans*;
(recto, mat) at l. right, in pencil, *218*;
at l. left, in pencil, Crane no. *L76.15*
(Evans).
REFERENCES: MANCO, pl. 18.

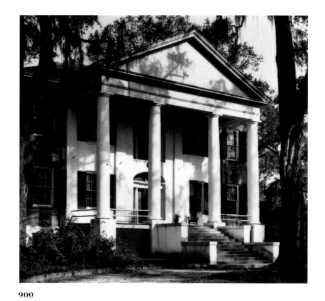

900

902

903

904

900
*Ante-Bellum Plantation House at
Tallahassee*, 1941
Image: 15.7 x 16.3 cm
(6 ³/₁₆ x 6 ¹³/₃₂ in.); original mount:
29.1 x 23.4 cm (11 ½ x 9 ¼ in.)
84.XM.956.923
MARKS & INSCRIPTIONS: (Recto, mount)
signed, at l. right below print, in pen-
cil, by Evans, *Walker Evans*; at l. left,
in black ink, by Evans, *ANTE-BELLUM
PLANTATION HOUSE AT TALLAHASSEE*; at
l. center, in pencil, *-5 ¹/₈-*; (verso,
mount) at l. left, in pencil, *80.5* [cir-
cled]; at l. center, in pencil, arrow
pointing to the right, *Evans*; at l. right,

in pencil, by Evans, *4.*; at u. right, in
pencil, *val/093* [underlined]/*29-21*
[inverted]; at l. left, in pencil, Crane
no. *L76.26(Evans)*
REFERENCES: MANCO, pl. 29.

901
*[Ante-Bellum Plantation House at Tal-
lahassee*]*, 1941
MEDIUM: Halftone
Image: 12.5 x 13 cm (4 ¹⁵/₁₆ x 5 ¹/₈ in.);
sheet: 16.4 x 16.3 cm (6 ⁷/₁₆ x 6 ³/₈ in.)
84.XM.956.870
MARKS & INSCRIPTIONS: (Recto) at
l. right, in black ink, *29* [space] *28*
[space] *9* [last two numbers have been

crossed out]; (verso) at u. left, Evans
stamp C; at l. left, in pencil, Crane
no. *L76.93(Evans)*.
REFERENCES: *MANCO, pl. 29.
NOTE: Not illustrated; duplicate of
no. 900.

902
*[Concrete Block Building with Shell
Decoration, Florida]*, 1941; printed
later
Image: 14.7 x 19.5 cm
(5 ¹³/₁₆ x 7 ²¹/₃₂ in.); sheet:
16.2 x 20.6 cm (6 ³/₈ x 8 ¼ in.)
84.XM.956.872
MARKS & INSCRIPTIONS: (Verso) at l. left,

Evans stamp C; at l. left, in pencil,
Crane no. *L76.68(Evans)*.

903
*[Concrete Block Building with Shell
Decoration, Florida]*, 1941
17.8 x 22.8 cm (7 x 8 ³¹/₃₂ in.)
84.XM.956.871
MARKS & INSCRIPTIONS: (Verso) at l. left,
Evans stamp C; at l. left, in pencil,
Crane no. *L76.69(Evans)*.

904
[Tabby Construction, Ruin, Florida],
1941; printed later
14.5 x 18.2 cm (5 ³/₄ x 7 ³/₁₆ in.)

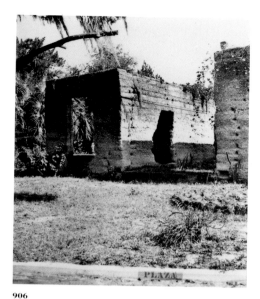

906

908

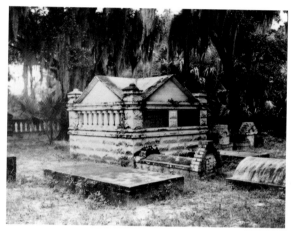

909

910

909
[Grave*]/[The Whitaker Mausoleum, Florida], 1941
16 x 19.8 cm (6 5/16 x 7 13/16 in.)
84.XM.956.841
MARKS & INSCRIPTIONS: (Verso) at right center, Evans stamp A; at l. left, in pencil, Crane no. L76.7(Evans).
REFERENCES: *MANCO, pl. 7 (variant).

910
[Statuette of a Cherub, Florida], 1941
Image: 22.5 x 17.9 cm (8 7/8 x 7 1/16 in.)
84.XM.956.920
MARKS & INSCRIPTIONS: (Verso) at u. right, Evans stamp C; at l. left, in pencil, Crane no. L76.51(Evans).

911
[Statuette of a Cherub, Florida], 1941; printed later
22.5 x 17.5 cm (8 7/8 x 6 7/8 in.)
84.XM.956.842
MARKS & INSCRIPTIONS: (Verso) at l. right, Evans stamp C; at l. left, in pencil, Crane no. L76.148(Evans).
NOTE: Not illustrated; duplicate of no. 910.

84.XM.956.806
MARKS & INSCRIPTIONS: (Verso) at right center, Evans stamp B; at l. left, in pencil, Crane no. L76.145(Evans).

905
[Tabby Construction, Ruin, Florida], 1941; printed later
14.6 x 18.3 cm (5 3/4 x 7 7/32 in.)
84.XM.956.848
MARKS & INSCRIPTIONS: (Verso) at l. right, partial Evans stamp A; at l. left, in pencil, Crane no. L76.115 (Evans).
NOTE: Not illustrated; duplicate of no. 904.

906
[Tabby Construction, Ruin, Florida], 1941; printed later
19.5 x 16.3 cm (7 11/16 x 6 7/16 in.)
84.XM.956.844
MARKS & INSCRIPTIONS: (Verso) at l. left, Evans stamp A; at l. left, in pencil, Crane no. L76.117(Evans).

907
[Tabby Construction, Ruin], 1941; printed later
19.6 x 16.4 cm (7 23/32 x 6 15/32 in.)
84.XM.956.805

MARKS & INSCRIPTIONS: (Verso) at l. right, Evans stamp C; at l. left, in pencil, Crane no. L76.146(Evans).
NOTE: Not illustrated; duplicate of no. 906.

908
[Tabby Construction, Ruin, Florida], 1941; printed later
14.5 x 15.4 cm (5 27.32 x 6 1/16 in.)
84.XM.956.849
MARKS & INSCRIPTIONS: (Verso) at l. left, Evans stamp A; at l. left, in pencil, Crane no. L76.116(Evans).

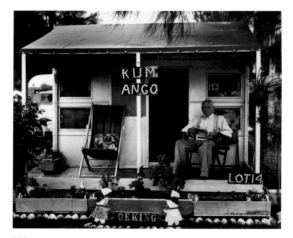

912

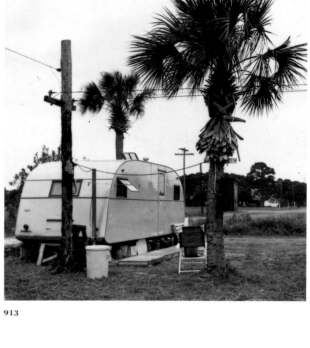

913

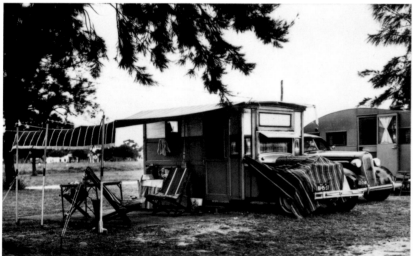

914

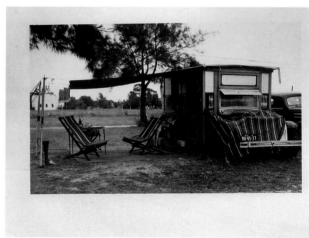

915

912
(Sarasota) Municipal Trailer Camp, 1941
Image: 15.3 x 18 cm (6 ¹⁄₃₂ x 7 ³⁄₃₂ in.); original mount: 25.7 x 20.4 cm (10 ³⁄₃₂ x 8 ¹⁄₃₂ in.)
84.XM.956.798
MARKS & INSCRIPTIONS: (Recto, mount) signed at l. right, in pencil, by Evans, *Walker Evans*; at l. left, in black ink, by Evans, *SARASOTA* [first word crossed out in pencil] *MUNICIPAL TRAILER CAMP*; at l. center, in pencil, *-5 ⅛-*; at l. right, in pencil, *#2?*; at l. right, in pencil, *7*; (verso, mount) at u. right, in pencil, *no ___./093* [underlined]/*29-3*

[inverted]; at l. right, in pencil, *72.5* [circled and inverted]; at l. left, in pencil, Crane no. *L76.1(Evans)*.
REFERENCES: MANCO, pl. 2.

913
Trailer in Camp (Sarasota), 1941
Image: 17.7 x 16.3 cm (6 ³¹⁄₃₂ x 6 ¹³⁄₃₂ in.); original mount: 25.6 x 20.4 cm (10 ¹⁄₁₆ x 8 ¹⁄₃₂ in.)
84.XM.956.945
MARKS & INSCRIPTIONS: (Recto, mount) signed at l. right, in pencil, by Evans, *Walker Evans*; at l. left, in black ink, by Evans, *TRAILER IN CAMP, SARASOTA* [last word crossed out in pencil]; at l.

center, in pencil, *-5 ⅛-*; at l. right, in pencil, by Evans, *13.*; (verso, mount) at u. right center, Evans stamp C; at u. right, in pencil, *val/093* [underlined]/*294*; at l. center, in pencil, [arrow pointing to right] *Evans*; at l. center, *80.5* [circled and inverted]; at l. left, in pencil, Crane no. *L76.5*.
REFERENCES: MANCO, pl. 5; FAL, p. 144 (variant).

914
[Recreational Vehicle with Striped Canopies], 1941
Image: 14.6 x 25.5 cm

(5 ¾ x 8 ¹¹⁄₁₆ in.); original mount: 20.4 x 25.5 cm (8 x 10 ¹⁄₁₆ in.)
84.XM.956.932
MARKS & INSCRIPTIONS: (Recto, mount) signed at l. right below print, in pencil, *Walker Evans*; (verso, mount) at center right, Evans stamp C; at left edge center, [arrow pointing to right] *Evans* [sideways]; (mat, recto) at l. right, in pencil, *213*; at l. left, in pencil, Crane no. *L76.126(Evans)*.

915
[Recreational Vehicle with Striped Canopies and Lawn Chairs], 1941

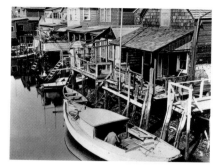

916

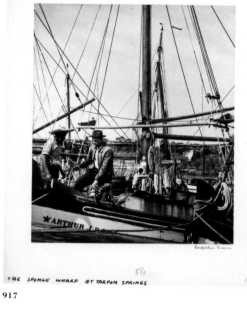

THE SPONGE WHARF AT TARPON SPRINGS

917

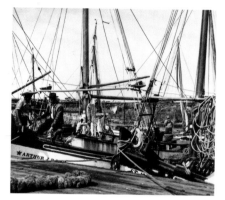

918

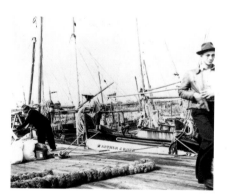

919

920

Image: 14.5 x 22.3 cm
(5 11/16 x 8 25/32 in.); sheet:
20.1 x 25.2 cm (7 29/32 x 9 15/16 in.)
84.XM.956.890
MARKS & INSCRIPTIONS: (Verso) at left
and right center, Evans stamp A; at
l. left, in pencil, Crane no. L76.127
(Evans).

916
[Boat and Houses on the Water, Florida], 1941
Image: 15.2 x 19.1 cm
(5 31/32 x 7 ½ in.); original mount:
19.4 x 21.6 cm (7 21/32 x 8 ½ in.)
84.XM.956.909

MARKS & INSCRIPTIONS: (Recto, mount)
signed at l. right, in pencil, by Evans,
Walker Evans; (verso, mount) at l. left,
in pencil, Crane no. L76.45(Evans).

917
The Sponge Wharf at Tarpon Springs,
1941
Image: 19.3 x 15.7 cm
(7 19/32 x 6 3/16 in.); original mount:
25.6 x 20.4 cm (10 3/32 x 8 1/32 in.)
84.XM.956.901
MARKS & INSCRIPTIONS: (Recto, mount)
signed at l. right, in pencil, by Evans,
Walker Evans; at l. left, in black ink,
by Evans, THE SPONGE WHARF AT TAR-

PON SPRINGS; at l. center, in pencil,
5 ⅛; at l. right, in pencil, 19; (verso,
mount) at l. center, Evans stamp C
twice; at u. right, in pencil, 83.5 [circled]; at l. left, in pencil, val/093
[underlined]/29-24; at l. left, in pencil,
Crane no. L76.19(Evans).
REFERENCES: MANCO, pl. 22.

918
[The Sponge Wharf at Tarpon
Springs*], 1941
Image: 18.1 x 19.4 cm (7 ⅛ x 7 ⅝ in.);
original mount: 25.6 x 20.5 cm
(10 1/16 x 8 1/16 in.)
84.XM.956.856

MARKS & INSCRIPTIONS: (Recto, mount)
signed at l. right, in pencil, by Evans,
Walker Evans; (verso, mount) at l. center, Evans stamp C [inverted]; at l. left,
in pencil, Crane no. L76.40(Evans).
REFERENCES: *MANCO, pl. 22 (variant).

919
[Sponge Wharf, Tarpon Springs, Florida], 1941; printed later
18.7 x 20.8 cm (7 ⅜ x 8 3/16 in.)
84.XM.956.822
MARKS & INSCRIPTIONS: (Verso) at center,
Evans stamp C; at l. left, in pencil,
Crane no. L76.43(Evans).

920
[Sponge Diver's Boat with Hanging
Sponges], 1941
Image: 16.1 x 15.8 cm (6 ⅜ x 6 7/32 in.);
original mount: 29.2 x 23.4 cm
(11 15/32 x 9 7/32 in.)
84.XM.956.929
MARKS & INSCRIPTIONS: (Recto, mount)
signed at l. right, in pencil, by Evans,
Walker Evans; (verso, mount) at
l. right, in pencil, 19.; at l. left, in pencil, Crane no. L76.44(Evans).

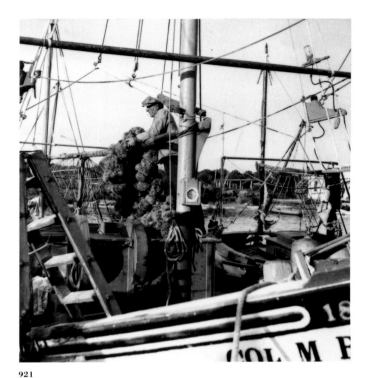

921

922

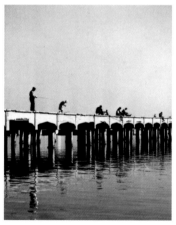

923

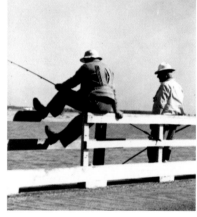

924

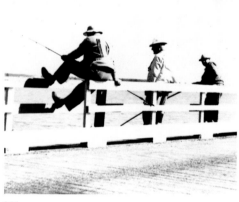

925

921
[*Fisherman in Sponge Boat, Florida*],
1941
Image: 16.9 x 15.7 cm
(6 ²¹/₃₂ x 6 ³/₁₆ in.); original mount:
25.7 x 20.4 cm (10 ⅛ x 8 ¹/₃₂ in.)
84.XM.956.855
MARKS & INSCRIPTIONS: (Recto, mount)
signed at l. right, in pencil, by Evans,
Walker Evans; (verso, mount) at
l. right, Evans stamp C; at l. left, in
pencil, Crane no. *L76.41(Evans)*.

922
[*Fisherman in Sponge Boat, Florida*],
1941

11.3 x 10.6 cm (4 ⁷/₁₆ x 7 ³/₁₆ in.)
84.XM.956.823
MARKS & INSCRIPTIONS: (Verso) at left
center, Evans stamp I [printed twice
lightly]; at l. left, in pencil, Crane
no. *L76.42(Evans)*.

923
*Fishing from Public Bridge (near Sara-
sota)*, 1941
Image: 18.8 x 13.7 cm
(7 ⁷/₁₆ x 5 ¹³/₃₂ in.); original mount:
25.5 x 20.4 cm (10 ¹/₃₂ x 8 ¹/₃₂ in.)
84.XM.956.884
MARKS & INSCRIPTIONS: (Recto, mount)
signed at l. right below print, in pen-

cil, by Evans, *Walker Evans*; at l. left,
in black ink, by Evans, *FISHING FROM
PUBLIC BRIDGE NEAR SARASOTA* [last
two words crossed out in pencil]; at l.
center, in pencil, -5 ⅛-; (verso, mount)
at u. right, Evans stamp C; at u. right
corner, in pencil, *val./093* [under-
lined]/*29.25* [inverted]; at l. right, in
pencil, [arrow pointing to right] *Evans*;
at l. left, in pencil, Crane no. *L76.4
(Evans)*
REFERENCES: MANCO, pl. 4.

924
[*Two Men Fishing from a Pier*], 1941
14.1 x 11.9 cm (5 ⁹/₁₆ x 4 ²¹/₃₂ in.)

84.XM.956.908
MARKS & INSCRIPTIONS: (Verso) at bottom
edge, Evans stamp B; at l. right, in
pencil, [arrow pointing to right] *Evans*;
at l. left, in pencil, Crane no. *L76.57
(Evans)*.

925
[*Three Men Fishing from a Pier*], 1941;
printed later
16.1 x 16.6 cm (6 ¹¹/₃₂ x 6 ¹⁷/₃₂ in.)
84.XM.956.906
MARKS & INSCRIPTIONS: (Verso) at
l. right, Evans stamp A; at l. left, in
pencil, Crane no. *L76.55(Evans)*.

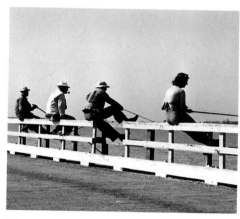

926

927

928

929

926
[*Three Men and a Woman Fishing from a Pier*], 1941
13.7 x 14.9 cm (5 ¹³⁄₃₂ x 5 ⅞ in.)
84.XM.956.907
MARKS & INSCRIPTIONS: (Verso) at center left, Evans stamp C; at l. center, in pencil, [arrow pointing to right] *Evans*; at l. left, in pencil, Crane no. *L76.56 (Evans)*.

927
[*Mallard Ducks, Florida*], 1941; possibly printed later
18.6 x 20.8 cm (7 ⁵⁄₁₆ x 8 ³⁄₁₆ in.)
84.XM.956.917

MARKS & INSCRIPTIONS: (Verso) at u. right, Evans stamp C; at l. left, in pencil, Crane no. *L76.48(Evans)*.

928
Pelican, 1941
Image: 18.5 x 13.4 cm (7 ¼ x 5 ¼ in.); original mount: 25.5 x 20.5 cm (10 ¹⁄₁₆ x 8 ¹⁄₁₆ in.)
84.XM.956.860
MARKS & INSCRIPTIONS: (Recto, mount) signed at l. right, in pencil, by Evans, *Walker Evans*; at l. left, in black ink, by Evans, *PELICAN*; at l. center, in pencil, —*3 ½*—; at l. right, in pencil, *22*;

(verso, mount) at center, Evans stamp C; at u. right, in pencil, *val/093* [underlined]/*29.8*; at l. center, in pencil, [arrow pointing to right] *Evans*; at l. right, in pencil, *67* [circled and inverted]; at l. left, in pencil, Crane no. *L76.28(Evans)*.
REFERENCES: MANCO, pl. 31.

929
[*Pelican on a Dock, Florida*], 1941
Image: 20.5 x 14.7 cm (8 ¹⁄₁₆ x 5 ¹³⁄₁₆ in.); original mount: 29.1 x 23.5 cm (11 ⁷⁄₁₆ x 9 ¼ in.)
84.XM.956.866

MARKS & INSCRIPTIONS: (Recto, mount) signed at l. right, in pencil, by Evans, *Walker Evans*; (verso, mount) at l. right, in pencil, *28*; at l. left, in pencil, Crane no. *L76.97(Evans)*.

931

932

934

936

930
[*Pelican on a Dock, Florida*], 1941
Image: 20.3 x 16.3 cm (8 x 6 ⁷⁄₁₆ in.);
original mount: 25.5 x 20.4 cm
(10 ¹⁄₁₆ x 8 ¹⁄₃₂ in.)
84.XM.956.876
MARKS & INSCRIPTIONS: (Recto, mount)
signed at l. right below print, in pen-
cil, by Evans, *Walker Evans*; (verso,
mount) at l. left, in pencil, *77* and
Crane no. *L76.100(Evans)*.
NOTE: Not illustrated; duplicate of
no. 929.

931
Pelican, 1941
Image: 19.5 x 14.4 cm
(7 ²¹⁄₃₂ x 5 ¹¹⁄₁₆ in.); original mount:
25.6 x 20.4 cm (10 ¹⁄₈ x 8 ¹⁄₃₂ in.)
84.XM.956.797
MARKS & INSCRIPTIONS: (Recto, mount)
signed at l. right, in pencil, by Evans,
Walker Evans; at l. left, in black ink,
by Evans, *PELICAN*; (verso, mount) at
l. left, in pencil, Crane no. *L76.95*
(*Evans*).

932
Pelicans at St. Petersburg, 1941
Image: 18.7 x 15.2 cm (7 ³⁄₈ x 6 in.);

original mount: 25.6 x 20.4 cm
(10 ³⁄₃₂ x 8 ¹⁄₃₂ in.)
84.XM.956.828
MARKS & INSCRIPTIONS: (Recto, mount)
signed at l. right, in pencil, by Evans,
Walker Evans; at l. left, in black ink,
by Evans, *PELICANS AT ST. PETERS-
BURG*; at l. right, in pencil, *20*; (verso,
mount) at u. right, Evans stamp C; at
l. right, in pencil, [arrow pointing to
right] *Evans*; at l. left, in pencil, Crane
no. *L76.101(Evans)*.

933
[*Pelicans at St. Petersburg*], 1941;
printed later

Image: 22.3 x 17.2 cm
(8 ¹³⁄₁₆ x 6 ²⁵⁄₃₂ in.); sheet:
23.4 x 18.6 cm (9 ⁷⁄₃₂ x 7 ⁵⁄₁₆ in.)
84.XM.956.840
MARKS & INSCRIPTIONS: (Verso) at u. left,
Evans stamp C [sideways]; at l. left, in
pencil, Crane no. *L76.96(Evans)*.
NOTE: Not illustrated; variant of
no. 932.

934
[*Two Pelicans on a Dock, Florida*],
1941
Image: 17.2 x 16.3 cm (6 ³⁄₄ x 6 ¹³⁄₃₂ in.);
original mount: 25.5 x 20.3 cm
(10 ¹⁄₁₆ x 8 in.)

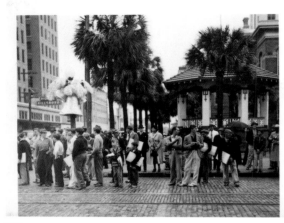

937

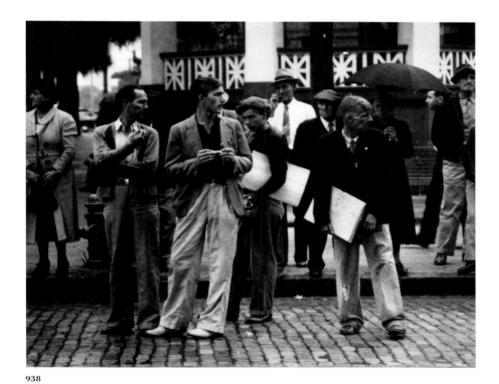

938

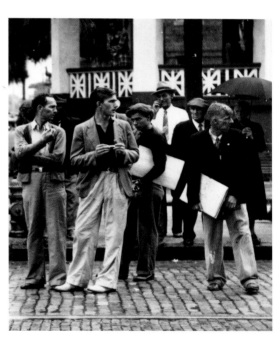

939

84.XM.956.922
MARKS & INSCRIPTIONS: (Recto, mount) signed at l. right, in pencil, by Evans, *Walker Evans*; (verso, mount) at center, Evans stamp C; at l. left, in pencil, Crane no. *L76.98(Evans)*.

935
[*Two Pelicans on a Dock, Florida*], 1941
Image: 16.7 x 14.5 cm (6 ¹⁹⁄₃₂ x 5 ¹¹⁄₁₆ in.); original mount: 29.2 x 23.5 cm (11 ½ x 9 ¼ in.)
84.XM.956.925
MARKS & INSCRIPTIONS: (Recto, mount) signed at l. right, in pencil, by Evans,

Walker Evans; (verso, mount) at l. right, in pencil, by Evans, *20*; at l. left, in pencil, Crane no. *L76.99 (Evans)*.
NOTE: Not illustrated; variant of no. 934.

936
[*Four Pelicans Sitting on a Pier, Florida*], 1941; printed later
16.8 x 20.8 cm (6 ⅝ x 8 ⁵⁄₃₂ in.)
84.XM.956.830
MARKS & INSCRIPTIONS: (Verso) at right center, Evans stamp A; at l. left, in pencil, Crane no. *L76.102(Evans)*.

937
[*Crowd Waiting at Street Corner, Tampa, Florida*], 1941
Image: 18.3 x 22.9 cm (7 ⁷⁄₃₂ x 9 in.); sheet: 20 x 24.9 cm (7 ⅞ x 9 ²⁵⁄₃₂ in.)
84.XM.956.178
MARKS & INSCRIPTIONS: (Verso) at u. right, Evans stamp C; at l. left, in pencil, Crane no. *L66.44(Evans)*.

938
[*Crowd Waiting at Street Corner, Tampa, Florida*], 1941
18.1 x 22.4 cm (7 ⅛ x 8 ¹³⁄₁₆ in.)
84.XM.956.194

MARKS & INSCRIPTIONS: (Verso) at u. center, Evans stamp C [inverted]; at l. left, in pencil, Crane no. *L66.136(Evans)*.

939
[*Crowd Waiting at Street Corner, Tampa, Florida*], 1941
14.2 x 11.7 cm (5 ⅝ x 4 ¹⁹⁄₃₂ in.)
84.XM.956.246
MARKS & INSCRIPTIONS: (Verso) at u. center, Evans stamp C; at l. left, in pencil, Crane no. *L66.43*; at l. center, in pencil, [arrow pointing to right] *Evans*.

940

941

942

943

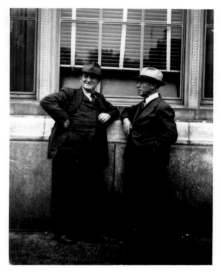

944

940
[*Group of Men in a Storefront Doorway, (Florida?)*], 1941; possibly printed later
Image: 16 x 15.7 cm (6 ⁵⁄₁₆ x 6 ³⁄₁₆ in.); sheet: 21.1 x 18.1 cm (8 ⁵⁄₁₆ x 7 ⅛ in.)
84.XM.956.836
MARKS & INSCRIPTIONS: (Verso) at l. right, Evans stamp C; at l. left, in pencil, Crane no. *L76.118(Evans)*.

941
[*Group of Men in a Storefront Doorway, (Florida?)*], 1941; possibly printed later
Image: 17.1 x 17.8 cm (6 ¾ x 7 in.); sheet: 18.7 x 20.2 cm (7 ⅜ x 7 ³¹⁄₃₂ in.)
84.XM.956.835
MARKS & INSCRIPTIONS: (Verso) at u. right, Evans stamp C [inverted]; at l. left, in pencil, Crane no. *L76.119 (Evans)*.

942
[*Three Businessmen, National Bank Building Entrance, Florida*], 1941; possibly printed later
16.5 x 22.6 cm (6 ¹⁷⁄₃₂ x 8 ⅞ in.)
84.XM.956.695
MARKS & INSCRIPTIONS: (Verso) at right center, Evans stamp A; at left, in pencil, Crane no. *L78.17(Evans)*.

943
[*Three Businessmen, National Bank Building Entrance, Florida*], 1941; possibly printed later
21.7 x 16.7 cm (8 ⁹⁄₁₆ x 6 ⁹⁄₁₆ in.)
84.XM.956.692
MARKS & INSCRIPTIONS: (Verso) at u. right, Evans stamp C; at l. left, in pencil, Crane no. *L78.16(Evans)*.

944
[*Two Businessmen, Florida City Street*], 1941; possibly printed later
Image: 22.6 x 17.4 cm (8 ¹⁵⁄₁₆ x 6 ⅞ in.); sheet: 23.9 x 18.7 cm (9 ¹³⁄₃₂ x 7 ¹¹⁄₃₂ in.)
84.XM.956.693

MARKS & INSCRIPTIONS: (Verso) at u. right and u. left, Evans stamp C; at l. left, in pencil, Crane no. *L78.18 (Evans)*.

945
The Green Benches at St. Petersburg, 1941
Image: 18.5 x 17.7 cm (7 ⁵⁄₁₆ x 6 ³¹⁄₃₂ in.); original mount: 25.5 x 20.3 cm (10 ¹⁄₃₂ x 8 in.)
84.XM.956.930
MARKS & INSCRIPTIONS: (Recto, mount) signed at l. right, in pencil, by Evans, *Walker Evans*; at l. center, in pencil, *-4 ½-*; at l. left, in black ink, by

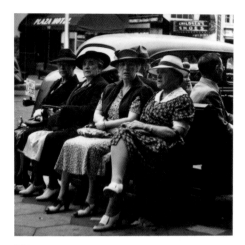

945

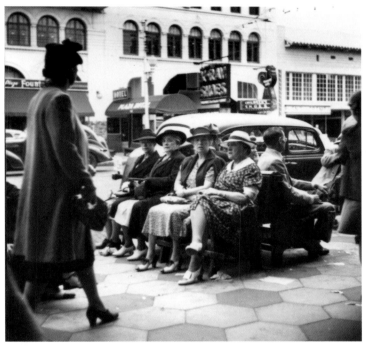

947

948

Evans, *THE GREEN BENCHES AT ST. PETERSBURG*; (verso, mount) at u. right, Evans stamp C; at l. right, in pencil, *65* [circled and inverted]; at l. right, in pencil, [arrow pointing to right] *Evans*; at u. right, *val/093* [underlined]/*29-18* [inverted]; at l. left, in pencil, Crane no. *L76.12* (*Evans*).
REFERENCES: MANCO, pl. 12 (variant).

946
[*The Green Benches at St. Petersburg**],
1941
18.1 x 18.2 cm (7 ⅛ x 7 ⁵⁄₃₂ in.)
84.XM.956.912

MARKS & INSCRIPTIONS: (Verso) at u. right, Evans stamp C; at l. center, in pencil, [arrow pointing to right] *Evans*; at l. left, in pencil, Crane no. *L76.88*(*Evans*).
REFERENCES: *MANCO, pl. 12 (variant).
NOTE: Not illustrated; variant of no. 945.

947
[*The Green Benches at St. Petersburg**],
1941
15.6 x 15.8 cm (6 ⁵⁄₃₂ x 6 ¼ in.)
84.XM.956.910
MARKS & INSCRIPTIONS: (Verso) at

l. right, Evans stamp A; at l. left, in pencil, Crane no. *L76.87*(*Evans*).
REFERENCES: *MANCO, pl. 12 (variant).

948
Men in the Street at Tampa, 1941
Image: 15.6 x 12.5 cm (6 ⅛ x 4 ¹⁵⁄₁₆ in.); mount: 29.2 x 23.7 cm
(11 ½ x 9 ¹¹⁄₃₂ in.)
84.XM.956.934
MARKS & INSCRIPTIONS: (Recto, mount) signed at l. center below print, in pencil, by Evans, *Walker Evans*; at l. left, in black ink, by Evans, *MEN IN THE STREET AT TAMPA*; at l. center, in pen-

cil, *-4"*-; (verso, mount) at l. left, in pencil, *82* [circled]; at l. right, in pencil, *32*; at l. right, in pencil, [arrow pointing to right] *Evans*; at u. right, in pencil, *val/093* [underlined]/*29-11*; (recto, mat) at l. right, in pencil, *219*; at l. left, in pencil, Crane no. *L76.9* (*Evans*).
REFERENCES: MANCO, pl. 9.

949

950

951

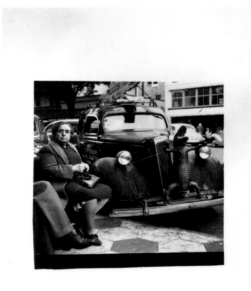

953

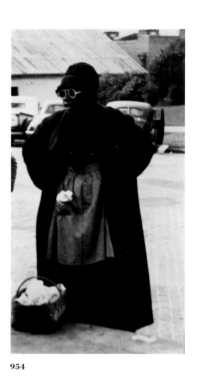

954

949
[Men in the Street at Tampa*], 1941;
printed later
15.9 x 15.6 cm (6 ⁹⁄₃₂ x 6 ⁵⁄₃₂ in.)
84.XM.956.825
MARKS & INSCRIPTIONS: (Verso) at u. left,
Evans stamp C; at l. left, in pencil,
Crane no. L76.90(Evans).
REFERENCES: *MANCO, pl. 9 (variant).

950
[Men in the Street at Tampa*], 1941;
printed later
15.9 x 15.5 cm (6 ⁹⁄₃₂ x 6 ⁹⁄₃₂ in.)
84.XM.956.824

MARKS & INSCRIPTIONS: (Verso) at
l. right, Evans stamp A; at l. left, in
pencil, Crane no. L76.89(Evans).
REFERENCES: *MANCO, pl. 9 (variant).

951
[Racetrack Spectators], 1941
22.3 x 18.2 cm (8 ²⁵⁄₃₂ x 7 ³⁄₁₆ in.)
84.XM.956.1076
MARKS & INSCRIPTIONS: (Verso) at
u. right, Evans stamp A; at l. left,
in pencil, Crane no. L78.24(Evans).

952
[Racetrack Spectators], 1941
22.3 x 18.3 cm (8 ¾ x 7 ⁷⁄₃₂ in.)

84.XM.956.1075
MARKS & INSCRIPTIONS: (Verso) at u. left,
Evans stamp A; at l. left, in pencil,
Crane no. L78.23.
NOTE: Not illustrated; duplicate of
no. 951.

953
[Woman with Car from "St. Petersburg
Alligator Farm"], 1941
Image: 14.5 x 14 cm (5 ¹¹⁄₁₆ x 5 ½ in.);
sheet: 25.2 x 19.5 cm
(9 ¹⁵⁄₁₆ x 7 ¹¹⁄₁₆ in.)
84.XM.956.938
MARKS & INSCRIPTIONS: (Verso) at l. cen-
ter, Evans stamp A; at l. center, in

pencil, [arrow pointing to right] Evans;
(recto, mat) at l. right, in pencil, 220;
at l. left, in pencil, Crane no. L76.128
(Evans).

954
[Woman in Sunglasses, Tallahassee,
Florida], 1941
13.7 x 7.2 cm (5 ⁷⁄₁₆ x 2 ²⁷⁄₃₂ in.)
84.XM.956.918
MARKS & INSCRIPTIONS: (Verso) at l. center,
Evans stamp A; at l. left, in pencil,
by Evans, Tallahassee, Fla., 1941; at
l. right, [arrow pointing to right]
at l. left, in pencil, Crane no. L76.49
(Evans).

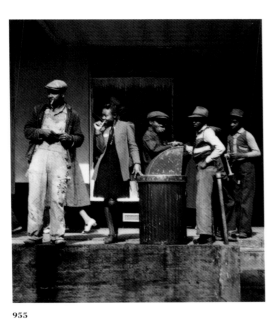

955

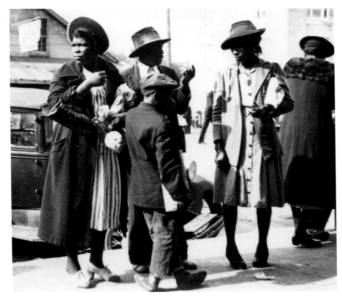

956

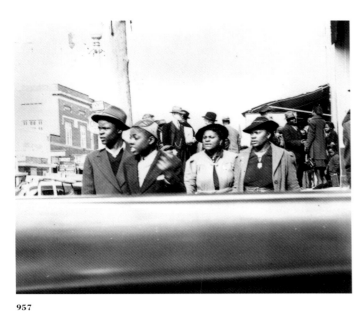

957

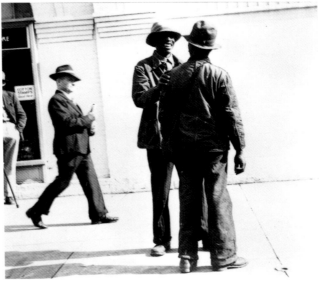

958

955
Negroes at Tallahassee, 1941
Image: 17.6 x 15.2 cm (6 ¹⁵/₁₆ x 6 in.);
original mount: 25.6 x 20.4 cm
(10 ¹/₁₆ x 8 in.)
84.XM.956.882
MARKS & INSCRIPTIONS: (Recto, mount)
signed at l. right below print, in pen-
cil, by Evans, *Walker Evans*; at l. left,
in black ink, by Evans, *NEGROES AT
TALLAHASSEE*; at l. center, in pencil,
5 ¹/₈; (verso, mount) at u. right, in pen-
cil, *val/093* [underlined]/*29.2*
[inverted]; at l. left, in pencil, *86.5*
[circled and sideways]; at l. center, in
pencil, [arrow pointing to right] *Evans*;

at l. left, in pencil, Crane no. *L76.21*
(*Evans*).
REFERENCES: MANCO, pl. 24.

956
[*Family on Sidewalk, Florida*], 1941;
printed later
18.2 x 20 cm (7 ³/₁₆ x 7 ⁷/₈ in.)
84.XM.956.818
MARKS & INSCRIPTIONS: (Verso) at
u. right, Evans stamp C [inverted]; at
l. left, in pencil, Crane no. *L76.37*
(*Evans*).

957
[*Two Women and Boys, Florida Street
Corner*], 1941; printed later
17.7 x 20.6 cm (6 ³¹/₃₂ x 8 ³/₃₂ in.)
84.XM.956.819
MARKS & INSCRIPTIONS: (Verso) at l. cen-
ter, Evans stamp C [inverted]; at l. left,
in pencil, Crane no. *L76.36*(*Evans*).

958
[*Men Conversing, Florida Town Side-
walk*], 1941; printed later
18.7 x 20.4 cm (7 ³/₈ x 8 ¹/₃₂ in.)
84.XM.956.820
MARKS & INSCRIPTIONS: (Verso) at
u. right, Evans stamp C; at l. left, in
pencil, Crane no. *L76.35*(*Evans*).

BLIND COUPLE IN TAMPA CITY HALL SQUARE

959

960

961

963

964

959
Blind Couple in Tampa City Hall Square, 1941
Image: 16 x 22.9 cm (6 5/16 x 9 1/32 in.); original mount: 20.2 x 25.5 cm (7 15/16 x 10 1/32 in.)
84.XM.956.815
MARKS & INSCRIPTIONS: (Recto, mount) signed at l. right, in pencil, by Evans, *Walker Evans*; at l. left, in black ink, by Evans, *BLIND COUPLE IN TAMPA CITY HALL SQUARE*; (verso, mount) at u. right, Evans stamp C; at right center, Crane stamp; at l. left, in pencil, Crane no. *L76.31(Evans)*.

960
[Blind Couple in Tampa City Hall Square], 1941
17.9 x 18.4 cm (7 1/16 x 7 1/4 in.)
84.XM.956.814
MARKS & INSCRIPTIONS: (Verso) at u. right, partial Evans stamp C [printed upside down with *WA* cut off]; at l. left in pencil, Crane no. *L76.32 (Evans)*.

961
[Winter Resorters]*, 1941
Image: 16.8 x 19.3 cm (6 5/8 x 7 19/32 in.) [on mount trimmed to image]; second mount: 45.9 x 38.2 cm (18 1/4 x 15 in.)

84.XM.956.939
MARKS & INSCRIPTIONS: (Recto, mount) signed and dated at right below print, by Evans, *Walker Evans 1941*; (verso, mount) at center, Evans stamp K; at center, wet stamp, in black ink, *RIGHTS RESERVED*; at u. center, in pencil, by Evans, *Crane*; at l. left, in pencil, Crane no. *L76.14(Evans)*.
REFERENCES: *MANCO, pl. 15 (variant).

962
[Winter Resorters]*, 1941; printed later
Image: 14.5 x 14.1 cm (5 11/16 x 5 17/32 in.); sheet: 18.1 x 16.7 cm (7 1/8 x 6 9/16 in.)

84.XM.956.838
MARKS & INSCRIPTIONS: (Verso) at l. right, Evans stamp C; at l. left, in pencil, Crane no. *L76.92(Evans)*.
REFERENCES: *MANCO, pl. 15 (variant).
NOTE: Not illustrated; variant of no. 961.

963
Winter Resorters, Florida, 1941
Image: 14.3 x 11.8 cm (5 5/8 x 4 21/32 in.); original mount: 25.7 x 20.4 cm (10 1/8 x 8 1/32 in.)
84.XM.956.947
MARKS & INSCRIPTIONS: (Recto, mount) signed at right below print, in pencil,

965

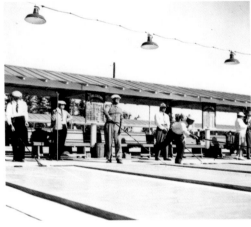

970

971

by Evans, *Walker Evans*; in right mount margin, in pencil, by Evans, *Can you/make the/words/HOME EDITION/*[arrow pointing to l. left]/*legible without/retouching?*; at l. center, in pencil, by Evans, *NOTE FOR ENGRAVER:/Please note unsightly light triangles, several of them, above the numbers* [meaning the numbers Evans has written out below the print]/*Could you simply black them all out* [last three words underlined]*, matching the black next to them./ALSO: Try to get clearly the veins* [last word is circled and with an arrow pointing to right leg of woman on left] *in left leg of left*

woman, but without retouching [last two words underlined]*./ALSO: We want the lettering on the newspaper at right to be clear as possible,-/again, without retouching* [last two words underlined]*/thank you, W.E.*; below image, in pencil, *1* [space] *234* [space] *5* [space] *67*; at l. center, in pencil, *-4″-*; (verso, mount) at u. center, in pencil, by Evans, *#215/WINTER RESORTERS, FLA., 1941*; at l. left, in pencil, *CUT 24* [number circled] *4 ⅝* [arrow pointing upward] *HIGH*; at l. left, in pencil, *NL/872* [underlined]/*2*; at left center, in black ink, *CROP* [arrow pointing to the right]; also, in

pencil, crop lines outlining print dimensions and a line diagonally made from u. left to l. right corners; at l. left, in pencil, Crane no. *L76.16*.
REFERENCES: MANCO, pl. 19 (variant); CRANE no. 209.

964
[*Winter Resorters**], 1941
18.2 x 18.1 cm (7 3/16 x 7 ⅛ in.)
84.XM.956.839
MARKS & INSCRIPTIONS: (Verso) at l. right, partial Evans stamp C; at l. left, Evans stamp A; at l. left, in pencil, Crane no. *L76.94(Evans)*.
REFERENCES: *MANCO, pl. 19 (variant).

965
[*Two Women Conversing, Florida*], 1941
17.6 x 20 cm (6 15/16 x 7 ⅞ in.)
84.XM.956.834
MARKS & INSCRIPTIONS: (Verso) at l. left, partial Evans stamp C; at right center, Evans stamp A; at l. left, in pencil, Crane no. *L76.132(Evans)*.

966
[*Two Women Conversing, Florida*], 1941
17.6 x 20 cm (6 15/16 x 7 ⅞ in.)
84.XM.956.833
MARKS & INSCRIPTIONS: (Verso) at u. right, Evans stamp C; at l. left, in pencil, Crane no. *L76.151(Evans)*.
NOTE: Not illustrated; duplicate of no. 965.

967
[*Two Women Conversing, Florida*], 1941
15.7 x 15.6 cm (6 3/16 x 6 5/32 in.)
84.XM.956.858
MARKS & INSCRIPTIONS: (Verso) at right center, Evans stamp B; at u. center, in pencil, *1* [circled]; at l. right, in pencil, *XX*; at l. left, in pencil, Crane no. *L76.34(Evans)*.
NOTE: Not illustrated; variant of no. 965.

968
[*Two Women Conversing, Florida*], 1941; printed later
14.4 x 15.7 cm (5 11/16 x 6 3/16 in.)
84.XM.956.864
MARKS & INSCRIPTIONS: (Verso) at l. left, wet stamp, in black ink, *W*; at l. right, in pencil, *17A* [mainly erased]; at l. left, in pencil, Crane no. *L76.133 (Evans)*.
NOTE: Not illustrated; variant of no. 965.

969
[*Two Women Conversing, Florida*], 1941; printed later
14.7 x 15.6 cm (5 13/16 x 6 ⅛ in.)
84.XM.956.832
MARKS & INSCRIPTIONS: (Verso) at right center, Evans stamp A; at center, in pencil, *29* [circled]; at l. left, in pencil, Crane no. *L76.33(Evans)*.
NOTE: Not illustrated; duplicate of no. 968.

970
[*Shuffleboard Players, Sarasota*], 1941
Image: 14.5 x 15.7 cm (5 ¾ x 6 3/16 in.); original mount: 25.5 x 20.5 cm (10 1/16 x 8 1/16 in.)
84.XM.956.896
MARKS & INSCRIPTIONS: (Recto, mount) signed at l. right below print, in pencil, by Evans, *Walker Evans*; (verso, mount) at l. right, Evans stamp C; at l. left, in pencil, Crane no. *L76.85 (Evans)*.

971
[*Shuffleboard Players, Sarasota*], 1941
Image: 19.9 x 16.4 cm (7 27/32 x 6 7/16 in.); original mount: 25.5 x 20.3 cm (10 1/16 x 8 in.)
84.XM.956.897
MARKS & INSCRIPTIONS: (Recto, mount) signed at l. right below print, in pencil, by Evans, *Walker Evans*; (verso, mount) at u. center, Evans stamp C; at l. center, in pencil, [arrow pointing to right] *Evans*; at l. left, in pencil, Crane no. *L76.86(Evans)*.

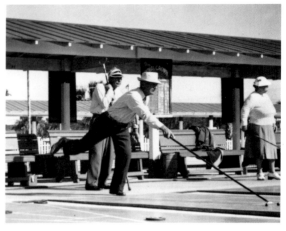

973

974

972

974

972
Shuffleboard Players (at Sarasota),
1941
Image: 18.3 x 15.4 cm (7 ⁷/₃₂ x 6 ¹/₁₆ in.);
original mount: 25.7 x 20.4 cm
(10 ⅛ x 8 ¹/₁₆ in.)
84.XM.956.869
MARKS & INSCRIPTIONS: (Recto, mount)
signed at l. right, in pencil, by Evans,
Walker Evans; at l. left, in black ink,
by Evans, *SHUFFLEBOARD PLAYERS AT
SARASOTA* [last two words have been
crossed out]; at center, in pencil, *5 ⅛*;
at l. right, in pencil, by Evans, *12*;
(verso, mount) at u. center, Evans
stamp C; at u. right, in pencil, *val/093*

[underlined]/*29-1*; at l. center, [arrow
pointing to right] *Evans*; at l. right,
86.5 [inverted and circled]; at l. left, in
pencil, Crane no. *L76.8(Evans)*.
REFERENCES: MANCO, pl. 8 (variant).

973
[*Shuffleboard Players**], 1941
Image: 13.1 x 15.7 cm (5 ⁵/₃₂ x 7 ²³/₃₂ in.);
original mount: 19.6 x 17.2 cm
(7 ¹¹/₁₆ x 6 ¾ in.)
84.XM.956.913
MARKS & INSCRIPTIONS: (Recto, mount)
signed at l. right, in pencil, by Evans,

Walker Evans; (verso, mount) at center,
Evans stamp C [sideways]; at l. center,
in pencil, [arrow pointing to right]
Evans; at l. left, in pencil, Crane
no. *L76.84(Evans)*.
REFERENCES: *MANCO, pl. 8 (variant).

974
[*Relief Carving, Ringling Bandwagon,
Winter Quarters, Sarasota*], 1941; pos-
sibly printed later
21.3 x 16.5 cm (8 ⅜ x 6 ½ in.)
84.XM.956.875
MARKS & INSCRIPTIONS: (Verso) at l. cen-
ter, Evans stamp C; at l. right, in
pencil, [arrow pointing to right] *Evans;*

at l. left, in pencil, Crane no. *L76.74
(Evans)*.

975
[*Ringling Bandwagon, Circus Winter
Quarters, Sarasota*], 1941
Image: 19.5 x 17.5 cm
(7 ¹¹/₁₆ x 6 ²⁹/₃₂ in.); original mount:
25.6 x 20.3 cm (10 ⅛ x 8 in.)
84.XM.956.831
MARKS & INSCRIPTIONS: (Recto, mount)
signed at l. right, in pencil, by Evans,
Walker Evans; (verso, mount) signed
at center, in pencil, by Evans, *Walker
Evans*; at l. center, Evans stamp C

975

976

979

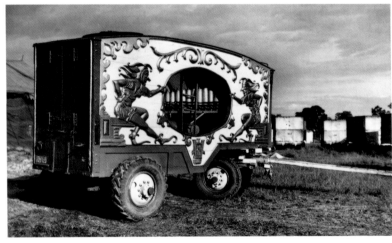

980

[sideways]; at center, in pencil, arrow pointing to artist's signature; at l. left, in pencil, Crane no. *L76.73(Evans)*.

976
[*Rear View of Ringling Bandwagon, Sarasota, Florida*], 1941
21.5 x 14.2 cm (8 ½ x 5 ¹⁹⁄₃₂ in.)
84.XM.956.903
MARKS & INSCRIPTIONS: (Verso) at right center, Evans stamp C [inverted]; at l. left, in pencil, Crane no. *L76.66 (Evans)*.

977
[*Rear View of Ringling Band Wagon, Sarasota, Florida*], 1941
21.7 x 14.4 cm (8 ¹⁷⁄₃₂ x 5 ¹¹⁄₁₆ in.)
84.XM.956.809
MARKS & INSCRIPTIONS: (Verso) at l. left, Evans stamp A; at l. left, in pencil, Crane no. *L76.140(Evans)*.
NOTE: Not illustrated; duplicate of no. 976.

978
[*Rear View of Ringling Bandwagon, Sarasota, Florida*], 1941
22 x 14.3 cm (8 ²¹⁄₃₂ x 5 ⅝ in.)
84.XM.956.904

MARKS & INSCRIPTIONS: (Verso) at l. center, Evans stamp C; at l. left, in pencil, Crane no. *L76.67(Evans)*.
NOTE: Not illustrated; variant of no. 976.

979
[*Three Circus Train Cars, Winter Quarters, Sarasota*], 1941; possibly printed later
18.2 x 22.8 cm (7 ³⁄₁₆ x 8 ¹⁵⁄₁₆ in.)
84.XM.956.803
MARKS & INSCRIPTIONS: (Verso) at center, Evans stamp A; at l. left, in pencil, Crane no. *L76.75(Evans)*.

980
[*Circus Wagon (Calliope Car), Winter Quarters, Sarasota*], 1941
Image: 14.8 x 23.2 cm (5 ¹³⁄₁₆ x 9 ⅛ in.);
original mount: 17 x 25.7 cm
(6 ¹¹⁄₁₆ x 10 ⅛ in.)
84.XM.956.851
MARKS & INSCRIPTIONS: (Verso, mount) signed at center, in pencil, by Evans, *WALKER EVANS*; at l. left, Evans stamp C; at l. left, in pencil, Crane no. *L76.76 (Evans)*.

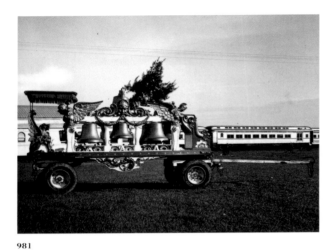

981

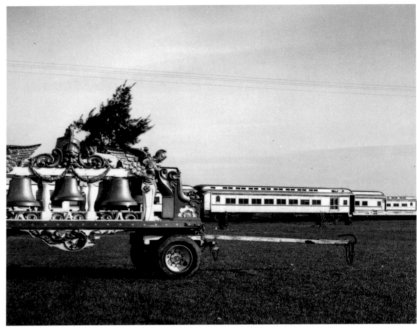

982

983

985

986

981
[*Decorated Wagon with Bells, Circus Winter Quarters, Sarasota*], 1941
Image: 16 x 21.4 cm (6 ⁵⁄₁₆ x 8 ⁷⁄₁₆ in.); original mount: 17.2 x 22.5 cm (6 ²⁵⁄₃₂ x 8 ⅞ in.)
84.XM.956.905
MARKS & INSCRIPTIONS: (Verso, mount) signed at center, in pencil, by Evans, *WALKER EVANS*, [with an arrow pointing down to name]; at left center, Evans stamp C [inverted]; at l. left, in pencil, Crane no. *L76.64(Evans)*.

982
[*Decorated Circus Wagon with Ringling Brothers Train, Winter Circus Quarters, Sarasota*], 1941
Image: 17.5 x 21.4 cm (6 ⅞ x 8 ⁷⁄₁₆ in.); original mount: 20.3 x 25.6 cm (8 x 10 ¹⁄₁₆ in.)
84.XM.956.887
MARKS & INSCRIPTIONS: (Verso, mount) signed at center, in pencil, by Evans, *WALKER EVANS* [with an arrow pointing down to EVANS]; at l. left, in pencil, Crane no. *L76.65(Evans)*.

983
[*Circus Winter Quarters**], 1941; possibly printed later

Image: 22.1 x 18.1 cm (8 ¾ x 7 ⅛ in.); sheet: 23.2 x 19.1 cm (9 ⅛ x 7 ½ in.)
84.XM.956.810
MARKS & INSCRIPTIONS: (Verso) at l. right, Evans stamp C [inverted]; at right center, in pencil, [arrow pointing to right] *Evans*; at l. left, in pencil, Crane no. *L76.139(Evans)*.
REFERENCES: *MANCO, pl. 16 (variant); FAL, p. 147 (variant).

984
[*Circus Winter Quarters**], 1941
21.6 x 17.3 cm (8 ½ x 6 ¹³⁄₁₆ in.)
84.XM.956.811
MARKS & INSCRIPTIONS: (Verso) signed at

l. right, in pencil, by Evans, *Walker Evans* [sideways]; at u. left, Evans stamp C [sideways]; at l. left, in pencil, Crane no. *L76.138(Evans)*.
REFERENCES: *MANCO, pl. 16 (variant); FAL, p. 147 (variant).
NOTE: Not illustrated; duplicate of no. 983.

985
Circus Winter Quarters, Sarasota, 1941
Image: 18.2 x 20.9 cm (7 ³⁄₁₆ x 8 ⁷⁄₃₂ in.); original mount: 20.4 x 25.7 cm (8 x 10 ⅛ in.)
84.XM.956.942

987

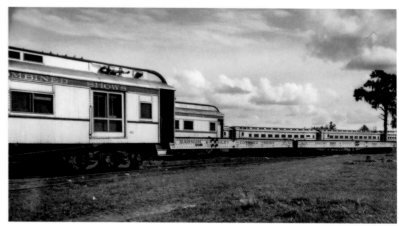

988

989

988
[*Ringling Bros. and Barnum & Bailey Show Train Cars, Winter Quarters, Sarasota*], 1941
Image: 14 x 24.2 cm (5 ½ x 9 ¹⁷⁄₃₂ in.); original mount: 20.3 x 25.7 cm (7 ³¹⁄₃₂ x 10 ⅛ in.)
84.XM.956.926
MARKS & INSCRIPTIONS: (Recto, mount) signed at l. right, in pencil, by Evans, *Walker Evans*; at l. center, in pencil, *4″* [space] *5″* [space] *6″*; at l. right, in pencil, *63*; (verso, mount) signed at center, in pencil, by Evans, *WALKER EVANS*; at u. right, Evans stamp C; at l. left, in pencil, Crane no. *L76.62 (Evans)*.

MARKS & INSCRIPTIONS: (Recto, mount) signed at l. right, in pencil, by Evans, *Walker Evans*; at l. left, in black ink, by Evans, *CIRCUS WINTER QUARTERS, SARASOTA* [last word crossed out in pencil]; at l. center, in pencil, *-5 ⅛-*; (verso, mount) at right center, Evans stamp C; at u. left, in pencil, *63* [circled]; at center, in pencil, [arrow pointing to right] *Evans* [sideways]; at l. right, in pencil, *val/093/29-28*; at l. left, in pencil, Crane no. *L76.143*.
REFERENCES: MANCO, pl. 16; FAL, p. 147 (variant).

986
[*Man at Work on Decorated Circus Wagon, Sarasota*], 1941
Image: 22.1 x 17.1 cm (8 ²³⁄₃₂ x 6 ²³⁄₃₂ in.); original mount: 25.4 x 20.3 cm (10 ¹⁄₃₂ x 8 in.)
84.XM.956.940
MARKS & INSCRIPTIONS: (Recto, mount) signed at l. right, in pencil, by Evans, *Walker Evans*; at right margin, in pencil, *3″/4″/5″*; at l. right margin, in pencil, *57*; (verso, mount) signed at center, in pencil, by Evans, *WALKER EVANS* [with arrow pointing down to EVANS]; at l. left, in pencil, Crane no. *L76.129*.

987
[*Detail of Circus Wagon, Sarasota*], 1941
Image: 22.2 x 15.1 cm (8 ¾ x 5 ¹⁵⁄₁₆ in.); original mount: 24.7 x 15.1 cm (9 ¾ x 6 ½ in.)
84.XM.956.877
MARKS & INSCRIPTIONS: (Recto, mount) signed at l. right below print, in pencil, by Evans, *Walker Evans*; (verso, mount) signed at center, in pencil, by Evans, *WALKER EVANS*; at u. center, Evans stamp C [sideways]; at l. left, in pencil, Crane no. *L76.63(Evans)*.

989
[*Balcony Car, Circus Train, Winter Quarters, Sarasota*], 1941
Image: 19.3 x 16.9 cm (7 ⅝ x 6 ¹¹⁄₁₆ in.); original mount: 25.7 x 20.4 cm (10 ³⁄₃₂ x 8 ¹⁄₃₂ in.)
84.XM.956.946
MARKS & INSCRIPTIONS: (Recto, mount) signed at l. right, in pencil, by Evans, *Walker Evans*; at right margin, in pencil, *3″/4″/5″*; at l. right margin, in pencil, *65*; (verso, mount) signed at center, in pencil, by Evans, *WALKER EVANS*; at u. left, Evans stamp C; at l. left, in pencil, Crane no. *L76.130*.

991

992

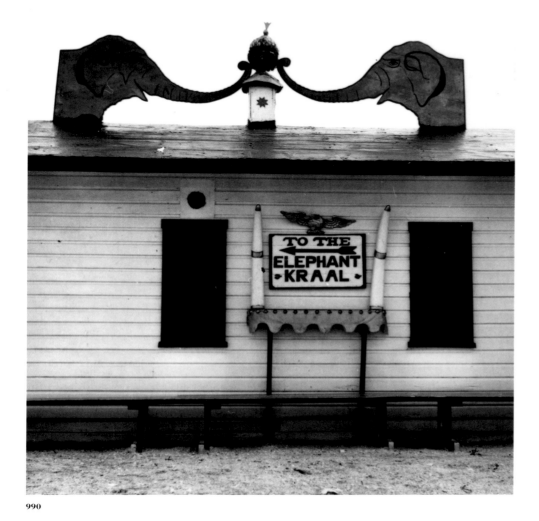

990

993

990
[*Elephant Building, Winter Quarters, Sarasota*], 1941
Image: 17.2 x 15.6 cm (6 ²⁵/₃₂ x 6 ⁵/₃₂ in.); original mount: 25.3 x 20.4 cm (9 ³/₃₂ x 8 ¹/₃₂ in.)
84.XM.956.883
MARKS & INSCRIPTIONS: (Recto, mount) signed at l. right below print, in pencil, by Evans, *Walker Evans*; at l. center, in pencil, *4″* [space] *5″* [space] *6″* [space] [all crossed out]; at l. right, in pencil, *98 ½*; (verso, mount) signed at center, in pencil, by Evans, *WALKER EVANS* [arrow pointing to artist's signa-

ture]; at l. left, in pencil, Crane no. *L76.60(Evans)*.

991
[*Circus Trainer with Elephant Lifting Its Foot, Winter Quarters, Sarasota*], 1941
Image: 17.1 x 20.2 cm (6 ¹¹/₁₆ x 8 in.); original mount: 20.3 x 25.5 cm (8 x 10 ¹/₁₆ in.)
84.XM.956.829
MARKS & INSCRIPTIONS: (Recto, mount) signed at l. right, in pencil, by Evans, *Walker Evans*; at right margin, in pencil, *¾″*; at l. right, in pencil, *75*; also,

[pencil line running length of print in right margin]; (verso, mount) signed at center, in pencil, by Evans, *WALKER EVANS*; at l. right, Evans stamp C; at center, in pencil, [arrow pointing down to artist's signature]; at l. left, in pencil, Crane no. *L76.78(Evans)*.

992
[*Two Circus Trainers with Reclining Elephant, Winter Quarters, Sarasota*], 1941; possibly printed later
17.2 x 23.1 cm (6 ¾ x 9 ³/₃₂ in.)
84.XM.956.852
MARKS & INSCRIPTIONS: (Verso) at right

center, Evans stamp C; at l. left, in pencil, Crane no. *L76.79(Evans)*.

993
[*Two Circus Trainers with Seven Elephants, Winter Quarters*], 1941; possibly printed later
17 x 21.6 cm (6 ¹¹/₁₆ x 8 ¹⁷/₃₂ in.)
84.XM.956.853
MARKS & INSCRIPTIONS: (Verso) signed at center, in pencil, by Evans, *WALKER EVANS* [arrow pointing toward artist's signature]; at l. right, Evans stamp C; at right edge, Evans stamp A; at l. left, in pencil, Crane no. *L76.80(Evans)*.

994

995

996

997

998

994
[*Circus Trainer with Five Elephants, Winter Quarters*], 1941; possibly printed later
16.2 x 19.5 cm (6 ³⁄₈ x 7 ¹¹⁄₁₆ in.)
84.XM.956.854
MARKS & INSCRIPTIONS: (Verso) signed at center, in pencil, by Evans, *WALKER EVANS* [arrow pointing toward artist's signature]; at l. right, Evans stamp C; at l. left, in pencil, Crane no. *L76.81* (*Evans*).

995
[*Six Circus Elephants Rehearsing with Trainers, Winter Quarters*], 1941

Image: 19.2 x 22.5 cm (7 ⁹⁄₁₆ x 8 ⁷⁄₈ in.); sheet: 19.5 x 24.3 cm (7 ²³⁄₃₂ x 9 ⁹⁄₁₆ in.)
84.XM.956.802
MARKS & INSCRIPTIONS: (Verso) at center, Evans stamp C [sideways]; at l. left, in pencil, Crane no. *L76.77*(*Evans*).

996
[*Circus Trainer Leading Elephant*], 1941
16.6 x 18.9 cm (6 ⁹⁄₁₆ x 7 ¹⁵⁄₃₂ in.)
84.XM.956.941
MARKS & INSCRIPTIONS: (Verso) signed at center, in pencil, by Evans, *WALKER EVANS* [with arrow pointing down to EVANS]; at u. left, Evans stamp C

[inverted]; at l. left, in pencil, Crane no. *L76.131*.

997
[*Two Lions in a Cage, Circus Winter Quarters, Sarasota*], 1941
Image: 16.9 x 22.3 cm (6 ²¹⁄₃₂ x 8 ²⁵⁄₃₂ in.); original mount: 20.3 x 25.5 cm (8 x 10 ¹⁄₁₆ in.)
84.XM.956.927
MARKS & INSCRIPTIONS: (Recto, mount) signed at l. right, in pencil, by Evans, *Walker Evans*; at l. margin, in pencil, 7 ½″ [space] 6 ½″ [with pencil line through numbers running the length of l. margin]; at l. right, in pencil, 86; (verso, mount) signed at center, in pen-

cil, by Evans, *WALKER EVANS* [with arrow pointing down to EVANS]; at u. left, Evans stamp C [inverted]; at l. left, in pencil, Crane no. *L76.61* (*Evans*).

998
[*Torn Ringling Brothers Poster*], 1941; possibly printed later
Image: 16.5 x 20.5 cm (6 ¹⁷⁄₃₂ x 8 ¹⁄₁₆ in.); sheet: 18 x 22.2 cm (7 ³⁄₃₂ x 8 ²³⁄₃₂ in.)
84.XM.956.914
MARKS & INSCRIPTIONS: (Verso) at center, Evans stamp C [sideways]; at l. left, in pencil, Crane no. *L76.58*(*Evans*).

999

1000

1002

REFERENCES: Alice Morris, "The Circus at Home." *Harper's Bazaar*, Apr. 1942, p. 64.

999
[*Baboon in Cage, Circus Winter Quarters*], 1941
Image: 17.5 x 13.5 cm
(6 ²⁹⁄₃₂ x 5 ⁵⁄₁₆ in.); original mount: 25.7 x 20.3 cm (10 ⅛ x 8 in.)
84.XM.956.885
MARKS & INSCRIPTIONS: (Recto, mount) signed at l. right, in pencil, by Evans, *Walker Evans*; at right margin, in pencil, *3/4*; at u. right margin, in pencil,

72 [sideways]; also, [pencil line running length of print in right margin]; (verso, mount) signed at center, in pencil, by Evans, *Walker Evans* [with arrow pointing sideways toward Evans]; at l. left, in pencil, Crane no. *L76.59(Evans)*.

1000
[*Two Giraffes, Circus Winter Quarters, Sarasota*], 1941
Image: 15.1 x 18.3 cm
(5 ¹⁵⁄₁₆ x 7 ³⁄₁₆ in.); original mount: 25.5 x 20.4 cm (10 x 8 in.)
84.XM.956.859
MARKS & INSCRIPTIONS: (Recto, mount)

signed at l. right, in pencil, by Evans, *Walker Evans*; at l. margin, in pencil, [drawn line]/*9 ½"*; at l. center, in pencil, *131*; (verso, mount) signed at center, in pencil, by Evans, *WALKER EVANS*; at u. right, Evans stamp C [sideways]; at center, in pencil, [arrow pointing to artist's signature]; at l. left, in pencil, Crane no. *L76.144(Evans)*.

1001
[*Two Giraffes, Circus Winter Quarters, Sarasota*], 1941
Image: 14.9 x 18.7 cm (5 ⅞ x 7 ⅜ in.); original mount: 25.8 x 21.1 cm (10 ⅛ x 8 ¹¹⁄₃₂ in.) [detached]

84.XM.956.889
MARKS & INSCRIPTIONS: (Verso) signed at center, in pencil, by Evans, *WALKER EVANS*; at right center, Evans stamp C; at center, in pencil, [arrow pointing up toward artist's signature]; at l. left, in pencil, Crane no. *L76.72(Evans)*; (verso mount) at center, Evans stamp C twice; at l. left in pencil, Crane no. *L76.72(Evans)*.
NOTE: Not illustrated; variant of no. 1000.

1002
[*Giraffe Looking Over Cage, Winter Quarters, Sarasota*], 1941
Image: 16.3 x 20.5 cm (6 ⁷⁄₁₆ x 8 ³⁄₃₂ in.); original mount: 20.4 x 25.6 cm (8 x 10 ⅛ in.)
84.XM.956.888
MARKS & INSCRIPTIONS: (Recto, mount) signed at l. right, in pencil, by Evans, *Walker Evans*; (verso, mount) signed at center, in pencil, by Evans, *Walker Evans* [with arrow pointing toward artist's signature]; at u. right, Evans stamp C; at l. left, in pencil, Crane no. *L76.71(Evans)*.

1941–1955

At *Fortune*

Faulkner Country

AT FORTUNE

*Color photography, that complex and ingenious invention, is still in
its infancy. But it has already reflected, in its uses, the true fresh beauties
(as well as the fulsome inanities) of the age.*

Walker Evans for *Fortune*, July 1954[1]

Although Walker Evans seldom exhibited or discussed the pictures he made for *Fortune*, these photographs constitute "the largest single body of work he produced."[2] Evans's association with this high-priced journal of the business world began in 1934, when *Fortune* published his photographs in two articles in their September issue: "The Communist Party" and "The Great American Roadside."[3] The latter piece was written by James Agee, as was the article "Six Days at Sea" that accompanied Evans's next published *Fortune* commission, an account of "a 'good average' cruise to Havana."[4] Before making this trip to Cuba for the magazine in 1937, Evans and Agee had been engaged by *Fortune* to report on the daily existence of a Southern cotton tenant farmer; they spent nearly a month in Hale County, Alabama, in the summer of 1936, gathering material for this story. But *Fortune* declined to print the results of their work. (See the chapter "*American Photographs*" for pictures from this assignment.)[5]

The journal's editors called upon Evans again in 1941 for a story about the effects of accelerated wartime production on the formerly depressed city of Bridgeport,

Connecticut.[6] He made several trips to that heavily industrial community in the summer of 1941 and came back with images from Main Street and a patriotic parade. The Getty collection includes ten pictures (nos. 1003–12) from this assignment, including a more complete printing of the image captioned "Bridgeport's Italian Women Insist upon Their Patriotism" (no. 1009), which appeared with the piece "In Bridgeport's War Factories" that September.[7] As we have seen, Evans had been fascinated by parade rituals from the very beginning of his career. However, his pictures of Main Street shoppers (nos. 1004–6)—seven of which, exclusive of the Getty images, were used as illustrations in *Fortune*—represent a more significant strain in his work, namely, the anonymous portrait.[8] Earlier in 1941 he had photographed unsuspecting passengers in the New York subway; now he made individual portraits on a busy street corner, his subjects too distracted by errands and traffic to acknowledge his presence. The *Fortune* caption indicates that these shoppers were part of a recent influx of 15,000 new inhabitants who local department stores were hoping would spend as freely as the workers who had swelled the city's population during World War I; the president of the Howland Department store was, however, reporting a "more somber buying mood" thus far.[9]

During the war, Evans worked as a book-review

Walker Evans. *Woman Shopper, Bridgeport*
(detail), 1941 [no. 1004].

editor for *Time* magazine. He returned to *Fortune*, now as
staff photographer, in 1945, and he would stay on its pay-
roll until a teaching job would eventually take him to New
Haven in 1965. The many years he spent as a photojournal-
ist—preparing photographs, layouts, and texts for *For-
tune*—are represented in strength at the Getty by two
black-and-white essays and by one color story that never
reached the printed page. For the first of these, produced
in Evans's third year with the magazine, *Fortune* devoted
nine pages to his work, publishing the unusually large
number of twenty images in a piece subtitled "A Portfolio
by Walker Evans." The main title of this essay was "Chi-
cago: A camera exploration of the huge urban sprawl of the
midlands"; it presented views of Michigan Avenue down-
town, the old South Side, and, as in Bridgeport, portraits of
pedestrians, this time at the corner of State and Randolph
Streets.[10] Of the fourteen Getty prints related to this photo-
essay (nos. 1026–39), half are on the subject of dilapidated
South Side townhouses, including the view of 2033 Prairie
Avenue that appears as a full-page plate in a comparable
cropping (no. 1032).[11] But in the finest tradition of Evans's
street portraits are three images of women shoppers
(nos. 1029–31), none of which is among the six street por-
traits (both male and female) chosen for the final layout.[12]

Not only did his images of average Americans
receive substantial space in the Chicago essay, but the pre-
ceding November a two-page piece called "Labor Anony-
mous" had been devoted to portraits made "on a Saturday
afternoon in downtown Detroit" of workers who happened
to pass Evans's strategically placed camera.[13] In Detroit,
he seems to have established himself inconspicuously in a
spot that allowed him to photograph selected pedestrians
against a plain plywood background. Those Americans
who ultimately appeared in a gridlike arrangement of *For-
tune*'s high-quality gravures were predominantly male
(eleven of the twelve pictured). The Getty holds two prints
from the series, both unused by *Fortune*—one of a preoc-
cupied blond woman whose mass fills the frame Evans cre-

Figure 1. Walker Evans. *Labor Anonymous:
Man on the Street, Detroit*, 1946 [no. 1024].

ated (no. 1025) and another of a young man with wavy hair
who was, perhaps, too handsome for the final selection
(no. 1024; fig. 1). Aside from the overly self-confident tone
that Evans, no doubt, would have disdained, the brief text
that accompanies the published pictures aptly reflects the
photographer's attempts at a random but representative
selection. This text begins: "The American worker, as he
passes here, generally unaware of Walker Evans' camera,
is a decidedly various fellow. His blood flows from many
sources. His features tend now toward the peasant and
now toward the patrician. His hat is sometimes a hat, and
sometimes he has molded it into a sort of defiant signa-
ture."[14] Continuing to laud the power of diversity in the
American workplace, the text points to a quality apparent
in both Getty portraits: "Another thing may be noticed
about these street portraits. Most of the men on these
pages would seem to have a solid degree of self-
possession. By the grace of providence and the efforts of

millions, including themselves, they are citizens of a victorious and powerful nation, and they appear to have preserved a sense of themselves as individuals."[15]

A second black-and-white essay from the *Fortune* years is well represented at the Getty. It resulted from negatives made in the studio rather than on the street and was entitled "Beauties of the Common Tool."[16] This portfolio originally appeared in 1955 as four full-plate illustrations and one half-page horizontal image. These five *Fortune* compositions (and several variations on them), as well as twelve other subjects, are part of the Museum's collection (nos. 1074–98, including duplicate prints; fig. 2). The open-end crescent wrench of German manufacture, captioned like the others in *Fortune* with its current price (fifty-six cents), can be seen in a different "pose" against a soft, possibly felt background in a Getty print (no. 1097). The Getty photograph that displays the image of this tool finally used in the essay (no. 1098) also bears an inscription in ink indicating the long exposure in afternoon light: "3 min. 3:15 sun." Another rare print exhibiting evidence of Evans's technique is the picture of chain-nose pliers (no. 1079); this photograph contains the notation: "2 ½ min. daylight sun 2 PM." In addition to the hardware items seen in *Fortune*, the implements Evans chose as "sitters" for this story also included a casing blade (no. 1081), a tape reamer (no. 1082), an engineer's pliers (no. 1083), a cylindrical awl (no. 1084), an auger drill bit (no. 1085), a bill hook tool (no. 1086), a two-blade knife (no. 1087), a "T" bevel (no. 1091), an all-steel wood chisel (no. 1093), and a crew punch (no. 1096).

As staff photographer for the journal that embodied corporate America, Evans enjoyed an unusual amount of freedom as he photographed many aspects of industrial life—factories, machinery, laborers. But he had not had the opportunity to portray the most fundamental, the most ordinary apparatus—the hand tool. It was clearly an aspect of American material culture that he valued highly, and the short introduction that he wrote is typically con-

Figure 2. Walker Evans. *Baby Terrier Crate Opener, by Bridgeport Hardware Mfg. Corp., 69 cents*, 1955 [no. 1077].

cise as he expresses his respect for these "tool classics." The first paragraph reads:

Among low-priced, factory-produced goods, none is so appealing to the senses as the ordinary hand tool. Hence, a hardware store is a kind of offbeat museum show for the man who responds to good, clear "undesigned" forms. The Swedish steel pliers pictured above, with their somehow swanlike flow, and the objects on the following pages, in all their tough simplicity, illustrate this. Aside from their functions— though they are exclusively wedded to function— each of these tools lures the eye to follow its curves and angles, and invites the hand to test its balance.[17]

Evans isolated these objects against plain surfaces for extended exposures, so that his large-format negatives

could capture every detail and nuance of texture and even, at times, reproduce the actual size of the object. Evans seemed to be after the minimal, not just the magnificent, elements of cheaply mass-produced forms. He used stark symmetry and 8 x 10-inch contact printing to interpret in two dimensions the physical presence of these modest household objects; in his text, he explained their attraction this way: "almost all the basic small tools stand, aesthetically speaking, for elegance, candor, and purity."[18]

Other fixtures of everyday life, in this case unavoidable but often unnoticed objects found on the street, are the theme of the third *Fortune* project found in considerable rare material in the Getty collection. Twenty-five 2¼ x 2¼-inch transparencies made between 1952 and 1954 were apparently intended for a future photo-essay in color to be called "Street Furniture" (nos. 1049–73).[19] As a supplement to the images Evans produced for "Street Furniture," the Getty possesses his accumulated working notes (on 4½ x 2½-inch and 5 x 3-inch notebook sheets) of March and May 1953, and a letter of introduction from *Fortune* asking for cooperation from those who might have found the photographer's work on this series suspect or peculiar.[20] He planned to document barber poles, fire hydrants, lampposts, traffic signs, mailboxes. Although the notes refer primarily to very specific locations in New York City, some of the transparencies on this subject were made in towns in Massachusetts and Connecticut. Evans's records of work done are often explicit about date, time of day, camera and film used, and the object photographed. Many of the jottings on these tiny sheets, however, have to do with where, when, and what he would work on next. There was a drinking fountain at Twenty-third and Madison that he wanted to shoot about 4:00 P.M., a candy machine on the southeast corner of Forty-ninth and Ninth, a Canal Street kiosk that he thought would need the morning sun, and manholes near Fifth and Twenty-third that should be photographed early in the day.

Evans had been using color for *Fortune* assign-

ments since he first joined its staff in 1945, and he welcomed, rather than resisted, this new direction in his own photojournalism.[21] Even so, his color work accounted for only a small fraction of the images employed in the published essays until 1950, when more than half of the pictures for the portfolio "Along the Right-of-Way" appeared in color.[22] These were also some of the best compositions in the medium that Evans had produced and were acclaimed in a pioneering article on Evans's color pictures as marking "the moment when his colour work can first bear comparison with the monochromes."[23] Between 1950 and 1954, the pages of *Fortune* presented six stories with substantial color work by Evans.[24] Unfortunately, the process of rotogravure color printing in the fifties was even less perfect than the color film it was based on; the range and intensity of hues in the published images appears even more limited than that probably available in the original Ektachromes. In fact, there is so little subtlety in the color found in these early fifties illustrations that the compositions often tend to be nearly monochromatic, as is the case in "Clay. The commonest industrial raw material," in which the overwhelming tone is a burnt sienna; or the color looks completely unnatural, as in most of the images in "Chicago River: The creek that made a city grow"; or the tints appear to be hand applied in the manner of turn-of-the-century postcards (one of the photographer's favorite collectibles), as in the pictures of nineteenth-century train stations composing the portfolio "The U.S. Depot."

Surprisingly, Evans's most successful efforts in color imagery from this *Fortune* period, all of which seem to exist only on the printed page or as transparencies, may well have been a few of the executive portraits he did on a regular basis between the fall of 1951 and the spring of 1954.[25] These prominent businessmen, appearing monthly under the heading of "*Fortune*'s Portrait," were pictured full-page adjacent to a narrative profile of their accomplishments. Some were traditionally posed in an office environment, such as Clifford F. Hood, President of U.S. Steel,

but even so, the quiet gray of Hood's beautifully tailored double-breasted suit offers an interesting counterpoint to the forest-green wall and off-white baseboard behind him.[26] His tie, embellished with abstract designs in shades of brown and gray, is actually more conspicuous than his own profile and is nicely balanced by the decorative edge of drapery, patterned in salmon, gray, and blue-green, that Evans included at the right.

The power of these portraits comes in part from the fact that Evans allows the physical size of America's corporate leaders to dominate the frame. Dressed predictably in neutral colors, this group of successful executives provides the perfect foil for experimenting with contrasting color backgrounds. In photographing outdoors, as he did in portraying Henderson Supplee, Jr., of Atlantic Refining, Evans did not always exploit this advantage. Supplee seems to tower above a foggy city skyline, the prominence of his starched white shirt and rose-colored paisley tie giving the picture the tone of an Arrow shirt advertisement.[27] Consequently, as a study in black-and-white portraiture, this image might be quite compelling; as color, it is less so. On the other hand, the portrait Evans turned in for Robert Mondell Ganger, a former advertising man and now "president and chief operating officer of the oldest and fifth-biggest U.S. tobacco business, P. Lorillard Co.," is a fine study in color composition as well as candid portraiture.[28] Cigarette in hand, Ganger is shown in conversation with a companion beyond the frame; in the background is a four-story brick structure, probably located on a New York street but suggesting the old tobacco warehouses of Durham, North Carolina. One critic has pointed to the special significance of the improbably successful color composition in this photograph. The "dissonance and imbalance of the colour affirms the thrust and aggression of the subject."[29] The glowing red-orange of the brickwork further animates Ganger's dynamic, on-the-job persona; the farsighted executive who introduced Kent filter-tip cigarettes is dressed in the cool beige and blue of his

profession, but his striped tie and gold collar points complete the composition by repeating the warm hues of the background.

Evans's color work was virtually never seen outside the magazines that commissioned it. Still, there were early critics who may have been, in part, responsible for the photographer's efforts to separate this material from his "serious" work. In 1957, James Thrall Soby, writing in *Modern Art and the New Past*, focused on four photographers—Alfred Stieglitz, Paul Strand, Henri Cartier-Bresson, and Evans—as exemplary, but closed his comments on the latter's photography with this disclaimer:

> *I must explain, however, that in discussing Evans' recent imagery, I mean to refer only to the photographs in black and white. Lately he has done a considerable amount of work in color for* Fortune, *and these photographs seem to me inferior. I don't know why it is that color photography always tends to look picturesque, even when produced by a strong talent like Evans'. . . . Let us hope that Evans will turn his back on color, at least until the process has progressed beyond its present hand-tinted banality.*[30]

Evans himself rarely commented on the medium of color photography; when he did, it was in reference to the accomplishments of others, and, even then, he was never unreservedly enthusiastic. The 1954 *Fortune* portfolio of six color pictures by Strand, Edward Weston, Charles Sheeler, and Charles Abbott was selected by Evans and opens with his favorable words about color quoted at the beginning of this chapter. It ends, however, with a cautionary note from the photographer: "Many photographers are apt to confuse color with noise, and to congratulate themselves when they have almost blown you down with screeching hues alone—a bebop of electric blues, furious reds, and poison greens."[31] He seemed to include a few color images only grudgingly in the section on photogra-

phy that he later prepared for the 1969 publication *Quality: Its Image in the Arts*. He prefaced these plates with comments that began: "Color tends to corrupt photography and absolute color corrupts it absolutely. Consider the way color film usually renders blue sky, green foliage, lipstick red, and the kiddie's playsuit. There are four simple words for the matter, which must be whispered: Color-photography is vulgar."[32]

This preface from the sixties also contains two other Evans insights that might be applied to the Getty's "Street Furniture" pictures. One has to do with the mundane subject matter: "When the *point* of a picture subject is precisely its vulgarity or its color-accident through man's hand, not God's, then only can color film be used validly."[33] The other is a sardonic statement on the aging of color transparencies: "It is a consoling thought that in fifty years both color transparencies and paper prints in color—*all* the color photography done in this period—will very probably have faded away."[34] Not quite half a century has passed since the twenty-five transparencies at the Getty were made, but the fading Evans predicted is beginning to occur and the original tones are now hard to distinguish from the pink tones creeping into every hue. In spite of this undeniable color-shift, the Getty transparencies are informative examples of the photographer's color work, and their subject or *point* may well be "vulgar," a branch of Evans's iconography that the photographer treasured rather than disdained. The signs, fire hydrants, barber poles, and trashcans of this series are manmade "color-accidents" that Evans artfully selected for tight compositions on film.

Occasionally in the "Street Furniture" series Evans's habit of seeing in black and white appears to keep him from exploiting potentially successful color arrangements. One might cite as an example the picture constructed around an Eighty-sixth Street lamppost that is much more about the varied forms of the bare trees and the silhouetted building, as well as the lamppost, than

about the possibilities of color (no. 1062). However, the majority of these pictures reflect deliberate thinking in color, whether it is to situate a painted red-and-white fire hydrant in the absurdly picturesque earth tones of an overgrown country field (no. 1052) or to dramatize the ingenuity of Coca-Cola as the shape of its familiar bottle becomes the luminous white form of a crossing guard, with Coke's bright red emblem serving as a protective shield for the vulnerable flat figure abandoned in the center of the road (no. 1071). The gaudy red of fire call boxes, like that of fire hydrants and barber poles, evidently attracted Evans's eye. He used one on an aging pole at First Avenue and Eighty-sixth Street in two compositions, a shot including street and sidewalk traffic made with a skylight filter (no. 1057) and a better effort made without the filter or the distracting traffic (no. 1058). Indeed, those pictures that display the subtlest color and would seem to be quintessential candidates for Evans's designing in black and white—such as the white-fluted lamppost base that borders a flower bed on the edge of a suburban tract (no. 1065) or the barber pole at 343 East Eighty-sixth that provides a crude counterpoint to more delicately wrought, cast-iron railings (no. 1060)—were, for their time, provocative, understated contributions to the history of the medium.

Two outstanding images from this series, both dated March 23, 1953, celebrate the commonplace colors of New York streets, from the mottled gray of well-traveled sidewalk surfaces to the garish paint and neon of commercial facades and signage. The *Red Shoeshine Chair* (no. 1059) presents the brightly colored elevated wooden seat as a kind of Everyman's throne, completely accessible, especially to those who might be having shoes repaired next door. This color ensemble centered around the red chair perpetuated in a brilliant manner Evans's treatment of the shoeshine trade and its accoutrements, a theme that appeared first in the Havana pictures and continued through his work in the South and the Bridgeport documentation of 1941.[35] The heavy balustrade that pro-

trudes brazenly into the foreground of a view made at 1609 First Avenue (no. 1061) seems to exist as a naive sculptural entity. By making it the center of attention, Evans has disguised its normal function as part of the unloading apparatus for the adjoining tavern and has poised the tones of its metallic surface next to the chalky grays of architectural motifs, the reds of painted brickwork, and the pastel

shades of neon trademarks. The best of the Street Furniture series is comparable to any of Evans's later work in color, but it is perhaps most relevant to think of it in the context of future *Fortune* essays like "The Pitch Direct," a portfolio that highlighted the street fairs of American shopkeepers, or the Polaroids of 1973–74 that would revel in the "vulgar" aspects of modern life.[36]

NOTES

1. Walker Evans, "Test Exposures. Six Photographs from a Film Manufacturer's Files," *Fortune* 5 (July 1954), 77.

2. Lesley K. Baier, *Walker Evans at "Fortune," 1945–1965*, exh. cat. (Wellesley College Museum: Wellesley, Mass., 1977), 6. Baier's catalogue essay chronicling Evans's years at *Fortune* laid the groundwork for this and all future investigations of Evans's career with that journal.

3. "The Communist Party," *Fortune* (Sept. 1934), pp. 69–74, 154–64 (7 photographs), and "The Great American Roadside," ibid., 57–63, 172, 174, 177 (1 photograph). See Baier, *Walker Evans at "Fortune,"* 61–63, for a listing of Evans's published work for *Fortune*.

4. "Six Days at Sea . . . on a 'good average' cruise to Havana," *Fortune* 16 (Sept. 1937), 117–20, 210, 212, 214, 216, 219–20 (19 photographs).

5. This collaboration was finally published in 1941 by Houghton Mifflin as *Let Us Now Praise Famous Men: Three Tenant Families*. Evans's pictures from this assignment became the property of the Resettlement Administration (per a prior agreement) after the magazine released them.

6. "In Bridgeport's War Factories," *Fortune* 24 (Sept. 1941), 87–92, 156, 158–62 (15 photographs).

7. Ibid., 92.

8. Ibid., 88–89.

9. Ibid., 89.

10. Walker Evans, "Chicago. A camera exploration of the huge, energetic urban sprawl of the midlands," *Fortune* 35 (Feb. 1947), 112–21.

11. Ibid., 115.

12. Ibid., 118.

13. "Labor Anonymous," *Fortune* 34 (Nov. 1946), 152–53.

14. Ibid., 153.

15. Ibid.

16. Evans, "Beauties of the Common Tool," *Fortune* 52 (July 1955), 103–7.

17. Ibid., 103.

18. Ibid.

19. Thirteen of the transparencies are not dated, but the remainder bear Evans's labels with dates ranging from 1952 to February 22, 1954. Additionally, there are two black-and-white prints at the Getty related to these color images; they are images from Boston Common dated May 1953 (nos. 1047–48).

20. See Appendix A for a further description of these documents.

21. Baier, *Walker Evans at Fortune*, 20.

22. Walker Evans, "Along the Right-of-Way," *Fortune* 42 (Sept. 1950), 106–13.

23. David Reed, "A Change in Direction: A Survey of Evans' Colour Photography," *Creative Camera* no. 159 (Sept. 1977), 314. This article by Reed was the first, and remains the only, essay to concentrate on Evans's color work of the *Fortune* years. However, it is not illustrated. Vicki Goldberg's article "Walker Evans: *Fortune* and Man's Eye," *American Photographer* X:1 (Jan. 1983), 56–63, includes three color plates (p. 57 reproduces no. 1059) and devotes one paragraph to a discussion of Evans's color work between 1945 and 1965, pointing out that "almost half of his photographs published in *Fortune* after 1950 were color." Paradoxically, Carol Squiers's piece for *Artforum*, "Color Photography: The Walker Evans Legacy and the Commercial Tradition" (Nov.

1978), 64–67, neither mentions nor illustrates Evans's own color work but discusses the influence of his subject matter, attitude, and expressive use of light on the work of younger photographers, particularly Stephen Shore. Outside of the fading pages of the original issues of *Fortune* and *Architectural Forum*, Evans's pre-1970 color pictures have been inaccessible until the publication of five plates (pp. 337–341, from Ektachrome and Kodachrome transparencies) in *Walker Evans: The Hungry Eye* (New York: Harry N. Abrams, 1993).

24. In addition to "Along the Right-of-Way," these include "Clay. The commonest industrial raw material" (Jan. 1951), "The Wreckers" (May 1951), "Chicago River: The creek that made a city grow" (Aug. 1951), "Imperial Washington" (Feb. 1952), and "The U.S. Depot" (Feb. 1953). The only representation of this color work at the Getty is one print (no. 1082, reproduced in black and white) from "The Wreckers." See the bibliography for more complete references.

25. It appears that *Fortune* began this regular feature of color-plate executive portraits in 1949. Ralph Steiner was one of the first photographers enlisted for this job, and he is credited with twelve portraits appearing between April 1949 and January 1951. According to Steiner's autobiographical *A Point of View* (Middletown, Conn.: Wesleyan University Press, 1978), 27–28, Evans arranged this *Fortune* commission for his friend and sometimes accompanied Steiner in his travels for this assignment. In 1951 Evans apparently took on this job himself, at least on an occasional basis (H. Landshoff, Dan Weiner, and Victor Jorgensen are also credited with some of the "*Fortune* Portraits" of the early fifties), and his color pictures of corpo-

rate heads are found in twenty-two issues between 1951 and 1954 (see the bibliography for a complete listing).

26. "Hood of U.S. Steel" (Feb. 1953). See the bibliography for more complete references.

27. "Supplee of Atlantic Refining," *Fortune* 48 (Aug. 1953), 129.

28. "Ganger of Lorillard," *Fortune* 47 (Jan. 1953), 104.

29. Reed, "A Change in Direction," 314.

30. James Thrall Soby, *Modern Art and the New Past* (Norman: University of Oklahoma Press, 1957), 172.

31. Evans, "Test Exposures," 80.

32. Walker Evans, "Photography," in Louis Kronenberger, ed., *Quality: Its Image in the Arts* (New York: Athenaeum, 1969), 208. The last four words of Evans's statement are in very small type.

33. Ibid.

34. Ibid.

35. For photographs on this subject in the Getty collection, see nos. 235 and 236 (Havana) and 571 (Southeastern U.S.). For relevant images made in Bridgeport, see *Walker Evans at Work*, 166.

36. Walker Evans, "The Pitch Direct. The sidewalk is the last stand of unsophisticated display," *Fortune* 58:4 (Oct. 1958), 139–43.

1003

At *Fortune*

The majority of the pictures in the following group are related to *Fortune* stories, either published or unpublished, that Evans prepared between 1941 and 1955. They are ordered chronologically by story or series, beginning with the Bridgeport, Connecticut, work of summer 1941; continuing through images of Biloxi, Mississippi, and of Kentucky, New York, and Detroit; to the Chicago essay of 1947 and the unused 1952–54 series Evans called "Street Furniture," made in New York and New England. The section is completed by twenty-five entries (including five duplicate prints) for images associated with *Fortune*'s "Beauties of the Common Tool," produced by Evans in 1955.

1004

1005

1006

1003
House, Bridgeport, Connecticut, 1941
18.6 x 22.4 cm (7 $^{11}/_{32}$ x 8 $^{27}/_{32}$ in.) [on original mount trimmed to image]
84.XM.956.520
MARKS & INSCRIPTIONS: (Verso) signed at l. center, in pencil, by Evans, *Walker Evans*; titled and dated at center, in pencil, by Evans, *House/Bridgeport, Conn. 1941*; at right center, Evans stamp A; at right center, wet stamp, in black ink, *MAY 1941*; at center, in pencil, by Evans, *1.*; at left center, in pencil, *#212*; at l. left, in pencil, *CUT 28* [number encircled] *4 ½"*[arrow

pointing upward] *HIGH*; also, in pencil, [line from u. left to l. right center]; (recto, mat) at l. right, in pencil, *212*; at l. left, in pencil, Crane no. *L78.10 (Evans)*.
REFERENCES: CRANE no. 206.

1004
[Woman Shopper, Bridgeport], 1941
17.8 x 13.2 cm (7 x 5 $^7/_{32}$ in.) [on original mount trimmed to image]
84.XM.956.522
MARKS & INSCRIPTIONS: (Verso) signed at u. center, in pencil, by Evans, *WALKER EVANS*; at center left, Evans

stamp B [sideways] at l. center, wet stamp, in black ink, *MAY 1941*; at l. center, in pencil, by Evans, *27*; at center, in pencil, [arrow pointing upward from Evans stamp B to Evans inscription]; at l. left, in pencil, Crane no. *L78.3(EVANS)*.

1005
|Woman Shopper, 1939–41
21.9 x 14.8 cm (8 $^5/_8$ x 5 $^{13}/_{32}$ in.)
84.XM.956.521
MARKS & INSCRIPTIONS: (Verso) at l. right, Evans stamp A; at center, in blue ink, by Evans, *WOMAN SHOP-PER/1939*; at left center, in pencil,

R28; at l. left, in pencil, Crane no. *L78.1(EVANS)*.

1006
A Woman Shopper, 1941
22.4 x 15.8 cm (8 $^{27}/_{32}$ x 6 $^7/_{32}$ in.) [on original mount trimmed to image]
84.XM.956.523
MARKS & INSCRIPTIONS: (Verso, mount) titled and dated at u. center, in pencil, by Evans, *A WOMAN SHOPPER/1941*; at l. center, Evans stamp B; at center, in pencil, *IB/R25/Gallery* [crossed out]; at l. left, in pencil, Crane no. *L78.2(EVANS)*.

1007

1008

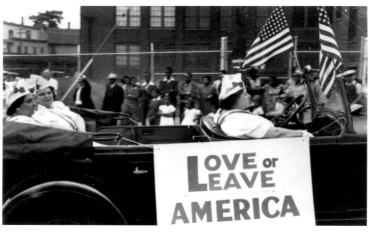

1009

1010

1007
[*Bridgeport War Memorial*], 1941
25.2 x 20.3 cm (9 ²³⁄₃₂ x 7 ³¹⁄₃₂ in.)
84.XM.956.527
MARKS & INSCRIPTIONS: (Recto) at bottom edge, in negative, *AGFA SAFETY FILM* [*backwards*]; (verso) at l. right, Evans stamp A; at u. right, in pencil, *11.*; at l. left, in pencil, Crane no. *L78.11*.
REFERENCES: WEAW, p. 167 (variant).

1008
[*Crowd Watching Bridgeport Parade*], 1941
Image: 18.2 x 23 cm (7 ⁵⁄₃₂ x 9 ¹⁄₁₆ in.); original mount: 19.5 x 24.1 cm (7 ¹¹⁄₁₆ x 9 ½ in.)
84.XM.956.525
MARKS & INSCRIPTIONS: (Recto, mount) signed at l. right, in pencil, by Evans, *Walker Evans*; (verso, mount) at l. center, in pencil, by Evans, *Bridgeport July 6 1941*; at l. left, in pencil, Crane no. *L78.6(Evans)*.

1009
[*Bridgeport Parade*]/[*Bridgeport's Italian Women Insist Upon Their Patriotism**], 1941
13.2 x 20.9 cm (5 ³⁄₁₆ x 8 ¼ in.)
84.XM.956.123
MARKS & INSCRIPTIONS: (Verso) at u. right, Evans stamp B; at l. right, Crane stamp; (recto, mat) at l. right, *119*; at l. left, in pencil, Crane no. *L65.116(Evans)*.
REFERENCES: *"Bridgeport's War Factories," *Fortune*, Sept. 1941, p. 92 (variant); WEAW, p. 168 (variant).

1010
Bridgeport, Connecticut, 1941
13.9 x 15.9 cm (5 ½ x 6 ⁹⁄₃₂ in.)
84.XM.956.526
MARKS & INSCRIPTIONS: (Verso) titled and dated at l. center, in pencil, by Evans, *Bridgeport CT./July 6 1941*; at right center, Evans stamp A twice; at l. left, in pencil, Crane no. *L78.9 (Evans)*.

1011

1013

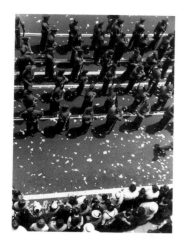

BRIDGEPORT JUL 6 1941

1012

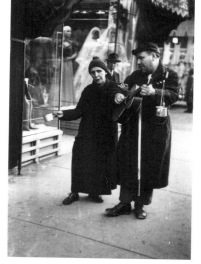

1014

1014
Halstead Street, Chicago, 1941
17.7 x 11.8 cm (6 ²¹/₃₂ x 4 ²¹/₃₂ in.)
84.XM.956.961
MARKS & INSCRIPTIONS: (Verso) at center, in pencil, by Evans, *Chicago/(not a "Fortune" photograph)/"HALSTED STREET"/1941*; at l. right, Evans stamp A; at center, in pencil, *S*; (recto, mat) at l. right, in pencil, *184*; at l. left, in pencil, Crane no. *L77.17(Evans)*.

1011
[Bridgeport Parade: Marching Band and Crowd], 1941
Image: 17.6 x 13.2 cm (6 ¹⁵/₁₆ x 5 ⁵/₃₂ in.); original mount: 23.5 x 17.6 cm (9 ⁹/₃₂ x 6 ²⁹/₃₂ in.)
84.XM.956.528
MARKS & INSCRIPTIONS: (Recto, mount) signed at l. right, in pencil, by Evans, *Walker Evans*; at l. left, wet stamp, in black ink, *BRIDGEPORT*; at l. right, wet stamp, in black ink, *JUL 6 1941*; (verso, mount) at l. left, in pencil, Crane no. *L78.7(Evans)*.

1012
[Bridgeport Parade: Marching Band and Crowd], 1941
Image: 18.2 x 12.9 cm (7 ³/₁₆ x 8 ⁷/₈ in.); original mount: 22.5 x 18.6 cm (8 ⁷/₈ x 7 ¹¹/₃₂ in.)
84.XM.956.524
MARKS & INSCRIPTIONS: (Recto, mount) signed at l. right, in pencil, by Evans, *Walker Evans*; at l. left, wet stamp, in black ink, *BRIDGEPORT*; at l. right, wet stamp, in black ink, *JUL 6 1941*; (verso, mount) at l. center, Crane stamp; at l. left, in pencil, Crane no. *L78.8(Evans)*.

1013
[Two Blind Street Musicians, Halsted Street, Chicago], 1941
14.1 x 19.3 cm (5 ⁹/₁₆ x 7 ⁵/₈ in.)
84.XM.956.958
MARKS & INSCRIPTIONS: (Verso) at l. center, Evans stamp F; at l. right, in pencil, *ALT/E4* [written twice and crossed out]/*E3/E3* [crossed out]; at l. left, in pencil, Crane no. *L77.2*.
REFERENCES: MoMA, p. 159 (variant).

1015
Chicago/[Two Blind Street Musicians, Halsted Street, Chicago], 1941
Image: 24.5 x 19.2 cm (9 ²¹/₃₂ x 7 ⁹/₁₆ in.); sheet: 25.2 x 20 cm (9 ¹⁵/₁₆ x 7 ⁷/₈ in.)
84.XM.956.969
MARKS & INSCRIPTIONS: (Verso) signed at u. center, in pencil, by Evans, [arrow pointing to right] *WALKER EVANS;* at left center, in pencil, by Evans, *Chicago*; at center, wet stamp, in black ink, *NOV 2 1941*; at l. center, Crane stamp; (recto, mat) at l. left, in pencil, Crane no. *L77.1(Evans)*.
NOTE: Not illustrated; variant of no. 1014.

1016

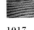

1017

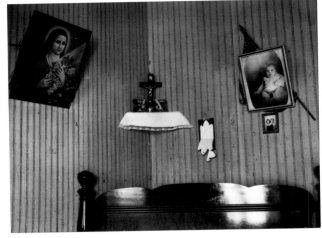

1018

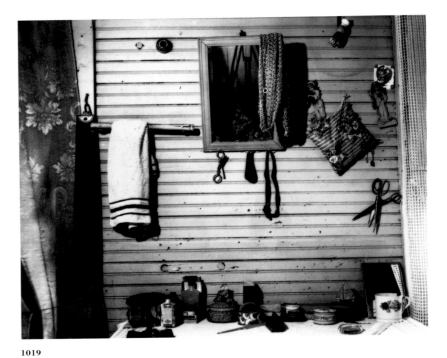

1019

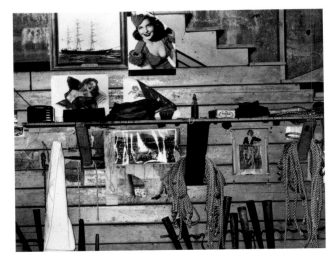

1020

1016
Bedroom Dresser, Shrimp Fisherman's House, Biloxi, Mississippi, 1945
Image: 23.8 x 18.7 cm (9 ⅜ x 7 ¹¹/₃₂ in.); sheet: 25.2 x 20.1 cm (9 ²⁹/₃₂ x 7 ¹⁵/₁₆ in.)
84.XM.129.15
MARKS & INSCRIPTIONS: (Verso) at l. left, in pencil, by Evans, *#844/Bedroom Dresser,/Shrimp Fisherman's House/Biloxi, Mississippi 1945*; at l. right, in pencil, Kahmen/Heusch no. *E18*; at l. right, Lunn Gallery stamp, and within two boxes, in pencil, *II* and *152–3*.
PROVENANCE: Lunn Gallery; Volker Kahmen and Georg Heusch.

REFERENCES: MoMA, p. 153; WEBR, p. 13, no. 18 (titled in German and dated, *Frisiertisch im Haus eines Krabbenfischers, Biloxi [Mississippi]*, 1945.
EXHIBITIONS: *Walker Evans*, Bahnhof Rolandseck, West Germany, Oct. 5–Nov. 30, 1978.

1017
[*Bedroom, Shrimp Fisherman's House, Biloxi, Mississippi*], 1945
Image: 23.8 x 18.7 cm (9 ¹³/₃₂ x 7 ¹¹/₃₂ in.); mount: 25.3 x 20.1 cm (9 ¹⁵/₁₆ x 7 ²⁹/₃₂ in.)
84.XM.129.16

MARKS & INSCRIPTIONS: (Verso, mount) at u. left, in pencil, *d-12*; at l. left, in pencil, *16* [circled]; at l. right, in pencil, Kahmen/Heusch no. *E19*; at l. right, Lunn Gallery stamp, and within two boxes, in pencil, *II* and *156*.
PROVENANCE: Lunn Gallery; Volker Kahmen and Georg Heusch.
REFERENCES: *MoMA, p. 157; WEBR, p. 12, no. 19 (titled in German and dated, *Schlafzimmer im Haus eines Krabbenfischers, Biloxi [Mississippi]*, 1945).
EXHIBITIONS: *Walker Evans*, Bahnhof

Rolandesck, West Germany, Oct. 5–Nov. 30, 1978.

1018
Bedroom/[Bedroom Wall, Fisherman's House, Biloxi, Mississippi], 1945
17.9 x 23.4 cm (7 ¹/₁₆ x 9 ⁷/₃₂ in.)
84.XM.956.950
MARKS & INSCRIPTIONS: (Verso) at left center, in blue ink, by Evans, *BEDROOM/1945*; at left center, Evans stamp F; at right, *2 14 ½/16*; at l. right, in pencil, *W* and *7* [circled]; at l. left, in pencil, Crane no. *L78.19*.

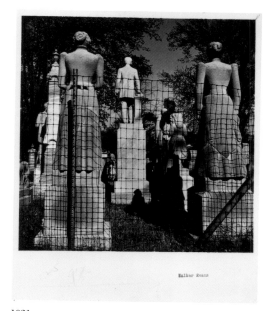

1021

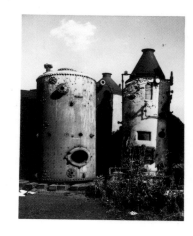

1023

1025

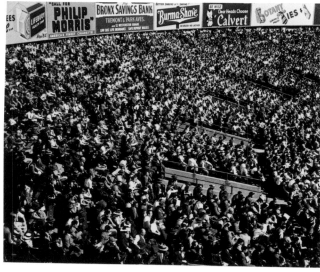

1022

1024

1019
[*Bathroom Wall, Fisherman's House, Biloxi, Mississippi*], 1945
Image: 16.8 x 20.3 cm (6 ⅝ x 8 in.); original mount: 20.1 x 22.3 cm (7 ²⁹⁄₃₂ x 8 ¾ in.)
84.XM.956.951
MARKS & INSCRIPTIONS: (Verso, mount) at l. left, Evans stamp A; at l. left, in pencil, Crane no. *L78.20(Evans)*.

1020
[*Basement Workshop, Fisherman's House, Biloxi, Mississippi*], 1945
Image: 15.9 x 19.3 cm (6 ¼ x 7 ⁹⁄₁₆ in.);

original mount: 25.5 x 20.3 cm (10 ¹⁄₁₆ x 8 in.)
84.XM.956.949
MARKS & INSCRIPTIONS: (Recto, mount) signed at l. right below print, in pencil, by Evans, *Walker Evans*; (verso, mount) signed at center, in pencil, by Evans, *WALKER EVANS*; at u. center, Evans stamp C; at l. left, in pencil, Crane no. *L78.21(Evans)*.

1021
[*Woodbridge Family Monument, Mansfield, Kentucky**], ca. 1945
Image: 19.9 x 19.2 cm (7 ²⁷⁄₃₂ x 7 ⁹⁄₁₆ in.); sheet: 25.1 x 20.2 cm (9 ⅞ x 7 ¹⁵⁄₁₆ in.)

84.XM.956.1079
MARKS & INSCRIPTIONS: (Recto) at l. right, Evans stamp A; at l. left, in pencil, *125/9 ½″* [with a horizontal line pointing to right below inscription]; (verso) at u. left, Evans stamp B; at u. right, Crane stamp; (recto, mat) at l. right, in pencil, *241*; at l. left, in pencil, *L78.30(Evans)*.
REFERENCES: LUNN, p. 12; *FAL, p. 158 (variant).

1022
[*Yankee Stadium with Capacity Crowd and Billboards*], 1946
16.6 x 19.5 cm (6 ¹⁷⁄₃₂ x 7 ¹¹⁄₁₆ in.)

84.XM.956.1081
MARKS & INSCRIPTIONS: (Verso) signed at l. center, in pencil, by Evans, *Walker Evans*; at center, in pencil, by Arnold Crane, *For Fortune/Early or mid 50s*; (recto, mat) at l. left, in pencil, Crane no. *L78.13(Evans)*.
REFERENCES: "The Yankees," *Fortune*, July 1946, p. 135 (variant).

1023
[*Two Junked Boilers, Possibly Detroit*], ca. 1946
Image; 17.3 x 13.4 cm (6 ¹³⁄₁₆ x 5 ¼ in.); sheet: 25 x 19.1 cm (9 ¹³⁄₁₆ x 7 ¹⁷⁄₃₂ in.)
84.XM.956.952
MARKS & INSCRIPTIONS: (Verso, at u. right, Evans stamp B; (recto, mat) at l. left, in pencil, Crane no. *L78.5 (Evans)*.

1024
[*Labor Anonymous: Man on the Street, Detroit*], 1946
Image: 17.6 x 11.5 cm (6 ¹⁵⁄₁₆ x 4 ¹⁷⁄₃₂ in.); sheet: 20.2 x 12.0 cm (7 ¹⁵⁄₁₆ x 4 ¹⁵⁄₁₆ in.)
94.XM.6.3
MARKS & INSCRIPTIONS: (Verso) at center, in pencil, *2/2c*; at l. right, in pencil, *"Labor Anonymous"/Fortune, November 1946"*; at right center, Lunn Gallery stamp, and within boxes, in pencil, *V and 607*.
PROVENANCE: George Rinhart and Tom Bergen; Harry H. Lunn, Jr.

1025
[*Labor Anonymous: Woman on the Street, Detroit*], 1946
11.8 x 10.2 cm (4 ²¹⁄₃₂ x 4 in.)
84.XM.956.965
MARKS & INSCRIPTIONS: (Verso) at l. cen-

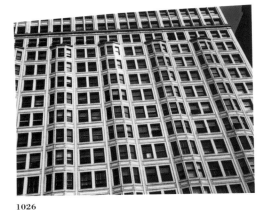

1026

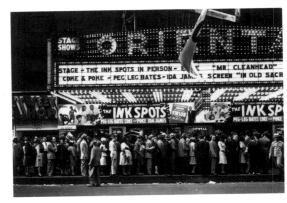

1027

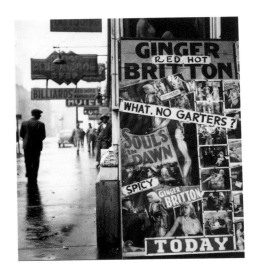

1028

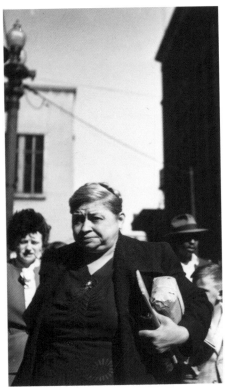

1029

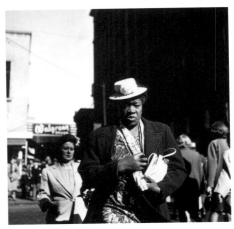

1030

ter, Evans stamp F; at u. center, in pencil, *2c*; at l. left, in pencil, Crane no. *L77.14(Evans)*.

1026
[*"The Skin-Deep, Perforated Screen of the City: Michigan Avenue."**], 1946
20.3 x 24.6 cm (7 ³¹⁄₃₂ x 9 ¹¹⁄₁₆ in.)
84.XM.956.956
MARKS & INSCRIPTIONS: (Verso) at l. right, Evans stamp F; at left center, in pencil, by Arnold Crane, *Chgo 46*; at l. left, in pencil, Crane no. *L77.10*.
REFERENCES: "Chicago: A Camera Exploration of the Huge, Energetic

Urban Sprawl of the Midlands," *Fortune*, Feb. 1947, p. 113 (variant).

1027
[*"Evening in the Loop"**], 1946
15.7 x 22.2 cm (6 ³⁄₁₆ x 8 ³⁄₄ in.)
84.XM.956.968
MARKS & INSCRIPTIONS: (Verso) at u. center, Evans stamp A; at l. right, Crane stamp; at u. right, in pencil, by Arnold Crane, *Chgo '46*; (recto, mat) at l. right, in pencil, *235*; at l. left, in pencil, Crane no. *L77.7(Evans)*.
REFERENCES: *"Chicago: A Camera Exploration," *Fortune*, Feb. 1947, p. 119; FAL, p. 151 (variant); WEAW,

p. 187 (reproduction of above-mentioned *Fortune* page).

1028
[*Chicago ("What, No Garters?")*], 1946
17.7 x 16 cm (7 x 6 ⁵⁄₁₆ in.)
84.XM.956.954
MARKS & INSCRIPTIONS: (Verso) at u. right, Evans stamp L; at u. center, in pencil, by Arnold Crane, *Chg. 46*; at l. left, in pencil, Crane no. *L77.15*.
REFERENCES: APERTURE, p. 91 (variant, dated 1947).
EXHIBITIONS: *Neither Speech Nor Language: Photography and the Written*

Word, J. Paul Getty Museum, Malibu, Calif., Feb. 28–May 12, 1991.

1029
[*Woman Shopper, State and Randolph Streets, Chicago*], 1946
19.6 x 10.9 cm (7 ¹¹⁄₁₆ x 4 ⁵⁄₁₆ in.)
84.XM.956.960
MARKS & INSCRIPTIONS: (Verso) signed at center, in pencil, by Evans, *WALKER EVANS*; at l. center, Evans stamp A; at center, in pencil, *44*; at l. center, *1 neg. S/S*; at l. left, in black china marker, *8G* [inverted]; (recto, mat) at l. left, in pencil, Crane no. *L77.9 (Evans)*.

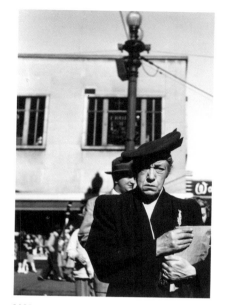

1031

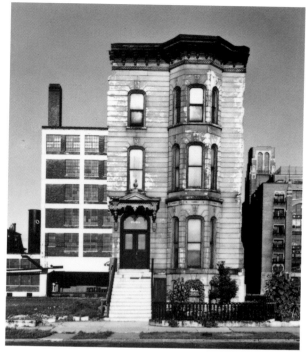

1032

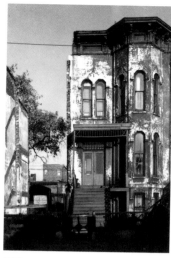

1033

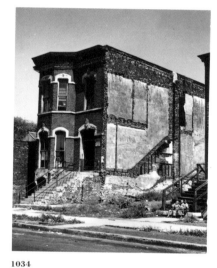

1034

1035

1030
[*Woman Shopper, Corner of State and Randolph Streets, Chicago*], 1946
19.4 x 18.1 cm (7 21⁄$_{32}$ x 7 1⁄$_{8}$ in.)
84.XM.956.955
MARKS & INSCRIPTIONS: (Verso) signed at center, in pencil, by Evans, [arrow pointing to right] *Walker Evans*; at l. right, Evans stamp A; at l. right, in black china marker, *1* [a large "b"?]; at l. left, in pencil, Crane no. *L77.11.*
REFERENCES: WEAW, p. 188 (variant, center left image).

1031
[*Corner of State and Randolph Streets, Chicago**], 1946

17.1 x 11.3 cm (6 23⁄$_{32}$ x 4 7⁄$_{16}$ in.)
84.XM.956.959
MARKS & INSCRIPTIONS: (Verso) signed at center, in pencil, by Evans, *WALKER EVANS*; at l. center, in black china marker, *10g* [written upside down]; at u. right, in pencil, *45*; at center, in pencil, *S*; at l. center, in pencil, *1 neg S/S* [circled]; (recto, mat) at l. left, in pencil, Crane no. *L77.8(Evans)*.
REFERENCES: *MoMA, p. 161 (variant).

1032
South Side/[*2033 Prairie Avenue, Chicago*], 1946
17.7 x 14.8 cm (6 31⁄$_{32}$ x 5 13⁄$_{16}$ in.)

84.XM.956.966
MARKS & INSCRIPTIONS: (Verso) at l. right, Evans stamp L; at u. center, in pencil, possibly by Evans, *Chicago* [circled] and at center, *SOUTH SIDE/ 1946*; (recto, mat) at l. right, in pencil, *234*; at l. left in pencil, Crane no. *L77.5(Evans)*.
REFERENCES: "Chicago: A Camera Exploration," *Fortune*, Feb. 1947, p. 115 (variant); FORTUNE, pl. 18 (variant); WEAW, pp. 190 (reproduction of above-mentioned *Fortune* page) and 191 (variant).

1033
South Side House/[*Chicago*], 1946
16.5 x 10.8 cm (6 ½ x 4 ¼ in.)
84.XM.956.970
MARKS & INSCRIPTIONS: (Verso) signed at l. right edge, in blue ink, by Evans, *by Walker Evans/please return print* [sideways]; at u. center, in pencil, *Chicago* [circled]; at center right, in pencil, *30* [crossed out]; and at center, in pencil, by Evans, *SOUTH SIDE HOUSE/1946*; at l. left, wet stamp, in red ink, *STORY NAME/STORY DATE/TAKEN FOR FORTUNE BY/FORTUNE PICTURE Not to be used/ for advertising or promotion/CAPTION*; at l. left, in pencil, next to *Fortune* label, *Chicago Portfolio/Feb '47/ Walker Eva__*; (recto, mat) at l. left, in pencil, Crane no. *L77.3(Evans)*.

1034
[*Dilapidated Brick Townhouse, South Side, Chicago*], 1946
16.8 x 13 cm (6 ⅝ x 5 ⅛ in.)
84.XM.956.962
MARKS & INSCRIPTIONS: (Verso) at u. center, Evans stamp B; at left center, wet stamp, in red ink, *STORY NAME/STORY DATE/TAKEN FOR FORTUNE BY/FORTUNE PICTURE Not to be used/for advertising or promotion/CAPTION*; at left, in pencil beside *Fortune* stamp, *Chicago Portfolio/Feb '47/Walker Evans*; at right center, in pencil, *32*; (recto, mat) at l. right, in pencil, *230*; at l. left, in pencil, Crane no. *L77.4(Evans)*.

1035
Prairie Ave., 21st St., South Side/ [*Chicago*], 1946
18.5 x 15.1 cm (7 9⁄$_{32}$ x 5 15⁄$_{16}$ in.)
84.XM.956.967

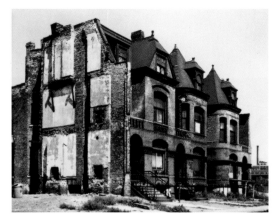

1036

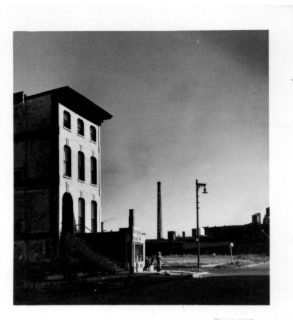

1038

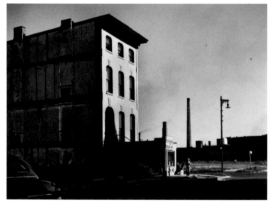

1037

1039

MARKS & INSCRIPTIONS: (Verso) at
l. right, Evans stamp F; at u. center, in
pencil, *Chicago* [circled] and at cen-
ter, in pencil, by Evans, *SOUTH SIDE/
1946/Prairie Ave, 21st St.*; (recto, mat)
at l. right, in pencil, *233*; at l. left, in
pencil, Crane no. *L77.6(Evans)*.

1036
South Side Houses, 1946
15.9 x 19.4 cm (6 ¼ x 7 ⅝ in.)
84.XM.956.964
MARKS & INSCRIPTIONS: (Verso) at l. cen-
ter, Evans stamp F, at u. center, in
pencil, *Chicago* [circled]; at center,

in pencil, by Evans, *SOUTH SIDE
HOUSES/1946*; at l. left, in pencil,
Crane no. *L77.13(Evans)*.

1037
[*South Side Corner with Buckner
Grocery, Chicago*], 1946
15.6 x 20 cm (6 ⁵/₃₂ x 7 ⅞ in.)
84.XM.956.957
MARKS & INSCRIPTIONS: (Verso) at u. left,
Evans stamp F; at l. right, Evans
stamp L; at u. left, in pencil, by
Evans, *Chicago South Side* [crossed
out]; at u. center, in pencil, *Chicago*
[circled]; at l. center, in pencil, *SOUTH*

SIDE/1946; at l. left, in pencil, Crane
no. *L77.16*.

1038
[*South Side Corner with Buckner
Grocery, Chicago*], 1946
Image: 18.6 x 16.8 cm
(7 ¹¹/₃₂ x 6 ¹⁹/₃₂ in.); sheet:
25.5 x 20.3 cm (10 ¹/₁₆ x 8 in.)
84.XM.956.963
MARKS & INSCRIPTIONS: (Recto, sheet) at
l. right below print, Evans stamp L;
(verso) at l. center, Evans stamp L; at
center, Evans stamp F; at l. left center,
Crane stamp; at center, in pencil, by

Evans, *same/size*; at u. right, in pencil,
LD 450-17 [written sideways]; at l. left,
in pencil, Crane no. *L77.12(Evans)*.

1039
[*Sunday in an Alley**], 1946
12.9 x 21.1 cm (5 ³/₃₂ x 8 ⁵/₁₆ in.)
84.XM.956.346
MARKS & INSCRIPTIONS: (Verso) at u. cen-
ter, in pencil, *Walker Evans/return*
[last word circled]; at right center, *OA
18690* [inverted]; at l. left, in pencil,
Crane no. *L67.84(Evans)*.
REFERENCES: *"Chicago," *Fortune*,
Feb. 1947, p. 119 (l. right image).

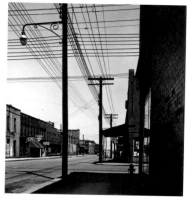

1040

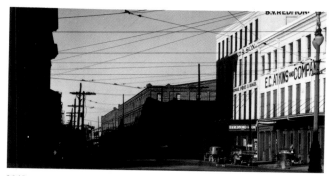

1041

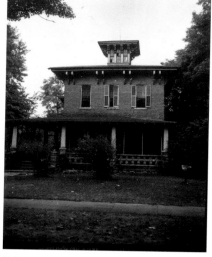

1043

1042

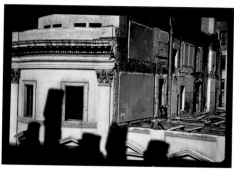

1044

no. 1 (titled in German and dated, *East Emt. Ranch*, 1949).
EXHIBITIONS: *Walker Evans*, Bahnhof Rolandseck, West Germany, Oct. 5– Nov. 30, 1978.

1043
[*White Pigeon, Michigan*], ca. 1950
12.6 x 10.1 cm (4 ³¹⁄₃₂ x 3 ³¹⁄₃₂ in.)
84.XM.956.696
MARKS & INSCRIPTIONS: (Recto) in negative, *ANSCO SUPERPAN PRESS*; (verso) at center, in pencil, *5E/White Pidgeon* (sic)/*Mich.*; at l. left, in pencil, Crane no. *L78.38*(*Evans*).

1044
[*"A Great Corinthian Town House on the Way to Extinction"**], 1951
MEDIUM: Chromogenic print
Image: 11.3 x 16.4 cm (4 ½ x 6 ¹⁵⁄₃₂ in.); sheet: 12.6 x 17.3 cm
(4 ¹⁵⁄₁₆ x 6 ¹³⁄₁₆ in.)
84.XM.956.1082
MARKS & INSCRIPTIONS: (Verso) at u. left, Evans stamp A; at l. left, on white label, in pencil, Crane no. *L78.57* (*Evans*).
REFERENCES: *"The Wreckers," Fortune*, May 1951, p. 104 (variant).

1040
[*Commercial Quarter, South 3rd St., Paducah, Kentucky**], 1947
19.3 x 17.3 cm (7 ¹⁹⁄₃₂ x 6 ¹³⁄₁₆ in.)
84.XM.956.953
MARKS & INSCRIPTIONS: (Verso) at l. center, Evans stamp A; at l. left, in pencil, Crane no. *L78.33*.
REFERENCES: "One Newspaper Town," *Fortune*, Aug. 1947, p. 105 (variant); *FORTUNE, pl. 30 (variant); WEAW, p. 199 (variant).

1041
[*Street Scene, Probably Paducah, Kentucky*], 1947
9.7 x 18.4 cm (3 ¹³⁄₁₆ x 7 ¼ in.)
84.XM.956.1080
MARKS & INSCRIPTIONS: (Verso) at l. left, Evans stamp A; at center, in pencil, *20* [partially cut off]/*A303/25W.*

1042
East Entrance/[*Painted Fence, Sandusky, Ohio**], ca. 1947; printed, 1949
Image: 18.2 x 28 cm (7 ⁵⁄₃₂ x 11 ¹⁄₃₂ in.); mount:
32.5 x 38.2 cm (12 ¹³⁄₁₆ x 15 ¹⁄₁₆ in.)

84.XM.129.17
MARKS & INSCRIPTIONS: (Verso) at l. right, in pencil, by Evans, *EAST ENTRANCE*; (recto, mount) signed and dated at l. right below print, in pencil, by Evans, *Walker Evans 1949*; (verso, mount) at right center, in pencil, by Evans, *1956* [erased]; at l. right, in pencil, *28* [circled]; at l. left, in pencil, Kahmen-Heusch no. *E1*.
PROVENANCE: Lunn Gallery; Volker Kahmen and Georg Heusch.
REFERENCES: "The American Bazaar," *Fortune*, Nov. 1947, p. 108 (variant); *WEAIR, n.p. (variant), WEBR, p. 6,

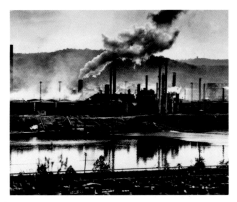

1045

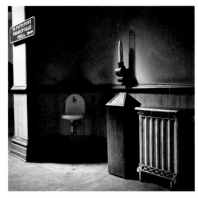

1046

1047

1048

1045
[KOPPERS Plant, Pittsburgh, Pennsylvania], ca. 1952
18.5 x 21.1 cm (7 ¼ x 8 ⁵⁄₃₂ in.) [on original mount trimmed to image]
84.XM.956.699
MARKS & INSCRIPTIONS: (Verso, mount) at center, Evans stamp L; at u. center, in pencil, *CC*; at l. left, in pencil, Crane no. *L78.39(Evans)*.

1046
Reading Outer Station, Pennsylvania, 1953
19.3 x 18.9 cm (7 ⅝ x 7 ⁷⁄₁₆ in.)
84.XM.956.1044
MARKS & INSCRIPTIONS: (Verso) at center, in pencil, by Evans, *Credit Fortune Magazine please/Walker Evans*; at l. center, Evans stamp G; at l. right, Evans stamp F over Evans stamp G; at l. center, in pencil, *for sale (permitted) on order only*; at l. center, in pencil, *"Reading Outer Station"/(PA.)/1953* [space] *1960* [last date is crossed out by Evans]; at l. center, Crane stamp; at l. left, in pencil, Crane no. *L78.12 (Evans)*.

1047
Boston Public Gardens, May 1953
Image: 14.3 x 21 cm (5 ⅝ x 8 ⁵⁄₃₂ in.); sheet: 18.5 x 21.8 cm (7 ⁵⁄₃₂ x 8 ¹⁹⁄₃₂ in.)
84.XM.956.1048
MARKS & INSCRIPTIONS: (Verso) signed, titled and dated at l. left, in pencil, by Evans, *Boston Public Gardens/May 1953/W. Evans*; at l. left, in pencil, Crane no. *L78.40(Evans)*.

1048
Boston Common, May 1953
Image: 21.3 x 14.8 cm (8 ¹³⁄₃₂ x 5 ¹³⁄₁₆ in.); sheet: 22.6 x 15.9 cm (8 ²⁹⁄₃₂ x 6 ¼ in.)
84.XM.956.1049
MARKS & INSCRIPTIONS: (Verso) signed, titled and dated at l. left, in pencil, by Evans, *Boston Common/May 1953/W. Evans*; at l. left, in pencil, Crane no. *L78.37(Evans)*.

1049

1050

1051

1052

1053

1054

1049
[*Street Furniture Series: Stockbridge, Massachusetts*], 1952
MEDIUM: Color Transparency
Image: 5.7 x 5.7 cm (2 ¼ x 2 ¼ in.); sheet: 6.8 x 6.2 cm (2 ¹¹⁄₁₆ x 2 ⁷⁄₁₆ in.)
84.XG.963.16
MARKS & INSCRIPTIONS: At l. right, on label adhered to transparency sleeve, in black ink, by Evans, *STOCKBRIDGE, MASS./1952* and Evans stamp A.

1050
[*Street Furniture Series: Silver and Gray Fire Hydrant, Eighty-sixth Street and York Avenue, Southeast Corner, New York City*], March 23, 1953
MEDIUM: Color transparency
Image: 5.7 x 5.7 cm (2 ¼ x 2 ¼ in.); sheet: 6.2 x 6.2 cm (2 ⁷⁄₁₆ x 2 ⁷⁄₁₆ in.)
84.XG.963.24
MARKS & INSCRIPTIONS: At bottom edge, on label adhered to transparency sleeve, in black ink, by Evans, *NYC 3/23/53/86th & York SE cor.* and Evans stamp A.

1051
[*Street Furniture Series: Metal Fire Hydrant on a City Sidewalk*], ca. 1953
MEDIUM: Color transparency
Image: 5.7 x 5.7 cm (2 ¼ x 2 ¼ in.); sheet: 7.1 x 6.2 cm (2 ²⁵⁄₃₂ x 2 ⁷⁄₁₆ in.)
84.XG.963.9

1052
[*Street Furniture Series: Red and White Countryside Fire Hydrant*], ca. 1953
MEDIUM: Color transparency
Image: 5.7 x 5.7 cm (2 ¼ x 2 ¼ in.); sheet: 6.2 x 6.2 cm (2 ⁷⁄₁₆ x 2 ⁷⁄₁₆ in.)
84.XG.963.25

1053
[*Street Furniture Series: Countryside Fire Hydrant*], ca. 1953
MEDIUM: Color Transparency
Image: 5.7 x 5.7 cm (2 ¼ x 2 ¼ in.); sheet: 6.7 x 6.2 cm (2 ⅝ x 2 ⁷⁄₁₆ in.)
84.XG.963.12

1054
[*Street Furniture Series: Black and White Countryside Fire Hydrant*], ca. 1953
MEDIUM: Color transparency
Image: 5.7 x 5.7 cm (2 ¼ x 2 ¼ in.); sheet: 6.2 x 6.2 cm (2 ⁷⁄₁₆ x 2 ⁷⁄₁₆ in.)
84.XG.963.26

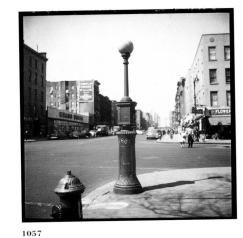

1055

1056

1057

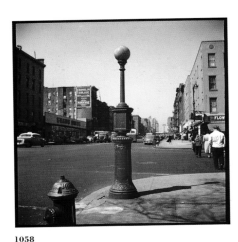

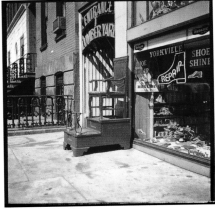

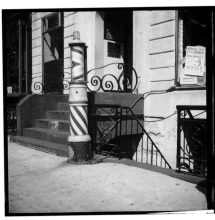

1058

1059

1060

1055
[*Street Furniture Series: Silver Mueller Company Fire Hydrant, Rural Route Near Mattapoisett, Massachusetts*], October 14, 1953
MEDIUM: Color transparency
Image: 5.7 x 5.7 cm (2 ¼ x 2 ¼ in.); sheet: 6.4 x 6.2 cm (2 ½ x 2 ⁷⁄₁₆ in.)
84.XG.963.14
MARKS & INSCRIPTIONS: At bottom edge, on label adhered to transparency sleeve verso, in black ink, by Evans, *Rt. 6 or 9* [space] *10/14/53/near Mattapoisett Mass.*

1056
[*Street Furniture Series: Silver Mueller Company Fire Hydrant, Rural Route near Mattapoisett, Massachusetts*], October 14, 1953
MEDIUM: Color transparency
Image: 5.7 x 5.7 cm (2 ¼ x 2 ¼ in.); sheet: 6.2 x 6.2 cm (2 ⁷⁄₁₆ x 2 ⁷⁄₁₆ in.)
84.XG.963.23
MARKS & INSCRIPTIONS: At bottom edge, on label adhered to transparency sleeve, in black ink, by Evans, *RT 6 or 9 10/14/53/near Mattapoisett, Mass.*

1057
[*Street Furniture Series: Fire Call Box, Corner of Eighty-sixth Street and First Avenue, New York City*], March 23, 1953
MEDIUM: Color transparency
Image: 5.7 x 5.7 cm (2 ¼ x 2 ¼ in.); sheet: 6.4 x 6.2 cm (2 ½ x 2 ⁷⁄₁₆ in.)
84.XG.963.18
MARKS & INSCRIPTIONS: At l. left, on label adhered to transparency sleeve, in black ink, by Evans, *NYC 3/23/53/ 86th & 1st NE Corner/Skylight filtered* and Evans stamp A.

1058
[*Street Furniture Series: Fire Call Box, Eighty-sixth Street and First Avenue, New York City*], March 23, 1953
MEDIUM: Color Transparency
Image: 5.7 x 5.7 cm (2 ¼ x 2 ¼ in.); sheet: 6.4 x 6.2 cm (2 ½ x 2 ⁷⁄₁₆ in.)
84.XG.963.10

1059
[*Street Furniture Series: Red Shoeshine Chair, 347 East Eighty-sixth Street, Yorkville, New York City*], March 23, 1953
Image: 5.7 x 5.7 cm (2 ¼ x 2 ¼ in.); sheet: 6.2 x 6.2 cm (2 ⁷⁄₁₆ x 2 ⁷⁄₁₆ in.)

1061

1062

1063

1064

84.XG.963.11
MARKS & INSCRIPTIONS: At l. left, on label adhered to transparency sleeve, in black ink, by Evans, *347 E. 86 NYC 3/23/53*; on label adhered to transparency sleeve, Evans stamp A.

1060
[*Street Furniture Series: Barber Pole, 343 East Eighty-sixth Street, New York City*], March 23, 1953
MEDIUM: Color transparency
Image: 5.7 x 5.7 cm (2¼ x 2¼ in.); sheet: 6.4 x 6.2 cm (2½ x 2⁷⁄₁₆ in.)

84.XG.963.8
MARKS & INSCRIPTIONS: At u. left, on label adhered to transparency sleeve, in black ink, by Evans, *343 E 86 NYC/ 3/23/53/used skylight filter* and Evans stamp A.

1061
[*Street Furniture Series: Decorative Protective Railing, 1609 First Avenue, New York City*], March 23, 1953
MEDIUM: Color transparency
Image: 5.7 x 5.7 cm (2¼ x 2¼ in.); sheet: 6.2 x 6.2 cm (2⁷⁄₁₆ x 2⁷⁄₁₆ in.)
84.XG.963.21

MARKS & INSCRIPTIONS: At bottom edge, on label adhered to transparency sleeve, in black ink, by Evans, *1609 - 1st Av. NYC/3/23/53* and Evans stamp A.

1062
[*Street Furniture Series: Lamppost, 315 East Eighty-sixth Street, New York City*], March 23, 1953
MEDIUM: Color transparency
Image: 5.7 x 5.7 cm (2¼ x 2¼ in.); sheet: 6.2 x 6.2 cm (2⁷⁄₁₆ x 2⁷⁄₁₆ in.)
84.XG.963.22

MARKS & INSCRIPTIONS: At bottom edge, on label adhered to transparency sleeve, in black ink, by Evans, *lamp-post* (sic) *at 315 E. 86 NYC/3/23/53/415* [last number is circled and followed by a question mark] and Evans stamp A.

1063
[*Street Furniture Series: Two White Posts Near the Coast, Possibly Mattapoisett, Massachusetts*], ca. 1953
MEDIUM: Color transparency
Image: 5.7 x 5.7 cm (2¼ x 2¼ in.); sheet: 6.4 x 6.2 cm (2½ x 2⁷⁄₁₆ in.)
84.XG.963.15

1064
[*Street Furniture Series: Two White Posts in Public Park, Possibly Mattapoisett, Massachusetts*], ca. 1953
MEDIUM: Color transparency
Image: 5.7 x 5.7 cm (2¼ x 2¼ in.); sheet: 6.2 x 6.2 cm (2⁷⁄₁₆ x 2⁷⁄₁₆ in.)
84.XG.963.19

1065

1066

1067

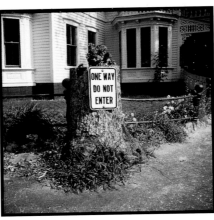

1068

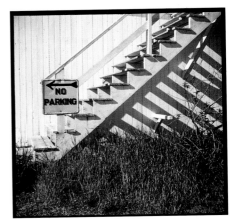

1069

1065
[*Street Furniture Series: Base of a White Lamppost in a Flower Bed, Possibly Mattapoisett, Massachusetts*], ca. 1953
MEDIUM: Color transparency
Image: 5.7 x 5.7 cm (2 ¼ x 2 ¼ in.); sheet: 6.2 x 6.2 cm (2 ⁷⁄₁₆ x 2 ⁷⁄₁₆ in.)
84.XG.963.20

1066
[*Street Furniture Series: White Lamppost, Possibly Mattapoisett, Massachusetts*], ca. 1953
MEDIUM: Color transparency
Image: 5.7 x 5.7 cm (2 ¼ x 2 ¼ in.); sheet: 6.7 x 6.2 cm (2 ²¹⁄₃₂ x 2 ⁷⁄₁₆ in.)
84.XG.963.29

1067
[*Street Furniture Series: Large Blue and Yellow Public Trashcan*], ca. 1953
MEDIUM: Color transparency
Image: 5.7 x 5.7 cm (2 ¼ x 2 ¼ in.); sheet: 6.2 x 6.2 cm (2 ⁷⁄₁₆ x 2 ⁷⁄₁₆ in.)
84.XG.963.28

1068
[*Street Furniture Series: One-Way Street Sign*], ca. 1953
MEDIUM: Color transparency
Image: 5.7 x 5.7 cm (2 ¼ x 2 ¼ in.); sheet: 6.2 x 6.2 cm (2 ⁷⁄₁₆ x 2 ⁷⁄₁₆ in.)
84.XG.963.31

1069
[*Street Furniture Series: "No Parking" Sign on White Staircase*], ca. 1953
MEDIUM: Color transparency
Image: 5.7 x 5.7 cm (2 ¼ x 2 ¼ in.); sheet: 6.2 x 6.2 cm (2 ⁷⁄₁₆ x 2 ⁷⁄₁₆ in.)
84.XG.963.13

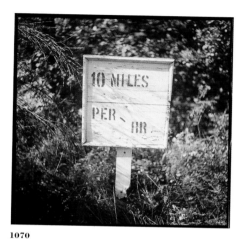

1070

1071

1072

1073

1070
[*Street Furniture Series: Wooden Speed Limit Sign*], ca. 1953
MEDIUM: Color transparency
Image: 5.7 x 5.7 cm (2 ¼ x 2 ¼ in.); sheet: 6.4 x 6.2 cm (2 ½ x 2 ⁷⁄₁₆ in.)
84.XG.963.30

1071
[*Street Furniture Series: Coca-Cola Sign*], ca. 1953
MEDIUM: Color Transparency
Image: 5.7 x 5.7 cm (2 ¼ x 2 ¼ in.); sheet: 6.4 x 6.2 cm (2 ½ x 2 ⁷⁄₁₆ in.)
84.XG.963.7

1072
[*Street Furniture Series: White Railing, 35 Main Street, Stonington, Connecticut*], February 22, 1954
MEDIUM: Color transparency
Image: 5.7 x 5.7 cm (2 ¼ x 2 ¼ in.); sheet: 6.2 x 6.2 cm (2 ⁷⁄₁₆ x 2 ⁷⁄₁₆ in.)
84.XG.963.17
MARKS & INSCRIPTIONS: At l. center, on label adhered to transparency sleeve, in black ink, by Evans, *35 Main St./ Stonington Conn./2/22/54.*

1073
[*Street Furniture Series: White Railing, 35 Main Street, Stonington, Connecticut*], February 22, 1954
MEDIUM: Color transparency
Image: 5.7 x 5.7 cm (2 ¼ x 2 ¼ in.); sheet: 6.2 x 6.2 cm (2 ⁷⁄₁₆ x 2 ⁷⁄₁₆ in.)
84.XG.963.27

1075

1074

1077

1074
[*Tin Snips by J. Wiss & Sons Co., $1.85**], 1955
25.2 x 20.3 cm (9 ²⁹⁄₃₂ x 8 in.)
84.XP.453.1
MARKS & INSCRIPTIONS: (Verso) at l. center, Lunn Gallery stamp [both squares empty]; at l. center, in pencil, *WE.171*.
PROVENANCE: George Rinhart; Samuel Wagstaff, Jr.
REFERENCES: *"Beauties of the Common Tool," *Fortune*, July 1955, p. 105 (variant); FORTUNE, pl. 45 (variant); FAL, p. 169 (variant); WEAW, p. 209 (variant).

1075
[*Bricklayer's Pointing Trowel, by Marshalltown Trowel Co., $1.35**], 1955
25.3 x 20.3 cm (9 ³¹⁄₃₂ x 8 in.)
84.XP.453.17
MARKS & INSCRIPTIONS: (Verso) at l. center, Lunn Gallery stamp twice [both squares empty].
PROVENANCE: George Rinhart; Samuel Wagstaff, Jr.
REFERENCES: *"Beauties of the Common Tool," *Fortune*, July 1955, p. 106 (variant); WEAW, p. 209 (variant).

1076
[*Bricklayer's Pointing Trowel, by Marshalltown Trowel Co., $1.35**], 1955
24.9 x 19.9 cm (9 ¹³⁄₁₆ x 7 ²⁷⁄₃₂ in.)
84.XM.956.1056
MARKS & INSCRIPTIONS: (Verso) at l. center, Evans stamp A; on white label, in pencil, Crane no. *L74.5/(Evans)*.
REFERENCES: *"Beauties of the Common Tool," *Fortune*, July 1955, p. 106 (variant); WEAW, p. 209 (variant).
NOTE: Not illustrated; duplicate of no. 1075.

1077
[*Baby Terrier Crate Opener, by Bridgeport Hardware Mfg. Corp., 69 cents**], 1955
25.3 x 20.3 cm (9 ³¹⁄₃₂ x 8 in.)
84.XM.488.33
MARKS & INSCRIPTIONS: (Verso) at u. right, Lunn Gallery stamp [both squares empty]; at u. left, in pencil, Wagstaff no. *W.Evans 30* [inverted].
PROVENANCE: George Rinhart; Samuel Wagstaff, Jr.
REFERENCES: *"Beauties of the Common Tool," *Fortune*, July 1955, p. 104 (variant); FORTUNE, pl. 44 (variant);

1080

1079

1081

FAL, p. 168 (variant); WEAW, p. 209 (variant).

1078
[*Baby Terrier Crate Opener, by Bridgeport Hardware Mfg. Corp., 69 cents**], 1955
25 x 20 cm (9 27/32 x 7 7/8 in.)
84.XM.956.1060
MARKS & INSCRIPTIONS: (Verso) at l. center, Evans stamp A; at l. left, in pencil, Crane no. *L74.17(Evans)*.
REFERENCES: *"Beauties of the Common Tool," *Fortune*, July 1955, p. 104 (variant); FORTUNE, pl. 44 (variant);

FAL, p. 164 (variant); WEAW, p. 109 (variant).
NOTE: Not illustrated; duplicate of no. 1077.

1079
[*Stahls Chain-Nose Pliers (Over Actual Size), from Eskilstuna, Sweden, $2.49**], 1955
24.9 x 19.9 cm (9 13/16 x 7 27/32 in.)
84.XM.956.1057
MARKS & INSCRIPTIONS: (Recto) at u. left, in black ink, by Evans, *2 ½ min. daylight sun 2 PM*; (verso) at u. left, Evans stamp A; at u. center, Evans stamp B;

at l. left, in pencil, Crane no. *L74.6 (Evans)*.
REFERENCES: *"Beauties of the Common Tool," *Fortune*, July 1955, p. 103 (variant, horizontal orientation); FORTUNE, pl. 43 (variant, horizontal orientation); WEAW, p. 208 (variant, horizontal orientation); FAL, p. 166 (variant, horizontal orientation).

1080
[*Stahls Chain-Nose Pliers (Over Actual Size), from Eskilstuna, Sweden, $2.49*], 1955
25 x 20 cm (9 13/16 x 7 7/8 in.)

84.XM.956.1055
MARKS & INSCRIPTIONS: (Verso) at l. center, Evans stamp A; at l. left, in pencil, Crane no. *L74.15(Evans)*.

1081
[*Casing Blade*], 1955
24.9 x 20.1 cm (9 13/16 x 7 29/32 in.)
84.XM.956.1052
MARKS & INSCRIPTIONS: (Verso) at l. center, Evans stamp A; at l. left, in pencil, Crane no. *L74.4(Evans)*.

1082

1083

1084

1085

1082
[*Tape Reamer*], 1955
25.1 x 20.2 cm (9 ⅞ x 7 ¹⁵⁄₁₆ in.)
84.XM.956.1053
MARKS & INSCRIPTIONS: (Verso) at
l. right, Evans stamp A; at l. left, in
pencil, Crane no. *L74.10(Evans)*.

1083
[*Engineer's Pliers with Rounded Nose*],
1955
24.9 x 20 cm (9 ²⁵⁄₃₂ x 7 ⅞ in.)
84.XM.956.1054
MARKS & INSCRIPTIONS: (Verso) at l. cen-
ter, Evans stamp A; at l. left, in pencil,
Crane no. *L74.12(Evans)*.

1084
[*Straight Cylindrical Awl*], 1955
25.1 x 19.9 cm (9 ⅞ x 7 ²⁷⁄₃₂ in.)
84.XM.956.1058
MARKS & INSCRIPTIONS: (Verso) at l. cen-
ter, Evans stamp A; at u. right, in
pencil, Crane no. *L74.1(Evans)*.

1085
[*Auger Drill Bit with a Flared Screw-
driver End*], 1955
25 x 20 cm (9 ²⁷⁄₃₂ x 7 ⅞ in.)
84.XM.956.1059
MARKS & INSCRIPTIONS (Verso) at l. cen-
ter, Evans stamp A; at u. right, in
pencil, Crane no. *L74.18(Evans)*.

1086

1087

1088

1091

1086
[*A Bill Hook Tool*], 1955
24.9 x 20.1 cm (9 ¹³⁄₁₆ x 7 ²⁹⁄₃₂ in.)
84.XM.956.1061
MARKS & INSCRIPTIONS: (Verso) at l. center, Evans stamp A; at u. right, in pencil, Crane no. *L74.11(Evans)*.

1087
[*Two-Blade Knife Seen at Forty-five-Degree Angle*], 1955
25 x 20 cm (9 ²⁷⁄₃₂ x 7 ⅞ in.)
84.XM.956.1062
MARKS & INSCRIPTIONS: (Verso) at l. right, Evans stamp A; at u. right, in pencil, Crane no. *L74.2(Evans)*.

1088
[*The "Superrench"—Two-Ended Wrench*], 1955
25 x 20.1 cm (9 ¹³⁄₁₆ x 7 ²⁹⁄₃₂ in.)
84.XM.956.1064
MARKS & INSCRIPTIONS: (Verso) at l. center, Evans stamp A; at u. right, in pencil, Crane no. *L74.21(Evans)*.

1089
[*The "Superrench"—Two-Ended Wrench*], 1955
25 x 20.1 cm (9 ²⁷⁄₃₂ x 7 ¹⁵⁄₁₆ in.)
84.XM.956.1063
MARKS & INSCRIPTIONS: (Verso) at l. cen-

ter, Evans stamp A; at l. left, in pencil, Crane no. *L74.7(Evans)*.
NOTE: Not illustrated; duplicate of no. 1088.

1090
[*The "Superrench"—Two-Ended Wrench*], 1955
25 x 20.2 cm (9 ²⁷⁄₃₂ x 7 ¹⁵⁄₁₆ in.)
84.XM.956.1065
MARKS & INSCRIPTIONS: (Verso) at l. center, Evans stamp A; at u. right, in pencil, Crane no. *L74.20(Evans)*.
NOTE: Not illustrated; duplicate of no. 1088.

1091
[*"T" Bevel*], 1955
25 x 20 cm (9 ¹³⁄₁₆ x 7 ⅞ in.)
84.XM.956.1067
MARKS & INSCRIPTIONS: (Verso) at l. right, Evans stamp A; at l. left, in pencil, Crane no. *L74.8(Evans)*.

1093

1094

1095

1096

1092
[*"T" Bevel*], 1955
24.8 x 20.1 cm (9 ⅝ x 7 ²¹⁄₃₂ in.)
84.XM.956.1066
MARKS & INSCRIPTIONS: (Verso) at
l. right, Evans stamp A; at l. left, in
pencil, Crane no. *L74.19(Evans)*.
NOTE: Not illustrated; duplicate of
no. 1091.

1093
[*All-Steel Wood Chisel*], 1955
24.9 x 20 cm (9 ¹³⁄₁₆ x 7 ⅞ in.)
84.XM.956.1068
MARKS & INSCRIPTIONS: (Verso) at l. cen-
ter, Evans stamp A; at l. left, in pencil,
Crane no. *L74.14(Evans)*.

1094
[*All-Steel Wood Chisel*], 1955
25 x 20.2 cm (9 ¹³⁄₁₆ x 7 ¹⁵⁄₁₆ in.)
84.XM.956.1069
MARKS & INSCRIPTIONS: (Verso) at l. cen-
ter, Evans stamp A; at l. left, in pencil,
Crane no. *L74.13(Evans)*.

1095
[*Mason's or Brick Chisel*], 1955
25.1 x 20.1 cm (9 ⅞ x 7 ²⁹⁄₃₂ in.)
84.XM.956.1070
MARKS & INSCRIPTIONS: (Verso) at l. cen-
ter, Evans stamp twice; at u. right, in
pencil, Crane no. *L74.3(Evans)*.

1096
[*Crew Punch*], 1955
25 x 20.2 cm (9 ⅞ x 7 ³¹⁄₃₂ in.)
84.XM.956.1071
MARKS & INSCRIPTIONS: (Verso) at
l. right, Evans stamp A; at l. left, in
pencil, Crane no. *L74.16(Evans)*.

1097

1098

1097
[*Open-End Crescent Wrench, German Manufacture, 56 Cents*], 1955
25 x 20.1 cm (9 ⅞ x 7 ²⁹⁄₃₂ in.)
84.XM.956.1072
MARKS & INSCRIPTIONS: (Verso) at u. center, Evans stamp A; at l. left, in pencil, Crane no. *L74.22(Evans).*

1098
[*Open-End Crescent Wrench, German Manufacture, 56 cents**], 1955
Image: 24.4 x 19.4 cm (9 ⅝ x 7 ⅝ in.); sheet: 25 x 20.1 cm (9 ⅞ x 7 ²⁹⁄₃₂ in.)
84.XM.956.1073
MARKS & INSCRIPTIONS: (Recto) at u. left, in black ink, by Evans, *3 min. 3:15 sun*; (verso) at l. center, Evans stamp A; at l. left, in pencil, Crane no. *L74.9 (Evans).*
REFERENCES: *"Beauties of the Common Tool," *Fortune* , July 1955, p. 107 (variant); FORTUNE, cover and pl. 47; FAL, p. 167 (variant); WEAW, p. 209 (variant, l. right image).

FAULKNER COUNTRY

Suggested: Detail of gesture, landscape, costume, air, action, mystery, and incident throughout the writings of William Faulkner.

James Agee, "Notes and Appendices," *Let Us Now Praise Famous Men*[1]

In 1948, William Faulkner brought out his first novel in six years, *Intruder in the Dust*.[2] Although between 1926 and 1942 he had published thirteen books, during the forties he worked on screenplays for Hollywood, and the world saw little of his labor on the new manuscript he had under way. The book changed Faulkner's critical as well as his financial standing in substantial ways; MGM bought the movie rights based on the galleys, and when released the novel garnered more attention from the literary press than anything the writer had done previously. The publication of this book was also the occasion for Walker Evans to revisit the South, make a series of photographs for his only commission from *Vogue* magazine (nos. 1099–1169), and, perhaps, think more about the author both he and his close friend Agee had long admired.[3] Besides Faulkner, Agee's "Notes and Appendices" to *Let Us Now Praise Famous Men* included other southern writers, such as Thomas Wolfe and Erskine Caldwell, who influenced his own understanding of a southern childhood. An Agee biographer points out that Wolfe's *Look Homeward, Angel* and

Walker Evans. *Faulkner Country:
1947 Roadside Grave of Lizzie Dotson* (detail), 1948
[no. 1143].

Faulkner's *The Sound and the Fury*, both appearing in 1929, were seminal to Agee's development as a writer.[4] While in the throes of creating his own southern epic, *Let Us Now Praise Famous Men*, he reported to Evans that Faulkner was a part of his dreams.[5] Evans himself, no doubt, had taken a great deal from Faulkner.[6] In fact, it is likely that his intense interest in and sympathy for the southern United States in the thirties came as much from reading Faulkner's early novels as from other sources: listening to southern friends like Agee and Tom Mabry, being exposed to Lincoln Kirstein's obsession with the Civil War and to the Agrarian contributors to Kirstein's journal *Hound & Horn*, passing through Georgia and the Carolinas on a Florida commission in 1934, and having his own boyhood interest in Civil War history. In the summer of 1948, Evans prepared an article for *Fortune* about the African American painter Jacob Lawrence's return trip to the South and his new series *In the Heart of the Black Belt*, based on the artist's latest impressions of that area and "the great hurt group of people" that was his subject.[7] As Faulkner's *Intruder in the Dust* went to press, *Vogue* sent Evans, too, back to the South.

Faulkner had described his work-in-progress as a "mystery-murder though the theme is more relationship between Negro and white."[8] The narrative is told primarily

from the point of view of sixteen-year-old Charles (Chick) Mallison, Jr., who in the course of the story proves that Lucas Beauchamp, an African American accused of murdering a white man, Vinson Gowrie, is innocent. Chick carries out this job of sleuthing with the help of a young black man named Aleck Sander and an elderly woman in the community, Miss Eunice Habersham, who is the sole occupant of a decrepit antebellum mansion outside of town. Much of the book is set in the town square of "Jefferson" (Faulkner's hometown of Oxford, Mississippi), always referred to as "the Square," and a graveyard in the place Faulkner calls Beat Four, a rural area so "solitary unique and alone out of all the county it was known to the rest of the county by the number of its survey coordinate."[9] To discover that not Lucas but the dead man's brother, Crawford Gowrie, was the murderer, the "kinless spinster" and the two boys visit this cemetery during the night and, going against every taboo, open the fresh grave of a white man.[10]

The psychic and physical atmosphere with which Faulkner surrounds Chick Mallison during this difficult episode in his life, and which Evans then tried to express in his photographs, can best be seen in a few illustrative excerpts on Jefferson and its environs. In Faulkner's typical, unpunctuated, stream-of-consciousness style, a two-page sentence in chapter seven describes the Mississippi countryside between the town (or more precisely the Square) and the graveyard in Beat Four:

> . . . and always beyond and around them the enduring land—the fields geometric with furrows where corn had been planted . . . the empty fields themselves in each of which on this day at this hour on the second Monday in May there should have been fixed in monotonous repetition the land's living symbol—a formal group of ritual almost mystic significance . . . : the beast the plow and the man integrated in one foundationed into the frozen wave of their furrow tremendous with effort yet at the

> same time vacant of progress, ponderable immovable and immobile like groups of wrestling statuary set against the land's immensity. . . .[11]

Not only the ritual of farming but the entire day-to-day business of Faulkner's imaginary Yoknapatawpha County has been disturbed by the arrest of Lucas Beauchamp for the killing of a white man. The small-town Square to which Chick and the action of the story return at least nine times becomes the scene of unusual tension and racial drama. The Square's evening appearance is dramatically rendered toward the beginning of the book: "the amphitheatric lightless stores, the slender white pencil of the Confederate monument against the mass of the courthouse looming in columned upsoar to the dim quadruple face of the clock."[12] Of course, the jail on the Square figures prominently in the story, and Faulkner takes the same care in describing it as he does in describing so much nineteenth-century Mississippi architecture: "It was of brick, square, proportioned, with four brick columns in shallow basrelief across the front and even a brick cornice under the eaves because it was old, built in a time when people took time to build even jails with grace and care."[13]

Not far from the Square are the "old big decaying wooden houses of Jefferson's long-ago foundation set like Miss Habersham's deep in shaggy untended lawns of old trees."[14] Miss Habersham's home seems to be the most legendary but is no less ruined than the others; she lives in a "columned colonial house on the edge of town which had not been painted since her father died and had neither water nor electricity in it."[15] But it is the graveyard in Beat Four, so central to this highly charged murder case, that possesses such fascination for the teenager, at night as well as in the daylight, when he really sees it for the first time. On this second visit, Chick's impression is of

> a fenced square of earth less large than garden plots he had seen and which by September would

probably be choked and almost impenetrable and well nigh invisible with sagegrass and ragweed and beggar lice, out of which stood without symmetry or order like bookmarks thrust at random into a ledger or toothpicks in a loaf and canted always slightly as if they had taken their own frozen perpendicular from the limber unresting never-quite-vertical pines, shingle-thin slabs of cheap gray granite of the same weathered color as the paintless church as if they had been hacked out of its flank with axes.[16]

The MGM version of *Intruder in the Dust*, directed by Clarence Brown from a screenplay by Ben Maddow, would appear the next year starring a southerner, Claude Jarman, Jr., as the young Chick Mallison, Jr., and Juano Hernandez as Lucas Beauchamp.[17] More immediately, the book received high praise from numerous critics upon its release that fall; among those turning in good reviews was Harvey Breit, the husband of Evans's longtime friend at *Harper's Bazaar*, Alice Morris. *Vogue* apparently decided in the summer of 1948 to run a fall piece on Faulkner in recognition of his latest publication. Theirs would not be a review of the book but rather a look at "the geography of William Faulkner's world"; it would consist of a portfolio of photographs depicting some of the author's recurrent themes, accompanied by quotations from his new book as well as from his earlier writings.

"Faulkner's Mississippi" appeared in the October 1948 issue of *Vogue*, with fourteen photographs by Evans laid out on six pages and excerpts from six of Faulkner's novels and two of his short stories. (For all but one of the *Vogue* images, usually in a variant cropping, see nos. 1112, 1115, 1125, 1136, 1138, 1146, 1149, 1152, 1154, 1155, 1161, 1166, and 1168.)[18] The images include references to things familiar in the landscape of Faulkner's writing, such as the plantation house (no. 1166), the courthouse square (no. 1146), the dogtrot cabin (no. 1125), the church of a rural black congregation (no. 1155), the crossroads store

(no. 1152), the cemetery (no. 1136), and the railroad (no. 1168). No author's name is attached to the article, although the caption under the title reads: "Six pages of photographs by Walker Evans."[19] The pictures and text are closely matched, suggesting that Evans may have been responsible for both. On the other hand, his wife at the time, Jane Sargeant, remembers that Evans made this southern trip in the summer of 1948 with a female editor from *Vogue* and her assistant.[20] Ms. Sargeant pointed this out with emphasis: Evans was always perturbed by anyone attempting to supervise his work. His unwelcome traveling companions were probably looking specifically for sites with literary relevance and might already have had definite ideas about the text. Whoever set the itinerary and finally selected the passages from Faulkner's oeuvre seems inexplicably to have avoided the obvious, that is, the town of Oxford, the author's residence and the site of much of his fiction, including *Intruder in the Dust*.[21] The subjects of five of the fourteen *Vogue* pictures can be traced to Ripley and Robinsonville in the far northern part of Mississippi and to Canton, Edwards, and Vicksburg in the south-central part of the state, but neither these nor any of the seventy-one photographs in the Getty collection, nor the additional twenty-eight posthumous prints reproduced in the 1982 book *Walker Evans at Work*, have yet been identified as coming from the author's hometown.[22]

The Getty prints, all once part of a book or photo-essay dummy titled by Evans "Faulkner Country," are, in fact, identified on the cover sheet of this mock-up as representing two states, Tennessee and Mississippi; the work is dated June 1948. Why and where in Tennessee this assignment may have taken the photographer is uncertain, but among the Getty prints are about twenty views of farmland being plowed and planted, some including simple board-and-batten cabins, that might derive from either of these southern states. Numerous other Getty views of houses and stores in town, as well as the weathered antebellum mansion captioned "Ruin Rising Gaunt" in the *Vogue* piece,

cannot now be traced to a particular Mississippi village. Some, however, have been traced to Ripley (nos. 1131–37), Edwards (nos. 1161–62), Canton (nos. 1146, 1154, 1159, 1169), Robinsonville (no. 1130), and the National Military Park in Vicksburg, Mississippi (nos. 1138–41).

The prints in this "Faulkner Country" group range in size from 1 ¹⁵⁄₁₆ x 1 ⅜ inches to 3 ⁹⁄₁₆ x 4 ⅝ inches in a typically rectangular or nearly square format, the extreme case being a severely horizontal image (*Crossties Cut Off Even*, no. 1168) measuring ³¹⁄₃₂ x 4 ¹⁷⁄₃₂ inches. Evans has described them as contact prints on the dummy cover sheet; they appear to be hand-trimmed (often in an irregular fashion) from 2 ¼ x 2 ¼-inch or 4 x 5-inch contact prints. (The photographer had evidently chosen to cut the prints down rather than do his cropping in the darkroom.) For *Vogue*, of course, enlargements were employed, though not always following the cropping of the corresponding Getty print. The interior view *Washwoman's Cabin* is the only *Vogue* subject not found at all in the Getty prints. Seventy-one Getty prints from this 1948 project were at one time assembled by Evans into the dummy previously mentioned, one to six prints to a page on thirty sheets of medium-weight, three-hole, letter-size (11 x 8 ½-inch) writing paper; these sheets are now at the Getty. Evans grouped the images by subject, occasionally two, three, or four to a sheet, sometimes juxtaposing two views of the same building, house, or gravestone. Sometimes he paired a near and far view of the same farm wagon or tenant home; sometimes he arranged multiple views on a page according to their architectural subject rather than their geographical location.

It has been suggested that Evans put together this thirty-one-page dummy as preparation for a photographic book that he hoped to publish.[23] For study purposes, this projected book mock-up has been reconstructed through the use of reproductions according to the "S" numbers appearing on the 11 x 8 ½-inch sheets that match the numbers usually found penciled on the verso of the contact prints. There are still two vacant spots indicated by the residue of Evans's original adhesive for which no corresponding Getty print could be found; otherwise, the images have been installed in compliance with the numbering system mentioned above or, where there is no number either on the print and/or on the page, by a process of selecting the most appropriate remaining image that, in size and format, fits the configuration implied by the adhesive stain from the original layout. The sequencing of the thirty dummy sheets is based on numbers assigned when the material was first inventoried after acquisition. The current progression includes the somewhat surprising occurrence of a hipped-roof board-and-batten cottage appearing in one view (no. 1118) on page eight and in a print from a different negative (no. 1149) on page twenty, while another house, this one a smaller, side-gable, board-and-batten structure, appears in a close view (no. 1150) on page twenty-one and in a distant one (no. 1119) on page eight that features recently planted fields.[24]

More importantly, this reconstructed mock-up shows a succession of landscape images portraying what Faulkner called "the land's immensity": broad flat farmland, frequently with the tiny figure of the tenant farmer working behind a mule and a plow (nos. 1103, 1106); the Mississippi River (no. 1115); cypress swamps (no. 1117); and sawmills (nos. 1122–23), all familiar sights in Faulkner's home state. Toward the middle of the sheets there is a group of five images of farm buildings, including an interesting four-crib log barn (no. 1126) and another arrangement of two railroad views near the Robinsonville train station, located on Mississippi's northwestern border with Arkansas (nos. 1129–30). The second half of the mock-up consists almost exclusively of architectural subjects, found both in town and in the fields, with the one diminutive portrayal of railroad tracks (no. 1168) being the exception. Falling in the middle of this re-creation of "Faulkner Country" are five pages containing thirteen prints on the subject of three graveyards: the Ripley cemetery containing

many nineteenth-century Faulkner (at that time Falkner) family graves (nos. 1131–37);[25] the seemingly endless rows of small, uniform Civil War stones in Vicksburg's National Cemetery (nos. 1138–41); and the isolated, crudely incised concrete grave of a woman named Lizzie Dotson (nos. 1142–43). Two of these graveyard pictures are part of the *Vogue* layout (nos. 1136, 1138); their central location and more numerous representation in the Getty's "Faulkner Country" give them greater significance. As has already been pointed out, graveyard imagery recurs frequently in the work of the Mississippi author. The nearly life-sized monument of Colonel William C. Falkner, Faulkner's great-grandfather, which Evans photographed in the family plot of the Ripley Cemetery (no. 1136), is only slightly disguised as that of Colonel John Sartoris in one of the last scenes of the 1929 novel *Sartoris*, a work heavily influenced by the author's own family history:

> *He stood on a stone pedestal, in his frock coat and*
> *bareheaded, one leg slightly advanced and one*
> *hand resting lightly on the stone pylon beside him.*
> *His head was lifted a little in that gesture of*
> *haughty pride which repeated itself generation after*
> *generation with a fateful fidelity, his back to the*
> *world and his carven eyes gazing out across the*
> *valley where his railroad ran, and the blue*
> *changeless hills beyond . . .*[26]

The figure of Colonel Falkner (1825–1889) still dominates this ramshackle, small-town cemetery that is now separated from its original community by Interstate 15, a Pizza Hut, and Fred's Department Store. Although Evans most likely photographed this memorial sculpture because of its connection to the famous author, its pompous Victorian style is reminiscent of the monuments he came across while traveling for the Resettlement Administration in the 1930s. In Bethlehem, Pennsylvania, he had found the double portrait stone memorial for Antonio and Maria

Figure 1. Walker Evans. *Bethlehem, Pennsylvania*, 1935 [no. 442].

Castellucci (no. 442; fig. 1) in the hillside cemetery from which he made a second, better-known view of the town itself (no. 441), a view that prominently features the cross of another headstone but again includes the Castellucci monument, seen in the middle ground facing the street. In New Orleans, he came across a large figurative piece known as the Margaret Statue that presents a robust seated woman comforting a small child.[27] On a trip to Mississippi for the Resettlement Administration in 1935, he had stopped at a cemetery to photograph the full-sized figures of a man and his dog stationed protectively atop a grave.[28] Even earlier, he had been looking for these relics of the Victorian era in New England: a sculpted gentleman dressed aristocratically in top hat and tails is shown leaning mournfully against a detail of what was probably a stone obelisk, in a 1933 view made in Cuttingsville, Vermont (fig. 2). Though apparently representing a northerner, this figure could quite easily pass for a historical character from Faulkner's Yoknapatawpha County.

The graves of Civil War dead (nos. 1138–41) found

Figure 2. Walker Evans. *Cuttingsville, Vermont*, ca. 1933.
Gelatin silver print, 20.3 x 14.6 cm (8 x 5¾ in.).
Courtesy of Robert Mann Gallery, New York.

among these 1948 pictures are evidence that Evans
returned to the battlefield park in Vicksburg he had visited
on a trip for the Resettlement Administration in 1936. How-
ever, on the previous trip he seems to have been inter-
ested, again, in the life-sized figurative pieces that were
erected by various states throughout this extensive
national park. The negatives held by the Library of Con-
gress show that Evans evidently traversed the entire
sixteen-mile extent of the park, photographing ambitious
bronze monuments to heroes such as Lee, Pemberton, and
Tilghman (no. 493), as well as those to anonymous infan-
trymen (no. 494) that are dispersed over the length of the
original battlefield.[29] Those more modest stone pieces spon-
sored by the state of Ohio in honor of various infantry divi-
sions received special attention (no. 495). All carved by

the same anonymous craftsman, they bear a distinctive
style that is at once sophisticated and naive, partially pol-
ished but with an unfinished edge.[30] Evans was drawn to
these simpler memorials, just as he was to the country
graves he and James Agee discovered in Hale County, Ala-
bama, that same year (nos. 564, 566). Marked by small,
plain headstones and decorated with milk bottles, Coca-
Cola bottles, and everyday kitchen utensils, they reflect
the same need to make fitting memorials out of meager
materials that is seen in the grave of Lizzie Dotson photo-
graphed by Evans in 1948 (nos. 1142–43).

Falling between these Resettlement Administra-
tion images of the thirties and the products of Evans's
Vogue assignment of the late forties is a group of pictures
made in Mansfield, Kentucky, of the Woodbridge family
monument (fig. 3). These views have been dated to circa
1945.[31] In each of them, the viewer can discern at least
half-a-dozen stiffly carved stone effigies, some full scale,
facing the same direction as if observing a solemn cere-
mony of infinite duration. It is reported by Faulkner's biog-
raphers that in 1954, after being shown one of Evans's
Mansfield, Kentucky, views by a friend, the writer was
inspired to do a short piece about it: "not really a story, not
an essay, but one of his intermediate forms."[32] Under the
title of "Sepulture South: Gaslight," this piece appeared in
the December 1954 issue of *Harper's Bazaar* accompanied
by Evans's photograph, a composition quite similar to the
one in the Getty, only reversed, suggesting that some of the
lifeless figures actually changed places.[33] In recounting
Faulkner's reaction to the photograph, Joseph Blotner has
said the picture "might have seemed bizarre or lugubrious
to one without his background."[34] Evans had probably
recognized far earlier that he and Faulkner had much in
common. Told like *Intruder* from the point of view of a
teenaged boy, "Sepulture South" presents this young man's
recollection of his grandfather's funeral and his own
"meditation on final things."[35] The inspiration provided by
Evans's work is obvious in several passages of vivid

Figure 3. Walker Evans. *Woodbridge Family Monument, Mansfield, Kentucky,* ca. 1945 [no. 1021].

description offered by the boy who once "wished we lived on Cemetery Street." First, as the funeral procession approaches the cemetery, he relates:

> *And now we could already see them, gigantic and white, taller on their marble pedestals than the rose-and-honeysuckle-choked fence, looming into the very trees themselves . . . gazing forever eastward with their empty marble eyes—not symbols: not angels of mercy or winged seraphim or lambs or shepherds, but effigies of the actual people themselves as they had been in life . . . carved in Italian stone by expensive Italian craftsmen and shipped the long costly way by sea back to become one more among the invincible sentinels guarding the temple of our Southern mores . . .* [36]

The boy then refers briefly to the death of his grandmother, and he wonders why the monument chosen for his grandfather ultimately presents him as a lawyer and orator rather than a soldier, as the boy would have liked. At the very end of this entire "meditation," he reiterates his fascination with his family plot in words that very nearly re-create the mood of Evans's original photograph:

> *And three or four times a year I would come back, I would not know why, alone to look at them, not just Grandfather and Grandmother but at all of them . . . stained now, a little darkened by time and weather and endurance but still serene, impervious, remote, gazing at nothing, not like sentinels, not defending the living from the dead by means of their vast ton-measured weight and mass, but rather the dead from the living. . . .* [37]

"Sepulture South" is a documented case of Faulkner's being influenced by photography, more specifically, by a work by Walker Evans. Other, more ambiguous cases of the author's involvement with photography could also be cited. For example, *Absalom, Absalom!* of 1936 contains a lengthy narrative spoken in the first person by Quentin Compson's father as he describes to his son how one of the book's nineteenth-century protagonists, Charles Bon, prepared his friend Henry Sutpen for some shocking news:

> *So I can imagine him, the way he did it: the way in which he took the innocent and negative plate of Henry's provincial soul and intellect and exposed it by slow degrees to this esoteric milieu, building gradually toward the picture which he desired it to retain, accept.* [38]

The vocabulary of photographic technology is laced through the entire passage, which continues over several pages; it is as if Faulkner is comparing the control of

a manipulative mind to the power of photography and implying the ability of both to establish reality. Mr. Compson continues with his musings on Bon's diabolical mind:

> *Because he (Bon) would be talking now, lazily, almost cryptically, stroking onto the plate himself now the picture which he wanted there; I can imagine how he did it—the calculation, the surgeon's alertness and cold detachment, the exposures brief, so brief as to be cryptic, almost staccato, the plate unaware of what the complete picture would show, scarce-seen yet ineradicable . . .*[39]

It would seem, then, that Faulkner was predisposed to the idea of photography as a complement to his work and, not surprisingly, welcomed the opportunity in 1954 to make an Evans picture the basis for a story.

Willie Morris, a member of a younger generation of Mississippi writers now living in Oxford, has been influenced by the work of both Faulkner and Evans. In 1990, he published a book in collaboration with the photographer William Eggleston, entitled *Faulkner's Mississippi*.[40] It combines biographical information, the recollections of townspeople and relatives, quotations from Faulkner's writings, and a present-day description of Oxford and Lafayette County (Faulkner's Yoknapatawpha), with Eggleston's color photographs. Eggleston's style and subject matter, here intended to "evoke the Mississippi of Faulkner's fictional world,"[41] could easily be characterized as "in the school of" Walker Evans. In fact, in his acknowledgments, Morris cites Evans's collaboration with James Agee on *Let Us Now Praise Famous Men* as a way of pointing out the major role played by Eggleston's pictures in their present cooperative venture. Funerary sculpture of any period is scarce in this collection of seventy-eight images, but a detail of a columned mausoleum, with a classically draped young woman in marble illuminated by a late-afternoon winter sky, would no doubt have found favor with Evans.[42] According to Morris's adjacent text, this monument was very likely found in Oxford's St. Peter's Cemetery, where Faulkner is buried. Its empathy for the mood and motifs of the author's southern novels is not unlike that found in Evans's images for "Faulkner Country."

The Faulknerian heritage comes naturally to Eggleston, a Tennessean still based in Memphis. For Evans, it was a part of a suburban-Chicago boy's continuing search for an old aristocracy. His trip through Faulkner territory in the late forties allowed him to reexamine themes from his earlier southern travels, such as antebellum architecture, small-town squares, rural cottages in the Delta landscape, the African American citizen, and memorials, private and public, homemade and mass-produced.

NOTES

1. James Agee and Walker Evans, *Let Us Now Praise Famous Men: Three Tenant Families* (Boston: Houghton Mifflin, 1941), 449.

2. William Faulkner, *Intruder in the Dust* (New York: Random House, 1948).

3. The commission resulted in "Faulkner's Mississippi," *Vogue* (Oct. 1, 1948), 144–49.

4. Laurence Bergreen, *James Agee: A Life* (New York: Penguin Books, 1985), 74. It is also said that Agee was so impressed with Wolfe's handling of small-town life in *Look Homeward, Angel* that at first he thought the subject no longer needed his attention. Interestingly, in relation to the prominence of death imagery in the work of Faulkner, Agee, and Evans, one of Wolfe's chief characters in that novel is Oliver Gant, stonecutter and father of the novel's hero, Eugene. Gant's shop displaying sample headstones and the angel of the book's title is located on the town square of Altamont. Wolfe describes "the reeking mossiness of Gant's fantastical brick shack, the great interior dustiness of the main room in front, sagging with gravestones—small polished slabs from Georgia, blunt ugly masses of Vermont granite, modest monuments with an urn, a cherub figure, or a couchant lamb, ponderous fly-specked angels from Carrara in Italy which he bought at great cost, and never sold." *Look Homeward, Angel: A Story of the Buried Life* (New York: Charles Scribner's Sons, 1929), 82.

5. Bergreen, *James Agee*, 219. While Faulkner's Baroque style seems to

have been a major influence on the final form of Agee's masterpiece, Wolfe's influence on the construction of this work should not be underestimated; the fictitious name of Gudger, which Agee chose for the tenant family (the Burroughses) to whom he was most attached, comes, perhaps, from Wolfe's character, Nan Gudger, a companion of Eugene Gant's sister, Helen (see *Look Homeward, Angel*, 220–21).

6. In a discussion about the photographer's library on May 4, 1993, John Hill, executor of the Evans Estate, described it as being largely literary, with a great deal of Russian material (Chekhov, Tolstoy, Gorky, Dostoyevski) and much work by Faulkner, as well as Henry James.

7. Walker Evans, "In the Heart of the Black Belt," *Fortune* 38:2 (Aug. 1948), 88–89.

8. Joseph Blotner, *Faulkner: A Biography* (New York: Random House, 1984), 490.

9. Faulkner, *Intruder in the Dust*, 36.

10. Ibid., 76.

11. Ibid., 147,

12. Ibid., 49.

13. Ibid.

14. Ibid., 119.

15. Ibid., 76.

16. Ibid., 157.

17. For the screenplay by Ben Maddow and an account of the making of this film—a critical but not a box-office success—see Regina K. Fadiman, *Faulkner's "Intruder in the Dust": Novel into Film* (Knoxville: University of Tennessee Press, 1978).

18. "Faulkner's Mississippi," *Vogue* (Oct. 1, 1948), 144–49.

19. Ibid., 144.

20. Phone conversation with the author, June 29, 1993.

21. Blotner (chapter 53), in recounting Faulkner's activities in 1948, places the author at home in Oxford that summer. Since Faulkner was known to be a very private person, it is possible that Evans and his colleagues worked elsewhere to respect the celebrated author's right to small-town seclusion. As the Library of Congress negatives show (see Jerald Maddox, *Walker Evans: Photographs for the Farm Security Administration, 1935–1938* [New York: Da Capo Press, 1973]), Evans had been through Oxford in 1936 while at work for the Resettlement Adminis-

tration and was perhaps more interested in photographing elsewhere (although he revisited Edwards and Vicksburg on this later trip). Because he did photograph in Ripley, not far from Oxford, as well as Robinsonville, and, according to the *Vogue* text, Holly Springs, in the northern part of the state, it does appear odd that the *Vogue* team would have bypassed Oxford, a place not out of the way on the route between Ripley and their southern destinations of Canton, Edwards, Vicksburg, etc.

22. See nos. 1130–41, 1146, 1154, 1159, 1161–62, 1169, for site locations for those Getty images that have thus far been identified. This information was gathered by the author primarily from a May 1993 trip through Mississippi and Alabama. Evans seems not only to have revisited the same towns he saw on earlier Resettlement Administration trips but in some cases returned to exactly the same spot, for example, in the very small town of Edwards, on Route 22 between Canton and Vicksburg, where I discovered he must have photographed the "scrolled, balconied house" on Magnolia Street used in the *Vogue* piece while standing on the same bridge from which he shot the Edwards railroad station in 1936 (no. 159; Maddox 109). The large, two-story home is well preserved, with a recent coat of yellow paint and white trim; the railroad tracks remain, but Evans's quintessential Thirties railroad station is now a parking lot. The images in *Walker Evans at Work* (New York: Harper and Row, 1982; pp. 171–72, 174–75, 177, 179) duplicate five of those at the Getty but otherwise represent different croppings or different negatives, including two that make it clear Evans did some of the work on this trip from his car. The original *Vogue* article is also reproduced in *Evans at Work* (pp. 170, 173, 176, 178).

23. John Hill, executor of the Walker Evans Estate, first suggested this possibility to the author while examining the Getty prints in Santa Monica in May 1991. With his urging, a photocopy reconstruction of the original mock-up was produced.

24. Identification of the vernacular building types chosen by Evans was made with the assistance of my husband, Ken Breisch.

25. William Faulkner's great-grandfather Colonel William Clark Falkner dropped the "u" from the family name at some point after 1847, when he was discharged from the Army. In 1918, when he joined the

Royal Air Force, Faulkner restored the "u" to his name. He also changed his place and date of birth for the purposes of declaring himself an Englishman. See Blotner, *Faulkner*, 26, 61.

26. William Faulkner, *Sartoris* (New York: Random House, 1929), 375.

27. *Walker Evans: Photographs for the Farm Security Administration, 1935–1938*, introduction by Jerald C. Maddox (New York: Da Capo Press, 1973), cat. no. 87.

28. Ibid., cat. no. 117.

29. Ibid., cat. nos. 156–62.

30. Ibid., cat. nos. 161–62. These reproductions make clear the heavy unfinished rustication with which the "Ohio" sculptor encased each of his figures and which Evans sometimes, as in the Getty picture, chose to eliminate from the composition. The author's May 1993 visit to the Vicksburg National Military Park confirmed that this framing device was part of the "Ohio" artist's trademark, used repeatedly in each of his works for the park.

31. For two other views of the same group of statuary, see William Faulkner, "Sepulture South: Gaslight," *Harper's Bazaar* LXXXVIII (Dec. 1954), 85, and *Walker Evans, First and Last* (New York: Harper and Row, 1978), 159.

32. Frederick R. Karl, *William Faulkner: American Writer* (New York: Weidenfeld and Nicolson, 1989), 894. I am grateful to Belinda Rathbone and Walter Hopps for the information that Evans's Mansfield, Kentucky, work was once the basis for a Faulkner piece.

33. William Faulkner, "Sepulture South: Gaslight," 84–85, 140–41. This piece can also be found in *Uncollected Stories of William Faulkner*, edited by Joseph Blotner (New York: Random House, 1979), 449–55. In the Blotner anthology, it is reported that Faulkner considered the titles "Sepulchure South: in Gaslight" and "Sepulchre South: Gaslight," before selecting the one that was published, using *sepulture*, a term meaning either burial or a burial-place. It appears that in making the view used in *Harper's Bazaar*, Evans moved slightly to the left of the position he chose for the Getty picture, probably to put the mounted figure in the middle of his composition. Additionally, in making the final print, he flipped the negative, causing the *Bazaar* image to look at first as if it

were made from the same vantage point as that in the Getty, but with a horseman who has magically materialized. It is also possible that the reversal was an accident for which *Bazaar* was responsible. However, Faulkner's narrator describes these marble effigies as "gazing forever eastward," which seems to argue for the reproduction agreeing in orientation with the print Faulkner saw.

34. Blotner, *Faulkner*, 1516.

35. Karl, *William Faulkner*, 894.

36. Blotner, *Uncollected Stories of William Faulkner*, 453–54.

37. Ibid., 455.

38. William Faulkner, *Absalom, Absalom!* (New York: Random House, 1936; Vintage, 1990), 87.

39. Ibid., 88.

40. Willie Morris and William Eggleston, *Faulkner's Mississippi* (Birmingham, Ala.: Oxmoor House, 1990).

41. Ibid., "Acknowledgements," n.p.

42. Ibid., 115.

1100

1103

1101

1099

1102

1104

Faulkner Country

The seventy-one prints that make up this section were first assembled by Evans in a book or photo-essay dummy that he entitled "Faulkner Country," with further notations as to place, date, and medium: "Tennessee and Mississippi/ June 1948/Contact Prints." Matching the photographer's numbers on the prints (verso) to those on the thirty dummy sheets (acquired with the loose prints), the author has been able to re-create Evans's page layouts. Although the pages that follow do not adhere strictly to this initial layout design, they do present the photographs in the approximate sequence, from beginning to end, in which they appeared in Evans's mock-up.

1105

1106

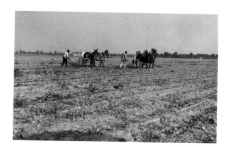

1108

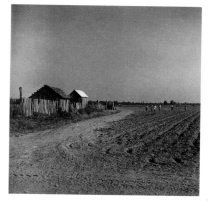

1107

1109

MARKS & INSCRIPTIONS: (Verso) at center, in pencil, *S47*; at right, in blue china marker, *C*; at l. left, in pencil, Crane no. *P77.50a.5.*

1104
[*Faulkner Country: Four Farmers in Plowed Field*], 1948
6.9 x 5.7 cm (2 ¾ x 2 ¼ in.)
84.XM.956.973
MARKS & INSCRIPTIONS: (Verso) at right, in pencil, *S*; at l. left, in pencil, Crane no. *P77.50a.6.*

1105
[*Faulkner Country: Three Women Working a Field*], 1948
4.4 x 4.1 cm (1 ¾ x 1 ⅝ in.)
84.XM.956.975
MARKS & INSCRIPTIONS: (Verso) at center, in pencil, *S2*; at right, in black china marker, *B*; at l. left, in pencil, Crane no. *P77.50a.7.*

1106
[*Faulkner Country: Plowing a Field*], 1948
3.3 x 5.4 cm (1 ⁵⁄₁₆ x 2 ⅛ in.)
84.XM.956.972
MARKS & INSCRIPTIONS: (Verso) at center, in pencil, *S47*; at right, in blue china marker, *D*; at l. left, in pencil, Crane no. *P77.50a.8.*

1107
[*Faulkner Country: Farmers and Small Frame Buildings*], 1948
5.2 x 4.9 cm (2 ¹⁄₁₆ x 1 ¹⁵⁄₁₆ in.)
84.XM.956.976
MARKS & INSCRIPTIONS: (Verso) at center, in pencil, *S49*; at center, in blue china marker, *C*; at l. left, in pencil, Crane no. *P77.50a.9.*

1108
[*Faulkner Country: Working a Field*], 1948
3.6 x 5.4 cm (1 ¹³⁄₃₂ x 2 ⅛ in.)
84.XM.956.974
MARKS & INSCRIPTIONS: (Verso) at center, in pencil, *S49*; and in blue china marker, *A*; at l. left, in pencil, Crane no. *P77.50a.10.*

1109
[*Faulkner Country: Plow in Newly Tilled Field*], 1948
5.4 x 5.3 cm (2 ⅛ x 2 ³⁄₃₂ in.)
84.XM.956.981
MARKS & INSCRIPTIONS: (Verso) at center, in pencil, *S4*; at l. left, in pencil, Crane no. *P77.50a.11.*
REFERENCES: WEAW, p. 171 (variant, top left image).

1099
[*Faulkner Country: Three Women and a Child Working a Field*], 1948
4.7 x 5.4 cm (1 ²⁷⁄₃₂ x 2 ⅛ in.)
84.XM.956.979
MARKS & INSCRIPTIONS: (Verso) at center, in pencil, *S45*; at u. right, in blue china marker, *B*; at l. left, in pencil, Crane no. *P77.50a.3.*

1100
[*Faulkner Country: Farmer with Mules*], 1948
4.9 x 3.5 cm (1 ¹⁵⁄₁₆ x 1 ⅜ in.)
84.XM.956.977

MARKS & INSCRIPTIONS: (Verso) at right center, in pencil, *S4*; at l. left, in pencil, Crane no. *P77.50a.2.*

1101
[*Faulkner Country: Three Women and a Child Working a Field*], 1948
4.2 x 5.4 cm (1 ¹¹⁄₁₆ x 2 ⅛ in.)
84.XM.956.980
MARKS & INSCRIPTIONS: (Verso) at center, in pencil, *S45*; at center, in blue china marker, *A*; at l. left, in pencil, Crane no. *P77.50a.1.*

1102
[*Faulkner Country: Two Children Working a Field*], 1948
3.4 x 5 cm (1 ⁵⁄₁₆ x 1 ³¹⁄₃₂ in.)
84.XM.956.978
MARKS & INSCRIPTIONS: (Verso) at center, in pencil, *S47*; at right, in blue china marker, *A*; at l. left, in pencil, Crane no. *P77.50a.4.*

1103
[*Faulkner Country: Plowing a Field*], 1948
4.6 x 5.5 cm (1 ²⁷⁄₃₂ x 2 ³⁄₁₆ in.)
84.XM.956.971

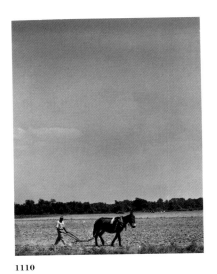

1110

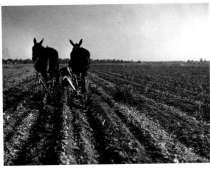

1111

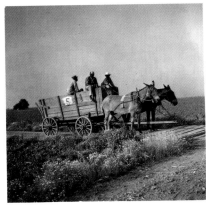

1112

1113

1114

1115

1110
[*Faulkner Country: Farmer with Mule*],
1948
6.5 x 5 cm (2 %₁₆ x 1 ³¹/₃₂ in.)
84.XM.956.983
MARKS & INSCRIPTIONS: (Verso) at l. left,
in pencil, *S28* and Crane
no. *P77.50a.12*.

1111
[*Faulkner Country: Two Mules and a
Plow*], 1948
4.4 x 5.5 cm (1 ¾ x 2 ⁵/₃₂ in.)
84.XM.956.982
MARKS & INSCRIPTIONS: (Verso) at center,

in pencil, *S49* and in blue china
marker, *B*; at l. left, in pencil, Crane
no. *P77.50a.13*.
REFERENCES: WEAW, p. 171 (variant, top
right image).

1112
[*Faulkner Country: Wagon with Mules
and Three Farmers*], 1948
5.4 x 5.3 cm (2 ⅛ x 2 ¹/₁₆ in.)
84.XM.956.984
MARKS & INSCRIPTIONS: (Verso) at center,
in pencil, *S6* and in black china
marker, *A*; at l. left, in pencil, Crane
no. *P77.50a.14*.

REFERENCES: "Faulkner's Mississippi,"
Vogue, Oct. 1, 1948, p. 144 (variant);
WEAW, p. 170 (variant).

1113
[*Faulkner Country: Marsh Scene*], 1948
8.1 x 11.5 cm (3 ³/₁₆ x 4 ½ in.)
84.XM.956.987
MARKS & INSCRIPTIONS: (Verso) at center,
in pencil, *S37* [last number is written
over a 9]; at l. center, in pencil, *37* fol-
lowed by, in blue china marker, *A*; at
u. center, in pencil, *S.57A* [partially
cropped off]; at l. left, in pencil, Crane
no. *P77.50a.15*.

1114
[*Faulkner Country: Planted Field*],
1948
8.2 x 11.5 cm (3 ¼ x 4 ½ in.)
84.XM.956.985
MARKS & INSCRIPTIONS: (Verso) at center,
in pencil, *S37* [crossed out with blue
china marker]; at u. center, in blue
china marker, *S.36C*; at l. left, in
pencil, Crane no. *P77.50a.16*.

1115
[*The Mississippi**]/[*Faulkner Country:
Residence on the Mississippi*], 1948
9 x 11.7 cm (3 ⁹/₁₆ x 4 ⅝ in.)

1116

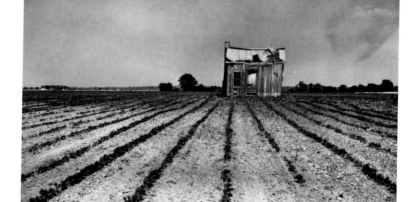

1118

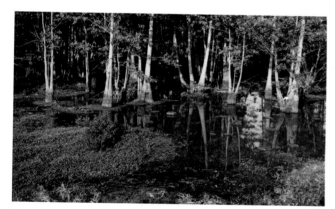

1117

1119

84.XM.956.986
MARKS & INSCRIPTIONS: (Verso) at center, in pencil, *S20*; at l. left, in pencil, Crane no. *P77.50a.17*.
REFERENCES: *"Faulkner's Mississippi," *Vogue*, Oct. 1, 1948, p. 148 (variant); WEAW, p. 178 (variant, reproduction of above-mentioned *Vogue* page, p. 148).

1116
[*Faulkner Country: Cypress Swamp*], 1948
4.7 x 6.7 cm (1 ⅞ x 2 ²¹⁄₃₂ in.)
84.XM.956.988

MARKS & INSCRIPTIONS: (Verso) at center, in pencil, *S39* followed by, in blue china marker, *C*; at l. left, in pencil, Crane no. *P77.50a.18*.

1117
[*Faulkner Country: Cypress Swamp*], 1948
6.3 x 9.9 cm (2 ½ x 3 ²⁹⁄₃₂ in.)
84.XM.956.989
MARKS & INSCRIPTIONS: (Verso) at center, in pencil *S39* [inverted] followed by, in blue china marker, *B* [upside down]; at l. left, in pencil, Crane no. *P77.50a.19*.

1118
[*Faulkner Country: Hipped-Roof Board-and-Batten Cottage with Outbuildings*], 1948
7.8 x 11.3 cm (3 ¹⁄₁₆ x 4 ⁷⁄₁₆ in.)
84.XM.956.990
MARKS & INSCRIPTIONS: (Verso) at center, in pencil, *S4*; at right center, in black china marker, *?*; at l. left, in pencil, Crane no. *P77.50a.20*.

1119
[*Faulkner Country: Abandoned Side-Gable Board-and-Batten House in Planted Field*], 1948
8.2 x 11.2 cm (3 ⁷⁄₃₂ x 4 ¹³⁄₃₂ in.)
84.XM.956.991
MARKS & INSCRIPTIONS: (Verso) at center, in pencil, *S25* followed by, in black china marker, *B*; at l. left, in pencil, Crane no. *P77.50a.21*.

1120

1122

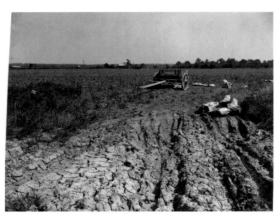

1121

1123

1120
[*Faulkner Country: Unpainted Farm Wagon*], 1948
9 x 9.6 cm (3 ¹⁷/₃₂ x 3 ²⁵/₃₂ in.)
84.XM.956.993
MARKS & INSCRIPTIONS: (Verso) at center, in pencil, *S4*; at l. left, in pencil, Crane no. *P77.50a.22.*

1121
[*Faulkner Country: Farm Wagon in Parched Field*], 1948
8.8 x 11.2 cm (3 ¹⁵/₃₂ x 4 ¹³/₃₂ in.)
84.XM.956.992

MARKS & INSCRIPTIONS: (Verso) at center, in pencil, *S10*; at l. left, in pencil, Crane no. *P77.50a.23.*

1122
[*Faulkner Country: Lumberyard Scene with Mound of Earth*], 1948
8.5 x 11.3 cm (3 ¹¹/₃₂ x 4 ¹⁵/₃₂ in.)
84.XM.956.995
MARKS & INSCRIPTIONS: (Verso) at center, in pencil, *S41*; at right center, in blue china marker, *A*; at l. left, in pencil, Crane no. *P77.50a.24.*

1123
[*Faulkner Country: Lumberyard*], 1948
8.2 x 11.8 cm (3 ⁷/₃₂ x 4 ⅝ in.)
84.XM.956.994
MARKS & INSCRIPTIONS: (Verso) at center, in pencil, *S58* [crossed out with blue china marker]; at u. center, in blue china marker, *S.38C*; at l. left, in pencil, Crane no. *P77.50a.25.*

1124
[*Faulkner Country: Dogtrot Cabin*], 1948
4.4 x 5.3 cm (1 ²³/₃₂ x 2 ³/₃₂ in.)
84.XM.956.999

MARKS & INSCRIPTIONS: (Verso) at center, in pencil, *S52* followed by, in blue china marker, *E*; at l. left, in pencil, Crane no. *P77.50a.26.*

1125
[*Dogtrot Cabin**]/[*Faulkner Country: Dogtrot Cabin*], 1948
3.9 x 5.4 cm (1 ¹⁷/₃₂ x 2 ⅛ in.)
84.XM.956.996
MARKS & INSCRIPTIONS: (Verso) at l. right, in pencil, *S52* [mostly obscured by blue china marker]; at center, in blue china marker, *S52D*; at l. left, in pencil, Crane no. *P77.50a.27.*

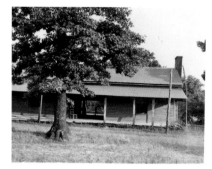

1124

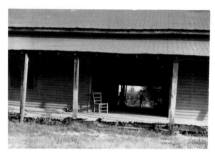

1125

1126

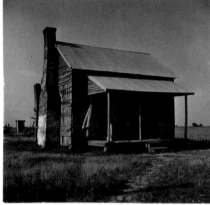

1127

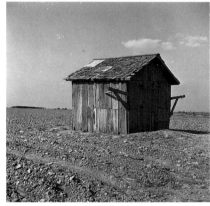

1128

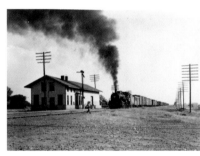

1129

1130

REFERENCES: *"Faulkner's Mississippi," *Vogue*, Oct. 1, 1948, p. 149 (variant); WEAW, p. 178 (variant, reproduction of above-mentioned *Vogue* page).

1126
[*Faulkner Country: Four-Crib Log Barn*], 1948
4.4 x 5.4 cm (1 ²³⁄₃₂ x 2 ⁵⁄₃₂ in.)
84.XM.956.998
MARKS & INSCRIPTIONS: (Verso) at center, in pencil, *S52* followed by, in blue china marker, *C*; at l. left, in pencil, Crane no. *P77.50a.28*.

1127
[*Faulkner Country: Small Frame House with Tin Roof*], 1948
5.6 x 5.5 cm (2 ⁵⁄₃₂ x 2 ⁵⁄₃₂ in.)
84.XM.956.997
MARKS & INSCRIPTIONS: (Verso) at left center, in pencil, *S45* followed by, in blue china marker, *F*; at l. left, in pencil, Crane no. *P77.50a.29*.

1128
[*Faulkner Country: Possibly a Drying House in Tilled Field*], 1948
5.6 x 5.4 cm (2 ³⁄₁₆ x 2 ⁵⁄₃₂ in.)
84.XM.956.1000

MARKS & INSCRIPTIONS: (Verso) at center, in pencil, *S45* followed by, in blue china marker, *D*; at l. left, in pencil, Crane no. *P77.50a.30*.

1129
[*Faulkner Country: Train Running Along Rural Roadside*], 1948
4.4 x 5.4 cm (1 ²³⁄₃₂ x 2 ⅛ in.)
84.XM.956.1001
MARKS & INSCRIPTIONS: (Verso) at center, in pencil, *S2* followed by, in black china marker, *C*; at l. left, in pencil, Crane no. *P77.50a.31*.

1130
[*Faulkner Country: Train at Robinsonville Station, Mississippi*], 1948
3.9 x 5.1 cm (1 ¹⁷⁄₃₂ x 2 ¹⁄₃₂ in.)
84.XM.956.1002
MARKS & INSCRIPTIONS: (Verso) at center, in pencil, *S2* followed by, in black china marker, *A*; at l. left, in pencil, Crane no. *P77.50a.32*.

1131

1132

1133

1135

1134

1131
[*Faulkner Country: Ripley Cemetery,
Ripley, Mississippi*], 1948
5.7 x 5.5 cm (2 ¼ x 2 ⁵⁄₃₂ in.)
84.XM.956.1003
MARKS & INSCRIPTIONS: (Verso) at u. cen-
ter, in pencil, *S52* followed by, in blue
china marker, *A*; at l. left, in pencil,
Crane no. *P77.50a.33*.

1132
[*Faulkner Country: Falkner Family
Tombstones, Ripley, Mississippi*], 1948
5.7 x 5.5 cm (2 ⁷⁄₃₂ x 2 ⁵⁄₃₂ in.)
84.XM.956.1004
MARKS & INSCRIPTIONS: (Verso) at center,
in pencil, *S52* followed by, in blue
china marker, *B*; at l. left, in pencil,
Crane no. *P77.50a.34*.
REFERENCES; WEAW, p. 179.

1133
[*Faulkner Country: Falkner Family
Tombstone (Little Vance Falkner and
Little Sister Lizzie), Ripley, Mississippi*],
1948
5.3 x 3.6 cm (2 ³⁄₃₂ x 1 ¹³⁄₃₂ in.)
84.XM.956.1006
MARKS & INSCRIPTIONS: (Verso) at
l. right, in pencil, *S*; at l. left, in
pencil, Crane no. *P77.50a.36*.
REFERENCES: WEAW, p. 179 (variant).

1134
[*Faulkner Country: Ripley Cemetery,
Ripley, Mississippi*], 1948
5.3 x 5.1 cm (2 ³⁄₃₂ x 2 in.)

84.XM.956.1005
MARKS & INSCRIPTIONS: (Verso) at center,
in pencil, *S44*; at right, in blue china
marker, *D* [partially cut off]; at l. left,
in pencil, Crane no. *P77.50a.35*.

1135
[*Faulkner Country: Ripley Cemetery,
Ripley, Mississippi*], 1948
3.1 x 4.3 cm (1 ³⁄₁₆ x 1 ²³⁄₃₂ in.)
84.XM.956.1007
MARKS & INSCRIPTIONS: (Verso) at center,
in pencil, *S44*; at right, in blue china
marker, *A* [cropped off]; at l. left, in
pencil, Crane no. *P77.50a.37*.

1136

1137

1138

1139

1136
[*Colonel Falkner's Monument**]/
[*Faulkner Country: Colonel William Falkner's Tomb with Other Family Graves, Ripley Cemetery, Ripley, Mississippi*], 1948
5.6 x 5.4 cm (2 3/16 x 2 1/8 in.)
84.XM.956.1010
MARKS & INSCRIPTIONS: (Verso) at u. center, in pencil, __S0 [partially cut off]; at center, in pencil, *S50* followed by, in blue china marker, *D*; at l. left, in pencil, Crane no. *P77.50a.38*.
REFERENCES: *"Faulkner's Mississippi," *Vogue*, Oct. 1, 1948, p. 149

(variant); WEAW, pp. 178 (variant, reproduction of above-mentioned *Vogue* page) and 179.

1137
[*Faulkner Country: Ripley Cemetery, Ripley, Mississippi*], 1948
5.6 x 5.1 cm (2 3/16 x 2 in.)
84.XM.956.1011
MARKS & INSCRIPTIONS: (Verso) at center, in pencil, *S44* followed by, in blue china marker, *B*; at l. left, in pencil, Crane no. *P77.50a.39*.
REFERENCES: WEAW, p. 179 (variant).

1138
[*Military Cemetery**]/[*Faulkner Country: National Cemetery, Vicksburg National Military Park, Mississippi*], 1948
9.5 x 11.7 cm (3 3/4 x 4 19/32 in.)
84.XM.956.1008
MARKS & INSCRIPTIONS: (Verso) at left center, in pencil, *S29*; at l. left, in pencil, Crane no. *P77.50a.40*.
REFERENCES: *"Faulkner's Mississippi," *Vogue*, Oct. 1, 1948, p. 147; WEAW, p. 176 (reproduction of above-mentioned *Vogue* page).

1139
[*Faulkner Country: Military Graveyard, National Cemetery, Vicksburg National Military Park, Mississippi*], 1948
9.3 x 11.8 cm (3 11/16 x 4 5/8 in.)
84.XM.956.1009
MARKS & INSCRIPTIONS: (Verso) at center, in pencil, *S31*; at l. left, in pencil, Crane no. *P77.50a.41*.

1140

1141

1144

1140
[*Faulkner Country: National Cemetery, Vicksburg National Military Park, Mississippi*], 1948
11.4 x 9.3 cm (4 ½ x 3 ²¹⁄₃₂ in.)
84.XM.956.1012
MARKS & INSCRIPTIONS: (Verso) at center, in pencil, *S31* followed by, in black china marker, *B*; at l. left, in pencil, Crane no. *P77.50a.42.*

1141
[*Faulkner Country: National Cemetery, Vicksburg National Military Park, Mississippi*], 1948
5.3 x 5.4 cm (2 ³⁄₃₂ x 2 ⁵⁄₃₂ in.)
84.XM.956.1013
MARKS & INSCRIPTIONS: (Verso) at center, in pencil, *S46* followed by, in blue china marker, *B*; at l. left, in pencil, Crane no. *P77.50a.43.*

1142
[*Faulkner Country: 1947 Roadside Grave of Lizzie Dotson*], 1948
9.9 x 9.1 cm (3 ²⁹⁄₃₂ x 3 ¹⁹⁄₃₂ in.)
84.XM.956.1014
MARKS & INSCRIPTIONS: (Verso) at center, in pencil, *S19*; at l. right, *MC* [most of inscription cropped off]; at l. left, in pencil, Crane no. *P77.50a.44.*
REFERENCES: WEAW, p. 177 (variant, bottom left image).

1143
[*Faulkner Country: 1947 Roadside Grave of Lizzie Dotson*], 1948
11.7 x 9.3 cm (4 ¹⁹⁄₃₂ x 3 ²¹⁄₃₂ in.)
84.XM.956.1015
MARKS & INSCRIPTIONS: (Verso) at center, in pencil, *S19*; at l. left, in pencil, Crane no. *P77.50a.45.*
REFERENCES: WEAW, p. 177 (bottom right image).

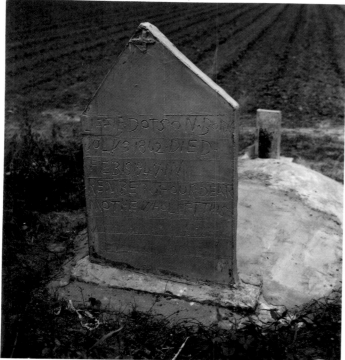

1142

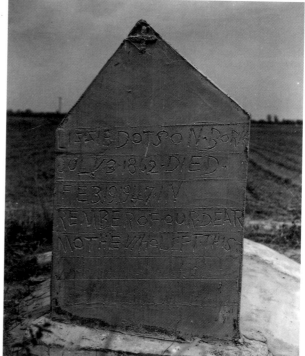

1143

1145

1146

1147

1144
[*Faulkner Country: Row of Shops, Courthouse Square, Probably Canton, Mississippi*], 1948
6.5 x 10.7 cm (2 %16 x 4 7/32 in.)
84.XM.956.1016
MARKS & INSCRIPTIONS: (Verso) at center, in pencil, *S23*; at l. left, in pencil, Crane no. *P77.50a.46.*

1145
[*Faulkner Country: Street with Rossie Hotel and Market, Probably Canton, Mississippi*], 1948
5.5 x 4.3 cm (2 3/16 x 1 11/16 in.)
84.XM.956.1017
MARKS & INSCRIPTIONS: (Verso) at center, in pencil, *S46* followed by, in blue china marker, *A*; at l. left, in pencil, Crane no. *P77.50a.47.*

1146
[*Courthouse**]/[*Faulkner Country: Madison County Courthouse (Est. 1855), Canton, Mississippi*], 1948
3.9 x 4.2 cm (1 17/32 x 1 5/8 in.)
84.XM.956.1018
MARKS & INSCRIPTIONS: (Verso) at u. center, in pencil, *S3*; at l. left, in pencil, *S3* [part of "S" has been cropped off]; at l. right, in pencil, *18* [circled and erased]; at l. center, in pencil, Crane no. *P77.50a.48.*
REFERENCES: *"Faulkner's Mississippi," *Vogue*, Oct. 1, 1948, p. 148

(variant); WEAW, p. 178 (variant, reproduction of above-mentioned *Vogue* page).

1147
[*Faulkner Country: Detail of Ohio Fourth Cavalry Monument, Vicksburg National Military Park, Mississippi*], 1948
4.4 x 6.1 cm (1 23/32 x 2 13/32 in.)
84.XM.956.1019
MARKS & INSCRIPTIONS: (Verso) at center, in pencil, *S34*; at l. left, in pencil, Crane no. *P77.50a.49.*
REFERENCES: WEAW, p. 177 (variant, top right image).

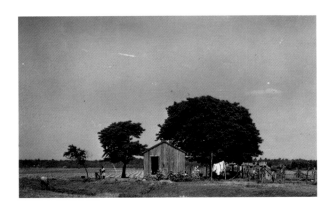

1148

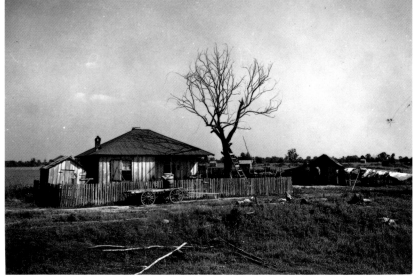

1149

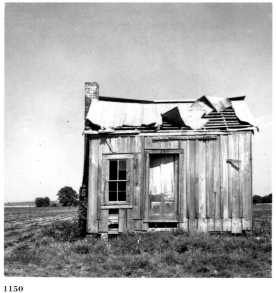

1150

1151

1148
[Faulkner Country: Probably a Tenant Farmer's House], 1948
5.7 x 8.9 cm (2 ¼ x 3 ½ in.)
84.XM.956.1020
MARKS & INSCRIPTIONS: (Verso) at center, in pencil, *S25*; at l. left, in pencil, Crane no. *P77.50a.50.*

1149
[Share-Cropper Cabin]/[Faulkner Country: Hipped-Roof Board-and-Batten Cottage With Outbuildings]*, 1948
7.8 x 11 cm (3 ⅟₃₂ x 4 ⁵⁄₁₆ in.)
84.XM.956.1021
MARKS & INSCRIPTIONS: (Verso) at center, in pencil, *S12*; at l. left, in pencil, Crane no. *P77.50a.51.*
REFERENCES: *"Faulkner's Mississippi," *Vogue*, Oct. 1, 1948, p. 149 (variant); WEAW, p. 178 (variant, reproduction of above-mentioned *Vogue* page).

1150
[Faulkner Country: Abandoned Side-Gable Board-and-Batten House], 1948
8.3 x 7.6 cm (3 ⁹⁄₃₂ x 3 in.)
84.XM.956.1022
MARKS & INSCRIPTIONS: (Verso) at l. left, in pencil, Crane no. *P77.50a.52.*

1151
[Faulkner Country: Painted Creole Cottage], 1948
8.3 x 11.7 cm (3 ⁹⁄₃₂ x 4 ¹⁹⁄₃₂ in.)
84.XM.956.1023
MARKS & INSCRIPTIONS: (Verso) at center, in pencil, *S9*; at l. left, in pencil, Crane no. *P77.50a.53.*

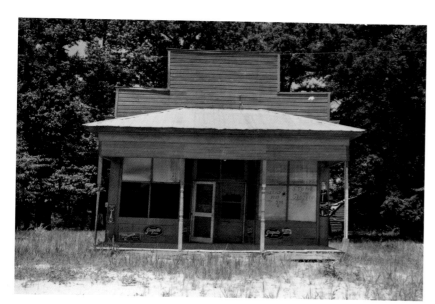

1152

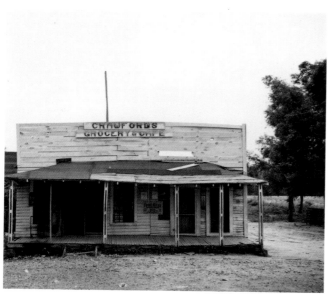

1153

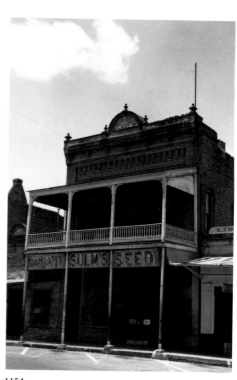

1154

1152
[Crossroads Store*]/[Faulkner Country: "Stop and Buy" Grocery Store, Mississippi], 1948
7.7 x 10.8 cm (3 1/32 x 4 1/4 in.)
84.XM.956.1024
MARKS & INSCRIPTIONS: (Verso) at center, in pencil, S58 [crossed out in blue china marker]; at u. center, in blue china marker, S38A; at l. left, in pencil, Crane no. P77.50a.54.
REFERENCES: *"Faulkner's Mississippi," Vogue, Oct. 1, 1948, p. 148 (variant); WEAW, p. 178 (variant, reproduction of above-mentioned Vogue page).

1153
[Faulkner Country: Crawford's Grocery and Cafe], 1948
8.1 x 9 cm (3 7/32 x 3 17/32 in.)
84.XM.956.1025
MARKS & INSCRIPTIONS: (Verso) at right center, S58 [inverted and crossed out with blue china marker]; at l. right, in blue china marker, S38B [inverted]; at l. left, in pencil, Crane no. P77.50a.55.

1154
[Store in Town*]/[Faulkner Country: "Sulm's Seed" Store (Est. 1904), Canton, Mississippi], 1948
9.8 x 6.1 cm (3 7/8 x 2 3/8 in.)
84.XM.956.1026
MARKS & INSCRIPTIONS: (Verso) at l. right, in pencil, S37 [crossed out with blue china marker]; at l. center, in blue china marker, S36A; at l. left, in pencil, Crane no. P77.50a.56.
REFERENCES: *"Faulkner's Mississippi," Vogue, Oct. 1, 1948, p. 146 (variant); WEAW, p. 176 (variant, reproduction of above-mentioned Vogue page).

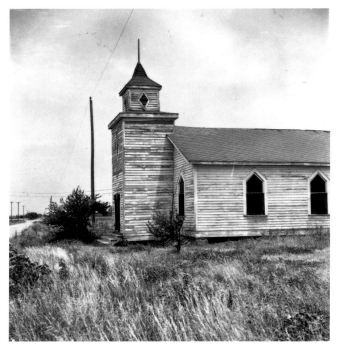

1155

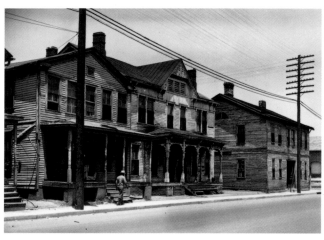

1158

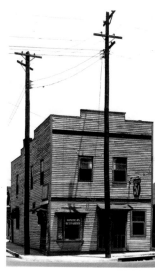

1159

1155
[*Country Church**]/*Faulkner Country:
White Frame Country Church*], 1948
10 x 9.3 cm (3 ¹⁵⁄₁₆ x 3 ²¹⁄₃₂ in.)
84.XM.956.1027
MARKS & INSCRIPTIONS: (Verso) at l. cen-
ter, in pencil, *S17*; at l. left, in pencil,
Crane no. *P77.50a.57.*
REFERENCES: *"Faulkner's Missis-
sippi," *Vogue*, Oct. 1, 1948, p. 149
(variant); WEAW, p. 175 (variant) and
p. 178 (variant, reproduction of above-
mentioned *Vogue* page).

1156
[*Faulkner Country: Dilapidated
I-House*], 1948
9.3 x 11.6 cm (3 ²¹⁄₃₂ x 4 ⁹⁄₁₆ in.)
84.XM.956.1028
MARKS & INSCRIPTIONS: (Verso) at center,
in pencil, *S24*; at l. left, in pencil,
Crane no. *P77.50a.60.*

1157
[*Faulkner Country: Two-Story Frame
House (I-House) with Drying Laundry*],
1948
9.1 x 11.4 cm (3 ¹⁹⁄₃₂ x 4 ½ in.)
84.XM.956.1029
MARKS & INSCRIPTIONS: (Verso) at center,
in pencil, *S27*; at l. left, in pencil,
Crane no. *P77.50a.59.*

1158
[*Faulkner Country: Three Two-Story
Houses on a Southern Street*], 1948
7.3 x 9.8 cm (2 ⅞ x 3 ⅞ in.)
84.XM.956.1030
MARKS & INSCRIPTIONS: (Verso) at center,
in pencil, *S27*; at l. left, in pencil,
Crane no. *P77.50a.60.*

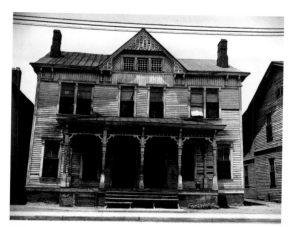

1156

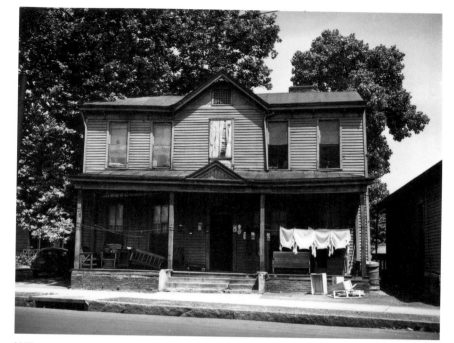

1157

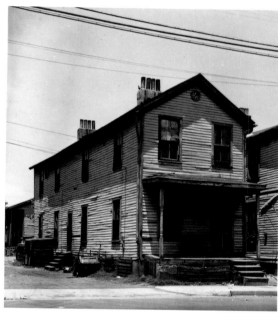

1160

1159
[*Faulkner Country: Front of Nishea's Beer Garden, Probably Canton, Mississippi*], 1948
7.1 x 4.1 cm (2 ¹³⁄₁₆ x 1 ¹⁹⁄₃₂ in.)
84.XM.956.1031
MARKS & INSCRIPTIONS: (Verso) at right center, in pencil, *S23*; at l. left, in pencil, Crane no. *P77.50a.61*.

1160
[*Faulkner Country: Two-Story Front-Gable Frame House in a Southern Town*], 1948
8.4 x 7.3 cm (3 ⁵⁄₁₆ x 2 ⅞ in.)
84.XM.956.1032
MARKS & INSCRIPTIONS: (Verso) at center, in pencil, *S26*; at l. left, in pencil, Crane no. *P77.50a.62*.

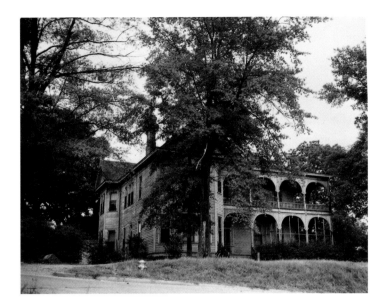

1161

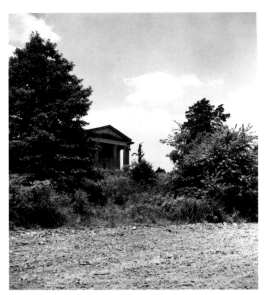

1163

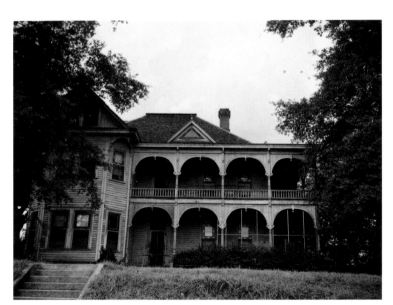

1162

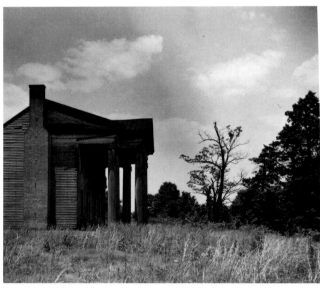

1164

1161
[*Scrolled Balconied House**]/[*Faulkner
Country: Magnolia Street, Edwards,
Mississippi*], 1948
8.9 x 10.8 cm (3 ¹⁷/₃₂ x 4 ¼ in.)
84.XM.956.1033
MARKS & INSCRIPTIONS: (Verso) at center,
in pencil, *S33* followed by, in black
china marker, *B*; at l. left, in pencil,
Crane no. *P77.50a.63*.
REFERENCES: *"Faulkner's Missis-
sippi," *Vogue*, Oct. 1, 1948, p. 149
(variant); WEAW, p. 178 (variant, repro-
duction of above-mentioned *Vogue*
page).

1162
[*Faulkner Country: Magnolia Street,
Edwards, Mississippi*], 1948
9.1 x 11.5 cm (3 ¹⁹/₃₂ x 4 ¹⁷/₃₂ in.)
84.XM.956.1034
MARKS & INSCRIPTIONS: (Verso) at l. left,
in pencil, *33*; at center, in pencil, *S33*;
at l. left, in pencil, Crane
no. *P77.50a.64*.

1163
[*Faulkner Country: Abandoned Greek
Revival Antebellum Mansion*], 1948
10.6 x 9.2 cm (4 ³/₁₆ x 3 ⅝ in.)
84.XM.956.1035
MARKS & INSCRIPTIONS: (Verso) at
u. right, in pencil, *W6* [partially
cropped]; at center, in pencil, *S16*
[crossed out with black china marker];
at l. left, in pencil, Crane
no. *P77.50a.65*.

1164
[*Faulkner Country: Abandoned Greek
Revival Antebellum Mansion, Side
View*], 1948
8.1 x 8.8 cm (3 ⁵/₃₂ x 3 ¹⁵/₃₂ in.)
84.XM.956.1036
MARKS & INSCRIPTIONS: (Verso) at center,
in pencil, *S18/015* [crossed out in
black china marker]; at u. center, in
black china marker, *S15*; at l. left,
in pencil, Crane no. *P77.50a.66*.
REFERENCES: WEAW, p. 172 (variant,
bottom left image).

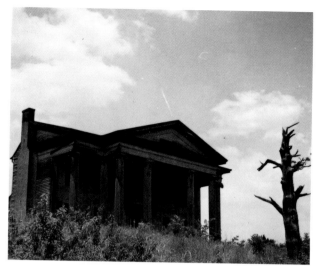

1165

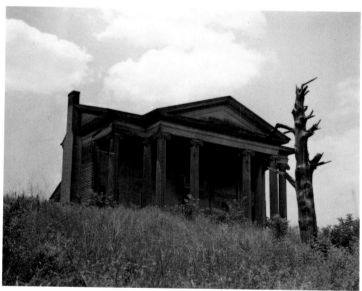

1166

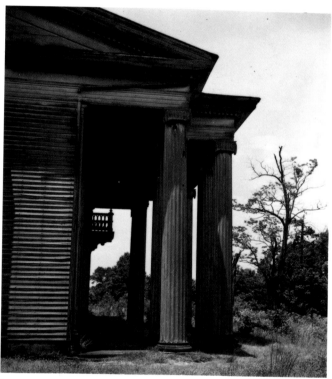

1167

1165
[*Faulkner Country: Abandonded Greek
Revival Antebellum Mansion*], 1948
7 x 8 cm (2 ¾ x 3 ⁵/₃₂ in.)
84.XM.956.1037
MARKS & INSCRIPTIONS: (Verso) at center,
in pencil, *S35*; at l. left, in pencil,
Crane no. *P77.50a.67*.
REFERENCES: WEAW, p. 172 (variant,
top image).

1166
[*Ruin Rising Gaunt**]/[*Faulkner
Country: Abandoned Greek
Revival Antebellum Mansion*], 1948
7.7 x 9.3 cm (3 ¹/₃₂ x 3 ¹¹/₁₆ in.)
84.XM.956.1038
MARKS & INSCRIPTIONS: (Verso) at center,
in pencil, *S8*; at l. left, in pencil,
Crane no. *P77.50a.68*.
REFERENCES: *"Faulkner's Missis-
sippi," *Vogue*, Oct. 1, 1948, p. 145
(variant); WEAW, p. 173 (variant, repro-
duction of above-mentioned *Vogue*
page).

1167
[*Faulkner Country: Abandoned Greek
Revival Antebellum Mansion, Side
View*], 1948
10.1 x 8.8 cm (3 ³¹/₃₂ x 3 ¹⁵/₃₂ in.)
84.XM.956.1039
MARKS & INSCRIPTIONS: (Verso) at center,
in pencil, *S14*; at l. left, in pencil,
Crane no. *P77.50a.69*.

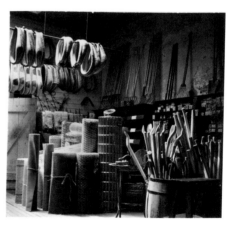

1168

1169

1168
[*Crossties Cut Off Even**]/[*Faulkner
Country: Railroad Tracks*], 1948
2.4 x 11.5 cm (31/32 x 4 $^{17}/_{32}$ in.)
84.XM.956.1041
MARKS & INSCRIPTIONS: (Verso) at left, in
pencil, *S33*; at center, in pencil, *S33*
[crossed out with black china marker];
at l. left, in pencil, Crane no. *L79.71*
(*Evans*).
REFERENCES: *"Faulkner's Missis-
sippi," *Vogue*, Oct. 1, 1948,
pp. 146–47 (variant, printed over the
gutter); WEAW, p. 176 (variant, repro-
duction of above-mentioned *Vogue*
pages).

1169
[*Faulkner Country: Sulm's Seed Store
Interior, Canton, Mississippi*], 1948
5.6 x 5.7 cm (2 $^{7}/_{32}$ x 2 ¼ in.)
84.XM.956.1040
MARKS & INSCRIPTIONS: (Verso) at center,
in pencil, *S52* [crossed out with china
marker]; at l. center, in blue china
marker, *S53A* [crossed out with china
marker]; at l. center, in pencil, *S51A*;
at l. left, in pencil, Crane
no. *P77.50a.71*.

1958–1974

The Polaroids and Other Work

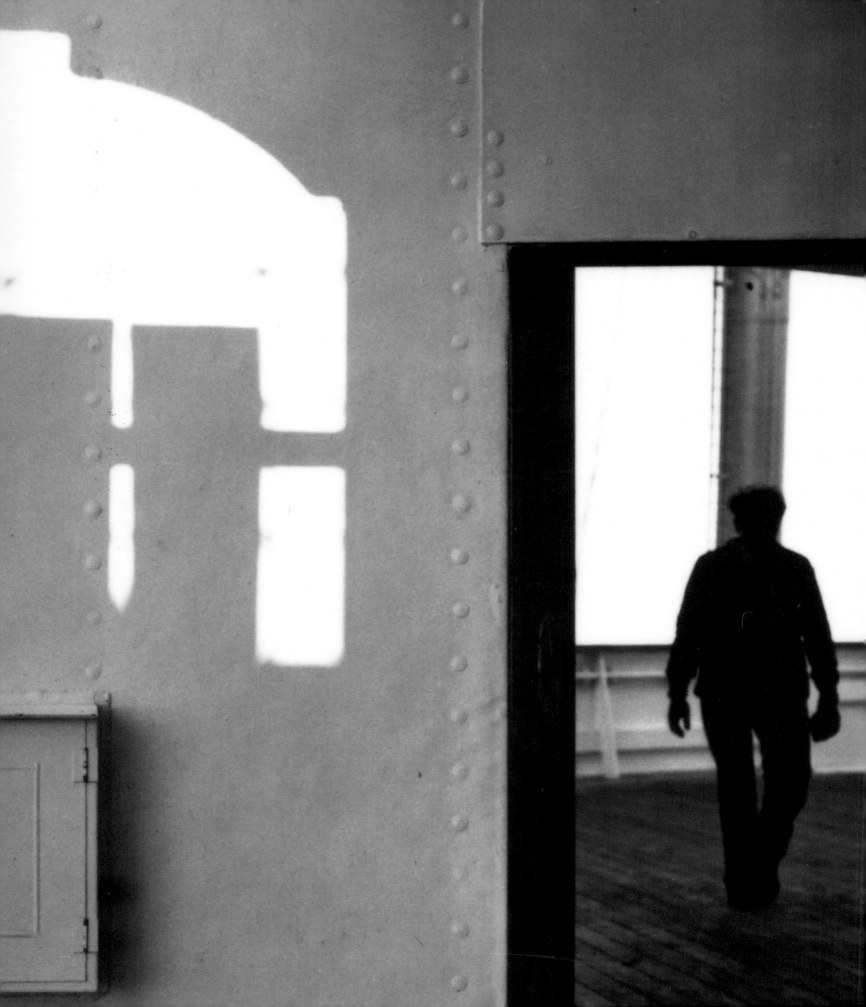

THE POLAROIDS AND
OTHER WORK

After all, I am getting older, and I feel that nobody should touch
a Polaroid until he's over sixty.

Walker Evans in an interview, fall 1974[1]

The Getty's sparse representation of Evans's work after 1955 contains a few additional prints made for *Fortune* assignments, such as the *Class A Steam Locomotive* (no. 1171) that would appear enlarged as a double-page spread in his portfolio "The Last of Railroad Steam," and the two images of Third Avenue antique displays (nos. 1181–82) made for an essay that did not reach the page in spite of Evans's pleasure in the subject.[2] Evans's continued contributions to photojournalism are also illustrated by work from two 1958 *Architectural Forum* essays: "The London Look" (no. 1170) and "Ship Shapes and Shadows" (nos. 1172–77).[3] The photograph *London Crescent*, used in a slightly cropped version, is evidence of the former; the latter is found in six large prints in the collection, only one of which (no. 1174; fig. 1) became part of the final layout, and it survives in just fragmentary form. Enlarged substantially and printed in high contrast, these studies of two famous ocean liners, the R.M.S. *Queen Mary* and the S.S. *Liberté*, seem to be a simplified updating by Evans of Charles Sheeler's 1929 painting *Upper Deck*, which was apparently based on a photographic study by the artist.[4]

Sheeler had referred to this painting as a piece marking his "turn away from abstraction toward design within fully realized forms."[5] For Evans, on the other hand, the opportunity to photograph on the deck of a venerable cruise ship seemed to inspire a return to compositions in the vein of his early abstractions, such as those at the Getty based on the forms of grain elevators or, more relevantly, nautical apparatus found in East Coast shipyards. He isolated the ships' parts (or "shapes") more stringently than Sheeler had and let the strong shadows assist him in emphasizing their design rather than their functional aspects.

Interiors from New York, New England (fig. 2), and Nova Scotia, one of which he chose for the 1966 publication *Message from the Interior* (no. 1183), are among the miscellaneous Getty prints from the last two decades of Evans's long career.[6] Two unusual portraits from 1969 of an unidentified acquaintance of Evans's reflect the teenage charm and awkwardness of their subject (nos. 1185–86). Even less familiar than such personal black-and-white portraits are the many Polaroid pictures he made of colleagues, friends, and students during the two years he experimented intensively with the new SX-70 camera (nos. 1187–92).[7] Introduced in the fall of 1972, Polaroid's SX-70 system offered the first integral, or non-peel-apart,

Walker Evans. *"Liberté": Promenade Deck, Port Forward* (detail), ca. 1958 [no. 1177].

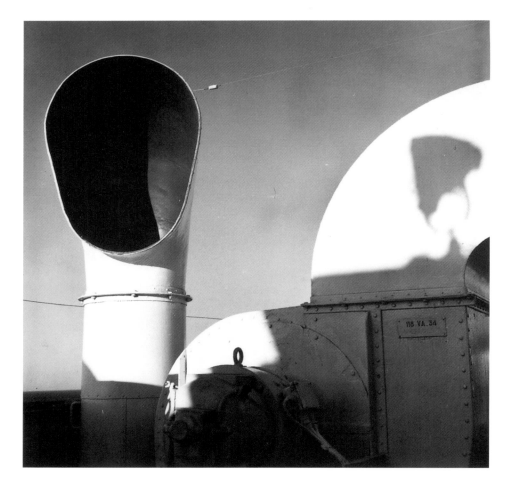

Figure 1. Walker Evans. *"Queen Mary":*
Ventilators, Starboard Promenade Deck (Aft),
ca. 1958 [no. 1174].

instant film and was hailed as technology that would radically change still photography. The developers of this "absolute one-step photography" realized that they would need to convince professional photographers of the merits of this new invention if they were to have it accepted as more than a gimmick or plaything.[8] To this end, they encouraged its use by photographers of Evans's stature by providing them with cameras, film, and enlargements on request. Evans had, in fact, already purchased an SX-70 camera on a 1972 trip to Atlanta, but he did not begin to use it until the next year, when Polaroid's generous offer of supplies persuaded him to take it out of storage.[9] Then, at the age of seventy, he became fascinated with this new medium, and, though he did refer to it on occasion as a toy, took it quite seriously, creating a body of more than 2,400 instant prints.[10]

Jerry Thompson, a companion during these last years, suggests that Evans enjoyed using the SX-70 because of its simplicity as well as its color potential.[11] He was finding it more and more difficult to deal with his Rolleiflex range finder; the Polaroid camera did not present this problem. The Polaroid allowed Evans to easily expose numerous frames of the same subject, as had been his practice with the older, more complex camera. Evans especially appreciated the immediacy of this new image-making process. At the end of each day, the prints were

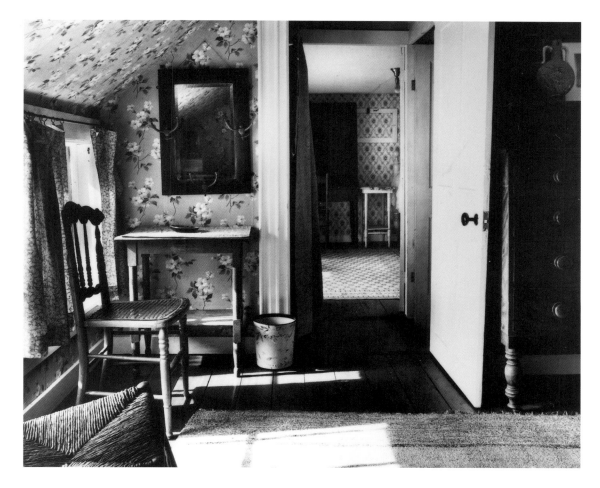

Figure 2. Walker Evans. *Upstairs Room, Walpole, Maine*, ca. 1962 [no. 1179].

there for him to review and edit; he routinely dated some of the prints, stamped others with his Old Lyme address stamp, and signed a few that were favorites. He admitted that his association with this "little gadget" for making color was contradictory; he thought of himself as "a gray man" and had sought to distance himself from the color medium altogether, including his own previous work for *Fortune*.[12] But now, in the years of his retirement, he claimed to be "rejuvenated" by this new technique, which he felt could "extend my vision and let that open up new stylistic paths that I haven't been down yet."[13] An art-critic friend confronted him with the idea that this one-step photography must be "immoral" because it did not require

"mastering a difficult technique," usually a requisite of "artistic achievement."[14] Evans disagreed: for the experienced artist, creating with the Polaroid could be the biggest challenge of all. "It reduces everything," he said in a 1974 interview, "to your brains and taste."[15]

The compact portability of the SX-70 was another of its attractions, and Evans got in the habit of taking it along when he traveled to speaking engagements or when he attended less formal social gatherings. He accumulated individual as well as group portraits during parties with colleagues. The Evans Estate archive contains numerous portraits of students, some with identifying annotations, such as that concerning Mark Foster Tenny, described by

Evans, in the tradition of his much earlier pictures of southern tenant farmers, as having an "old American" face. Museum curators, such as John Szarkowski of MoMA and Davis Pratt, then at the Fogg Art Museum, are also among the faces, as are other photographers like Lee Friedlander. Among the handful of Polaroid prints by Evans at the Getty is one of the most beautifully composed of these many portraits from the seventies, that of his friend Virginia Hubbard and her infant son, Ezra (no. 1190). Made in Florida in the summer of 1974, this unique image possesses more intimacy, is a closer, more subjective picture, than any other single image in the Evans canon. It has been tightly composed, employing the mother's back and left profile to frame the wide eyes and very round head of the little boy. It would have made a fine black-and-white picture, but the color lends it an immediacy appropriate to the mood portrayed; the glistening flesh tones radiate the heat of a Florida summer and increase the feeling of revealed privacy, a perhaps unintentional element of this very personal work.

Still-life studies played a much larger role, proportionally, in this late Polaroid work than they had in Evans's earlier professional career. He now composed with a dressmaker's mannequin, a bouquet of dead roses in a glass vase, an old bicycle against the house, or simply took as his subject a partially consumed blueberry pie. Within the Getty sampling of six Evans Polaroids, the *Green Hydrant* (no. 1192) comes closest to qualifying for this now-important category of Evans's oeuvre; it also represents a continued interest in "street furniture" and his series for both *Fortune* and *Architectural Forum* in the fifties. The *Fortune* project was never published, but in January 1958, his portfolio entitled "Color Accidents" appeared in *Architectural Forum* and featured six color compositions, "small harmonies for the eye" Evans called them, discovered on the Manhattan streets.[16] These images have more to do with the cumulative layers of pigment on urban walls than with the colors of the actual lamps, benches, and hydrants found on city streets. According to Evans's pre-Polaroid aesthetic, such "color accidents" legitimized this new form of photography: "When the *point* of a picture subject is precisely its vulgarity or its color-accident through man's hand, not God's, then only can color film be used validly."[17] In his accompanying text for the "Color Accidents" piece, Evans compared the hues and forms he discovered on these encrusted walls to those that might be found in the abstract work of Paul Klee or Jackson Pollock and expressed his satisfaction with these "finds" that could bring such "counterpleasure":

> American cities other than Boston, Charleston, and New Orleans are notably lacking in small harmonies for the eye. But there is a stimulating counterpleasure to be found in certain metropolitan by-streets. This is the restless cacaphonic [sic] design created by time, the weather, neglect, and the fine hand of delinquent youth. The bitter colors and ironic forms splashed and molded on many an old door or torn wall have their own way of arresting attention. In Manhattan, these wry compositions abound; but they must be collected with care.[18]

Graffiti, highlighted in his images from the 1950s of the "pocks and scrawls of abandoned walls,"[19] took on new significance for Evans as he experimented with the Polaroid process. A Getty print displaying graffiti carved into the red-painted wall of a frame building (no. 1191) is a fine example of this motif, surpassing much of what Evans himself had done in this vein and comparable to the work of graffiti connoisseurs like Brassaï, Aaron Siskind, or Helen Levitt, with the last of whom Evans seems to have photographed such subject matter in the thirties. The three remaining Getty Polaroids deal with only slightly more formal public letter forms, those of handmade signs advertising produce or used as traffic signals (nos. 1187–89). From his early New York images of billboards and neon Broad-

way marquees, to his general-store signs made by regional sign painters or local proprietors of the rural South, to his later *Fortune* essays on the variety of American advertising logos or the familiar insignia of railroad freight cars, Evans's work always reflected his affinity for signage of every type. For him, signs were, as we might say today, "collectibles," as well as subjects for his camera. When he took up the SX-70, he indulged his voracious appetite for signs and would sometimes choose one to photograph in great detail. In the Estate archive there are numerous views of the spray-painted "DEAD END" sign also found at the Getty (no. 1188). In the Museum's print, Evans's composition of heavy irregular black letters surrounded by cheap

bright colors suggests the garish negativism of American Punk culture that it predates by nearly a decade. In the Polaroids, he spent a great deal of time isolating letters of all colors—whether spray-painted like these, stenciled, or professionally hand-painted—against all sorts of contrasting backgrounds. He was collecting these letterforms and fragmentary signs, according to Thompson, with an eye toward creating an "alphabet book," which he envisioned in a 9 x 12-inch format. While still well enough to do so, he had begun to make preliminary selections for what would have been his first book in color and a revelation to those who had long followed the work of this extraordinary "gray man."

NOTES

1. Bill Ferris, "A Visit with Walker Evans," in *Images of the South: Visits with Eudora Welty and Walker Evans*, Southern Folklore Reports, no. 1 (Memphis: Center for Southern Folklore, 1977), 37.

2. Walker Evans, "The Last of Railroad Steam," *Fortune* 58:3 (Sept. 1958), 137–41. Additional prints made in preparation for a 1962 essay on Third Avenue may be seen in a private collection in New York state.

3. Walker Evans, "The London Look," *Architectural Forum* 108:4 (Apr. 1958), 114–19, and "Ship Shapes and Shadows," *Architectural Forum* 109:4 (Oct. 1958), 122–25.

4. For both the photograph and the subsequent painting, see Karen Lucic, *Charles Sheeler and the Cult of the Machine* (Cambridge, Mass.: Harvard University Press, 1991), figs. 25, 34.

5. Sheeler quoted in Constance Rourke, *Charles Sheeler: Artist in the American Tradition* (New York: Harcourt, Brace, 1938), 166.

6. Walker Evans, *Message from the Interior* (New York: Eakins Press, 1966). *The Parlor Chairs, Oldwick, New Jersey* is plate 8 in this square-format book.

7. Examples of this late color work have only recently appeared in color in the survey by John T. Hill and Gilles Mora, *Walker Evans: The Hun-*

gry Eye (New York: Harry N. Abrams, 1993), 342–52. Ten Polaroid images were reproduced in black and white in the 1982 *Walker Evans at Work* (New York: Harper and Row), 234–37. The work was first shown publicly in a selection of four pictures included in the exhibition *Photography Unlimited*, Sept. 13–Oct. 16, 1974, at the Fogg Art Museum, Harvard University. The only substantial showing of the work has been *Walker Evans: Polaroids 1973–1974*, which took place at the 292 Gallery, New York, in March– April 1993, when about three dozen prints from the collection of Virginia Hubbard were exhibited. Strangely enough, Evans's SX-70 work was not part of *One of a Kind: Recent Polaroid Color Photography*, an exhibition organized in 1979 that primarily included work done in the late seventies by photographers of a younger generation. However, Eugenia Janis, in her catalogue essay "A Still Life Instinct: The Color Photographer as Epicurean" (*One of a Kind: Recent Polaroid Color Photography* [Boston: David R. Godine, 1979], 9–21), discusses Evans's long history of using color for his *Fortune* assignments and cites his divided attitude as an example of the pervasive guilt and ambivalence about color felt by American photographers up to that point.

8. Mark Olshaker, *The Instant Image: Edwin Land and the Polaroid Expe-*

rience (New York: Stein and Day, 1978), 171.

9. This background information about Evans's experience with the SX-70 was provided by John Hill, executor of the Evans Estate, in conversation with the author, New Haven, May 5, 1993. As well as film, Polaroid furnished 5 x 5, 8 x 8, and 10 ¾ x 10 ⅝-inch Type C print enlargements of those SX-70 images Evans selected. The contents of the Evans Estate archive show that the photographer took liberal advantage of this arrangement.

10. Virginia Hubbard, Evans's friend and beneficiary, shared reminiscences of his attitude and practice with the Polaroid on a visit she made to Santa Monica in February 1993. The bulk of the Polaroid prints Evans produced in 1973–74 are held by the Evans Estate; smaller groups of these late works can be seen at the 292 Gallery, New York, and in the private collections of a few friends who received them from the artist as gifts.

11. Jerry Thompson, photographer and Evans's companion in the 1970s, generously offered his comments and analysis of Evans's work with the SX-70 in a phone conversation with the author, August 5, 1993.

12. These and the following comments by Evans about the Polaroid process are from page eighteen of a transcription of his discussion with a Yale

University class, reprinted from *Yale Alumni Magazine* as "The Thing Itself is Such a Secret and So Unapproachable" in *Image* 17:4 (Dec. 1974), 12– 18. In response to a student's question, Evans remarks that he does not consider black-and-white photography to be a more honest medium than color; both can distort reality. But, he says, "I happen to be a gray man; I'm not a black-and-white man. I think gray is truer. You find that in other fields. E. M. Forster's prose is gray and it's marvelous."

13. Ibid.

14. Ibid.

15. Ferris, "A Visit with Walker Evans," 37.

16. Walker Evans, "Color Accidents," *Architectural Forum* 108:1 (Jan. 1958), 110–15. This picture essay is not represented in the Getty collection.

17. Walker Evans, "Photography," in *Quality: Its Image in the Arts*, edited by Louis Kronenberger (New York: Athenaeum, 1969), 208.

18. Evans, "Color Accidents," 110.

19. Ibid.

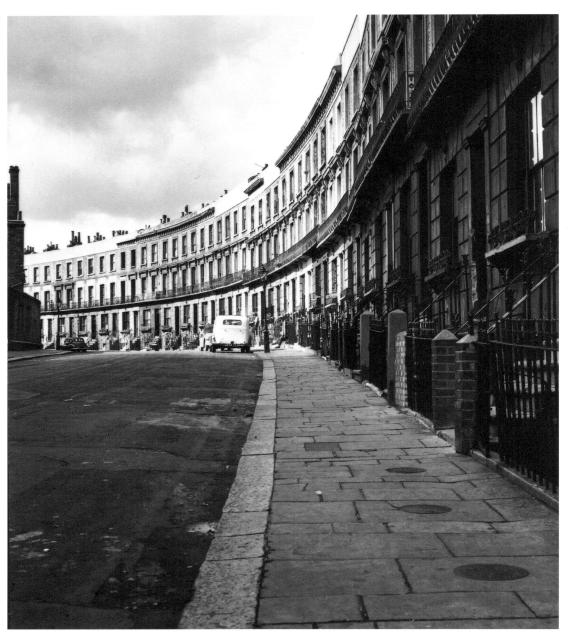

1170

The Polaroids and Other Late Work

The contents of this last catalogue section consist of a small array of miscellaneous prints dating from 1958 to 1974, with work from *Fortune* and *Architectural Forum* essays interspersed with personal work, chiefly interior views made in Maine, Nova Scotia, and New York in the late 1950s and 1960s. The photographs are ordered chronologically; following two 1969 portraits of an unidentified male are six Polaroids of 1973–74, color images in a new medium from Evans's last years of work.

1171

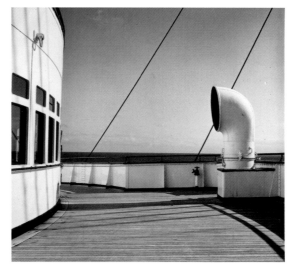

1172

1173

1174

Mary PROMENADE DECK BOW VIEW STATE [crossed out] *PORT*; at l. right, Evans stamp A; (verso) signed at center, in pencil by Evans, *Walker Evans*; at center, Evans stamp A; at center, in blue pencil, *80% POS*; at l. right, Lunn Gallery stamp [both squares empty]; at l. right, in pencil Wagstaff no. *W. Evans 24*.
PROVENANCE: George Rinhart; Samuel Wagstaff, Jr.
REFERENCES: *The J. Paul Getty Museum: Handbook of the Collections*, Malibu, Calif.: J. Paul Getty Museum, 1986, p. 213.

1173
[*"Queen Mary": Ventilators, Starboard Aft*], 1958
Image: 36.6 x 29.6 cm
(14 ⁷⁄₁₆ x 11 ⁵⁄₈ in.); sheet:
37.9 x 30.5 cm (14 ¹⁵⁄₁₆ x 12 ¹⁄₁₆ in.)
84.XM.488.36
MARKS & INSCRIPTIONS: (Recto) in lower margin, in blue ink, by Evans, *QUEEN MARY VENTILATORS STARBURD* (sic) *AFT*; at l. right, Evans stamp A; (verso) signed, at center, in pencil, by Evans, *Walker Evans*; at center, Evans stamp A; at right center, in blue pencil, *80% POS*; at l. right, Lunn Gallery stamp [both squares empty]; at l. right, in pencil, Wagstaff no. *W. Evans 23*.
PROVENANCE: George Rinhart; Samuel Wagstaff, Jr.

1174
[*"Queen Mary": Ventilators, Starboard Promenade Deck (Aft)*], ca. 1958
Image: 29.4 x 29.5 cm (11 ⁹⁄₁₆ x 11 ⁵⁄₈ in.); sheet: 37.9 x 30.5 cm (14 ¹⁵⁄₁₆ x 12 in.)
84.XM.488.37
MARKS & INSCRIPTIONS: (Recto) at lower center margin, in blue ink, by Evans, *QUEEN MARY/VENTILATORS/STARBOARD, PROMENADE DECK/(AFT)*; at l. right, Evans stamp A; (verso) signed at center, in pencil, by Evans, *Walker Evans*; at center, Evans stamp A; at l. right, Lunn Gallery stamp [both squares empty]; at l. right, in pencil, Wagstaff no. *W. Evans 22*.
PROVENANCE: George Rinhart; Samuel Wagstaff, Jr.
REFERENCES: "Ship Shapes and Shadows," *Architectural Forum*, Oct. 1958, p. 122 (variant).

1170
[*London Crescent*], 1958
24.6 x 21 cm (9 ¹¹⁄₁₆ x 8 ¼ in.)
84.XM.956.1046
MARKS & INSCRIPTIONS: (Verso) at center, Evans stamp A; at l. right, in red pencil, *F8* [underlined]; at u. center, in blue ink, *C7906* [inverted]; at l. left, printed on label, *Time Inc.* and typed, *LONDON (GALLERY STORY) 5/58*.
REFERENCES: "The London Look," *Architectural Forum*, Apr. 1958, p. 119 (variant).

1171
Class A Steam Locomotive, The Second Set of Drivers, September 1958
16.3 x 21.4 cm (6 ¹³⁄₃₂ x 8 ¹³⁄₃₂ in.)
84.XM.956.1045
MARKS & INSCRIPTIONS: (Verso) at center, in black ink, by Evans, *"The Last of Railroad Steam"/taken for Fortune/ September 1958/Norf* [crossed out] *Roanoke, V./in the Norfolk & Western RR yards* [followed by arrow pointing to other Evans inscription]; at u. right, in blue ink, by Evans, *CLASS A LOCOMO-TIVE, STEAM/THE SECOND SET OF DRIVERS*; at center, Evans stamp G; at

l. left, in pencil, Crane no. *L78.35 (Evans)*.
REFERENCES: "The Last of Railroad Steam," *Fortune*, Sept. 1958, pp. 138–39 (variant, across the gutter).

1172
[*"Queen Mary": Promenade Deck, Bow View, Port Side*], ca. 1958
Image: 26.4 x 26.8 cm
(10 ⅜ x 10 ¹⁷⁄₃₂ in.); sheet:
35.3 x 27.9 cm (13 ¹⁵⁄₁₆ x 11 in.)
84.XM.488.1
MARKS & INSCRIPTIONS: (Recto) at l. center, in blue ink, by Evans, *On Queen*

1175

1176

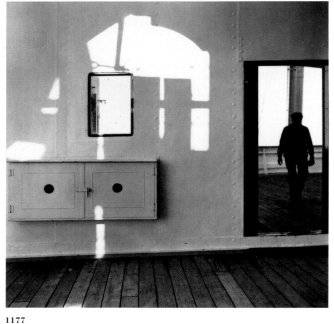

1177

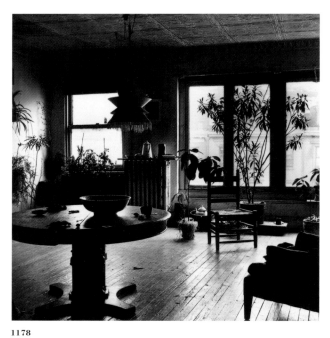

1178

1175
[*"Liberté": Life Preserver Catapult, Boat Deck, Starboard Side*], ca. 1958
Image: 36.6 x 24.4 cm (14 7/16 x 9 5/8 in.); sheet: 38 x 30.5 cm (14 15/16 x 12 in.)
84.XM.488.38
MARKS & INSCRIPTIONS: (Recto) at center left margin, in blue ink, by Evans, *LIBERTÉ/Boat deck,/Starboard side/ Life preserver/catapult*; at l. center, Evans stamp A; (verso) signed at center, in pencil, *Walker Evans*; at center, Evans stamp A; at l. center, in blue pencil, *50%/POS*; at right center, Lunn Gallery stamp [both squares empty]; at

l. right, in pencil, Wagstaff no. *W. Evans 26.*
PROVENANCE: George Rinhart; Samuel Wagstaff, Jr.

1176
[*"Liberté": Boat Davits Detail, Port Side*], ca. 1958
Image: 28.9 x 29.4 cm (11 3/8 x 11 9/16 in.); sheet: 38 x 30.5 cm (14 15/16 x 12 in.)
84.XM.488.34
MARKS & INSCRIPTIONS: (Recto) in lower left margin, in blue ink, by Evans, *LIB-ERTÉ/BOAT DAVITS ETC DETAIL, PORT SIDE*; at l. right, Evans stamp A;

(verso) signed at center, in pencil, by Evans, *Walker Evans*; at center, Evans stamp A; at right center, in blue pencil, *80% POS*; at right center, Lunn Gallery stamp [both squares empty]; at l. right, in pencil, Wagstaff no. *W. Evans 27.*
PROVENANCE: George Rinhart; Samuel Wagstaff, Jr.

1177
[*"Liberté": Promenade Deck, Port Forward*], ca. 1958
Image: 29.4 x 29.5 cm
(11 9/16 x 11 5/8 in.);
sheet: 37.9 x 30.5 cm
(14 15/16 x 12 1/16 in.)

84.XM.488.35
MARKS & INSCRIPTIONS: (Recto) in lower margin, in blue ink, by Evans, *LIBERTÉ/Promenade deck, port forward*; at l. right, Evans stamp A; (verso) signed at center, in pencil, *Walker Evans*; at center, Evans stamp A; at center, in blue pencil, *80% POS*; at right, Lunn Gallery stamp [both squares empty]; at l. right, in pencil, Wagstaff no. *W. Evans 25.*
PROVENANCE: George Rinhart; Samuel Wagstaff, Jr.

1179

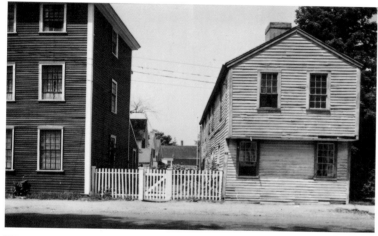

1180

1181

1178
Third Avenue, New York City/[Mary Frank's Flat, New York City],
ca. 1956–59
Image: 25.8 x 25.1 cm (10 3/16 x 9 7/8 in.); mount: 25.8 x 38 cm (18 x 15 in.)
84.XM.956.1050
MARKS & INSCRIPTIONS: (Recto, mount) signed at l. right below print, in pencil, by Evans, *Walker Evans*; (verso, mount) at center, Evans stamp C; at center, in pencil, by Evans, *Third Ave./N.Y.C./1956?*; at l. left, in pencil, Crane no. *L78.29(Evans)*.

1179
[Upstairs Room, Walpole, Maine],
ca. 1962
15.4 x 18.5 cm (6 3/32 x 7 5/16 in.)
84.XM.956.691
MARKS & INSCRIPTIONS: (Verso) at u. center, Evans stamp M; at center, in pencil, *R18*; at l. left, in pencil, Crane no. *L78.54(Evans)*.

1180
[Two Frame Houses, New England],
1962
10.1 x 15.7 cm (3 31/32 x 6 3/16 in.)
84.XM.956.1042

MARKS & INSCRIPTIONS: (Verso) at l. right, Evans stamp A; at l. right, wet stamp, in black ink, *JUL 8-1962*; at l. left, in pencil, Crane no. *L78.22 (Evans)*.

1181
Third Avenue, New York City, Antique Sidewalk Display, 1962
Image: 24.1 x 16.2 cm (9 1/2 x 6 3/8 in.); sheet: 24.6 x 16.9 cm (9 11/16 x 6 21/32 in.) [mounted to second sheet of exposed paper]
84.XM.956.1043

MARKS & INSCRIPTIONS: (Verso mount) titled and dated at center, in blue ink, by Evans, *Third Ave New York City/Antique sidewalk display/1962*; at center, Evans stamp G; at l. left, on white label, Crane no. *L78.41/Evans*.

1182

1183

1184

1182
3rd Avenue Antiques, New York City,
1962
Image: 24.1 x 16.2 cm (9 ½ x 6 ⅜ in.);
sheet: 25.3 x 20.4 cm (9 ³¹⁄₃₂ x 8 ⅛ in.)
84.XM.956.1047
MARKS & INSCRIPTIONS: (Verso) dated at
center, in pencil, by Evans, *1962*;
at l. center, in black ink, by Evans,
3rd Ave. Antiques/NYC; at center,
Evans stamp G.

1183
*Old Wick, New Jersey/[The Parlor
Chairs, Oldwick, New Jersey*],
ca. 1958–62

Image: 28.1 x 22.7 cm
(11 ¹⁄₁₆ x 8 ¹⁵⁄₁₆ in.); mount:
45.8 x 38 cm (18 x 15 in.)
84.XM.956.1051
MARKS & INSCRIPTIONS: (Recto, mount)
signed at l. right below print, in pen-
cil, by Evans, *Walker Evans*; at l. left,
in pencil, by Evans, *for Arnold Crane*;
(verso, mount) at center, in pencil,
by Evans, *Old Wick* (sic), *N.J./1962*; at
center, Evans stamp C and wet stamp,
in black ink, *RIGHTS RESERVED*; at
l. left, in pencil, Crane no. *L78.28*
(Evans).
REFERENCES: *MFTI, pl. 8 [dated 1958];
MoMA, p. 170 (variant).

1184
Interior, Chester, Nova Scotia, Canada,
1969
Image: 19.2 x 19.1 cm
(7 ¹⁹⁄₃₂ x 7 ¹⁷⁄₃₂ in.); fragmentary original
mount: 29.4 x 23.9 cm
(11 ⁹⁄₁₆ x 9 ¹³⁄₃₂ in.)
84.XM.129.18
MARKS & INSCRIPTIONS: (Recto, mount)
signed and dated at l. right, in pencil,
by Evans, *Walker Evans 1969*; (verso,
mount) on yellow card affixed to verso
of mount, in pencil, by Evans, *Interior/
Chester N.S. Canada/August 1969*; on
same card, below inscriptions, Evans
stamp C, and wet stamp, in black ink,

RIGHTS RESERVED; at l. right, in pencil,
Kahmen-Heusch no. *E20*.
PROVENANCE: Lunn Gallery; Volker
Kahmen and Georg Heusch.
REFERENCES: MoMA, p. 173 (variant,
titled and dated, *The Home Organ,
Chester, Nova Scotia*, 1968); WEBR,
p. 11, no. 20 (titled and dated, *Harmo-
nium, Chester, Nova Scotia [Canada]*,
August 1969).
EXHIBITIONS: *Walker Evans*, Bahnhof
Rolandseck, West Germany, Oct. 5–
Nov. 30, 1978.

1185

1186

1185
[*Maine*], 1969
Image: 11.6 x 15.3 cm (4 ⅝ x 6 ½32 in.);
original mount: 45.6 x 38.1 cm
(18 x 15 in.)
84.XM.488.20
MARKS & INSCRIPTIONS: (Recto, mount)
signed at right below print, in pencil,
Walker Evans; (verso, mount) at l. cen-
ter, in pencil, *650/08*; at l. right, in
pencil, Wagstaff no. *W. Evans 19*.
PROVENANCE: George Rinhart; Samuel
Wagstaff, Jr.

1186
[*Maine*], 1969
Image: 19.3 x 18.8 cm (7 ¹⁹⁄32 x 7 ⅜ in.);
original mount: 45.7 x 38 cm
(18 x 15 in.)
84.XM.488.21
MARKS & INSCRIPTIONS: (Recto, mount)
signed at right below print, in pencil,
by Evans, *Walker Evans*; (verso,
mount) at l. right, in pencil, Wagstaff
no. *W. Evans 20*.
PROVENANCE: George Rinhart; Samuel
Wagstaff, Jr.

1187

1188

1189

1187
[*Two Signs: "Sweet Yellow Corn" with "Butter and Sugar"*], ca. 1973–74
MEDIUM: Polaroid SX-70
Image: 7.9 x 7.8 cm (3 ⅛ x 3 1/16 in.); sheet: 10.8 x 8.8 cm (4 ¼ x 3 ½ in.)
93.XM.15.1
MARKS & INSCRIPTIONS: (Recto, sheet) in bottom margin, in pencil, *Holmes* [space] *1D/1S*; (verso, sheet) at bottom center, in red ink, by Evans, *39.*; at bottom left, Evans stamp N; imprinted at l. center, *007740951* [space] *POLAROID®* twice (one partial); at l. center, in pencil, *G292.399*.

PROVENANCE: Virginia Hubbard; Marty Carey; 292 Gallery.

1188
[*Graffiti: "Dead End"*], ca. 1973–74
MEDIUM: Polaroid SX-70
Image: 7.9 x 7.8 cm (3 ⅛ x 3 1/16 in.); sheet: 10.8 x 8.8 cm (4 ¼ x 3 ½ in.)
93.XM.15.2
MARKS & INSCRIPTIONS: (Recto, sheet) at bottom, in pencil, *Holmes* [space] *1D/1S*; (verso, sheet) at bottom center, in red ink, by Evans, *21.*; at bottom left, Evans stamp N; imprinted at l. center, *100304351* [space] *POLAROID®;* at bottom right, in pencil, *G292.396*.

PROVENANCE: Virginia Hubbard; Marty Carey; 292 Gallery.

1189
[*Painted Wall: Abstraction in Yellow, Red, and Black*], ca. 1973–74
MEDIUM: Polaroid SX-70
Image: 7.9 x 7.8 cm (3 ⅛ x 3 1/16 in.); sheet: 10.8 x 8.8 cm (4 ¼ x 3 ½ in.)
93.XM.15.3
MARKS & INSCRIPTIONS: (Verso, sheet) imprinted at l. center, *087401861* [space] *POLAROID®;* at bottom right, in purple pencil, *JH/1D/1S* [sideways]; at bottom left, in pencil, *G292.401*.
PROVENANCE: Virginia Hubbard; Marty Carey; 292 Gallery.

1190

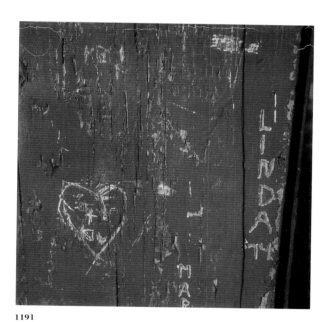

1191

1192

1190
[*Virginia Hubbard Holding Her Son*],
1974
MEDIUM: Polaroid SX-70
Image: 7.9 x 7.8 cm (3 ⅛ x 3 ¹⁄₁₆ in.);
sheet: 10.8 x 8.8 cm (4 ¼ x 3 ½ in.)
93.XM.7.1
MARKS & INSCRIPTIONS: (Verso, sheet) at
bottom center, in blue ink, by Evans,
W.E./Destin Fla/Aug 12 1974;
imprinted at l. center, *06740831*
[space] *POLAROID®.*
PROVENANCE: Virginia Hubbard.

1191
[*Graffiti on Red Fence*], 1974
MEDIUM: Polaroid SX-70
Image: 7.9 x 7.8 cm (3 ⅛ x 3 ¹⁄₁₆ in.);
sheet: 10.8 x 8.8 cm (4 ¼ x 3 ½ in.)
93.XM.7.2
MARKS & INSCRIPTIONS: imprinted at
l. center, *1009740112* [space]
POLAROID®.
PROVENANCE: Virginia Hubbard.

1192
[*The Corey Company Fire Hydrant*],
1974
MEDIUM: Polaroid SX-70
Image: 7.9 x 7.8 cm (3 ⅛ x 3 ¹⁄₁₆ in.);
sheet: 10.8 x 8.8 cm (4 ¼ x 3 ½ in.)
93.XM.7.3
MARKS & INSCRIPTIONS: (Verso, sheet)
dated at bottom right, in red ink, by
Evans, *9/27/74*; imprinted at l. center,
00077409382 [space] *POLAROID®.*
PROVENANCE: Virginia Hubbard.

APPENDIX A

Walker Evans Ephemera in the Getty Collection

Introduction

In addition to its holding of photographs by Walker Evans, the Getty Museum possesses an archive of related documents and other nonphotographic materials acquired from Arnold Crane in 1984.[1] This collection consists of correspondence, sketches and notes for unrealized projects, materials related to publications of Evans's work, documents associated with an exhibition of Evans's photographs at the Art Institute of Chicago in 1947, and a group of materials related to an unpublished *Fortune* portfolio entitled "Street Furniture" from 1953.

The earliest piece of correspondence in the collection is an unfinished letter from Evans to his friend Ernestine Evans, an editor at J. B. Lippincott Company, written while he was working on a commission in Hobe Sound, Florida, in February 1934. On his hotel's yellow stationery, complete with a kitschy palm-tree logo, Evans meditates on what the subject of his next photographic project should be. He writes: "I know that now is the time for picture books. An American city is the best . . . American city is what I'm after. So might use several, keeping things typical."[2] Later, when Evans put together a portfolio for *Fortune* on Chicago (one of the cities mentioned in his letter), he returns to this subject by writing about and photographing the grit, grime, and decay of a typical American city.[3] The second half of the letter is devoted to a comical, stream-of-consciousness description of Florida. He writes: "Florida is ghastly and very pleasant where I am, away from the cheap part. One feels good, naturally, coming out of N.Y. Winter. This island [is] a millionaire's paradise and I'd like to be a millionaire as you know." Evans escaped the New York winter to Florida again in 1941, when he made photographs to illustrate Karl Bickel's book *The Mangrove Coast: The Story of the West Coast of Florida* (1942).

Also in the collection are two letters from W. Eugene Smith, addressed to Evans at *Fortune*. They suggest a friendship between the two photographers, perhaps based on similar artistic beliefs and ideals. In the first letter, dated November 27, 1954, Smith writes: "I have written to you, thinking that perhaps you most would understand . . . "[4] He writes about his dissatisfaction with his work at *Life* magazine and his desire to leave it. He writes: "I will do no photography . . . that compromises my intelligence, my taste, my integrity." Smith concludes by asking Evans to pass along word of his "freedom" to the editors at *Fortune*. In the second letter, dated February 3, 1955, Smith returns to the subject of his professional situation, writing: "[I] have been trying to free myself of certain mud-mired chains . . . Now, I think I am nearly ready to emerge into a position for a true re-entry into work."[5]

Smith apparently felt that Evans would be sympathetic to his situation and perhaps instrumental in helping him to find future commissions.

Among these documents is a group of notes and letters written by Evans's friend and collaborator, James Agee. In a draft of an introductory text for *Let Us Now Praise Famous Men*, written in his small, tight script, Agee states:

The authors wish to express their regret that the price of this volume is so high: at such a price it is all but inevitably discriminated into hands least qualified to touch the subject that it treats of. It must be added, however, that many unusual concessions were made, and courtesies extended to us, which we thoroughly appreciate: and that if there were more photographs, and if it were possible to give this second part of the text its proper proportions, the volume would be even less available to any save bibliophiles. It is needless to state in personal anger[?] what is, merely, scientific fact: that even the most disinterested of efforts must, at times, qualify themselves if an investment is to be safeguarded.[6]

In addition to their collaboration on *Let Us Now Praise Famous Men*, Evans and Agee seem to have had plans for another joint project, one focused on the plight of the urban poor. A note that contains the handwriting of both Evans and Agee begins with the statement: "In almost every respect the Williamsburg and the Harlem projects are managed alike." (In 1954, Agee was commissioned to write a script for a documentary on Colonial Williamsburg.)[7] This is followed by a record of three photographs, including one taken in a Harlem housing project, and a discussion of the rents charged in Harlem tenements.

The collection is particularly strong in materials relating to Evans's published work. Among these is a proof copy of the second edition of *American Photographs*, reprinted by the Museum of Modern Art in 1962.[8] The Getty owns prints of sixty-nine of the eighty-seven photographs reproduced in the book (or their variants). In addition, many of the actual prints on view at the 1938 MoMA exhibition *Walker Evans: American Photographs* exist in the collection (see Appendix B).

One of Evans's proof copies for *Wheaton College Photographs* (1941) is also included in this material.[9] Its title page is signed by Evans, and comments, made in red pencil by the printer, appear throughout the copy. Thirty-three prints from this series are in the Getty collection, including twenty-three of the twenty-four photographs reproduced in the book.[10] Most of the Wheaton College prints in the collection are mounted on 12 3/8 x 10 3/32-inch lightweight boards, with a number corresponding to their position in the publication handwritten at the bottom of the page. It is possible that these images originally belonged to an early mock-up of the publication. Plate proofs of images for the MoMA publication *Walker Evans* (1971) are also included in this collection.[11]

In addition to Agee's draft for the introductory text to *Let Us Now Praise Famous Men*, other materials related to the first edition of the book (1941) exist in the collection. One of these is the engraver's proof of the book's halftone reproductions.[12] On most of the plates, detailed corrections were made in pencil by a hand that appears to be that of Frances Strunsky Collins (later Frances Lindley), then editor for publications at MoMA. These marks were no doubt made in consultation with Evans.[13] Galley proofs of Agee's text for the first edition of the book are also in the collection.[14] Materials relating to the second edition of *Let Us Now Praise Famous Men* (1960) include a carbon copy of an eight-page draft of Evans's foreword[15] and proofs of the halftone reproductions.[16]

Between 1938 and mid-1941, Evans made a series of photographs of passengers in the New York subway. Eighty-nine of these images were published in *Many Are*

Called (1966). Related to the Getty's extensive collection of photographs from the subway series are three sheets of proofs for *Many Are Called* and two drafts of the introductory text.[17] The first text is titled "UNPOSED PHOTO-GRAPHIC RECORDS OF PEOPLE" and describes Evans's process in making these images as an objective one, resulting in a "pure record." He writes: "I would like to be able to state flatly that sixty-two people came unconsciously into range before an impersonal fixed recording machine during a certain time period, and that all these individuals who came into the film frame were photographed, and photographed without any human selection for the moment of lens exposure."[18] The second text explains why Evans chose the subway as the locale for this series.[19] He writes: "That is where the people of the city range themselves at all hours under the most constant conditions for the work in mind." Several of Evans's rough notes on this series are also included in this group.[20]

Also in the collection are two proof copies of Evans's book *Message from the Interior* (1966). The first has a complete set of the halftone reproductions included in the book.[21] The second contains two copies of plates 7 to 12 and may have been sent to Evans by the publisher so that he could make a choice for the optimum quality of reproduction.[22]

One of Evans's unrealized ideas for a publication, documented by thirteen items in the collection, was a picture-book guide to works in the Metropolitan Museum of Art, tentatively entitled *Art without Boredom . . . Relax.*[23] In a proposal for the book, Evans discusses his intention of using photographs to introduce a public that was not particularly interested in museums to the collection of the Metropolitan. He writes:

> *The author proposes to photograph one hundred objects and paintings in the Metropolitan Museum in such a way that all atmosphere of scholarship,*

> *art history, aesthetic theory and analysis; cultural explanation and academic tabulation . . . is absent; so that the pictures are presented solely for the excitement and the surprise these things carry in themselves. There shall be nothing present to remind the reader of the manner in which a large potential museum public often thinks it ought to look at museum contents. The photographs would be made as though by a stimulated member of the public, and made of his selection of the things that arouse love and excitement and pleasure in him.*[24]

A list of the approximate production figures for the book indicates that the publication was intended to consist of one hundred 5 x 7-inch halftone plates and fifty pages of text, with the actual size of the book being 7 ½ x 10 inches.[25]

As he worked his way through the Metropolitan Museum's galleries, Evans apparently carried 3 x 5-inch index cards with him. He made pencil sketches of objects in the museum on two of the cards in this collection.[26] He also recorded brief descriptions of several objects and made other notations.[27] Evans describes this project as "window shopping in a museum,"[28] "a relaxed art book,"[29] and a "popular scrapbook of a museum's contents."[30] In one note he refers to it as "an unscholarly handbook designed to arouse enthusiasm, surprise, excitement and pleasure not above amusement and gaiety by no means excluding the impressive on [or?] the dignified . . . An unbuttoned art book . . . For people who do not go to museums."[31] Although Evans was clearly very excited about this project and had gone as far as researching production figures, it is unlikely that preparations for the publication went much beyond those that are represented in this collection, and a book was never realized.

In 1946, Evans made a series of photographs in Chicago that appeared in a *Fortune* portfolio in February

1947 entitled "Chicago: A camera exploration of the huge, energetic urban sprawl of the midlands."[32] From November 14, 1947, to January 4, 1948, several of these Chicago pictures were exhibited, along with various other photographs, in a one-person show of Evans's work at the Art Institute of Chicago. Among the documents relating to this exhibition is correspondence between Evans and Carl O. Schniewind, then Curator of the Department of Prints and Drawings at the Art Institute. These letters primarily discuss the logistics of the exhibition and give insight into how particular Evans was about how his prints were to be mounted and exhibited. In an unsigned copy of a letter to Schniewind, dated October 17, 1947, in his characteristically polite manner, Evans requests that his mats be "a cold, pure white with matte surface."[33] He also states his preference for "white, thin, and flat frames" and asks for "glass free of tone itself." Evans's thoughts on dry-mounting in this letter are particularly eloquent: "I thing[k] dry-mounting is all right—in fact just the thing, provided the tissue never shows at picture borders. That takes care, as you know. That infinitesimal edging of shiny tissue that sometimes peeks over print edges is like a flat note in a violin solo, to me, or shall we say, a slur upon a lady's name?"

Another item in this group is a handwritten letter to Evans from Hugh Edwards, then Associate Curator of Prints and Drawings at the Art Institute, who apparently played a large role in organizing this exhibition. He writes: "I am writing you a long letter now. It wi[ll] take many pages [for me] to tell [you] how happy your show made me. Seeing these prints has helped me get straightened out again. For me it is the best thing we have ever had here. As Jack Kimber[?], the boy from Okla[homa] says, 'Walker Evans is the only American left'—and he means that in the sense of days before the American Legion."[34]

A telegram with the heading "Walker Evans Art Exhibit," dated November 26, 1947, describes the exhibition as: "72 pictures, mounted on vertical mats, protected by panes of glass and hung severely, side by side in the narrow, white walled gallery."[35] It continues: "This show has had virtually no publicity and it's not the sort of thing to attract hordes of art lovers. The print galleries never draw nearly as well as painting at the Art Institute anyway." Of the public's reaction to the show, it reports: "There were a few interested people not only gazing but really peering at the pictures." Hugh Edwards is quoted as saying "It's the first time in ages I've seen people really look at pictures in the Art Institute."

Twenty-four Chicago photographs and forty-one "miscellaneous prints" are recorded on a preliminary exhibition list that is part of the collection.[36] This original group was to be augmented by eighteen prints, according to a note at the top of the document. At least six of Evans's Chicago photographs in the Getty Museum's collection appear to have been among the total of eighty-three images from which the final selection for the exhibition was made.[37]

Between 1952 and 1954, Evans spent several months making photographs for an intended *Fortune* portfolio entitled "Street Furniture."[38] A letter from Evans's editor, Albert L. Furth, meant to be carried by Evans while he worked on this project, states that he was authorized by *Fortune* to photograph "street signs and fixtures."[39] Although the portfolio was never published, Evans made numerous photographs in New York City, Boston, and nearby suburban areas, keeping a meticulously detailed record of the photographs he took and planned to take in a tiny notebook. One 5 x 3-inch and eleven 4 ½ x 2 ½-inch notebook sheets document when and where photographs were taken and often include information about the camera Evans was using.[40] Two black-and-white prints and twenty-five color transparencies from the "Street Furniture" series exist in the Getty collection.[41]

Laura Muir

NOTES

1. The chronological list that follows this summary is based on cataloguing records prepared by Carol Payne.

2. See JGPM 84.XG.963.42. Evans had been commissioned to photograph the Island Inn (where he was staying). This letter is undated. The February 1934 date is given in WEAW, p. 98, where this letter was first published.

3. Walker Evans, "Chicago: A camera exploration of the huge, energetic urban sprawl of the midlands," *Fortune* 35 (Feb. 1947), 112–21.

4. See JGPM 84.XG.963.47.1.

5. See JGPM 84.XG.963.47.2.

6. See JGPM 84.XG.963.44.

7. See JGPM 84.XG.963.48. For more information on Agee's Williamsburg project see Laurence Bergreen, *James Agee: A Life* (New York: E.P. Dutton, 1984), 400–6.

8. See JGPM 84.XG.963.38.

9. See JGPM 84.XG.963.34.

10. See nos. 815–47. The fifteenth image in *Wheaton College Photographs* (1941), *Everett Quadrangle*, is not represented in the Getty collection.

11. See JGPM 84.XG.963.39.

12. See JGPM 84.XG.963.35.1–.63.

13. It has been determined that the pencil inscriptions found on these halftone proofs are not those of Evans but are probably those of Frances Lindley (formerly Frances Collins), according to her son, Charles.

14. See JGPM 84.XG.963.36.1–.8.

15. See JGPM 84.XG.963.45.

16. See JGPM 84.XG.963.37.1–.4.

17. See JGPM 84.XG.963.40.1–.3.

18. See JGPM 84.XG.963.50.2. Revised version of this text appears in WEAW, p. 160.

19. See JGPM 84.XG.963.50.4. Revised version of this text appears in WEAW, p. 161.

20. See JGPM 84.XG.963.50.6,.7.

21. See JGPM 84.XG.963.41.1.

22. See JGPM 84.XG.963.41.2.

23. See JGPM 84.XG.963.49.1–.4 and JGPM 84.XG.963.49.6–.15. This group of materials is undated. It is likely, however, that Evans was working on this project during the late 1930s. It was at that time that Evans was preparing an application for a Guggenheim Fellowship, and it is possible that the Metropolitan book was one of Evans's ideas for a grant project. Evans received a Guggenheim Fellowship in 1940, but, due to illness, was not able to spend much time on his project until 1941, when he completed his subway series. Evans may also have planned to submit this proposal to the Metropolitan. It is an idea that may have been inspired by Evans's experience of photographing African art at MoMA in 1935.

24. See JGPM 84.XG.963.49.1.

25. See JGPM 84.XG.963.49.2.

26. See JGPM 84.XG.963.49.8, .9.

27. See JGPM 84.XG.963.49.6, .8, .9, .11, and .14.

28. See JGPM 84.XG.963.49.8.

29. See JGPM 84.XG.963.49.14.

30. See JGPM 84.XG.963.49.14.

31. See JGPM 84.XG.963.49.15.

32. Evans, "Chicago," 112–21.

33. See JGPM 84.XG.963.51.7.

34. See JGPM 84.XG.963.51.4.

35. See JGPM 84.XG.963.51.1.

36. See JGPM 84.XG.963.51.2.

37. These photographs (nos. 1014, 1032–33, 1035–37) all possess an inscription in pencil, written in the same hand in each case, and titles that match those recorded on the Art Institute of Chicago exhibition list (JGPM 84.XG.963.51.2).

38. See JGPM 84.XG.963.33. All items relating to the "Street Furniture" series are housed in a folder with the preceding accession number. Individual items within the folder have not been given accession numbers.

39. See JGPM 84.XG.963.33.

40. See JGPM 84.XG.963.33.

41. For black-and-white prints, see nos. 1047–48. For color transparencies, see nos. 1049–73.

A Chronological Checklist

1. Holograph four-page letter in ink to Ernestine Evans from WE on letterhead from Island Inn, Hobe Sound, Florida [1934]. 84.XG.963.42.

2. Typewritten one-page text with holograph title "PROJECT FOR AN ART BOOK" for proposed picture-book guide to the collection of the Metropolitan Museum of Art, New York [late 1930s]. 84.XG.963.49.1.

3. Typewritten list of "BOOK PRODUCTION PRICE FIGURES" for Metropolitan Museum book, n.d. 84.XG.963.49.2.

4. Holograph one-page note in pencil on book production figures for Metropolitan Museum book, n.d. 84.XG.963.49.3.

5. Holograph draft in pencil of text for Metropolitan Museum book titled "Art without Boredom[. . .]Relax," n.d. 84.XG.963.49.4.

6. Holograph one-page description in pencil of museum objects, n.d. 84.XG.963.49.6.

7. Holograph one-page note in pencil for Metropolitan Museum book, n.d. 84.XG.963.49.7.

8. Holograph description of museum objects and thumbnail sketch of museum object in pencil on 3 x 5-inch index card, n.d. 84.XG.963.49.8.

9. Holograph description of museum objects and thumb-

nail sketch of museum object in pencil on 3 x 5-inch index card, n.d. 84.XG.963.49.9.

10. Holograph notes in pencil of production figures for Metropolitan Museum book on 3 x 5-inch index card, n.d. 84.XG.963.49.10.

11. Holograph description in pencil of museum objects on 3 x 5-inch index card, n.d. 84.XG.963.49.11.

12. Holograph notes in pencil for Metropolitan Museum book on 3 x 5-inch index card, n.d. 84.XG.963.49.12.

13. Holograph notes in pencil for Metropolitan Museum book on 3 x 5-inch index card, n.d. 84.XG.963.49.13.

14. Holograph description in pencil of museum objects on 3 x 5-inch index card, n.d. 84.XG.963.49.14.

15. Holograph notes in pencil for Metropolitan Museum book on 3 x 5-inch index card, n.d. 84.XG.963.49.15.

16. *Fortune* stationery envelope addressed to WE with "AGEE" written above return address at *Fortune* in pencil, postmarked May 25, 1939, Brooklyn, New York. 84.XG.963.43.1.

17. One-page note in pencil in James Agee's hand, n.d. 84.XG.963.43.2.

18. One-page note in pencil in James Agee's hand, n.d. 84.XG.963.43.3.

19. One-page draft of an introductory text for *Let Us Now Praise Famous Men* (1941) in pencil in James Agee's hand. 84.XG.963.44.

20. Engraver's proof with some corrections in blue and black pencil of halftone reproductions of photographs for first edition of *Let Us Now Praise Famous Men* (1941). 84.XG.963.35.1–.63.

21. Uncorrected galley proofs of first edition of *Let Us Now Praise Famous Men* (1941) housed in original manilla envelopes (except for 84.XG.963.36.8). 84.XG.963.36.1–.8.

22. Corrected proofs of text and halftone reproductions of photographs for *Wheaton College Photographs* (1941), corrections made by editor in red pencil, signed by WE in pencil. 84.XG.963.34.

23. Mock-up of title page for proposed book of subway photographs, holograph title in pencil "PHOTOGRAPHS OF METROPOLITAN FACES" (1942). 84.XG.963.50.1.

24. Typewritten one-page text with holograph title "UNPOSED PHOTOGRAPHIC RECORD OF PEOPLE" and corrections in pencil, n.d. 84.XG.963.50.2.

25. Typewritten one-page text ["UNPOSED PHOTOGRAPHIC RECORD OF PEOPLE"], n.d. 84.XG.963.50.3.

26. Holograph one-page text in pencil about the subway photographs, n.d. 84.XG.963.50.4.

27. Holograph one-page text in pencil about the subway photographs, n.d. 84.XG.963.50.5.

28. Holograph one-page note in pencil about the subway photographs, 1942. 84.XG.963.50.6.

29. Holograph one-page text in pencil about the subway photographs, n.d. 84.XG.963.50.7.

Seven items below relating to the Art Institute of Chicago exhibition *Walker Evans Retrospective* (Nov. 14, 1948–Jan. 4, 1949):

30. Mimeographed typewritten one-page telegram to Seaver Buck from Serrell Hillman, Nov. 26, 1947. 84.XG.963.51.1.

31. Typewritten two-page preliminary exhibition list for *Walker Evans Retrospective*, Nov. 6, 1947. 84.XG.963.51.2.

32. Typewritten two-page letter to WE from Carl O. Schniewind, Curator, Department of Prints and Drawings, Art Institute of Chicago on Art Institute of Chicago letterhead, Sept. 4, 1947. 84.XG.963.51.3.

33. Holograph letter in ink to WE from Hugh Edwards, Associate Curator, Department of Prints and Drawings, Art Institute of Chicago (1947). 84.XG.963.51.4.

34. Carbon copy of typewritten one-page letter to Carl O. Schniewind from WE, Oct. 22, 1947. 84.XG.963.51.5.

35. Typewritten two-page letter to WE from Carl O. Schniewind on Art Institute of Chicago letterhead, Oct. 21, 1947. 84.XG.963.51.6.

36. Carbon copy of typewritten two-page letter to Carl O. Schniewind from WE, Oct. 17, 1947. 84.XG.963.51.7.

Folder containing the following eight items relating to the "Street Furniture" project ["STREET FURNITURE" written on front of folder twice in red pencil], 1952–54. All under accession no. 84.XG.963.33 (except no. 44):

37. Envelope and typewritten one-page letter to "Whom it may Concern" from Albert L. Furth, Executive Editor, *Fortune* magazine, on *Fortune* letterhead, signed in ink by both Furth and WE, June 18, 1953.

38. Carbon copy of above with "cc: Walker Evans" typewritten at upper right of page, June 18, 1953.

39. Pages from WE's notebook relating to records and plans for "Street Furniture" project (one 5 x 3-inch note sheet; eleven 4½ x 2½-inch note sheets), 1952–54.

40. Holograph notes on the "Street Furniture" project, 1952–54.

41. WE's travel expense report, 1952–54.

42. Holograph note in pencil on the "Street Furniture" project, 1952–54.

43. Empty folder ["STREET FURNITURE" written on front of folder in pencil], 1952–54.

44. Contact sheet of a "Street Furniture" subject with nine black-and-white frames of a staircase image (*No Parking*

[84.XG.963.13]), on verso "WE/4" in unknown hand, 1952–53. 84.XG.963.32.

45. Holograph one-page note written by WE and James Agee regarding the Harlem project [1954]. 84.XG.963.48.

46. Typewritten one-page letter to WE from W. Eugene Smith on Smith's personal letterhead, signed in ink "Gene Smith," Nov. 27, 1954. 84.XG.963.47.1.

47. Typewritten one-page letter to WE from W. Eugene Smith on Smith's personal letterhead, signed in ink "Gene Smith," Feb. 3, 1955. 84.XG.963.47.2.

48. Mimeographed announcement requesting contributions to the James Agee Trust Fund [1955]. 84.XG.963.46.

49. Holograph one-page text in pencil regarding sixteen women's faces and hats, related to the subway project, ca. 1959? 84.XG.963.49.5.

50. Carbon copy of typewritten text "FOREWORD FOR 'LET US NOW PRAISE FAMOUS MEN' FOR LOVELL THOMPSON AND PAUL BROOKS FROM WALKER EVANS," 1959. 84.XG.963.45.

51. Reproduction proofs of halftone reproductions of photographs for second edition of *Let Us Now Praise Famous Men* (1960). 84.XG.963.37.1–.4.

52. Unbound copy of second edition of *American Photographs* (1962). 84.XG.963.38.

53. Holograph one-page list of professions, apparently related to the subway project, n.d. 84.XG.963.52.

54. Partial set of three reproduction proofs of halftone reproductions of photographs for *Many Are Called* (1966), all three signed by WE in pencil. 84.XG.963.40.1–.3.

55. Photocopies of galley proof text and reproduction proof of halftone reproductions of photographs for *Message from the Interior* (1966). 84.XG.963.41.1.

56. Some text pages and partial set of fine-grain halftone plates from *Message from the Interior* (1966), bound in black wrappers, holograph inscription in ink to Arnold Crane. 84.XG.963.41.2.

57. Uncorrected page proofs of *Walker Evans* (1971). 84.XG.963.39.1.

58. Corrected page proofs of *Walker Evans* (1971). 84.XG.963.39.2.

59. Reproduction proofs of halftone reproductions of photographs with captions for *Walker Evans* (1971). 84.XG.963.39.3.

60. Holograph one-page note in pencil with doodles in margins, n.d. 84.XG.963.53.

APPENDIX B

American Photographs and the Getty Collection

The Exhibitions

On each of the Getty Museum photographs listed below, at least one of the following Museum of Modern Art identification numbers appears: loan number, installation number, or circulating exhibition group number.[1] The appearance of any of these numbers indicates that the print was on loan to MoMA for the 1938 exhibition *Walker Evans: American Photographs* and/or the MoMA-organized circulating exhibition *American Photographs by Walker Evans*.[2] The circulating exhibition was considerably different from the New York show. Although some of the same

prints were included, there were numerous eliminations and additions to the original group shown at MoMA. (See the chapter "*American Photographs:* Evans in Middletown," for a discussion of both exhibitions.)

Those photographs possessing an installation number (which may have corresponded to their placement in the New York show) are listed in order according to this number.[3] The fifteen photographs that do not possess installation numbers are listed separately in order of their catalogue numbers.[4]

MoMA install. no.	MoMA circ. exh. group no.	MoMA loan no.	JPGM cat. no.	MoMA install. no.	MoMA circ. exh. group no.	MoMA loan no.	JPGM cat. no.
14	IV	38.2945	149	68	X	38.2258	498
18		38.2330	568	72	II	38.2950	455
23	VI	38.2352	530	75		38.2412	487
26	VIII	38.2331	497	77		38.2949	519
31	XII	38.2369	501	83		38.2339	525
33	V	38.2273	428	84		38.2948	509
38	VIII	38.2335	169	87	XVIII	38.2947	130
40		38.2299	103	92	VI	38.2424	478
44	XV	38.2289	577	98	X	38.2254	448
54	X	38.2325	564	101	III	38.3045	144
58	IX	38.2358	549	102	III	38.3055	143
59	XV	38.2368	557	106	IV	38.3049	195
65	II	38.2377	194			38.2382	121
67	II	38.2271	153			38.2375	162

MoMA install. no.	MoMA circ. exh. group no.	MoMA loan no.	JPGM cat. no.	MoMA install. no.	MoMA circ. exh. group no.	MoMA loan no.	JPGM cat. no.
		38.2300	257			38.304	447
		38.2359	259			38.2357	472
		38.2395	275			38.2285	474
		38.2321	285			38.2262	475
		38.2288	293			38.2948	509
		38.2426	313			38.2321	515
		38.2419	322				

The Book

The following photographs appear to have been included in a mock-up for the 1938 publication *American Photographs* (referred to below as AMP). Each image is mounted on a heavy three-hole-punched sheet of paper complete with inscriptions indicating in which section of the book the image was to be included (I or II) and its plate number.

AMP no.	AMP part	JPGM cat. no.	AMP no.	AMP part	JPGM cat. no.
1	I	205	7	II	507
4	I	127	9	II	483
9	I	168	10	II	451
11	I	104	12	II	166
20	I	233	13	II	422
21	I	476	15	II	484
27	I	452	16	II	572
28	I	436	18	II	482
31	I	439	20	II	196
36	I	496	21	II	161
44	I	578	23	II	569
46	I	514	24	II	453
3	II	435	26	II	155
5	II	443	28	II	152
6	II	446	35	II	154
6	II	445	37	II	131

NOTES

1. These are found on one of two MoMA loan labels (see "Stamps and Labels" [pp. xvi–xvii] for reproductions) or handwritten on the verso of the print or its mount. Three Getty Museum photographs that do not possess any MoMA identification numbers may also have been on loan at the time of the exhibition. The inscription for no. 489 reads: *W.E./c/o Mr. Mabry/ Museum of Modern Art*. Thomas Mabry, then executive director of MoMA, was a key figure in the organiza-tion of the *American Photographs* exhibition. The inscription for no. 503 reads: *c* [circled] *this was used/Am. Photographs/MMA 1938*. The inscription for no. 562 reads: *No Number/ Evans*. This is written by the same hand that recorded all of the MoMA loan numbers in which a "38.xxxx" number is followed by "/Evans."

2. An installation list for the circulat-ing exhibition was consulted in the Registrar's files at MoMA.

3. See Gilles Mora and John T. Hill, *Walker Evans: The Hungry Eye* (New York: Harry N. Abrams, 1993), 160–97, for a discussion of the 1938 *Ameri-can Photographs* exhibition at MoMA and reproductions of the images pre-sented in an order corresponding to installation number.

4. These photographs may have been rejected from the final selection of images for the exhibition. Their loan numbers indicate that they were among the photographs initially selected for the exhibition, but the fact that they were assigned neither instal-lation nor circulating exhibition group numbers suggests that they were included in neither the New York nor the circulating exhibition.

APPENDIX C

Selected One-Person and Group Exhibitions

Selected One-Person Exhibitions

Note: The number of exhibited photographs by WE is given when known.

Walker Evans: Photographs of Nineteenth-Century Houses. Museum of Modern Art, New York (Nov. 16–Dec. 8, 1933). Organized by Lincoln Kirstein. Circulated to 14 venues. 39 photographs.

Photographs of African Negro Art by Walker Evans. Circulated by the Museum of Modern Art to 16 venues. (1935–37). 75 photographs.

Walker Evans: American Photographs. Museum of Modern Art, New York (Sept. 28–Nov. 18, 1938). Circulated to 10 venues as *American Photographs by Walker Evans.* 100 photographs.

Walker Evans Retrospective. Art Institute of Chicago, Chicago (Nov. 14, 1947–Jan. 4, 1948). Organized by Carl O. Schniewind and Thomas Dabney Mabry. 75 photographs.

Walker Evans: American Photographs. Museum of Modern Art, New York (June 8–Aug. 14, 1962). 25 photographs from the 1938 exhibition.

Walker Evans. Art Institute of Chicago (Nov. 13, 1964–Jan. 10, 1965). Organized by Hugh Edwards. 60 photographs.

Walker Evans' Subway. Museum of Modern Art, New York (Oct. 5–Dec. 11, 1966). Organized by John Szarkowski. 40 photographs.

Walker Evans: An Exhibition of Photographs by Walker Evans from the Collection of the Museum of Modern Art, New York. Ottawa, National Gallery of Canada (1966). 28 photographs.

Walker Evans. Robert Schoelkopf Gallery, New York (Dec. 20, 1966–Jan. 7, 1967). 40 photographs.

Walker Evans: Paintings and Photographs. The Century Association, New York (Feb. 25–Apr. 5, 1970). Organized by A. Hyatt Mayor. 9 paintings, 45 photographs.

Walker Evans. Museum of Modern Art, New York (Jan. 26–Apr. 11, 1971). Organized by John Szarkowski. Also traveled to: Corcoran Gallery, Washington, D.C.; San Francisco Museum of Modern Art; Museum of Fine Arts, St. Petersburg, Fla.; City Art Museum of St. Louis; University of Michigan Museum of Art at Ann Arbor; Art Institute of Chicago; and the Museum of Fine Arts, Boston. In 1975–76, the number of photographs was reduced to 80, and the exhibition traveled to Helsinki, Rotterdam, Paris, Vienna, Stockholm, Oslo, Düsseldorf and Bielefeld, Oxford, and Brussels. 202 photographs.

Photographs: Walker Evans. Robert Schoelkopf Gallery, New York (Jan. 30–Feb. 25, 1971).

Walker Evans: Forty Years. Yale University Art Gallery, New Haven, Conn. (Dec. 1971–Jan. 16, 1972).

Walker Evans. Mind's Eye Gallery and Bookstore, Vancouver, B.C., Canada (July 26–Aug. 20, 1972). 50 photographs from the collection of Jim Dow.

Walker Evans. Robert Schoelkopf Gallery, New York. (Apr. 21–May 17, 1973). 58 photographs.

Walker Evans: A Selected Retrospective of Photographs. The Print Club, Philadelphia (Mar. 15–Apr. 15, 1974).

Walker Evans: Photographs from the "Let Us Now Praise Famous Men" Project. Michener Galleries, Humanities Research Center, University of Texas, Austin (Mar. 24–May 5, 1974). 92 photographs.

Walker Evans. National Gallery of Canada, Ottawa (Aug. 2–Sept. 8, 1974).

Photographic Perspectives: Walker Evans. Park Square Gallery, University of Massachusetts, Boston (Nov. 8–26, 1974).

Walker Evans: Vintage Photographs, 1928–1972. Lunn Gallery/Graphics International, Ltd., Washington, D.C. (Jan. 18–Mar. 5, 1975). 65 photographs.

Walker Evans: Photographies Originales de 1929–1947. Yajima/Galérie, Montreal, Quebec (Apr. 9–May 3, 1975).

Walker Evans Memorial. Museum of Modern Art, New York (Apr. 14–June 22, 1975). 8 photographs.

Photographs by Walker Evans (1903–1975). International Museum of Photography at George Eastman House, Rochester, N.Y. (Apr. 23–May 31, 1975).

Walker Evans. Cronin Gallery, Houston (Feb. 1–26, 1977).

Walker Evans: Photographs 1938–1971. Robert Schoelkopf Gallery, New York (Mar. 7–Apr. 2, 1977). 36 photographs.

Walker Evans: A Retrospective Exhibition from the Collection of Arnold Crane. Museum of Contemporary Art, Chicago (July 23–Sept. 4, 1977). Also, Institute of Contemporary Art, Boston (June 28–Sept. 3, 1978), and Sidney Janis Gallery, New York (Jan. 6–Feb. 4, 1978). 250 photographs.

Walker Evans at "Fortune," 1945–1965. Jewett Arts Center, Wellesley College Museum, Wellesley, Mass. (Nov. 16, 1977–Jan. 23, 1978). Organized by Lesley K. Baier. 62 photographs.

Walker Evans. Simon Lowinsky Gallery, San Francisco (Fall, 1978).

Walker Evans: An Exhibition to Commemorate the Publication of First and Last. Including the Eight Images in the Deluxe Edition, the Fifteen Images in Portfolio I, and a Selection of Prints from the Walker Evans Archive. Lunn Gallery/Graphics International, Ltd., Washington, D.C. (Sept. 16–Oct. 18, 1978).

Walker Evans. Bahnhof Rolandseck, Rolandseck, West Germany. (Oct. 5–Nov. 30, 1978). Organized by Dr. Volker Kahmen and Georg Heusch. 20 photographs.

Walker Evans: Photographs. Center Gallery, Gorham Campus, University of Southern Maine, Gorham, Me. (Nov. 1–19, 1978). 50 photographs.

Walker Evans. Archetype Gallery, New Haven, Conn. (May 26–June 29, 1979).

Walker Evans: Lost and Found. Drink Hall, Saratoga Springs Preservation Foundation, Inc., and the Walker Evans Estate, Saratoga Springs, N.Y. (July 3–Aug. 29, 1979). 72 photographs.

Walker Evans: Photographs of New York State. Organized by the Eakins Press Foundation and Saratoga Springs Preservation Foundation, photographs courtesy of the Estate of Walker Evans and the Lunn Gallery, Washington, D.C., 1979. Also, Port Washington Library, Port Washington, N.Y. (Sept. 9–Oct. 12, 1982).

Walker Evans: An Exhibition of Photographs from the California Museum of Photography and the Minneapolis Institute for the Arts. University Art Gallery, University of California-Riverside (Jan. 7–Feb. 1, 1980).

Walker Evans. Lyme Historical Society, Old Lyme, Conn. (Jan. 1981).

Walker Evans. Galérie Baudoin Lebon, Paris (Jan. 15–Feb. 28, 1981).

Walker Evans Retrospective. Comfort Gallery, Haverford College, Haverford, Penn. (Feb. 7–Mar. 8, 1981). 95 photographs.

Walker Evans. Milwaukee Arts Center, Milwaukee, Wis. (Apr. 2–May 3, 1981). Organized by V. P. Curtis.

Walker Evans: Eighty Photographs by Walker Evans/Works from 1928–1973. Yajima/Galérie, Montreal, Quebec (May 20–June 20, 1981).

Walker Evans (1903–1975) Retrospektive. PPS. Galerie F. C. Gundlach, Hamburg (May 13–June 19, 1981).

Walker Evans. Rawshenbush Library, Sarah Lawrence College, Bronxville, N.Y. (Sept. 1981).

Walker Evans: Photographs from 1929 to 1971. Impressions Gallery of Photography, York, England (Sept. 12–Oct. 10, 1981).

Walker Evans: Photographs of Chicago. Kelmscott Gallery, Chicago (Nov. 1981).

Walker Evans: Many Are Called. Photographs Made in the New York City Subways 1938–41. Fraenkel Gallery, San Francisco (Mar. 2–Apr. 3, 1982). 22 photographs.

Walker Evans 1903/1974. IVAM Centro Julio Gonzalez. Valencia, Spain (1983). Organized by Jeff Rosenheim. Also traveled to Madrid and Barcelona.

Walker Evans. Blue Sky Gallery, Portland, Oreg. (Jan. 4–Feb. 1, 1984).

Walker Evans, 1903/1974. Palazzina Mangani, Fiesole, Italy (Mar. 29–May 1, 1984).

Walker Evans: Vintage Photographs from American Photographs and "Fortune" Magazine. Pace/MacGill Gallery, New York (June 1–July 4, 1984).

The Sunny South: Depression Era Photographs by Walker Evans. High Museum of Art, Atlanta (May 21–Oct. 13, 1985).

Walker Evans: Leaving Things As They Are. The Promised Gift of Mr. and Mrs. David C. Ruttenberg to the Art Institute of Chicago. Art Institute of Chicago (Sept. 12–Nov. 8, 1987). Organized by David Travis. 146 photographs.

Walker Evans: Photographs. Robert Schoelkopf Gallery, New York (Nov. 2–30, 1987).

Walker Evans: A Portfolio of African Art. Robert Goldwater Library, Metropolitan Museum of Art, New York (Feb. 9–July 1, 1988). 30 photographs.

Walker Evans: American Photographs. Edward Steichen Photography Center, Museum of Modern Art, New York. (Jan. 19–Apr. 11, 1989). Organized by Peter Galassi.

Walker Evans: Havana 1933. PhotoFest, Houston, Tex. (Feb. 10–Mar. 10, 1990). [Exhibition prints produced from the original negatives by the Walker Evans Estate.]

Walker Evans Amerika: Bilder aus den Jahren der Depression. Städtische Galerie im Lenbachhaus, Munich (Aug. 15–Oct. 1990).

Walker Evans Subways and Streets. National Gallery of Art, Washington, D.C. (Nov. 24, 1991–Mar. 1, 1992). Organized by Sarah Greenough. 66 photographs.

Walker Evans: An Alabama Record. J. Paul Getty Museum, Malibu, Calif. (Apr. 7–June 21, 1992). Organized by Judith Keller. 44 photographs.

Walker Evans: Polaroids 1973–1974. 292 Gallery, New York (Mar. 4–Apr. 10, 1993). 33 photographs.

Walker Evans: The Brooklyn Bridge and Selected Photographs. Zabriskie Gallery, New York (Feb. 23–Apr. 16, 1994). 9 gravures plus a selection of vintage photographs.

Selected Group Exhibitions

International Photography. Harvard Society for Contemporary Art, Cambridge, Mass. (Nov. 7–29, 1930). Organized by Lincoln Kirstein. 17 photographers. 10 photographs by WE.

Photographs for Art and Industry. Museum of Science and Industry, New York (1931).

Photographs by Three Americans. John Becker Gallery, New York (Apr. 18–May 8, 1931). With Margaret Bourke-White and Ralph Steiner.

Philadelphia International Salon of Photography. Pennsylvania Museum of Art, Sixty-ninth Street Branch, Upper Darby, Penn. (Mar. 1–31, 1932). Organized by Philip N. Youtz. 200 photographs by 189 photographers. 1 photograph by WE.

Modern Photographs by Walker Evans and George Platt Lynes. Julien Levy Gallery, New York (Feb. 1–19, 1932).

Modern Photography at Home and Abroad. Albright Art Gallery, Buffalo, N.Y. (Feb. 5–25, 1932). 27 photographers. 7 photographs by WE.

International Photographers. Brooklyn Museum of Art, Brooklyn, N.Y. (Mar. 8–31, 1932). 39 photographers. 12 photographs by WE.

Documentary and Anti-Graphic: Photographs by Manuel Alvarez Bravo, Henri Cartier-Bresson, and Walker Evans. Julien Levy Gallery, New York (Apr. 23–May 7, 1935).

Photography 1839–1937. Museum of Modern Art, New York (Mar. 17–Apr. 18, 1937). Organized by Beaumont Newhall. 132 photographers. 6 photographs by WE.

First International Photographic Exposition. Grand Central Palace, New York (Apr. 18–29, 1938). 81 photographs by FSA photographers. 1 photograph by WE.

Art in Our Time: Tenth Anniversary Exhibition. Museum of Modern Art, New York (May 10–Sept. 30, 1939). Organized by Beaumont Newhall. 7 photographs by WE.

Sixty Photographs: A Survey of Camera Esthetics. Museum of Modern Art, New York (Dec. 31, 1940–Jan. 12, 1941). 60 photographs by 31 photographers. 3 photographs by WE.

American Photographs at $10. Museum of Modern Art, New York (Dec. 2, 1941–Jan. 4, 1942). 1 photograph by WE.

Masters of Photography. Museum of Modern Art, New York, 1943.

One Hundred Years of Portrait Photography. Museum of Modern Art, New York (Nov. 4–Dec. 7, 1943).

Art in Progress: A Survey Prepared for the Fifteenth Anniversary of the Museum of Modern Art, New York. Museum of Modern Art, New York (May 24–Sept. 17, 1944). 60 photographers. 8 photographs by WE.

The Museum Collection of Photography. Museum of Modern Art, New York (July 2–Sept. 6, 1947). 1 photograph by WE.

Fifty Photographs by Fifty Photographers. Museum of Modern Art, New York (July 27–Sept. 26, 1948). 1 photograph by WE.

Color Photography. Museum of Modern Art, New York (May 10–June 25, 1950). 85 photographs by 85 photographers. 1 photograph by WE.

Abstraction in Photography. Museum of Modern Art, New York (May 2–July 4, 1951). 162 photographs by 103 photographers. 4 color photographs by WE.

Twelve Photographers. Museum of Modern Art, New York (July 13–Aug. 12, 1951). 15 photographs by WE.

Photographs by Fifty-one American Photographers. Museum of Modern Art, New York (Aug. 1–Sept. 17, 1951). 1 photograph by WE.

Then and Now. Museum of Modern Art, New York (Aug. 6–19, 1952). Approx. 50 photographs. 1 photograph by WE.

Contemporary American Photography. Museum of Modern Art, New York (Japan 1953–Paris 1955). 6 photographs by WE.

Cinquante Ans D'art Aux Etats-Unis: Collections du Museum of Modern Art de New York. Musée National d'Art Moderne, Paris (Apr.–May 1955). 100 photographs by 36 photographers in the photography section. 4 photographs by WE.

Farm Security Administration Photography. Brooklyn Museum, Brooklyn, N.Y. (1955). Organized by T. Anthony Caruso. 100 photographs by 12 photographers.

Diogenes with a Camera III. Museum of Modern Art, New York (Jan. 17–Mar. 18, 1956). With Manuel Alvarez Bravo, August Sander, and Paul Strand. 9 photographs by WE.

Photographs from the Museum Collections. Museum of Modern Art, New York (Nov. 26, 1956–Jan. 18, 1957).

The Bitter Years, 1935–1941. Museum of Modern Art, New York (Oct. 18–Nov. 25, 1962). Organized by Grace Mayer. 12 photographers. 16 photographs by WE.

USA FSA: Farm Security Administration Photographs in the Depression Era. Allen R. Hite Art Institute, University of Louisville, Ky. (Jan. 15–Feb. 24, 1962). Organized by Robert J. Doherty. 92 photographs. 8 photographs by WE.

The Photographer's Eye. Museum of Modern Art, New York (May 25–Aug. 23, 1964). Organized by John Szarkowski. 5 photographs by WE.

Contemporary Art at Yale: 1. Yale University Art Gallery, Yale University, New Haven, Conn. (Jan. 13–Feb. 15, 1965). 25 photographs by WE.

An Exhibition of Work by the John Simon Guggenheim Memorial Foundation Fellows in Photography. Photography Department, Philadelphia College of Art, Philadelphia (Apr. 15–May 13, 1966). Organized by Sol Mednick. 31 photographers.

Just Before the War: Urban America from 1935 to 1941, As Seen by Photographers of the Farm Security Administration. Newport Beach Art Museum, Balboa, Calif. (Sept. 30–Nov. 10, 1968). Organized by Thomas H. Garver. 15 photographers. 19 photographs by WE.

Museum of Modern Art Photography Exhibit. University of St. Thomas, Houston, Tex. (Spring 1969). 103 photographs by 93 photographers. 1 photograph by WE.

The Highway. Institute of Contemporary Art, University of Pennsylvania, Philadelphia (Jan. 14–Feb. 25, 1970). 59 works by 42 artists. 6 photographs by WE.

The Descriptive Condition—Seven Photographers. Boston University (Mar. 23–Apr. 10, 1970). With Henri Cartier-Bresson, Robert Frank, André Kertész, Joel Meyerowitz, Tod Papageorge, and Garry Winogrand.

Photo Eye of the 20s. George Eastman House, Rochester, N.Y. (Oct. 15, 1970–Jan. 18, 1971). Organized by Beaumont Newhall. 158 photographs by 30 photographers. 4 photographs by WE.

Eleven American Photographers. The Emily Lowe Gallery, Hofstra University, Hempstead, Long Island, N.Y. (Apr. 10–May 12, 1972). Organized by Robert Doty. With Timothy O'Sullivan, Solomon Butcher, Alfred Stieglitz, Robert Frank, Charles Currier, Edward Weston, André Kertész, Harry Callahan, Emmett Gowin, and Duane Michals. Also, traveled by the U.S.I.S. to the Philippines, Malaysia, and Thailand in 1973.

Looking At Photographs. Museum of Modern Art, New York (1973). Organized by John Szarkowski. 100 photographs by 100 photographers.

Photography Unlimited. William Hayes Fogg Art Museum, Harvard University, Cambridge, Mass. (Sept. 13–Oct. 16, 1974). Organized by Davis Pratt. 105 photographs by 47 photographers. 4 Polaroid SX-70 prints by WE.

Photography in America. Whitney Museum of American Art, New York (Nov. 20, 1974–Jan. 12, 1975). Organized by Robert Doty. 259 photographs by 86 photographers. 6 photographs by WE.

Farm Security Administration. Centro Studi e Museo della Fotografia e dall'Istituto di Storia dell'Arte, Università di Parma, Parma, Italy (1975). Organized by Arturo Carlo Quintavalle. 300 photographs by FSA photographers. 33 photographs by WE.

Fourteen American Photographers: Walker Evans, Robert Adams, Lewis Baltz, Paul Caponigro, William Christenberry, Linda Connor, Cosmos, Robert Cumming, William Eggleston, Lee Friedlander, John R. Gossage, Gary Hallman, Tod Papageorge, Garry Winogrand. Baltimore Museum of Art (Jan. 21–Mar. 2, 1975). Organized by Renato Danes. 150 photographs by 14 photographers. 20 photographs by WE.

A Survey of Polaroid Color Photography. International Center of Photography, New York (Dec. 1975).

America Observed: Etchings by Edward Hopper, Photographs by Walker Evans. California Palace of the Legion of Honor, San Francisco (Sept. 4–Oct. 24, 1976). 33 photographs by WE.

Roy Stryker: The Humane Propagandist. Photographic Archives, University of Louisville, Louisville, Ky. (1977). 63 photographs.

People and Places of America: Farm Security Administration Photography of the 1930s. Santa Barbara Museum of Art, Santa Barbara, Calif. (Oct. 15–Nov. 20, 1977). Organized by Richard J. Kubiak. 54 photographs.

The Presence of Walker Evans. Institute of Contemporary Art, Boston (June 28–Sept. 3, 1978). 130 photographs by 8 photographers. Shown simultaneously with *Walker Evans: A Retrospective Exhibition from the Collection of Arnold Crane*.

William Carlos Williams and the American Scene, 1920–1940. Whitney Museum of American Art, New York (Dec. 12, 1978–Feb. 4, 1979). Organized by Dickran Tashjian. 4 photographs by WE.

Two Classic Documentary Photographers: Marion Post Wolcott and Walker Evans. Nova Gallery, Vancouver, B.C., Canada (Apr. 10–28, 1979).

Photography Rediscovered: American Photographs, 1900–1930. Whitney Museum of American Art, New York (Sept. 19–Nov. 25, 1979). Organized by David Travis and Anne Kennedy. 241 photographs by 34 photographers. 12 photographs by WE.

Images de l'Amérique en Crise: Photographies de la Farm Security Administration, 1935–1942. Bibliothèque Publique d'Information, Centre Georges Pompidou, Paris (Dec. 1979–Mar. 1980). 80 photographs. 12 photographs by Evans.

Robert Frank/Walker Evans. G. Ray Hawkins Gallery, Los Angeles (July 15–Aug. 2, 1980).

Walker Evans and Robert Frank: An Essay on Influence. Yale University Art Gallery, New Haven, Conn. (Jan. 21–Mar. 15, 1981). Organized by Tod Papageorge. 25 photographs by each photographer. Also traveled: Daniel Wolf Gallery, New York (Mar. 31–Apr. 25, 1981), Fraenkel Gallery, San Francisco (June 17–July 25, 1981); and G. H. Dalsheimer Gallery, Baltimore (Sept. 13–Oct. 11, 1981).

The Railroad in the American Landscape: 1850–1950. Wellesley College Museum, Wellesley, Mass. (Apr. 15–June 8, 1981). Organized by Susan Walther.

Cubism and American Photography, 1910–1930. Sterling and Francine Clark Art Institute, Williamstown, Mass. (Oct. 31–Dec. 6, 1981).

Color As Form: A History of Color Photography. International Museum of Photography at George Eastman House, Rochester, N.Y. (July 2–Sept. 5, 1982). Organized by John Upton and Ron Emerson. 269 photographs. 1 color photograph by WE.

Three Generations: Walker Evans, Robert Frank, Tod Papageorge. University Art Galleries, Creative Arts Center, University of New Hampshire at Durham (Sept. 13–Oct. 20, 1982). Organized by Effie Malley.

Mountaineers to Main Streets: The Old Dominion As Seen Through Farm Security Photographs. Chrysler Museum, Norfolk, Va. (May 3–June 16, 1985). Organized by Brooks Johnson.

The Machine Age in America, 1918–1941. Brooklyn Museum, Brooklyn, N.Y. (Oct. 17, 1986–Feb. 16, 1987).

Photography in the American Grain: Discovering a Native American Aesthetic, 1923–1941. Center for Creative Photography, University of Arizona, Tucson (1987). Organized by Terence Pitts.

Photographs Beget Photographs. Minneapolis Institute of Arts, Minneapolis, Minn. (Jan. 14–Mar 29, 1987). Organized by Christian A. Peterson. 12 photographers, including WE.

The Viewer as Voyeur. Whitney Museum of American Art, New York (Apr. 30–July 8, 1987).

Adolphe Braun, Walker Evans, André Kertész: Photographers of Sculpture: Other Photographers of Sculpture. Comfort Gallery, Haverford College, Haverford, Penn. (Apr. 9–May 1988). Organized by William Earle Williams and Anne Nelson. 97 photographs and 11 books. 11 photographs by WE.

The Art of Photography, 1839–1989. Museum of Fine Arts, Houston (Feb. 11–Apr. 30, 1989). Organized by Daniel Wolf. Approximately 462 photographs. 10 photographs by WE. Also traveled: Australian National Gallery, Canberra (June 17–Aug. 27, 1989), and Royal Academy of Arts, London (Sept. 23–Dec. 23, 1989).

The New Vision: Photography Between the World Wars. Ford Motor Company Collection at the Metropolitan Museum of Art, New York (Sept. 22–Dec 31, 1989). Organized by Maria Morris Hambourg.

Experimental Photography: The Machine Age. J. Paul Getty Museum, Malibu, Calif. (Sept. 26–Dec. 10, 1989). Organized by Judith Keller. 3 photographs by WE.

Of Time and Place: Walker Evans and William Christenberry. Amon Carter Museum, Fort Worth, Tex. (Apr. 27–June 24, 1990). Organized by Thomas W. Southall. 53 photographs by both artists, plus 2 sculptures by Christenberry. Also traveled: Wichita Museum, Wichita, Kans. (Dec. 1, 1990–Jan. 20, 1991); Portland Museum of Art, Portland, Oreg. (Feb. 17–Apr. 15, 1991); and The Friends of Photography, Ansel Adams Center, San Francisco (July 3–Sept. 9, 1991).

Walker Evans and Jane Ninas in New Orleans, 1935–1936. Historic New Orleans Collections, New Orleans (Jan. 16–Mar. 23, 1991). Organized by Jeff Rosenheim. 65 photographs.

Neither Speech nor Language: Photography and the Written Word. J. Paul Getty Museum, Malibu, Calif. (Feb.

28–May 12, 1991). Organized by Judith Keller. 8 photographs by WE.

Edward Hopper und die Fotographie. Museum Folkwang, Essen, Germany (June 28–Sept. 27, 1992).

Walker Evans and Dan Graham. Witte de With, Center for Contemporary Art, and Museum Boymans-van Beuningen, Rotterdam (Aug. 29–Oct. 11, 1992). Also traveled: Musée Cantini, Marseille, France (Nov. 6–Oct. 10, 1993; Westfaelisches Landesmuseum für Kunst un Kulturgeschichte (Jan. 31–Mar. 21, 1993); and Whitney Museum of Art, New York (Dec. 17, 1993–Mar. 17, 1994).

Devotion, Faith, and Fervor: The Faithful and the Damned. 292 Gallery, New York (Jan. 21–March 5, 1994). Organized by Sarah Morthland. At least 9 photographers, including WE.

A SELECTED
WALKER EVANS BIBLIOGRAPHY

Compiled by William S. Johnson,
revised and expanded by Michael Hargraves

CONTENTS

*Note: Entries are arranged
chronologically. When several
entries fall on the same date, they
are arranged alphabetically.*

PORTFOLIOS

Walker Evans: Fourteen Photographs. Introduction by Robert Penn Warren. Essay by Walker Evans. New Haven, Conn.: Ives-Sillman, 1971. 14 mounted gelatin silver prints, up to 9½ x 7½ in. on 18 x 14¾ in. mounts, each signed. Printed by Thomas A. Brown from the original negatives under WE's supervision. Edition of 100 sets, numbered and signed by WE. Published Feb. 15, 1971. Contains:

1. *Minstrel Showbill, Alabama*, 1936;
2. *Boarding House, Porch, Birmingham, Ala.*, 1936;
3. *Bed and Stove, Truro, Mass.*, 1931;
4. *"Joe's Auto Graveyard," Near Bethlehem, Pa.*, 1936;
5. *Dock-worker, Havana*, 1932;
6. *Wellfleet, Mass.*, 1931;
7. *Country Church Near Beaufort, S.C.*, 1935;
8. *Bessemer, Ala.*, 1936;
9. *Fish Market Near Birmingham, Ala.*, 1936;
10. *Child's Grave, Alabama*, 1936;
11. *Barber Shop, New Orleans*, 1935;
12. *Tenant Farmer's Wife, Alabama*, 1936;
13. *Farmhouse, Westchester County, N.Y.*, 1936;
14. *Roadside Sign, Louisiana*, 1936.

Walker Evans: Selected Photographs. Introduction by Lionel Trilling. New York: Double Elephant Press, 1974. 15 mounted gelatin silver prints, up to 15½ x 12 in. on 19¾ x 15 in. mounts, each signed by WE, printed by Richard Benson, John Deeks, and Lee Friedlander, from the original negatives, under WE's supervision. Edition of 75 sets, plus 15 artist's proofs. Contains:

1. *Saratoga Springs, New York*, 1931;
2. *Maine Pump*, 1933;
3. *Breakfast Room at Belle Grove Plantation, White Chapel, Louisiana*, 1935;
4. *Minstrel Poster, Alabama*, 1935;
5. *Shoeshine Sign in Southern Town*, 1936;
6. *Main St., Ossining, New York*, 1932;
7. *Penny Picture Display, Savannah*, 1936;
8. *Kitchen Wall, Alabama Farmstead*, 1936;
9. *Portrait of James Agee*, 1937;
10. *Doorway, 204 West 13th Street, New York City*, ca. 1931;
11. *Lunchroom Buddies, New York City*, 1931;
12. *Stamped Tin Relic, New York City*, 1930;
13. *Tin False Front Building, Moundville, Alabama*, 1936;
14. *Ruin of Tabby (Shell) Construction, St. Mary's, Georgia*, 1936;
15. *Dock Workers, Havana*, 1932.

Walker Evans I. New Haven, Conn. and Washington, D.C.: Estate of Walker Evans and Graphics International, 1977. 15 mounted gelatin silver

prints, up to 10 x 8 in. on 20 x 16 in. mounts, each print embossed in the margin with the estate's seal. Printed posthumously by Thomas A. Brown and Baldwin Lee. Edition of 75 numbered portfolios plus 15 *hors commerce* copies. Selected images, 1929–71 (the first of three projected portfolios.) Published June 1, 1977, by the Estate of Walker Evans, distributed by Lunn Gallery/Graphics International, Ltd. Contains:

1. *Brooklyn Bridge, New York*, ca. 1929;
2. *Luna Park, Coney Island, New York*, 1928;
3. *Roadside, Lewisburg, Alabama*, 1936;
4. *Water Fountain, Havana*, 1932;
5. *Girl in Window, Havana*, 1932;
6. *Lincoln Kirstein, New York*, ca. 1931;
7. *Berenice Abbott, New York*, ca. 1930;
8. *Torn Movie Poster, Truro, Mass.*, 1931;
9. *Billboard Painters, Florida*, 1934;
10. *Church Interior, Alabama*, 1936;
11. *Subway, New York*, 1938;
12. *Woodbridge Monument, Mayfield, Kentucky*, ca. 1945;
13. *Kingston Station, Rhode Island*, 1953;
14. *Santa Monica, Calif.*, 1953;
15. *Robert Frank's Stove, Nova Scotia*, 1971.

The Brooklyn Bridge. New York: Eakins Press Foundation, 1994. 9 hand-pulled photogravures, each sheet measuring 17 x 14 in., printed on Rives BFK paper, made by Jon Goodman from the original negatives lent by the Estate of Walker Evans. Images selected by Leslie Katz. Limited to 100 numbered copies and 15 publisher's proofs, lettered A to O. Each set bound in a cloth box, with 4 pp. of letterpress, including title page, essay by Katz, Hart Crane's prelude "To Brooklyn Bridge," and colophon. Published Feb. 1994.

BOOKS BY OR WITH WALKER EVANS
1930s

Crane, Hart. *The Bridge*. Paris: Black Sun Press, 1930. Three photogravures by WE. Limited ed. of 250 copies, including 50 signed by Crane, plus 25 review copies and 8 special copies lettered A to H. First American ed. New York: Horace Liveright, 1930. One frontispiece halftone and a portrait of Crane on the dust jacket by WE. Second printing later in 1930 contains a different WE frontispiece. A new edition issued in 1970 contains no ills. by WE.

Beals, Carleton. *The Crime of Cuba*. Philadelphia: J. B. Lippincott, 1933. 31 aquatone plates by WE. Reprint. New York: Arno Press, 1970.

African Negro Art: A Corpus of Photographs by Walker Evans Prepared by the Museum of Modern Art, New York, Under a Grant from the General Education Board as a Record of the Exhibition of African Negro Art Directed by James Johnson Sweeney at the Museum, March 18 to May 19, 1935. Typescript prepared by Dorothy Canning Miller. New York: Museum of Modern Art, 1935. 477 original gelatin silver prints by WE, housed in 4 bound vols. Typescript of 45 pp. 14 sets produced. Not for general sale.

Evans, Walker. *American Photographs*. With an essay by Lincoln Kirstein. New York: Museum of Modern Art, 1938. 87 halftones by WE. Reprint, with a foreword by Monroe Wheeler. New York: MoMA, 1962. Reprint. New York: East River Press, 1975. Reprint, with new afterword by Peter Galassi. New York: MoMA, 1988.

1940s

Agee, James, and Walker Evans. *Let Us Now Praise Famous Men: Three Tenant Families*. Boston: Houghton Mifflin, 1941. 31 halftones by WE. Enlarged ed., with 62 halftones and a foreword by WE. Boston: Houghton Mifflin, 1960. Reprint. Boston: Houghton Mifflin, 1981; and 1988, with a new introduction by John Hershey. First British ed. London: Peter Owen, 1965. First American paperback ed. New York: Ballantine Books, 1966 and 1972. First French ed., *Louons maintenant les grands Hommes*. Paris: Librairie Plon, 1972. First German ed., *Preisden will ich die großen Männer*, trans. Karin Graf and Helmut M. Braem-Preis, with 61 halftones by WE. München: Schirmer/Mosel, Feb. 1993.

Evans, Walker. *Wheaton College Photographs*. Foreword by J. Edgar Park. Norton, Mass.: Wheaton College, 1941. 24 halftones by WE.

Bickel, Karl A. *The Mangrove Coast: The Story of the West Coast of Florida*. New York: Coward-McCann, 1942. 32 halftones by WE. Second ed. published without WE illus.

1960s

Evans, Walker. *Many Are Called*. With an introduction by James Agee. Boston: Houghton Mifflin, 1966. 89 halftones by WE.

Evans, Walker. *Message from the Interior*. Afterword by John Szarkowski. New York: Eakins Press, 1966. 12 fine-grain halftones by WE.

Kouwenhoven, John A. *Partners in Banking: An Historical Portrait of a Great Private Bank, Brown Brothers Harriman & Co. 1818–1968*. Garden City, N.Y.: Doubleday, 1968. 55 halftones by WE.

BOOKS ABOUT OR INCLUDING WALKER EVANS
1930s

Ringel, Fred J., ed. *America as Americans See It. Illustrated by over One Hundred American Artists*. New York: Literary Guild, 1932. Frontispiece halftone by WE.

Rivera, Diego. *Portrait of America*. With an explanatory text by Bertram D. Wolfe. New York: Covici, Friede, 1934. Of the murals at Rockefeller Center, several unidentified ills. are by WE.

MacLeish, Archibald. *Land of the Free*. New York: Harcourt, Brace, 1938. 3 halftones by WE. First paperback ed., New York: DaCapo, 1977.

Nixon, Herman Clarence. *Forty Acres and a Steel Mule*. Chapel Hill: University of North Carolina Press, 1938. 8 halftones by WE.

1940s

Anderson, Sherwood. *Home Town: Photographs by Farm Security Administration Photographers*. New York: Alliance Book Corp., 1940. 7 halftones by WE.

Melvin, Bruce L., and Elna N. Smith. *Youth in Agricultural Villages*. Washington, D.C.: Works Progress Administration, Division of Social Research, 1940. 1 halftone by WE.

Pennsylvania: A Guide to the Keystone State. Compiled by Workers of the Writers' Program of the Work Projects Administration in the State of Pennsylvania. New York: Oxford University Press, 1940. 2 ills. by WE.

Alabama: A Guide to the Deep South. Compiled by Workers of the Writers' Program of the Work Projects Administration in the State of Alabama. New York: Richard R. Smith, 1941. 1 ill. by WE.

Raper, Arthur, and Ira De A. Reid. *Sharecroppers All*. Chapel Hill: University of North Carolina Press, 1941. 1 halftone by WE.

Wright, Richard, and Edwin Rosskam. *Twelve Million Black Voices: A Folk History of the Negro in the United States*. New York: Viking, 1941. Dust jacket ill. and 1 halftone by WE.

Brenner, Anita, and George R. Leighton. *The Wind That Swept Mexico: The History of The Mexican Revolution, 1910–1942. Text by Anita Brenner. 184 Historical Photographs Assembled by George R. Leighton*. New York and London: Harper and Brothers, 1943. [WE assisted in the planning of the book and made prints from the historical negatives at his studio.]

Crane, Hart. *The Collected Poems of Hart Crane*. Edited by Waldo Frank. New York: Liveright,

1946. Black and Gold edition. Contains a half-tone portrait of Crane by WE.

1950s

Radin, Paul, and James Johnson Sweeney. *African Folktales and Sculpture.* New York: Pantheon Books, 1952. 165 halftones with 113 by WE. Rev. ed., with 187 halftones, 113 by Evans, 1964. Reissue, two paperback volumes. Radin, Paul. *African Folktales.* Sweeney, James Johnson. *African Sculpture.* Princeton, N.J.: Princeton University Press, 1970. 187 halftones, 113 by WE.

Roy, Claude. *Arts Sauvages.* Paris: Robert Delpire, 1957. 20 ills. by WE. First American ed. *The Art of the Savages,* translated by E. S. Seldon. New York: Griffen Books, 1958.

Soby, James Thrall. *Modern Art and the New Past.* Norman: University of Oklahoma Press, 1957. ["Four Photographers: Walker Evans," pp. 168–72.]

Newhall, Beaumont, and Nancy Newhall, eds. *Masters of Photography.* New York: Castle Books, 1958. 9 ills. by WE. ["Walker Evans," pp. 150–59.]

1960s

Stefferud, Alfred. "The Lean Years." In *After a Hundred Years: The Yearbook of Agriculture 1962,* edited by Alfred Stefferud, pp. 513–24. United States Department of Agriculture. Washington, D.C.: U.S. Government Printing Office, 1962. 1 ill. by WE. [Survey and portfolio of FSA photographers.]

Morgan, Willard D., ed. "Walker Evans: Biography." *Encyclopedia of Photography,* vol. 7. New York: Greystone Press, 1963. 3 ills by WE. [WE discussed pp. 1310–12.]

Elliot, George P. *A Piece of Lettuce.* New York: Random House, 1964. ["Photographs and Photographers," pp. 90–103. Reprinted from Dec. 1962 *Commentary,* discusses FSA, WE, Dorothea Lange, and Edward Weston.]

Sloan, Alfred P., Jr. *My Years with General Motors.* Edited by John McDonald and Catherine Stevens. Garden City, N.Y.: Doubleday and Co., Inc., 1964. [WE served as picture editor for the 95 historical and contemporary ills.]

Crane, Hart. *The Complete Poems and Selected Letters and Prose of Hart Crane.* Edited by Brom Weber. New York: Liveright, 1966. Contains a halftone portrait of Crane by WE. First British ed. London: Oxford University Press, 1968.

Freedgood, Seymour. *The Gateway States: New Jersey, New York.* New York: Time, Inc., 1967. 13 color ills. by WE.

Lomax, Alan, Woody Guthrie, and Pete Seeger. *Hard Hitting Songs for Hard Hitting People.* New York: Oak Publications, 1967. 9 ills. by WE. [Songbook, illustrated with FSA photos.]

Unterecker, John. *Voyager: A Life of Hart Crane.* New York: Farrar, Straus and Giroux, 1969. 3 ills. by WE. [Numerous anecdotes about WE.]

1970s

Walker Evans. Introduction by John Szarkowski. New York: Museum of Modern Art, 1971. 100 halftones by WE. Reissue. MoMA, 1974. First British ed., London: Secker and Warburg, 1972.

Morse, John D., ed. *Ben Shahn.* New York: Praeger, 1972. [Reprints of essays and articles by Ben Shahn or about Ben Shahn. "Chapter VII: Photography," pp. 132–39, contains three articles written by Shahn in which he mentions WE, from whom he learned how to photograph.]

Hurley, F. Jack. *Portrait of a Decade: Roy Stryker and the Development of Documentary Photography in the Thirties.* Baton Rouge: Louisiana State University Press, 1972. 15 ills. by WE.

Lynes, Russell. *Good Old Modern: An Intimate Portrait of The Museum of Modern Art.* New York: Athenaeum, 1973.

Sontag, Susan. *On Photography.* New York: Dell, 1973. [WE mentioned throughout, discussed on pp. 30–31 in "America, Seen Through Photographs, Darkly," pp. 27–48.]

Stott, William. *Documentary Expression and Thirties America.* New York: Oxford University Press, 1973. 31 ills. plus dust jacket by WE. [WE and *Let Us Now Praise Famous Men* extensively discussed in "Part Four: *Let Us Now Praise Famous Men,*" pp. 259–314.]

Stryker, Roy Emerson, and Nancy Wood. *In This Proud Land. America, 1935–1943, As Seen in the FSA Photographs.* Greenwich, Conn.: New York Graphic Society, 1973. 13 ills. by WE.

Walker Evans: Photographs for the Farm Security Administration, 1935–1938. A Catalog of Photographic Prints Available from the Farm Security Administration Collection in the Library of Congress. Introduction by Jerald C. Maddox. New York: Da Capo Press, 1973. 552 halftones by WE. Issued in paperback and in a library binding.

Doherty, Robert J. *Social Documentary Photography in the U.S.A.* Lucerne: C. J. Bucher, 1974. 4 ills. by WE.

The Years of Bitterness and Pride. Farm Security Administration, FSA Photographs, 1935–1943. Walker Evans–Ben Shahn–Dorothea Lange–Marion Post Wolcott–Carl Mydans–Russell Lee–

Jack Delano–Arthur Rothstein–John Vachon. New York: McGraw-Hill, 1975. 38 ills. by WE.

O'Neil, Hank. *A Vision Shared: A Classic Portrait of America and Its People, 1935–1943.* Foreword by Bernarda Shahn; afterword by Paul S. Taylor. Photographs and comments by John Collier, Jack Delano, Walker Evans, Theo Jung, Dorothea Lange, Russell Lee, Carl Mydans, Arthur Rothstein, Ben Shahn, Marion Post Wolcott, John Vachon. New York: St. Martin's Press, 1976. 33 ills. by WE, plus a portrait.

Ferris, Bill, and Carol Lynn Yellin, eds. *Images of the South: Visits with Eudora Welty and Walker Evans.* Memphis, Tenn.: Center for Southern Folklore, 1977. Includes an interview plus 15 ills. by Evans.

Janis, Eugenia Parry, and Wendy MacNeil, eds. *Photography Within the Humanities: John Morris, Paul Taylor, Gjon Mili, Robert Frank, Frederick Wiseman, John Szarkowski, W. Eugene Smith, Susan Sontag, Irving Penn, Robert Coles.* Danbury, N.H.: Addison House Publishers; Wellesley, Mass.: Art Department, Jewett Arts Center, Wellesley College, 1977. [Portrait of WE and dedication of the effort in memory of WE, p. 5; WE discussed as an influence, p. 8; 1 ill. by WE, pp. 55, 62, 143, 150, 151; 2 ills. by WE, pp. 88–89; Robert Frank discusses WE, pp. 61, 63, 65; John Szarkowski discusses WE, p. 90; 1 ill. by WE, p. 118 selected by Susan Sontag as one of nine photos which she suggested for her portion of the accompanying exhibition; Robert Coles discusses WE, pp. 142, 144, 149–150.]

Maddow, Ben. *Faces: A Narrative History of the Portrait in Photography.* Boston: New York Graphic Society/Chanticleer Press, 1977. 5 ills. by WE.

Walker Evans. New York: Fotofolio, 1977. 12 photomechanical postcards by WE, bound in acetate covers.

Walker Evans: First and Last. New York: Harper and Row, 1978. 219 halftones by WE. Deluxe ltd. first ed. of 75 copies in slipcase with a gelatin silver print of *Truckdrivers, New York City,* ca. 1934; printed ca. 1978, embossed with the estate stamp in the margin. First British ed. London: Secker and Warburg, 1978. 219 halftones by WE.

Parry, Pamela Jeffcoat, comp. *Photography Index: A Guide to Reproductions.* Westport, Conn. and London: Greenwood Press, 1979. [Contains listing of photographs by WE published in anthologies and general books.]

Trachtenberg, Alan. *Brooklyn Bridge: Fact and Symbol.* Chicago: University of Chicago Press, 1979. ["A Walker Evans Portfolio," pp. 171–83; "Afterword: Walker Evans's Brooklyn Bridge," pp. 184–93.]

Walker Evans. Introduction by Lloyd Fonvielle. Millerton, N.Y.: Aperture, 1979. 44 halftones by WE. Reprinted 1993.

1980s

Gassner, Hubertus. "Die Reise ins Innere: 'Amerika Den Amerikanern Vorstellen' Die Fotografen der 'Farm Security Administration.'" (Journey into the Interior: 'America Presented to The Americans,' The Photographers of the 'Farm Security Administration.') In *Amerika, Traum und Depression, 1920/40,* edited by E. Gillen and Y. Leonard, pp. 313–52. Berlin, Germany: NGBK, 1980. [WE included.]

Moss, Martha. *Photography Books Index: A Subject Guide to Photo Anthologies.* Metuchen, N.J. and London: Scarecrow Press, 1980. [Contains listing of photographs by WE published in anthologies.]

Black, Patti Carr, ed. *Documentary Portrait of Mississippi: The Thirties: Photographs by Arthur Rothstein, Ben Shahn, Walker Evans, Dorothea Lange, Russell Lee, Marion Post Wolcott.* Jackson: University Press of Mississippi, 1982. 15 ills. by WE. ["Walker Evans in Mississippi," (Portfolio) pp. 28–43; 1 ill. by WE on front cover and reprinted, p. 3 and discussed, pp. 5–6.]

Stokes, Philip. "Walker Evans' Plain Style." In *Three Classic American Photographs, Texts and Contexts,* by James L. Enyeart, Robert D. Monroe, and Philip Stokes, with a foreword by Aaron Scharf. Exeter, England: American Arts Documentation Centre, University of Exeter, 1982.

Walker Evans at Work: 745 Photographs Together with Documents Selected from Letters, Memoranda, Interviews, Notes. With an essay by Jerry L. Thompson. New York: Harper and Row, 1982. 745 halftones from the original negatives by WE. Issued simultaneously in paperback. Second paperback ed., New York: IconEditions, 1994.

Watkins, Charles Alan. "The Blurred Image: Documentary Photography and the Depression South." Ph.D. diss., University of Delaware, 1982. [WE discussed throughout "Appendix I: Walker Evans Photographs by Subject," p. 388. Bibliographical essay, pp. 371–79.]

Appel, Alfred, Jr. *Signs of Life: American Popular Culture from World War II to the Present, Reexamined Through a Close-up Exploration of 109 Photographs, Movie Stills, and Other Images of the Past Five Decades.* New York: Alfred A. Knopf, 1983. 5 ills. by WE. [WE's photograph rephotographed in Lee Friedlander's *Cambridge, MA, 1975.*]

Bowen, Amanda Wick. "Walker Evans' American Photographs." Master's thesis, University of California, Berkeley, 1983.

Dixon, Penelope. Introduction and essays by Fortune Ryan. *Photographers of the Farm Security Administration: An Annotated Bibliography, 1930–1980.* New York: Garland Publishing, 1983. [Contains more than 250 references by or about WE, many of them annotated, organized by type of publication.]

Lockridge, Rebecca Bryant. "Margaret Bourke-White and Walker Evans: A Study of Motive and the Aesthetics of Feminine and Masculine Principles." Master's thesis, Ohio State University, 1983.

Auer, Michele, and Michel Auer. *Encyclopédie Internationale des Photographes de 1939 à Nos Jours / Photographers Encyclopedia International 1839 to the Present.* Hermance, Switzerland: Editions Camera Obscura, 1984. 1 ill. by WE. [Selection titled *Evans, Walker 1903–1975,* with chronology, bibliography, list of exhibitions in English and French.]

Green, Jonathan. *American Photography: A Critical History, 1945 to the Present.* Pictures selected and sequenced by Jonathan Green and James Friedman. New York: Harry N. Abrams, 1984. 10 ills. by WE, 1 in color. [Numerous mentions of WE throughout, plus a portrait of him on p. 41.]

Susman, Warren I. *Culture as History: The Transformation of American Society in the Twentieth Century.* New York: Pantheon Books, 1984. [Walker Evans and *Let Us Now Praise Famous Men* discussed, pp. 178, 182.]

Jussim, Estelle, and Elizabeth Lindquist-Cock. *Landscape as Photograph.* New Haven, Conn.: Yale University Press, 1985. 2 ills. by WE.

Moss, Martha. *Photography Books Index: II. A Subject Guide to Photo Anthologies.* Metuchen, N.J. and London: Scarecrow Press, 1985. [Contains listing of photographs by WE published in anthologies.]

Stoeckle, John D., M.D., and George Abbott White. *Plain Pictures of Plain Doctoring: Vernacular Expression in New Deal Medicine and Photography. 80 Photographs from the Farm Security Administration.* Cambridge, Mass.: MIT Press, 1985. [WE discussed throughout chap. 4, "Ideology and the Vernacular."]

Ward, Joseph Anthony. *American Silences: The Realism of James Agee, Walker Evans, and Edward Hopper.* Baton Rouge: Louisiana State University Press, 1985. Contains "Walker Evans," pp. 115–67.

Agricola, John D. "A Picturesque Approach to an Examination of 'Shelter' in James Agee's and Walker Evans' *Let Us Now Praise Famous Men.*" Ph.D. diss., Ohio University, 1987.

Photography in the American Grain: Discovering a Native American Aesthetic, 1923–1941. Center for Creative Photography, University of Tucson, Arizona, 1987. 8 ills. by WE.

Robinson, Cervin, and Joel Herschman. *Architecture Transformed: A History of the Photography of Buildings from 1839 to the Present.* New York: MIT Press and the Architectural League of New York, 1987. 5 ills. by WE.

Shloss, Carol. *In Visible Light: Photography and the American Writer, 1840–1940.* New York: Oxford University Press, 1987. [Part of the book examines the link between James Agee and WE.]

Suffrin, Mark. *Focus on America: Profiles of Nine Photographers.* New York: Scribner's, 1987. [Biographical essays on nine photographers, written for the younger reader. Included are WE, Mathew Brady, William H. Jackson, Edward Curtis, Lewis Hine, Dorothea Lange, Berenice Abbott, Margaret Bourke-White, and W. Eugene Smith.]

Fleischhauer, Carl, and Beverly W. Brannan. *Documenting America, 1935–1943.* Essays by Lawrence W. Levine and Alan Trachtenberg. Berkeley: University of California Press in association with the Library of Congress, 1988. 25 ills by WE. [WE discussed throughout but mainly in "New York City Block," pp. 128–45.]

Naylor, Colin, ed. *Contemporary Photographers. 2d ed.* Chicago: St. James Press, 1988. 1 ill. by WE. ["Evans, Walker," pp. 283–85, consists of a biographical chronology, list of individual exhibitions, list of selected group exhibitions, list of collections holdings, publications, and an essay on WE by William Stott.]

Turner, Peter, and Gerry Badger. *Photo Texts.* London: Travelling Light, 1988. ["Walker Evans and Lee Friedlander: Photographing Photographs," pp. 53–54. WE discussed in "Seeing Clearly: The Rise of Modernism," pp. 74–87.]

Orvell, Miles. *The Real Thing: Imitation and Authenticity in American Culture, 1880–1940.* Chapel Hill, N.C., and London: University of North Carolina Press, 1989. [*Let Us Now Praise Famous Men* discussed, pp. 272–86.]

Maharidge, Dale, and Michael Williamson. *And Their Children After Them: The Legacy of Let Us Now Praise Famous Men, James Agee, Walker Evans, and the Rise and Fall of Cotton in the South.* Foreword by Carl Mydans. New York: Pantheon Books, 1989.

Mora, Gilles. *Walker Evans: Havana 1933.* Sequence by John T. Hill. London: Thames and Hudson, 1989. 70 halftones from the original negatives by WE. First American ed. New York: Pantheon Books, 1989. First Spanish ed. Valencia, Spain: IVAM Centre Julio Gonzalez, 1989. Lim-

ited ed. of 50 copies of the Pantheon Books ed., each with an original gelatin silver print of *Havana Citizen*, printed by Edward Grazda, issued in 1991, distributed by Distributed Art Publications, New York.

Mora, Gilles. *Walker Evans*. Paris: Belfond/Paris Audiovisuel, 1989.

Trachtenberg, Alan. *Reading American Photographs: Images As History Mathew Brady to Walker Evans*. New York: Hill and Wang, 1989. 42 ills. by WE. Reissue, paperback. New York: Noonday Press, 1990.

Ware, Robert O. "Walker Evans, the Victorian House Project, 1930–1931." Master's thesis, University of New Mexico, 1989.

1 9 9 0 s

Gill, Brendan. *A New York Life: Of Friends and Others*. New York: Poseidon Press, 1990. [Chap. on WE, pp. 302–5.]

Walker Evans. Photo Poche #45. Introduction par Gilles Mora. Paris: Centre National de la Photographie, 1990.

Brix, Michael, and Birgit Mayer, eds. *Walker Evans America*. Essay by Michael Brix. New York: Rizzoli, 1991. 163 ills. by WE.

Guimond, James. *American Photography and the American Dream*. Chapel Hill: University of North Carolina Press, 1991. Cover and frontispiece by WE.

Gassan, Arnold, and A. J. Meek. *Exloring Black and White Photography*. Madison, Wis.: WCB Brown and Benchmark, 1993. 4 ills. of FSA photographs by WE. [WE discussed on pp. 17, 28–29, and 32.]

Mora, Gilles, and John T. Hill. *Walker Evans: The Hungry Eye*. New York: Harry N. Abrams, 1993. 470 ills., including 25 color plates by WE.

Smith, Terry. *Making the Modern: Industry, Art and Design in America*. Chicago and London: University of Chicago Press, 1993. [WE discussed in chap. 8, "Of the People, For the People," pp. 283–328.]

Rylant, Cynthia. *Something Permanent: Photographs by Walker Evans, Poetry by Cynthia Rylant*. San Diego: Harcourt Brace, 1994. 30 ills by WE, plus front and back dust jacket. [Book of photographs and poetry designed for young adults.]

PICTURE ESSAYS AND ARTICLES BY OR WITH WALKER EVANS
1 9 3 0 s

Evans, Walker. "Sky Webs." *USA* (Summer 1930): cover and p. 102. 2 ills. by WE: title image plus Brooklyn Bridge photograph on the cover.

Evans, Walker. "Photographic Studies." *Architectural Record* 68 (Sept. 1930): 193–98. 5 ills. by WE.

Evans, Walker. "New York City." *Hound & Horn* 4 (Oct.–Dec. 1930): following p. 42. 4 ills. by WE.

"Mr. Walker Evans Records a City's Scene." *Creative Art* 7 (Dec. 1930): 453–56. 4 ills. by WE.

Paine, Lyman. "Architecture Chronicle. Is Character Necessary?" *Hound & Horn* 4 (Apr.–June 1931): 411–15. 2 ills. entitled *New School for Social Research* and *The Red Cross Building*.

Wright, Frank Lloyd. "Tyranny of the Skyscraper." *Creative Art* 8 (May 1931): 324–32. 2 ills. by WE.

Evans, Walker. "The Reappearance of Photography." *Hound & Horn* 5 (Oct.–Dec. 1931): 125–28.

Evans, Walker. "South Street: 1932." *Hound & Horn* 6 (Oct.–Dec. 1932). 1 ill. by WE.

Evans, Walker. "Untitled." *Hound & Horn* 6 (Apr.–June 1933): following p. 418. 3 ills. by WE.

Evans, Walker. "Cuba Libre: Photographs." *Hound & Horn* 7 (July–Sept. 1934): following p. 586. 3 ills. by WE.

Evans, Walker. "Hart Crane, Brooklyn, NY, 1929." *Hound & Horn* 7 (July–Sept. 1934): facing p. 682. 2 ills. by WE.

"The Communist Party . . . in the U.S. has only 26,000 recognized members. But you have to add to that number half a million 'sympathizers,' half a dozen rival sects." *Fortune* 10 (Sept. 1934): 69–74, 154, 156, 159, 160, 162. 7 ills. by WE.

[Agee, James.] "The Great American Roadside. Paintings by John Stuart Curry." *Fortune* 10 (Sept. 1934): 53–63, 172, 174–75. 1 ill. credited to WE.

[Agee, James.] "Havana Cruise: Six Days at Sea." *Fortune* 16 (Sept. 1937): 117–20, 210, 212, 214, 216, 219–20. 19 ills. by WE.

"Life In the U.S. . . . Photographic. Mississippi." *Scribner's Magazine* 105 (Apr. 1939): 30–35, 40. 2 ills. by WE: *River Boat* (FSA), p. 30, and *McInerney's*, p. 35.

West, Anthony. "Middletown and Main Street." *Architectural Review* 85 (May 1939): 218–20. 9 ills. by WE.

"Brooklyn and Queens." *Fortune* 20 (July 1939): 144–47, 218, 220, 222, 224. 1 ill. by WE, *View down a street in Brooklyn*, p. 145.

Hamill, Katharine. "2,196 Families are Living in the Williamsburg and Harlem River Housing Projects." *Harper's Bazaar* 72 (Aug. 1939): 100–3, 132. 7 ills. by WE, plus a portrait of him on p. 30 with brief biographical note.

1 9 4 0 s

Agee, James, and Walker Evans. "Colon: From *Let Us Now Praise Famous Men*." *New Directions in Prose and Poetry 1940* (1940): 181–92. 4 ills. by WE.

Evans, Walker. "Main Street, Southern Town." *Survey Graphic* 29 (Jan. 1940): 4 (frontispiece).

"In Bridgeport's War Factories . . . 26,000 defense workers are busy making shells, Tommy guns, airplanes, machine tools. But this time their mood is sober, and the whole town dreads the aftermath." *Fortune* 24 (Sept. 1941): 87–92, 156, 158–62. 15 ills. by WE.

Morris, Alice S. "The Circus at Home. Photographed in Sarasota by Walker Evans." *Harper's Bazaar* 75 (Apr. 1942): 64–65, 116. 3 ills. by WE.

"The Small Shop. It is the philosophy and the pleasure of Mr. and Mrs. Phelps, craftsmen in leather, of New York City. The profits, moreover, are comfortable." *Fortune* 32 (Nov. 1945): 158–61. 1 color and 2 black-and-white ills. by WE.

"The Boom in Ballet. The dancers are gifted. The public response is superb. The bookkeeping is provocative." *Fortune* 32 (Dec. 1945): 180–88, 220, 224, 226, 229. Approx. 8 ills. by WE.

"Collins Co., Collinsville, Connecticut. A phenomenon of Yankee shrewdness and conservatism bids, passes, and survives." *Fortune* 33 (Jan. 1946): 110–15, 193–94. 2 color and 5 black-and-white ills. by WE. [Biographical sketch of WE in "*Fortune*'s Wheel," p. 2.]

"The Criticism of Edwin Denby. Photographs by Walker Evans." *Dance Index* 5 (Feb. 1946): 25–56, cover. 10 ills. by WE.

"Adventures of Henry and Joe in Autoland. The sun shines on Willow Run as Kaiser-Frazer undertakes to make cars, profits, and—who knows?—history." *Fortune* 33 (Mar. 1946): 96–103, 228, 230, 232, 234, 237–38, 240. 9 ills. by WE.

"Homes of Americans—Portfolio. A selection of native designs in many manners and periods." *Fortune* 33 (Apr. 1946): 148–57. 33 ills., 7 by WE. [All others selected by WE from diverse sources, including FSA photos in the Library of Congress, with 4 by Russell Lee, 3 by Jack Delano, 1 by Marion Post Wolcott, 1 by John Vachon, 2 by Arthur Rothstein, etc.]

"The Yankees. The player's the thing, as thousands cheer, but it takes business brains to make even a winning club pay a profit." *Fortune*

34 (July 1946): 130–39, 169, 171, 172, 175, 176. 7 ills. by WE.

"Labor Anonymous. On a Saturday afternoon in downtown Detroit." *Fortune* 34 (Nov. 1946): 152–53. 11 ills. by WE.

Evans, Walker. "Chicago; a camera exploration of the huge, energetic urban sprawl of the midlands. A portfolio by Walker Evans." *Fortune* 35 (Feb. 1947): 112–21. 20 ills. by WE.

"The Rebirth of Ford. Under New Management, The Company is Out to Regain Lost Leadership. . . ." *Fortune* 35 (May 1947): 81–89. 5 ills. by WE.

"One-Newspaper Town. The Sun-Democrat has a monopoly on Paducah's front porches but not on the minds of its readers." *Fortune* 36 (Aug. 1947): 102–7. 11 ills. by WE.

Evans, Walker. "Chicago." *Horizon (London)* (Oct. 1947): 2 leaves between 98–99. 4 ills. by WE.

"The American Bazaar—A picture gallery of the chief activity of Americans—selling things to one another." *Fortune* 36 (Nov. 1947): 108–21. 1 color and 2 black-and-white ills. by WE, pp. 108–9.

"Is the Market Right? While business booms, Wall Street slumps. Is the market now a sound business index? A review of the Street's newest perplexities." *Fortune* 37 (Mar. 1948): 77–83, 193–96. 10 ills. by WE.

Evans, Walker. "'Main Street looking North from Courthouse Square.' A portfolio of American picture postcards from the trolley car period (ca. 1890–1910)." *Fortune* 37 (May 1948): 77–83. 18 postcard ills. from the collection of WE.

Evans, Walker. "In the Heart of the Black Belt. Jacob Lawrence, painter, brings his cotton-country impressions up to date." *Fortune* 38 (Aug. 1948): 88–89. [Text only by WE.]

"Faulkner's Mississippi. The geography of William Faulkner's world, of his ten novels, his short stories, of his new novel, 'Intruder in the Dust.' Six pages of photographs by Walker Evans." *Vogue* (Oct. 1, 1948): 144–49. 14 ills. by WE.

"In the Mississippi of Faulkner's special world. As photographed for *Vogue* by Walker Evans." In "William Faulkner Returns to the Trials of the Youthful Heroine of 'Sanctuary.'" *New York Times Book Review* (ca. Oct. 1948). 1 ill. by WE.

Steichen, Edward. "In and Out of Focus." *U.S. Camera Annual 1949* (1948): 12–13. 6 ills. by WE with the title *Corner of State and Randolph Streets, Chicago*, plus a biographical note.

Evans, Walker. "Summer North of Boston. 'Sacrificing openly to the ivory idol—whose name is leisure,'—Henry James." *Fortune* 40 (Aug. 1949): 74–79. 1 color and 5 black-and-white ills. by WE.

1950s

Evans, Walker. "The Gentle Truckers. With few bad words and little bellowing, they are moving a fabulous amount of freight." *Fortune* 41 (May 1950): 102–6, 134, 136, 139–40, 142–43. 9 ills. by WE.

Evans, Walker. "Along the Right-of-Way. Seven photographs by Walker Evans of middle-western and eastern landscapes seen through train windows." *Fortune* 42 (Sept. 1950): 106–13. 4 color and 3 black-and-white ills. by WE.

Evans, Walker. "Brady's People: Not So Very Dead." *American Society of Magazine Photographers News [Infinity]* 7 (1951): 15. 1 ill. by WE.

Evans, Walker. "Clay. The commonest industrial raw material: a portfolio." *Fortune* 43 (Jan. 1951): 80–88. 6 color and 10 black-and-white ills. by WE.

"Business Roundup: Accuracy of precision-instrument bearings approaches the immeasurable." *Fortune* 43 (Apr. 1951): 19. 2 ills. by WE.

Evans, Walker. "The Wreckers. A note, in photograph and prose, on the ceremony of tearing down a house." *Fortune* 43 (May 1951): 102–5. 1 black-and-white and 6 color ills. by WE.

"Chicago River: The creek that made a city grow." *Fortune* 44 (Aug. 1951): 99–103. 5 black-and-white and 8 color ills. by WE.

"People: Craig of A.T.&.T. Telephone's new president is a company career man." *Fortune* 44 (Nov. 1951): 116–17. 1 color ill. by WE.

"The World of Kennecott—II: Kennecott Copper & Cash." *Fortune* 44 (Nov. 1951): 88–93, 167–68, 170, 172, 175–76. 14 black-and-white and 2 color ills. by WE. [4 candid portraits subtitled "Charles R. Cox in conversational action," pp. 90–91; 4 black-and-white ills. of employees at Kennecott, pp. 162, 167–68.]

"People: McCaffrey of International Harvester." *Fortune* 44 (Dec. 1951): 114–15. 1 color ill. by WE.

Offergeld, Robert. "Flair Visits California." *Flair Annual 1953* (1952): 119–25. 2 ills. by WE.

"Walker Evans at Santa Monica." *Flair Annual 1953* (1952): 126–27. 2 ills. by WE.

"People: Carlton of 3M. New products, new growth, new phase." *Fortune* 45 (Jan. 1952): 92–93. 1 color ill. by WE.

Evans, Walker. "Imperial Washington. A Portfolio by Walker Evans." *Fortune* 45 (Feb. 1952): 94–99. 7 black-and-white and 6 color ills. by WE. [Additional color view, "U.S. Treasury Building, Washington, D.C.," p. 70, and 1 black-and-white ill., "FTC Building," p. 107.]

"Portrait: Cisler of Detroit Edison. The Mid-Century Executive." *Fortune* 45 (Mar. 1952): 122–23. 1 color ill. by WE.

"Portrait: Southern Pacific's Russell. Details, Hard Work, and Tradition." *Fortune* 45 (Apr. 1952): 134–35. 1 color ill. by WE.

"Portrait: Cordiner of General Electric. Reorganization by Pure Reason." *Fortune* 45 (May 1952): 132–33. 1 color ill. by WE.

"U.N. Capitol." *Fortune* 45 (May 1952): 97–99. 7 ills. by WE.

"Portrait: Towe of American Cyanamid. The Art of Informal Management." *Fortune* 45 (June 1952): 124–25. 1 color ill. by WE.

"Portrait: Boeschenstein of Fiberglas. Managing a New Industry." *Fortune* 46 (July 1952): 108–9. 1 color ill. by WE.

"Portrait: McCollum of Continental Oil. Detail Decentralized, Initiative Encouraged." *Fortune* 46 (Sept. 1952): 126–27. 1 color ill. by WE.

"Portrait: Stolk of American Can. Management by Understatement." *Fortune* 46 (Oct. 1952): 148–49. 1 color ill. by WE.

"Portrait: Dial of Union Carbide & Carbon. The Anonymous Pursuit of an Advancing Frontier." *Fortune* 46 (Nov. 1952): 136–37. 1 color ill. by WE.

"Portrait: Stewart of National Dairy. Manager of Managers." *Fortune* 46 (Dec. 1952): 145–45. 1 color ill. by WE.

"Portrait: Ganger of Lorillard. An Advertising Man Takes Over." *Fortune* 47 (Jan. 1953): 104–5. 1 color ill. by WE.

Evans, Walker. "The U.S. Depot: A Portfolio by Walker Evans." *Fortune* 47 (Feb. 1953): 138–43. 2 black-and-white and 8 color ills. by WE.

"Portrait: Hood of U.S. Steel. New President of a New Organization." *Fortune* 47 (Feb. 1953): 146–47. 1 color ill. by WE.

"Portrait: White of the New York Central." 'The *Century* Will Run on Schedule.'" *Fortune* 47 (Mar. 1953): 126–27. 1 color ill. by WE.

Evans, Walker. "Out of Anger and Artistic Passion." *New York Times Book Review*, May 3, 1953. 4 ills. by WE.

Evans, Walker. "Vintage Office Furniture." *Fortune* 48 (Aug. 1953): 123–27. 5 ills. by WE.

"Portrait: McCloy of the Chase. Talent for Conversation." *Fortune* 47 (June 1953): 140–41. 1 color ill. by WE.

"Portrait: Vickers of Sperry Corp. Planning Against Famine." *Fortune* 48 (July 1953): 102–3. 1 color ill. by WE.

"Portrait: Supplee of Atlantic Refining. Not sheer size but strength." *Fortune* 48 (Aug. 1953): 128–29. 1 color ill. by WE.

"Portrait: F. W. Ecker of the Metropolitan. Responsibility to 34 Million People." *Fortune* 48 (Sept. 1953): 126–27. 1 color ill. by WE.

"Portrait: Simpson of the B. & O. 'We Went Out and Got the Business.'" *Fortune* 48 (Nov. 1953): 148–49. 1 color ill. by WE.

"Portrait: Newman of Dun & Bradstreet." *Fortune* 48 (Dec. 1953): 134–35. 1 color ill. by WE.

Evans, Walker. "Portfolio: Over California. An extraordinary set of aerial photographs by William Garnett." *Fortune* 49 (Mar. 1954): 105–12. [Text only by WE.]

Saunders, Dero A. "The Twilight of American Woolen. Amid a swirl of court fights, rump meetings, and last-minute offers, an old New England company has bumbled perilously close to liquidation . . ." *Fortune* 49 (Mar. 1954): 92–96, 198, 200, 202, 204. 4 ills. by WE. [Views of mill buildings.]

"Portrait: Rathbone of Jersey Standard. Business First, Then Statesmanship." *Fortune* 49 (May 1954): 118–19. 1 color ill. by WE.

Evans, Walker. "Test Exposures: Six Photographs from a Film Manufacturer's Files." *Fortune* 50 (July 1954): 77–80. [Portfolio of color photographs by Ansel Adams, Paul Strand, Charles Sheeler, Charles Abbott, and Edward Weston.] [Text only by WE.]

Evans, Walker. "October's Game." *Fortune* 50 (Oct. 1954): 132–37. 10 color ills. by WE.

Evans, Walker, and James Agee. "Rapid Transit: Eight Photographs." *i.e. Cambridge Review* (Winter 1955–56): 16–25. 8 ills. by WE.

Evans, Walker. "Beauties of the Common Tool: A Portfolio." *Fortune* 52 (July 1955): 103–7. 5 ills. by WE.

Evans, Walker. "Portfolio of Victorian Architecture," pp. 37–40. In "In Defense of the Victorian House" by John Maass. *American Heritage* 6 (Oct. 1955): 34–41. 9 ills. by WE.

Evans, Walker. "The Congressional." *Fortune* 52 (Nov. 1955): 118–22. 10 ills. by Robert Frank. [Text only by WE.]

Evans, Walker. "'These Dark Satanic Mills.' The old mill stream is a good place to find some mellow Americana. A portfolio by Walker Evans." *Fortune* 53 (Apr. 1956): 139–46. 10 color ills. by WE.

Evans, Walker. "'Downtown': A last look backward. A portfolio by Walker Evans." *Fortune* 54 (Oct. 1956): 157–62. 9 ills. by WE.

Evans, Walker. "Robert Frank." In *U.S. Camera Annual*, ed. Tom Maloney, p. 90. New York: U.S. Camera, 1957.

Kirstein, Lincoln. "Sources of Inspiration." *Print* 11 (Feb.–Mar. 1957): 56–57. 2 ills. by WE.

Evans, Walker. "Before They Disappear. A portfolio of freight-car emblems." *Fortune* 55 (Mar. 1957): 141–45. 13 color ills. by WE.

Evans, Walker. "The Stones of du Pont. A portfolio by Walker Evans." *Fortune* 55 (May 1957): 167–70. 6 color ills. by WE.

Brown, Joe David. "Henley Forever." *Sports Illustrated* 6 (June 24, 1957): 14–18. 3 color and 1 black-and-white ills. by WE [Views of Henley Regatta.]

"St. Andrews." *Sports Illustrated* 7 (July 1, 1957): 32–34. 3 color ills. by WE

Evans, Walker. "Gallery: Color Accidents." *Architectural Forum* 108 (Jan. 1958): 110–15. 6 color ills. by WE.

Evans, Walker. "Gallery: The London Look." *Architectural Forum* 108 (Apr. 1958): 114–19. 10 ills. by WE.

Evans, Walker. "The Last of Railroad Steam. A Portfolio by Walker Evans." *Fortune* 58 (Sept. 1958): 137–41. 6 ills. by WE.

Evans, Walker. "Pigskin Combat." *Sports Illustrated* 9 (Sept. 22, 1958): 92–93. [Text only by WE; WE comments on oil painting by Hedda Stern.]

Evans, Walker. "Gallery: Ship Shapes and Shadows." *Architectural Forum* 109 (Oct. 1958): 122–25. 5 ills. by WE.

Evans, Walker. "The Pitch Direct: The sidewalk is the last stand of unsophisticated display. A portfolio by Walker Evans." *Fortune* 58 (Oct. 1958): 139–43. 6 color ills. by WE.

Evans, Walker. "And That Is That." *Fortune* 58 (Dec. 1958): 85–88. 7 ills. by WE.

1960s

"Beauties of the Past." *Sports Illustrated* 12 (May 30, 1960): 46–49. 5 color and 1 black-and-white ills. by WE. [Photographs of classic automobiles.]

Evans, Walker. "Books and Men: James Agee in 1936." *Atlantic Monthly* 206 (July 1960): 74–75.

Evans, Walker. "Summer at Harbor Point." *Fortune* 62 (July 1960): 120–23. 14 ills. by WE.

Evans, Walker. "On the Waterfront." *Fortune* 62 (Nov. 1960): 144–50. 9 color ills. by WE.

Evans, Walker. "People and Places in Trouble. A Portfolio by Walker Evans." *Fortune* 63 (Mar. 1961): 110–17. 9 ills. by WE.

Evans, Walker. "Gallery: Primitive Churches." *Architectural Forum* 115 (Dec. 1961): 102–7. 7 ills. by WE.

Evans, Walker. "When 'Downtown' was a Beautiful Mess." *Fortune* 65 (Jan. 1962): 100–6. 9 postcards from the collection of WE.

Evans, Walker. "Walker Evans: the Unposed Portrait." *Harper's Bazaar* 95 (Mar. 1962): 120–25. 8 ills. by WE.

Evans, Walker. "The American Warehouse." *Architectural Forum* 116 (Apr. 1962): 94–98. 4 ills. by WE.

Evans, Walker. "The Auto Junkyard." *Fortune* 65 (Apr. 1962): 132–37. 8 color ills. by WE.

Evans, Walker. "'Come on down.'" *Architectural Forum* 117 (July 1962): 96–100. 7 postcards from the collection of WE.

Evans, Walker. "Those Little Screens. A photographic essay by Lee Friedlander with a comment by Walker Evans." *Harper's Bazaar* 96 (Feb. 1963): 126–29.

Evans, Walker. "Collector's Items. Antiquing yields different rewards for those who browse. To photographer Walker Evans, fascination lies in the compositions of New York City store fronts. Malcolm Bradbury, a professor in Birmingham, England, digs beneath surfaces— and in a recent excavation, wonders if he's uncovered a literary original." *Mademoiselle* 57 (May 1963): 182–85. 5 ills. by WE.

Evans, Walker. "America's Heritage of Great Architecture is Doomed . . . It Must be Saved." *Life* 55 (July 5, 1963): 52–60. 14 ills. by WE.

R[otzler], W[illy]. "amerikanische architektur— gestern." (American Architecture—Yesterday.) *Du* 24 (June 1964): 2–16. 12 ills. by WE.

Evans, Walker. "The Athenian Reach. A Portfolio by Walker Evans." *Fortune* 69 (June 1964): 138–42. 6 ills. by WE.

Evans, Walker. "American Masonry. A Portfolio by Walker Evans." *Fortune* 71 (Apr. 1965): 150–53. 7 color ills. by WE.

Evans, Walker. "Photography." In *Quality, Its Image in the Arts*, ed. Louis Kronenberger, pp. 169–211. New York: Athenaeum, 1969.

1970s

Katz, Leslie. "Interview with Walker Evans." *Art in America* 59 (Mar.–Apr. 1971): 82–89.

Evans, Walker. "'James Agee in 1936,' 'Agee on Photography: from *Let Us Now Praise Famous Men*,' and 'Walker Evans [portfolio].'" *Harvard Advocate* 105 (Feb. 1972): 23–24, 27, 28–34, cover. 7 ills. by WE.

"Dialogue between Walker Evans, Robert Frank, and various students and faculty members of the program in graphic design and photography at Yale University." *Still/3 (Yale)* (1973): 2–6.

Evans, Walker. "The Snap-shot." *Aperture* 19 (1974): 94–95. 2 postcard ills. from collection of WE.

Evans, Walker. "'The Thing Itself' is Such a Secret and So Unapproachable." *Yale Alumni Magazine* 37 (Feb. 1974): 12–16. 2 ills. by WE.

"A Concise Chronology of Instant Photography 1947–1974." *Camera (Lucerne)* 53 (Oct. 1974): 1–58. 1 ill. by WE, p. 44; technical data, p. 57.

"Brother, Can You Spare a Line? How is our current economic situation different from the Depression of the 1930s? Random opinions, from some people who ought to know." *Village Voice* 19 (Dec. 2, 1974): 6–8. 2 ills. by WE: pp. 5, 9. [also, "Walker Evans: Photographer," p. 6.]

Evans, Walker. "Walker Evans on Himself," ed. Lincoln Caplan. *New Republic* 175 (Nov. 13, 1976): 23–27. 1 ill. by WE.

"Walker Evans." In *Artists In Their Own Words*, interviews by Paul Cummings, pp. 82–100. New York: St. Martin's Press, 1979. [1971 interview with WE.]

1980s

Evans, Walker. "Walker Evans, Visiting Artist: A Transcript of his Discussion with the Students of the University of Michigan, 1971." In *Photography: Essays & Images*, ed. Beaumont Newhall, pp. 310–20. New York: Museum of Modern Art, 1980. 6 ills. by WE.

ARTICLES ON WALKER EVANS; REVIEWS OF EXHIBITIONS AND BOOKS

1930s

Knowlton, Walter. "Around the Galleries." Ex. review of *3 American Photographers*, John Becher Gallery, New York. Photographers: Margaret Bourke-White, Ralph Steiner, and WE. *Creative Art* 8 (May 1931): 372–76. [WE discussed, pp. 375–76.]

Jewell, Edward Alden. "Art: One View of 'Surrealisme.'" Ex. review of *Photographs by Walker Evans and George Lynes*, Julien Levy Gallery, New York. *New York Times*, Feb. 1, 1932: 21. ["The 'Surrealisme' show at the Julien Levy gallery has come and gone . . . the gallery has now opened a much less taxing exhibition of modern photography by Walker Evans and George Lynes . . ."]

S[terne], K[atharine] G[rant]. "Art: Photographs That Interest." Ex. review of *Photographs by Walker Evans and George Lynes*, Julien Levy Gallery, New York. *New York Times*, Feb. 4, 1932: 16.

"The Week In New York: Roster of Recently Opened Shows: Julien Levy Gallery." Ex. review of *Photographs by Walker Evans and George Lynes*, Julien Levy Gallery, New York. *New York Times*, Feb. 7, 1932: sect. 8, p. 10.

Armstrong, Henry E. "A First Hand Study of Cuban-American Relations." Book review of *The United States and Cuba*, by Harry F. Guggenheim. *New York Times Book Review*, May 27, 1933: 3, 20. 2 ills. by WE, p. 3. ["The illustrations on this page are from photographs taken by Walker Evans for *The Crime of Cuba*."]

Butcher, Fanny. Book review of *The Crime of Cuba*. *Chicago Daily Tribune*, Aug. 19, 1933: 8.

Gruening, Ernest. "How Cuba Became What She Is Today. Carleton Beals Lays the Blame on the United States and the Platt Amendment." Book review of *The Crime of Cuba*. *New York Herald Tribune Books* 9 (Aug. 20, 1933): 3.

Denny, Harold N. "Cuba, the Crucified Republic. Carleton Beals Indicts the Machado Regime and American Penetration." Book review of *The Crime of Cuba*. *New York Times Book Review*, Aug. 20, 1933: sect. 5, pp. 1, 14. 1 ill. by WE.

Porter, Russell B. "Before Machado Fell." Book review of *The Crime of Cuba*. *Saturday Review* 10 (Aug. 26, 1933): 61, 66.

Cantwell, Robert. "Outlook Book Choice of the Month." Book review of *The Crime of Cuba*. *New Outlook* 162 (Sept. 1933): 53.

"The World of Books: Cuba." Book review of *The Crime of Cuba*. *Review of Reviews* 88 (Sept. 1933): 4. [Although WE is not mentioned, his photographs are discussed.]

Jenks, Leland Hamilton. "Can Cuba Recover?" Book review of *The Crime of Cuba*. *Nation* 137 (Sept. 6, 1933): 275–76.

Buell, Raymond Leslie. "Why Machado Fell." Book review of *The Crime of Cuba*. *New Republic* 76 (Sept. 13, 1933): 135–36.

"Books in Brief." Book review of *The Crime of Cuba*. *Forum and Century* 90 (Oct. 1933): v–vi.

"Classified Books: 900 History." Book review of *The Crime of Cuba*. *Booklist* 30 (Oct. 1933): 44.

Wilson, P. W. "Books of the Month." Book review of *The Crime of Cuba*. *Current History* 39 (Oct. 1933): vi.

Hutchinson, Paul. "October Survey of Books: Cuba Libre?" Book review of *The Crime of Cuba*. *Christian Century* 50 (Oct. 4, 1933): 1241.

Baker, Robert L. "Exploited Cuba." Book review of *The Crime of Cuba*. *Current History* 39 (Nov. 1933): x.

"Book review." Book review of *The Crime of Cuba*. *Cleveland Open Shelf* (Nov. 1933): 11.

Brickell, Herschel. "The Literary Landscape: Our Little Friend Cuba." Book review of *The Crime of Cuba*. *North America* 236 (Nov. 1933): 473–74.

Carter, Burnham. "The Bookshelf." Book review of *The Crime of Cuba*. *Atlantic Monthly* 152 (Nov. 1933): 10, 12, 14.

Herring, Hubert C. "Prelude on Cuba." Book review of *The Crime of Cuba*. *Survey Graphic* 22 (Nov. 1933): 568.

Jones, Chester Lloyd. "Book Reviews and Notices." Book review of *The Crime of Cuba*. *American Political Science Review* 27 (Dec. 1933): 1013–14.

Kirstein, Lincoln. "Walker Evans' Photographs of Victorian Architecture." *Museum of Modern Art Bulletin* 1 (Dec. 1933): 4. 1 ill. by WE.

Inman, Samuel Guy. "New Books in Review: A Sordid Crime." Book review of *The Crime of Cuba*. *Yale Review* 23 (Dec. 1933): 405–7.

Langer, William L. "Some Recent Books: Latin America." Book review of *The Crime of Cuba*. *Foreign Affairs* 12 (Jan. 1934): 352.

"New Books: Shorter Notices." Book review of *The Crime of Cuba*. *Catholic World* 138 (Jan. 1934): 505.

"Photographic Corpus." *Museum of Modern Art Bulletin* 2 (Mar.–Apr. 1935): 8. [Notice that the Museum is preparing 14 sets of photographs taken by WE of the exhibition *African Negro Art*, to be known as the *Photographic Corpus of African Negro Art*, financed by the General Education Board.]

Devree, Howard. "In the Galleries—A Reviewer's Week." Ex. review of *Antigraphic Photography*, Julien Levy Gallery, New York, Apr. 23–May 7, 1935. *New York Times*, Apr. 28, 1935: sect. 10, p. 7. [Ex. included WE, Henri Cartier-Bresson, and Manuel Alvarez Bravo.]

Steichen, Edward. "The FSA Photographers." In *U.S. Camera Annual 1939*, pp. 43–66. New York: U.S. Camera, 1938. 3 ills. by WE.

Newhall, Beaumont. "Documentary Approach to Photography." *Parnassus* 10 (Mar. 1938): 2–6.

"The South—A Great Agricultural and Rising Industrial Region." *Building America: Illustrated Studies of Modern Problems* 3 (May 1938): 12–13. 1 ill. by WE, p. 13.

McCausland, Elizabeth. "Rural Life in America as the Camera Shows It." Book review of *American Photographs*, reviewed with exhibition, *Documents of America. Springfield (Mass.) Sunday Union and Republican*, Sept. 11, 1938: 6E.

Jewell, Edward Alden. "Art: Three Exhibitions in Modern Museum: . . . Evans Pictures Shown . . ." Ex. review of *American Photographs*, reviewed with *Georges Rouault* and *100 Useful Objects. New York Times*, Sept. 28, 1938: 22.

"Walker Evans' Show at Museum of Modern Art." Ex. announcement of *American Photographs*, Museum of Modern Art, New York. *Photo Notes (Photo League, New York)* (Oct. 1938): 2.

"Books." Book review of *American Photographs. Boston Transcript*, Oct. 1, 1938: 1.

Jewell, Edward Alden. "Camera: Aspects of America in Three Shows." Ex. review of *American Photographs*, Museum of Modern Art, New York. *New York Times*, Oct. 2, 1938: sect. 9, p. 9. 2 ills. by WE. [Reviewed with two concurrent exhibitions.]

"Art: Recorded Time." Ex. and book review of *American Photographs*, Museum of Modern Art, New York. *Time* 32 (Oct. 3, 1938): 43. 1 ill. by WE.

Davidson, Martha. "New Exhibitions of the Week: Evans' Brilliant Camera Records of Modern America." Ex. review of *American Photographs*, Museum of Modern Art, New York. *Artnews* 37 (Oct. 8, 1938): 12–13.

Williams, William Carlos. "Sermon with a Camera." Book review of *American Photographs. New Republic* 96 (Oct. 12, 1938): 282–83.

"Briefly Noted: General." Book review of *American Photographs. New Yorker* 14 (Oct. 15, 1938): 71.

Coates, Robert M. "The Art Galleries: Americans in Photographs and in Rebuttal—Rouault." Ex. review of three exhibitions held simultaneously at the Museum of Modern Art, New York: *Useful Objects Under Five Dollars, Rouault Prints*, and *American Photographs by Walker Evans. New Yorker* 14 (Oct. 15, 1938): 53–54.

Vechten, Carl Van. "Born to Use a Lens. If All America Except Evans' Photographs Were Razed They Would Tell Our Story." Book review of *American Photographs. New York Herald Tribune Books* 15, Oct. 16, 1938: 4. 1 ill. by WE.

Rogers, John William. "Odd Photographs on Exhibition in New York Museum." Ex. review of *American Photographs*, Museum of Modern Art, New York. *Dallas Times-Herald*, Oct. 30, 1938: n.p. 4 ills. by WE.

Seitlin, Percy. "Book Reviews." Book review of *American Photographs. PM (New York)* 4 (Oct.–Nov. 1938): 77–79. 3 ills. by WE.

Roosevelt, Eleanor. "My Day: Pictures Tell the Story of Mankind's Soul." Book notice of *American Photographs. Washington News (D.C.)*, 1938: n.p.

Wheeler, Dinsmore. "Cross-Country Camera." Book review of *American Photographs. Partisan Review* 6 (Fall 1938): 120.

"Books: American Photographs by Walker Evans." Book and ex. review, plus a letter of response from Glenway Wescott. *U.S. Camera* 1 (Autumn 1938): 47, 64.

Mabry, Thomas Dabney. "Walker Evans' Photographs of America." Book review of *American Photographs. Harper's Bazaar* 71 (Nov. 1, 1938): 84–85, 140. 3 ills. by WE.

Williamson, Samuel T. "American Photographs by Walker Evans." *New York Times Book Review*, Nov. 27, 1938: sect. 6, p. 6.

"Book Reviews: *American Photographs*." *American Photography* 32 (Dec. 1938): 919.

"The Revealing Lens: Photographs by Walker Evans." Ex. review of *American Photographs*, Museum of Modern Art, New York. *Survey Graphic* 27 (Dec. 1938): 612–13. 4 ills. by WE.

Seldes, Gilbert. "The Lively Arts: No Soul in the Photographs. Walker Evans' pictures are not posed, nor bitterly candid; they simply show American people and places as they are." Book review of *American Photographs. Esquire* 10 (Dec. 1938): 121, 242–43. 1 ill. by WE.

Whiting, F. A., Jr. "New Books on Art: Walker Evans." Book review of *American Photographs. Magazine of Art* 31 (Dec. 1938): 720–22. 1 ill. by WE.

Stonier, G. W. "Book Reviews and Notices." Book review of *American Photographs. New Statesman and Nation* n.s. 16 (Dec. 10, 1938): 1018, 1020.

Lorentz, Pare. "Putting America on Record." Book review of *American Photographs. Saturday Review* 19 (Dec. 17, 1938): 6. [Three books reviewed, including *American Photographs*.]

Blakeston, Oswell. "Reviews of Books." Book review of *American Photographs. Life and Letters Today* 20 (Jan. 1939): 99–100.

"American Faces: Photographs from the Farm Security Administration." *Survey Graphic* 28 (Feb. 1939): 98–100. 1 ill. by WE, p. 100.

"Books: *American Photographs*." *London Studio* 117 (Feb. 1939): 88.

Kellogg, Paul, ed. "American Faces. Calling America: A Special Number of Survey Graphic on the Challenge to Democracy." *Survey Graphic* (ca. 1939): 44–46. 1 ill. by WE, p. 45. [This seems to be a compilation issue, taken from earlier issues. FSA photos from Feb. 1939 issue.]

King, Alexander. "Minority Report on Documentation." *Minicam Photography* 2 (May 1939): 34–39, 75–79. 4 ills. by WE.

1940s

Howe, Hartley E. "You Have Seen Their Pictures." *Survey Graphic* 29 (Apr. 1940): 236–38. 1 ill. by WE. [FSA photos].

"The Small Town—A New Book Presents Great Pictures of Rural America by the U.S. Government." Book review of *Home Town* by Sherwood Anderson, with FSA photos. *P.M.'s Weekly* (Oct. 13, 1940): 46–49. 2 ills. by WE.

Stoney, George C. "No Room in Green Pastures." *Survey Graphic* 30 (Jan. 1941): 14–20. 1 ill. by WE. [FSA photos].

Brown, Robert W. "Photos Join Paintings in Museum of Modern Art." *Popular Photography* 8 (Feb. 1941): 38, 110. [Notes that photographs by WE available with others in the show of 51 prints, *Circulating Exhibition 35*, now available from the museum.]

"Museum of Modern Art's Photo Department." *U.S. Camera* 1 (Feb. 1941): 28, 82. [WE mentioned, p. 28 in *Sixty Photographs*; discussed, p. 82 in *Photography at the Museum of Modern Art*.]

"'Sixty Photographs.'" Ex. review of *Sixty Photographs*, Museum of Modern Art, New York. *Photo Notes (Photo League, New York)* (Mar.–Apr. 1941): 4. [WE listed as having 3 photos in the exhibition.]

Stanley, Edward. "Roy Stryker—Photographic Historian." *Popular Photography* (July 1941): 28–29. 1 ill. by WE.

Etzkorn, Leo R. "New Book Survey: Subject Books." Book review of *Let Us Now Praise Famous Men. Library Journal* 66 (Aug. 1941): 667.

Thompson, Ralph. "Books of the Times." Book review of *Let Us Now Praise Famous Men. New York Times*, Aug. 19, 1941: 19. 1 ill. by WE.

Rodman, Selden. "The Poetry of Poverty." Book review of *Let Us Now Praise Famous Men. Saturday Review* 24 (Aug. 23, 1941): 6. 1 ill. by WE.

Lechlitner, Ruth. "Alabama Tenant Families." Book review of *Let Us Now Praise Famous Men. New York Herald Tribune Books* 17 (Aug. 24, 1941): 10.

Pippett, Roger. "Books: Farm-Tenant Misery Shown in Full Scale." Book review of *Let Us Now Praise Famous Men. P.M.'s Weekly* 2 (Sept. 7, 1941): 42. 1 ill. by WE.

Cort, John C. "Contemporary Social Problems." Book review of *Let Us Now Praise Famous Men. Commonweal* 34 (Sept. 12, 1941): 499–500.

"Briefly Noted: General." Book review of *Let Us Now Praise Famous Men. New Yorker* 17 (Sept. 13, 1941): 75.

Breit, Harvey. "Cotton Tenantry." Book review of *Let Us Now Praise Famous Men. New Republic* 105 (Sept. 15, 1941): 348, 350.

Thompson, E. C. "Books." Book review of *Let Us Now Praise Famous Men. Churchman* 155 (Sept. 15, 1941): 19.

"Books." Book review of *Let Us Now Praise Famous Men. Springfield (Mass.) Republican*, Sep. 21, 1941: sect. E, p. 7.

Barker, George. "Books and the Arts: Three Tenant Families." Book review of *Let Us Now Praise Famous Men. Nation* 153 (Sept. 27, 1941): 282.

"Books." Book review of *Let Us Now Praise Famous Men. Time* 38 (Oct. 13, 1941): 104.

Herbst, Josephine. "Books." Book review of *Let Us Now Praise Famous Men. Decisions* 2 (Nov.–Dec. 1941): 112–15.

"Current Publications Received." Book review of *Let Us Now Praise Famous Men. Social Studies* 32 (Dec. 1941): 378.

Trilling, Lionel. "Books: Greatness with One Fault in It." Book review of *Let Us Now Praise Famous Men. Kenyon Review* 4 (Winter 1942): 99–102.

Goodman, Paul. "Books: *Let Us Now Praise Famous Men*." Book review of *Let Us Now Praise Famous Men. Partisan Review* 9 (Jan.–Feb. 1942): 86–87.

Stryker, Roy E. "Documentary Photography." *Complete Photographer* 4 (Apr. 10, 1942): 1364–74. 1 ill. by WE, p. 1368, and another titled *Sheriff of Duncan, Arizona*, p. 1370. [FSA photographers.]

van Gelder, Robert. "West Florida as the Last Frontier." Book review of *The Mangrove Coast. New York Times Book Review*, Apr. 19, 1942: 2.

Busch, Arthur J. "Fellowships for Photographers: Grants from the Guggenheim Foundation enable photographers of outstanding ability to devote a full year to creative work." *Popular Photography* 11 (Oct. 1942): 22–23, 82–83.

"Negroes and the Commonweal." *Survey Graphic* 31 (Nov. 1942): 49. 1 ill. by WE.

Fitzgerald, Robert. "Reviews." Book review of *Let Us Now Praise Famous Men. Furioso* 2 (1943): 36–39.

Kavan, Anna. "Selected Notices." Book review of *Let Us Now Praise Famous Men. Horizon (London)* 9 (Apr. 1944): 285.

"Art: Puritan Explorer." Ex. review of *Walker Evans*, Art Institute of Chicago. *Time* 50 (Dec. 15, 1947): 73. 1 ill. by WE.

Weiner, Dan. "50 Photographs by 50 Photographers." Ex. review of *50 Photographs by 50 Photographers*, Museum of Modern Art, New York. *Photo Notes (Photo League, New York)* (Fall 1948): 31–33. [WE mentioned, p. 32.]

"Photographs by Walker Evans." *J. B. Speed Art Museum Bulletin (Louisville, Ky.)* 9 (Mar. 1948): 2.

"Fortune's Wheel: Freewheeling Cameraman." *Fortune* 37 (May 1948): 32. 1 ill. by WE.

Newhall, Beaumont. "Shooting Straight. The history of documentary photography, and how it has influenced camera work." *Modern Photography* 13 (Sept. 1949): 44–51, 102, 106.

1950s

"Man-made America." *Architectural Review* 108 (Dec. 1950): 338–414. [Special issue devoted to this topic. 1 ill. titled *Main Street, with WWI statue* by WE used as frontispiece on p. 338; 2 on p. 353 and 1 on p. 363 also credited to WE.]

"Photography at the Museum of Modern Art." *Museum of Modern Art Bulletin* 19 (1952): 1–24. [1 ill., p. 12, depicting a panel of several photographs taken in Chicago by WE.]

"A Fortune Album. Twenty-five years of industrial photography." *Fortune* 51 (Jan. 1955): 72–81. 1 color ill. by WE.

Deschin, Jacob. "Social Document: F.S.A. Anniversary Show At Brooklyn Museum." *New York Times*, Mar. 6, 1955: sect. 2, p. 16.

Soby, James Thrall. "Walker Evans." Ex. review of *Diogenes with a Camera III*, Museum of Modern Art, New York. *Saturday Review* 39 (Feb. 18, 1956): 28–29. 2 ills. by WE.

Newhall, Beaumont. "Photography as Art in America." *Perspectives U.S.A.* (Spring 1956): 122–33. 1 ill. by WE.

Frank, Robert. "A Statement . . ." In *U.S. Camera Annual 1958*, ed. Tom Maloney, p. 115. New York: U.S. Camera, 1957.

White, Minor. "Book Reviews: Three 1958 Annuals." *Aperture* 5 (1957): 172–73. [WE's defense of Robert Frank's *The Americans* acknowledged and praised by White.]

1960s

Smith, Henry Holmes. "Concerning Significant Books: Two For the Photojournalists." Book reviews of *Let Us Now Praise Famous Men* and *American Photographs. Aperture* 8 (1960): 188–92.

"The Lean Thirties." *Harvester World* (Feb.–Mar. 1960): cover, 6–15. 2 ills. by WE [FSA photographs].

Hicks, Granville. "Not for Casual Giving." Book review of *Let Us Now Praise Famous Men. Saturday Review* 43 (Dec. 3, 1960): 21.

Grigsby, Gordon K. "The Photographs in the First Edition of *The Bridge*." *Texas Studies in Literature and Language* 4 (Spring 1962): 5–11. 3 ills. by WE.

Canaday, John. "Art: Camera Vs. Painter. A Tired Question Is Still a Basic One." *New York Times*, June 10, 1962: sect. 2, p. 10.

Deschin, Jacob. "Photography: Portrait of an Era. *American Photographs* by Evans Reissued." *New York Times*, June 10, 1962: sect. 2, p. 12. 1 ill. by WE.

Weiss, Margot. Book review of *American Photographs. Infinity* 11 (Sept. 1962): 13.

Soby, James Thrall. "The Muse Was Not for Hire." Book review of *American Photographs. Saturday Review* 45 (Sept. 22, 1962): 57–58. 2 ills. by WE.

Doherty, Robert J. "USA/FSA: Farm Security Administration Photographs of the Depression Era." *Camera (Lucerne)* 41 (Oct. 1962): 9–51. 5 ills. by WE. [FSA photographs.]

Hammarlund, Roger T. "Portrait of an Era: These are the pictures that altered America— the searching, seeking, uncensored views of the lean years that truely interpret the conditions of an impoverished land and its people." *U.S. Camera* 25 (Nov. 1962): 68–75, 88. 2 ills. by WE. [FSA photographs.]

Herbst, Josephine. "Books: The Daybooks of Edward Weston; Walker Evans, American Photographs." *Arts Magazine* 37 (Nov. 1962): 62–64. 1 ill. by WE.

Massar, Phyllis Dearborn. "Faces, Houses, and Streets." Book review of *American Photographs*. *Progressive Architecture* 43 (Nov. 1962): 188, 191.

Elliott, George P. "Things of This World." Book review of *American Photographs. Commentary* 34 (Dec. 1962): 540–43.

"President Gave Retroactive Pay." *New York Times*, Jan. 14, 1965: 38. [Announcement that President Johnson has initiated a "White House program of photography." Agency heads ordered to submit three photographs a month detailing their programs and activities, these images to be reviewed by an expert panel of four photographers: WE, Ansel Adams, W. Eugene Smith, and John Szarkowski.]

"FSA Historische Bilddokumente aus den USA." *Fotografie (Leipzig)* 19 (July 1965): 246–51. 1 ill. by WE.

"What Agee found in Alabama in 1936." Book review of first British ed. of *Let Us Now Praise Famous Men*, published by Peter Owen. *Times Literary Supplement (London)* 64 (July 15, 1965): 598. 1 ill. by WE.

"The John Simon Guggenheim Memorial Foundation Fellows in Photography 1937–1965." *Camera (Lucerne)* 45 (Apr. 1966): 5, 12–13. 2 ills. by WE.

"Newsfront: Two books and an exhibit honor Walker Evans." Ex. and book reviews of *Many Are Called* and *Message from the Interior. Popular Photography* 59 (Dec. 1966): 13–14.

Scherman, David E. "Things and People." Book reviews of *Many Are Called* and *Message from the Interior. New York Times Book Review*, Dec. 4, 1966: sect. 7, p. 2–3, 46.

"The Talk of the Town: The Art of Seeing." *New Yorker* 42 (Dec. 24, 1966): 26–27. [Discussion of books by WE, his reception at the Museum of Modern Art "a few days ago," etc.]

Rauc, Robert. "Beaucoup d'appels." Book review of *Many Are Called. Techniques Graphiques* (1967): 182.

Campbell, Lawrence. "Show at Schoelkopf Gallery." Ex. review of *Walker Evans*, Schoelkopf Gallery, New York. *Artnews* 65 (Jan. 1967): 12.

"Briefly Noted: General." Book review of *Message from the Interior. New Yorker* 42 (Jan. 7, 1967): 95–96.

Wallace, George. "Exhibition at the Norman Mackenzie Art Gallery." Ex. review of *Walker Evans, American Photographs. Artscanada* (Jan. 24, 1967): supp., p. 5.

Tillim, Sidney. "Walker Evans: Photography as Representation. 'Photography shapes time, not things.'" *Artforum* 5 (Mar. 1967): 14–18. 8 ills. by WE.

Sylvester, David. "Walker Evans: A World of Stillness and Silence." *Sunday Times Magazine (London)*, Mar. 31, 1968: 36–41. 8 ills. by WE.

1970s

"Gallery: Walker Evans' Flavor of the Past." *Life* 69 (Aug. 14, 1970): 6–9. 3 ills. by WE.

Kramer, Hilton. "An Era Lives in Photos at Evans Show." Ex. review of *Walker Evans*, Museum of Modern Art, New York. *New York Times*, Jan. 28, 1971: 42. 1 ill. by WE.

Kramer, Hilton. "The Best In Their Line." Ex. review of *Walker Evans*, Museum of Modern Art, New York. *New York Times*, Feb. 7, 1971: sect. 2, p. 21. 1 ill. by WE. [Reviewed with Henri Cartier-Bresson exhibition.]

Coleman, A. D. "Photography: Did He Find the Real U.S.A.?" Ex. review of *Walker Evans*, Museum of Modern Art, New York. *New York Times*, Feb. 14, 1971: sect. 2, p. 38.

Gruen, John. "Galleries & Museums: The Lean and Hungry Look." Ex. review of *Walker Evans*, Museum of Modern Art, New York. *New York* 4 (Feb. 15, 1971): 59. 1 ill. by WE.

"Comment: Walker Evans Returns." Ex. review of *Walker Evans*, Museum of Modern Art, New York. *Design* (Mar. 1971): 18. 2 ills. by WE.

McQuade, Walter. "Life Photography Review: Visual clues to who we were, and are. A Walker Evans retrospective." *Life* 70 (Mar. 5, 1971): 12. 5 ills. by WE.

Dennis, Landt. "People: Raising the Photograph to True Art." *Christian Science Monitor* 63 (Mar. 12, 1971): 19. 4 ills. by WE.

Weiss, Margaret R. "Double Documentary." Ex. review of *Walker Evans*, Museum of Modern Art, New York. *Saturday Review* 54 (Mar. 13, 1971): 84–85. 2 ills. by WE. [Reviewed with *W. Eugene Smith*, Jewish Museum, New York.]

Rice, Leland. "Photography: Walker Evans." Book review of *Walker Evans. Artweek* 2 (Apr. 17, 1971): 7.

Hoshino, Marvin. "Walker Evans at the Museum of Modern Art." *Infinity* 20 (June 1971): 4–10, cover. 8 ills. by WE.

Lanes, Jerrold. "Walker Evans: The Image as Process and as Subject." *Artforum* 9 (June 1971): 74–75. 4 ills. by WE.

Cohen, Stu. "Photography and the Farm Security Administration." *Boston Review of the Arts* 1 (June 20, 1971): 19–30, cover. 1 ill. by WE.

Coke, Van Deren. "Notes on Walker Evans and W. Eugene Smith." *Art International* 15 (June 20, 1971): 56–59. 6 ills. by WE.

Sobieszek, Robert. "Another Look at Walker Evans." *Art In America* 59 (Nov.–Dec. 1971): 120–122. 3 ills. by WE.

Kramer, Hilton. "Second Evans Retrospective—Smaller but Powerful." Ex. review of *Walker Evans*, Yale University Art Gallery, New Haven, Conn. *New York Times*, Dec. 10, 1971: 50. 1 ill. by WE.

Allen, Henry. "An Informal Shot Of Walker Evans. Walker Evans: 'What An Artist Is Doing Is a Very Arrogant Thing.'" *Washington Post*, Apr. 22, 1972: B1, B2. 1 ill. by WE. [Report on a talk WE gave to a class at the Corcoran School of Art.]

"Farm Security Administration: The Compassionate Camera. Photographs from the files of the U.S. Farm Security Administration to be exhibited at the Victoria and Albert Museum, 21 February to 25 March 1973." *Creative Camera* (Mar. 1973): 84–93. 2 ills. by WE.

Kramer, Hilton. "Other Exhibitions This Week: Walker Evans." Ex. review of *Walker Evans*, Robert Schoelkopf Gallery, New York. *New York Times*, Apr. 28, 1973: 20.

"Exhibitions." Ex. review of *Walker Evans*, Robert Schoelkopf Gallery, New York. *Artnews* 72 (Summer 1973): 98.

Stryker, Roy, and Nancy Wood. "In This Proud Land." *American Heritage* 34 (Aug. 1973): 40–55, 81. 2 ills. by WE. [Story of FSA photographers.]

Cathcart, Linda. "Review 7: USA." Ex. review of *Walker Evans*, Robert Schoelkopf Gallery, New York. *Studio International* 186 (Sept. 1973): 103.

Kramer, Hilton. "The New Discovery of America: *Documentary Expression and Thirties America—In This Proud Land*." Book review of *Documentary Expression and Thirties America* by William Stott and *In This Proud Land* by Roy Stryker and Nancy Wood. *New York Times Book Review*, Jan. 20, 1974: sect. 7, p. 4–5. 1 ill. by WE. [FSA photograph.]

Stott, William. "Visions of America." *Harper's* 248 (Feb. 1974): 81.

"Edward Grazda." *Camera* 53 (May 1974): 38–44. [WE and Robert Frank mentioned as influences.]

Bostick, Christina. "Photography." Book review of *Walker Evans: Photographs for the Farm Security Administration, 1935–1938. Library Journal* 99 (May 1, 1974): 1292–93.

"Humanities: Art." Book review of *Walker Evans: Photographs for the Farm Security Administration, 1935–1938. Choice* 11 (Sept. 1974): 929.

Murray, Joan. "Walker Evans' Images of America." Ex. review of *Walker Evans*, Highland Gallery, San Francisco. *Artweek* 5 (Nov. 23, 1974): 11. 1 ill. by WE.

Stott, William. "Walker Evans, Robert Frank, and the Landscape of Dissociation." *Artscanada* 31 (Dec. 1974): 83–89. 2 ills. by WE.

Mellow, James R. "Walker Evans Captures the Unvarnished Truth." Ex. review of *Walker Evans*, Robert Schoelkopf Gallery, New York. *New York Times*, Dec. 1, 1974: sect. D, pp. 37–38. 1 ill. by WE.

White, Robert. "Faces and Places in the South in the 1930s: A Portfolio." *Prospects: An Annual Journal of American Cultural Studies* 1 (1975): 415–29, plus 32 unnumbered pages between pp. 416–17. 10 ills. by WE.

Shipman, Dru. "Publications: The Literature of Photography." Book review of *The Crime of Cuba*, p. 22. *Exposure* 13 (Feb. 1975): 20–25.

Hellman, Roberta, and Marvin Hoshino. "Photography: What Frank Saw." *Village Voice* 20 (Feb. 3, 1975): 98. [WE and Robert Frank and their influence on younger photographers.]

Rosler, Martha. "Lee Friedlander's Guarded Strategies." *Artforum* 13 (Apr. 1975): 46–53. 2 ills. by WE.

"Elegiac Camera." *New York Times*, Apr. 11, 1975: 31. 1 ill. by WE. [Brief elegiac statement, companion piece to the obituary, p. 28.]

Whitman, Alden. "Walker Evans Dies: Artist With Camera." *New York Times*, Apr. 11, 1975: 28. 1 ill. by WE plus brief note, "Walker Evans Dies," p. 1.

Pritchard, Peter. "Top photographer Walker Evans dies." *Democrat and Chronicle (Rochester, N.Y.)*, Apr. 12, 1975: sect. C, p. 1. 1 ill. by WE.

Kramer, Hilton. "Art View: Walker Evans: A Devious Giant." *New York Times*, Apr. 20, 1975: D1, D33. 1 ill. by WE.

Hellman, Roberta, and Marvin Hoshino. "Walker Evans 1903–1975." *Village Voice* 20 (Apr. 21, 1975): 97.

"The Talk of the Town: Notes and Comment: Walker Evans." *New Yorker* 51 (Apr. 21, 1975): 30.

Lloyd, Valerie. "To Walker Evans in Praise of his Life 1903–1975." *British Journal of Photography* 122 (Apr. 25, 1975): 348–53, cover.

"Walker Evans Dies." *Artweek* 6 (Apr. 26, 1975): 12.

Fondiller, Harvey V. "Shows We've Seen." Ex. review of *Walker Evans, Russell Dritsch, Jean-Claude Gautrand—Three Contrasts*, Neikrug

Galleries, New York. *Popular Photography* 76 (June 1975): 48, 113.

McBride, Stewart Dill. "Living Today—Catching It In Black & White." *Times Union*, June 5, 1975: 15.

Hellman, Roberta, and Marvin Hoshino. "Photography: Anthropologist With a Camera." *Village Voice* 20 (June 9, 1975): 99–100.

"Walker Evans '22." *Andover Bulletin* 69 (Summer 1975): 24. [Obituary.]

Deschin, Jacob. "Walker Evans 1903–1975." *Popular Photography* 77 (Aug. 1975): 107. [Obituary, with portrait.]

"Photographie: Paris. La photographie de la banalité." Ex. review of *Walker Evans*, Centre Culturel Americain, Paris. *L'Oeil*, Nov. 1975: 71.

"The Evans No One Remembers." *Time-Life Photography Year 1976* (New York: Time-Life Books, 1976), pp. 222–27. 2 color and 3 black-and-white ills. by WE from *Fortune* articles.

Shipman, Dru. "Publications: Comparative review of monographs." *Exposure* 14 (1976): 16–29. [Annotated bibliographical essay lists and describes seven books, p. 26: *American Photographs, The Crime of Cuba, Let Us Now Praise Famous Men, Many Are Called, Message from the Interior, Walker Evans, Walker Evans: Photographs for the F.S.A.*]

Wainwright, Loudon. "Walker Evans—A Crusty Colossus." *Time-Life Photography Year 1976* (New York: Time-Life Books, 1976), pp. 218–21. 4 FSA ills. by WE.

Kozloff, Max. "Photos within Photographs." *Artforum* 14 (Feb. 1976): 34–39. [WE discussed, pp. 36–37.]

Westerbeck, Colin L., Jr. "How Others Live: Some Recent Photography Books." *Artforum* 15 (Sept. 1976): 40–45.

Brundin, J. "Walker Evans, Photographs." Ex. review of *Walker Evans*, Museum of Modern Art, Oxford. *Arts Review (U.K.)* 28 (Oct. 1, 1976): 515.

Badger, Gerry. "Walker Evans and The Art of the Real, Part I." *British Journal of Photography* 123 (Nov. 5, 1976): 978–80. 2 ills. by WE.

Badger, Gerry. "Walker Evans and The Art of the Real, Part II." *British Journal of Photography* 123 (Nov. 12, 1976): 992–94. 3 ills. by WE.

Bunnell, Peter C. "An Introduction to Evans' Work and His Recollections." *New Republic* 175 (Nov. 13, 1976): 27–29.

Honnef, Klaus. "Fotografie auf der *Documenta 6*. Das Spektrum der fotografischen Möglichkeiten. 3. Fotografische Methoden 3.2. Systema-

tische Bestandsaufnahme." *Kunstforum International* 22 (1977): 251–87. 13 ills. by WE. [Portfolios by WE, Dixon & Boole, Atget, Zille, Curtis, Brassaï, Lange, R. Lee, Parks, Rothstein, Shahn. Special issue of this journal functioned as the catalogue for the *Documenta 6* exhibition held in Kassel, Germany.]

Kempf, Michel. "Hommage à sept grands disparus." *Photo Revue (Paris)* (Jan. 1977): 56–59. [Obituaries of WE, Wynn Bullock, Paul Strand, Imogen Cunningham, Minor White, Josef Sudek, and Man Ray.]

Jeffrey, Ian. "Photography." Ex. review of *Walker Evans*, Museum of Modern Art, Oxford. *Studio International* 193 (Jan.–Feb. 1977): 16–17. 1 ill. by WE.

"Photoclassics." *Photo World* (Apr.–May 1977): 126–27. *Bud Field and Family, AL, 1936* (illus.), plus brief discussion.

Tannenbaum, Judith. "Walker Evans." Ex. review of *Walker Evans*, Robert Schoelkopf Gallery, London. *Artsmagazine* (May 1977): 36.

French-fraser, Nina. "Photography: Homegrown Icons, Handmade Tanks." Ex. review of *Walker Evans*, Robert Schoelkopf Gallery, New York. *Artnews* 76 (May 1977): 126–27.

Bayer, Jonathan. "In Search of a Photographic Language." *Artscribe* 7 (July 1977): 23–30.

Jeffrey, Ian. "Image and Dream: The Photography of Walker Evans and Paul Strand." *Artscribe*, July 1977: 30–35.

Stern, James. "Walker Evans (1903–1975): A Memoir." *London Magazine*, n.s., 17 (Aug.–Sept. 1977): 5–29.

Badger, Gerry. "The Post Office at Sprott, Alabama." *Creative Camera* (Sept. 1977): 304–5. 1 ill. by WE.

Badger, Gerry. "A Short Essay on Walker Evans: or 'These pictures, with all their clear, hideous and beautiful detail.'" *Creative Camera* (Sept. 1977): 294–95.

"Walker Evans: Prints from the Library of Congress, Washington D.C., U.S.A." *Creative Camera* (Sept. 1977): 296–303, 306–13, cover. 17 ills. by WE.

Reed, David. "A Change of Direction: A Survey of Evans' Colour Photography." *Creative Camera* (Sept. 1977): 314–15.

Weaver, Mike. "Walker Evans: Magic Realist." *Creative Camera* (Sept. 1977): 292–94.

Ritchin, F. "Snapshot Mastery." *Horizon* 20 (Oct. 1977): 75–79. [Use of Polaroid SX-70 by WE, Mark Cohen, Jim Hughes, Charles Sillery.]

"News: Exhibitions: Evans at *Fortune*." Ex. review of *Walker Evans at Fortune*, Wellesley

College Museum, Wellesley, Mass. *Art Journal* 37 (Winter 1977/78): 158.

Arbus, Doon. "Walker Evans 1st and Last." Book review. *Nation* 227 (1978): 497–98.

Herwaldt, David. "Correspondents: Boston: Walker Evans at 'Fortune.'" Ex. review of *Walker Evans at Fortune*, Wellesley College Museum, Wellesley, Mass. *Afterimage* 5 (Jan. 1978): 19–20. 6 ills. by WE.

Hale, Nike. "Walker Evans: An American Eye." Ex. review of *Walker Evans*, Sidney Janis Gallery, New York. *Artworld* 2 (Jan. 14–Feb. 10, 1978): 6. 1 ill. by WE.

Thornton, Gene. "Photography View: Walker Evans—Creator of Beautiful Objects." Ex. review of *Walker Evans*, Sidney Janis Gallery, New York. *New York Times*, Jan. 22, 1978: sec. II, pp. 23–24. 1 ill. by WE.

Lindley, Daniel A., Jr. "Walker Evans, Rhetoric, and Photography." *Exposure* 16 (Mar. 1978): 28–38.

Gautrand, Jean-Claude. "Walker Evans." *Le Photographe* (May 1978): 32–34. 7 ills. by WE.

Scully, Julia, and Andy Grundberg. "Currents: American Photography Today." *Modern Photography* 42 (Sept. 1978): 82–87, 124–25, 128. 10 ills. by WE. [WE discussed as an influence on contemporary photographers.]

Trachtenberg, Alan. "The Presence of Walker Evans." Ex. review of *The Presence of Walker Evans*. *Atlantic Monthly* 242 (Sept. 1978): 47–54.

Scully, Julia, and Andy Grundberg. "Currents: American Photography Today. Robert Frank's iconoclastic, outsider's view of America in the 50s provided both form and substance for the next generation." *Modern Photography* 42 (Oct. 1978): 94–97, 196, 198, 200. [WE discussed as an influence on Frank.]

Stuttaford, Genevieve. "PW Forecasts." Book review of *Walker Evans: First and Last. Publisher's Weekly* 214 (Oct. 2, 1978): 121.

Squiers, Carol. "Color Photography: The Walker Evans Legacy and the Commercial Tradition: Stephen Shore, Kenneth McGowan, Neal Slavin." *Artforum* 17 (Nov. 1978): 64–67.

Edwards, Owen. "Lime-Lighted Photography Books." Book review of *Walker Evans: First and Last. Saturday Review* 5 (Nov. 25, 1978): 42–44. 1 ill. by WE.

Trachtenberg, Alan. "The Artist of the Real." *Afterimage* 6 (Dec. 1978): 10–13, cover.

Trachtenberg, Alan. "Camera Work: Notes Toward an Investigation." *Massachusetts Review* 19 (Dec. 1978): 834–58. [WE's subway portrait series compared to Robert Frank's bus series, pp. 852–57.]

Manning, Jack. "*First and Last*." Book review. *New York Times Book Review* 83 (Dec. 3, 1978): 13.

"Choice for Christmas." Book review of *Walker Evans: First and Last. Christian Century* 95 (Dec. 6, 1978): 1186.

Viskochil, Larry A. "Photography." Book review of *Walker Evans: First and Last. Library Journal* 103 (Dec. 15, 1978): 2511.

Michener, Charles. "Charles Michener on Photography: The Year's Books (Part II)." Book review of *Walker Evans: First and Last. New Republic* 179 (Dec. 16, 1978): 21–25.

"Books: Notable." Book review of *Walker Evans: First and Last. Time* 113 (Jan. 8, 1979): 78–79.

Fischer, Hal. "Photography: Walker Evans—A Contemporary View." Ex. review of *Walker Evans*, Simon Lowinsky Gallery, San Francisco. *Artweek* 10 (Feb. 3, 1979): 13. 2 ills. by WE.

Ratcliff, Carter. "Elements of Style. '. . . For 50 years the eye of Walker Evans fixed a cool, steady gaze at the ongoing saga of everyday style in America . . .'" Book review of *Walker Evans: First and Last. New York* 12 (Feb. 12, 1979): 76–77. [Reviewed with *Great Photographic Essays from Life*.]

Badger, Gerry. "Recent Books." Book review of *Walker Evans: First and Last. British Journal of Photography* 126 (Feb. 16, 1979): 145–47.

Wittmar, Bob. "The Decade of Despair—A Local Photo Story of the Depression." *Morning Call (Allentown, PA)*, Feb. 23, 1979: n.p. [Discusses the FSA photographers who worked in Pennsylvania: WE, Jack Delano, and John Vachon.]

Grundberg, Andy. "Books in Review." Book review of *Walker Evans: First and Last. Modern Photography* 43 (Mar. 1979): 71.

Bennett, Derek. "Books: Walker Evans Revisited." Book review of *Walker Evans: First and Last. Printletter* 4 (Mar.–Apr. 1979): 26. 1 ill. by WE.

"Books Received." Book review of *Walker Evans: First and Last. Print Collector's Newsletter* 10 (Mar.–Apr. 1979): 27.

Goldberg, Vicki. "Books: Walker Evans. Fresh Eyes on an Environment We Created and Disdained." Book review of *Walker Evans: First and Last. American Photographer* 2 (Apr. 1979): 10, 12. 1 ill. by WE.

"Books." Book review of *Walker Evans: First and Last. Camera (Lucerne)* 58 (May 1979): 45.

Novak, Joe. "Books in Review: *Walker Evans: First and Last*." Book review of *Walker Evans: First and Last. Camera 35* 24 (Aug. 1979): 14–15. 1 ill. by WE.

Malcolm, Janet. "Photography: Slouching Towards Bethlehem, Pa." Book review of *Walker Evans: First and Last* and others. *New Yorker* 55 (Aug. 6, 1979): 70–74, 77–80.

Hellman, Roberta, and Marvin Hoshino. "Robert Frank." Ex. review of *Robert Frank, The Americans and New York Photographs*, Sidney Janis Gallery, New York. *Artsmagazine* 54 (Sept. 1979): 18.

Osborne, Scott. "A Walker Evans Heroine Remembers." *American Photographer* 3 (Sept. 1979): 70–73. [Interview with Allie Mae Burroughs Moore, a subject of *Let Us Now Praise Famous Men*.]

Borcoman, James. "A Dialogue with Solitude: David Heath: Un Dialogue avec solitude." *Journal of the National Gallery of Canada* (Oct. 5, 1979): 1–8. [Heath discusses the influence of *American Photographs* on his work, p. 2.]

Patton, Phil. "Review of Books: Photography." Book review of *Walker Evans: First and Last. Art In America* 67 (Nov. 1979): 31.

Trachtenberg, Alan. "Walker Evans' *Message from the Interior*: a reading." *October* (Winter 1979): 5–29. 12 ills. by WE.

"Lest We Forget." *Reporter* (Nov. 1979): 32–37. 2 ills by WE. [Portfolio of FSA photographs.]

Lohse, Bernd. "Bücher." Book review of *Walker Evans: First and Last. Foto Magazin* 31 (Nov. 1979): 44, 46.

1980s

Crozier, Atk. "Walker Evans 1st and Last." Book review of *Walker Evans: First and Last. Journal of American Studies* 14 (1980): 461–65.

Photo Bulletin. Robert Frank, Walker Evans. Los Angeles: G. Ray Hawkins Gallery, 1980. [Includes chronology.]

Johnstone, Mark. "Pictorial Stratifications." Ex. review of *Walker Evans*, University of California, Riverside. *Artweek* 11 (Jan. 26, 1980): 13–14. 1 ill. by WE.

"Received and noted." Book review of *Walker Evans*, by John Szarkowski. *Afterimage* 7 (Feb. 1980): 15

Curtis, James C., and Sheila Grannen. "Let Us Now Appraise Famous Photographs: Walker Evans and Documentary Photography." *Winterthur Portfolio* 15 (Spring 1980): 1–23, front cover. 17 ills. by WE.

Raines, Howell. "Let Us Now Revisit Famous Folk." *New York Times Magazine*, May 25, 1980: 31–36, 38, 40, 42, 46. 4 ills. by WE. [Writer Howell Raines and photographer Susan Woodley Raines revisit the families photographed in *Let Us Now Praise Famous Men*.]

"Agee and Evans and Famous Folk." *New York Times Magazine*, June 22, 1980: sect. 6, p. 70. 1 ill. by WE. [Letters by Margaret Higgens, Frank Logue, Jerry L. Thompson, Lawrence R. Fondation, and Barbara Scott Winkler, written in response to article by Howell Raines and Susan Woodley Raines published on May 25, 1980.]

McCullough, F. "Exhibition reviews." Ex. review of *Walker Evans: 1929–1971*, Stills Gallery, Edinburgh, Scotland. *Arts Review (U.K.)* 32 (Aug. 15, 1980): 359.

Groot, P. "Andy Warhol en de film-noir: de ontluistering van de Amerikaanse droom." "(Andy Warhol and the film noir: the tarnishing of the American dream.)" *Museum-Journal (Netherlands)* 25 (Oct. 1980): 258–65. [WE as an influence.]

Edwards, Owen. "Exhibitions: The Magnetic Eye: Amazement mixed with a truly innocent fear." Ex. review of *Diane Arbus*, Robert Miller Gallery, New York. *American Photographer* 4 (Nov. 1980): 17–18. [WE, among others, as an influence.]

Sless, R. D. "Walker Evans." Ex. review: *Walker Evans*, Third Eye Centre, Glasgow, Scotland. *Arts Review (U.K.)* 32 (Nov. 7, 1980): 518.

"Latent Images: A Sense of Place." *American Photographer* 5 (Dec. 1980): 24. [WE's 1936 photograph paired with an excerpt from William Carlos Williams's *A Recognizable Image*.]

Maingois, Michel. "Walker Evans." Ex. review of *Walker Evans*, Galerie Baudoin Lebon, Paris, France. *Zoom (Paris)*, 1981: 22–33, 127. 12 ills. by WE.

Mora, Gilles. "Walker Evans/James Agee: Du couple à trois. Littérature, photographie et réel dans *Louons maintenant les grands hommes*." *Cahiers de la Photographie* (1981): 37–47.

Schofield, Jack. "Walker Evans." *Zoom (USA)*, 1981: 58–67. 10 ills. by WE.

Thompson, Nicola, ed. *Techniques of the World's Great Photographers*. London and Oxford: A QED Book, Phaidon Press, 1981. [Robert Frank mentioned as a follower of WE, p. 128.]

"*Let Us Now Praise Famous Men*." Book review of 1981 ed. *New York Times*, Jan. 4, 1981: 23.

Raynor, Vivien. "Art: Walker Evans Photos Shown." Ex. review of *Walker Evans*, Lyme Historical Society, Old Lyme, Conn. *New York Times*, Jan. 11, 1981: sect. 23, p. 22.

Strasser, Catherine. "Walker Evans: Baudoin Lebon/Paris." Ex. review of *Walker Evans*, Galerie Baudoin Lebon, Paris, France. *Flash Art*, Mar.–Apr. 1981: 46. 1 ill. by WE.

Baldwin, Roger. "Regional Reviews: Connecticut." Ex. review of *Walker Evans and Robert Frank: An Essay on Influence*, Yale University Art Gallery, New Haven, Conn. *Art New England* 2 (Mar. 1981): 6.

"Actualités: Evans et Frank photographes américains." Ex. review of *Walker Evans and Robert Frank: An Essay on Influence*, Daniel Wolf Gallery, New York. *Connaissance des Arts*, Apr. 1981: 48. 1 ill. by WE.

Papageorge, Tod. "From Walker Evans to Robert Frank: A Legacy Received, Embraced and Transformed." *Artforum* 19 (Apr. 1981): 33–37. 2 ills. by WE.

Michener, Charles. "Charles Michener on photography: The Struggle to Live with Reality." Book and ex. review of *Walker Evans and Robert Frank: An Essay on Influence*, Yale University Art Gallery, New Haven, Conn. *New Republic* 184 (Apr. 4, 1981): 27–30. 1 ill. by WE.

Thornton, Gene. "Photography View: Walker Evans—Robert Frank." Ex. review of *Walker Evans and Robert Frank: An Essay on Influence*, Daniel Wolf Gallery, New York. *New York Times*, Apr. 5, 1981: sect. 2, p. 33.

McDarrah, Fred. "Voice Centerfold." Ex. notice of *Walker Evans and Robert Frank: An Essay on Influence*, Daniel Wolf Gallery, New York. *Village Voice* 26 (Apr. 8, 1981): 61.

Davis, Douglas. "Photography: Shooting from the Hip." Ex. review of *Walker Evans and Robert Frank: An Essay on Influence*, Daniel Wolf Gallery, New York. *Newsweek* 97 (Apr. 13, 1981): 96, 98. [Reviewed with the book *William Klein: Photographs*.]

Baier, [Lesley]. "Visions of Fascination and Despair: The Relationship between Walker Evans and Robert Frank." *Art Journal* 41 (Spring 1981): 55–63. 4 ills. by WE.

Baldwin, Roger. "Evans and Frank at Yale." Ex. review of *Walker Evans and Robert Frank: An Essay on Influence*, Yale University Art Gallery, New Haven, Conn. *Views: The Journal of Photography in New England* 2 (Spring 1981): 21.

Albright, Thomas. "Art: Evans and Frank: Photographic Pairs." Ex. review of *Walker Evans and Robert Frank: An Essay on Influence*, Fraenkel Gallery, San Francisco. *San Francisco Chronicle*, June 25, 1981: 49.

Cassell, James. "Robert Frank's *The Americans*: An Original Vision Despite Tod Papageorge's Challenge." Ex. review of *Walker Evans and*

Robert Frank: An Essay on Influence, Yale University Art Gallery, New Haven, Conn. *New Art Examiner* 8 (Summer 1981): 1, 8.

Fondiller, Harvey V. "Shows We've Seen: Evans/ Frank: An Exercise in Pairing." Ex. review of *Walker Evans and Robert Frank: An Essay on Influence*, Daniel Wolf Gallery, New York. *Popular Photography* 88 (July 1981): 48.

Murray, Joan. "Keeping Up with Bay Area Shows." Ex. notice of *Walker Evans and Robert Frank: An Essay on Influence*, Fraenkel Gallery, San Francisco. *Artweek* 12 (July 4, 1981): 11–12.

Osman, Colin. "Books received." Book review of *Walker Evans and Robert Frank: An Essay on Influence*. *Creative Camera*, Aug. 1981: 196.

Westerbeck, Colin L., Jr. "Reviews: New York." Ex. review of *Walker Evans and Robert Frank: An Essay on Influence*, Daniel Wolf Gallery, New York. *Artforum* 20 (Sept. 1981): 75–76.

Manthorne, Katherine E. "The Railroad in the American Landscape: 1850–1950." Ex. review. *Arts Magazine* 56 (Sept. 1981): 17.

Caldwell, John. "Exhibition of Walker Evans Extends his Reputation." Ex. review of *Walker Evans: Photographs of New York State*, Raushenbush Library, Sarah Lawrence College, Bronxville, N.Y. *New York Times*, Sept. 13, 1981: sect. 22, p. 26. 2 ills. by WE.

Stevens, Elizabeth. "New Photo-As-Fine-Art Gallery Opens Its Doors." Ex. review of *Walker Evans and Robert Frank: An Essay on Influence*, G. H. Dalsheimer Gallery, Baltimore. *Baltimore Sun*, Sept. 13, 1981: sect. D, p. 12.

Purchase, Steve. "Art Seen: Two Good But Quite Different Photography Exhibits." Ex. review of *Walker Evans and Robert Frank: An Essay on Influence*, G. H. Dalsheimer Gallery, Baltimore. *Baltimore Evening Sun*, Sept. 17, 1981: 11.

Kaufmann, James. "Reviews: Loose Links." Book review of *Walker Evans and Robert Frank: An Essay on Influence* by Tod Papageorge. *Afterimage* 9 (Oct. 1981): 17–18.

Zelevansky, Lynn. "Tod Papageorge: Daniel Wolf." Ex. review of *Walker Evans and Robert Frank: An Essay on Influence*, Daniel Wolf Gallery, New York. *Flash Art* (Oct.–Nov. 1981): 56.

Crisman, Jeff. "Chicago." Ex. review of *Walker Evans: Photographs of Chicago*, Kelmscott Gallery, Chicago. *New Art Examiner* 9 (Nov. 1981): 18.

Phillips, Deborah C. "New York Reviews: Louis Faurer." Ex. reviews of *Louis Faurer*, Light Gallery, New York. *Artnews* 80 (Dec. 1981): 176. [WE as an influence.]

Harwood, Suzanne de Lotbiniere. "Walker Evans at the Yajima Gallery." *Art Magazine* 56 (Nov. 1981–Jan. 1982): 54–55. 1 ill. by WE.

Garner, Gretchen. "Book Reviews." Book review of *Walker Evans and Robert Frank: An Essay on Influence*, by Tod Papageorge. *Exposure* 20 (1982): 38–40.

"Books." Book review of *Walker Evans and Robert Frank: An Essay on Influence. The Photographer's Gallery* (Sept. 1982): 42. 1 ill. by WE.

Stuttaford, Genevieve. "PW Forecasts." Book review of *Walker Evans at Work. Publisher's Weekly* 222 (Oct. 29, 1982): 38.

Scandrette, Onas C. "Vignettes from Photographic History: Walker Evans and the Farm Security Administration." *PSA Journal (Photographic Society of America)* 48 (Nov. 1982): 15–18. 4 ills. by WE.

Ritchen, Fred. "Walker Evans: A Way of Working." *CameraArts* 2 (Dec. 1982): 48–59, 82–83. 1 color and 42 black-and-white ills. by WE.

Thompson, Jerry L. "Walker Evans: A Technical Profile." *CameraArts* 2 (Dec. 1982): 82–83. 1 ill. by WE.

Grundberg, Andy. "Photography Books." Book review of *Walker Evans at Work. New York Times Book Review*, Dec. 5, 1982: 11.

Johnson, R. Alan. "Walker Evans at Work." Book review of *Walker Evans at Work. Christian Century* 99 (Dec. 8, 1982): 1262.

Ashton, Dore. "Walker Evans at Work." Book review of *Walker Evans at Work. Nation* 235 (Dec. 25, 1982): 18.

Goldberg, Vicki. "Walker Evans: *Fortune* and Man's Eye." *American Photographer* 10 (Jan. 1983): 56–63. 3 color and 3 black-and-white ills. by WE.

Pincus, Robert L. "*Walker Evans at Work.*" Book review of *Walker Evans at Work. Los Angeles Times*, Jan. 30, 1983: 89.

DeCournoyer, Daniel. "Walker Evans at Work." Book review of *Walker Evans at Work. PSA Journal* 49 (Apr. 1983): 6.

Ennis, Michael. "The Roadside Eye: Robert Frank's photographs are unstudied but eloquent snapshots that reveal the tensions underlying life in the fifties." *Texas Monthly* 11 (Nov. 1983): 180–83. [WE and Robert Frank compared.]

Karmel, Pepe. "Review of Books: Photography." Book review of *Walker Evans at Work* and others. *Art in America* 71 (Nov. 1983): 23, 25.

Gibb, R. "Entering Time in a House Photographed by Walker Evans." *New Letters* 50 (1984): 76–77.

Muller, Christopher. "On the Intended Effect of the Narrative Form in James Agee's Book *Let Us Now Praise Famous Men.*" *Wiss. Zeits. der Humboldt-Universitat zu Berlin. Gesellschaftswissenschaftliche Reihe* (East Germany) 33 (1984): 405–7.

Trachtenberg, Alan. "Walker Evans' America: A Documentary Invention." In *Observations: Essays on Documentary Photography, Untitled no. 35*, ed. David Featherstone, pp. 56–66. Carmel, Ca.: The Friends of Photography, 1984. 6 ills. by WE.

Curtis, James C. "Book Reviews: *Walker Evans at Work.*" *Winterthur Portfolio* 19 (Winter 1984): 322–24.

"Walker Evans at Work: 745 Photographs, Together with Documents Selected from Letters, Memoranda, Interviews, Notes." Book review. *Popular Photography* 91 (Feb. 1984): 54.

Siegle, Jeanne. "After Sherrie Levine." *Arts Magazine* 59 (June 1985): 141–44. [Interview with Levine concerning her rephotographing WE's *Sharecroppers, Hale County, AL, 1936; After Walker Evans, 1981* reproduced, p. 143.]

Schmid, Joachim. "Ein Interview mit Robert Frank." *Fotokritik (Berlin)*, June 1985: 16–21. [Robert Frank describes some of his memories of WE.]

Bogardus, R. F. "American Silences—The Realism of James Agee, Walker Evans, and Edward Hopper." Book review. *American Quarterly* 38 (1986): 127–34.

Matus, Todd. "The Pause that Refreshes: Walker Evans and Coca-Cola." In *Studies in Photographic Criticism: Essays by Graduate Students in Photography*, edited by Richard Bolton. Carbondale, Ill.: Department of Cinema and Photography, Southern Illinois University, 1986.

Cohen, M. A. "American Silences: The Realism of James Agee, Walker Evans, and Edward Hopper." Book review. *American Literature* 58 (1986): 140–41.

Kidd, S. "American Silences: The Realism of James Agee, Walker Evans, and Edward Hopper." Book review. *Journal of American Studies* 20 (1986): 48–79.

Kramer, V. A. "American Silences: The Realism of James Agee, Walker Evans, and Edward Hopper." Book review. *Modern Fiction Studies* 31 (1986): 753–54.

Scott, W. B. "American Silences: The Realism of James Agee, Walker Evans, and Edward Hopper." Book review. *Kenyon Review* 8 (1986): 131–35.

Stange, Maren. "'Symbols of Ideal Life': Technology, Mass Media, and the FSA Photography

Project." *Projects: A Journal of American Cultural Studies* (1986): 81–104.

Goodman, Tom. "Unauthorized." Book review of *Walker Evans at Work* and *James Agee: A Life* by Laurence Bergreen. *Afterimage* 13 (Jan. 1986): 18.

Klein, Joe. "The End of the Road; In the Years Since James Agee and Walker Evans, The Sharecropper Has Given Way to the Migrant Worker, But One Reality Endures: American Hardship." *Esquire* 105 (May 1986): 160.

Stott, William. "*Documentary Expression* Revisited." *Exposure* 24 (Spring 1986): 7–11. 1 ill. by WE.

Welch, Marguerite. "After Evans and Before Frank: The New York School of Photography." *Afterimage* 14 (Summer 1986): 14–16.

Eliot, Alexander. "Walker Evans." *Main* 2 (Oct.–Nov. 1987): n.p. 3 ills. by WE.

Bergala, Alain. "A Photographer's Viewpoint: An Interview with Wim Wenders." *UNESCO Courier* 41 (Apr. 1988): 4–7. 1 ill. by WE. [Accompanied by a brief descriptive paragraph on Evans, p. 6. Wenders discusses the influences of WE's photographs on his own work.]

Hambourg, Maria Morris. "Photography Between the Wars: Selections from the Ford Motor Company Collection." *Metropolitan Museum of Art Bulletin* 45, Part 4 (Spring 1988): 1–56.

Reed, Thomas Vernon. "Unimagined Existence and The Fiction of the Real: Postmodernist Realism in *Let Us Now Praise Famous Men.*" *Representations* 24 (Fall 1988): 156–76. 4 ills. by WE.

"Seven Masters." *Life*, vol. II, no. 10 (Fall 1988): 38–44. 1 ill. by WE. [WE, Eugène Atget, Alfred Stieglitz, Julia Margaret Cameron, Edward Weston, Henri Cartier-Bresson, and Ansel Adams.]

Fiskin, Judy. "Borges, Stryker, Evans: The Sorrows of Representation." *Views: The Journal of Photography in New England* 9 (Winter 1988): sect. 2, pp. 2–6.

Fryer, Judith. "The Traffic in Representative Men: Reading Alan Trachtenberg's *Reading American Photographs.*" *Exposure* 27 (1989): 45–53.

Mora, Gilles. "Walker Evans et la ville." *Revue française d'études américaines* 14 (1989): 57–62.

Grundberg, Andy. "Review/Photography: An Evans Show, 50 Years Later." Ex. review of *American Photographs*, Museum of Modern Art, New York. *New York Times*, Jan. 19, 1989: C19–C20. 1 ill. by WE.

"Topics of the Times: Looking at America." Editorial. *New York Times*, Jan. 31, 1989: sect. 1, p. 22.

Goldberg, Vicki. "Connoisseur's World: Fly on the Wall." Ex. and book review of *American Photographs*, Museum of Modern Art, New York, 50th anniversary exhibition and book. *Connoisseur* 219 (Feb. 1989): 26. 2 ills. by WE.

Kirstein, Lincoln. "Focus on America: Walker Evans: American Photographer." *USA Today* 117 (Mar. 1989): 54–59. 8 ills. by WE. [Portfolio drawn from 1989 reissue of *American Photographs*, Museum of Modern Art, New York.]

"Walker Evans: *American Photographs*." *Booklist* 85 (Mar. 15, 1989): 1237.

"Walker Evans: *American Photographs*." *Los Angeles Times Book Review*, Mar. 19, 1989: 11.

Maharidge, Dale. "The Long Journey Home: A Search for the People and Places Celebrated in *Let Us Now Praise Famous Men*." *Rolling Stone* (Mar. 23, 1989): 87–94. 16 ills. [5 ills. by WE taken in Alabama in 1936 and 11 of the same people or places taken by Michael Williamson in the 1980s.]

Kozloff, Max. "Signs of Light: Walker Evans' American photographs." Book review of *American Photographs*, reissued, with an accompanying exhibition at the Museum of Modern Art, New York. *Artforum* 27 (Apr. 1989): 114–18. 6 ills. by WE.

Woodward, Richard B. "Reviews: Walker Evans." Ex. review of *Walker Evans: American Photographs*, Museum of Modern Art, New York. *Artnews* 88 (Apr. 1989): 206. 1 ill. by WE.

Takata, K. "Towards an elegance of movement: Walker Evans and Robert Frank revisited." *Journal of American Culture* 12 (Spring 1989): 55–64.

Graw, Isabelle. Review of *American Photographs* at the Museum of Modern Art, New York. *Flash Art* 147 (Summer 1989): 150.

Coleman, A. D. "American Photographs: Walker Evans." *Modern Photography* 53 (July 1989): 25.

"Walker Evans: *American Photographs*." *Modern Photography* 53 (July 1989): 25.

McFeeley, William S. "Reading American Photographs: Images as History, Mathew Brady to Walker Evans." *New York Times Book Review*, Aug. 20, 1989: 15.

Kao, Deborah Martin. "Lee Friedlander's Factory Valleys: Structure, Artifice, Culture." *Views: Journal of Photography in New England* 10–11 (Summer–Fall 1989): 10–13. [WE's books cited as examples and discussed.]

Goldberg, Vicki. "Critic at Large: The Real America. Reinventing history with photographs." Book review of *Reading American Photographs: Photographic Images as History, Mathew Brady to Walker Evans* by Alan Trachtenberg. *American Photographer* 23 (Dec. 1989): 60, 62.

Grundberg, Andy. "Photography." Book review of *Walker Evans: Havana 1933*. *New York Times Book Review*, Dec. 3, 1989: 20.

"Expositions: Walker Evans, Havana 1933." Ex. and book review of *Walker Evans: Havana 1933*, FNAC Montparnasse, Paris: Contrejour. *Photo Magazine* (Dec. 1989–Jan. 1990): 18–19. 1 ill. by WE.

1990s

Mayer, Jutta. "Bücher: Walker Evans: Amerika." Book review of *Walker Evans: Amerika. Bilder aus den Jahren der Depression*. *Camera Austria* 35 (1990): 65–66.

Diehl, Digby. "Walker Evans: Havana 1933." Book review. *Playboy* 37 (Jan. 1990): 30.

Webb, Virginia-Lee. "Art as Information: The African Portfolios of Charles Sheeler and Walker Evans." *African Art* 24, Part 1 (Jan. 1990): 56–63, 103.

Russo, Antonella. "Tre mostre a New York: Walker Evans. American Photographs." Ex. review of *Walker Evans: American Photographs*, Museum of Modern Art, New York. *Fotologia (Florence)* 12 (Spring 1990): 101. 1 ill. by WE.

"Snapshots: Of Time and Place." Ex. review of *Of Time and Place: Walker Evans and William Christenberry*, Amon Carter Museum, Fort Worth, Tex. *Popular Photography* 97 (June 1990): 8.

Desnoes, Edmundo. "Evans in the Night of Photography." Book review of *Walker Evans: Havana 1933*. *Aperture* 120 (Summer 1990): 75–76. 2 ills. by WE.

Rosenblum, Naomi. "Book Reviews: Real Life and Symbolic Pictures." Book review of *Reading American Photographs* by Alan Trachtenberg. *Art Journal* 49 (Summer 1990): 178–181. [Reviewed with *Symbols of Ideal Life: Social Documentary Photography in America, 1890–1950* by Maren Stange.]

Parker, David P. "*And Their Children After Them: The Legacy of 'Let Us Now Praise Famous Men': James Agee, Walker Evans, and The Rise and Fall of Cotton in the South.*" Book review. *Historian* 53 (Autumn 1990): 135–36.

"Walker Evans: *Of Time and Place*." *University Press Book News* 2 (Dec. 1990): 45.

Vieilledent, C. "The Representation of the Earth in *Let Us Now Praise Famous Men*." *Revue française d'études américaines* 48 (1991): 299–307.

Stange, Maren. "Documentary Photography in American Social Reform Movements: The FSA Project and Its Predecessors." In *Multiple Views: Logan Grant Essays on Photography, 1983–89*, edited by Daniel P. Younger, pp. 195–223. Albuquerque: University of New Mexico Press, 1991.

Flynt, Wayne. "*And Their Children After Them: The Legacy of 'Let Us Now Praise Famous Men': James Agee, Walker Evans, and The Rise and Fall of Cotton in the South.*" Book review. *Journal of Southern History* 57 (Feb. 1991): 134–36.

Olin, Margaret. "'It Is Not Going to Be Easy to Look into Their Eyes': Privilege of Perception in *Let Us Now Praise Famous Men*." *Art History* 14 (Mar. 1991): 92–115.

Leviatin, David. "*And Their Children After Them: The Legacy of 'Let Us Now Praise Famous Men': James Agee, Walker Evans, and the Rise and Fall of Cotton in the South.*" Book review. *Oral History Review* 19 (Spring–Fall 1991): 109.

Boissier, Jean-Louis. "La Collection . . . à l'Oeuvre." *La Recherche photographique* (June 1991): 82–91. 5 ills. by WE.

Kempf, Jean. "Le rêve et l'histoire." *La Recherche photographique* (June 1991): 58–65. 2 ills. by WE. [Article about the FSA. Also includes ills. by Dorothea Lange, Russell Lee, Arthur Rothstein.]

Nixon, Bruce. "The Long Life of a Very Small Place." Ex. review of *Of Time and Place: Walker Evans and William Christenberry*: Ansel Adams Center, San Francisco. *Artweek* 22 (Aug. 15, 1991): 11–12.

Weaver, Mike. "Clement Greenberg and Walker Evans: Transparency and Transcendence." *History of Photography* 15 (Summer 1991): 128–30.

Collins, Kathleen. "Walker Evans: America." Book review. *Library Journal* 116 (Oct. 1, 1991): 96.

"Walker Evans: America." Book review. *Bookwatch* 12 (Nov. 1991): 12.

"Walker Evans: America." Book review. *Americana* 19 (Nov.–Dec. 1991): 22.

"Walker Evans: America." Book review. *Tribune Books (Chicago)*, Dec. 8, 1991: 2.

DeCosse, D. E. "Let us now praise a famous book." Book review of *Let Us Now Praise Famous Men*. *America* 165 (Dec. 21–28, 1991): 490–91.

Rabinowitz, P. "Voyeurism and Class-Consciousness, James Agee and Walker Evans, *Let Us Now Praise Famous Men*." *Cultural Critique* 21 (1992): 143–70.

Rubinstein, Meyer Raphael. "Walker Evans—America." Book review. *Arts Magazine* 66 (Jan. 1992): 95–96.

Natal, J. "*Walker Evans: America, Pictures from the Great Depression*." Book review. *Choice* 29 (Feb. 1992): 888.

Cardinal, Roger. "Of Time and Place: Walker Evans and William Christenberry." Book review. *History of Photography* 16 (Spring 1992): 83–84.

Nickel, Douglas R. "American Photographs Revisited." *American Art* 6 (Spring 1992): 79–97.

Keller, Judith. "Evans and Agee: The Great American Roadside." *History of Photography* 16 (Summer 1992): 170–71.

Muchnic, Suzanne. "Walker Evans." Ex. review of *Walker Evans: An Alabama Record*, J. Paul Getty Museum, Malibu. *Artnews* 91 (Sept. 1992): 125.

Stahel, Thomas H. "Let Us Now Praise a Famous Book (50th Anniversary of James Agee's and Walker Evans's book, *Let Us Now Praise Famous Men*)." *America* 19 (Dec. 21, 1992): 490.

Hagen, Charles. "Walker Evans at Gallery 292." Ex. review. *New York Times*, Apr. 2, 1993, C29.

Buchanan, T. "Bedroom of Floyd Burroughs Home." *History of Photography* 17 (Summer 1993): 214–15.

Hulick, Diana Emery. "Walker Evans and Folk Art." *History of Photography* 17 (Summer 1993): 139–46.

Rathbone, Belinda. "Walker Evans: The Rich Pastime of Window-Gazing." *History of Photography* 17 (Summer 1993): 135–38.

Keller, Judith. "Walker Evans and *Many Are Called*." *History of Photography* 17 (Summer 1993): 152–65.

Orvell, Miles. "Walker Evans and James Agee: The Legacy." *History of Photography* 17 (Summer 1993): 166–71.

Ware, Robert. "Walker Evans: Impersonality and Metaphor." *History of Photography* 17 (Summer 1993): 147–51.

Purvis, Alston W. "The Extraordinary Signs of Walker Evans." *Print* 46 (Sept.–Oct. 1993): 52–61.

Collins, Kathleen. "*Walker Evans: The Hungry Eye*." Book review. *Library Journal* 118 (Nov. 15, 1993): 76.

Leggett, Jo. "Book Review: *Walker Evans: The Hungry Eye*." *Newsletter of The Friends of Photography* 16 (Nov.–Dec. 1993): 12.

Grundberg, Andy. "*Walker Evans: The Hungry Eye*." Book review. *New York Times Book Review*, Dec. 5, 1993: 85.

McKenna, Kristine. "Book Review: *Walker Evans: The Hungry Eye*." *Los Angeles Times*, Dec. 5, 1993: 26.

Gamerman, Amy. "*Walker Evans: The Hungry Eye*." *Wall Street Journal*, Dec. 7, 1993: A14, A16.

Hagen, Charles. "Observers of America in an Unlikely Pairing." Ex. review of *Walker Evans and Dan Graham*, Whitney Museum, New York. *New York Times*, Dec. 25, 1993: B10.

Hagen, Charles. "What Walker Evans Saw on His Subway Rides." Ex. review of *Walker Evans: Subway Photographs and Other Recent Acquisitions*, National Gallery of Art, Washington, D.C. *New York Times*, Dec. 31, 1993: B1–B2.

SELECTED CATALOGUES: ONE-PERSON EXHIBITIONS

1960s

Walker Evans: An Exhibition of Photographs by Walker Evans from the Collection of the Museum of Modern Art, New York. Selected and Organized by the Dept. of Circulating Exhibitions, Museum of Modern Art. Introduction by James Borcoman. Queen's Printer, Ottawa, 1966. 5 ills. by WE.

1970s

Walker Evans, Artist-in-Residence: An Exhibition of Photographs, 1928–1972. Hopkins Center, Dartmouth College, Hanover, N.H., Oct. 27–Nov. 26, 1972. 24 halftones by WE. With exhibition poster, limited to 100 signed and numbered copies by WE. Single sheet measuring 19¼ x 27½ in., reproducing a photograph by WE.

Walker Evans. Statement by John Szarkowski. Robert Schoelkopf Gallery, New York, 1973. 8 ills. by WE.

Stott, William (comp.). *Walker Evans: Photographs from the "Let Us Now Praise Famous Men" Project*. Austin: University of Texas Humanities Research Center, 1974.

Walker Evans. Kluuvin Galleria, Helsinki, Finland, 1975. Organized by the International Council of the Museum of Modern Art, New York.

Walker Evans: Photographs. An Exhibition Circulated under the Auspices of the International Council of the Museum of Modern Art, New York [held at the] *Museum of Modern Art, Oxford, England*. Introduction by Valerie Lloyd. Arts Council of Great Britain, London, 1976. 6 ills. by WE.

Baier, Lesley K. *Walker Evans at Fortune, 1945–1965*. Wellesley College Museum, Wellesley, Mass., 1977. 31 halftones by WE.

Walker Evans: Photographs 1938–1971. Robert Schoelkopf Gallery, New York, 1977. 4 ills. by WE.

Walker Evans: A Retrospective Exhibition from the Collection of Arnold Crane. Foreword by Stephen Prokopoff; introduction by Arnold H. Crane. Museum of Contemporary Art, Chicago, 1977. 2 ills. by WE (folding brochure/poster).

Walker Evans. Introduction by Arnold H. Crane. Sidney Janis Gallery, New York, 1978. 29 halftones by WE.

1980s

Katz, Leslie George. *Walker Evans: Photographs of New York State*. Cat. of traveling ex., 1980. 5 ills. by WE.

Curtis, V. P. *Walker Evans*. Milwaukee (Wis.) Arts Center, 1981. 3 ills. by WE.

Walker Evans 1903–1974. Conselleria de Cultura. Educación i Ciencia de la Generalitat Valenciana, Valencia, Spain, 1983. [Includes "Walker Evans: Fotograf America" by Jeff Rosenheim, pp. 9–13; "Let Us Now Praise Famous Men. La Representacio con Apropicio" by Vincent Todoli, pp. 14–19; and "Walker Evans: Artista de la Cosa Real" by Alan Trachtenberg, pp. 20–24.]

Walker Evans: Leaving Things As They Are. The Promised Gift of Mr. and Mrs. David C. Ruttenberg to the Art Institute of Chicago. Art Institute of Chicago, 1987. 12 ills. by WE.

The Agee Legacy: "Let Us Now Praise Famous Men." Knoxville: University of Tennessee, 1989. [Program for James Agee conference and exhibit of WE photographs.]

1990s

Walker Evans Amerika: Bilder aus den Jahren der Depression. Städtische Galerie im Lenbachhaus, Munich, 1990. [Includes essays by Michael Brix, Christine Heiss, and Ulrich Keller.] Numerous ills. by WE.

Greenough, Sarah. *Walker Evans: Subways and Streets*. National Gallery of Art, Washington, D.C., 1991. [Includes "Many are Called and Many are Chosen. Walker Evans and the Anonymous Portrait" by Sarah Greenough, pp. 13–46, and a "Chronology" by Julia Thompson, pp. 119–23.]

SELECTED CATALOGUES: GROUP EXHIBITIONS

1930s

Philadelphia International Salon of Photography. Pennsylvania Museum of Art, Sixty-Ninth Street Branch, Upper Darby, Pa., 1932. 1 ill. by WE, listed as no. 66.

Photography 1839–1937. Museum of Modern Art, New York, 1937. 6 ills. by WE, listed as nos. 438–43, p. 113, and as pl. 62.

Art in Our Time: Tenth Anniversary Exhibition. Museum of Modern Art, New York, 1939. [The photography section of this show, titled *Seven American Photographers*, was organized by Beaumont Newhall. 2 ills. by WE, WE ex. prints listed as nos. 335–41, pp. 276–77.]

1940s

The Exhibition: Sixty Photographs. Bulletin of the Museum of Modern Art 8 (Dec. 1940–Jan. 1941): 5–14. [Served as catalogue. 3 ills. by WE, nos. 15–17, listed in "Check List," pp. 6–7.]

Art in Progress: A Survey Prepared for the Fifteenth Anniversary of the Museum of Modern Art, New York. Museum of Modern Art, New York, 1944. [60 photographers represented in this large, mixed-media retrospective exhibition, including WE.]

1950s

50 Ans d'art aux Etats-Unis: Collections du Museum of Modern Art de New York. Musée National d'Art Moderne, Paris, 1955. [4 ills. by WE, nos. 477–80, p. 100 in *Catalogue des photographies.*]

1960s

The Bitter Years, 1935–1941, edited by Edward Steichen; introduction by Grace M. Mayer. Museum of Modern Art, New York, 1962. [27 ills. by FSA photographers, including 2 by WE.]

USA FSA: Farm Security Administration Photographs in the Depression Era. Introduction by Robert J. Doherty. Allen R. Hite Art Institute, University of Kentucky, Louisville, 1962. 5 ills., 1 by WE. [The 8 photographs in exhibition by WE listed in the checklist, p. 6.]

Contemporary Art at Yale: 1. Yale University Art Gallery, New Haven, Conn., 1966. 1 black-and-white and 2 color ills. [First in a series of exhibitions of faculty members of the Yale School of Art and Architecture. Artists: WE, Norman Ives (graphics), Lester Johnson (painting).]

An Exhibition of Work by the John Simon Guggenheim Memorial Foundation Fellows in Photography. Photography Department, Philadelphia College of Art, 1966. 58 black-and-white and 3 color ills. [WE included.]

Just Before the War: Urban America from 1935 to 1941 as seen by photographers of the Farm Security Administration. Introduction by Thomas H. Garver. Statements by Arthur Rothstein, John Vachon, and Roy Stryker. Newport Beach Art Museum, Balboa, Cal., 1968. 59 ills., 3 by WE. [19 photographs in exhibition by WE listed in the checklist, p. 61.]

1970s

The Highway. Institute of Contemporary Art, University of Pennsylvania, Philadelphia, 1970. 22 ills., 2 by WE, p. 24. [6 photographs by WE in exhibition listed, p. 34.]

Photography in America. New York: Random House, published for the Whitney Museum of American Art, A Ridge Press Book, 1974. 246 black-and-white and 13 color ills., 6 by WE, pp. 132–37.

Farm Security Administration. Centro Studi e Museo della Fotografia e dall' Istituto di Storia dell'Arte, Università di Parma, Italy, 1975. 300 ills., 33 by WE.

America Observed: Etchings by Edward Hopper, Photographs by Walker Evans. California Palace of the Legion of Honor, San Francisco, 1976. 9 ills. by WE.

People and Places of America: Farm Security Administration Photography of the 1930s. Santa Barbara Museum of Art, California, 1977. 5 ills. by WE.

Roy Stryker: The Humane Propagandist. Photographic Archives, University of Louisville, Ky., 1977. 6 ills. by WE, pp. 18–23.

The Presence of Walker Evans. Institute of Contemporary Art, Boston, 1978. 5 ills. by WE, plus 2 portraits of him. ["The Presence in Walker Evans" by Isabelle Storey, pp. 5–15, and "The Artist of the Real" by Alan Trachtenberg, pp. 17–26.]

Walker Evans. Bahnhof Rolandseck, Rolandseck, West Germany, 1978. 20 ills. by WE. [Exhibition based upon the collection of Dr. Volker Kahmen and Georg Heusch; catalogue text by Kahmen.]

William Carlos Williams and the American Scene 1920–1940. Whitney Museum of American Art, New York, 1978. 3 ills. by WE, pp. 130–31. [4 photographs by WE listed in the checklist, p. 163.]

Photography Rediscovered: American Photographs, 1900–1930. Whitney Museum of American Art, New York, 1979. 12 ills. by WE. [WE's biography and ill. nos. 52–63, pp. 163–64.]

Images de l'Amerique en crise: Photographies de la Farm Security Administration, 1935–1942. Bibliothèque Publique d'Information, Centre Georges Pompidou, Paris, 1979. 12 ills. by WE, pp. 14–23.

1980s

Cubism and American Photography, 1910–1930. Essays by John Pultz and Catherine B. Scallen. Sterling and Francine Clark Art Institute, Williamstown, Mass., 1981. 3 ills. by WE, p. 63.

Papageorge, Tod. *Walker Evans and Robert Frank: An Essay on Influence.* Yale University Art Gallery, New Haven, Conn., 1981. 25 ills. by each photographer.

Color As Form: A History of Color Photography. International Museum of Photography at George Eastman House, Rochester, N.Y., 1982. 1 color ill. by WE, p. 21. [WE's ill. listed as no. 141.]

Weber, Bruce. *The Sun and the Shade: Florida Photography, 1885–1983.* West Palm Beach, Fla.: Norton Gallery & School of Art, 1983. 6 ills. by WE.

Johnson, Brooks. *Mountaineers to Main Streets: The Old Dominion as Seen Through the Farm Security Administration Photographs.* Chrysler Museum, Norfolk, Va., May 3–June 16, 1985. 2 ills. by WE.

Photographs Beget Photographs. Minneapolis Institute of Arts, Minnesota, 1987. 1 ill. by WE. ["After Walker Evans" by Sherrie Levine, plus 8 of Levine's photos from her After Walker Evans series listed, p. 58.]

The Viewer as Voyeur. Whitney Museum of American Art, New York, 1987. [Mixed-media show.]

Nelson, Anne, and Stephen Perloff. *Adolphe Braun, Walker Evans, André Kertész: Photographers of Sculpture: Other Photographers of Sculpture.* Comfort Gallery, Haverford College, Pa., 1988. 11 ills. by WE. ["The Photographic Style of Walker Evans" by William Earle Williams, p. 18.]

The Art of Photography, 1839–1989. Houston, Tex.: Yale University Press in association with the Museum of Fine Arts, Houston; Australian National Gallery, Canberra; and Royal Academy of Arts, London, 1989. 10 ills. by WE, pp. 304–11. [WE's essay "Photography" from *Quality: Its Image in the Arts*, pp. 301–2.]

Hambourg, Maria Morris, and Christopher Phillips. *The New Vision. Photography Between the World Wars.* Ford Motor Company Collection at the Metropolitan Museum of Art, New York. Met-

ropolitan Museum of Art, New York; distributed by Harry N. Abrams, 1989. 6 ills. by WE.

1990s

Southall, Thomas W. *Of Time and Place: Walker Evans and William Christenberry. Untitled No. 51.* The Friends of Photography, San Francisco, and the Amon Carter Museum, Fort Worth, Tex., in association with the University of New Mexico Press, Albuquerque, 1990. 20 black-and-white and 3 color ills. by WE.

Walker Evans and Jane Ninas in New Orleans, 1935–1936. Essay by Jeff L. Rosenheim. Historic New Orleans Collections, 1991. 63 ills. by WE.

Chevrier, Jean-François, Allan Sekula, and Benjamin H. D. Buchloh. *Walker Evans and Dan Graham.* Witte de With, Rotterdam, The Netherlands, and Whitney Museum of Art, New York, 1992. 46 ills. by WE.

Költzsch, Georg-W., Heinz Liesbrock, and Gerd Blum. *Edward Hopper und die Fotografie: die Wahrheit des Sichtbaren.* Cologne: DuMont, 1992. [Museum Folkwang, Essen, 28 Juni–27 September 1992.] WE discussed in chapter entitled "Zum Verhältnis von Bild und Realitiät bei Evans und Hopper" by Gerd Blum, pp. 129–36. 19 ills. by WE.

FILMS AND VIDEOS ON WALKER EVANS

Pakay, Sedat. *Walker Evans: His Time, His Presence, His Silence.* 16mm, 22 min. 1970. Distributed by Film Images/Radim Films, New York. [WE is interviewed at his home where he discusses all major periods of his life.]

Bell, Carol. *"Let Us Now Praise Famous Men": Alabama 40 Years On.* BBC-TV, 16mm, 35 min. 1979. Distributed by Arts Council of Great Britain, London. Directed by Bell. Produced by Alan Yentob. [Interviews with individuals photographed by WE and written about by Agee in the 1930s. Interweaves various families' memories and feelings with words and images from the book.]

Bell, Carol, Alan Yentob, and Robert S. McElvaine. *Let Us Now Praise Famous Men Revisited.* Blue Ridge Mountain Films. 58 min. 1988. Distributed by PBS Video, Alexandria, Va. [Part of the American Experience series.]

Spears, Ross, and Silvia Kersusan. *To Render a Life: "Let Us Now Praise Famous Men" and the Documentary Vision.* Released by the James Agee Film Project. 88 min. 1992. [The film had its premiere in Durham, N.C., on Jan. 24, 1992.]

INDEX

Numbers in italics refer to catalogue numbers.